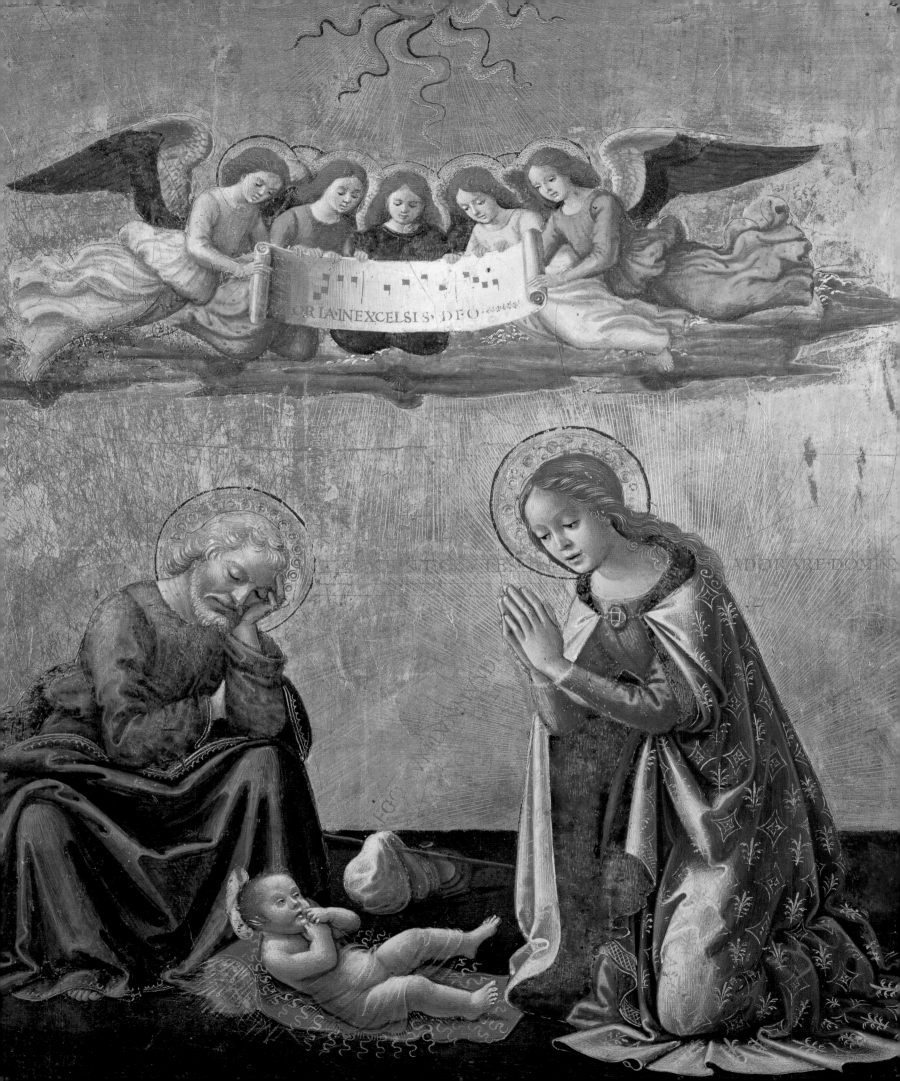

THE INVISIBLE MADE VISIBLE

ANGELS FROM THE VATICAN

Allen Duston, O.P., and Arnold Nesselrath

Art Services International, Alexandria, Virginia 1998

The Invisible Made Visible: Angels from the Vatican
The exhibition is drawn from the Vatican collections and is
organized and circulated by Art Services International,
Alexandria, Virginia.
Copyright © 1998 Art Services International. First edition 1998, second
printing 1999. All rights reserved.

The U.S. exhibition and tour are made possible by a generous grant from
DaimlerChrysler Corporation.

The Canadian exhibition is made possible by generous grants from
Chrysler Canada Ltd., Bell Canada, and the Hill Family.

Alitalia is the official airline of the exhibition.

Library of Congress Cataloging-in-Publication Data
The invisible made visible : angels from the Vatican / Allen Duston
[coordinator of the exhibition] ; Arnold Nesselrath [guest curator].
 p. cm.
 Catalog of a traveling exhibition organized and circulated by Art
Services International.
 Includes bibliographical references (p.) and index.
 ISBN 0-88397-126-7 (hardcover).—ISBN 0-88397-125-9 (pbk.)
 1. Angels in art—Exhibitions. 2. Art—Exhibitions. 3. Art—
Vatican City—Exhibitions. I. Duston, Allen. II. Nesselrath, Arnold.
III. Art Services International.
N8090.I58 1998
704.9'4864'07473—DC21 97-28426
 CIP

Cover: Cat. 2, Baciccia, *Concert of Angels*
Frontispiece: Cat. 33, Il Ghirlandaio, *The Nativity* (detail)

Edited by Jane Sweeney
Designed by Derek Birdsall RDI, Omnific Studios, London
Map of the Vatican City State by Michael Robinson
Printed on Garda Matt 135gsm by Amilcare Pizzi S.p.A., Milan
Printed and bound in Italy

Photo Credits
Photographs kindly supplied by the owners of works of art with the
following additions or substitutions. Cole-Christian essay: figs. 8a, b,
Alinari/Art Resource, N.Y.; fig. 12, © A.C.L., Brussels. Duston essay: figs. 1,
9–14, 17, 20, Vatican Museums; figs. 2, 19, M. Sarri; figs. 3, 15, P. Zigrossi;
fig. 4, L. Ionesco; figs. 7, 18, 21, G. Vasari; fig. 16, Arturo Mari. Sannibale-
Liverani essay: fig. 9, Alinari/Art Resource, N.Y.; figs. 11, 13, Deutsches
Archäologisches Institut, Rome. Nesselrath essay: fig. 3, Istituto Suore
Benedettine di Priscilla; figs. 5, 12, Scala/Art Resource, N.Y.; fig. 6, by
permission of the Director of Antiquities and the Cyprus Museum;
fig. 8, Ryszard Petrafils, Prague; fig. 9, Ingeborg Limmer; fig. 10, Ministero
per i Beni Culturali e Ambientali, Rome; fig. 11, Celia Koerber; fig. 14,
Jörg P. Anders; fig. 15, O. Zimmermann. Catalogue: cats. 34, 35, 52,
74, 97, A. Bracchetti; cat. 36, fig. 3, Novgorodskij gosudarstvenuyj musej-
zapovednik; cat. 41, fig. 1, cat. 54, fig. 2, cat. 55, fig. 1, cat. 71, fig. 2, cat. 92,
fig 1, cat. 96, fig. 2, Alinari/Art Resource, N.Y.; cat. 42, fig. 1, cat. 71, fig. 1,
Ministero per i Beni Culturali e Ambientali, Rome; cat. 46, P. Zigrossi;
cat. 47, fig. 1, Nicola Grifoni and Ministero per i Beni Culturali Ambientali,
Florence; cat. 47, fig. 2, Ministero per i Beni Culturali e Ambientali,
Bologna; cat. 50, figs. 2, 3, Trustees, The National Gallery, London; cat. 56,
fig. 1, Cameraphoto-Arte, Venice; cat. 61, fig. 1, Betina Jacot-Descombes;
cat. 66, figs. 1-3, Jörg P. Anders; cat. 83, fig. 1, Archivio Fotografico
Soprintendenza per i Beni Artistici e Storici, Rome; cat. 92, fig. 2, Fabbrica
di San Pietro in Vaticano, Rome; cat. 97, fig. 1, Studio Basset-Caluire; cat. 98,
fig. 1, C. N. B. & C., Bologna.

CONTENTS

THE ANGELS

From the first pages of the Book of Genesis to the last pages of the
Book of Revelation, Sacred Scripture testifies to the existence and
activity of the spiritual, non-corporeal beings we call "angels."
They belong to the realm of eternity, where they are God's servants
and messengers: the "mighty ones who do his word, hearkening to
the voice of his word" (Ps. 103:20; cf. *Catechism of the Catholic
Church*, 329).

Above all, the angels serve the saving plan of the Incarnate Word.
An angel announces the Saviour's coming. Choirs of angels hail
his birth. Angels protect Jesus in his infancy, serve him in the
desert, strengthen him in his agony in the garden, and proclaim
his resurrection to the astonished women at the empty tomb
(cf. *ibid.*, 333). Angels watch over the first community of the Lord's
disciples and intervene to guide and guard Peter and the others.
They accompany God's people on their pilgim way to the Father's
house. They will be present at Christ's return, when the Son of Man
will come in his glory, "and all the angels with him" (Mt. 25:31).

In her Liturgy and devotion, the Church confesses her faith in the
angels, and invokes their help and protection. She venerates their
memory with special Feastdays. Christian art and literature are full
of angels' stirrings.

Through the angels, the invisible world plays a vital—though
hidden—role in the visible world of man's history. The fallen
angels tempt us away from our filial inheritance. The good angels,
our friends and allies in every suitable action done for God and
neighbour, lead us on the path of holiness, justice and peace with
every other being. Each one of us has a *guardian angel*, our silent
and discreet counselor, whose intercession and watchful care bring
us immeasurable assistance in facing the challenges of life.

May the members of the Church know the angels better and love
them more. May each one of us cherish the friendship of the angel
who is at our side "to light, to guard, to rule and guide." May we
echo on earth the song of the angels in heaven as they praise God's
glory for ever: *Holy, holy, holy Lord, God of power and might!*

Joannes Paulus II

HONORARY COMMITTEE

PRESIDENT
His Eminence Rosalio José Cardinal Castillo Lara
President of the Pontifical Commission for the Vatican City State

MEMBERS
His Eminence Roger Michael Cardinal Mahony
Archbishop of Los Angeles

His Eminence William Henry Cardinal Keeler
Archbishop of Baltimore

His Eminence Adam Joseph Cardinal Maida
Archbishop of Detroit

The Most Reverend Agostino Cacciavillan
Apostolic Pro-Nuncio to the United States of America

The Most Reverend Justin Francis Rigali
Archbishop of St. Louis

The Most Reverend Joseph Keith Symons
Bishop of Palm Beach

The Most Reverend Gianni Danzi
Secretary of the Pontifical Commission for the Vatican City State

Marquis Giulio Sacchetti
Special Delegate of the Pontifical Commission for the Vatican City State

It gives me a great deal of pleasure to send this exhibition from the Vatican to the participating museums in the United States. More than four years ago, the Patrons of the Arts in the Vatican Museums expressed the hope that the Vatican exhibition in 1983 would have a successor. This hope has come to pass in *The Invisible Made Visible: Angels from the Vatican*, which is the fruit of much cooperation here and in the United States. I am certain that the focus of this exhibition, angels, will be especially appreciated in the United States, where there has been an increasing interest in the subject.

The catalogue that accompanies this exhibition is outstanding for both its presentation and its content. It is enriched by a beautiful page written by the Holy Father on the theology of angels. The introductory essays describe the meaning of angels in the Judeo-Christian religious tradition as well as their artistic and iconographic history. The viewer thus gains the accurate historical and religious perspective from which to contemplate and enjoy the exhibition. These works of art and what they represent help to better understand these intermediaries between God and man, these beings of ineffable beauty and light who speak of the divine source of all.

The preparation of such an exhibition with its accompanying publication is a complex undertaking. I would like to thank those in the Vatican who have given so generously of their time and talents; Art Services International for its organizational expertise; the Chrysler Corporation for its generous sponsorship; and the Patrons of the Arts in the Vatican Museums for their continuous generosity to the Vatican Museums and for their encouragement in making this exhibition a reality.

My sincere best wishes for the success of the exhibition and my prayers go not only to those who have prepared the exhibition, but also to the hundreds of thousands of Americans who will have the opportunity to view and experience angels from the Vatican.

Rosalio José Cardinal Castillo Lara
President of the Pontifical Commission for the Vatican City State

ACKNOWLEDGMENTS

The subject of *The Invisible Made Visible: Angels from the Vatican* strikes an immediate chord in the hearts of its audience. Visualizing these evanescent beings, who were created to act as intermediaries between heaven and earth, has been the province of artists for millennia. In this exhibition and catalogue, the rich collections of the Vatican have provided a superb opportunity to view a broad range of artistic treatments of angels and to study their iconography.

Art Services International is immeasurably honored that Pope John Paul II has lent his benevolent attention to this project. The patronage of His Holiness inspires our gratitude and attests to the significance of this endeavor. His Eminence Rosalio Josè Cardinal Castillo Lara, President of the Pontifical Commission for the Vatican City State, has supported this project from the outset, and we commend him for entrusting the Vatican's treasures to the exhibition.

We are proud to credit the thesis of the exhibition to Fr. Allen Duston, O. P., Representative of the Pontifical Commission of the Vatican City State to the Patrons of the Arts in the Vatican Museums. The enthusiasm that the project has evoked from the outset is evidence of his astute judgment. Collaborating with him could not have been more gratifying, and we are pleased to recognize his fundamental place in the formation and realization of this enterprise, extending to his contribution of an essay for this catalogue. Dr. Francesco Buranelli, Acting Director General of the Vatican Museums, is to be remembered for his support and encouragement of the project. We thank Dr. Edith Cicerchia, Secretary of the Vatican Museums, and Dr. Francesco Riccardi, Administrator for the Vatican Museums, for appreciating the worth of this exhibition and for providing crucial assistance. We further acknowledge Dr. Alessandra Uncini, Assistant of the General Inventory and Head of the Office for Exhibitions at the Vatican, and Dr. Andrea Carignani, whose efficiency has been indispensable in making the arrangements for the tour.

The realization of this undertaking is the direct result of DaimlerChrysler Corporation's generosity and commitment in supporting cultural enrichment in the United States. We are indebted to Robert J. Eaton, Chairman, for his immediate appreciation of the benefits of this project and his full endorsement. In addition we are pleased to recognize A.C. (Bud) Liebler, Senior Vice President-Marketing, and W. Frank Fountain, Senior Vice President-Government Affairs, for their vision and their support. For the Canadian venue we are once again grateful to Chrysler Canada Ltd., and in particular to Bob Renaud, Vice President-Marketing, Larry Latta, Vice President-Sales and Service, Othmar Stein, Vice President-Public Relations, and J. H. MacDonald, Marketing Promotions Manager, for their enthusiastic support of the exhibition's presentation at the Art Gallery of Ontario. To DaimlerChrysler as a whole, the members of their Supervisory and Management Boards, employees, stockholders, and automobile dealer network, we express the most sincere gratitude for making this rich cultural experience possible. We also wish to rec-

ognize Bell Canada for their commitment to the arts and their enthusiastic support of the Canadian exhibition -- in particular Lynton R. Wilson, Chairman of the Board of BCE, Jean C. Monty, Chairman and Chief Executive - Bell Canada, John W. Sheridan, Executive Vice President - President Ontario and Kenneth R. Gingerich, Associate Director of Public Affairs. We are also grateful to the Hill Family - specifically Frederick, Carol and Paul - for their involvement was crucial in ensuring that this exhibition be presented for the benefit of Canadian audiences. Our appreciation goes also to John E. Connelly, Chief Executive Officer, J. Edward Connelly Associates, Pittsburgh, for helping us to forge this bond as well as for his dedicated efforts to expand the success of the exhibition.

This presentation is dedicated to the Patrons of the Arts in the Vatican Museums, whose mission is to support the conservation of works of art in the Vatican so that they may be displayed now and preserved for future generations. They deserve our most special thanks for their endeavors, which have directly benefited the works of art in this exhibition, and we are pleased to acknowledge individually the members of this group who have sponsored conservation projects. It is the good fortune of both Art Services International and the Patrons of the Arts in the Vatican Museums that they share in the generous dedication of Roma S. Crocker as Trustee and Chairman of the D.C. Chapter, respectively. Her conviction - that the art collections so fundamental to the good works of the Vatican are one of its greatest ambassadors - soon became ours. The benefits of the alliance are manifest in this project.

We wish to identify Maurizio De Luca, Chief Painting Restorer, and Nazzareno Gabrielli, Director of Scientific Research, as supporters of the project from the very beginning. To them and the Vatican conservators goes credit for the sparkling appearance of these works of art and for the scientific knowledge that their examinations have given us.

We are delighted to acknowledge our colleagues at the museums hosting the exhibition, for it is through them that the American and Canadian people may benefit from the exhibition. We thank Henry T. Hopkins, Director, and Cynthia Burlingham, Acting Chief Curator, UCLA at the Armand Hammer Museum of Art and Cultural Center, Los Angeles; Dr. James D. Burke, Director, and Dr. Sidney M. Goldstein, Associate Director, Saint Louis Art Museum; Samuel Sachs II, Director, and Tara Robinson, Coordinator of Exhibitions, The Detroit Institute of Arts; Dr. Gary Vikan, Director, and Dr. Marianna S. Simpson, Assistant Director for Curatorial Affairs, The Walters Art Gallery, Baltimore; Dr. Christina Orr-Cahall, Director, and David Setford, Curator, Norton Museum of Art, West Palm Beach; and Matthew Teitelbaum, Director, and Jill Cuthbertson, Project Coordinator, Art Gallery of Ontario, Toronto.

It is the catalogue that will continue to reach new audiences after the works of art are returned to their different repositories at the Vatican, and we enthusiastically commend the authors for the fine scholarship and graceful writing evident in this volume. Led by Fr. Duston and Prof.

Arnold Nesselrath, Guest Curator of the exhibition, our essayists and the authors of the scholarly entries are acknowledged on page 16. We are extremely grateful for their diligence and for the illuminating results of their efforts. Our translators, too, deserve notice for their role in bringing the luster of the authors' words to our language. Translations were provided by Lisa Dasteel, Leonora Dodsworth, Jennifer Grego, Iris Jones, Lorna Maher, Henry McConnachie, Speer Ogle, Eugene Rizzo, and Peter Spring, who also compiled the Glossary. It is a pleasure to distinguish Patricia Bonicatti for her untiring skill in orchestrating the work of the authors and translators and Dr. Guido Cornini for his very special expertise in obtaining the photography for the catalogue. They did much to ensure that a multitude of parts were blended into a seamless whole. We wish to credit also Sara Savoldello, Maria Bernett, and Rosanna Di Pinto for their continuing and invaluable assistance. We thank the photographic librarians and archivists who made exceptional efforts to provide the many comparative illustrations throughout the volume. In particular, we single out Luisa Orto at Art Resource, New York, Suor Maria Francesca at the Istituto Suore Benedettine di Priscilla, Rome, and Suzanne Warner at Yale University Art Gallery. The efforts of these dedicated individuals were given their final form through the expertise of our editor Jane Sweeney, our designer extraordinaire Derek Birdsall of Omnific Studios, London, and our printer Amilcare Pizzi S.p.A., Milan. Art Services International is honored to have collaborated with such outstanding professionals.

We are grateful to Alitalia, the official airline of the exhibition, and particularly to Dr. Salvatore Colantuoni, Public Relations Manager, Rome, and Marta-Marie Lotti, Manager of Press and Public Relations, New York, for their confidence and support.

It is a pleasure to acknowledge Julien Stock of Sotheby's, London, for his invaluable assistance. Also instrumental in the realization of this project have been Jack McNamara, Mary T. Graettinger, Greg Bogich, Sue Coffin, William McDonald, Harold Campbell, Sergio Gobbi, Elizabeth Heil, Msgr. Robert Zagnoli, and Msgr. Pietro Amato.

We are continually gratified with the expertise of the staff of Art Services International in arranging and implementing the details of the exhibition and its tour: Ana Maria Lim, Douglas Shawn, Donna Elliott, Betty Kahler, Mina Koochekzadeh, Sally Thomas, Sheryl Kreischer, and Kerri Spitler. We thank them for their dedication and for their splendid achievement.

Lynn K. Rogerson Joseph W. Saunders
Director Chief Executive Officer

Art Services International

UCLA at the Armand Hammer Museum of Art and Cultural Center
Los Angeles, California

Saint Louis Art Museum
Saint Louis, Missouri

The Detroit Institute of Arts
Detroit, Michigan

The Walters Art Gallery
Baltimore, Maryland

Norton Museum of Art
West Palm Beach, Florida

Art Gallery of Ontario
Toronto, Ontario

DAIMLERCHRYSLER

Throughout the ages, mankind has called upon angels in every language and by many names. Common men, women and children everywhere have looked to them for guidance and protection and to serve as their intermediary to their Supreme Being. Artists have employed their special creative gifts in visualizing these usually unseen beings in stone and marble, in frescoes and tapestries, and in all manner of paintings.

For almost 500 years some of the world's most beautiful depictions of angels have been housed, appropriately, in the Vatican Museums. Many of these magnificent objects have never visited America. Until now.

DaimlerChrysler Corporation is proud to bring *The Invisible Made Visible: Angels from the Vatican* to the United States. We are humbled by the genius that created the individual works of art and awed not only by their beauty but also by the sacred beliefs and traditions they represent. We hope this exhibition, like the angels themselves, will help lead all of us who experience it more humanely and more peacefully into the next millennium. At the very least, we hope you will enjoy the exhibition and appreciate its significance.

At DaimlerChrysler Corporation we believe in the value of the arts and recognize arts and cultural support as a Corporate responsibility, as a way of giving back to the communities in which we live and operate. We're proud to bring you *The Invisible Made Visible: Angels from the Vatican*. We encourage you to support this exhibition and other arts and cultural programs whenever and wherever you can.

On behalf of the employees of DaimlerChrysler Corporation and of our dealers, thank you for attending. We hope you will find this magnificent collection memorable.

Robert J. Eaton
Chairman
DaimlerChrysler Corporation

PATRONS OF THE ARTS IN THE VATICAN MUSEUMS

California Chapter
Florida Chapter
International Chapter
London, England, Chapter
Massachusetts Chapter
Midwest Chapter
New York Chapter
Pennsylvania Chapter
Philadelphia Chapter
South Carolina Chapter
Southern United States Chapter
Texas Chapter
Washington, D.C., Chapter

SPONSORS OF CONSERVATION IN THIS EXHIBITION

Marilyn and James M. Augur
Maria E. Bernett
Dr. David, Leann, Hunter, and Taylor Benvenuti
Joseph J. Bianco
Dr. and Mrs. Joseph V. Braddock
John J. Brogan
Mrs. Dillon-Smyth Crocker
Mr. and Mrs. Robert A. Day and Family
Mr. and Mrs. T. J. Day
The Willametta K. Day Foundation
Helen Duston
Florence B. D'Urso
Bill, Lorraine, and Corinne Dodero
Mr. and Mrs. Samuel J. Frankino
Mr. and Mrs. James P. Kelly
Marcia Pond MacNaughton
James, Angie, Thomas, Siobhan, and James III McNamara
Nelson Angelo Monteleone
Lucille G. Murchison
Lucia Nielsen Musso
Helen Nielsen
Mr. and Mrs. James B. Rettig
Percy P. Steinhart III
John H. Surovek
Allen Wright Thrasher
John Edward Toole
Eric F. Green and Jock Truman
Mr. and Mrs. Leo A. Vecellio, Jr.
Mary M. Viator
Kathleen Waters

FOREWORD

Like living beings, art treasures are subject to the wear and tear of time and environment. To ensure that the great collections of the Vatican Museums will be available for the edification, enjoyment, and spiritual guidance of future generations as they have been to those of the past, the Patrons of the Arts in the Vatican Museums was formed in the early 1980s. The impetus for the founding of the organization was the restoration of art objects to tour the United States in the 1983 exhibition *The Vatican Collections: The Papacy and Art.*

The conservation and restoration of objects of art from all ages and cultures, as preserved in the Vatican Museums, remains to this day the patrons' primary goal. The restoration of the paintings and sculpture in this, the second exhibition to tour America from the Vatican, *The Invisible Made Visible: Angels from the Vatican*, has been accomplished with the help of the many members of this organization whose names can be found on the opposite page. Pope John Paul II recognized their devotion at a special audience for the group in April 1997 when he said, "Your patronage enables the Vatican Museums to offer a unique witness to spiritual values as it opens its doors each day to visitors from widely different backgrounds and from every part of the world."

From its inception, *The Invisible Made Visible: Angels from the Vatican* has had three principal goals. Because not everyone has the opportunity to travel to Rome and the Vatican, the first objective is to allow many people in the United States an opportunity to benefit from some of the works of art in the Vatican collections. Second, we wish to thank our American patrons of the Vatican Museums for not only their ongoing generosity and dedication to the cause of helping to conserve what has been entrusted to us, but also their service as articulate ambassadors for the Vatican Museums. And third, we hope that this exhibition—which originated at the request of our patrons—will serve as a catalyst for publicizing our activities.

We encourage everyone to join us in this great work. It is our hope that this exhibition will not only demonstrate the diversity and beauty of the works of art from all times and cultures housed in the Vatican, but also move people to assist the patrons in preserving this important world cultural heritage. This Herculean task has been made possible by their dedication and generosity of heart.

Those who are interested in joining us as Patrons of the Arts in the Vatican Museums may learn more about the Patrons through the Vatican web site (www.vatican.va). My sincere thanks for your interest.

Allen Duston, O.P.
Patrons of the Arts in the Vatican Museums

The strong cultural bonds that have for many years forged close contacts between the most important American cultural institutions and the Vatican Museums give rise to this exceptional exhibition. It is designed to bring to a wider audience the artistic treasures that the Vatican has for centuries commissioned, safeguarded, diffused, and promoted as an important heritage of mankind. The present exhibition is devoted to angels and how they have been represented through the centuries. To anyone visiting the rooms of the exhibition or turning over the pages of this catalogue, it will become clear that the image of angels has varied in the history of art; it has altered in response to changing times, changing artistic styles, changing cultural situations. But the visitor will also be aware how substantially unchanged angels have remained, right up to our own day, in the collective imagination and how charged they have always been with a particular fascination that transcends all fashions and styles. In giving form to these purely spiritual beings, each artist has given expression, on the one hand, to man's most intimate yearnings for contact with God effected through celestial messengers and for the protection provided by guardian angels, and, on the other, to his most uncontrollable fears of the avenging angels as seen in the expulsion from Eden and the Apocalypse.

The works on display may be divided into two groups. The ancient Assyrian, Etruscan, and Greco-Roman images comprise significant iconographic precedents from which the typology of angels has developed. This group consists of sculptures, sarcophagi, cinerary urns, and vases, in which winged beings, *eroti*, and *nikai* are represented, and Etruscan mirrors and candelabra adorned with figures of *lasas* and other similar winged figures. Second is a heterogeneous group consisting of panel paintings, canvases, paintings on paper, a fresco, tapestries, liturgical furnishings in metal and wood, liturgical vestments, marble reliefs, and glazed terra-cottas. These more recent objects are datable from the Middle Ages to our own day and have an iconographic common denominator, angels, whether incorporated in Old and New Testament scenes, represented as isolated figures, or forming part of symbolic representations such as the Deisis or the Trinity.

From these varied images, the evolution of the figure of the angel clearly emerges. In Christian iconography the first representations of angels are in the form of divine messengers. This role corresponds to the meaning of their name (Greek *angelos*, meaning herald). Initially the type, represented as a beardless youth dressed in tunic and pallium, was devoid of wings; only in the fourth century was the figure of the angel enriched with wings and nimbus. In funerary art the angel represents divine assistance, the intermediary between God and man. In scenes of *Maestàs*, Christ and the Virgin Mary appear surrounded by a throng of angels, just as the ancient Roman emperor appears in official representations with his entourage of dignitaries.

Angels are never precisely described in the Bible. We may note in sacred texts, however, a progressive change in the image and tasks of angels: at first they are custodians and guardians, perhaps with a non-human appearance, and later they seem to assume a clearly human appearance, in

contact with the world of Greek culture. Angels, of course, are never represented in Jewish art, which deliberately eschewed the representation of the human figure.

It was only in the Roman West that these figures, generically described as "radiant" or "shining" and with clearly human attributes, acquired physiognomy and characteristics borrowed or transformed from the pagan iconographic repertoire and from mythological beings well known in antiquity, which were considered mediators between the divine world, celestial or infernal, and the terrestrial world. Vanths, *lasas*, winged victories, *genii* and *eroti*, and Mercury (the Greek Hermes), the winged messenger par excellence, endowed the traditional iconography of angels with their youthful features and what was to become their most recognizable attribute, their wings. White or polychrome, broad and robust like those of the archangels or small and vibrant like those of the putti, wings characterize these celestial companions of ours throughout art, from the Early Christian period down to our own day.

In the Old and New Testaments, angels fulfill an important function. They are protagonists of meetings with men and women, to whom they bring divine messages and in favor of whom they intervene. Angels intervene in the life of the protagonists of the Old Testament and accompany, step by step, the human life of Jesus, from his conception to his Resurrection. In particular, they assist and protect Joseph: they reveal to him the mystery of the birth of the Savior; they rouse him from his slumber; they place him on his guard against danger; they show him the way, in much the same way as they do with all of us, who are often perturbed by events that we fail to understand. To Mary, on the other hand, already willing to understand and obey, their role is merely that of messengers of the divine will. In the case of Jesus, angels are the mouthpiece of glad tidings, the festive chorus that announces his birth; they look after him in the wilderness and console him during the Passion; they become, at the end of Christ's mortal life, the single radiant angel seated on the stone rolled away from the tomb. Familiar to us from Holy Scripture are these archangels, protagonists of countless paintings and frescoes, each with its own characteristics. We known them by name and even, I would say, by temperament: Raphael the traveling companion of Tobias; the warrior Michael, sword of the Lord; the heavenly messenger Gabriel, vehement in word and radiant in sudden apparition: "Rejoice, so highly favored! The Lord is with you" (Luke 1:28). Then we have the hosts of angels that provide a glory around God. They adore him and serve him: "I heard the sound of an immense number of angels gathered round the throne … there were ten thousand times ten thousand of them and thousands upon thousands" (Rev 5:11). These infinite hosts of angels surround God, Christ, and the Virgin, are present in countless sacred paintings and have, in art as in faith, the task of providing an intermediary between us and the ineffable celestial divinity, to prefigure it in some sense in the limited human mind, to reflect our feelings, and to guide our steps toward the Father, silent but ever-present companions at our side.

The wisest of religious minds—theologians, Doctors of the Church, and ecclesiastical writers—have disserted with wisdom and doctrinal

subtlety on the nature of angels, on their function, and even (proverbially) on their sex. Yet there is little doubt that the essence of angels has been conveyed to each of us by the images that artists of all ages have created and that in every Western culture have been reproduced ad infinitum. Each of us imagines the angel of the Lord in the way that the artists throughout the ages have depicted him: child, adolescent, or young man, of resplendent beauty and equipped with wings that suspend him between the earth, to which he is drawn by his duty as messenger and the care of the human beings entrusted to him, and the heavens to which he is called by the irresistible love of God.

I would like to express my warm gratitude to my superiors who authorized and supported this exhibition and enabled it to be realized: to the Holy See's Secretary of State, His Eminence Cardinal Angelo Sodano; to the President of the Pontifical Commission for the Vatican City State, His Eminence Rosalio José Cardinal Castillo Lara; to the Vicar of Rome, His Eminence Camillo Cardinal Ruini; to the late Archpriest of the Patriarchal Liberian Basilica of Santa Maria Maggiore, His Eminence Ugo Cardinal Poletti; to the Master of the Liturgical Celebrations of the Supreme Pontiff, Msgr. Piero Marini; and to the Special Delegate of the Pontifical Commission for the State of Vatican City, His Excellency Marchese Don Giulio Sacchetti. I also wish to express my deep thanks to Art Services International for their generous and expert collaboration and to the Patrons of the Arts in the Vatican Museums for their constant participation in our cultural initiatives. Finally, it is my pleasure to acknowledge the valuable contribution made by the members of the Vatican Museums' staff, too many to be listed here, without whom it would not have been possible to realize this exhibition.

Francesco Buranelli
Acting Director General of the Vatican Museums

Vatican Museums
Administration of the Patrimony of the Apostolic See
Office of the Liturgical Celebrations of the Supreme Pontiff
Chapter of the Basilica of Saint John Lateran
Chapter of the Basilica of S. Maria Maggiore

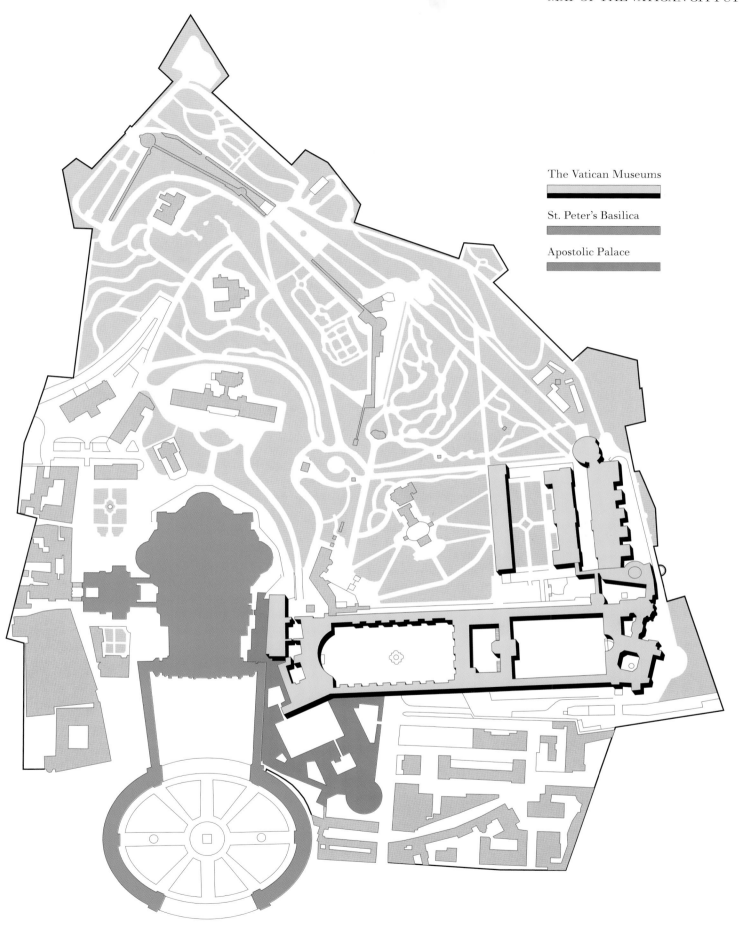

The Vatican Museums

St. Peter's Basilica

Apostolic Palace

PAPAL PATRONAGE AND COLLECTING THROUGH THE CENTURIES

Allen Duston, O.P.

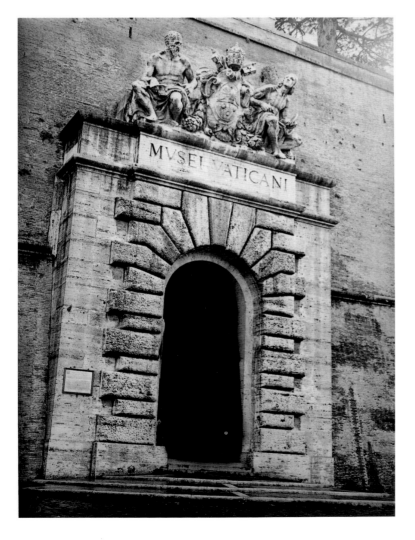

The Vatican Museums

Above the entrance to the Vatican Museums are two large recumbent stone figures representing Michelangelo Buonarotti of Florence and Raphael Sanzio of Urbino (fig. 1). These two artists represent the genius of the Italian Renaissance, and the majority of the visitors who stream through this entrance come to see their work. Art lovers seek to immerse themselves in the light and beauty of the images on the walls and ceiling of the Sistine Chapel and the Apartment of Pope Julius II. There is a direct link between these artists and today's visitors that is the legacy of Pope Julius II della Rovere (1503–13). It was he, the genius behind the geniuses so to speak, who brought Michelangelo and Raphael to work in the Vatican. He also began the first papal collection of sculpture, which over almost five hundred years expanded to become the Pontifical Monuments, Museums, and Galleries.

For the most part, the Renaissance popes were men of great culture and learning. They had an interest in many fields of study and human expression, among which were art, architecture, and book collecting. In the Vatican this translated itself into private collections of manuscripts and books that eventually became the nucleus of the Apostolic Library initiated under Pope Sixtus IV della Rovere (1471–84). The collections of sculpture and paintings eventually became the Vatican Museums.

In 1506, Pope Julius II placed several important pieces of classical sculpture, which he acquired for the papal collection, in the courtyard of the Belvedere summer palace built by his predecessor Innocent VIII Cibo (1484–92). Among these were the *Apollo Belvedere* and the *Laöcoon*, which can be seen there today (fig. 2). Throughout most of the sixteenth century, Julius II's successors continued to transform and adorn the private papal gardens and the summer palace with important sculpture of ancient Rome, including the *Belvedere Torso* and the Hermes now identified as the *Antinous*. This collection became known as the Antiquarium of the Statues (Antiquario delle Statue) and was accessible to men of letters, artists, and thinkers of the day. Many great artists visited to study and copy these masterpieces of antiquity, including Raphael, Bramante, and Michelangelo, whose works in painting, architecture, and sculpture transformed and embellished the Vatican for future generations.

In the late sixteenth and seventeenth centuries, the popes spent a great deal of their energy on doctrinal and ecclesiastical matters that had been challenged by the Protestant Reform, in turn opposed by the Counter-Reformation. During these years, the Basilica of St. Peter's was finished, and the colonnade was constructed under the guiding genius of Gian Lorenzo Bernini. However, the private art collections of the popes were untouched.

At the beginning of the eighteenth century, Pope Clement XI Albani (1700–21) assembled a museum in the Belvedere Palace, which consisted principally of carved inscriptions, most often from the Roman catacombs, and bas-reliefs collected as historical documents. These and several private collections given to the popes, containing ancient coins, bronze and ivory statuettes, vases, and paintings, formed the nucleus of the Profane Museum (Museo Profano) and the Christian Museum (Museo Cristiano). They were established as part of the Apostolic Library and continue to exist today. Thus there were two distinct collections of ancient art and artifacts in the Vatican until the pontificate of Clement XIV Ganganelli (1769–74): The Antiquarium in the Belvedere Palace, unchanged

since the middle of the sixteenth century, and the Vatican Museums proper in the Apostolic Library, divided into sacred and profane sections.

Clement XIV and his treasurer, Giovanni Angelo Braschi, the future Pope Pius VI (1775–99), were concerned about the dispersion of Roman antiquities from the Papal States. Rome was the center of the European trade in these objects, most of which came from Italy, and were sold particularly to English, German, and Russian dealers and collectors. Legislation was introduced to stem the flow, and hence new acquisitions found their way into the papal collections. With this sudden increase, a new museum was needed to house the works. The Belvedere Palace was transformed with new interiors and additions inspired by the architecture of ancient Rome. The old and new were joined ingeniously by use of ancient materials such as columns, capitals, and paving mosaics, creating well-articulated spaces with varying perspectives in a harmonious environment. The original courtyard containing the Antiquarium was rearranged with a new portico, and the galleries of the museum were linked to the library by means of the grand staircase designed by Michelangelo Simonetti (fig. 3). This was opened in 1784. Work continued in the refinement of the spaces and the addition of ceiling frescoes, stucco work, and two more galleries above the library corridor: the Gallery of the Candelabra (Galleria dei Candelabri), containing more Roman sculpture, inscriptions, and candelabra, and the first Picture Gallery

Fig. 1. Entrance to the Vatican Museums

Fig. 2. View of the Octagonal Courtyard of the Belvedere Palace

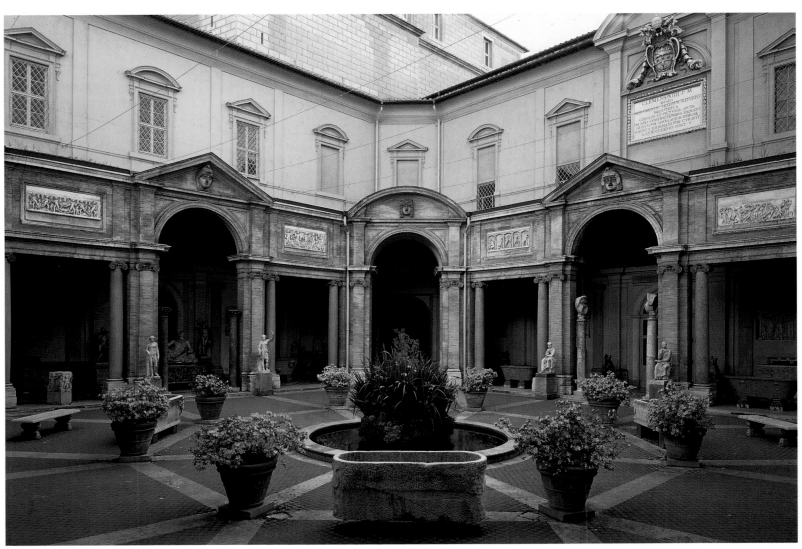

(Pinacoteca). Begun under the pontificate of Clement XIV, this new museum complex was known as the Clementinum Museum (Museo Clementino); to honor the two popes who collaborated on the structure as well as the contents of the collections, it was later renamed the Pio-Clementine Museum (Museo Pio Clementino) as it is known today.

The pontificate of Pius VI ended during the chaos created by the French Revolution and the rise of Napoleon Bonaparte. Napoleon's armies occupied most of Europe, including the Papal States. All of the conquered territories were obliged to subscribe to the Treaty of Tolentino (1797), which required that important works of art be ceded to the French Republic. These works from the Vatican, including Roman sculpture and paintings from the museum as well as manuscripts, coins, cameos, and gems from the library and archives, were dispatched to Paris between April and June of 1797 and displayed in the Musée Napoléon in the palace of the Louvre (fig. 4). To add insult to injury, Pope Pius VI himself was taken prisoner by the French and died in exile in Valence in 1799.

Fig. 3. Anonymous (Bernardino Nocchi?), *Simonetti Stairway*, c. 1780, tempera. Vatican Museums, inv. 16430

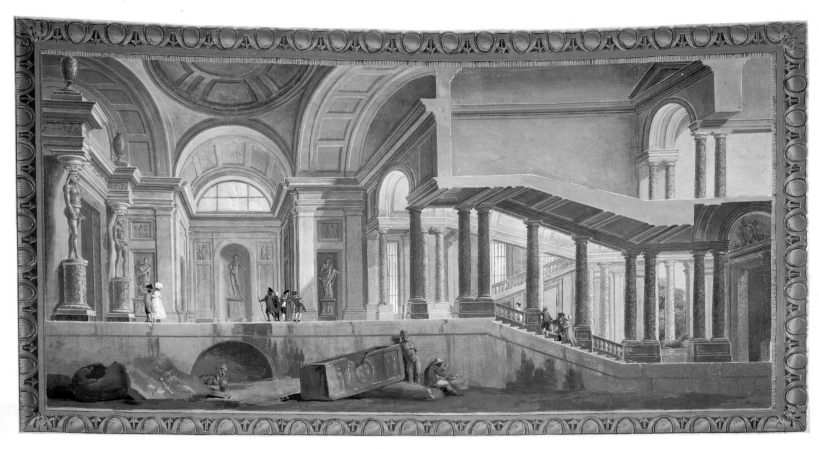

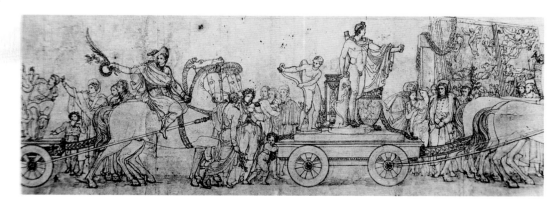

Fig. 4. Achille-Joseph Etienne Valois, *The Triumphal Arrival in Paris of Works of Art from the Vatican in 1798* (detail), drawing. Manufacture Nationale de Sèvres

His successor, Pope Pius VII Chiaramonti (1800–23), was elected in Venice and triumphantly returned to Rome later in the same year. In order to shore up the exhausted Vatican collections, yet another law was passed in 1802 prohibiting the export of art from the Papal States. It also required that those with aesthetic objects to sell first present them for inspection and possible acquisition by the Vatican. At the same time an annual sum of ten thousand *scudi* was allotted, and a commission of experts was set up to carry out the acquisitions. The sculptor Antonio Canova became director of fine arts for the Papal States and a member of the commission. Newly acquired works, many of them Roman antiquities, began to fill some of the gaps left by Napoleon's avarice. However, the Picture Gallery had been decimated and was closed, and the few remaining paintings dispersed throughout the Apostolic Palace.

In 1805, work began on a new museum, which was called the Chiaramonti Museum (Museo Chiaramonti) in honor of Pius VII. This was located in the Corridor of Bramante, which is approximately 318 m (1,043 ft.) long. It had been constructed at the beginning of the sixteenth century to link the Papal Apartment of Julius II with the Belvedere Palace in the Vatican gardens. Half of the corridor was dedicated to antiquities from the Papal States acquired after the law of 1802 (fig. 5). The other half was used for the Lapidary Gallery (Galleria Lapidaria) containing Greek, Roman, and early Christian inscriptions (fig. 6). Today both of these collections are preserved in the same enormous gallery.

After the fall of Napoleon in 1814, the Congress of Vienna ruled that works of art removed by the French were to be returned to their rightful owners. Canova was appointed Papal Plenipotentiary for the recovery of works of art and arrived in Paris in August 1815 to retrieve the objects plundered from Rome and the Papal States. His work, though obstructed by the French, was eventually successful thanks to the intervention of the allies, especially the English. A majority of the treasures, though by no means all, from both the museum and the library found their way back to the Vatican.

Fig. 5. Anonymous, *Chiaramonti Museum in the Corridor of Bramante*, 1878, engraving. From F. Way, *I Musei del Vaticano* (Milan, 1878)

Fig. 6. Anonymous, *Allegory of the Founding of the Lapidary Gallery*, 1818, fresco. Vatican Museums

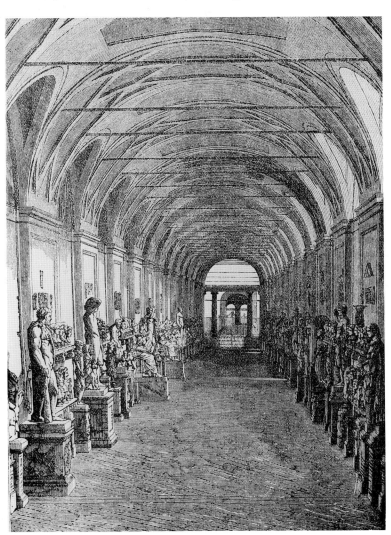

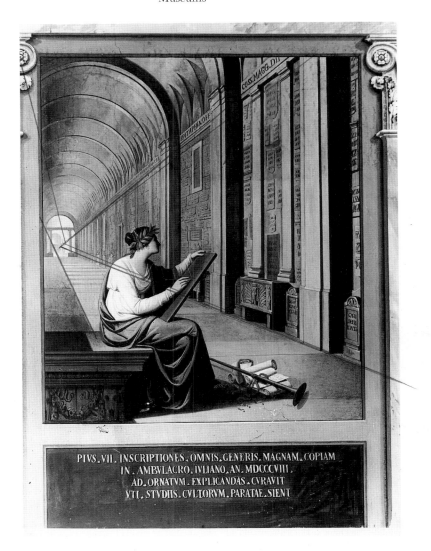

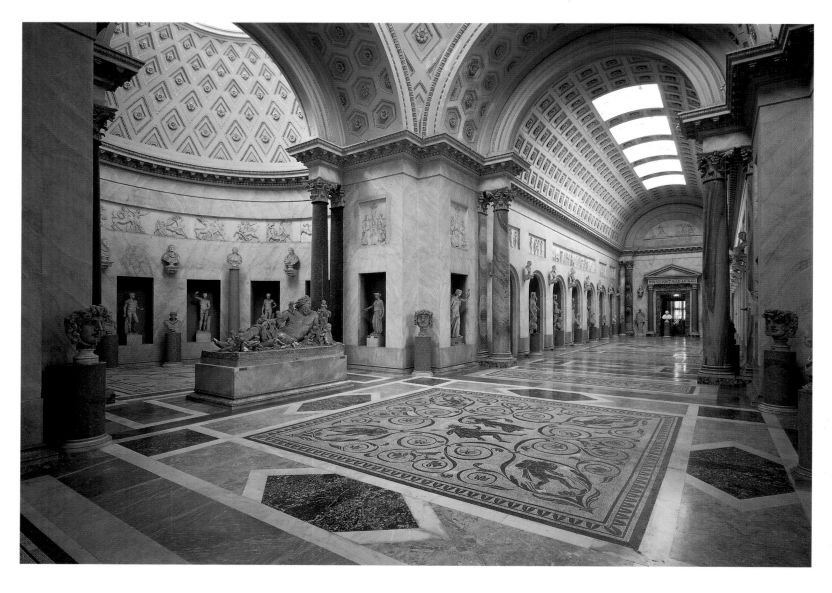

Fig. 7. The Braccio Nuovo in 1992

Fig. 8. Anonymous, *Pope Gregory XVI Visits the Gregorian Etruscan Museum*, 19th century, engraving. Vatican Museums

Pope Pius VII's continued interest in the fine arts and his delight at seeing the recovered works resulted in the creation of a new wing for the Chiaramonti Museum, the reestablishment of the Picture Gallery, and the reconstitution of the acquisition commission, which eagerly set to work expanding the Vatican collections. Egyptian sculpture, which later formed the nucleus of the Egyptian Museum, came to the collection at that time. The new gallery of the Chiaramonti Museum was called the New Wing (Braccio Nuovo). It was designed in a neoclassical style by Raffaelle Stern, with enormous skylights in the barrel-vaulted ceiling to illuminate the Roman sculpture, mosaics, columns, and antique reliefs exhibited there. The work was completed and dedicated by Pius VII in 1822 (fig. 7).

The Picture Gallery was composed mainly of the paintings returned from Paris, many of which had come originally from convents and churches throughout the Papal States. Works by Perugino, Raphael, Fra Angelico, Barocci, Domenichino, and Caravaggio augmented the collection. Until the twentieth century, the paintings were moved from one part of the Apostolic Palace to another because there was not sufficient gallery space to display them. Pius VII installed them in the Borgia Apartments, and only in 1932 did they find their home in a proper picture gallery built specifically for that purpose.

The pontificate of Gregory XVI Cappellari (1831–46) marked another period of great activity in the Vatican Museums. Ever-increasing interest in Etruria and Etruscan art, sparked by discoveries unearthed at new archaeological sites in the Papal States, made it necessary for the pope to protect this ancient Italian cultural heritage. He did so by promulgating new laws forbidding the exportation of Etruscan art and artifacts from the Papal States, by founding the Pontifical Academy of Archaeology to oversee all excavations, and by establishing in the Vatican the Gregorian Etruscan Museum (Museo Gregoriano Etrusco). Named in his honor and inaugurated in 1837, it contains sculpture, bronzes, terra-cottas, gold work, inscriptions, Greek and Etruscan vases, and furnishings found in the Etruscan necropolises (fig. 8).

Pope Gregory XVI founded yet another museum in the Vatican related to the deciphering of Egyptian hieroglyphics by Jean François Champollion in 1818 and the subsequent Egyptomania that swept Europe. Champollion, a French archaeologist and epigrapher, was supported in his work by the Vatican and hence formed a close relationship with many scholars and archaeologists at the papal court, with whom he deciphered ancient papyri and monuments. Pope Gregory XVI followed with great eagerness contemporary developments in archaeology and philology. His fascination with Egyptology and his interest in the humanities, with their implications for biblical theology, sparked his desire to establish several archaeological collections. In 1839 he founded the Egyptian Museum, which was the first in Europe established solely for the purpose of enhancing the public's understanding of Egyptian art and culture. The Gregorian Egyptian Museum (Museo Gregoriano Egizio) contains monumental sculpture and other Egyptian art and artifacts collected over the late eighteenth and early nineteenth centuries by popes, missionaries, and archaeologists. Gregory XVI personally selected most of the works for his museum (fig. 9).

Gregory's keen interest in the preservation of the past for study and enjoyment is responsible for another museum that opened during the last year of his pontificate in the former papal residence beside the cathedral of Rome, Saint John Lateran. It housed Greco-Roman antiquities that continued to accumulate within the Vatican palaces. With little room left within the Vatican walls for yet another collection, in 1846 the Lateran Profane Museum (Museo Profano Lateranense) and a small Lateran Picture Gallery (Pinacoteca Lateranense) were inaugurated in the Lateran Palace. Some one hundred years later, both of these collections found their way back to the Vatican Museums, where they are today.

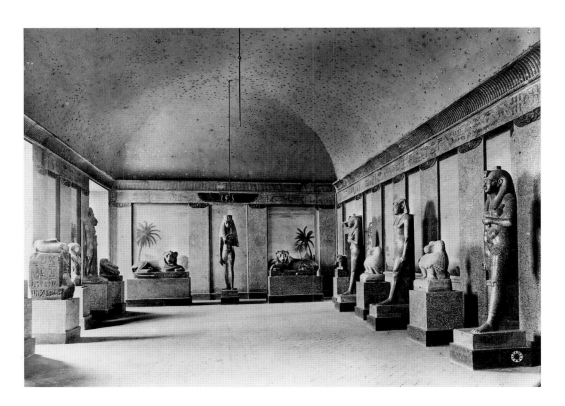

Fig. 9. Former installation at the Gregorian Egyptian Museum

Gregory's successor, Pope Pius IX Mastai-Ferretti (1846–78), though often preoccupied with political upheaval in the Papal States and the formation of the Italian Republic, still found time to establish a new museum. The Pius Christian Museum (Museo Pio Cristiano) that bears his name was opened in 1854 in the Lateran Palace. Renewed interest during the mid-nineteenth century in the Roman paleo-Christian churches and catacombs was the impetus for the founding of both the Commission for Sacred Archaeology (1852) and Pius' new museum, which was the first of its kind and in importance. It contained sculpture, sarcophagi, and inscriptions. Today this collection, too, can be found within Vatican City. These early Christian antiquities are vital manifestations of the Gospel faith and witness to its importance in the lives of the early believers. They are visual reflections of the faith that the Church has preserved throughout the centuries.

Until the pontificate of Pope Pius XI Ratti (1922–39), the Vatican Museums continued to accrue art mostly through gifts and benefactions. Rooms were refurbished and some collections shifted or, as in the case of the Picture Gallery, continually relocated in preexisting spaces. In 1929, under Pius XI, a concordat was signed with the Italian state that created the Vatican City State. In order to allow visitors easier access to the Vatican Museums, a new public entrance was built in the Vatican wall on the Viale Vaticano (see fig. 1); also, a new building was constructed in the Vatican Gardens to finally give a permanent home to the Picture Gallery (fig. 10). This large collection includes paintings, frescoes, and icons, ranging from the twelfth to the nineteenth centuries, as well as the tapestries designed by Raphael for the Sistine Chapel. Today, the Picture Gallery building also houses the Vatican Museums' scientific laboratory, restoration studios, photographic archives, and library. Both the new entrance and the Picture Gallery were dedicated in 1932.

In 1925, yet another chapter in the history of the Vatican Museums was initiated when Pius XI organized an exhibition at the Lateran Palace that chronicled missionary endeavors throughout the non-European world. Since the seventeenth century, missionaries had been sending to the Vatican a wide variety of artifacts, art, and other objects associated with the many cultures and religions they encountered on their journeys around the globe. These had been preserved in a number of private collections. They were displayed at the exhibition along with a large number of other works assembled for the occasion. At its conclusion, the pope thought it would be an excellent idea to use this material as the nucleus for a museum dedicated to anthropology, ethnology, and non-European religions and cultures. Given the collection's origins in the missionary activity of the Church, Pius XI gave it the name Pontifical Museum of Missionary Ethnology (Pontifico Museo Missionario-Etnologico). Its primary purpose was not as an art collection; rather it was to be a didactic and scientific museum at the service of the missions. Inaugurated in 1927, it remained in the Lateran Palace until the 1960s, when it found a permanent location at the Vatican.

Pope Pius XII Pacelli (1939–58) was elected on the eve of World War II. For a good part of the war, the Vatican Museums were also used for other purposes: as storehouses for Italian works of art transferred from the war zones (fig. 11); as supply depots for the needy; and as dormitory space for a constant stream of refugees from all over Europe who were fleeing the conflagration (fig. 12). After the war, the galleries were restored and reopened to the public once again. New works of art were acquired from excavation sites, gifts, and accessions. This was especially the case in the areas of Egyptian, Etruscan, and Roman art as well as a series of seventeenth-century tapestries. Besides acquisitions, other works were rediscovered in the storerooms of the museums and put on display, such as the head of a horse from the Parthenon. The immediate postwar period was also one of renewal and reinstallation of the galleries, and emphasis was placed upon publishing scientific studies about the collections and guidebooks.

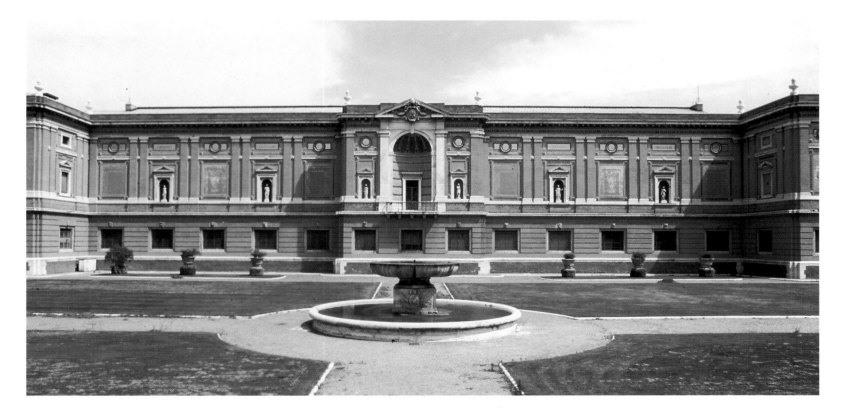

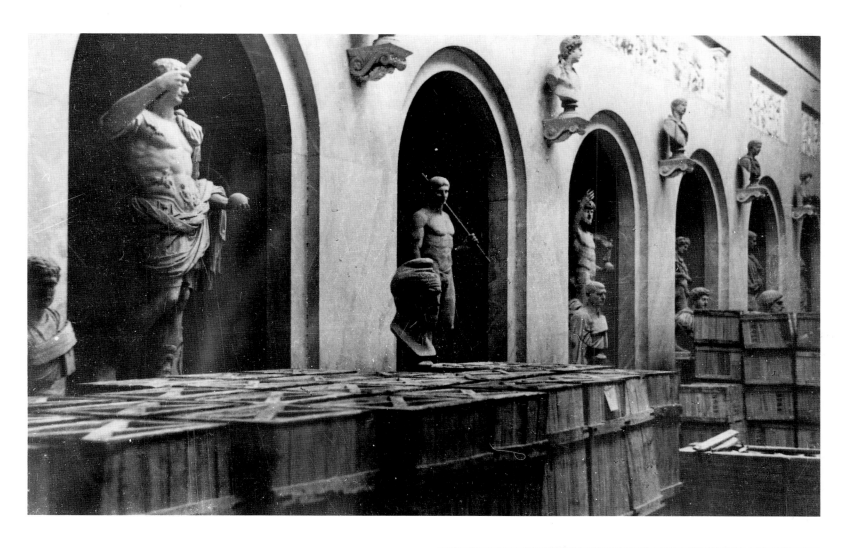

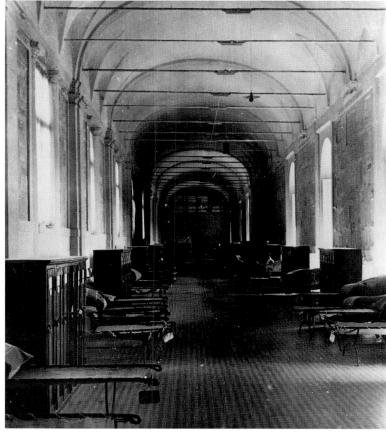

Fig. 10. The Vatican Picture Gallery

Fig. 11. Works of Art Stored in the Vatican
during World War II

Fig. 12. Dormitory in the Vatican for Refugees of
World War II

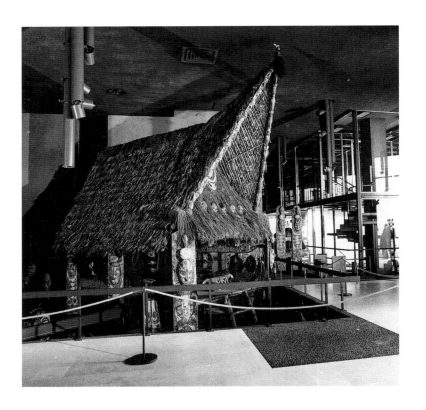

During the pontificate of Pope John XXIII Roncalli (1958–63), a decision was made to consolidate within Vatican City all of the museums previously established in the Lateran Palace (Gregoriano Profano, Pio Cristiano, and Missionario-Etnologico). The Lateran Museums were closed to the public in 1963, the works of art carefully stored, and construction began on a new building within the precinct of the Vatican City adjacent to the Picture Gallery. The building was finished and the collections installed and opened to the public in 1970 under John XXIII's successor, Pope Paul VI Montini (1963–78). The Pio Christian Museum, with its extensive collection of early Christian sarcophagi, sculpture, mosaics, and inscriptions from the Christian and Jewish catacombs of Rome, occupies the mezzanine overlooking the Gregorian Profane Museum with its rich collection of Roman sculpture, mosaics, and inscriptions. The Missionary Ethnological Museum is housed in the subterranean space of the same building and demonstrates the religious expressions of non-European countries and cultures (fig. 13).

Pope Paul VI was keenly interested in the relationship between contemporary art and religion. He met with artists in the Sistine Chapel in 1964 to initiate a rapprochement between the Church and the contemporary art world. "We must again become allies. We must ask of you the possibilities which the Lord has given you, and there-

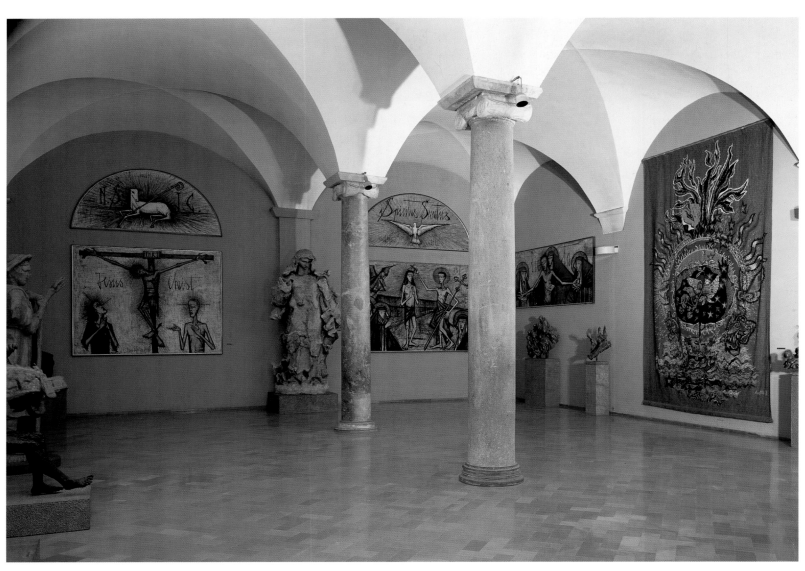

fore, within the limits of the functionality and finality which form a fraternal link between art and the worship of God, we must leave to your voices the free and powerful chant of which you are capable." An important response to this open invitation to form a new and vital relationship between the Church and contemporary artists resulted in generous gifts from artists, collectors, foundations, and national committees. In 1973, Pope Paul VI opened a new collection within the Vatican, the Collection of Modern Religious Art (Collezione D'Arte Religiosa Moderna) dedicated to this renewed relationship between contemporary artists and the Church. The collection is installed in the Borgia Apartment, which had been frescoed at the end of the fifteenth century by Pinturicchio, and in a number of rooms below the Sistine Chapel (fig. 14).

The most recent of the museums in the Vatican was founded in 1973, also at the request of Pope Paul VI, and is known as the Vatican Historical Museum (Museo Storico Vaticano). Part of this museum is housed in the Vatican, and the other more varied collections are in the Apostolic Palace of Saint John Lateran. In the Vatican is the Carriage Pavilion, which contains carriages, sedan chairs, and automobiles used by the popes and important members of the papal court (fig. 15). The museum in the Lateran Palace, inaugurated in 1990, is composed of two distinct yet complimentary sections: the papal apartments and the collections properly speaking. The papal apartments consist of a number of large halls, galleries, offices, and a chapel that were frescoed under Pope Sixtus V Peretti (1585–90). The walls in several of the rooms are hung with tapestries from the seventeenth and eighteenth centuries that were woven in the tapestry works of Gobelins, Barberini, and San Michele. These rooms, furnished with antique furniture, reflect the splendor of the papal court. The other collections housed at Saint John Lateran include portraits of the popes from the year 1500 to the present; objects used during papal ceremonies; paraphernalia of the Pontifical Army Corps; and a variety of court dress worn by the now-dissolved Corps of the Noble Guard.

Under the present pontiff, John Paul II Wojtyla (1978–), the Holy See's interest in and awareness of the role of art in the lives of the faithful and, indeed, of all people, continues. The research and preservation of art is a high priority of the Vatican Museums and its conservation studios. The restoration of Michelangelo's work in the Sistine Chapel, which was completed in 1994, clearly bears witness to this dedication (fig. 16). On the day of the presentation of the restored Sistine Chapel, Pope John Paul II remarked, "The frescoes that we contemplate here introduce us to the world of Revelation. The truths of our faith speak to us here from all sides. From them the human genius has drawn its inspiration, committing itself to portraying them in forms of unparalleled beauty. This is why the *Last Judgment*, above all, awakens within us the keen desire to profess our faith in God, Creator of all things seen and unseen."

Aware that the aesthetic articulations of all ages and cultures can majestically and powerfully express our ineffable God, the Vatican Museums have a profound commitment to art conservation and as importantly to education. To this end, the Vatican, realizing that many people cannot journey to Rome to see these works, has organized and participated in many exhibitions that travel the world so that the beauty and truth of its artistic treasures may move people everywhere to know the Divine Creator of all things.

Fig. 13. The Missionary Ethnological Museum

Fig. 14. The Collection of Modern Religious Art

Fig. 15. Carriage Pavilion of the Vatican Historical Museum

Fig. 16. His Holiness Pope John Paul II Celebrating the Mass in the Sistine Chapel after the Completion of the Restoration of Michelangelo's Paintings, 1994

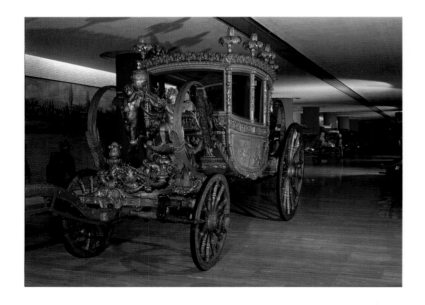

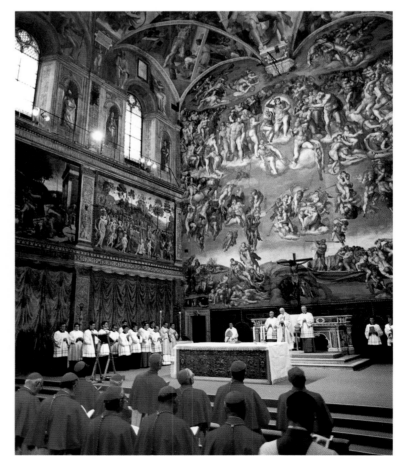

The Basilica of Saint John Lateran

The Basilica of Saint John Lateran was the first of the four patriarchal basilicas of Rome, all of which occupy sites sacred to the Christian community from the earliest centuries. An inscription in Latin on the facade encapsulates its history and significance for both the Church in Rome and the Church universal: *Omnium urbis et orbis Ecclesia Mater et Caput* (The Mother Church of the City and the World). Still today, Saint John Lateran is the cathedral of Rome and of the world. The Emperor Constantine gave this property to Pope Saint Miltiades (311–14) with the purpose of building a church for the See of Rome and a residence for the popes. The popes resided in the Apostolic Palace next to the cathedral for almost a thousand years, until 1309, when they left for Avignon.

The grand and elegant facade visible today was built between 1734 and 1736 by Alessando Galilei. In the two-storied portico is a loggia from which the popes have traditionally given their annual *Urbi et Orbi* (to the city and the world) address and blessing. Above the portico is a cornice that is crowned with statues of Christ, the Apostles, and Doctors of the Church along with Saints John the Baptist and John the Evangelist, the two saints to whom the basilica is dedicated (fig. 17).

Fig. 17. Alessando Galilei, *The Basilica of Saint John Lateran*, 1734–36.

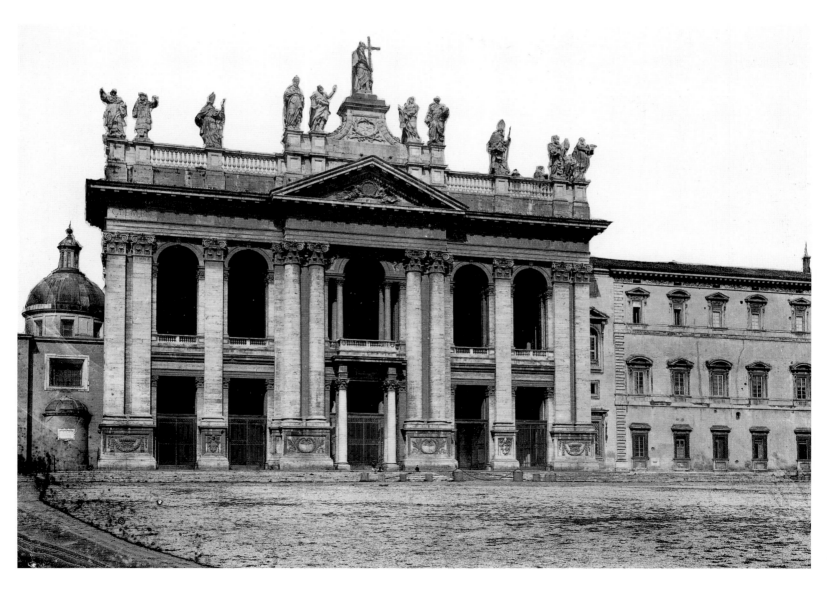

The vast interior is dominated by a long nave with two aisles on each side. This is the work of Francesco Borromini, constructed under the patronage of Pope Innocent X Pamphili (1644–55) for the Holy Year of 1650. Its austerity is broken by colossal statues of the apostles set in the massive piers, which were designed by disciples of Bernini. At the intersection of the nave and transept, the work of Giacomo della Porta in the late sixteenth century, is the papal altar surmounted by a fourteenth-century *baldacchino*. The *confessio* contains a large number of relics of early Christian martyrs, the most important of which are the heads of Saints Peter and Paul.

The imposing apse of the church was rebuilt under Pope Leo XIII Pecci (1878–1903) in 1885. The mosaics seen today are a reconstruction of the thirteenth-century work of Jacopo Torriti and Jacobo da Camerino, which were in turn based on the antique models from the fourth century. Beneath the head of Christ, the Holy Spirit descends upon the Cross, displayed on a hill from which flow the "living waters that give life to the world." The Virgin, Saints Peter and Paul, John the Baptist, John the Evangelist, and others stand on the banks of the Jordan River and look on in awe at the mystery. In the frieze, below the feet of the Apostles, are miniature figures of the thirteenth-century artists (fig. 18).

At the end of the transept to the left of the apse is the entrance to one of the most beautiful cloisters in all of Rome, which today serves as part of the basilica's museum. Dating from the early thirteenth century, it is the work of Iacobo and Pietro Vassalletto. To the right of the apse is the entrance to the present museum of the Treasury of the Lateran Basilica. After the popes returned from Avignon and chose the Vatican as their residence, much of the treasury's contents were transferred there and, with the vagaries of history, disappeared. Today the visitor sees principally liturgical vessels and vestments from the seventeenth century to the present day, which belong to the Chapter of the Basilica.

Fig. 18. Apse of Saint John Lateran

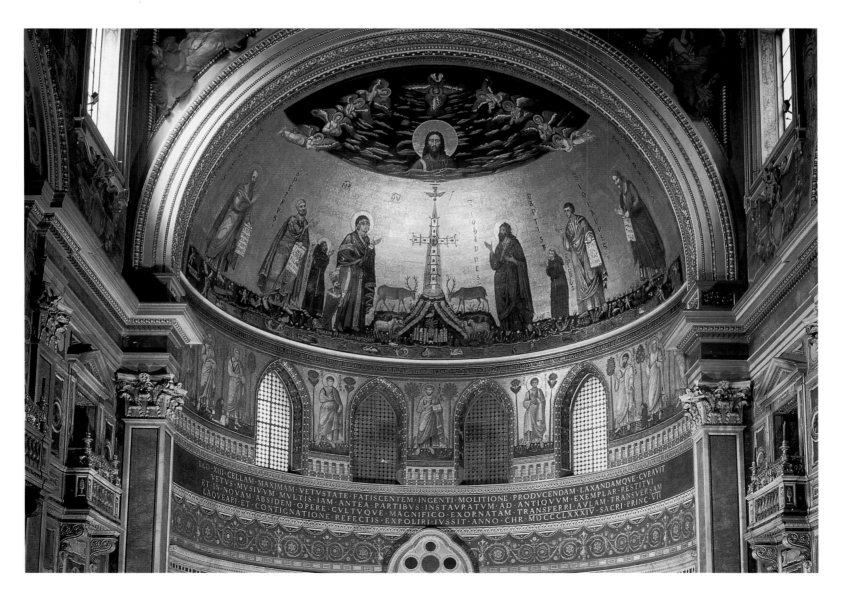

The Basilica of Santa Maria Maggiore

According to an ancient tradition, on the night of August 4, 352, the Virgin Mary appeared on the Esquiline Hill to Pope Liberius (352–66) and a Roman nobleman by the name of John. Her message was that they were to build a church in her honor on the spot where in the morning they would find snow outlining the form the basilica was to take (fig. 19). The promised snow appeared, plans were drawn up, and the first major church in Rome in honor of Mary was erected. Its original title was S. Maria della Neve (Our Lady of the Snow), also know as the Basilica Liberiana in honor of the pope, and later more commonly called Santa Maria Maggiore (Saint Mary Major). Today this church ranks as another of the four major patriarchal basilicas of Rome.

The present main facade (fig. 20) is a work of the eighteenth century, designed by Ferdinando Fuga, and for the most part covers that of the twelfth century, which was ornately decorated with mosaic. Some of this mosaic, which recounts the story of the founding of the basilica, is still visible through the open loggia of the upper story. The campanile, the highest in Rome, was given its present form in 1377 by Pope Gregory XI (1370–78).

The interior of this church reveals its true grace. The vast hall-like interior, conceived in the true basilica style, is well proportioned and richly enhanced by some of the most beautiful and well-preserved mosaics in Rome. The visitor's eye is led easily down the length of the nave, above which hovers the coffered ceiling decorated with the first gold brought back from the Americas and presented to the pope by Queen Isabella and King Ferdinand of Spain. The splendid mosaics of the triumphal arch executed in the fifth century under Pope Sixtus III (432–40) frame both the high altar and the apse. They represent scenes from the lives of the Old Testament patriarchs and the Virgin Mary. The decoration of the apse, dating from the pontificate of Pope Nicholas IV (1288–92), is the culminating point of all the mosaics in the church. They commemorate the Council of Ephesus (431), which proclaimed Mary to be the mother of God (Theotokos). The Virgin is pictured seated on a throne next to Christ her son, who is crowning her queen of heaven (fig. 21).

The high altar is flanked on either side by two splendid baroque chapels, which form a kind of shallow transept to the basilica form of the nave: to the right is the Sistine Chapel, or Chapel of the Blessed Sacrament, and to the left is the Borghese Chapel. The Sistine Chapel by Domenico Fontana is a splendid complex of frescoes and sculpture dominated by the majestic tombs of Pope Pius V Ghislieri (1566–72) and Pope Sixtus V Peretti (1585–90). The Borghese Chapel opposite is even more sumptuous in its decoration and contains the tombs of Pope Paul V (1605–21), the Borghese pope, and Pope Clement VIII Aldobrandini (1592–1605). The cupola and upper walls are frescoed, and the altar is richly decorated with agate and lapis lazuli. In an ornate gilt frame above the altar is *Salus Populi romani*, a celebrated medieval miracle-working icon of the Virgin Mary.

Fig. 19. Jacopo Zucchi, *The Miracle of the Snow*, 1580. Vatican Museums, inv. 42157

Fig. 20. Ferdinando Fuga, *Facade of Santa Maria Maggiore*, 18th century with 14th-century campanile

Fig. 21. *Apse of Santa Maria Maggiore*, 13th century, mosaic

The treasury of Santa Maria Maggiore, once rich in liturgical objects and vestments especially from the middle ages, today is primarily composed of material from the eighteenth century onward. This, as for the treasuries and sacristies of the other principal Roman churches, is due to the vicissitudes of time and history: the lamentable sackings of the city of Rome, pillages, thievery, and the disintegration of metal, wood, and fabric.

The Papal Sacristy

The origins of the Papal Sacristy are linked with the organization of the liturgical ceremonies presided over by the pope and thus date back as far as the Roman liturgy itself. In fact, sources show that the Keepers of the Sacred Papal Vestments already existed in the time of the Emperor Constantine in the fourth century. Their role was to keep the sacred vessels and vestments from being used by anyone except the pope.

Gradually, as the *Ceremonial* (the compendium of the principal papal liturgical ceremonies) imposed an increasing quantity and variety of styles for the different vessels and vestments used in the religious ceremonies, the importance of the Papal Sacristy grew, and it became a permanent part of all Roman basilicas where the pope regularly celebrated Mass. In the centuries following the Edict of Constantine (313), the Papal Sacristy was not housed in just one place, as each basilica had its autonomous collection of papal vestments.

The first consolidated Papal Sacristy was in the Lateran Basilica, where the popes originally resided. The sacristy was attached to the pontiff's residence so that the vestments and vessels could be used according to the needs of the variety of religious services.

In the fifteenth century, the office of Keeper of the Papal Sacristy was given a permanent character by Pope Alexander VI Borgia (1492–1503). His papal bull *Ad sacram*, dated October 15, 1497, granted to the Order of Hermits of Saint Augustine the privilege of being the apostolic sacristans. This was official recognition of an existing tradition, because a member of this order was usually in charge of running the Papal Sacristy. According to the bull, this custom was so ancient that human memory could not recall when it began. The keeper's role is minutely described in an old volume of the *Ceremonial of the Apostolic Palace*.

The events connected with the moving of the papal residence, and with it the sacristy, led to the transformation of the liturgy and the vestments used by the pope. After the move, the increased lavishness of the ceremonies gave rise to the need not just to store the valuable objects, but also to safeguard them.

From the Lateran, the sacristy was transferred to the Vatican, then to the Quirinal, and finally back to the Vatican after Rome fell to the Piedmontese troops in 1860.

At a certain point the *sacrario liturgico*, meaning the place where the holy relics were kept, was added to the Papal Sacristy, and the keeper thus acquired the faculty of authenticating relics and distributing them. His title changed as his duties grew. This is documented in a privilege granted by Alexander VII Chigi (1655–67) in 1656. In it the pope authorized a Sienese friar, Antonio Landucci, to conduct excavations to find the bodies of martyrs and then to hold the relics for safekeeping within the Vatican. On July 6, 1669, Pope Clement IX Rospigliosi (1667–69) granted to the Monsignor Sacristan the right to authenticate relics and to use the titular coat of arms of the Papal Sacristy to testify to their authenticity. In 1714, special cupboards were built to hold these relics in his apartment at the Quirinal Palace. Since 1870, the relics have been kept in the Apostolic Palace of the Vatican, specifically in the Cappella Matilde or Redemptoris Mater, as it is know today.

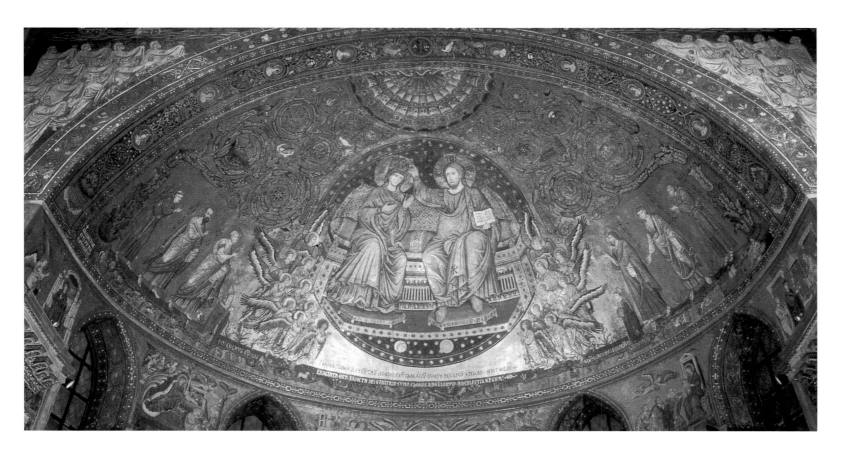

ANGELS AND THE WORLD OF SPIRITS
Basil Cole, O.P., and Robert Christian, O.P.

"The Angel of the Lord declared unto Mary...." These words echo the beginning of one of the biblical narratives of Jesus' conception and birth.[1] The story of the archangel Gabriel announcing to Mary that she, though a virgin, was to give birth to the Messiah depicts in a few verses the reality and the functions of angels (fig. 1).

The angel was sent by God to this world to make the announcement. Since God's realm was thought of as "above" our world, angels are often visually represented with wings, much the way Jupiter's messenger, Mercury, had wings on his sandals, hat, and wand (fig. 2). How else but by flying could God's messengers get from heaven to earth and back?

Angels in the Christian tradition are not gods like the pagan Mercury, but are special messengers of the one God. They are creatures whose being is above that of humans but not equal to that of God. Mary trusts the angel and responds to God's message because she recognizes Gabriel as a superior being used by God to make his message credible. Hence she responds, "I am the handmaid of the Lord. Let what you have said be done to me."[2]

At the end of Jesus' life, after his burial, an angel of the Lord descends from heaven to roll away the tombstone and announce to Mary Magdalene "and the other Mary" that they should have no fear: Jesus is risen as he said he would.[3] Again, the angel brings an astounding message and, like the message of the Incarnation, it communicates a divine favor that lies at the heart of the Christian faith.

Fig. 1. Mariotto di Nardo, *The Annunciation*, 1385, tempera on wood. Vatican Museums, inv. 40101

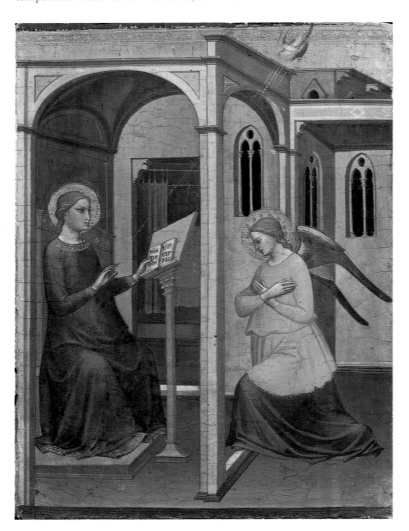

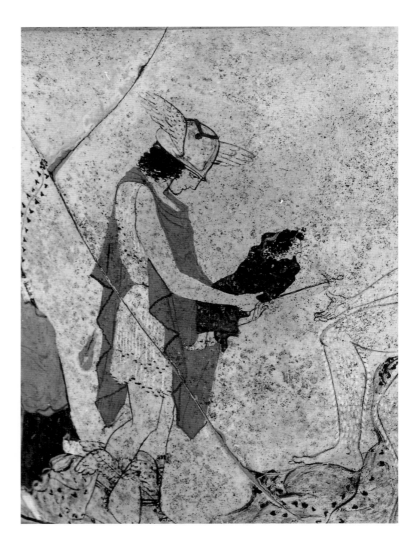

When angels are not bearing messages, their main function is to give God glory. Christian art shows this in angelic musicians, angelic choirs, and clouds of angels surrounding the deity and the saints (fig. 3).[4] The Bible speaks of "ten thousand times ten thousand of them and thousands upon thousands" shouting in praise of God.[5] God does not need any of this, but we do if we are to perceive the grandeur of God. The angels show the majesty of a God who is almighty and yet all-loving. A related function of these bearers of God's promises is to protect the people whom God has created.

This exhibition and catalogue display dozens of artistic representations of angels from the Vatican. Angels are visually portrayed as perfectly beautiful, without the flaws of flesh-and-blood creatures. God communicates who he is and what his love means by angels (fig. 4). In the pages that follow, we will explore the nature of Christian belief about angels. That belief is conditioned by artistic representations and, to some extent, determines what is expressed in art.

This exhibition is thus a meditation. Theology provides a reflection based on God's revelation in the Bible. Art provides insight into the human receptivity to God's message and into the human response to God.

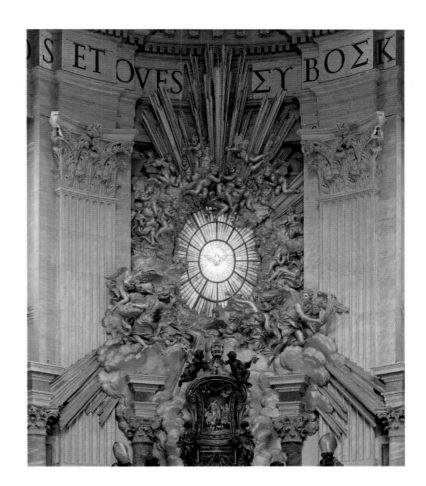

Fig. 2. Attic, *White-ground Calyx-Krater* (detail), c. 440–430 B.C. Vatican Museums, inv. 16586

Fig. 3. Gian Lorenzo Bernini, *The Throne of Saint Peter* (upper part), 1657–66. St. Peter's Basilica, Vatican

Fig. 4. Raphael, *The Coronation of the Virgin* (detail), 1502–03, oil on canvas. Vatican Museums, inv. 40334

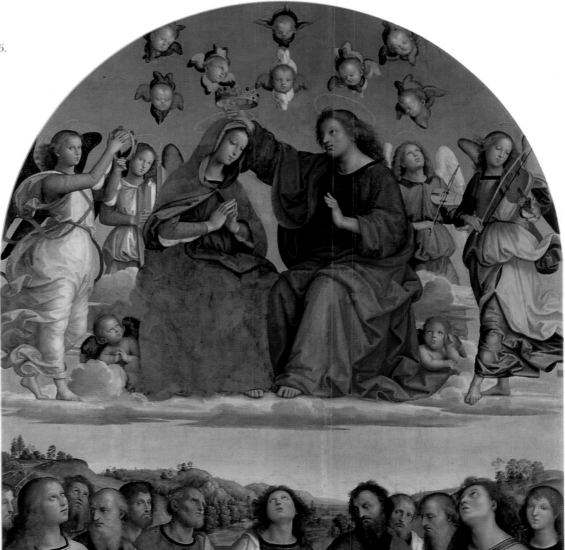

Fig. 5. Raphael, *The Deliverance of Saint Peter* (detail), 1513, fresco. Stanza d'Eliodoro, Vatican

Fig. 6. Michelangelo, *Angels with Trumpets*, detail from *The Last Judgment*, 1537, fresco. Sistine Chapel, Vatican

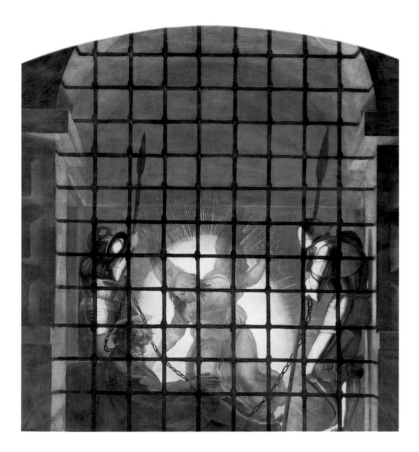

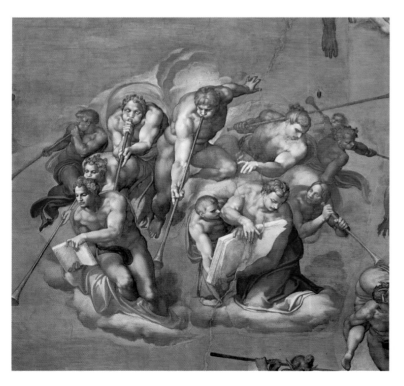

What Are Angels?

Angels are spirits, non-corporeal beings. Like human beings, they have intelligence; they can choose for or against God, but, unlike humans, their choice is irrevocable.[6] Also unlike humans, they have no bodies. Consequently, they are not sexually differentiated. They do not reproduce, but are directly created by God. Having no bodies, they cannot die, although bad angels, the evil spirits called devils, will be cast into hell by God at the end of time.[7] Since angels serve as God's messengers and, since they express God's glory, they can assume a perceptible if somewhat ethereal appearance. Only then can they climb Jacob's ladder[8] or, for that matter, dance on the head of a pin.

Pure spirits though they are, angels speak, sing,[9] and appear in various guises in the Bible. They appear as the four animals singing the seraphic hymn in the Book of Revelation: the winged lion, bull, human, and eagle.[10] The angels who visit Abraham and Lot have human form.[11] So does the archangel Raphael and, apparently, so does Gabriel. The four Gospel accounts of the empty tomb on Easter morning describe the angels as human in appearance but with an evident brightness. Mark's version speaks simply of a young man in a white robe (16:5). In Matthew this creature has a face, but it is like lightning (28:3). Luke speaks of two men in dazzling attire (24:4), while John speaks of two angels in white (20:12). Neither the angel who released the apostles after their imprisonment in Jerusalem (fig. 5) nor the angel who appeared in dreams to Mary's husband Joseph is described at all. But they are clearly neither ordinary humans nor God.

Jewish thought immediately before the Christian era held that angels were immaterial beings, but earlier Hebrew thinking dwelled less on the nature of angels than on their role as bearers of Yahweh's messages and instruments of his will. Although their normal place is in Yahweh's court,[12] they often appeared among humans in human guise. Their true identity as angels was only recognized after they had delivered their messages.[13]

Angels exist to show God's glory. Angels are much more than messengers. Their very existence tells of the glory of God. As the work in this exhibition makes clear, words alone cannot adequately express the glory of God; yet the words of the biblical writers paint vivid images of the angels manifesting God's majesty. John speaks suggestively of "four angels, standing at the four corners of the earth, holding the four winds of the world back to keep them from blowing over the land or the sea or in the trees" until they should "devastate land and sea."[14] Another has "a rainbow over his head; his face was like the sun … his legs were pillars of fire" and his voice was "like a lion roaring."[15] In the Book of Revelation, the angels fly, blow trumpets (fig. 6), bear incense, and show John the river of life.[16]

Scripture records the names of three of the seven archangels.[17] The names all end in *-el*, a suffix meaning God, which points to the particular way they reflect God's glory. Raphael means "God heals," Gabriel means "strength of God," and Michael means "who is like God."[18] Nonscriptural traditions, not part of official Church teaching, give names for many other angels.[19] Usually the differentiation among angels seems not to be connected to a particular function that concerns people; the activities of angels simply indicate that there is much more to creation than what is visible.[20] Therefore, it is held that angels were created at the beginning of time: God created both the material world and purely spiritual beings, the angels, when he created the existing world out of nothing.[21] Man is prone to take pride

in thinking of himself, made in God's image and likeness, as next to God in the order of creation. The existence of angels praising God shows humans, who are the object of God's solicitude, that most of their activity is not of the highest order and, in fact, that they are not the summit of creation. Indeed, the image of angels surrounding the divine throne and singing God's praises is a reminder of what mankind is called to after this life, an eternity of fellowship in and with God. Then "they are the same as the angels."[22]

Why Do Angels Exist?

The scriptural evidence for the existence of angels is convincing. Since humans are familiar with creatures that can be observed, measured, and analyzed, it is tempting to conclude that what cannot be empirically verified must not exist. Biblical revelation concerning angels reminds us that, although humans are created in God's image and likeness, they are nonetheless more unlike God than like God. The medieval teacher (in Latin, *doctor*) known as the Angelic Doctor, Saint Thomas Aquinas, used this dissimilarity as a philosophical premise for asserting the existence of angels. His concept of existence was hierarchical. All being was arranged in descending order from God down to inert matter. If humans are the only material creatures made in God's image and likeness, and if all other material beings are even less like God than man, then, Thomas reasoned, there must be unseen strata of immaterial beings between our intelligence and God's omniscience, beings who image God more closely than do humans. These are the angels, themselves arranged in "hierarchies" or choirs.[23] Their very existence teaches mankind a needed lesson in humility. Original Sin, after all, was the sin of trying to stop being made in God's image and to become gods instead. The existence of angels reminds us of how far we are from ever achieving what the serpent promised (fig. 7).

It could be asked why God has used angelic messengers. Jews and Christians have long been accustomed to humans speaking as God's messengers: prophets, apostles, evangelizers and, in a more extended way, bishops and the pope.[24] Indeed, a central tenet of Christianity is that Jesus is God become man. However, it would be a mistake to dismiss the biblical and liturgical references to angels as metaphors for God or for God's chosen human instruments. Angels became necessary as God's messengers because the Old Testament taught that one could not look upon God directly and live[25] and because the prophets were frequently ignored or disobeyed. When God wished to intervene in human affairs in an extraordinary way, he could therefore neither come directly nor use human messengers whose credibility could be questioned. The announcement that the son of God would become human could only be trusted if made by an angel.

Since the death and resurrection of Jesus and the sending of the Spirit at Pentecost to guide the Church until Jesus comes again "in the glory of his Father with the holy angels,"[26] the angelic office of divine messenger has been overshadowed by the angelic functions of praising God and protecting God's people. These functions make it necessary to speak of the kinds of angels distinguished in tradition.

Fig. 7. Michelangelo, *The Original Sin*, detail from *The Sistine Ceiling*, 1512, fresco. Sistine Chapel, Vatican

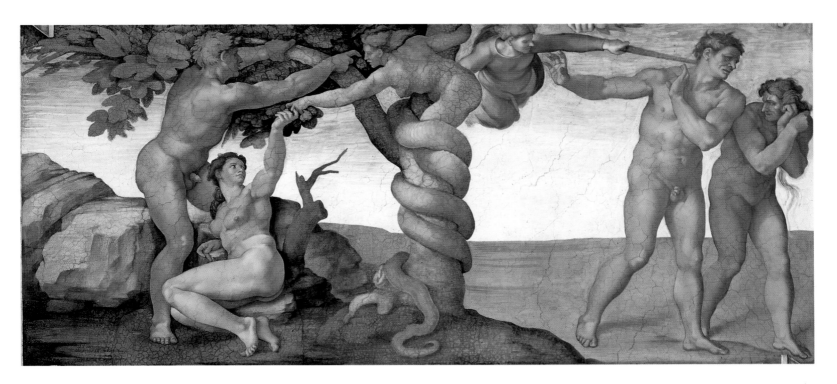

The Choirs of Angels

The opening section of the central prayer of the Mass, the Preface, concludes an address of praise and thanksgiving to God the Father by "uniting" the voices of those present with those of the choirs of angels (fig. 8). The original Latin texts of the prefaces name the choirs. The preface for Trinity Sunday concludes, "the Angels and Archangels, the Cherubim and Seraphim, praise You with one voice." The preface for the First Sunday in Lent ends with the celebrant proclaiming that all sing to God's glory "with Angels and Archangels, with Thrones and Dominations, and with all the militant hosts of heaven." And several other prefaces finish with a reference to "heavenly Virtues and angelic Powers."[27] The nine choirs unite with the saints in heaven and with worshipers on earth in praising God as holy.

It has been noted that "when the liturgy of the church praised God, it did so in the company of the angels, together with apostles, prophets, martyrs, and all the righteous. The hymns of the angels incessantly praise God in an ineffable chorus before the divine tabernacle, either heaven or the church or both."[28] Although the terms choir and hierarchy are often used interchangeably, choir might be preferable, since it refers to adoration of God, the highest activity of which a creature is capable. The medieval mystic Saint Hildegard of Bingen, when recounting her vision of the ranks of angelic legions, describes their choral praise: "All these legions, with their marvelous voices in multiple harmonies, resounded the praises of God who works marvels in the souls of the blessed; and they glorified God magnificently" (fig. 9).[29]

Medieval authorities found these nine choirs in Scripture,[30] but insisted that they should be hierarchically arranged to correspond to these writers' rather "vertical" conception of reality under God. These arrangements betray a concern for just what qualities are involved in glorifying God and in being God's messengers. Saint Thomas, for example, considers various possibilities, but ranks the angels in descending order. Seraphim, who are depicted as red because their name means fire maker, are most closely united to God in the warmth of charity.[31] Cherubim know God's secrets. Thrones know the patterns of creation as they are found in the mind of God. Dominations appoint things to be done, while virtues communicate the strength (*virtus*) of carrying out what must be done and powers distribute tasks to other angels. Principalities (whose name means beginners) begin what must be done, whether as singers or as leaders of the heavenly "host" or army. Archangels announce great things to the human race, while angels without any special title announce lesser matters.[32]

This kind of listing may seem improbable today. But the ranking of so many choirs of angels between us and God is another reminder that, while we have been made "little less than the angels,"[33] we are less than they. There is more to reality than what human beings can dream of, and God is more than simply their creator and redeemer. Angelic choirs surrounding God show the often self-centered humans that God, not man, is the center of being.

Figs. 8a, b. *Thrones* and *Virtues*, c. 1225, mosaic. Baptistery, Florence Cathedral

Fig. 9. Giotto and Workshop, *Christ Enthroned*, detail from *The Stefaneschi Altarpiece*, c. 1320, tempera on wood. Vatican Museums, inv. 40120

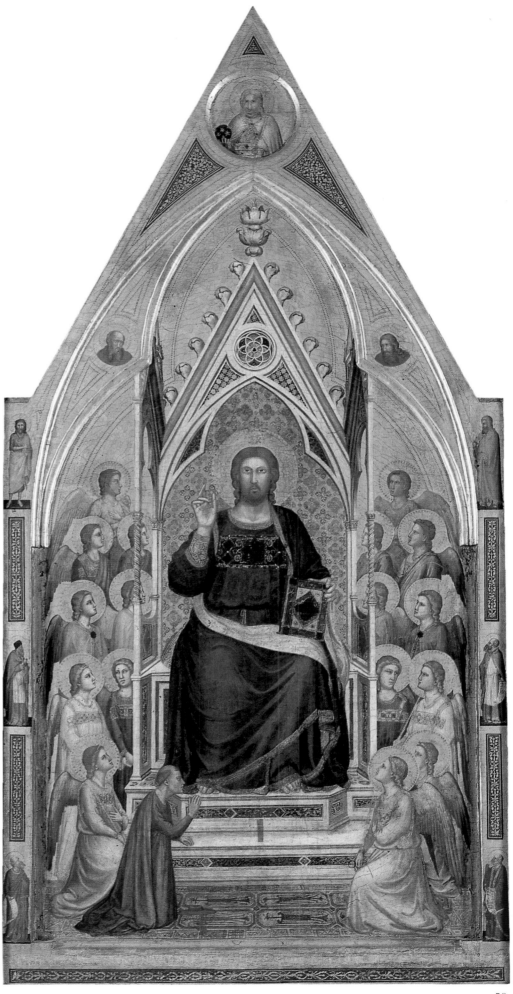

Fig. 10. Master of the Life of the Baptist (Giovanni Baronzio?),
Young Saint John the Baptist (detail), c. 1340,
tempera on wood. Vatican Museums, inv. 40185

Fig. 11. Nicolò and Giovanni, *The Last Judgment* (detail), 2nd half
12th century, tempera on wood. Vatican Museums, inv. 40526

Guardian Angels

The second day of October is when the liturgy of the Roman Church commemorates guardian angels. The opening prayer of the Mass that day reads: "God our Father, in your loving providence you send your holy angels to watch over us. Hear our prayers, defend us always by their protection, and let us share your life with them for ever." Guardian angels are thus not a metaphorical personification of God's providential care for the people he has made, but personal beings who act on behalf of God for our welfare. The story of the archangel Raphael accompanying, protecting, and advising the young Tobias who was journeying on behalf of Tobit is a model of the notion of guardian angels.[34] Our Lord's words to his disciples, "See that you never despise any of these little ones, for I tell you that their angels in heaven are continually in the presence of my Father in heaven,"[35] have traditionally been understood to mean that each person has a guardian angel (fig. 10).

Given the disasters that may afflict people during their lives, it is important to recall that the care of the angels is not a magic protection against peril in this world. God has endowed individuals with free choice that, when abused, can bring harm to themselves and others. Moreover, the dynamic processes of the world result in natural phenomena that, from the point of view of those victimized by them, are natural catastrophes. God's care, exercised through his angels (and saints, for that matter), is meant to help us to choose the good, and ultimately, to choose eternal life, not constant protection in this existence. The worst danger to which people are exposed is the danger of choosing to turn away from God through serious sin. Protecting us from losing mortal existence is not the job of guardian angels, but protecting us from losing eternal life is.

Guardian angels can remove neither the free choice of human beings nor the consequences that follow from their wrong choices. But they are part of the chain of love that links God to his human creation. Loving God, the guardian angels love us, God's creation, and so they pray for our salvation. They intercede with God that we might know God as our supreme good, so favored with grace that we make the right choices even in times of pain and confusion. In this sense, the opening prayer for the Feast of the Guardian Angels speaks of our being defended by their protection from everlasting punishment and thus sharing God's life with the angels forever.

The Veneration of Angels

We venerate angels in order that we might achieve the most intense union with God possible. Veneration of the angels is a veneration of God who reveals the design of creation through them, a design that includes our eternal happiness with him, with the saints, and with the angels. Angels are praised in order that God may be praised. Their total union with God offers us a glimpse of what awaits those who will enter God's kingdom after this life. The angels' intercession can be requested in prayer just like the intercession of a saint, since the charity that binds them personally to God binds them personally to each person (fig. 11). As a result, the angels want us to reach our supreme good, heaven, to be with God and to be with them. If freely asked in prayer to pray for us to God, they will do so. This is all part of God's design.

Demons

Scripture and Church teaching are silent about precisely what the angels had to undergo in order to attain their happiness. Saint Thomas Aquinas reflects the theological tradition when he says that as soon as they were created, they were given a free choice to serve their creator or to reject him. Some chose to resist God, wanting to be like God on their own terms rather than dependent on him (fig. 12). This sounds like the temptation Satan presented to Adam and Eve. But whereas the human race was never entirely forsaken by God after its sin, the fallen angels became God's enemies. The reason is found in the difference between angelic nature and human nature. The intellect of angels is so superior to human understanding that, seeing more clearly the consequences of their choice, they are also more culpable if they choose evil.[36]

The leader of the fallen angels, commonly referred to in the singular as the devil,[37] is named Lucifer (light bearer). The name is ironic, as his title, Prince of Darkness, indicates. Christ is the true light,[38] and since light permits sight, the light of Christ is said to illuminate reality. It lets us see things as the Creator intended, and that is the truth which sets us free. Indeed, Jesus called himself the Way, the Truth, and the Life. Lucifer's realm, instead, shuns the light that reveals the truth; his domain, hell, is an eternal alienation from the life of the Savior.

The First Letter of Peter, in a passage that is part of the Church's official Night Prayer, warns the faithful to "Be calm but vigilant, because your enemy the devil is prowling round like a roaring lion, looking for someone to eat. Stand up to him, strong in faith."[39] God permits evil in creatures endowed with free choice in order that good may come from it, in particular so that we might be purified of inordinate attachment to any good that is not God. As Job's struggle with the evils inflicted by the bad angel whom God permitted to molest him shows, evil, when resisted, will be defeated, and the victor will share in God's glory.[40]

The devil is often represented as a serpent, the form the deceitful tempter assumed in the Garden of Eden,[41] a horned goat, a satyr, or a dark monster dragging the souls of the damned away from God's kingdom of light to the realm of evil and darkness.

Fig. 12. Pieter Bruegel, *The Fall of the Rebel Angels*, tempera on wood. Musées Royaux des Beaux-Arts de Belguique, Brussels

Angels in Art

Angels, while pure spirit, are generally drawn, carved, and painted in ways that express a beauty and goodness exceeding the beauty and goodness of human beings who, since they are made in God's image and likeness, are the logical starting point for depicting God's messengers. Since the fourth century, they have been made recognizable also by wings. Although wings were a device used in Persian angelology, the Greek representations of Nike (winged Victory) seem to be the artistic basis for later Christian depictions of angels.[42]

Because angels already possess the joy of heaven, they are shown expressing that joy the way humans do: dancing, singing, and playing musical instruments (fig. 13). Their wings may be brilliantly hued, but their clothes are usually white, the traditional western color for purity and joy. Being messengers, they are sometimes attired in the vesture of those who proclaim God's word in the liturgy: albs and deacons' stoles and often copes. Since angels are united to God by love, they hover in contented contemplation around the people God loves (this is especially the case with putti, a form taken from paganism but inserted in Christian contexts). Since angels have superior knowledge, they may also be shown with many eyes.[43]

Even though angels have no bodies and are therefore asexual, they were generally portrayed until the nineteenth century as male or androgynous, reflecting the fact that the Scriptures speak of angels in masculine terms. More recently, angels have sometimes been depicted as feminine.

The substance of this essay is found in the pages that follow and in the exhibition. Artists have tried to visualize the inexpressible angelic beauty and express it in human forms. What appear in these pages are only pale images of a reality we cannot fully understand. But the images point, not to metaphor or myth, but to reality. Their own existence is part of the divine majesty and the divine plan. And the heart of that plan is God's love, which gratuitously created all things, "visible and invisible,"[44] and has given to angels and human beings the possibility of living forever in that love.

Fig. 13. Benozzo Gozzoli, *Madonna della Cintola* (detail), 1450–52, tempera on wood. Vatican Museums, inv. 40262

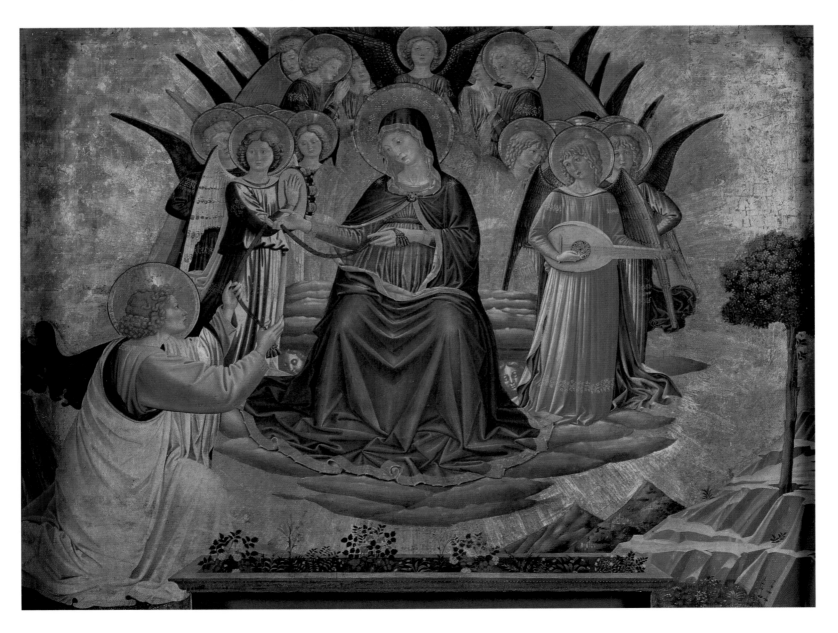

1. Luke 1:26–28.
2. Luke 1:38.
3. Matthew 28:1–8.
4. See, for example, Fra Angelico's *Angeli musicanti* and Tintoretto's *Last Supper*.
5. Revelation 5:11.
6. Thomas Aquinas, *Summa Theologiae*, I, 64, 2.
7. Genesis 1:15; Revelation 20:7–10.
8. Genesis 28:13. Concerning the appearances angels can assume, see *Summa Theologiae* I, 51, 2, in particular his reply to the first objection: "Angels need an assumed body, not for themselves, but on our account; that by conversing familiarly with men they may give evidence of that intellectual companionship which men expect to have with them in the life to come. Moreover, that angels assumed bodies under the Old Law was a figurative indication that the Word of God would take a human body; because all the apparitions in the Old Testament were ordained to that one whereby the Son of God appeared in the flesh."
9. The angels are said to sing so that we will understand that they are praising God; see Isaiah 6:3 and Matthew 2:13–14 (e.g., the angels singing after announcing to the shepherds the birth of the Messiah).
10. Revelation 4:8.
11. Genesis 18:1–22.
12. See Job 1:6; 2:1.
13. See Tobit 12:11:15, where Raphael reveals his identity and his task.
14. Revelation 7:1.
15. Revelation 10:1–3.
16. Revelation 22:1.
17. The tradition that there are seven archangels comes from Raphael's testimony, "I am Raphael, one of the seven angels who stand ever ready to enter the presence of the glory of the Lord" (Tobit 12:15).
18. Pope Saint Gregory the Great (590–604) gives us these meanings in a homily that is now part of the Church's Office of Readings for the Feast of the Archangels, September 29 (Hom 34, 8–9: PL 76, 1250–1251).
19. The Lateran Synod of 745 condemned in no uncertain terms those who would presume to name any but the three archangels named in Scripture. Referring to a prayer of petition addressed to Uriel, Raguel, Tubuel, Michael, Inias, Tubuas, Sabaoc, and Simiel, they synod noted that only Michael was a legitimate name. Any other name (in general, coming from Jewish traditions) might in fact be the name of a demon, and thus should not be admitted (Mansi 12:384q–r).
20. *Summa Theologiae* I, 50, 4.
21. The Fourth Lateran Council (1215), in a teaching repeated at the First Vatican Council (1870), teaches that God created both orders, the spiritual and the material (*angelicam videlicet et mundanam*) together (*simul*) at the beginning of time, and then (*deinde*) man (DS 800).

22. Luke 20:36. The full text is, "Jesus replied, 'The children of this world take wives and husbands, but those who are judged worthy of a place in the other world and in the resurrection from the dead do not marry because they can no longer die, for they are the same as angels, and being children of the resurrection they are sons of God.'" The term "sons of God" is a play on the term used in Job 1 to indicate angels.
23. *Summa Theologiae* I, 108, QQ. 2–4.
24. Second Vatican Council, *Dogmatic Constitution on Divine Revelation Dei Verbum*, 7 and 10.
25. Exodus 3:6.
26. Mark 8:38.
27. For example, all the prefaces for the Sundays of Easter, both prefaces for the time after the Ascension, and the preface for Pentecost.
28. Jaroslav Pelikan, *The Christian Tradition*, vol. 2, *The Spihristendom (600–1700)* (Chicago: University of Chicago Press, 1981), 142.
29. Saint Hildegard of Bingen (d. 1179), *Scivias*, book 1, 6th Vision. *Scivias* (Know the Ways) is the basis of Hildegard's musical compositions. These were released by Angel Records in 1994.
30. Seraphim in Isaiah 6:2; cherubim in Ezekiel 1; thrones in Colossians 1:16; dominations, virtues, powers, and principalities in Ephesians 1:21; archangels in Jude, and angels in many places.
31. Saint Thomas Aquinas depends heavily on Pseudo-Dionysius' *The Celestial Hierarchy*, dating from about A.D. 600. The seraphim rank ahead of the cherubim, for instance, for the same reason that charity ranks ahead of faith: it denotes a more complete union with God.
32. *Summa Theologiae* I, 108, 6.
33. Psalm 8:6.
34. Tobit 5:12.
35. Matthew 18:10.
36. *Summa Theologiae* I, 58, 5.
37. *Catechism of the Catholic Church*, 391.
38. John 1:9. John's writings are referred to in the *Catechism of the Catholic Church* (392) as the scriptural basis for the names given to the devil, especially John 8:44, 1 John 3:8, and Revelation 12:9.
39. 1 Peter 5:8–9.
40. Job 42:10.
41. Genesis 3:1ff.
42. Jane Dillenberger, *Style and Content in Christian Art* (New York: Crossroad, 1988), 180.
43. See Ezekiel 1:18.
44. The Nicene Creed.

WRESTLING WITH ANGELS:
THE INVISIBLE MADE VISIBLE

Arnold Nesselrath

In speaking of angels, we have a very precise idea, indeed a clear visual image, of what these beings, who are by their very nature spiritual and hence invisible to human sight, physically look like.[1] Contrary to what it is that essentially distinguishes them, namely their spiritual nature, we conceive of angels as youthful winged human beings of noble figure, dressed in long ceremonial vestments or we picture various other types of angels, such as radiant child-like apparitions or little winged putti. Angels crop up in many different fields; they have no precise connotation; they can be used not only in the religious dimension, but in every conceivable secular context too. In speaking of angels, we can be sure that the concept they express, be it only in its external form, that of a supernatural being, will be immediately understood.

It is not only in the Bible or in theological treatises that angels are mentioned. Nor are they confined just to religious stories and legends; we find them, for instance, in Dante's *Divine Comedy* and Goethe's *Faust*. They also occur in every conceivable pagan context, especially in esoterica. So the idea of angels has developed not only outside Christian belief, but outside the religious sphere altogether.[2] Ever since angels have been imagined with wings, the fascination with angels has been presumably just as great as man's dream to be able to fly. And even now that this dream has long been realized, the fascination shows no signs of abating. Indeed, even in our own jet-setting world, a veritable fashion for angels has reigned. Nor is it just at Christmastime that angels crop up as decorations on every conceivable object, on clothes, curtains, crockery, greeting cards, videos, gift packs, or wrapping paper. They are marketed in innumerable books, in exhibitions, on calendars, bookmarks, posters, or in magazines and newspapers in every form and with every conceivable theme. They have even advanced to take starring roles in films.[3] Science, too, is subjecting the phenomenon to renewed scrutiny; a whole field of research has specialized outside theology on this theme. A history of angels has developed, once again flying in the face of the second of their main properties, their timelessness and agelessness. Of course, the history in question is not that of the species of angels in any evolutionary sense, but that of the ways in which the above-described idea of angels has been historically shaped in theology, art, or the history of ideas. A preoccupation with angels takes place, and has done so, presumably, always more or less widely, at all levels, from the highly intellectual plane to the naive, sentimental approach, from folklore to the wholly secularized world of popular culture.

The idea we have of angels was in the first place formed by artists. Ever since the very beginnings of Christian art, artists were faced with the task of making visible the invisibility of angels.[4] Figurative art has, in the process, perhaps more so than in its representation of God the Father, given form to a type that has spread far beyond its original context with all its characteristics and lent itself readily to transposed or altered connotations. Everyone knows, or thinks he knows, what angels look like, so everyone thinks he can use them in any way he likes.

Etymologically considered, the word for angel originates in many languages, as perhaps no other phenomenon does, from the same linguistic root: the Greek word *angelos* (from which derives, for instance, the Latin *angelus*, the English *angel*, the German *Engel*, the French *ange*, the Italian *angelo*, the Spanish *angel*). It thus preserves its original connotation, that of the herald or messenger,[5] a connotation perfectly exemplified by the angel's salutation in the Gospel of

Luke 2:10: "Behold, I bring you good tidings of great joy." The essay by Basil Cole and Robert Christian in this volume exhaustively treats the theme of the angel from a more properly theological point of view. But the word's etymological root and the functions performed by angels as heavenly messengers also have consequences for their artistic representation. In essence, angels perform three sorts of activities[6]: they serve, they announce,[7] and they worship, pray, or perform liturgical actions.[8] Consequently, they are almost never, with the possible exception of the archangel Michael and perhaps the archangel Raphael,[9] represented as the main figures in a narrative composition.[10] For artists, angels are mainly a transitive element, directed at another figure. Often they appear collectively, in heavenly hosts, as glories of angels or as celestial choirs. They are often used to frame the main events or protagonists or are reduced to playing a symbolic role as ornamental figures. Yet angels are never merely ornamental. They retain a divine aura. Nor are they merely passive observers: they experience joy and grief just like human beings,[11] as most movingly expressed by Antonello da Messina in the weeping angel in his *Pietà* (fig. 1).[12]

The idea and hence the representation of angels has not fundamentally changed since the Council of Trent in the sixteenth century. The essential features that still determine our image of angels today can hardly be more clearly formulated than in the treatise of Federico Cardinal Borromeo, the *De pictura sacra* of 1625. The individual elements that formed this angel type over the centuries are in some sense canonized in this book. At the same time their meaning is explained: "Per indicare la velocità si attribuiscono le ali, la veste per decoro, l'aspetto umano perchè non ce ne è altri di più perfetti, la figura è giovanile, a indicare forza e vigore che nessuna decadenza senile può insidiare" (Angels are endowed with wings to denote speed; with a garment for decorum; with a human appearance, because there is no other more perfect; their figure is youthful to denote strength and vigor, which no senile decline can threaten).[13]

Earlier forms that underlined the meaning of angels' wings and that find no mention in this canonical definition, such as the wheels of the cherubim described by Ezekiel (fig. 2),[14] have increasingly fallen out of fashion among artists.

The present exhibition lacks examples especially of the early Christian and medieval forms of representation of angels because the participating Vatican institutions possess no portable works of art that would illustrate these periods, so important in the typological development of our theme. For this reason, it is right that a few short introductory remarks be made on this crucial early phase in which the iconography of angels emerged and took shape. Without entering in any detail into specialized research on the question, a few key questions are nonetheless relevant for a better understanding of angel images, for instance: Since when have figurative representations of angels occurred at all in western art? Since when have they been represented with a feature we now consider *de rigueur*, their wings? Have any attempts been made to express, or to suggest, their invisibility? How do artists respond to the need not only to give form to the invisible being, but also figuratively to describe its various characteristics, for instance in the invention of the angel-putto? The question as to the possible pre-Christian models for the Christian iconography of angels is investigated by Maurizio Sannibale and Paolo Liverani in their essay in the present catalogue. I will therefore begin my survey with the earliest known Christian representations of angels.

Fig. 1. Antonello da Messina, *Dead Christ Supported by an Angel*, oil on wood. Museo del Prado, Madrid

Fig. 2. Nicolò and Giovanni, *The Last Judgment* (detail), 12th century, tempera on wood. Vatican Museums, inv. 40526

The Earliest Christian Angel Type: Men without Wings in Dazzling Apparel

How angels should be represented, or whether they ought to be represented at all, was repeatedly discussed by the early Church. At the Synod of Laodicea in the second half of the fourth century the cult of angels was prohibited,[15] but at the second Council of Nicaea in 787 their representation was sanctioned.[16] The very first representation of a Christian angel has been identified, not without some skeptical reactions, in a mural painting in the Catacomb of Priscilla in Rome (fig. 3) dating to the late second or first half of the third century. Insofar as the poorly preserved fresco can be interpreted at all, it has been identified as a scene of the Annunciation, in which the matronly seated figure to the left is interpreted as Mary and the standing figure, in the pose of an orator, to the right, as the archangel Gabriel.[17] The latter figure seems to be male and is dressed in tunic and pallium, but, above all, the figure is beardless and wingless.

Despite all the doubts surrounding the correct interpretation of the fresco in the Catacomb of Priscilla, there are wider grounds for thinking that the early Christian angel type did at least broadly resemble the figure represented in this painting. The *Reception of Vibia into the Heavenly Banquet* in the Catacomb of Sabazio on the Appian Way, dating to the early to mid fourth century, depicts a similarly beardless and wingless man, also dressed in tunic and pallium, explicitly described in the accompanying inscription as ANGELUS BONUS. The mural in this case is admittedly situated in a burial ground of the syncretists, a group that attempted to reconcile or combine different or opposite religious beliefs, both pagan and Christian. Nonetheless their art was so strongly influenced by early Christian iconography that a parallelism in their respective iconographies can be assumed.[18] In fact, a similar figure accompanying a youth holding a fish appears in the cemetery of Trasone; it has been interpreted, in the context of the two other previously cited paintings, as a representation of the archangel Raphael with the young Tobias.[19]

This type of male figure dressed in the classical manner may appear either with or without a beard.[20] But in any case he is wingless; wings do not distinguish the earliest Christian type of angel. Artists were far more intent upon stressing the angel's resemblance to man, the form that corresponded to the male-dominated structures of late-antique society, and, more specifically, to the type of male angel explicitly described in the Easter narratives of the Gospels, "men in dazzling apparel."[21] Even though it was quite soon, the end of the fourth century, that angels came to bear a close resemblance to the winged figures of victories familiar to us from ancient art, especially so in such examples as the sixth-century mosaics at Ravenna, the ancient Roman goddess of victory can be discounted as the direct prototype from which Christian iconography derived its earliest representation of angels. Even the sex is different: the goddess Victoria is female and angels are mainly male.[22] Above all, however, Victoria is invariably represented in ancient art with the wings of birds, whereas the wings of Christian angels, with their growing and ever more differentiated symbolic content, were subjected to successive transformations in form.

Fig. 3. Anonymous, *The Annunciation*, fresco. Catacomb of Priscilla, Rome

Another Early Christian Conception of Angels

The newly created early Christian type of angel was in no way so clear-cut in definition as that described by Federico Borromeo in the seventeenth century. That is hardly surprising: Borromeo had the benefit of a long-consolidated Christian tradition, stretching over fourteen centuries, on which to draw. No such prescriptive tradition was available for the artist in the fourth century: he had to define the iconographic type himself. This was at a time when classical antiquity was still very much alive, widely disseminated, and, above all, familiar. Perhaps an indication of the quest for a yet-to-be-invented angel iconography is to be found in the representations that symbolize this celestial being by the motif of the intervention of a human arm stretching down from heaven.[23] In adopting this motif almost as an alternative to the "men in dazzling apparel," many an early Christian artist almost entirely dispensed with the representation of angels in human form. Instead they preferred to place the emphasis on the intervention of supernatural forces and on the divine mission of the *angelos*. This alternative angel type was especially well suited for scenes of action, in which it could be introduced as a divine force actively and directly intervening in earthly affairs, for instance in the *Sacrifice of Abraham*, where it is used to hold the patriarch's arm.

Angels with Wings: Or, Reflections on Wings

The iconographic creation of a winged human figure for the representation of an angel is often traced back in origin to a passage in Tertullian's *Apologeticum*, dating approximately to the year 197. In this passage, Tertullian declares of spirits in general, but indirectly (according to context) of angels, that all spirits, and hence angels too, had wings.[24] Yet the fact is that no representations of angels with wings from before the fourth century have survived.[25] And even once the winged angel had been introduced, the wingless type of the men in dazzling apparel was not discarded: its tradition continued, as in the *Resurrection of Christ* in the Trivulzio Ivory (fig. 4).[26] In the *Annunciation* on the triumphal arch of Santa Maria Maggiore in Rome, dating to the pontificate of Sixtus III (432–40), it is even possible to capture a moment in which an artist hesitated, undecided, between the winged and wingless angel type: the angel in the *sinopia* (underlying preparatory drawing) has no wings, and wings were added only during the actual execution of the mosaic. The motif of the wingless angel was deliberately taken up again and used by artists of later periods.

The wings of the angel are a symbol for the celerity and ease with which these beings move about in heaven and on earth. If angels are weightless, they ought not to need this aid to flight. But given the concrete human body with which they are imagined, their ability to fly at all must be dependent on several physiological constraints: it has been calculated, for instance, that they would need a wingspan of between 12 and 40 m (39 and 131 ft.), a specialized skeleton, and powerfully developed muscles.[27] That reflections on these physiological requirements have not filtered down into the actual representations of angels is not surprising. The nobility of their figure would have suffered as a result. And yet the wings of angels never ceased to pose a challenge to artists of all periods and all cultures. They tested their ingenuity and fired their imagination in their quest to invent ever new and original ways of representing them, especially since the various forms of angels' wings were not, as we have seen, iconographically fixed, but took on further connotations in the course of time. In

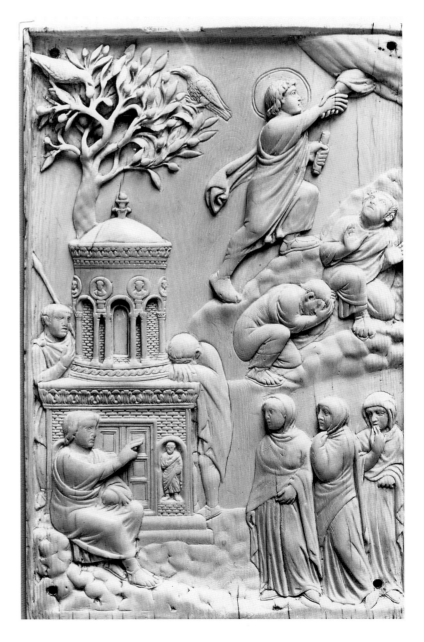

Fig. 4. Anonymous, *The Resurrection of Christ (Trivulzio Ivory)*, 5th century. Bavarian National Museum, Munich

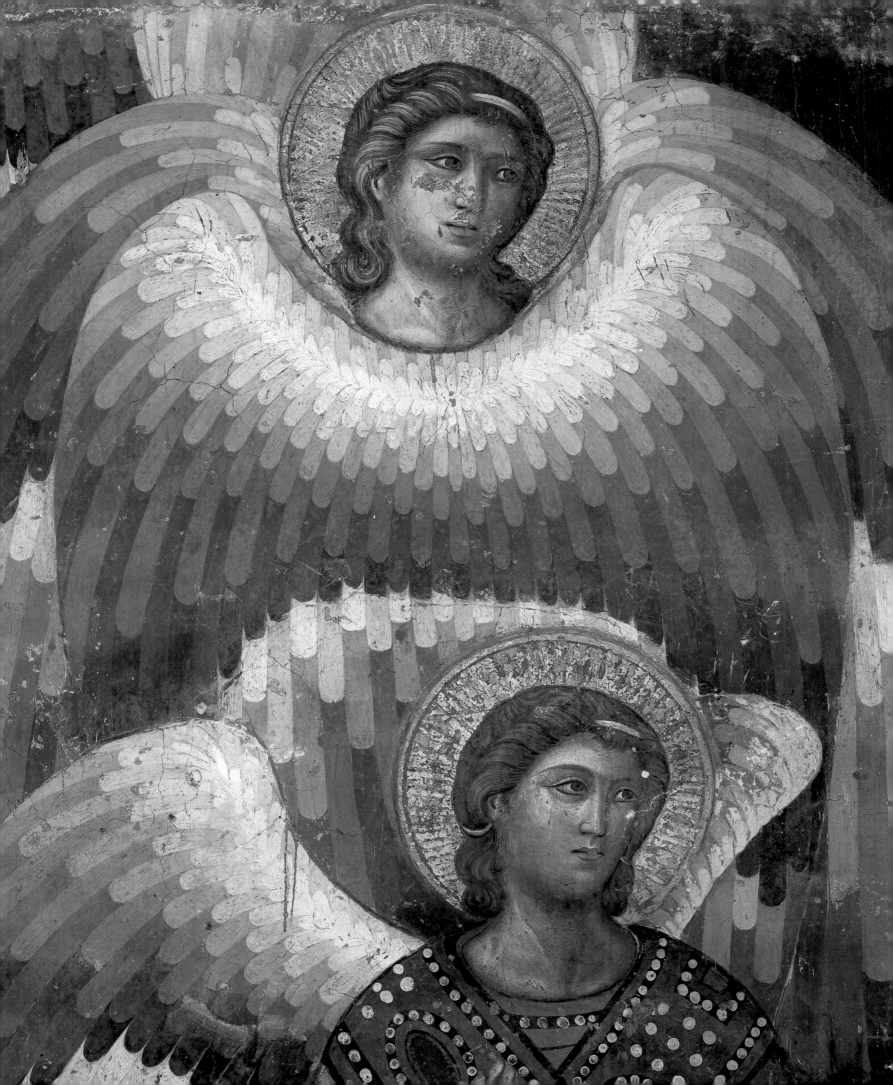

this quest, most artists completely ignored the formal prototypes for human winged figures, which were available to them from Greek[28] and Roman antiquity,[29] such as victories, Eros, or erotes, and susceptible to reinterpretation in a Christian guise. They developed an iconography of their own.

A particularly striking example of the original ways in which angels' wings were interpreted by Christian artists are those found around the year 1300 in the works of Cavallini[30] (fig. 5) or Giotto and his workshop[31]; only in contour can they be distinguished as birds' wings. These pinions have far more the effect of manifestations of light; indeed one could say that, according to the modern way of thinking, these angels move almost with the speed of light. The wings are depicted with an enormously impressive, intense, and above all dazzling polychromy; they are built up gradually from tiny strips of color of the same hue, which are arranged like overlapping scales and graduated in tone from dark to light, until they finally culminate in the plenitude of light of a dazzling white or yellow. Since the wings in these cases have lost any kind of anatomical structure, they are not supported by any organic part of the angels' bodies. Only by divine light are the angels sustained. This interpretation is reinforced by the rainbow-hued mandorla that surrounds the figure of Christ in Giotto's *Last Judgment* in the Arena Chapel in Padua; it is similarly built up of graduated, scale-like overlapping strips of color, developing in tone to the brightest light.[32]

Another distinctive feature of angels' wings through the centuries is their incorporation of peacock feathers. Angels' wings that consist wholly of peacock feathers or are sporadically decorated with such have repeatedly inspired artists in the most far-flung places of the earth and in the most diverse periods to find ever-new forms of expression. Such wings have developed a particularly long and widely disseminated pictorial tradition. Peacock feathers are per se especially magnificent and frequently appear as attributes of royalty. It is possible that the basis of this particular iconographic detail can be traced back to an observation from the vision of Ezekiel in which the cherubim are described: "Their bodies, their backs, their hands, their wings, and the wheels—the wheels of all four—were covered in eyes In order to transform this literary image into pictorial terms, artists had recourse to peacock feathers, especially since the "eyes" in peacocks' tails had (so to say) been taken literally by classical mythology; they were interpreted as the eyes of the hundred-eyed guardian of Io, Argus, whose eyes, after he had been lulled to sleep and slain by Mercury, were placed by Juno in the tail of the peacock, a bird sacred to her divinity.[34] As a Christian symbol the peacock stands for eternity, renewal, and immortality,[35] so that the feeling of having the eyes of God upon one, which Ezekiel experiences, was associated with these invisible properties of angels through the peacocks' eyes in their wings. Examples of angels with peacocks' wings are legion. For instance, the wings of the archangels Gabriel and Michael in the sixth-century apse mosaic (fig. 6) in the Panayia Angeloktistos church in Kiti on Cyprus already have the pattern of peacocks' plumage and their long tail feathers with eyes.[36] A fresco in the atrium of the tenth-century cathedral in Faras in the Sudan[37] depicts a crowned angel who protects the three youths thrown into the fiery furnace[38] by shielding them with his patterned wings, which are spangled over with peacocks' eyes and sparely but regularly laced with peacock feathers. The plumage of the archangel Gabriel in the

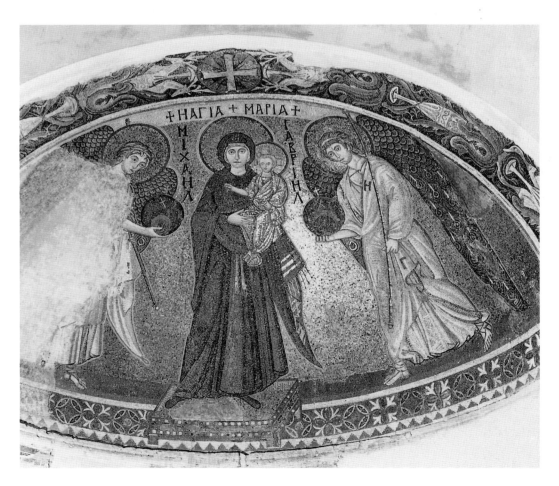

Fig. 5. Pietro Cavallini, *The Last Judgment* (detail), c. 1300, fresco. Church of S. Cecilia, Rome

Fig. 6. Anonymous, *Madonna with the Archangels Gabriel and Michael*, 6th century, mosaic. Panayia Angeloktistos Church, Kiti, Cyprus

Fig. 7. Filippo Lippi, *The Annunciation.*
Alte Pinakothek, Munich

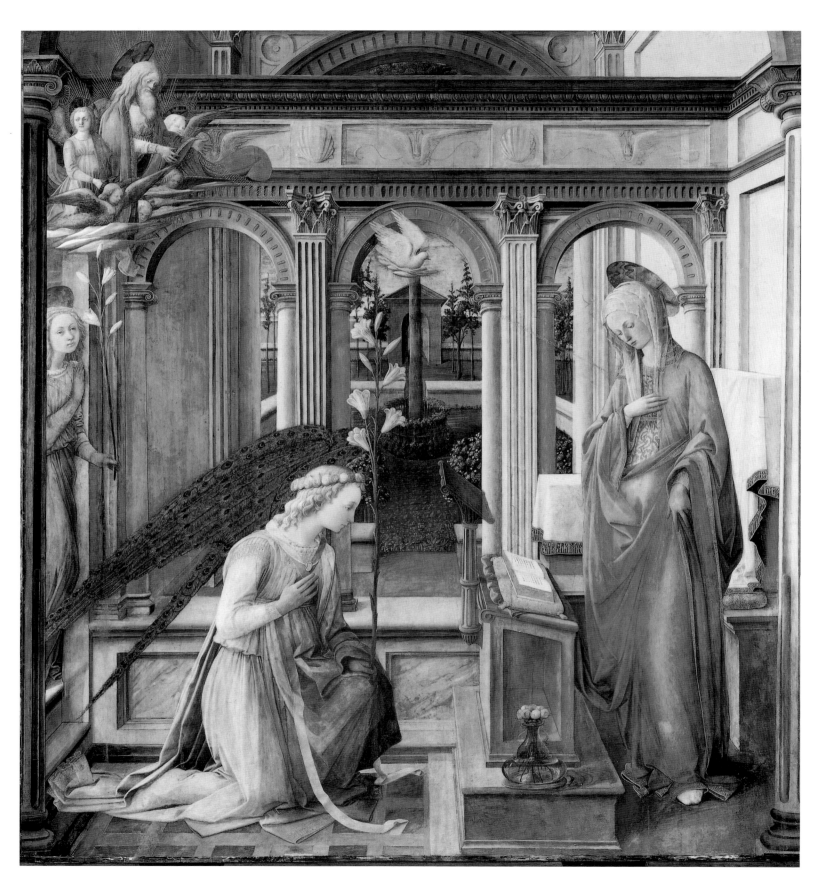

Annunciations by the Italian Renaissance master Filippo Lippi in Munich (fig. 7) and in London[39] or in the colossal wooden sculpture of the same theme by the German sculptor Veit Stoss[40] consists entirely of peacock feathers. The wings in these works have lost all anatomical reference; for peacock feathers, with their long quills and trailing plumage, are singularly ill-adapted to flight. They are not intended to support any weight, belonging to the tail and not to the wings of the peacock. Incorporated in angels' wings, they play a purely symbolic role. Giving visibility to angels' symbolic connotations took precedence, in short, over their anthropomorphic representation. Assembled from symbolical elements, the angel's figure as such is a creation of the mind; or, rather, the angel is a spiritual being that can only reveal its true appearance in the mind.

Even where the anatomy of a bird's wings, in most cases those of the goose, is retained, the wings may contain peacock feathers. Sometimes these are simply bundled together and attached to the wings' ends; sometimes the peacock tail feathers are decoratively laid over them as a symbolic allusion. This is the case, for instance, in the wings of the archangel Michael weighing souls in Hans Memling's *Last Judgment* triptych from the Marian church at Gdansk (fig. 8), dating to the period between 1466 and 1473.[41] Especially magnificent, almost regal in ornateness, are the kneeling angels in their sumptuous brocaded vestments in the scene of the *Adoration of the Shepherds* in Hugo van der Goes' Portinari Altarpiece of 1475 in the Uffizi, Florence. Their wings are the wings of birds: brightly colored, ornithologically varied, they too include the heavily symbolic peacock's eyes in their plumage.[42]

Wings are, in these cases, an ornithological element through which some of the spiritual properties of angels are made visible and manifest. This element, bound up as it is with angels almost as much as it is with birds, developed its own inner dynamic. Particularly original is the way in which Veit Stoss treated this theme. In his polychromed limewood *Annunciation*, he went far beyond the significance of wings as signs for celerity and ease of movement. Of the various tiny music-making angels suspended in the air, who joyfully swarm around Mary and Gabriel, one in particular not only has wings borrowed from birds in the usual way, but has almost been transformed into a bird altogether: his whole body is covered in a suit of bird's plumage (fig. 9).[43] The wing symbolism has here been taken to its extreme conclusion, producing what is tantamount to an iconographic hybrid form.

Fig. 8. Hans Memling, *Saint Michael*, detail from *The Last Judgment*. Muzeum Narodowe, Gdansk

Fig. 9. Veit Stoss, *The Annunciation* (detail), 1517–18, polychromed limewood. Church of Saint Lorenz, Nuremberg

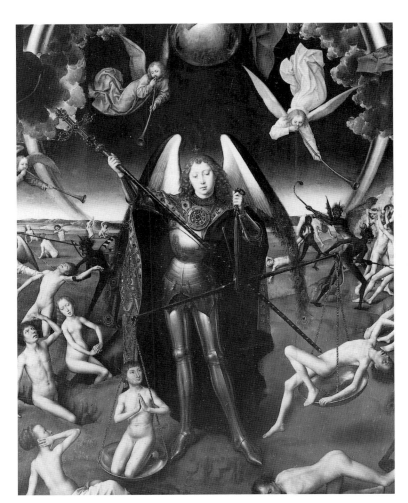

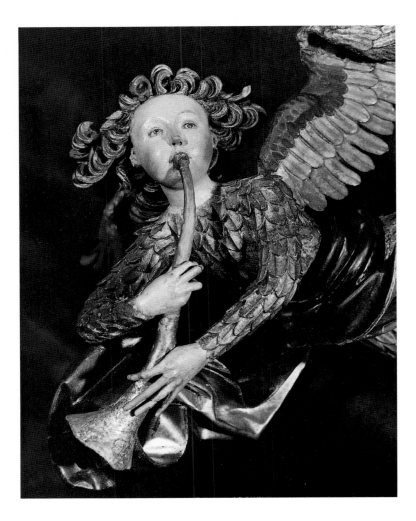

Wings have virtually become the iconographic distinguishing mark of angels. They may therefore be used to differentiate the good from its antithesis, the bad. Just as angels, as good spirits, as heralds of the power of good, are characterized by the wings of birds that fly by day, so evil spirits, emissaries of the devil, are equipped with the wings of bats that can only fly by night.[44]

That it should be so self-evident to represent angels as winged has also prompted reflection on this iconographic detail, which is sometimes taken to the point that the wings are left out. Thus in Jan van Eyck's *Ghent Altarpiece* of 1432, the music-making angels, who fill two panels, are represented entirely without wings.[45] Here the wings would be redundant: music itself (as we say) has wings, and here the music transformed into pictorial images has itself assumed the representation of the spiritual dimension.

Michelangelo, too, though for different reasons, deliberately represented his angels without wings. On the ceiling of the Sistine Chapel, in the *Last Judgment*, and in the Pauline Chapel, they fly without the by-then standardized equipment for flight. By means of their winglessness and also their nakedness, Michelangelo wished to stress, rather, the similarity between them and human beings. His angels wear no dazzling apparel. They have no obvious attributes. They cannot, as in the early Christian iconography, be identified by their outward appearance. There has even been some speculation in recent research whether the youthful figure among the otherwise child-like figures surrounding God the Father in the scene of the *Creation of Adam* on the Sistine ceiling might be not an angel at all, but rather be intended to represent the still-to-be-created Eve.[46] But if one recognizes that it was Michelangelo's habit to represent angels without wings, the glories of angels and the angels of the Passion in the *Last Judgment* require no further interpretation of this kind. The idea of wingless angels seems not, in any case, to have been anomalous at the time. Vasari's erroneous interpretation of several figures in Raphael's *School of Athens* as the Evangelists being inspired by angels[47] corresponds to Agostino Veneziano's engraving of the *Four Evangelists* (fig. 10).[48] Here the angel of Matthew is represented without wings.

The theme of the wingless angel has continued to fascinate artists. Particularly impressive is Ernst Barlach's version of the theme. Barlach deliberately reverses the physical properties, or suspends the gravitational pull, of his sculpture of *Der Schwebende* (literally, "the floating one") for the World-War-I war monument in the Antoniterkirche in Cologne (fig. 11).[49] Nor does he compensate for this by iconographic means. Yet he does not make one feel that the figure is held up by chains in the air. Hands crossed over its breast, the larger-than-life-size sculpture has a kind of simplified blocklike profile. With its chin pushed forward, it floats like a zeppelin, horizontally on the air. The figure's slightly sagging dress expresses, indeed, the force of gravity, but this the figure, by the very fact that it is floating, seems to have entirely overcome. Wings, which might have been able to support it or assist it in flight, are absent; instead, the enormous weight of the sculpture is deliberately underlined by the smooth surface of the bronze. Barlach, however, apparently is suspending the law of gravity by stylistically fashioning the statue in the expressionist idiom typical of him, so that the two large chains by which it is suspended from the vaulting are not perceived as belonging to it. It is precisely the absence of wings that makes the floating, or flying, of this angel so striking.

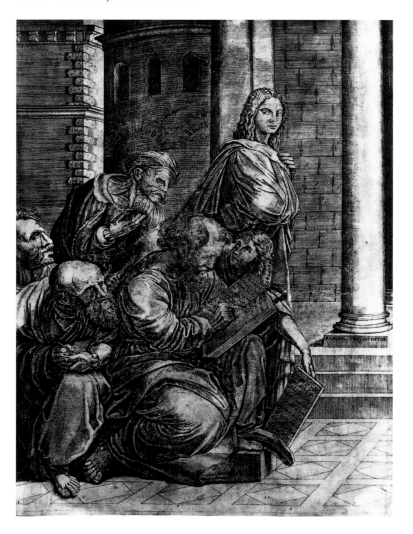

Fig. 10. Agostino Veneziano, *Four Evangelists*, copy after Raphael's *School of Athens*, 1524, engraving. Istituto Nazionale per la Grafica, Rome

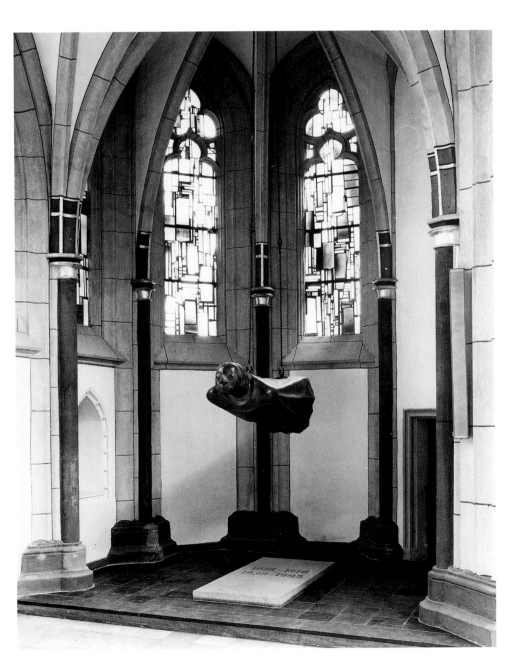

(left and above)
Fig. 11. Ernst Barlach, *Der Schwebende*, 1927.
Antoniterkirche, Cologne

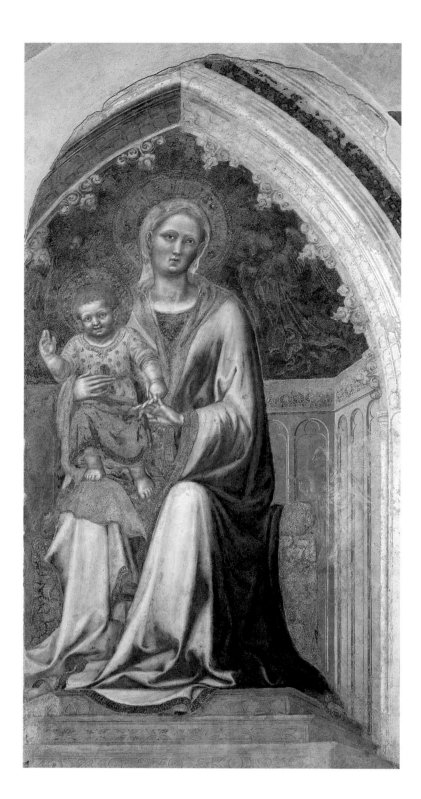

"Invisible" Angels

By being furnished with symbolic wings and also by the iconographic differentiation of these wings, angels take on varying degrees of material form, sometimes more, sometimes less. But not infrequently artists have tried, in their representation of angels, to dispense with matter altogether: that is, they have confronted the phenomenon of incorporeality. How could this be represented, or even suggested, in paint? In his *Maestà* in the Cathedral of Orvieto (fig. 12), dating to the autumn of 1425, Gentile da Fabriano engraved the outlines of two angels onto the gold ground, while two others, of whom only the one to the right is preserved, were represented as impalpable beings: diaphanously painted in white lime, they rest as light as clouds, as faint as air, on the sides of the Madonna's armless brocaded throne.[50] Even among Gentile's contemporaries the work was admired and praised on this account as "tam subtiliter et decore pulchritudinis" (so subtle and so beautifully decorous).[51]

It is not only as single beings that such "invisible" angels appear. Since spirits are as invisible as air, artists have also tried to represent them as such: they have formed whole clouds consisting of nothing but transparent angels and putti. In Raphael's *Disputà* in the Stanza della Segnatura in the Vatican, putti descend the rays of the golden glory that fills the upper part of the lunette behind the Trinity and are transformed below it into a bank of clouds.[52] In his *Madonna of Foligno* (fig. 13),[53] the small blue-gray putti are equally insubstantial; swarming around the golden disc of the sun before which the Madonna is enthroned, they dissolve before the eyes into a bank of cloud, below which lies the earthly sphere. What in Perugino or Ghirlandaio had been winged heads, painted in natural incarnate tones on a bright aureole, have here dissolved into a no-longer material and hence almost realistic heaven. The curtain that is raised in front of Raphael's *Sistine Madonna*[54] reveals an apparently innumerable throng of angels composed of nothing but light and air.

Fig. 12. Gentile da Fabriano, *Maestà* (detail), 1425, fresco. Cathedral, Orvieto

Fig. 13. Raphael, *Angel Clouds*, detail from *Madonna di Foligno*, c. 1511, oil on canvas. Vatican Museums, inv. 40329

This form of diaphanous angel has a tradition in Italy.[55] But artists north of the Alps also grappled with the problem of how to represent the discarnate nature of spiritual beings. In his *Saint John on Patmos* (fig. 14) of 1504–05,[56] Hieronymus Bosch represented the revelation to the apostle in the form of a light-blue angel apparently formed of glass or mist appearing on the hilltop in the middle distance. This visionary angelic being is also equipped with wings, which are laden with symbols. The usual bird's pinions are overlaid by the butterfly wings of the soul or the Horae (Hours) and, apart from the eyes described by Ezekiel, which adorn the edges of the wings, two prominent peacock's eyes are also attached to their upper part.

Apart from the air, it was light that enabled the artist to represent the transparency of angels' spiritual being. As heralds of God they are penetrated by divine light.[57] Of the wings created out of divine light we have already spoken. In Simone Martini's *Annunciation* (Uffizi, Florence), not only the wings of the archangel Gabriel are golden, but his whole figure also is painted in shades of gold or yellow. This color suffuses the whole painting with its luminous gold ground, on which the words of the angel's greeting are inscribed and with which the gold of the halos is also merged.

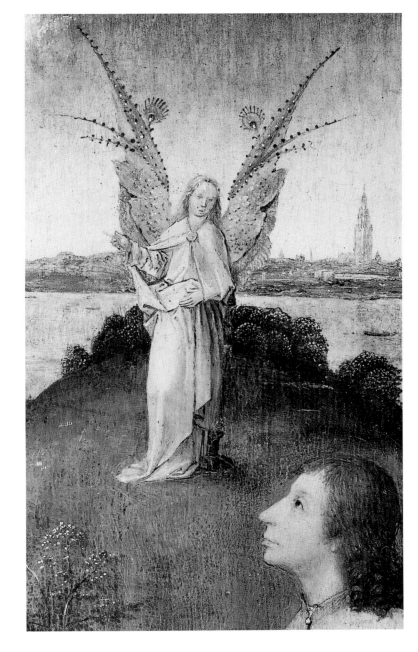

Fig. 14. Hieronymus Bosch, *Saint John on Patmos* (detail), 1504–06, oil on wood. Staatliche Museen Preussischer Kulturbesitz, Gemäldegalerie, Berlin

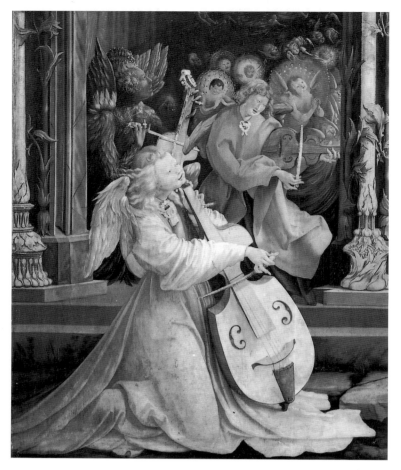

Two creations of almost the same year, the one to the north, the other to the south of the Alps, capture the divine light in unique and naturalistic ways, as opposed to the gold ground: Matthias Grünewald's *Concert of Angels* in the Nativity panel of his *Isenheim Altarpiece* of 1514 (fig. 15),[58] and Raphael's *Deliverance of Saint Peter* (fig. 16) in the Stanza di Eliodoro of 1512–13.[59] Here Raphael confronted almost every conceivable source of earthly light—torchlight, moonlight, daybreak, reflection, illumination—with the divine light of the angel who liberates Peter. This radiant light, it too painted, outshines all the other forms of light, even, it seems, the real daylight streaming through the window below. The same colors that Raphael used in his fresco recur in Grünewald's panel painting. What is iconographically baffling, since the painting is a heavily allegorized Christmas picture, also remains unfathomable at the formal level, due to the great burst of light with which the picture is filled and the various fantastic creatures that throng the scene behind the concert of angels. Both paintings are similar forms of representing supernatural events, or visions of angels, through light.

Fig. 15. Matthias Grünewald, *Concert of Angels*, detail from *The Isenheim Altarpiece*, 1512–16, oil on wood. Musée d'Unterlinden, Colmar

Fig. 16. Raphael, *The Deliverance of Saint Peter*, 1512–13, fresco. Stanza di Eliodoro, Vatican

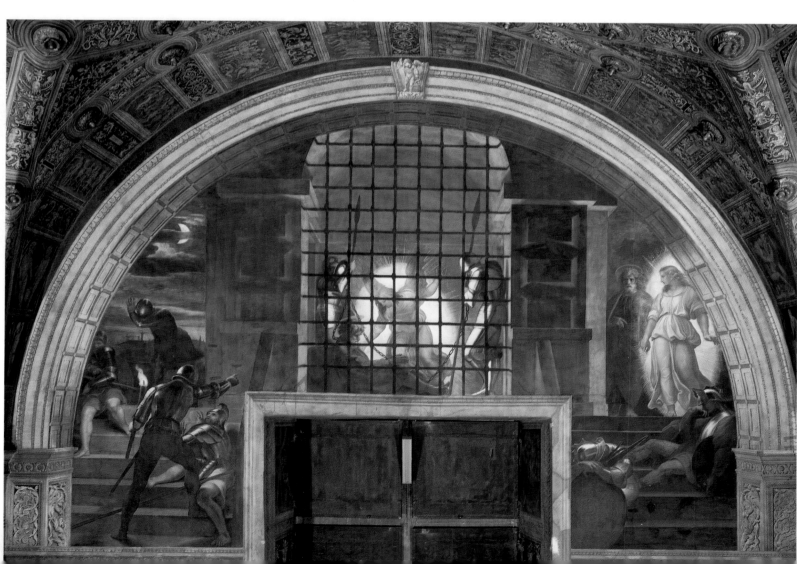

Angel Types

The representations of angels cited above may suffice to suggest how inexhaustible are the host of angels and their figurative representations. There has been a good deal of thought, and not only in theology, about the number, types, and names of the angels.[60] Although only four angels are known by name, the archangels Gabriel, Michael, Raphael, and Uriel,[61] by the fifth century Pseudo-Dionysius the Areopagite, in his *Hierarchia coelestia*, tried to divide the angels into three triads of three, nine choirs in all. First are the seraphim, cherubim, and thrones; second, the dominions, virtues, and powers; and third, the principalities, archangels, and angels.[62] Artists have not infrequently alluded to this division into nine groups in their compositions, such as in the dome of the Baptistery in Florence[63] or in the portico below the Loggia delle Benedizioni in Saint John Lateran in Rome, where painters under Pope Sixtus V (1590–95) even painted nine separate compartments each with a single choir of angels. In spite of this, no firm iconography for each separate choir was developed. Only the seraphim, with their normally six wings and absence of body, and the similarly, sometimes even identically, represented cherubim[64] are clearly differentiated from the rest.[65] Since the archangels mainly occur in the narrative scenes traditionally associated with them, here too some particular iconographic features have developed: one may think of the iconography, even female at times, of Gabriel, the archangel of the Annunciation,[66] or that of Saint Michael, commonly represented as a soldier or knight in shining armor (see fig. 8).[67]

The putto, a more frequent and in some periods much-loved type of angel, does not form part of the nine choirs of angels. But some of the choirs are sometimes represented in this infantile form. In the period around 1300 one finds miniature angels that more closely resemble dwarfs that the more customary child putti of later times. Among others, these lilliputian angels show the Holy Family the way to Egypt or fly in grief around Christ on the Cross (fig. 17) or over the *Lamentation of Christ* in the three corresponding frescoes by Giotto in the Scrovegni Chapel in Padua (1304–06). Not much more than a century later, undoubtedly also under the influence of the antique representations of *erotes*, the putto became a common motif in Italian Renaissance art. It is found not only as heraldic support or in dancing groups as in Donatello's *Singing Gallery* for the Cathedral in Florence (1433),[68] but also in religious contexts, as in Donatello's *tondi* of the Four Evangelists for the pendentives of the Old Sacristy in S. Lorenzo in Florence (1435). During the same period the type of child angel was also propagated north of the Alps, though seldom so nakedly or so sensuously as its southern species. It can be found, for instance, in the paintings of Stephan Lochner and the Cologne school; there it has its counterpart in the contemporary religious literature of the period.[69]

Fig. 17. Giotto, *Weeping Angel*, detail from *The Crucifixion*, 1304–06, fresco. Scrovegni Chapel, Padua

Fig. 18. Giotto and Workshop, *The Soul of Saint Peter Carried to Heaven*, detail from *The Stefaneschi Altarpiece*. Vatican Museums, inv. 40120

Fig. 19. Albrecht Dürer, *Angels' Mass*, c. 1500, drawing. Musée des Beaux Arts, Rennes, inv. C 110–1

The Principle of Good and Evil

In whatever form angels appear, as a level in the celestial hierarchy between God and man they always stand for the principle of good. As God's messengers they herald the advent of the Day of Judgment. While the devil thrusts the damned to the left of Christ into the pit of hell, angels receive the blessed to his right. The role of the *psychopomp*, the escorter of the soul played in ancient mythology by Hermes, the messenger of the gods who was also endowed with more than one set of wings, was taken over by angels in Christian iconography, and not only in the Last Judgment.[70] In the Stefaneschi Altarpiece, a work of the school of Giotto for St. Peter's in the Vatican dating to the middle of the first half of the fourteenth century, they accompany, for instance, the souls of the apostles Peter and Paul to heaven after their martyrdom; like the angels, the souls of the two apostles are imagined as their physical likenesses with wings (fig. 18).

How far the use of angels as the principle of the good can go is shown in a satirical and hence all the more striking way by Albrecht Dürer in his so-called *Angels' Mass* or *Recording of the Pious and Sinful Thoughts during the Divine Office* (fig. 19), a drawing dating to the years around 1500.[71] Between the angels who celebrate the liturgical function (above) and those who present the scene to the spectator (below) are grouped, around the edge of the sheet as in a choir, a number of canons whose thoughts and fantasies during the service are illustrated in little clouds like balloons in a cartoon. Tiny angels and devils meanwhile vie with each other in trying to draw the attention of the would-be worshipers; the contest between them is a prefiguration of the struggle for their souls on the day of the Last Judgment. While one angel holds out a crucifix to one canon, a devil simultaneously tempts him with a succulent roast fowl on a spit; a second canon dreams of being rescued from the flames of purgatory by an angel; a third contemplates the Madonna and child over a crescent moon; a fourth is being tempted by a devil with a naked woman; a fifth is being proffered an over-large beaker by a colossal winged grasshopper. As in contemporary legends, an angel in the center in front of the altar and two devils immediately below him to the left write down the thoughts of the canons, which they will later read out during the Last Judgment and which the archangel Michael will throw into the balance.

Angel Ornaments

Angels thus embody the principle of goodness and holiness and of the presence of God in the world. As such they also have their significance as ornament in the sacred sphere. In no-narrative decorations, though their outward appearance may be reduced to mere heads or wings, wherever an artist includes them, their representation remains an expression of their essential being: they are heralds of God.[72] The same principle holds true for architecture. In the angel pier of the cathedral of Strasbourg, the tectonic principle is apparently suspended and the vaulting is supported by angels who at the same time, by their attributes, point to the Last Judgment and the abolition of all human construction and order on the Last Day.

* * *

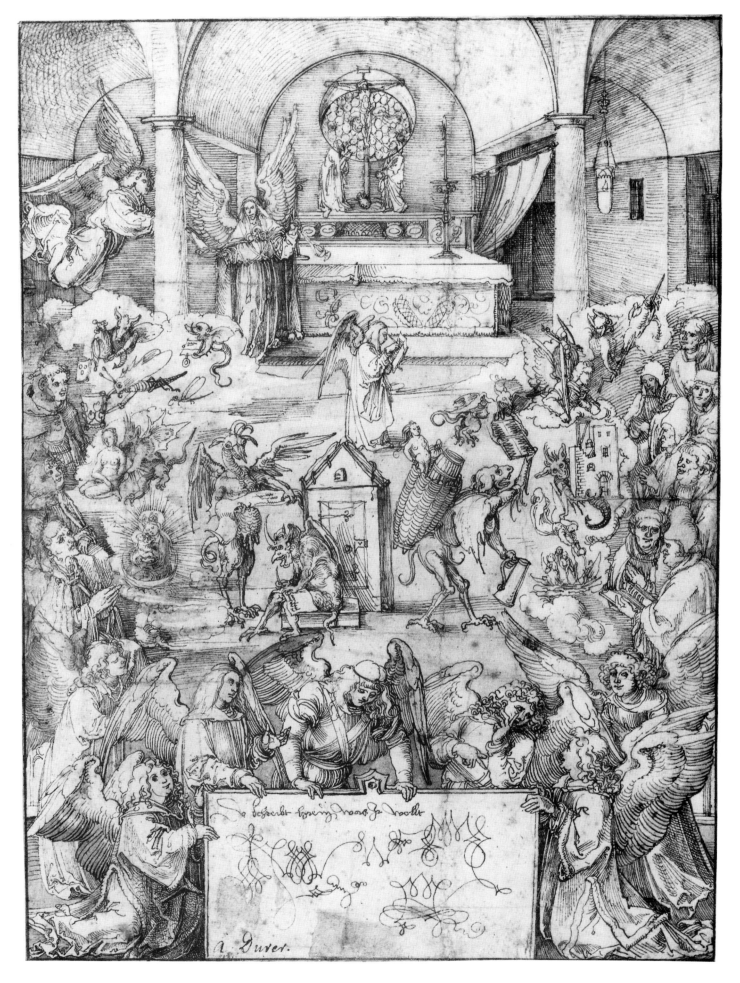

Angels have posed a challenge to artists of all times since the very beginnings of Christian iconography. The challenge consisted in how to represent a spiritual principle that could not be clothed in an allegory, since the angel is a being that resembles man. The invention of the angel figure was, after some time, quite naturally reflected in the nonreligious sphere, as in literature and music. Its further dissemination, its enrichment with symbolical meanings, acquired almost a momentum of its own. The theoretical and above-all theological grappling with the angel theme resulting in what were virtually treatises on angels—including such important texts of Church history as those of Pseudo-Dionysius the Areopagite, the Doctors of the Church (Saints Jerome, Ambrose, Augustine, and Gregory the Great), Saint Thomas Aquinas, and others[73]—seems hardly to have had any iconographic impact on the way angels were represented either during or immediately subsequent to their appearance.

The most famous angels of our own days seem to be the two winged putti below Raphael's *Sistine Madonna* (fig. 20) in Dresden. They are hardly creations of our own time; indeed they are almost half a millennium old. Their continuing success and present popularity are hard to explain. They combine the sacred with the profane, childish mischievousness with high art. They are easily reproducible and media-friendly. And they have in turn inspired other similar angel pairs.[74] They don't belong to the Vatican. They were not even intended for the Vatican; they were destined instead for a distant church, S. Sisto in Piacenza. But that hasn't stopped the Romans from adopting them as their own, and reproducing them on postcards together with the Colosseum, the Pantheon, the Trevi Fountain, and other familiar sights of the Eternal City. However banal, it is fitting they should at least be mentioned in our exhibition catalogue.

Fig. 20. Raphael, *Two Angels*, detail from *The Sistine Madonna*, 1512–16, oil on canvas. Gemäldegalerie Alte Meister, Staatliche Kunstsammlungen, Dresden

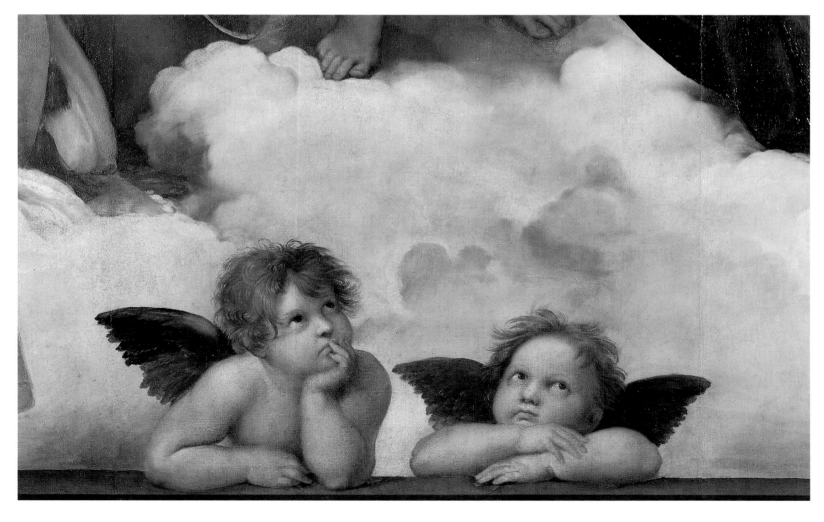

I should like to thank Max Eugen Kemper for his kind suggestions and Peter Spring for his improvements when translating my text.

1. Michl 1962, cc. 124–25; *New Catechism of the Catholic Church*, art. 9, para. 5, nos. 328–336; Bussagli 1995, 81–90, 93, and 97; Ladner 1995, 92.
2. Godwin 1995; Ladner 1995, 92.
3. Such as Frank Capra's *It's a Wonderful Life* with James Stewart and Donna Reed, 1946; Wim Wenders' *Wings of Desire* with Bruno Gans and Solveigh Domartin, 1988; or the recent CBS television drama *Touched by an Angel*.
4. The angel iconographies have undergone different developments in the Byzantine Church and in the Roman Church and its derivations. In Byzantine culture, angels remained more closely bound up with the liturgy and with the salient liturgical moments of the Orthodox calendar, for instance when angels are represented handing Communion to the apostles (Hamann-MacLean 1976, 2:134–37 and 153–56). They also retain more prominently their role as the representatives of God, as in the icons in which the three angels who visit Abraham stand for the Trinity, a type made especially famous thanks to Andrej Rublev's icon of 1551 in the Tretjakov Gallery in Moscow (see Hamann-MacLean 1976, 2:72–74).
5. Wirth, c. 626; Bussagli 1995, 40.
6. Passelecq and Poswick 1979.
7. See cats. 76–80.
8. See cats. 81–94.
9. See cats. 7, 93, and 94.
10. See cats. 33–80.
11. See Glossary.
12. Museo del Prado, Madrid. See L. Sciascia and G. Mandel, *L'opera completa di Antonello da Messina* (Milan, 1967), 95–96, no. 49.
13. Bussagli 1995, 44.
14. Vatican Museums, inv. 40526.
15. Michl 1962, 199; Wirth, c. 627; Bussagli 1995, 32.
16. Godwin 1995, 126.
17. Wirth, c. 627; Bussagli 1995, 48–49 and 311, fig. on p. 49.
18. Wirth, c. 627; Bussagli 1995, 48–49 and 311, fig. on p. 48.
19. Wirth, c. 627; Bussagli 1995, 48, fig. on p. 49.
20. See for instance the representation of the prophet Bileam with the angel in the New Catacombs on the Via Latina (H. and M. Schmidt 1989, 129–30, fig. 43, and Bussagli 1995, 53–54, fig. on p. 54).
21. Mark 16:55 and Luke 24:4. See Bussagli 1995, 236.
22. H. and M. Schmidt 1989, 129; Bussagli 1995, 63–71. On the relations of angels to their ancient prototypes, see the essay by Sannibale and Liverani, "The Classical Origins of Angel Iconography," in this volume.
23. Bussagli 1995, 45–46 and 218 (angel as executive arm of God).
24. Michl 1962, c. 627; Bussagli 1995, 58 and 90.
25. Whether the symbol for the evangelist Matthew in the apse of S. Pudenziana in Rome can be interpreted as the first representation of a winged angel (Michl 1962, cc. 627–28) must remain in doubt, since the mosaic in this zone is heavily restored and renewed. Since it would (if accepted) be the only nude angel in early Christian art, the figure in its existing form is all the more dubious and requires a careful analysis of its condition before it can be firmly placed in its historical context.
26. Munich, Bayerische Nationalmuseum.
27. Godwin 1995, 141–43.
28. Hamann 1964, 92, fig. 70.
29.See the Sannibale and Liverani essay in this volume.
30. Such as in Rome, church of S. Cecilia, Cavallini's *Last Judgment*.
31. Assisi, Upper Church, fresco cycle of the Life of Saint Francis: *The Vision of the Heavenly Thrones*, *The Stigmatization*, *The Death of Saint Francis*, *The Healing of the Fatally Wounded Giovanni di Lerida*, *The Confession of a Woman Restored to Life*, and *The Lamentation of Christ*.
32. Related to the angel made of light is the angel made of fire, as exemplified by a miniature in the *Commentary on Isaiah*, produced in Reichenau around the year 1000 and now in the Staatsbibliothek in Bamberg (Nigg and Gröning 1978, 77, fig. on p. 77). On the theme of the angel as a being of fire, see Bussagli 1995, 237–41.
33. Ezekiel 10:12.
34. Ovid, *Metamorphoses*, 1:721–22.
35. Ladner 1995, 143.
36. G. Der Parthog, *Byzantine and Medieval Cyprus* (New Barnet, 1995), 223–24, fig. on p. 260 above.
37. Nigg and Gröning 1978, 80–81, fig. on pp. 80–81.
38. Daniel 3:25.
39. Nigg and Gröning 1978, figs. on pp. 42 (below) and 43.
40. *Veit Stoss in Nürnberg. Werke des Meisters und seiner Schule in Nürnberg und Umbegung* (Munich, 1983), 194–209, color plates 49–73; G. Sello, *Veit Stoss* (Munich, 1988), pls. 106 and 114. The polychrome limewood sculpture, set in a

medallion and suspended in the nave of the Church of Saint Lorenz in Nuremberg, is known in German as the *Englischer Gruss*.
41. Corti and G. T. Faggin, *L'opera completa di Memling* (Milan, 1969), pls. III, IV and V; H. and M. Schmidt 1989, fig. 51.
42. Nigg and Gröning 1978, figs. on pp. 94–95.
43. H. and M. Schmidt 1989, fig. 46.
44. Godwin 1995, 140–41. See also cat. 5.
45. R. Brignetti and G. T. Faggin, *L'opera completa dei Van Eyck* (Milan, 1968), pls. XII and XIII. All the other angels in the altarpiece have wings, even the archangel Michael in his combat against the dragon, represented as a wooden sculpture carved in the choristers' desk. See Bussagli 1995, 313.
46. F. Mancinelli, "Cappella Sistina," in Angelo Tartuferi, *Michelangel—pittore, scultore e architetto* (Bagno a Ripoli, 1993), 50. A precedent for the angels in Michelangelo's *God the Father in Glory with Angels*, some with wings and some without, may be found in the fresco in the upper part of Michele Gimabono's Seregno tomb at S. Anastasia in Verona. Filippa M. Aliberti Gaudioso, *Pisanello—i luoghi del gotico internazionale nel Veneto* (Milan, 1996), fig. p. 77.
47. Vasari 1906, 4:332.
48. K. Oberhuber, *Polarität und Synthese in Raphaels "Schule von Athen"* (Stuttgart, 1983), fig. 26.
49. Nigg and Gröning 1978, fig. on p. 68. The statue was cast in 1927; see further, *Ernst Barlach Werke und Werkentwürfe aus fünf Jahrzehten. Ernst Barlach Katalog I. Plastik 1894-1937. Auswahl und Kommentar Elmer Jansen* (Berlin, 1981), 87–89.
50. The angel to the right only reemerged following the recent restoration: see further, A. De Marchi, *Gentile da Fabriano. Un viaggio nella pittura italiana alla fine del gotico* (Milan, 1992), 196–97, 212 nn. 50–51, pl. 69; Bussagli 1995, 244.
51. Vasari 1906, 3:16–17.
52. Of the putti in the *Disputà*, Shearman comments: "The *putto* which is made of cloud, which seems a transient condensation of vapour into angelic form, is a remarkable invention, and still more extraordinary is the light-filled Heaven entirely composed of such angelic clouds." Though the cloud-putto can be traced back earlier to the circle of Mantegna and Giovanni Bellini, the idea of an inner or remote heaven which is a dense, light-saturated cloud of such putti seems, in Shearman's view, to be Raphael's own invention: John Shearman, "Raphael's Clouds, and Correggio's," in *Studi su Raffaello*, ed. M. Sambucco Hamond and M. Letizia Strocchi (Urbino, 1987), 660.
53. Vatican Museums, inv. 40329. See Bussagli 1995, 101.
54. Staatliche Kunstsammlungen, Gemäldegalerie Alte Meister, Dresden.
55. Bussagli 1995, 243–44.
56. Berlin, Staatliche Museen Preussischer Kulturbesitz, Gemäldegalerie. See I. Schlégl and M. Cinotti, *Das Gesamtwerk von Hieronymus Bosch* (Lucerne-Freudenstadt-Vienna, 1966), 102, no. 33 A; Nigg and Gröning 1978, fig. on p. 22.
57. See Daniel's description of an apparition of an angel in a burst of light (Dan. 10:5–6).
58. Musée Unterlinden, Colmar.
59. A. Nesselrath, "La Stanza d'Eliodoro," in *Raffaello nell'appartamento di Giulio II e Leone X* (Milan, 1993), 245.
60. See "Angels and the World of Spirits" by Basil Cole and Robert Christian in this volume.
61. H. and M. Schmidt 1989, 146–60.
62. H. and M. Schmidt 1989, 128, 133, and 140–70; Bussagli 1995, 192–98 and 286–99; Godwin 1995, 24–49; Ladner 1995, 91–98.
63. H. and M. Schmidt 1989, 143, fig. 48.
64. The cherub in the scene of the *Stigmatization of Saint Francis* is for obvious reasons mainly represented as a Crucifix, but furnished with the six wings of a cherub. See cat. 66.
65. Hamann-MacLean 1976, 2: Register, 50–51; H. and M. Schmidt 1989, 142–44; Ladner 1995, 46 and 95–94.
66. H. and M. Schmidt 1989, 157–58; Godwin 1995, 41–44.
67. H. and M. Schmidt 1989, 149–57; Godwin 1995, 32–41.
68. Nagel 1994, 16–17.
69. H. and M. Schmidt 1989, 135–37.
70. Bussagli 1995, 122–23.
71. Musée des Beaux-Arts, Rennes, inv. C 100-1. F. Winkler, *Die Zeichnungen Albrecht Dürers*, vol. 1 (1484–1502), (Berlin, 1936):124–25, no. 181, pl. 181; *Albrecht Dürer 1471–1971* (exh. cat. Munich, 1975), 196–97, no. 378, fig. on p. 196.
72. See cats. 81–97.
73. Bussagli 1995, 192–98.
74. Similar angel pairs are often chosen for popular reproductions and postcards, such as William Bouguereau (1803–70), *Le premier baiser* or, as a detail enlarged, two angels from Guercino's (1591–1666) *Madonna with the Protector Saints of Modena* in the Louvre in Paris, or the two reading child-angels from Rosso Fiorentino's (1494–1540) *Madonna and Saints* in the Uffizi in Florence.

THE CLASSICAL ORIGINS OF ANGEL ICONOGRAPHY
Maurizio Sannibale and Paolo Liverani

In discussing the iconography of angels, one must inevitably consider the Greco-Roman roots of art. The Greco-Roman world is at the basis of western civilization. This world included the Etruscans, among the most important people of ancient Italy. From their civilization we rediscover themes and language of Greek art, selected and elaborated in a special way. The Etruscans lived between the Tiber and the Arno Rivers in central Italy, with cities also to the south in Campania and to the north in the valley of the Po River. After centuries of fighting, they were incorporated into the Roman state, of which they became an essential part. During the first century B.C. the Latin language progressively and finally substituted their original language, of which only a relatively small number of inscriptions remain.

First of all, a few basic concepts must be clarified. It is obvious that the main iconographic models for angels as they are commonly portrayed in Western art are of classical origin. Greco-Roman culture is full of divine or semi-divine beings who resemble angels, at least in their exterior, such as messengers, winged beings, and personifications of abstract concepts. But no figure in classical culture has the spiritual significance and functions that an angel has in Judeo-Christian religion. The oldest models and the fundamental theological and spiritual concepts that are intrinsically connected with angels have nothing to do with the classical world, but are entirely derived from the Old and New Testaments. The Bible's prohibition to make divine images or any kind of image, as can be seen in the episode of the Golden Calf in the Book of Exodus, kept the Jews from elaborating their own iconography. Jewish sources have not been included in this exhibition because, even though they are of fundamental importance, they are all written, not visual sources.

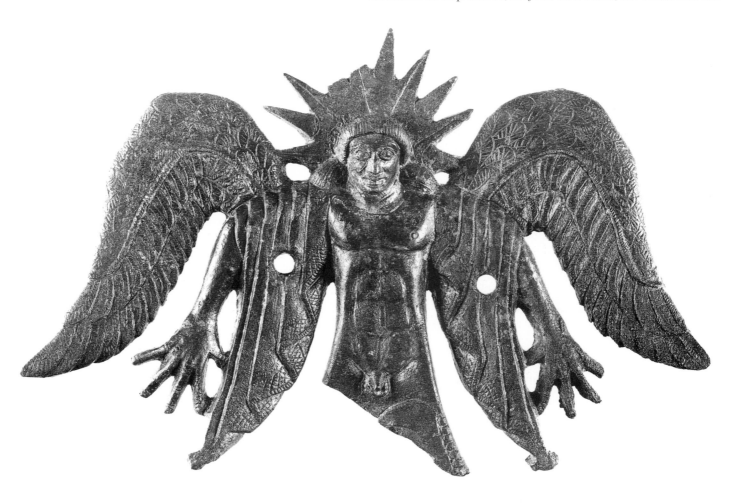

One image in this exhibition does concisely remind us of the importance of these sources. It is the relief that portrays an Assyrian *genius*, a visual reminder of the images available to biblical authors (cat. 10). The Jews were in fact surrounded by the culture of the great Middle-Eastern civilizations, the influence of which was particularly strong during the period of the Babylonian exile in the sixth century B.C. Descriptions of angels by biblical authors during or after this period of exile are frequently modeled on Assyrian *genii*.[1]

The equivalence of the winged figure with the angel is not a foregone conclusion, as our culture usually assumes it to be, but is the result of centuries of evolution. The oldest images of Christian angels are actually wingless. It is therefore important to examine the visual sources and the ideas that have been expressed in the images of the winged angel, producing the form we have known since childhood. This inquiry will also give a more profound idea of the images' meanings.

The oldest images of winged figures in classical culture gradually evolved, passing through the classical age and Hellenism, on to the middle ages and the Renaissance. Much of the familiar iconography, part of the collective consciousness of medieval and modern art, is in fact rooted in the characterizations and the models for composition elaborated by the classical world. The anthropomorphization of the supernatural is a characteristic of Greek culture and figurative art, and as such it was passed on to the Etruscan and Italic world at a fairly early date.

Religion in the Etruscan-Italic world was complex and had its own special characteristics, some of which have not yet been fully understood because the ancient religious sources are inadequate. A simple linguistic and iconographic equation between Etruscan gods and their Greek and Roman counterparts is misleading, even though a process of transmission, selection, assimilation, and syncretism did of course occur.

Winged figures in Etruscan-Italic art date to archaic times and to some extent descend from the monstrous beings with animal attributes typical of ancient Middle-Eastern cultures. Wings are a characteristic attribute of gods and also of the innumerable types of male and female spirits who accompany both humans and gods, which to some extent are the forerunners of the Roman *genius*.

The bronze figure with rays (possibly Sol/Usil) dating from the end of the sixth century B.C., which is part of the chariot found at the Roma Vecchia property (fig. 1),[2] is endowed with wings. So is the Eos carrying Kephalos on the famous mirror from Vulci dated 470–460 B.C. (fig. 2).[3] Wings also distinguish the mythical divinator Chalcas, in another mirror from Vulci from the late fifth century B.C., as a mediator between gods and men. The mirror shows him intently studying the liver of a sacrificed animal, trying to interpret the inscrutable will of the gods (fig. 3).[4]

Fig. 1. Etruscan, *Sol/Usil*, late 6th century B.C., bronze. Vatican Museums, inv. 12369

Fig. 2. Etruscan, *Mirror Found at Vulci with Eos Carrying Kkephalos*, 470–460 B.C., bronze. Vatican Museums, inv. 12241

Fig. 3. Etruscan, *Mirror Found at Vulci with Chalcas*, late 5th century B.C., bronze. Vatican Museums, inv. 12240

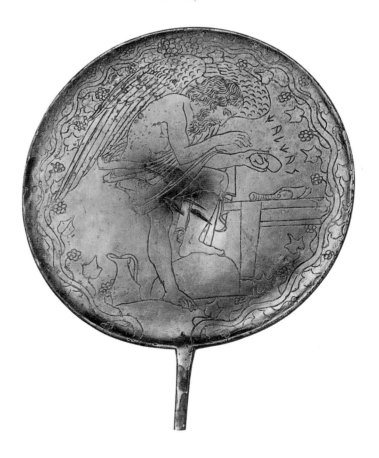

Among other winged beings in antiquity, the one who is best known and most frequently portrayed in art and in literature is the Greek god Eros, whose iconography eventually developed into a fundamental archetype.[5] In the works of Homer, Eros is still an abstract concept of desire in general, while Hesiod (Theog. 120) makes him the third primordial power after Chaos and Ge. This is probably why in the sanctuary of Tespie (Boeotia) he was worshipped in aniconic form. Later traditions generally made him the son of Aphrodite, although other versions of his genealogy did exist.

Between the end of Archaism (530–480 B.C.) and the Severe Style phase (480–460 B.C.), the iconography of Eros settled into a young and winged figure. Attic vase paintings of the fifth century B.C. mostly show him in a male sphere. Only at the end of the fifth century does he start appearing consistently in a female environment: everyday life in the *gynaeceum*, scenes showing games or women preparing their toilet, and marriage preparations. He also appears in this role in Italiot ceramics, particularly those produced in Apulia, where his appearance was gradually transformed and rendered so womanly that he could be mistaken for a hermaphrodite (cats. 13–15).[6]

During the fourth century B.C., Eros became a favorite subject of such great sculptors of the time as Praxiteles and Lysippus, who made some of the most famous images of him. The *Eros of Tespie*, which was made by Lysippus between 338 and 335 B.C., is one of the best documented examples because many copies were made of it. A Roman copy from the Emperor Hadrian's time is exhibited here (cat. 12).

From the second half of the fourth century B.C. onward, the figure of Eros dominated the production of Italiot vase paintings, becoming omnipresent even in other art forms in Magna Grecia (southern Italy) such as small sculptures and jewelry, and was increasingly used simply as a decorative element (fig. 4). At the same time, Eros' original persona was enriched by new variations on his activities and attributes, and these additions to some extent are precursors of the Roman Amor.

Fig. 4. Southern Italy (?), *Pendant with Eros*, 4th–1st centuries B.C., gold. Formerly Falcioni Collection. Vatican Museums, inv. 13566

Fig. 5. Carlo Ruspi, 1862, after *Wall Painting Showing Vanth, François Tomb at Vulci* of 4th quarter 4th century B.C. Vatican Museums, inv. 14896

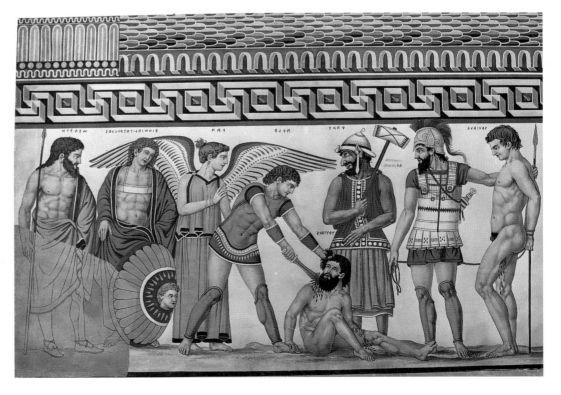

As far as Etruria is concerned, in the middle of the fifth century B.C. there were mirrors with Eros standing out alone against the figured background.[7] It seems unlikely, though, that the winged genius shown on the Vatican mirror, which dates from the beginning of the fifth century B.C. (cat. 11), can be identified as Eros, since it could as easily represent another personification.

From the second half of the fourth century B.C. onward, mirrors can be found showing Eros together with Turan and Atunis or with other figures, some of which are identified by inscriptions and some of which are nameless. Eros also becomes a constant presence in the Etruscan female environment, as can be seen in mirrors and vase paintings, similar to the contemporary Italiot world (cats. 13–15).

On the handle of a *cista* from Praeneste, a winged genius (Eros?) hands an *alabastron* to a similar winged female figure.[8] This introduces the significant iconography of the winged female genius, which was characteristic of Etruscan religion and is generically and sometimes incorrectly called Lasa. This term has in fact been extended to include all types of female personifications, both winged and wingless, that appear in Etruscan mythological and funerary iconography.[9]

The name Lasa is documented by epigraphic sources, mostly on mirrors, between the mid-fourth and third centuries B.C.[10] It always refers to a graceful young female figure, which two times out of three has wings but no specific attributes, even in terms of clothing. She is represented naked, half-clothed, or enveloped in heavy drapery, sometimes without attributes, holding in her hands objects that are always different: the *alabastron* (oblong container for unguents or perfume) and *discerniculum* (needle used in dressing hair), a scepter or a spear, a necklace, a small branch, a scroll. The attribute of the *alabastron* is not specific to Lasa, because other minor gods of Turan's circle or related to the female world also can be endowed with it (cats. 18–20).

The lack of a specific iconography and the fact that an epithet is sometimes used to describe her nature and function make Lasa one of the polyvalent goddesses who have been identified with the nymph. The name qualified by the epithet would indicate a specialization in a particular area. Her existence is also seemingly documented on the bronze liver of Piacenza,[11] where the area of Lasl is next to that of Tinia (Zeus). The similarity between "Lasa" and "Lasl" has suggested a possible correspondence between Lasa Vecu and the nymph Vegoia, who was a prophetess and assisted Tinia in defending order and justice.[12] Therefore the appearance of Lasa on a mid-fourth-century mirror together with Ajax and Amphiaraus seems like an iconographic mistake, with Lasa usurping the role of the funerary demon Vanth.[13]

Vanth is one of the best-known infernal goddesses of the Etruscan pantheon, though she is often confused with Lasa or with other minor gods because they are similar iconographic types.[14] The most famous and possibly also the oldest representation of Vanth is in the François Tomb in Vulci, which dates from the last quarter of the fourth century B.C. She appears in the scene of the sacrifice of the Trojan prisoners, without any attributes but identified by the inscription (fig. 5).[15] She is the counterpart of Charon, who carries a hammer that symbolizes the death blow.[16]

Vanth is shown also in a contemporary ceramic group that clearly shows the role played by this *psychopomp* demon who accompanied souls into the afterlife.[17] The details of this role are further specified on the later sarcophagus of *Hasti Afunei*, where three female figures seem to assist during the three moments of passage: death, the journey, and the entrance into the underworld.[18]

Vanth's range of activity is expressed in an image inside the Anina Tomb in Tarquinia, which dates from the first half of the third century B.C. She and Charon stand on either side of the door (a variation on the Greek couple Hades and Persephone), seemingly presiding over the passage to the afterlife.[19] Vanth wears the typical tunic with crossed straps and carries a torch, which lights the way toward the underworld and is an attribute used in scenes that have a dramatic ending. An example of this is the torch carried by the demon (often doubled), who watches, excitedly but without taking part, in the fight between Eteocles and Polynices that resulted in the death of both (fig. 6).[20] Serpents are another of Vanth's attributes, a clear reference to the underworld and inspired by Hecate and the Erinnyes; they are also a common attribute of Charon and the demon Tuchulca.[21]

Fig. 6. Etruscan, *Thana Helusnei Urn*, 1st half 2nd century B.C., terra-cotta with polychrome. Vatican Museums, inv. 16254

Fig. 7a, b. Etruscan, from Tarquinia, *Poet's Sarcophagus*,
late 4th century B.C., nenfro. Vatican Museums,
inv. 14561

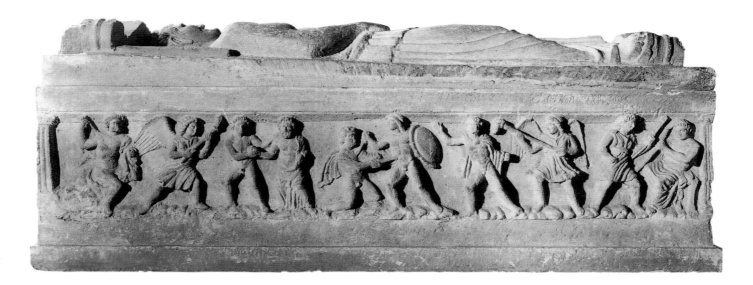

Fig. 8. Etruscan, *Sarcophagus from the the Vipinana
Tomb at Tuscania*, late 4th–early 3rd century B.C.,
nenfro. Vatican Museums, inv. 14947

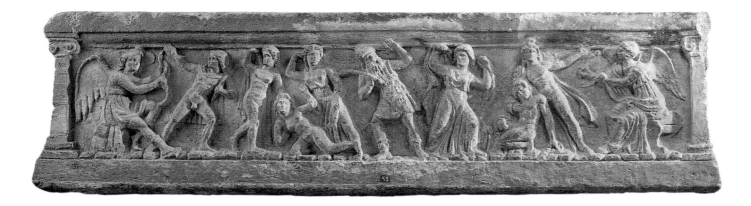

The link between Vanth's iconography and the Greek Erinnyes (goddesses of revenge and justice) is obvious in Etruscan reliefs, which clearly show that they are taken from Greek models. It is well known that the iconography of the Erinnyes was strongly affected by the tragic theater, particularly by the myth of Orestes (see the *Oresteia* by Aeschylus). Examples of this can be seen in Attic vase paintings of the fifth century B.C.[22] On the *Poet's Sarcophagus* from Tarquinia,[23] one side of which shows Orestes and Pylades leaning over an altar with the bodies of Aegisthus and Clytemnestra on it, the winged figures in the relief are likely Erinnyes (fig. 7a). The winged figures on the other side of the sarcophagus, who hold torches while they watch the fight between Eteocles and Polynices (fig. 7b), must, on the other hand, have a funerary meaning. They resemble reliefs on some cinerary urns, where this particular motif was repeated endlessly (see fig. 6).[24]

Another example of a Fury can be seen on the Todi urn, which shows Pelops killing Oinomaos. Along the sides of the urn a more strictly funerary iconography is used, similar to that used on the *Poet's Sarcophagus* (see cat. 21).

Funerary symbolism explains how even the most important gods of Olympus could be transformed into winged demons. On the sarcophagus from the *Vipinana Tomb* (late fourth–early third century B.C.), which shows the massacre of Niobe's children, Apollo and Artemis look like Etruscan demons as they go about their killing (fig. 8).[25]

Even Aphrodite sometimes is portrayed with wings, such as in the reliefs on urns from Volterra that show the myth of Paris (second century B.C.). This Etruscan version of the myth suggests an identification between Aphrodite and Vanth.[26]

The mirror from Vulci in this exhibition (cat. 16) summarizes the way in which the image of a winged figure, male or female, was generically associated with different personifications of Etruscan gods. On the mirror are three figures: Maristura[n], a nude god, Thesan, a heavily draped goddess, and Mus, a half-naked female divinity who carries a zither, a distinguishing attribute that may identify her with a later figure on the antefix (cat. 22). The three gods on the mirror are quite strongly differentiated, yet all of them have wings.

Going back to the funerary aspect, this discussion of winged beings in Etrusco-Italic art can be brought to a close with a short description of the urn of *Arnth Velimnas* (fig. 9).[27] This extraordinary construction dates from the second half of the third century B.C.; the base has two winged female figures seated on either side of the door of Hades, which is painted in the middle of the block. The serene attitude of these two funerary *genii* is in harmony with their role as assistants in the passage toward the afterlife. The modern-day observer cannot help feeling that the figures are vaguely familiar, since they have been assimilated into the aesthetic experience of western art. But the familiarity goes further: this urn, with its sculpted and scenographic effects, is actually a forerunner of the Renaissance funerary monument, which was to come into being fully seventeen centuries after this Etruscan prototype.[28]

Maurizio Sannibale

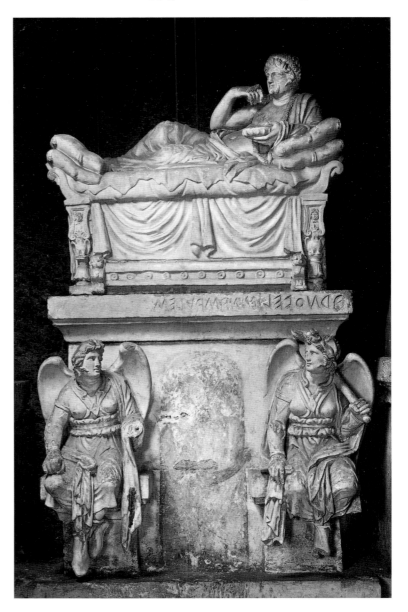

Fig. 9. Etruscan, *Cinerary Urn of Arnth Velimnas*, 2nd half 3rd century B.C., travertine. Hypogeum of the Volumni, Perugia

Leaving aside the less common winged figures, the two most frequently portrayed winged figures on both public and private monuments in Roman times are Eros and Victory. In a discussion of Roman art, Eros' Latin name would be Amor. He often appears together with his mother, Aphrodite (Venus for the Romans), the goddess of beauty and love. For example, they appear together on the small pediment of the tomb of *Claudia Semne*, which was built in the third decade of the second century A.D. The bust of the dead woman is in the middle of the pediment (cat. 23); she is portrayed like Venus, and on either side are two cupids whose function is to make the dead woman's identification with the goddess immediately comprehensible.

However, in many representations Eros tends to lose his original meaning and appears in generically idyllic and bucolic contexts. This tendency was already widespread in Hellenistic times. It can be clearly seen in the fragment of a pilaster (cat. 26) that was produced by sculptors in Asia Minor during the first half of the third century A.D., one of innumerable examples of harvesting cupids. This particular iconography can also be seen in early Christian funerary art, where the figures have of course lost every pagan connotation and

remain an abstract symbol, in this case alluding to heavenly happiness. Other scenes with cupids on a boat heading into port, which can been seen on sarcophagi (cat. 27), have a similar meaning, and so do the far rarer images of musical cupids (cat. 28), which may well have inspired Renaissance artists.

As the figure of Eros lost much of its original meaning, it started to appear in heraldic poses on both pagan (cat. 31) and Christian (cat. 30) sarcophagi. In the Christian sarcophagus exhibited here, besides Eros there are also four winged figures who are holding either animals or fruits, alluding to the various seasons of the year. These are the personifications of the seasons or *genii*, similar to Eros but with a highly symbolic meaning. They suggest the eternal repetition of the seasons and therefore symbolize life after death. As in the other funerary images described here, the meaning of the winged figures had become purely symbolic and could be accepted even by Christians. These small cupids could also be used in such a genre scene as a cart race for the sarcophagus of a child (cat. 29), using a common funerary image but giving it a more suitably childlike quality.[29]

The other winged character of great figurative importance in the Roman world was Victory,[30] the equivalent of the Greek Nike.[31] Her iconography is extremely varied: she always has wings and descends from the sky carrying symbols such as a crown, a palm frond, a trophy, or a shield, all of which represent success in battle. Victory was often accompanied by other divinities, and during the Roman Empire she was increasingly associated with the emperor, so that eventually she was often called Victoria Augusta. She is shown in reliefs and in public monuments standing beside the emperor, in the act of crowning him or, in any case, as the messenger of his victories, which served to strengthen the empire. She was soon used also in funerary art to represent victory over death. Funerary urns and sarcophagi often had a pair of winged victories on them, facing each other in the heraldic pose already used for Eros and holding a shield or a crown with a portrait of the dead person or a tablet with the deceased's name inscribed on it (see cat. 24).

Some aspects of early Christian art in relation to pagan art are significant to the origins of angel iconography. It is a fact that Christians borrowed heavily from pagan art, and the parts they borrowed can be broadly grouped into three categories: elements of pagan origin, which were used without making any changes in artworks commissioned by Christians; figures inspired by pagan iconography; and figures actually taken from it, reinterpreted in a Christian manner. This is hardly surprising, considering that Christian art is rooted in a classical figurative vocabulary that is of pagan origin. Even before iconographic mutations occurred, the intrinsic meaning of the images was profoundly modified on the basis of New Testament sources and the works of the Church Fathers.[32]

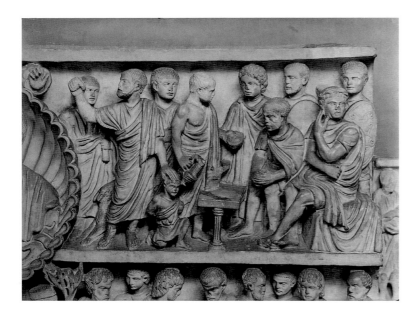

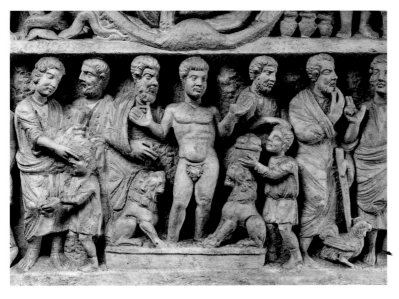

Fig. 10. Early Christian, *Sacrifice of Isaac*, 2nd third 4th century A.D., marble. Vatican Museums, inv. 31543

Fig. 11. Early Christian, *Daniel in the Lion's Den*, 2nd quarter 4th century A.D., marble. Vatican Museums, inv. 31427

Even considering just the simplest examples, it has already been seen how some figures (harvesting cupids, *genii* of the seasons) were reutilized without creating any problems because they were considered abstract symbols. Other images entered the standard Christian repertory with a purely decorative function: this is obvious, for example, in the sarcophagus lid exhibited here (cat. 32). The theme is clearly Christian, as can be seen from the Epiphany scene on the right side of the relief. Beside the scene, two cupids hold up a tablet that must have once been painted with the name of the woman buried in the sarcophagus, and two victories hold up a drapery as a background for the bust of the dead woman.

Thus it is not too surprising that angels have iconographic forerunners in pagan art. However, in the first images, angels have no wings. Starting from the scene with Jonah in the Catacombs of Priscilla in Rome, which dates from the second half of the third century A.D., through many frescoes and sarcophagi all the way to the end of the fourth century, angels have no distinguishing features and can be identified only on the basis of context. This is visible, for example, in the scene of the *Sacrifice of Isaac* (fig. 10) and in one showing *Daniel in the Lion's Den* (fig. 11).[33]

These angels are in no way different from the other men portrayed in the scenes: they wear dalmatics and pallia and usually have a youthful appearance (although some of them are bearded, indicating an older man) and they have no specific attributes. In many passages of the Bible they are, in fact, simply called "men," such as the angels given hospitality by Abraham (Gen. 18:2), by Lot (Gen. 19:10 ff.), and by Samson's mother (Judg. 13:6), and the two angels who appear in front of the devout women on their way to Christ's sepulcher on Easter morning (Lk. 24:4; see also Mk. 16:5). Even the archangels sometimes look like men, such as when Gabriel appears to Daniel (Dan. 8:5; 10:5–15), or Raphael appears to Tobias (Tob. 5:4). In many other passages there is no description at all of the angel: see, for example, the description of the annunciation to Zacharias of Saint John the Baptist's birth in the Gospel of Luke (1:11) or the annunciation to Mary (Lk. 1:26 ff.). It is easy to understand why initially no specific iconography was created for God's messengers.

This situation changed distinctly between the end of the fourth century and the beginning of the fifth, when the iconography now considered typical of angels (wings, a long gown, and a halo[34]) was developed. These changes came about for textual, iconographic, and social reasons. First of all, some biblical texts allowed for different iconographic choices. Examples of this can be seen in the passages describing the flight of angels in Daniel (9:21) and Revelation (14:6)

and the angels' returning to heaven after announcing Christ's birth to the shepherds (Lk. 2:15); or, again, the angels' descent from heaven at Easter (Mt. 28:3) or John's visions of them in Revelation (10:1; 18:1; 20:1). Also, special categories of angels such as the cherubim and seraphim were described as having two or even six wings. Already in the year 197, Tertullian had written that "every spirit has wings; this is why angels and demons can go everywhere in an instant" (*Apologeticum* 22; *PL* I.466). The ancients understood very well (in fact, probably better than we do) that this attribute had no naturalistic connotation but was actually a metaphor for the possibility of carrying the divine message immediately to man. This concept is expressed clearly by Isidore of Seville (560–636). He explains that painters are allowed to portray angels with wings if the wings "express their rapid flight, just as in poets' fables the winds are said to have feathers, because of their swiftness, of course!" (*Etymologiarum* VII.5.3; *PL* LXXXII.272).

When artists wanted to portray an angel with wings, they inevitably sought inspiration from other winged figures commonly used in the art of their time. They probably didn't consider Eros particularly suitable because of his nudity and because his connections with pagan mythology were still a sore point. Victory must have seemed far more appropriate, since she was the personification of an abstract concept and also the messenger of the gods who brought the news of victories.

In order to understand such a significant change, one must also bear in mind some profound changes that occurred in the fourth century. Christianity, which had been persecuted for three centuries as a *superstitio illicita* (illegal superstition), was at last recognized by the Emperor Constantine's edict in Milan in 313. In fact, the emperor actually encouraged public worship by building imposing basilicas in Rome and throughout the empire. Eventually, the end of paganism was made official by the Constitutions of the Emperor Theodosius in 391 and 392, which were confirmed by his sons Arcadius and Honorius in 395 in their decree that pagan temples were to be shut down. It is obvious that the iconography of Victory was not likely to be used by a persecuted Christianity, particularly since it was widely used in imperial art. The choice to use Victory is far more comprehensible if the figure is seen to represent victory over pagan cults and the social recognition of the new religion.

The new iconographic models were therefore taken rather freely from Victory. The first examples of winged angels, on the sarcophagus from Sarigüzel[35] (fig. 12) and on the wooden doors of the Basilica of Saint Ambrose in Milan,[36] which both date from the end of the

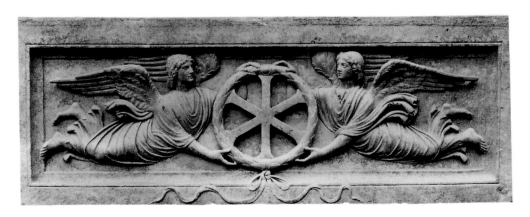

Fig. 12. Roman, *Sarcophagus from Sarigüzel*, late 4th century A.D., marble. Deutsche Archaeologisches Institut, Rome

fourth century, show them facing each other in a heraldic pose, holding a crown with the Christian monogram *chi-ro*, the first two letters of Christ's name in Greek (Christòs). These pieces faithfully copy classical iconography, but others only use some classical elements, in this case the wings, to create a new iconographic model. An example of this is the Pignatta sarcophagus in Ravenna,[37] which is from the same period and has the first definite image of the Annunciation on one side (fig. 13).

During the first half of the fifth century, the iconography of angels as we know them, youthful figures with wings and haloes, became fixed and definite. The great mosaic cycles at S. Maria Maggiore in Rome and S. Vitale in Ravenna have the first examples of a chromatic distinction between different types of angels (fig. 14). This artistic convention is related to the concept that the bodies of angels are made of ether, which is pure and luminous as a flame in good angels, (who are therefore in red), and thicker, darker, damp, and "nocturnal" in the angels who rebelled against God, the demons, who were rendered in tones of azure and deep blue.[38]

Subsequently, the functions and iconography of angels diversified and became more specialized. But their development is a subject for Byzantine and medieval art.

Paolo Liverani

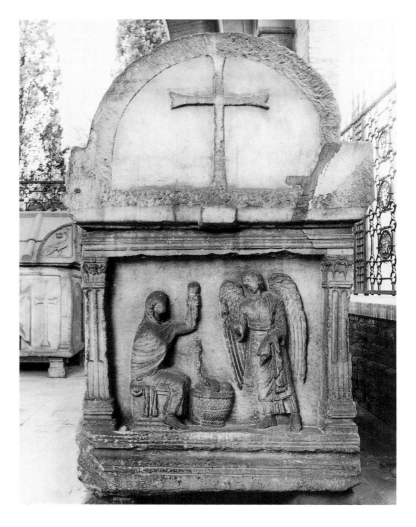

Fig. 13. Early Christian, *Annunciation* from *Pignatta Sarcophagus*, late 4th century A.D., marble. Quadrarco di Braccioforte, Ravenna

Fig. 14. Early Christian, *Angels*, 1st half 5th century A.D., mosaic. Santa Maria Maggiore, Rome

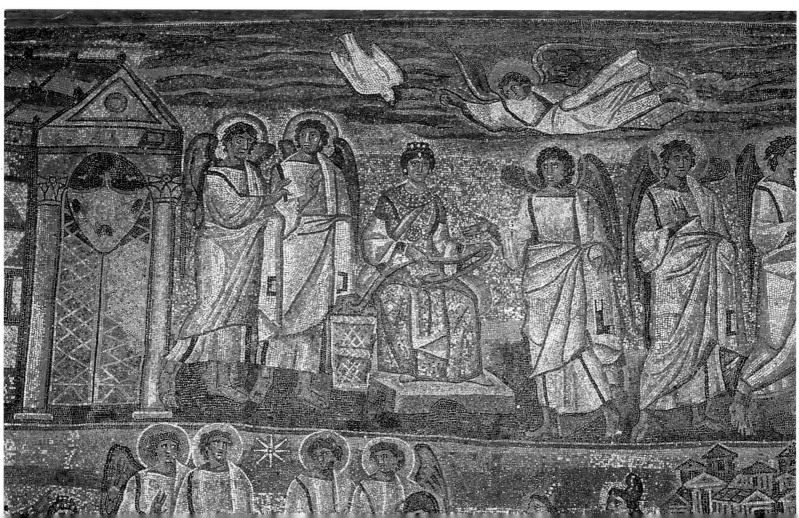

1. See cat. 10 for a broader discussion of this topic.

2. Roma Vecchia is located six miles outside Rome on the Appian Way. E. Q. Visconti, *Il Museo Pio Clementino* 5 (Rome, 1796): pl.B.IV; Musei Etrusci … monimenta 1842, pl. LXXIV, 11; Colonna 1996, 346–49, fig. 10.

3. Pfister-Roesgen 1975, 21–22, S 2, pl. 2; Fischer Graf 1980, 11, V2: pl. 1: 2; R. Bloch and N. Minot in LIMC, see "Eos/Thesan," no. 30, with bibliography; R. D. De Puma, "Eos and Memmon on Etruscan Mirrors," in *Murlo and the Etruscans. Art and Society in Ancient Etruria* (Madison, Wisconsin, 1994), 180–89, fig. 16.7.

4. Pfister-Roesgen 1975, 63–64, S 45, pl. 49; Fischer Graf 1980, 42–44, V:26, pl. 10:3; V. Saladino in LIMC, see "Kalchas," no. 1, with bibliography.

5. E. Speier in EAA, 3, see "Eros"; A. Hermary, H. Cassimatis, and R. Volkommer in LIMC, see "Eros"; I. Krauskopf in LIMC, see "Eros in Etruria."

6. Some genre scenes are given a ritualistic quality by the presence of a *phiale*, which suggests a libation to the gods. However, there are no definite signs of a cult in Southern Italy, although some scholars link the iconography of Eros as a statue in a *naiskos* or on a column with a cult.

7. ES 1, 120:2, cit. from I. Krauskopf in LIMC, see "Eros in Etruria," no. 8.

8. Krauskopf in LIMC, see "Eros in Etruria," no. 40; Ciste 1 2,232–36, no. 70.

9. See, for example, S. De Marinis in EAA, vol. 4, see "Lasa."

10. Rallo 1974; R. Lambrechts in LIMC, see "Lasa."

11. This bronze model of a sheep's liver is divided into areas that correspond to the various Etruscan gods. The liver of the sacrificial animal was used by *haruspices* for divinatory purposes; finally, see Colonna 1994.

12. Serv., *ad Aen.*, 6, 72; L. B. van der Meer, *The Bronze Liver of Piacenza. Analysis of a Polytheistic Structure* (Amsterdam, 1987), 109–12.

13. ES, CCCLIX; Rallo 1974, 18, n. 1.

14. S. De Marinis in EAA, vol. 7, see "Vanth"; Spinola 1987, 56–67.

15. Vaticano 1987, 85–94, figs. 3, 7, with bibliography; Spinola 1987, 56, fig. 1.

16. F. De Ruyt, *Charun démon étrusque de la mort* (Rome, 1934).

17. B. Klakowicz, *La collezione dei conti Faina in Orvieto* (Rome, 1970), 136, nn. 19, 21; Spinola 1987, 57, figs. 2b–c, 3, with bibliography.

18. Herbig 1952, no. 76; Spinola 1987, 58, fig. 6, with further bibliography.

19. Steingräber 1985, 287–88, n. 40; Spinola 1987, 57, fig. 4, with bibliography. See also Tomba dei Caronti (Steingräber 1985, 305, n. 55, tabs. 61–63) and Tomba del Cardinale (Steingräber 1985, 303, n. 54, tabs. 59–60).

20. Sannibale 1994, 144–45, n. 23. For the type, see Sannibale 1994, 116–19, n. 21.1.

21. Steingräber 1985, 334–35, fig. 131; M. Cristofani, "Pittura funeraria e cele-brazione della morte: il caso della tomba dell'Orco," in *Atti del convegno internazionale di studi "La Lombardia per gli Etruschi"* (Milan, 1986), 200ff., tab. LIII: 20.

22. H. Sarian in LIMC, see "Erinys."

23. Gregorian Etruscan Museum, inv. 14561. Bibliography: Herbig 1952, 43–44, n. 79, tabs. 33–34, with bibliography; H. Sarian in LIMC, see "Erinys," nos. 30, 92; R. M. Gais in LIMC, see "Aigisthos," n. 30; G. Colonna, in *Gli Etruschi e l'Europa* (Milan, 1992), 332.

24. See note 20.

25. Gregorian Etruscan Museum, inv. 14947. Herbig 1952, n. 80, tab. 30; G. Colonna, "Archeologia dell'età romantica in Etruria: i Campanari di Toscanella e la tomba dei Vipinana," in *StEtr* 46 (1978):105, J 1, 112–13; I. Krauskopf in LIMC, see "Artemis/Artumes, n. 52; I.Krauskopf in LIMC, see "Apollon/Aplu," n. 23.

26. O. W. von Vacano, "Vanth-Aphrodite," in *Hommages à Albert Grenier* 3 (1962):1546ff.; G. Scheffer, "Harbingers of Death? The Female Demon in Late Etruscan Funerary Art," in *Munuscula Romana* 17 (1991):51–63; Sannibale 1994, 48, n. 193.

27. A. von Gerkan and F. Messerschmidt, "Das Volumniergrab bei Perugia," RM 57 (1942):122–235, tab. 20.

28. See, for example, in Florence, Bernardo Rossellino's Bruni monument in the church of Santa Croce (Pope-Hennessy 1971, fig. 60), or Antonio Rossellino's Tomb of the Cardinal of Portugal in S. Miniato al Monte (Pope Hennessy 1971, fig. 64).

29. R. Amedick, *Die antiken Sarkophagreliefs* IV.14, *Die Sarkophage mit Darstellungen aus dem Menschenleben. Vita privata* (Berlin, 1991); K. Schauenburg, *Die antiken Sarkophagreliefs* vol. 2, *Die stadtrömischen Eroten-Sarkophage 3, Zirkusrennen und verwandte Darstellungen* (Berlin, 1995).

30. W. Koehler in EAA 6 (1996), see "Vittoria," 1191–92; T. Hölscher, *Victoria romana. Archäologische Untersuchungen zur Geschichte und Wesensart der römis-chen Siegesgöttin von den Anfängen bis zum Ende des 3.Jhs.n.Chr.* (Mainz, 1967).

31. A. Moustaka, A. Goulaki Voutira, and U. Grote in LIMC, vol. 6 (1992), see "Nike," 850–904.

32. Finally, see F. Bisconti, "Genesi e primi sviluppi dell'arte cristiana: i luoghi, i modi, i temi," in *Dalla Terra alle Genti. La diffusione del cristianesimo nei primi secoli* (exh. cat. Milan, 1996), 71–93.

33. There is an extensive bibliography on the origins of angel iconography in early Christian art: see T. Klauser, *Reallexikon für Antike und Christentum* 5 (1962), "Engel X (in der Kunst)," 258–322; C. Carletti, *Dizionario patristico e di antichità cristiane* 1 (1983), see "Angeli II. Iconografia," 202–03; D. Estevil, *La imagen del angel en la Roma del siglo IV: estudio de iconologia* (Rome, 1994); Bussagli 1995.

34. On the classical forerunners of the halo and its use in early Christian art, see A. Ahlqvist, *Tradition och rörelse. Nimbusikonografin i den romersantika och fornkristna konsten* (1990).

35. A. Pasinli, *Istanbul Archeological Museums* (Istanbul, 1989), 72, n. 76.

36. A. Goldschmid, *Die Kirchentür des Hl. Ambrosius in Mailand* (Strasbourg, 1902), tabs. 1, 5b, see 6a; O. Wulff, *Altchristliche und byzantinische Kunst* 1 (Berlin-Neuhabelsberg, 1914), tab. 9.

37. G. Valenti Zucchini, *I sarcofagi a figure e a carattere simbolico, "Corpus" della scultura paleocristiana, bizantina e altomedioevale di Ravenna* 2 (Rome, 1968):30–31, n. 11, fig. 11c; P. Testini, "Su una discussa figurazione del Sarcofago detto del profeta Eliseo o Pignatta," *Felix Ravenna* (1977), 319–37.

38. E. Kirschbaum, "L'angelo rosso e l'angelo turchino," *Rivista di Archeologia Cristiana* 17 (1940):209–48.

Note to the Reader

Dimensions are given in centimeters with inches in parentheses, height before width before depth or thickness.

Any bibliographical or note reference repeated more than once is shortened, with a full reference in the Bibliography. Shortened references to books, periodicals, and manuscripts are in the form of author and date of publication; shortened references to exhibition catalogues are in the form of city and date of publication.

ANGELS FROM THE VATICAN

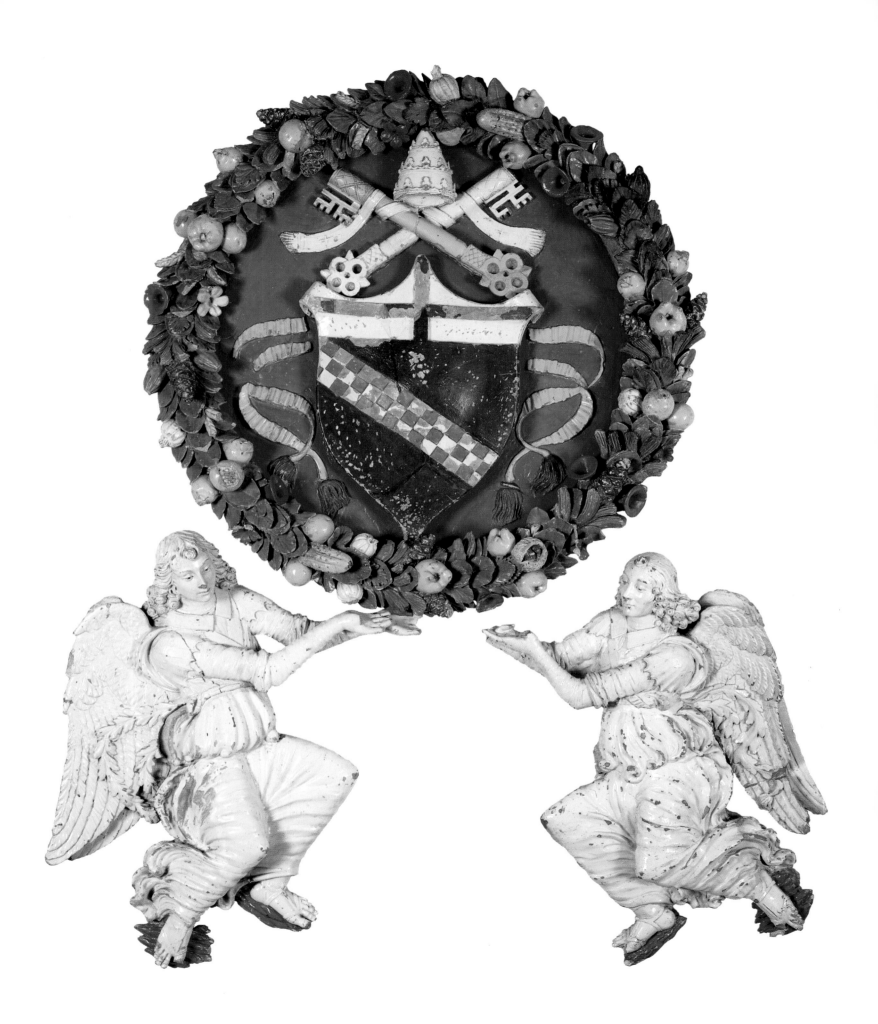

Benedetto Buglioni (Florence, c. 1461–1521)
WREATH WITH THE COAT OF ARMS OF POPE
INNOCENT VIII SUPPORTED BY TWO ANGELS
c. 1484–87
Glazed terra-cotta
Diameter of wreath 121 cm (47⅝ in.); height
left angel 96 cm (37¾ in.), right angel 90 cm
(35½ in.)
Vatican Museums, inv. 44087

Conservation courtesy of Thomas, Siobhan,
and James III McNamara, in loving memory
of their grandfather, Harold Jack Benvenuti

Exhibitions: New York 1983–84.

Literature: A. Marquand, *Benedetto e
Santi Buglioni* (Princeton, 1921), 3, fig. 1;
C. Pietrangeli, "Il Museo Clementino
Vaticano," in *Rendiconti della Pontificia
Accademia di Archeologia* 27 (1951–52):94;
D. Redig de Campos, *I Palazzi Vaticani*
(Bologna, 1967), 76; E. Micheletti, "Benedetto
Buglioni," in *Dizionario biografico degli
italiani* 15 (1972), 26–27; O. Raggio in New
York 1983–84, 49, cat. 14; F. Mancinelli in
Bolletino dei Musei e Gallerie Pontificie 4
(1983), 123–30.

The coat of arms held by two angels was
originally placed on the north side of the
Courtyard of the Statues (Cortile delle Statue)
over the doorway leading to the apartment
of Pope Innocent VIII (1484–92) in the
Palazzetto del Belvedere. The Palazzetto was
built during Innocent VIII's papacy around
1484–87, and it is likely that the coat of arms
was executed around 1487.

The earliest documents relating to the
work are from the eighteenth century. It is
mentioned first in Agostino Taja's description
of the Belvedere Courtyard, written around
1712.[1] An anonymous Italian drawing of
around 1720–27 shows a wall in the courtyard
with the large coat of arms above the left
doorway (fig. 1).

The coat of arms was replaced by that of
Pope Clement XIV at the time of the building
of the Pio Clementine Museum (1769–74), as

Fig. 1. Anonymous Italian, *Belvedere Courtyard*,
1720-27, drawing. British Museum, London, King's
Library, 75 K, vol. 3, King's Maps

Facciata del cortile delle statue che resta addoso alle stanze dei modelli

can be seen in the allegorical fresco by Anton Raphael Mengs on the ceiling of the Cabinet of the Papyri. In 1844 the armorial was taken to the new Profane Museum in the Lateran Palace. Around this date (or earlier?), the arms of Pope Gregory XVI were executed in plaster to cover the arms of Pope Innocent VIII. The arms of Gregory XVI were removed when the work was restored in 1897; its new location was the Borgia Apartments. The coat of arms has been exhibited in the Vatican Picture Gallery since 1983 after a restoration carried out in 1982.

The armorial of the Genoese Giovanni Battista Cibo, crowned by the papal insignia, the tiara and the crossed keys, is surrounded by a continuous wreath of fruit, vegetables, grains, flowers, and leaves. Two symmetrically positioned angels support the richly ornamented wreath. Both angels raise their arms to hold the bottom of the wreath. Their wings are spread and their knees are bent to demonstrate the weight of the shield, but the quiet happiness expressed in their youthful faces shows that the effort is not taxing.

Angels supporting a shield with a coat of arms can be found frequently in Italian Renaissance art. At first mainly small, nude putti were used for this image in adaptation of antique examples; later in the quattrocento, adolescent angels assumed that role. The theme was soon well established in Florence, executed in terra-cotta by Luca della Robbia and his followers, especially Andrea and Giovanni della Robbia, and in the workshop of Benedetto Buglioni. The coat of arms of Innocent VIII was attributed to Benedetto Buglioni by Allan Marquand in 1921,[2] and this attribution was confirmed by O. Raggio and F. Mancinelli.[3] Comparisons of the two angels with other works by Buglioni, for example, the *Altarpiece of the Resurrection* in the Museo Civico in Pistoia (documented for the year 1490), help to corroborate this attribution.

It is also clear that Buglioni's style followed the tradition established by the work of Andrea Verrocchio (c. 1435–88). Verrocchio's monument of Cardinal Niccolò Forteguerri in the cathedral of Pistoia shows many resemblances to Buglioni's angels (fig. 2).
Johannes Röll

1. *Descrizione del Palazzo Apostolico Vaticano* (Rome, 1750), 399.
2. Marquand 1921, 3, fig. 1.
3. Raggio in New York 1982, 49, cat. 14, and Mancinelli 1983, 123–30.

Cat. 1. with the arms of Pope Gregory XVI, before restoration in 1897

 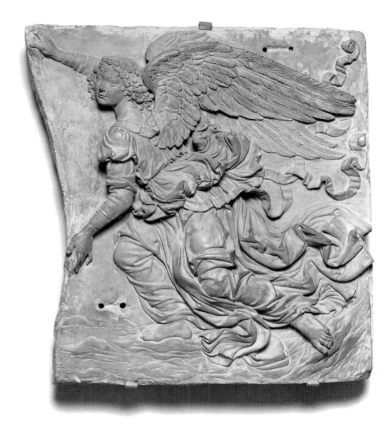

Fig. 2. Andrea Verrocchio, *Angels* (*Bozzetti* for the *Monument to Cardinal Niccolò Forteguerri* at the Cathedral, Pistoia). Réunion des Musées Nationaux, Paris

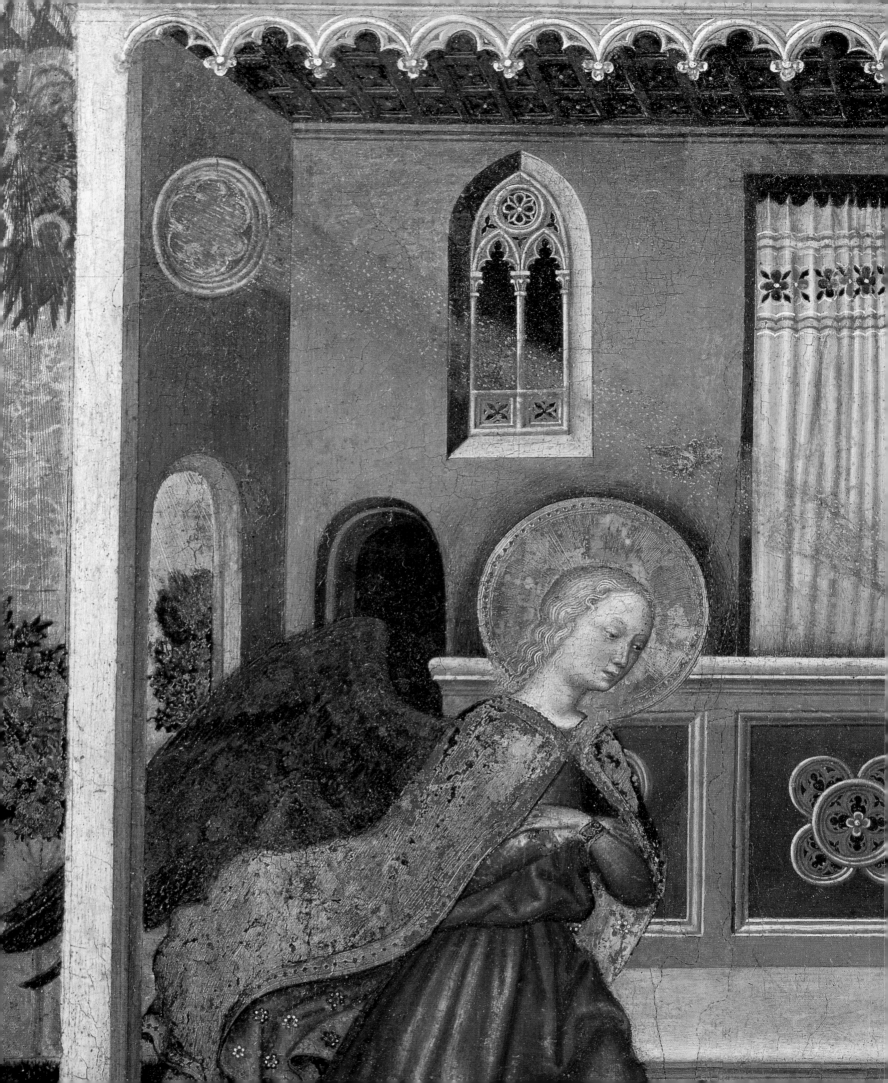

WHAT IS AN ANGEL?

2

Giovanni Battista Gaulli, called Baciccia
(Genoa, 1639–Rome, 1709)
CONCERT OF ANGELS, c. 1672
Oil on canvas
49 x 98 cm (19¼ x 38⅝ in.)
Vatican Museums, inv. 40752

Conservation courtesy of the Samuel J. and
Connie M. Frankino Charitable Foundation

Exhibitions: Vatican City 1981; Vatican City
1990.

Literature: E. Waterhouse, *Baroque Painting in
Rome* (Rome, 1937), 68; B. Biagetti, "Pitture da
cavalletto," in *Atti della Pontificia Accademia
Romana di Archeologia. Rendiconti* 18
(1941–42):284, fig. p. 283; M. V. Brugnoli,
"Contributi a Giovan Battista Gaulli," in
Bollettino d'Arte 34 (1949):237; R. Enggass,
"The Religious Paintings of Giovanni Battista
Gaulli," Ph.D. diss., University of Michigan,
1954, 1:81–82; R. Enggass, "Three Bozzetti by
Gaulli for the Gesù," *Burlington Magazine* 99
(1957):151–52; Enggass 1964, 153–54, fig. 56;
D. Graf, *Die Handzeichnungen von Guglielmo
Cortese und Giovan Battista Gaulli* (Düsseldorf,
1976), 2 vols., 1:111, nos. 314–15, figs. 401–02
(*Kataloge des Kunstmuseum Düsseldorf* 3, 2/1);
P. Santa Maria Mannino in Vatican City 1981,
75, no. 46; E. Levy in Vatican City 1990, 194,
no. 121, with further bib.

This painting entered the Vatican Museums in
1924, the gift of Cavaliere Antonio Castellano
of Naples,[1] as a work of Correggio's school.
It was published for the first time by Biagetti,[2]
who attributed it to Giovanni Lanfranco,
although Waterhouse[3] had already rightly
attributed it to Gaulli. It was quoted again by
Brugnoli[4] and finally repeatedly analyzed and
studied by Robert Enggass in his fundamental
research on Baciccia.[5]

This delightful sketch is a study for the
section on Paradise in the great fresco within
the cupola of the church of the Gesù in Rome,
a commission Gaulli accepted from the Jesuits
in 1672. As regards the finished painting, not
visible at present as the entire vault of the
Gesù is under restoration, the sketch presents
few variations. Three drawings by Baciccia for
a *Concert of Angels*, which could represent an
early idea for this sketch (some figures such as
the angels singing on the right, the angel with
the tambourine, and the one with the harp are
almost identical, even if they are reversed)
are in the Kunstmuseum in Düsseldorf.[6]

Baciccia's magnificent fresco, which covers
the vault of the Society of Jesus' principal
church, represents a complex allegory of the
Triumph of the Name of Jesus, to whose
special adoration Ignatius of Loyola had
dedicated his order. In the cupola in particular,
Paradise Singing Hymns to Jesus is depicted
with groups of angels. The exhibited sketch
shows some of them in their typical attitudes
of praising the Lord, singing hymns, and
playing musical instruments. The background
with gilded clouds depicts the very, very bright
Empyrean (as is indicated by the Greek
etymology of the word, signifying "inflamed
or burning"), which already in the middle
ages was considered the seat of spiritual light
and of the blessed.
Maria Antonietta De Angelis

1. Historical Archive of the Vatican Museums, b. 62a,
fasc. 1, 1924.
2. Biagetti 1941–42, 284, fig. p. 283.
3. Waterhouse 1937, 68.
4. Brugnoli 1949, 237.
5. Enggass 1954, 1:81–82; Enggass 1957, 151–52;
Enggass 1964, 153–54, fig. 56.
6. Graf 1976, nos. 314, 315 r.

3

Cretan School
ANGELIC CHOIR OF THE NATIVITY
mid-16th century
Tempera on canvas over wood
14.5 x 13.5 cm (5¾ x 5⅜ in.)
Vatican Museums, inv. 40031

Conservation courtesy of John H. Surovek for his son, Clay Surovek

Provenance: Vatican Library

Literature: Barbier de Montault 1867, 138, no. 8; Muñoz 1928, 15, no. 65, pl. XXXI, 3; Vatican 1934, 13, no. 31; Vatican 1993, 81, no. 9 c; Bianco Fiorin 1995, 18, no. 6, fig. 9.

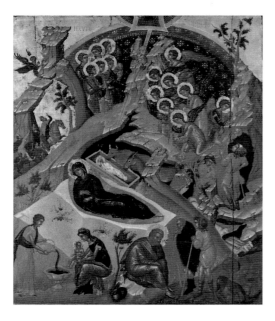

Fig. 1. Cretan School, *Nativity*, 16th century, tempera on panel. Museo dell'Istituto Ellenico, Venice

This small panel represents a group of angels set sharply against the deep ultramarine ground of a nocturnal sky that is hatched diagonally with golden rays and studded with golden stars. It is undoubtedly the fragment of a much larger icon of the Nativity, itself traditionally conceived as a composite of complementary episodes of the various moments of the mystery of the Incarnation. In fact, the edges of the present panel show signs of having been sawn through, at some unspecified period, and its base subsequently bordered by a dark-colored band.

The center of the original panel would have been dominated by the figure of the Virgin, recumbent in front of the entrance to the dark cave in which Jesus was born in Bethlehem, in the midst of a landscape of steep rocks of roughly pyramidal form. Beside her would have been placed the infant Jesus lying in swaddling clothes in the manger, overlooked by the ox and the ass. The principal scene would have been surrounded by a series of secondary episodes associated with the birth of Our Lord: the washing of the infant, Joseph in conversation with an elderly shepherd while the other shepherds rejoice in the glad tidings announced to them by an angel, and, in the upper half of the composition, the arrival of the Magi, their gaze fixed on the star that had led them to Bethlehem. Two groups of angels would have been placed on either side of the top of the rock grotto, the one group kneeling in adoration while the other, "beholding this mystery with awe," is "struck with amazement" and "singing in chorus in heaven," "rejoiced in this day," in response to the fulfillment of the prophetic oracle, according to the rich evocation of the scene in the Byzantine hymnals of the liturgy of Christmas.[1]

The little panel in the Vatican, which depicts this particularly graceful detail of the angels rejoicing, can be associated with a series of paintings of the Cretan school ranging in date from the second half of the fifteenth century to the first half of the sixteenth century and even beyond. They are found both as portable icons in museums (Athens, Venice, Saint Petersburg, Patmos)[2] or in private collections[3] and in frescoes dating to the mid-sixteenth century in monastic churches of the Great Lavra and Docheiariu on Mount Athos.[4] One of the salient characteristics of all these representations of the Nativity is precisely the emphasis on the glorification of the event by choirs of angels, as exemplified in the present panel. No doubt following the model of some Constantinopolitan icon, itself reflecting the more restless expressionism of such frescoes as those of the churches of the Periblebtos and the Pantanassa at Mistra in the Peloponnisos,

executed in the fourteenth and fifteenth centuries, these paintings, with their elegance of gesture, delicacy of feature, and luminosity of color, combined the purest pictorial traditions of the art of the Palaeologans with the refinements of the early Italian Renaissance (fig. 1). The choir of angels, represented here in its liturgical function of everlasting praise and adoration, strikingly recalls the similar compositions of paintings of the Great Lavra and Docheiariu, as well as that of the *Nativity* of the iconostasis in the church of San Giorgio dei Greci in Venice, attributed to Michael Damaskinos and dated to the late sixteenth century.[5] The three angels in the front row, with their wings heightened in gold, in particular, are remarkable for the softness of the modeling of their features, the measured gracefulness of their attitudes, and the rhythmical cadence of their drapery folds. These are qualities that are allied with a nuanced chromatic range typical of the Cretan school, but that would soon betray a tendency to become crystallized in a more facile academic manner.
Michel Berger

1. See the *Idiomelia* of Christmas Eve.
2. On the iconography of the Nativity of Christ in Byzantine art in general: Millet 1916, 95–96; G. Ristow, *Die Geburt Christi in der frühchristlichen und byzantinischen-ostkirchlichen Kunst*, Iconographia Ecclesiae Orientalis (Recklinghaus, 1963). On the icons of the Cretan school: M. Chadzidakis 1962, 30–31, no. 13 (10); N. Chadzidakis, *Icons of the Cretan School (15th–16th Century* (exh. cat. Benaki Museum, Athens, 1983), 34, no. 24, fig. 24; Bandera Viani 1988, 14–15, no. 18 and fig. 18; N. Chadzidakis 1993, 62, no. 12, fig. 12; M. Alpatov, *Le icone russe. Problemi di storia e di interpretazione artistica* (Turin, 1976), 254 and fig. 206.
3. This is the case of the icon from the former Volpi collection (D. Buckton, *Byzantium, Treasures of Byzantine Art and Culture from British Collections* [London, 1994], 213–15, no. 228), recently placed on the art market again (see M. Saunders-Rawlins, "An Important Collection of Greek and Russian Icons, the Property of a Family Trust, London," in *Christie's International Magazine* [November/December 1995], 40, 93).
4. Millet 1916, 95–96, fig. 38; G. Millet, *Monuments de l'Athos, 1. Les peintures* (Paris, 1927), pl. 119, 2 and pl. 258, 2.
5. Chadzidakis 1962, 57–58, no. 30, pls. 20–21; Bandera Viani 1988, 84, no. 152.

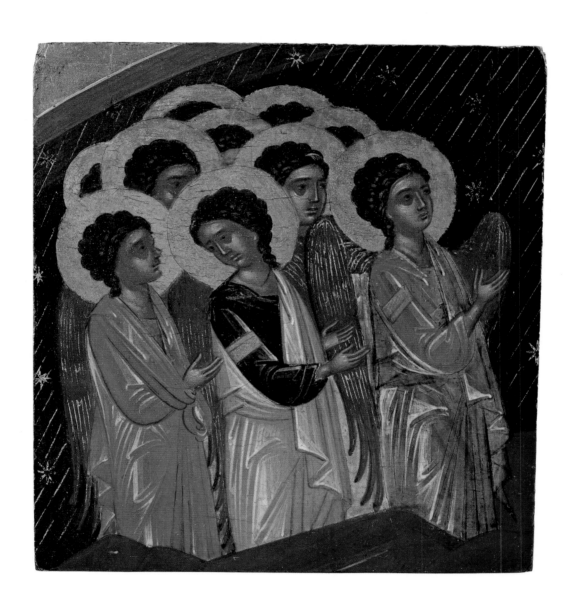

4

Italian
MUSICAL ANGELS WITH EMBLEM OF THE TRINITY
17th century
Carved wood, stuccoed and painted
c. 57 x 66 cm (22½ x 26 in.)
Vatican Museums, inv. 44542

Conservation courtesy of John J. Brogan

Exhibitions: The piece is being exhibited for
the first time.

The group was probably the top part of a small
portable shrine or perhaps an insignia used in
religious processions.

In the upper section of the work is an
emblem of the Trinity, an eye inserted into a
triangle, surrounded by golden shafts of light
and by a halo of clouds and six-winged heads
of seraphim. The lower part is a charming
"angelic concert," with full-length figures
grouped together imitating with naive fantasy
a typical orchestra of the baroque. The angels
play rather sketchily carved instruments,
which can however be identified as a harp, an
organ, a *viola da gamba*, a *viola da braccio*, and
two *theorbos*. Other angels are reading their
scores while they sing. Another angel pumps
the organ's bellows, carved with naive realism.

Apart from the organ, only string
instruments are used, suggesting the effect of
chamber music. The absence of other wind
instruments is surprising, considering that
flutes and trumpets were traditionally used
in music to represent the exaltation and
glorification of both divine and earthly power.
Maria Antonietta De Angelis

5

Circle of Corrado Giaquinto (Molfetta, 1703–Naples, 1766)
SATAN BEFORE THE LORD, mid–18th century
Oil on canvas
88 x 116.5 cm (34¾ x 45⅞ in.)
Vatican Museums, inv. 40800

Conservation courtesy of John H. Surovek in honor of his parents, Helen V. and Thomas A. Surovek, Sr.

Literature: G. C. Sestieri, "Contributi a Sebastiano Conca," II, in *Commentari* 21 (1970):136, nos. 154, 155.

This painting and its pendant (fig. 1) entered the Vatican Picture Gallery in December 1913. The exhibited painting depicts God addressing a devil, who in turn points downward. The devil has the usual attributes of the fallen angel: dark coloring, bats' wings, pointed ears. The scene, difficult to interpret, may illustrate a passage from the Book of Job (1:1–12), where it is said that Satan obtained God's permission to torment the rich man Job, who only after exercising the virtue of patience was able to defeat his abuser and regain his lost wealth. The pendant represents what had gone before: Job sacrificing to God to ask for blessings on his sons. The painting depicts a mature man and a young woman with children sacrificing a ram.

The lunette shape of the two compositions, their dimensions, and the swift manner in which they were executed suggests two sketches for frescoes, perhaps part of a more extensive cycle. In the Vatican Museums the two paintings were first attributed to Sebastiano Conca by B. Biagetti, then to Corrado Giaquinto by Deoclesio Redig de Campos. Sestieri maintains that they are the result of collaboration between Conca and his workshop. In fact, the two paintings appear to be closely connected with Giaquinto's very fluid and clear style, with its moderately rococo characteristics. They cannot, however, be definitely attributed to Giaquinto because of some stylistic traits that are not convincing. These include the modeling of the locks of hair and the outline of the figure of the devil. The disjointed intrusion of the modeling, which is massive and tends overmuch to the classical in the man and the woman in the other painting, is also an element foreign to Giaquinto's style. It remains therefore to attribute the work to an anonymous follower of the maestro from Molfetta, someone who was uncertain in his stylistic formulation.

The exhibited painting and its pendant are part of a group of paintings given to Pope Pius X (1903–14) by the Sacred Congregation for the Propagation of the Faith. The two paintings are to be found in two manuscript inventories preserved in the Historical Archive of the Vatican Museums (*Carlo Pietrangeli, Pinacoteca*), the first, drawn up by Msgr. della Volpe in 1908, referring to the Ferrieri Collection, when it was in the Palazzo Mignanelli, the second made in 1912 by Pietro Costa, the Regent of the Floreria Apostolica, when the collection of paintings was given to Pius X. In both inventories they bear the nos. 168 and 169 and the title *Biblical Subject*.
Maria Antonietta De Angelis

Fig. 1. Circle of Corrado Giaquinto, *Job Sacrificing to God to Ask for Blessings on His Sons*. Vatican Museums, inv. 40801

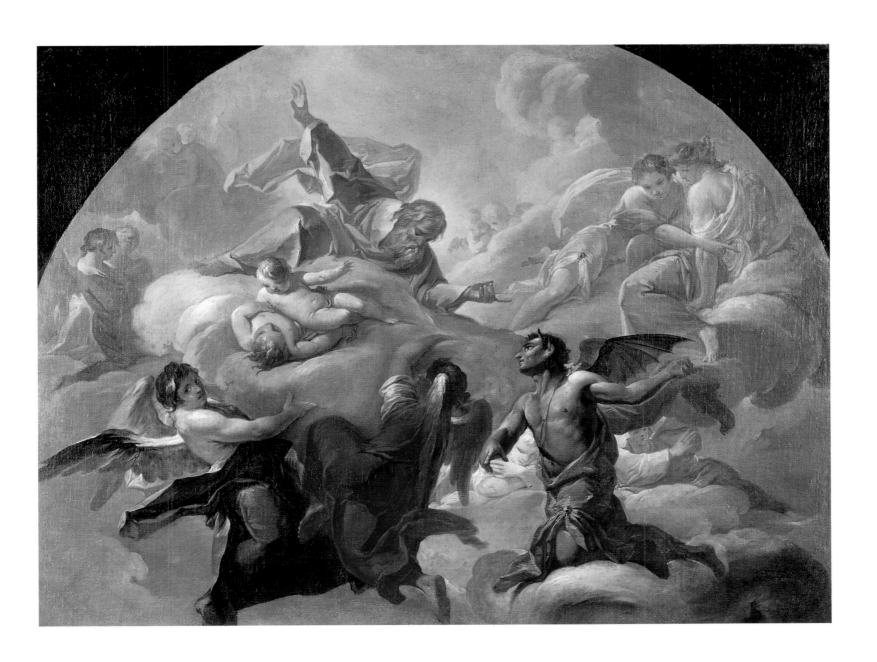

6

Marino Marini (Pistoia, 1901–Viareggio, 1980)
THE FALL OF THE ANGEL, 1963
Oil on canvas
150 x 150 cm (59 x 59 in.)
Vatican Museums, inv. 24842

Provenance: Gift of Marina Marini.

Exhibitions: Pittsburgh, Carnegie
Institute, Dept. of Fine Arts, *International
Exhibition of Contemporary Painting and
Sculpture*, 1967; Munich, Bayerische
Staatsgemäldesammlungen, Staatsgalerie
Moderner Kunst, *Marino Marini. Bilder aus
seinem atelier*, 1980–81, cat. 26, colorplate;
Pistoia, Convento del Tau, *Marino pittore*,
1987, cat. 121, colorplate; Milan, Palazzo Reale,
Marino Marini—mostra antologica, 1989–90,
cat. 130, colorplate.

Literature: A. M. Hammacher, *Marino Marini.
Sculpture*; *Painting, Drawing* (New York:
Abrams, 1969); Lorenzo Papi, *Marino Marini*
(Priuli e Verlucca editori, n.d. [1989]).

Marino Marini is universally known as a
sculptor. It is only in the last two decades that
recognition of his work as a painter has been
growing, this despite the artist's declaration
"I have always felt the need to paint and to
draw, and I never begin a sculpture without
having first understood its pictorial essence"
(1969).

In the more familiar iconography, the angel
is the focal point of man's fantasy, hope, and
simple emotions and invariably a supernatural
figure who guides our path to salvation. Yet in
Marini's representation of this idea, the angel
is a being who identifies with and is sometimes
opposed to man but who remains indissolubly
linked to him.

The dichotomy of apocalypse/resurrection,
death/rebirth is a constant in the art of Marini.
"Man is dead and the angel is risen or, rather,
the fallen angel is dead and a man is born."[1]

The Fall of the Angel marks an important
transition in Marini's restlessly shifting art.
In the 1960s, in particular, ideas that had
hitherto been formulated for sculpture alone
were transferred to painting. While at the same
time maintaining a range of references to
Marini's sculptural works, the present painting
nonetheless retains its own unique autonomy.

In this contorted version of the angel
theme, one of the first of several, the artist
seems to emancipate himself from the neo-
cubist influences of the 1950s and move toward
a more decided abstraction. At the same time,
Marini's chromatic range tends toward
lyricism, as if perhaps to play down the tragic
sentiment of the image.
Mario Ferrazza

1. Papi 1989.

7

Italian
MONSTRANCE WITH SAINT MICHAEL
2nd half 18th century
Gilded bronze, silver, gilded silver, precious
stone inlays
68 cm (26¾ in.)
Basilica of Saint John Lateran, Rome

Conservation courtesy of
Mr. and Mrs. James B. Rettig

Literature: Lateran Guidebook 1986, 12.

Donated to Pope John Paul II (1978–) by the
then-president of the Italian Republic, Sandro
Pertini, in 1984, the exact place of origin of
this monstrance is difficult to identify. There is
no visible silversmith's stamp, nor have the two
coats of arms on its base been identified. The
one to the front, below the crest and two facing
dragons, consists of an escutcheon containing
five sirens and a scroll with the letter *M* below;
the one to the rear has a crown above a two-
headed eagle grasping between its talons a
flaming heart transfixed by two arrows.

The pedestal of the monstrance is richly
decorated with volutes, which recur on a
smaller scale around the circular frame of the
transparent ostensory that is adorned also with
the eucharistic symbols of grapes and grain.
The vertical shaft of the monstrance is formed
by the slender winged figure of the archangel
Michael; the figure is cast and has separately
added ornamental features and accoutrements
such as the shield, the decorations of the
cuirass, and the bandolier from which a sword
was probably slung, as is suggested by two holes
for rivets or screws on the side. These stylistic
features date the monstrance to the second half
of the eighteenth century, the fully developed
rococo period.

The youthful figure of the archangel, who
supports on his head the transparent ostensory
in which the consecrated Host was contained,
has a symbolic justification. The motto he
bears on his shield, QUIS UT DEUS (Who like
God), qualifies the archangel as the champion
of the supreme authority of God, and hence
his presence is justified as the metaphorical
upholder of the particle in which God is
manifested.
Maria Antonietta De Angelis

8

Giovanni di Paolo (Siena, 1395/1400–1482)
THE ANNUNCIATION
Tempera on wood
43.5 x 33 cm (17⅛ x 13 in.)
Vatican Museums, inv. 40131

Conservation courtesy of Marcia Pond
MacNaughton in honor of her mother

Literature: C.Brandi, *Giovanni di Paolo*
(Florence, 1947), 34, 38; E. Carli, *Le tavolette di
Bicherna e di altri Uffici dello Stato di Siena*
(Florence, 1950), no. 44; Berenson 1968, 179;
L. Borgia, E. Carli, M. A. Ceppari, U. Morandi,
P. Sinibaldi, and C. Zarrilli, *Le Bicherne. Tavole
dipinte delle magistrature senesi (secoli
XIII–XVIII)* (Rome, 1984); Volbach in
Pinacoteca Vaticana 1987, 45, 46.

Art in Siena during the middle ages and until
the late Renaissance permeated all areas of
public and private life. The people of this city
not only felt the need to decorate their palaces
and churches with exquisitely fine art work,
but also used their aesthetic sensitivity to
embellish such humble products of their
community as the account books of their tax
office, as if art could somehow dignify tax
collecting. This strange alliance between art
and bureaucracy is one of the most original
manifestations of Sienese art and involved
some of the finest artists.

The account books of the most important
offices of Siena's medieval municipality had
covers made of decorated wooden panels.
These were called *bicherne*, the name of a
financial office that started decorating its
manuscripts before any other office did and
continued to do so extensively.

This practice was eventually adopted by
the Gabella Generale (general tax office),
the Consistory, the Cassieri e fortezze
(cashiers and fortresses), and the city itself.
Several corporations, such as the Hospital of
Santa Maria della Scala and the Opera
metropolitana, also decorated their account
books, as did a few lay societies such as the
one dedicated to Saint John the Baptist.

Production of these decorated book covers
started in 1257 and continued until the middle
of the fifteenth century, by which time people
in the offices became aware that intensive use
of the account books caused damage to the
paintings. It was decided to stop using the
wooden panels for decorating books and
instead to produce small paintings, still on
wood, to hang on the walls of the offices.

The two most important financial
institutions of the local administration, which
had the greatest number of paintings of this
kind, were the Bicherna and the Gabella
Generale. The Bicherna was Siena's financial
office, and its name is a corruption of the
word *blacherna*, which might come from
the Imperial Palace of the Blacherne in
Constantinople, where the treasury was kept.
The Bicherna had a *camerario* (chamberlain),
who looked after and administered the
municipality's properties, and four officials,
who drew up the accounts with the assistance
of copyists. There were also notaries who made
sure that the statutes were respected.

As the taxes (*gabelle*) increased, a specific
office was established in the thirteenth century
to collect and administer them, called the
Gabella generale e dei contratti (general
office for taxes and contracts), which was
separate from the Bicherna. This office had a
camerlengo (chamberlain), who was chosen
from a religious order, three officials, who were
citizens of Siena and nominated by the city

government, and a judge, who had to be a
foreigner. They were assisted by notaries and
various subordinates.

The Vatican panel depicting the
Annunciation comes from this last office.
It shows the Virgin Mary, seated on a chest
with her hands joined in prayer and wrapped
in a voluminous cloak. The Archangel Gabriel
stands before her with his arms crossed
and holding an olive branch in one hand,
symbolizing peace. In the middle of the
painting, between the figures of Mary and the
archangel, is a finely worked vase holding a
bunch of lilies. They symbolize Mary's purity
and virginity, which Saint Bernard described
as *inviolabile castitatis lilium.* Above the vase,
God's blessing hand sends out rays of light that
carry the dove of the Holy Spirit toward Mary.

In the middle section of the panel are the
family coats of arms of the Bichi, Simoni,
Cristofani, Guelfi, Tolomei, and Pannilini(?).
Below them is an inscription:
QUESTA E LENTRATA ELUSCITA
DELLA GENERALE CHABELLA
DELCO/MUNE DISIENA ALTEMPO
DESAVI HUOMINI. PIETRO
DIGIOVA(N)NI/ BATT(IST)A
CHAMARLENGHO. GIOVA(N)NI
DISIMONE DISERE AGNOLO/ PIETRO
DIMISERE GIOVA(N)NI (CHRIST)OFANI.
ANTONIO DIGUELFO PIZZICAIUO/LI.
MISERE JACOPO TALOMEI.
ASSEGUITORI. EGIOVA(N)NI DIPIETRO
PAN(N)ILINI. ISCRIPTORI. ESER
GIOVA(N)NI DI BARTOLOMEO DIPIE/RO
LORO NOTAIO PER SEI MESI
I(N)COMI(N)CIATI ADI PRIMO GENNAIO
1444 EFINITI PER TUTTO GIUGNIO.1445.

At the end of the inscription is a shield
with an unidentified coat of arms.

Because of its high quality, the painting
has been attributed to Giovanni di Paolo. The
influence of Gentile da Fabriano and Sassetta
is clearly visible, and stylistically the work
resembles the predella of the *Paradise* in the
Metropolitan Museum of Art, New York.

The book cover originally belonged to
Galgano Bichi, an abbot. In 1706 it passed to
the Marquis Bonaventura d'Ansano Chigi
Zondadori and then became the property of
the Sacred Museum of the Vatican Library,
ending up in the Vatican's Picture Gallery
in 1909.
Anna Maria De Strobel

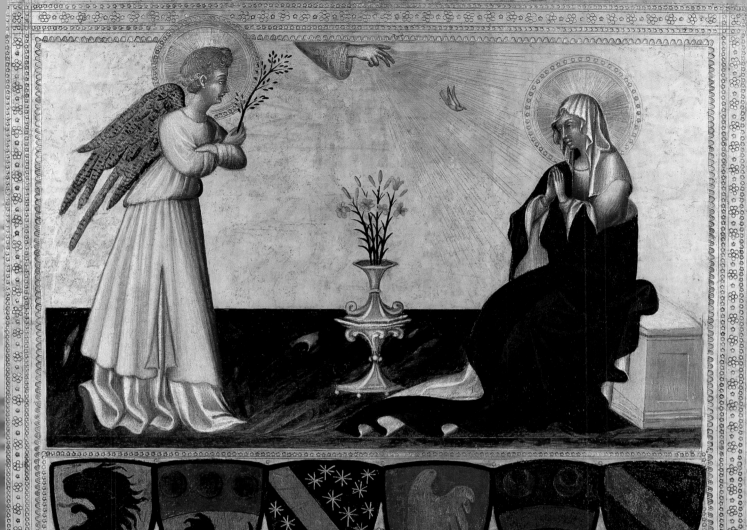

Qvesta elentrata elvscita della generale chabella del co
mune disiena. altempo defaui buomini..pietro digiouáni
batta chamarlengho. giouáni disimone disere agniolo.
pietro dimisere giouáni xpofani. antonio diguelfo piçcicaino
lo. misere iacomo talomei. asseguitori. egiouáni dipietro pa
nilini. Iscriptori. eser giouáni di bartalomeo dipie
ro loro notaio persei mesi icomiciati adi primo di
gennaio 1444 efiniti pertucto giugno. 1445.

9

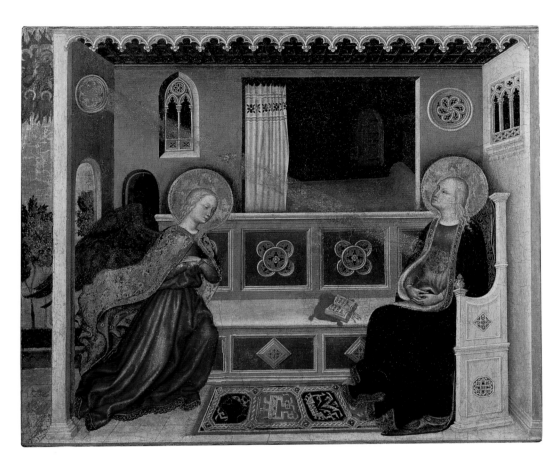

Gentile da Fabriano and Workshop (Fabriano, c. 1370–Rome, 1427)
THE ANNUNCIATION, c. 1425
Tempera and gold leaf on wood
40.6 x 48.4 cm (16 x 18¼ in.)
Vatican Museums, inv. 40601

Conservation in 1997 courtesy of Florence B. D'Urso in honor of Rev. Gregory A. Mustaciuolo

Restorations: 1840, 1960, 1975.

Provenance: 1800, Rome, Agostino Mariotti collection, no. 58 (Luparelli 1800, c. 69); 1820, Vatican Library, Christian Museum (following purchase of the painting by Pius VII); 1867, Vatican Library, Christian Museum, Cupboard X, no. 12 (Barbier de Montault 1867, 154); Vatican Library, Christian Museum, Showcase O, II, no. 106 (D'Achiardi 1929, 28); in the Vatican Picture Gallery since 1909.

Exhibitions: The painting is being exhibited for the first time.

Literature: "Indice del Museo dell'avvocato Agostino Mariotti," Vatican Library, MS. Vat. Lat. 9189, c. 9 (1800); D. Luparelli, "Descrizione dei quadri del Museo dell'avv. D. Agostino Mariotti nella maniera che l'ha collocato nel Palazzo del Monte Vecchio," MS, c. 1800, Archives of the Vatican Library, Fald. 67, c. 69; "Nota di molte tavole dipinte antiche appartenenti alla Biblioteca Vaticana ristaurate da Carlo Ruspi per Commissione dell'Acc.mo Mons. Laureani primo Custode della suddetta Biblioteca" (1840); Barbier de Montault 1867, 154; D'Achiardi 1929, 28; R. Longhi, "Fatti di Masolino e Masaccio," in *La Critica d'arte* 5 (1940):191; L. Grassi, "Considerazioni intorno al Polittico Quaratesi," in *Paragone* 15 (1951):29; L. Grassi, *Tutta la pittura di Gentile da Fabriano* (Milan, 1953), 41, 64; Bellosi 1966, 6; F. Mancinelli, "Arte Medioevale e Moderna," in *Bollettino dei Monumenti, Musei e Gallerie Pontificie*, I/1 (years 1959–75), 1977, 141; E. Micheletti, *L'opera completa di Gentile da Fabriano* (Milan, 1976), 92, cat. 44; K. Christiansen, *Gentile da Fabriano* (London, 1982), 131, cat. XLIII; A. De Marchi, *Gentile da Fabriano. Un viaggio nella pittura italiana alla fine del gotico* (Milan, 1992), 49–50, 127, 172, 191 nn. 101–02; F. Rossi in Pinacoteca Vaticana 1994, 96–99, cat. 27 and fig. 84.

Gentile da Fabriano, one of the major exponents of Italian painting of the early fifteenth century, was an artist of complex formation. Open to the influence of the latest Gothic currents of the international style, he was also actively interested in the role that Florentine humanism assigned to the arts in renewing a culture emerging from the ashes of feudalism. This small panel, which combines the rigor of perspective construction with embellishments of pronounced courtly inspiration, is generally dated to around the year 1425, the year in which the painter, en route to Rome at the invitation of Pope Martin V Colonna (1417–31), spent a period of residence in Florence, where he was to create some of his greatest masterpieces.

Gentile's treatment of the theme of the Annunciation rests on the one hand on the authority of the written sources (such as the Gospel of Luke and some apocryphal texts of later elaboration), and on the other on a widespread iconographic tradition, which can be traced back to the prototype venerated in the church of SS. Annunziata in Florence, whose simplified, devotional character it retains. The scene takes place in a room enclosed on three sides and opened in front as if by a portico. The room is lit by little rose windows and other windows of elaborate Gothic design. A frieze of miniature trefoil arches runs along the upper cornice of the room, defining the front edge of its coffered ceiling. An open arched doorway, through which the angel enters, admits to a garden, in which trees laden with fruit can be glimpsed to the far left. The Virgin is startled by the angel's annunciation as she sits, hands folded in her lap and open prayer book beside her, on an L–shaped settle, richly ornamented with intarsia panels in the shape of diamonds, lozenges, and intersecting circles. The simplicity combined with the refinement of taste of the furnishings brings to mind the comfort of an affluent bourgeois interior of the period; this is also recalled by the domestic intimacy of the bedroom alcove disclosed, beyond the drawn curtain, in the background. The profusion of gold, liberally applied over much of the panel, underlines the salient moments of the visionary experience and at the same time heightens the main lines of the perspective construction.

The relation of this small Annunciation to a fresco of the same subject in the church of S. Spirito in Arezzo, attributed to the school of Agnolo Gaddi, was pointed out by Grassi,[1] though the relation is not one of complete dependence. The accentuation of the descriptive qualities in the Vatican panel should rather be related to the tendency to place sacred themes in a context of fully bourgeois domestic life that Antal[2] saw taking shape in Florence even in the course of the fourteenth century and that took on renewed vitality in the early years of the following one. But Gentile's composition, though following this trend, at the same time develops the narrative implications of the theme by incorporating in it inventions of apparent realism and of subtle symbolic connotation as well, such as the opening of the alcove on the same axis as the submissive figure of Mary, a motif that resumes or anticipates solutions present in the work of Giovanni del Biondo, Bicci di Lorenzo, Cenni di Ser Francesco, and especially Fra Angelico (Museo del Prado, Madrid) and Masolino (National Gallery of Art, Washington). Alongside elements of strict textual observance, such as the inscriptions on the Madonna's mantle (AVE MARIA, which is the *salutatio angelica* of Luke 1:28) and on the book (an abbreviated version of ECCE ANCILLA DOMINI. FIAT MIHI SECUNDUM VERBUM TUUM, as in Luke 1:38), we also find iconographic variants referable to the circulation of texts such as the *Armenian Gospel of Childhood* or the *Book of the Nativity of Mary*, both used in the versions elaborated by more recent hagiographers such as the Pseudo Bonaventura.[3] In an even more significant way, in combining the moment of *annuntiatio* with that of *conceptio* according to the widespread interpretation of Luke 1:35 ("The Holy Spirit will come upon you ... and the power of the Most High will cover you with its shadow"), Gentile dissociates himself from the apocryphal representation of the conception *per aurem*, so dear to the fourteenth-century tradition,[4] preferring to it the canonical version of the conception *per uterum*, visualized by the ray of golden light that has its source in the divine apparition in the upper left-hand corner of the panel, and, after passing through the rose window, comes to rest on the gently swollen womb of Mary in prayer.[5] The motif of the fruit trees, laden with golden apples, a probable allusion to the fullness of man's condition before the Fall, is matched in two panels of Fra Angelico at the Prado in Madrid and in Cortona, where the theme of the Annunciation is associated with that of the Expulsion from Eden, alluding to the mystery of the Incarnation and the centrality of Mary in God's plan of redemption from the original sin.

Documented in the collection of the lawyer Agostino Mariotti in the early nineteenth century, the panel entered the Christian Museum of the Vatican Library in 1820. It was transferred to its present location, the Vatican Picture Gallery, in 1909, though long consigned to the gallery's storerooms. Only on the occasion of its restoration in 1960 was it removed from storage. Longhi (1941), who was the first to see it, published it as a work of Gentile da Fabriano, dating it to the master's Florentine period. Subsequently, Grassi (1951, 1953) and Bellosi (1966) confirmed the attribution to Gentile, preparing the way for a full recognition of the work's autograph status that would culminate, a few years later, in the highly positive judgement of Micheletti (1976), who considered "the extreme fineness of the pictorial treatment ... a sufficient reason for endorsing the attribution to the master, in a particularly fruitful stage of his career."[6] Of a contrary view was Christiansen (1982), who recalled that the *Annunciation* was not included among the works of Gentile listed by Berenson (1968)[7] and pronounced it a "work of low quality which cannot be reconciled with any of his autograph paintings."[8] Rossi, in his recent contribution, takes an intermediate position: he assigns the material execution of the work to one of Gentile's workshop assistants who, "in a milieu between Umbria and Lazio, had found a devout provincial patronage of his own, interested in gothic and Florentine models, but inclined to a slightly archaizing mysticism."[9] A second version of the subject, of more modest quality, is preserved in the Barbara Piasecka Johnson collection in Princeton.[10]

Guido Cornini

1. Grassi 1953, 41.
2. F. Antal, *Florentine Painting and Its Social Background* (London, 1948), 139.
3. Rossi in Pinacoteca Vaticana 1994, 97.
4. On the conception *per aurem*, see *I Vangeli Apocrifi*, ed. M. Craveri (Turin, 1969), 157 and n. 4.
5. The motif of the divine ray traversing the window, particularly widespread in the Franco-Flemish area, has been convincingly associated with a passage of Saint Bernard affirming: "Sicut splendor solis vitrum absque laesione perfundit et penetrat ... sic Dei Verbum, splendor Patris, virgineum habitaculum adiit et inde clauso utero prodiit" (Just as the splendor of the sun pierces the glass and penetrates without shattering it, in the same way the Word of God, Splendor of the Father, enters the virginal body and is born of a closed womb.) See M. Meiss, "Light as Form and Symbol in Some Fifteenth Century Paintings," in *Art Bulletin* 27 (1945): 175–81.
6. Micheletti 1976, 92, cat. 94.
7. Berenson 1968.
8. Christiansen 1982, 131, cat. XLIII.
9. Rossi in Pinacoteca Vaticana 1994, 99.
10. A. S. Labuda, in *Opus Sacrum. Catalogue of the Exhibition from the Collection of Barbara Piasecka Johnson*, ed. J. Grabski (Vienna, 1990), 50–55; see also De Marchi 1992, 172–73, fig. 91; 191 n. 102.

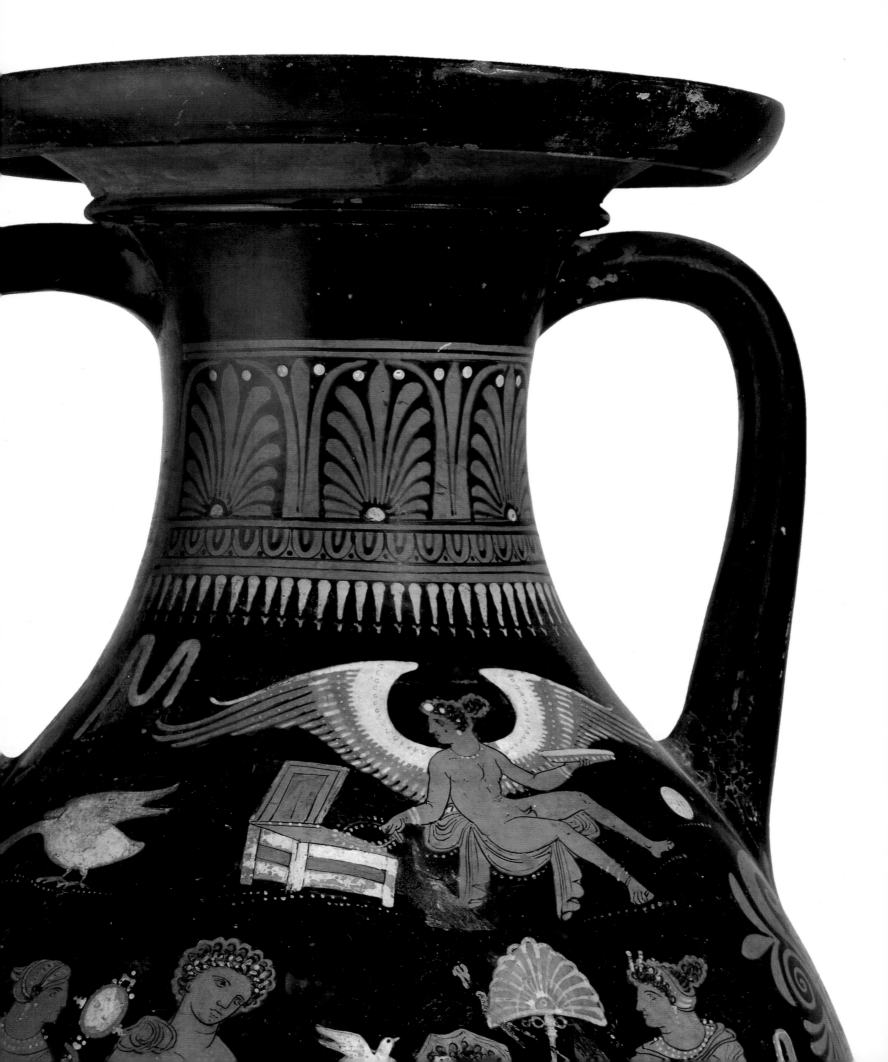

ORIGINS OF ANGEL ICONOGRAPHY

Detail of cat. 13 (actual size)

10

Neo-Assyrian, Kingdom of Assurnasirpal II
(883–859 B.C.)
WINGED GENIUS
Stone
77.5 x 73 cm (30½ x 28¾ in.)
Vatican Museums, inv. 14989

Exhibitions: Rome, Palazzo delle Esposizioni,
I rilievi neo-assiri presso i musei italiani, 1995.

Literature: D. Bernot (ed.), *Génies, anges et
démons.* Sources Orientales 8 (Paris, 1971); L.
Cagni, nos. 2–3, in R. Dolce and M. Nota Santi
(eds.), *Dai palazzi assiri. Immagini di potere da
Assurnasirpal II ad Assurbanipal (IX–VII cent.
B.C.),* "L'Erma" in Bretschneider (Rome,
1995), 96–99; D. O. Edzard, "Gute Dämonen,"
in H. Haussig (ed.), *Wörterbuch der
Mythologie,* vol. 1 (Stuttgart, 1965):49; A. Reef,
*The Belief in Angels in the Bible and Early
Israel,* 2 vols. (in Hebrew, with an index in
English), (Jerusalem, 1979); W. von Sateen,
"Die Schutzgenien Lamassu und Shedu in der
babylonisch-assyrischen Literatur," in
Baghdader Mitteilungen 3 (1964):148–56;
F. A. M. Wiggermann, *Mesopotamian
Protective Spirits. The Ritual Texts.* Cuneiform
Monographs 1 (Groningen, 1992).

In the Christian tradition, which is strongly
anchored to the tradition of biblical theology,
there are nine categories (or "choirs") of
angels. They are called angels, archangels,
seraphim, cherubim, virtues, thrones,
dominions, principalities, and powers. The
name angel is the common denominator for
the nine angelic ranks. It is derived from the
Greek *ánghelos,* which means "messenger"
or "envoy" and translates the biblical Hebrew
mal'akh, which has the same meaning and
is the most frequently used to specifically
indicate angels. Angels bear God's particular
words to humanity or execute his specific
commands on earth.

In the biblical Hebrew text, only three
of the nine angelic orders of the Hebrew-
Christian tradition are present: angels,
seraphim, and cherubim.

Angels are mentioned often in the Old
Testament. Their first mention is in Genesis
16:7–11, which tells of an angel of the Lord
who appears in order to comfort Hagar, a slave
of Sarah, Abraham's wife. Here it is interesting
to note that Hagar identifies, in a certain sense,
the angel of the Lord with the Lord himself
(v. 13). The archangels—Michael, Gabriel, and
Raphael—are called by their proper names in
the Bible; however, they are not distinguished

as archangels but rather given the title of
angels. Biblical angelology is particularly well
developed in the books of Daniel, Ezekiel, and
Tobit, which may be dated in the first
millennium B.C.

Seraphim, according to the name's Hebrew
etymology, are "the burning ones." They are
mentioned in Isaiah 6: 2–6, where they sing
the praise of God. With reference to their
image, it is said that they are endowed with six
pairs of wings: two for covering their faces, two
for covering their feet (in order to hide their
sex), and two for flying. It is said that one of
them flies toward Isaiah and purifies his mouth
with a live coal taken from the altar (hence the
name "the burning ones").

Biblical angelology has a close relationship
to Mesopotamian angelology, particularly
with reference to the cherubim. Angels occur
frequently in Mesopotamian literature and art,
especially in the neo-Assyrian period of the
first millennium B.C. Many good "genii," of
divine origin and responsible for protecting
mankind, appear in this sphere. The two most
famous categories are those of the Lamassu
and the Shēdu, imagined and portrayed
anthropomorphically but endowed with
"superhuman" features such as aquiline wings
and, at times, actually with the head of an
eagle. The characteristics and functions
mentioned regarding Mesopotamian "angels"
coincide to a great extent with those of biblical
angels.

In the biblical description of seraphim
in Isaiah 6:2–6 evoking mythical beings
(human figures endowed with aquiline
wings), the link between biblical angelology
and Mesopotamian iconography is evident.
The relationship between the two kinds of
angelology is even more clear in the case
of cherubim. The derivation from the
Mesopotamian world to the biblical one is
unquestioned because the verbal root for
"cherub," which means "worshiper" or "one
who blesses," is not found in the Hebrew
vocabulary, whereas it is well known in the
Assyro-Babylonian vocabulary (*karābu,
kāribu,* etc.). The Old Testament lacks visual
representations even in this case, but the literal
descriptions are more than sufficient to help
us understand the image that the ancient
Hebrews had of cherubim and of angels in
general.

The first time that the cherubim are
mentioned in the Bible is in Genesis 3:24. It is
written there that God placed cherubim to the
east in the Garden of Eden in order to prevent
man, who had been driven away, to come near
the tree of life. The most important reference
is in Exodus 25:18–22 (see also 37:7–9;
Numbers 7:89; 1 Kings 6:23–28; etc.), where

the story of the building of two golden,
winged cherubim to decorate the lid of the
Ark of the Testimony is told.

The Mesopotamian, Neo-Assyrian
iconography represents good spirits, the
protectors of mankind, in forms that are
analogous to those of the biblical seraphim.
These spirits generally have human bodies, at
times eagle's heads, and large aquiline wings.
They often carry a bucket of "lustral water"
in the left hand and an aspergillum (a pine-
cone, twig, or something similar) with which
to sprinkle it.

An example of the representation of
Mesopotamian winged genii, a forerunner of
biblical angels, is to be found in the exhibited
Neo-Assyrian relief fragment. An inscription
on the lower border of the relief dates it to the
kingdom of Assurnasirpal II (883–859 B.C.).
The relief comes from the capital Nimrud
(Kalkhu). Perfect comparisons are found in
reliefs preserved in two Oxford museums,
and various less-perfect comparisons exist
elsewhere, which demonstrate that its subject
matter was repeated frequently.

This example depicts a winged genius with
a human body. He has a dense, square beard
represented with stripes and curls and thick
hair that falls to his shoulders from under his
headdress (tiara). This protective spirit wears a
long flounced garment that drapes down from
his shoulder to his ankles. His legs and feet
are bare, and a bracelet adorns each wrist.
Two long, wide, finely molded aquiline wings
project from his shoulders. A pair of stylized
taurine horns, a symbol of divinity, is part of
the front part of his headdress, which tightly
fits the nape of his neck. The Mesopotamian
winged genii were considered to be of
divine origin and therefore they participate
in divine nature.

The winged genius exhibited here kneels
before a plant, characteristically represented
here and elsewhere and commonly thought
to be the tree of life (as in Genesis 2:9). The
protective spirit with wings is touching this
tree with both his hands, reaching out at
different levels.

Luigi Cagni

11

Etruscan
ENGRAVED MIRROR, early 5th century B.C.
Bronze
Height 16.7 x diameter 14 cm (6⅝ x 5½ in.)
Vatican Museums, inv. 12250

Literature: E. Speier in EAA III, 1960, see *Eros*
pp. 428, 431, fig. 522; ES V, tab. 15.

The provenance of this mirror is unknown.
The tang or shank (connecting the handle)
is broken and in part missing. Much of the
surface is disfigured by corrosion. The metal
is misshapen in various points, the result of
oxidation, particularly along the edges.
The patina is largely reddish brown, with
malachite formations.

This is a circular mirror with a short
rectangular neck, from which juts a short
tapered tang to be inserted into a handle
of another material, which is missing.
The smooth edge of the mirror, slightly
indented, has a raised border on its opposite
side. Around the center of the visual field
is an impressed circle.

Framing the scene on the mirror is a
circular wreath of lanceolate leaves (tapering
to spearheads). At the center, seen in profile, is
a winged nude male figure running to the left.
The face, also in profile, is characterized by the
almond-shaped eye, which is represented with
the frontal view according to the canons of
archaic art. The disproportionately thin
arms are raised in keeping with the figure's
forward movement. The wings join the body
at abdominal level. The figure is wearing a
tutulus (conical cap) and what appears to be
winged footwear. Below, between his feet,
is a duck depicted in profile, and at each side
of the figure is a lotus flower.

With some degree of reserve, the figure
on the mirror has been interpreted as Eros.
Winged male personifications, running or
flying, have been documented in mirrors of
the archaic style. An example would be the
fine specimen in Berlin,[1] dated at the close
of the sixth century B.C., with the figure still
represented (according to the archaic usage)
as running "while still seated."

From a strictly iconographic point of view,
the Vatican mirror may be compared with two
other exemplars depicting Eros (?), stylistically
heterogeneous but related to the present work
by the specific detail of the winged footwear.[2]

Outside the field of mirrors, the theme of
the winged personage running or flying is
expressed in the bas-relief of a sandstone
obelisk now in the cloister of the church of
S. Francesco in Città della Pieve, dated at the
fifth century B.C. In that case the figure,
likewise with arms apart and raised as in the
case of the exhibited mirror, appears to bear
some relationship with symbology drawn
from the heavenly bodies.[3]
Maurizio Sannibale

1. ES IV, CCCXXVIII, 2; Zimmer 1995, n. 2.
2. ES I, CXX, 1–2.
3. F. Roncalli in Vaticano 1988, 78–82, no. 4.6.

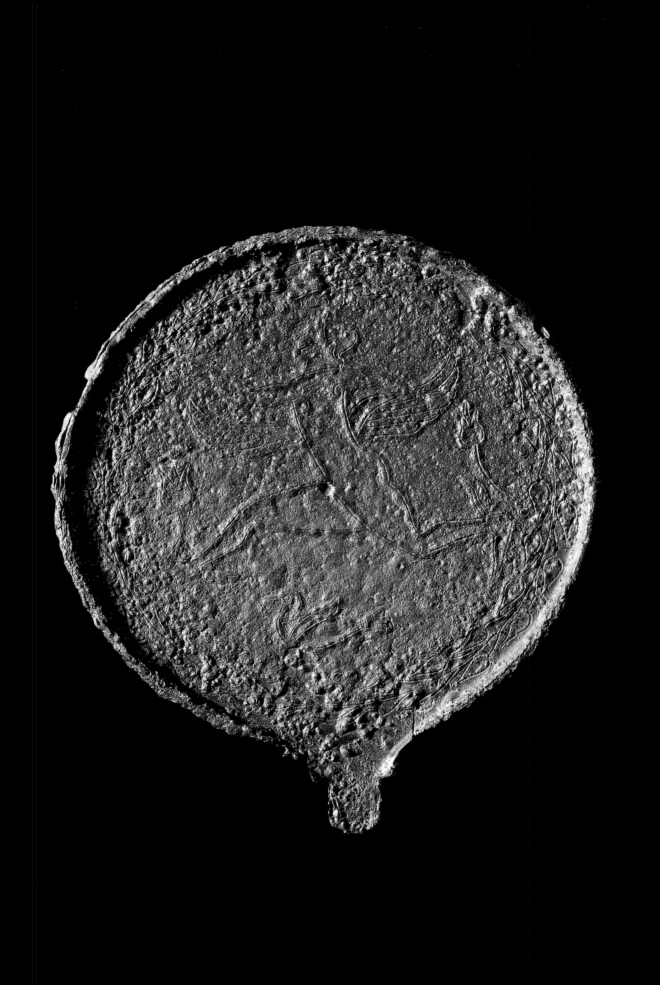

12

After Lysippus (Greece, 4th century B.C.)
EROS OF TESPIA, mid 2nd century A.D.
White marble
133 x 55 x 44 cm (52⅜ x 21⅝ x 17⅜ in.)
Vatican Museums, inv. 1509

Exhibitions: Rome, Palazzo delle Esposizioni,
Lisippo, l'arte e la fortuna [Milan], 1995;
Toyota, Japan, Municipal Museum of Art,
*The Human Body in Ancient Art from the
Vatican Museums*, 1996.

Literature: W. Amelung, *Die Sculpturen des
Vaticanischen Museums* 1 (Berlin, 1903):633,
no. 495, tab. 67; H. Döhl, "Der Eros des Lysipp,
Frühhellenistische Eroten," Ph.D. diss.,
Göttingen, 1968, 55, no. 34; M. Collignon,
Lysippe (Paris, 1904), 68, fig. 14; P. Moreno,
"Modelli lisippei nell'arte decorativa di età
repubblicana ed augustea," in *L'art décoratif à
la fine de la république et au début du principat.
Table ronde—Rome 1979* (Rome, 1981),
173–227, 176, fig. 14; *Bildkatalog der
Skulpturen des Vatikanischen Museums*, vol. 1,
Museo Chiaramonti (Berlin-New York, 1995),
2: tabs. 720–22; 3:62*; P. Liverani in Milan
1995, 117, no. 4.15.5; P. Liverani in Toyota
1996, 117, 181–82.

This statue was found in Rome near the
baptistery of the basilica of Saint John Lateran
in 1828, together with the statues of Emperor
Titus and his daughter, Julia, both of which
are now on display in the Vatican Museums.
When it was found, the sculpture was
broken in many pieces. The restoration was
undertaken by the sculptor Antonio D'Este.
Carrara marble was used to supplement the
nose and chin, the arms, the left foot and three
toes of the right foot, two-thirds of the quiver,
the base, and other minor wedges; Pentelic
marble (from Mount Pentelicus in Greece)
was used for the wings; the penis is missing.
Some misunderstandings by the nineteenth-
century restorer may be observed: the quiver,
in fact, was put back together upside-down,
and the right wing should have been raised a
little higher. Red marks, perhaps preparation
for painting the statue, may be observed on
the tree trunk.

According to the genealogy that was
established in the classical age, Eros was the
son of Aphrodite, the goddess of love and
beauty. He is often portrayed with a bow that
he uses to strike the hearts of men and gods,
causing passionate love. His wings allude to
his speed and omnipresence.

The statue is a Roman work of art from the
first half of the second century A.D. However,
it conveys, in a substantially faithful way, the
bronze original executed by Lysippus for the
Greek city of Tespia in Boeotia, probably
between 338 and 335 B.C. The artist depicts
Eros in the act of testing the flexibility of his
bow. With his left hand he grasps it in the
center and pulls toward himself, while his right
hand and his leg hold the ends steady. Lysippus
also proved himself with this same theme,
which appears to be particularly suitable to the
sculptor, in another work called the *Eros of
Myndos*. In fact, he has given this statue a
sense of dynamic tension and action that can
be found in all of his work.
Paolo Liverani

13

Apulia, Southern Italy
RED-FIGURED PELIKE, C. 330–320 B.C.
Ceramic
Height 50.7 x diameter of mouth 23 cm
(19⅞ x 9 in.)
Vatican Museums, inv. 18129

Literature: Pistolesi 1829–38, III: tab. 65;
Trendall 1953–55, 185–87, tab. L, a, c, Y23;
A. Stenico in EAA I, see *Apuli vasi*, 505, fig.
683; G. Schneider Herrmann, "Spuren eines
Eroskultes in der italischen Vasenmalerei," in
Bulletin Antieke Beschaving 45 (1970), 100,
fig. 17; Rallo 1974, 21, tab. V, 1; Trendall 1976,
45; Trendall and Cambitoglou 1978–82, 2:491,
no. 27.

The provenance of this *pelike* (jug) is
unknown. The piece is whole, with a slight
deformation on the front, evidently occurring
prior to baking. The clay has orange impasto.[1]
The details of the red figures were painted in
white and yellow before baking. On the neck is
an additional decoration. On the front, a frieze
of palmettes alternates with lotus flowers,
below which are a series of dotted ovoli and
another series of white pendants. On the back
are a garland of laurel leaves with white
berries and a flower at the center, ovoli dotted
below, and a string of white dots. Beneath the
figured area runs a meander interrupted by
checkered squares, themselves intersected
diagonally, with a rosette in the center of each.
Beneath the handles, fan-shaped palmettes
appear above volutes (spiral figures).

A wedding scene is the subject of the main
side. Four personages are arranged on planes
marked with dots. At the center, on an
elaborate throne rendered with bright touches
of white and yellow, is seated a woman, with
her feet placed on a stool. She is wearing a
peplos (shawl-like garment) and himation
(light mantle) that covers her head as well. Her
hair is long and very curly, and she is adorned
with a *stephane* (diadem), a double string of
pearls, and armlets. Behind the throne is a
thymiaterion (incense-burner) on a pyramid-
shaped base.

In front of her is a youth, nude except for
a cloak that hangs from his right shoulder,
crossing his left arm and covering his back.
His hair is bound with a garland of leaves.
With his left arm he offers a dove to the seated
lady while he leans on a white staff. His right
hand rests lightly on his hip. Behind the youth
is a woman clad with the peplos and a cloak
wrapped around the lower part of her body.
Her hair is gathered in a *sakkos* (net), and she is
adorned with pendant earrings, necklace, and
armlets. She holds a mirror in her left hand;
from her right dangles a ball attached to a thin
string. A *phiale* (low pouring vessel) lies at her
feet.

Framing the scene on the right is a second
female figure holding in her raised right
hand a *flabellum* (fan) and with her other a
tympanon (a type of drum). She wears a peplos
covered by a transparent shawl. Her hair is
held in place by a band (*sphendone*) and fixed
to the forehead by a *stephane* that rays out. Her
earrings, a necklace, armlets, and footwear are
all painted onto her figure in white. A second
pouring vessel has been abandoned at her feet,
while to her right hangs a fringed length of
cloth.

Above and slightly to the right in relation to
the throne, the terrain once again demarcated
by a string of dots, a nude Eros reclines on a
folded cloak. With his wings spread wide, he is
in the act of removing a garland from an open
box. To the left, a white goose pecks at a flower,
above which a length of cloth is arranged in a
festoon.

On the secondary side, also above a dotted
line indicating a new plane of action, a woman,
with a bunch of grapes in her right hand and a
tympanon in her raised left hand, gives chase to
a nude youth, his head encircled by a white
diadem. A cloak trails from his left arm (with
which he holds a pouring vessel), whereas his
right hand grips a garland adorned with white
dots. Through the garland passes a length of
white cloth. Between the two figures is a laurel
shrub with berries; a shoot of the same plant
can be seen to the right of them. Hovering
above both figures, framed as it were by two
pendant lengths of cloth, is an Eros similar to
the other one, holding in his right hand a long
wreath of laurel. In the background are two
flowers, one above on the left, the other below
and to the right.

The Vatican pelike was attributed by
Trendall to the Painter of Dario or to a master
painter of his circle (a conventional figure
active between 330 and 320 B.C.). Other nuptial
scenes have been attributed to the same artist.[2]
Maurizio Sannibale

1. Munsell, 10 yr 7/6.
2. Trendall and Cambitoglou 1978–82, 2:482–86.

14

Apulia, Southern Italy
KRATER WITH COLUMN-LIKE HANDLES
c. 330–320 B.C.
Ceramic
Height 48 x diameter of mouth 31.7 cm
(18⅞ x 12½ in.)
Vatican Museums, inv. 18079

Literature: Albizzati 1920, 157, fig. 8; Trendall 1953–55, 128–29, V 46, tabs. XXXIIh, XXXIIIh; Trendall and Cambitoglou 1978–82, 810, no. 137.

The provenance of this krater (wide two-handled bowl) is unknown. There is a gap in part of the lip on the secondary side; the base is missing but has been repaired in modern times (perhaps in the nineteenth century) with a wooden stand. Eros' wing is chipped.

On the orange clay mixture,[1] red figures have finishing touches overpainted in white and yellow. Accessory decorations on the krater include a wave motif on the frontal fillet and underneath the depicted figures, crossed squares on the handles, a series of short vertical stripes on the shoulder, double rows of dots between narrow vertical stripes that frame the figures on the two sides, and a metope with vine of ivy leaves alternated with filled-in circles surrounded by dots on the shoulder.

On the primary side, the nude Eros is depicted seated on a pile of stones, underscored with wide white and yellow strokes of paint. His wings are folded behind his back, with background painting and overpainted details. He wears *armillae* (bracelets), earrings, a diadem, a pearl necklace, a string of pearls as a shoulder strap, and more pearls around his thigh. He is wearing *endromides* (lightweight shoes used for running or hunting) executed with overpainting. His hair is pulled back on top of his head and held in place with a *sphendone* (headband) tied with ribbons. In his lowered right hand he holds a bunch of grapes and, in his outstretched left hand, a low, parallelepiped *cista* (container) with the lid raised and a garland of flowers hanging from it. In the background, in the upper left corner, is a window; an ivy leaf with vine shoots is dangling above the *cista*; in the upper right corner is a triangle formed by dots. On the lower left side are small white plants, and there is a flower with four petals to the right of the pile of stones.

The entire opposite side depicts a woman's head in profile. Her hair is pulled back and held in a radial net (*kekryphalos*), with the details overpainted. She wears a diadem (*stephane*) on her forehead, a circular dangling earring, and a necklace (all executed with overpainting). In the background, there is a half palmette in the upper left-hand corner and a half palmette and a spiral in the two lower corners.

The krater has been attributed by Trendall to the Group of Trieste S 403, who are associated with the works of the Painter of Ganymede,[2] a conventional figure active in the years 330–320 B.C.
Maurizio Sannibale

1. Munsell, 10 YR 7/6.
2. Trendall and Cambitoglou 1978–82, 793–95.

15

Apulia, Southern Italy
ASKOS WITH A SEATED WOMAN AND EROS
c. 330–310 B.C.
Ceramic
Height 26 x width 21.9 x diameter of mouth
9 cm (10¼ x 8⅝ x 3½ in.)
Vatican Museums, inv. 18109

Conservation courtesy of Lucille G. Murchison in memory of Mary Ethel Gannon

Literature: Trendall 1953–55, 158–59, Y 3, tab. XLIIa–b; Trendall 1976, 44; M. A. Del Chiaro, "Late Etruscan Duck-Askoi," in *Revue Archéologique* (1978):37, fig. 13; F. Van der Wielen, "Canosa et sa production céramique," in *Genava* 26 (1978): 145, fig. 4; Trendall and Cambitoglou 1978–82, 875, no. 99.

The provenance of this *askos* is unknown. It has been reassembled from various fragments, with a few small gaps. The details are executed with much overpainting in white on a very pale brown clay mixture.[1] The vessel has a horizonal-brimmed lip on a short neck, and a ribbon-like handle is attached horizontally. There is a frieze of *ovoli* (quarter sections of circular or elliptical shape) between two parallel stripes on the neck with finishing touches overpainted. A wave motif encircles the *askos* under the depicted figures. There are palmettes and large lateral spirals under the handle, with overpainted finishing touches that extend over approximately half of the vessel's surface.

The figures were painted on the front part of the vase underneath the mouth. On the right side, a bell-shaped double flower rises from the ground. Next is Eros, naked, with large wings behind his back and many details and finishing touches of the background overpainted. His hair is pulled up on top of his head and held in place by a headband (*sphendone*) with flying ends. It is embellished with a diadem (*stephane*) made up of a string of pearls that were overpainted. Eros wears earrings, *armillae* (bracelets), a pearl necklace, and a string of pearls worn as a shoulder strap. He bends forward with his right leg raised above a large, bell-shaped flower. A *taenia* (ribbon) is lying over his right thigh. His left hand holds a long garland of flowers. His right hand, holding a flower wreath, is raised and stretched out in front of him.

Opposite Eros on the left side, a young woman, dressed in a long chiton and footwear, is seated on a pile of stones. Her hair is arranged in the same style as Eros'. She too wears earrings, a necklace, and *armillae*. Her left hand lifts a *phiale* (shallow vessel) with a large ivy leaf dangling from it, and her right hand holds a *situla* (a kind of bucket), painted with broad white stripes. Another *phiale* is lying on the ground underneath the *situla*.

The *askos*, made in Apulia, was formerly attributed to the workshop of the Painter of Pateras.[2] More recently it has been attributed to the Painter of Baltimore, a conventional figure active between 330 and 310 B.C.[3]
Maurizio Sannibale

1. Munsell, 10 YR 7/3.
2. Trendall 1976, 44.
3. Trendall and Cambitoglou 1978–82, 856–60.

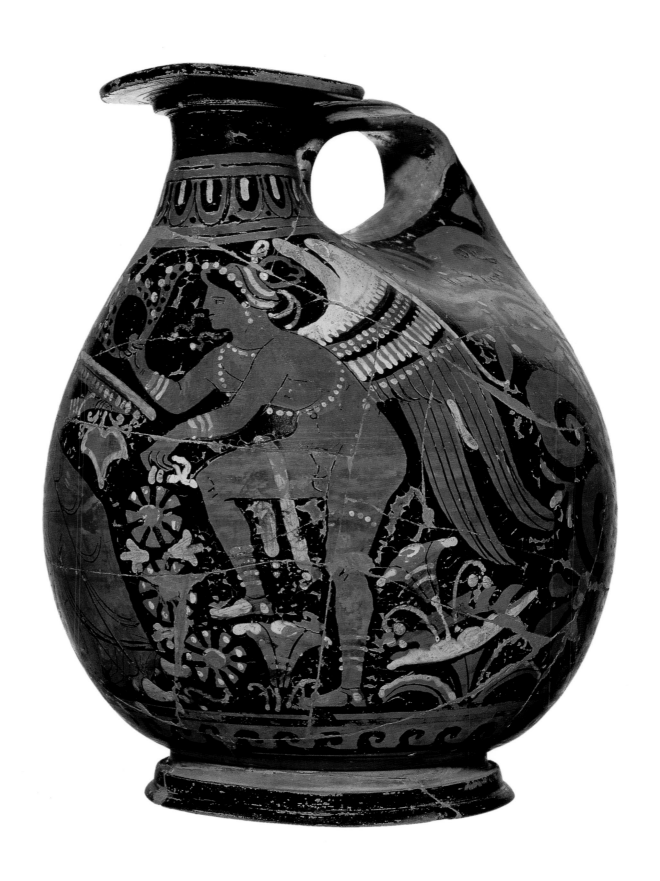

Etruscan
ENGRAVED MIRROR, c. 4th quarter
4th century B.C.
Bronze
Height 30.4 x diameter 18.6 cm (12 x 7¾ in.)
Vatican Museums, inv. 12647

Literature: E.Braun in BullInst 1836, 171 (see
Buranelli 1992, 297, doc. 35); S.Campanari,
*Di uno specchio volcente rappresentante il
risorimento di Adone* (Rome, 1840), 8; Musei
Etrusci … monimenta (1842), 1: tab. XCIII;
Monumenti del Museo Etrusco … (1842), 1:
tab. XXIII; ES IV, 28–29, tab. CCCLXXXI,
Paralipomena 328 (CCVI); CII 2141; Helbig
1912, 371, no. 639; C.Pauli in Roscher
1884–1937, see "Turan," col. 1287; Martelli
1941, 44; E.Vetter in RE 7 A, 2 (1948), col.
1368, see "Turan"; Mansuelli 1948–49, 68, 85,
96; Pfiffig 1975, 280; R. Lambrechts in LIMC,
see "Alpan," no. 3; M. Cristofani in LIMC, see
"Maris I," no. 4; M.Bonamici in LIMC, see
"Mousa, Mousai (in Etruria)," no. 1; Van der
Meer 1995, 190–91, fig 91.

The patina of this mirror, which was found at
Vulci in the excavation of 1836, was removed
in the course of earlier restoration efforts,
no doubt through the method known as
electrolysis. A considerable part of the
engraved decoration and the inscriptions have
been lost due to the process of corrosion that
has eaten into the surface. On the reflecting
side, corrosion has produced pore-like pustules.

This circular mirror has a broad tang that
tapers in its lower part, at which point it was
once inserted into a handle, now lost, made of
another material. The wide quadrangular neck
has points that are slightly expanded. The edge
of the mirror is decorated to the points of the
neck with a row of double-edged *ovoli* in relief,
overflowing onto the reflecting side. At the
level of the rim it is finished with beading
separated by grooving.

On the reflecting side, at the level of the
exergue and the extension, appears the torso of
a draped figure with spread wings against an
undulating motif. The personage, with rich
hairstyle and wavy locks, is turned in profile.
She is identified as Aurora in the inscription
(reading from right to left) that appears below.
The average height of the letters is 2–5 mm:
ᴎᴙ⟨ᴈᴑ (*θesan*).

On the back of the mirror, the visual field
is spread out over three levels. In the upper
exergue, the upper part of a female figure is
slightly turned, her long hair disordered and
parted in the middle. On the border of the
exergue is an inscription (height of the letters
1.9–3 mm) referring to the personages below:
ᴎᴙ1⟨. ıı ᴎ ᴈ ı⟨' ⟨ıᴑᴠ⟨ʀıᴑᴙᴍ
(*maristura[n]* [--] xx *ten* xx [--] [*a*]*lpan*).

In the central section, framed by a rich
motif of marine creatures that overflows onto
the exergue above, are depicted a man and a
woman embracing. The man, nude except for a
chlamys that covers his shoulders, is turned
slightly with his right leg seen from the front.
He approaches the woman, with his left arm on
her shoulder. The female figure turns to face
him in profile with her left leg flexed and her
right arm placed on his shoulder. She wears a
short transparent tunic, the folds of which
allow us to see the lines of her body. Her long
hair is fixed in place by a thin dotted band.
Next to the couple are two figures standing and
facing them.

To the left stands a female figure, her left
leg crossed, her profile turned to the right. Her
curly hair is gathered on the head and held in
place with a dotted double band that allows a
single curl to cross her forehead. She is nude
except for a cloak that comes down from her
shoulders to cover her back, and she wears both
a necklace and armlet.

Symmetrically positioned on the other
side of the couple is a winged male figure,
nude except for the chlamys, his torso turned
as he leans forward slightly. His head is seen
in profile. One foot is placed on a slight
elevation of the terrain, while his left arm
is outstretched and holding a staff. His hair,
which reaches down to his neck, is held in
place by a headband.

The lower exergue is separated by a strip
inside of which are engraved a serpent and two
birds; at the center is an inscription (average
height of the letters 1.8–3 mm) identifying the
personage below: ⟨ᴠᴍ (*mus*).

The winged female figure, semi-draped
on the lower part of her body and intent
on playing a four-stringed lyre, holds the
plectrum in her right hand (see cat. 22).
Her short hair is in disordered locks; she wears
an armlet and has footwear that curls up in
the front.

This mirror constitutes one of the key
documents bearing witness to the assimilation
in Etruria of the Muse, a typical figure of
Greek mythology. Together with the image
comes the inscription *mus*, clearly derived from
the Greek *mousa*. So it is both an iconographic
and linguistic borrowing, so to speak. In
appearance, the figure recalls certain minor
deities in the retinue of Turan (see cats. 18, 19,
20). We cannot rule out the possibility of a
double significance, as this might also be an
allusion to amorous joy and fecundity.[1]

Any attempt to decipher the visual field has been seriously compromised by its state of preservation. In spite of gaps in the inscriptions, the central couple has been variously interpreted as Venus and Adonis, Peleo and Tethys, Paris and Helen, Alchsentre and Elina, or Theseus and Helen. The identity of the lateral figures is easier to pinpoint thanks to the inscriptions. Maris, a male divinity erroneously associated with the Latin Mars, is linked to other divinities in inscriptions. In this case, the personage on the right, "maristura[n]," may be equated to Maris of Turan. With the same goddess, in part traceable to the Greek Aphrodite, is also associated Alpan (portrayed on the left). She is a minor divinity, part of the circle of Turan, with whom she is frequently associated in other exemplars that have come down to us. The identity of the figure in the upper exergue is uncertain.

Both for its shape and for the layout of the visual field, the Vatican mirror recalls exemplars from Volterra of the last quarter of the fourth century B.C.,[2] Vulci,[3] Tuscania,[4] Castel Giorgio,[5] and Todi.[6]

The central couple also finds points of comparison with other mirrors,[7] as does the lyre player, similarly represented on a mirror from the tomb denominated François di Vulci[8] and another formerly part of the Campana Collection in Saint Petersburg.[9]

Regarding the winged figure of Θesan on the reflecting side, it may be compared to the exemplar from Castel d'Asso[10] as well as another in the Museo Archeologico in Naples, it too having a similar layout for the visual material.[11]

Maurizio Sannibale

1. Mansuelli 1948–49, 66–69; M. Bonamici in LIMC, see "Mousa, Mousai (in Etruria)," 685.
2. ES V, 60 = Bonfante 1977, 156 ss., tab. XXIVa.
3. ES CLXXXI; Rebuffat Emmanuel 1973, no. 5; Rallo 1974, tab. XXVI, 1–2, R. Lambrechts in LIMC, see "Iasa," no. 4.
4. Pallottino 1930, 49–87.
5. ES V, 34.
6. Bendinelli 1914, c. 621, tab. III; Mansuelli 1946–47, 36; Bonfante 1977, tab. XXVa, ES CCLVIIB; Van der Meer 1983, no. 1; Bonfante 1977, tab. XXI–XXIII = De Puma 1987, no. 4.
7. ES CCXC; ES 5, 23–25.
8. Vaticano 1987, 121–22, fig. 5.
9. ES CCCXXII; R. Lambrechts in LIMC, see "Alpan," no. 6; M. Bonamici in LIMC, see "Mousa, Mousai (in Etruria)," no. 2.
10. ES V, 23; Rallo 1974, 29–31, tab. XVII, 1.
11. ES LXXXII; Rallo 1974, 54, tab. XXXIII, 2.

17

Etruscan
PATERA WITH HANDLE REPRESENTING A FEMALE
FIGURE, late 4th–early 3rd century B.C.
Cast and laminated bronze
Height 41 x diameter 23.2 x height of basin
3.6 cm (16⅛ x 9¼ x 1⅜ in.)
Vatican Museums, inv. 12275

Conservation courtesy of Lucille G. Murchison
in memory of Mary Ethel Gannon

Literature: Musei Etrusci ... monimenta
(1842), 1: tab. LXII,1; Monumenti del Museo
Etrusco... (1842), 1: tab. XIII,1; Dohrn 1963,
538, no. 719.

The patina on this *patera* (bowl) is compact
emerald green (malachite). The piece is
chipped in some places with deteriorated
molding, and corrosion in the form of blisters
appears on the laminated part of the basin.
A small gap has been repaired on the patera's
shoulder on the external side under the edge.
Its provenance is unknown.

This *patera* from the Gregorian Etruscan
Museum has a short-brimmed, horizontal rim.
The raised border is decorated with a string of
ovoli (rounded convex molding) and finished
with beading and a pair of spindle whorls
where the handle is attached.

The handle was cast using the lost-wax
process. It represents a scantily clad winged
female figure: her clothing is draped over one
shoulder, covers her back, and is held in place
by a *fibula* (brooch) on her breast and a belt
tied around her waist. Her finely chiseled
wings were cast separately and then
mechanically attached by a riveting pin,
rectangular in cross section. She has long,
flowing hair, and her face is turned slightly
toward the right. She wears a diadem, a
necklace, *armillae* (bracelets), and footwear
with a raised tongue behind the heels. Her left
arm is bent and turned toward her shoulder;
her right one is curved slightly with her hand
on her hip. The figure is standing on a molded
circular base that is attached to the *patera* by
light brazing, probably using a pewter-lead
alloy. This same method was used to attach the
movable handle with a plaque of a woman's
small head in strong relief. It was placed above
the basin on the patera's shoulder.

The iconography of a winged woman is
reminiscent of a personification often
represented in the production of Etruscan
bronzes, ceramics, and mirrors beginning in
the fourth century B.C.(see cats. 18, 19, 20),
generally known as Lasa.[1]

A very similar *patera* comes from Chiusi
and is exhibited next to this one in the Vatican
Collections.[2] These two *pateras* may be
compared to a solitary handle to be found in
the Louvre Museum[3] and a *patera* from Chiusi
found in the British Museum.[4] Generally, the
figure may be compared with the solitary
patera handle representing a wingless body
from the Sperandio necropolis near Perugia.[5]
A *patera* with a handle shaped like a winged
figure comes from the Talamone necropolis.[6]
There is also documentation of similar fictile
figures made of ceramic ware with a black
glaze from the "Malacena factory."[7]

It appears that the geographical area in
which these objects circulated was
concentrated in the inland cities of Etruria,
such as Perugia (see above) and Chiusi (see
Gregorian Etruscan Museum inv. 12263).
Similar objects were also produced in Vulci.[8]
They can also be found in Bolsena[9] and Todi.[10]
Maurizio Sannibale

1. Rallo 1974; Thomson De Grummond 1982, 114, 116,
figs. 52–53, 58–59, 93, 99; Lambrechts in *LIMC*, under
entry "lasa."
2. Gregorian Etruscan Museum, inv. 12263; *Musei
Etrusci ... monimenta* 1842, 1: tab. LXII, 2; *Monumenti
del Museo Etrusco ...* (1842), 1: tab. XIII,2; Dohrn
1963, 538, no. 719.
3. De Ridder 1913–15, 2:137, no. 3022, tab. 106.
4. Walters 1899, 109, no. 657.
5. F. Moretti in *NotSc* 1900, 556–58, fig. 6.
6. Milani 1898, 101.
7. Fiumi 1976, 62, fig. 124.
8. Gregorian Etruscan Museum, inv. 12234; *Musei
Etrusci ... monimenta* (1842), 1: tab. LXI, 1;
Monumenti del Museo Etrusco ... (1842), 1: tab. XII,1;
Dohrn 1963, 538, no. 719; see also a specimen from
Canino: Haynes 1985, 215, no. 158.
9. Richter 1915, 218, no. 599; Haynes 1985, 239, 320,
no. 195.
10. Proietti 1980, 308–09, no. 439.

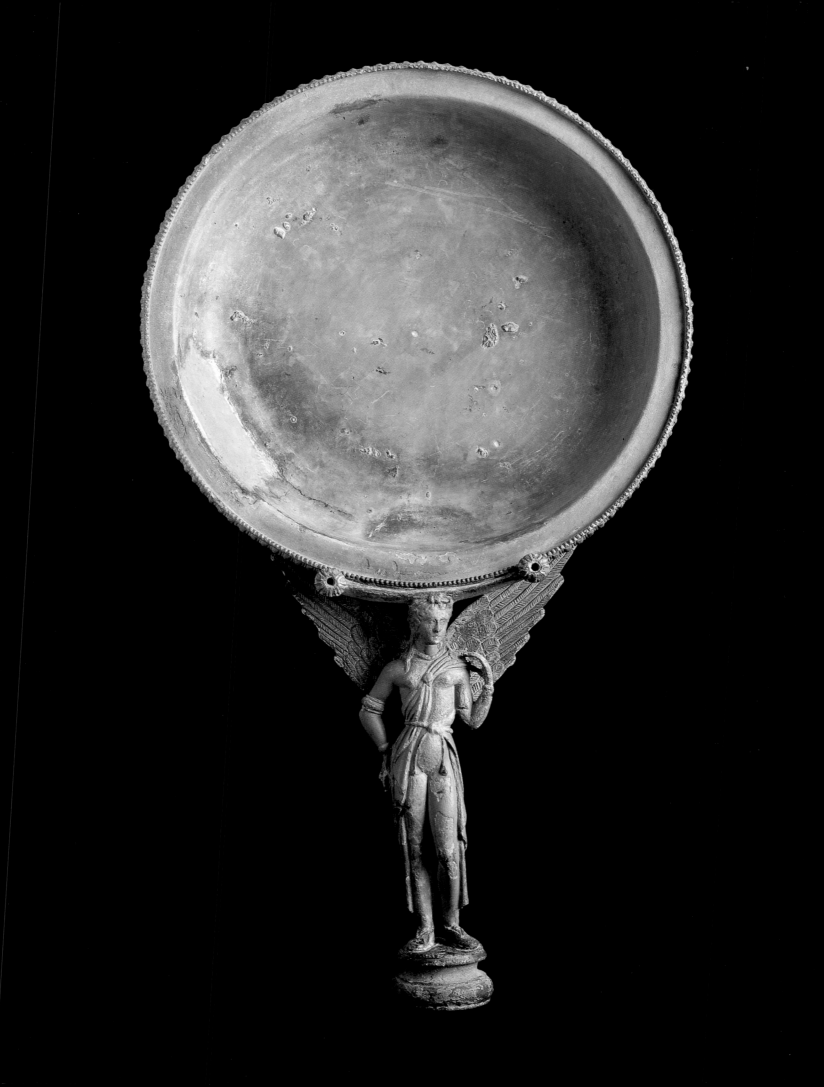

18

Etruscan
TYPE A CANDELABRUM
2nd half 5th–late 4th century B.C.
Cast bronze
Height 103.5 x statuette 9.8 x diameter of shaft
.8–1.5 cm (40¾ x 3⅞ x ½ in.)
Vatican Museums, inv. 12406

Conservation courtesy of Lucille G. Murchison
in memory of Mary Ethel Gannon

Literature: Musei Etrusci ... monimenta
(1842), 1, tab. LXXIX,2; Monumenti del
Museo Etrusco ... (1842), 1, tab. LII,2; Giglioli
1935, tab. CCCIX,4; Dohrn 1963, 517; Testa
1989, 24–28, no. 5.

The candelabrum was unearthed at the Camposcala estate in Vulci in an excavation by V. Campanari under the direction of the papal government in 1837. The bronze has a green patina, mostly composed of malachite (basic copper carbonate), with partial formations of cuprite (copper oxide). The finial statuette is attached by a modern threaded dowel. It is probably not the original, because it does not fit perfectly onto the plinth of branches on which it is set.

The piece is composed of various parts, separately cast and assembled later. The tripod is in the shape of leonine feet and has no base; its sinuous legs, polygonal in cross section, join in a cylinder that tapers slightly at the top. The cylinder is crowned with a corolla composed of eleven hemispheres, placed where the shaft fits into the tripod. The shaft is smooth and slender and has a tang. An inverted disk and a molded spool, with a plinth of branches above, are inserted into the top of the shaft. The finial statuette, composed of a female winged figure standing on a low cylindrical base, is set above the plinth. The figure is clothed in a long, sleeveless chiton that is narrow at the waist and folds over itself. On her feet she wears *calcei* (half-boots) with upturned toes. Her legs are slightly separated, and the left one is flexed. Her arms are bent slightly and held close to her chest. She holds attributes: an *alabastron* (container for perfume) in her left hand and a *discerniculum* (long hairpin) in her right hand. Her outspread wings are characterized by deep engraved furrows in the front. Her hair is arranged with a large headband and pulled back into a bun at the nape of her neck.

The heterogeneity of the candelabrum and the crown, clearly shown in the scientific examination, is confirmed by the corresponding chronological gap that emerges from a critical analysis of the two parts. In fact, the candelabrum can be compared to characteristic specimens of the fifth century B.C., and it appears that it cannot be dated beyond the second half of that century.[1] On the other hand, although specific comparisons between crowns of candelabra and small sculptures in general are missing,[2] the winged figure is not datable before the end of the fourth century B.C. on the basis of iconographic and stylistic elements.[3] In this regard, iconographical comparisons that can be made concerning the production of mirrors (see cats. 19, 20) seem to fit very well. The winged women depicted on these mirrors, generally defined as *lasa*, are holding attributes such as the *alabastron* and the *discerniculum*. Thus, although they are linked to the world of women, as shown by their role as handmaidens (*ornatrices*), these personifications also represent minor deities of the Turan circle. In the mirrors, they may be identified with the names Snenath, Mean, Zipna, Munthuch, Achvizr.[4]

Maurizio Sannibale

1. Testa 1989, 27.
2. For a general comparison, see Giglioli 1935, 58, tab. CCCX,4 (patera handle from Perugia); R. Lambrechts in LIMC, under entry "*lasa,*" no. 47. Winged figures of the same iconographic type appear in the engravings of Prenestine *cistas* (vessels): R. Lambrechts in LIMC, under entry "*lasa,*" no. 24.
3. Testa 1989, 27.
4. Rallo 1974, 54–58; R. Lambrechts in LIMC, under entry "*lasa.*"

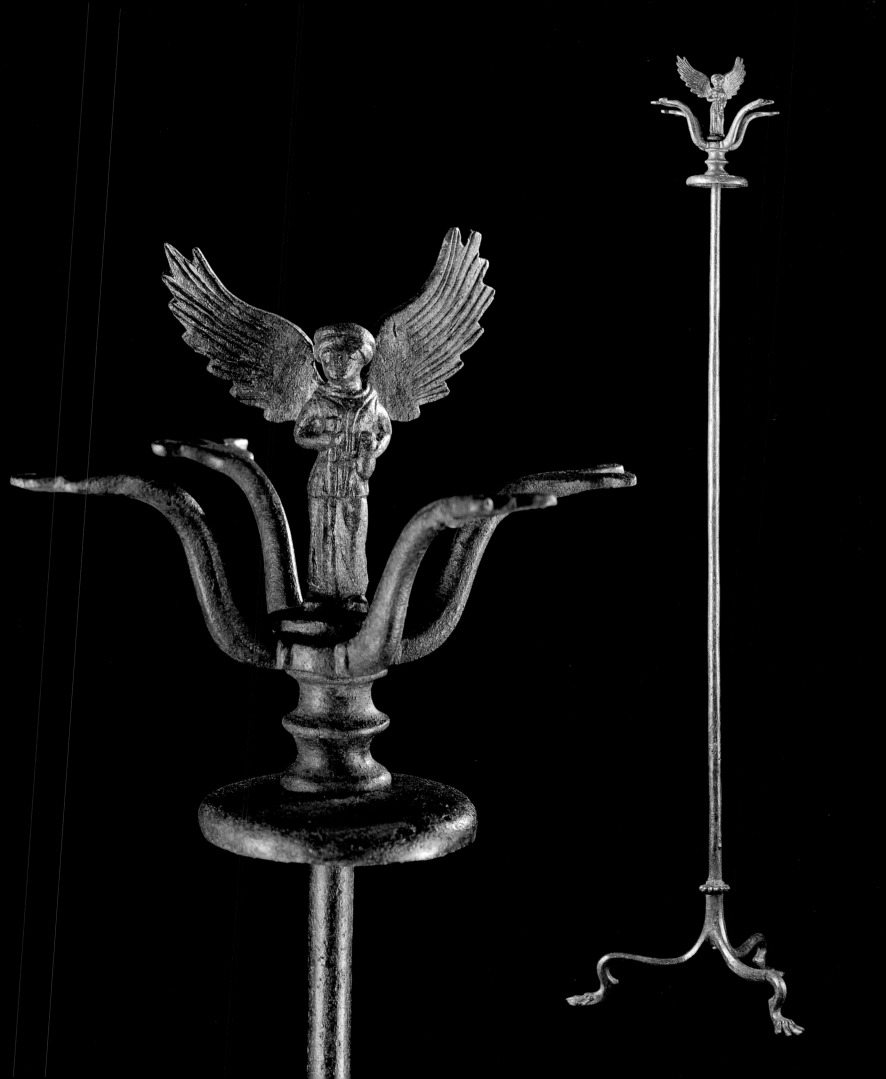

19

Etruscan
ENGRAVED MIRROR
Late 4th–1st half 3rd century B.C.
Bronze
Height 21.7 x diameter 16.4 cm (8½ x 6½ in.)
Vatican Museums, inv. 12262

Literature: Fischer Graf 1980, 3, no. 27.

This mirror in the Gregorian Etruscan Museum was discovered intact. The patina is mostly composed of malachite with partial formations of cuprite. Its provenance is unknown.

The circular form has a rectangular extension, with receding points, connected to a short tang with tapered edges. It was intended to be inserted into a missing handle made of different material. The edge profile is smooth and tilted slightly with a raised rim. On the reflecting side, the extension is decorated with an engraved lotus flower and a beaded edge.

The entire rear side is covered with a foreshortened nude female figure who is moving toward the left with her wings outspread. Her left arm is curved upward, and she holds an *alabastron* (container for perfume). Her right arm is delicately outstretched accompanying her movement. The left leg bears her weight and is seen from the front; the right leg is bent and seen from the side. Her face is in profile; her short, wavy locks of hair are adorned with a diadem. She wears *endromides* (lightweight shoes used for running or hunting) on her feet.

The subject reproduced here is generally denoted as a *lasa* (Etruscan divinity), although there is some uncertainty and difference of opinion.[1] In this work the description is very close to the complete iconography from which the more stylized and customary representations seem to derive (see cat. 20). The only difference is the lack of a large hairpin (*discerniculum*) in the other hand. The hairpin, which could be used not only for its primary function in hairdressing but also to dip into and sprinkle the scented essence as well,[2] together with the *alabastron*, would have completed the set of attributes.

The Vatican's specimen represents an incomplete copy of a mirror formerly in the Bazzichelli Collection in Viterbo (fig. 1).[3] In it a fawn precedes and looks backward at the winged figure who is holding a dead bird in her right hand. Both representations include the detail of the curved left arm carrying an *alabastron*; this iconography is not found elsewhere.

For its stylistic and iconographic characteristics, the mirror under consideration pertains to the works customarily attributed to the Maestro delle lase (Master of Lasas).[4] In particular, it stands out for the high quality of its workmanship and can thus be compared to those specimens dated between the end of the fourth and the first half of the third centuries B.C.[5] Besides the above, less-refined specimens exist of the same subject[6]; from them unoriginal and inconsistent reproductions have been made (see cat. 20). They have been extensively represented in a vast series comprehensively designated the Maestri delle Lase e dei Dioscuri.[7]

These works are particularly widespread in northern Etruria, mainly centering around Volterra, followed by Chiusi. In southern Etruria, the most important works are found in Tarquinia.

Maurizio Sannibale

1. Rallo 1974; Lambrechts in LIMC, see entry *"lasa."*
2. Rebuffat-Emmanuel 1973, 490–93.
3. ES V, 29,2.
4. Mansuelli 1946–47, 56; Mangani 1985, 29, group no. 2.4; Wiman 1990, 156–61.
5. See, in particular, Sassatelli 1981b, no. 5, one of the Bologna-Benacci objects accompanying the deceased; it is datable because of its association with a black-glaze *skyphos* (drinking cup) from the Ferrara Group T 585; see also Sassatelli 1981a, no. 30; Salskov Roberts 1981, no. 12; De Puma 1987, no. 18 = Wiman 1990, 159, fig. 12.1:8; Lambrechts 1987, no. 21; Cateni 1995, no. 25.
6. Lambrechts 1987, no. 23; Liepmann 1988, nos. 7–8; Von Freytag Löringhoff 1990, no. 11.
7. Mansuelli 1946–47, 62–65; for subsequent bibliography, see Literature above.

Fig. 1. Modern line drawing of Etruscan mirror in BC, Viterbo, from ES V, 29, 2

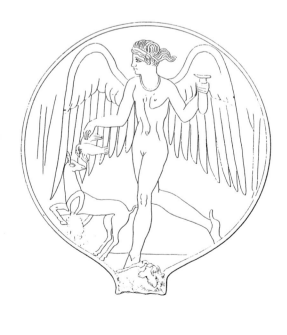

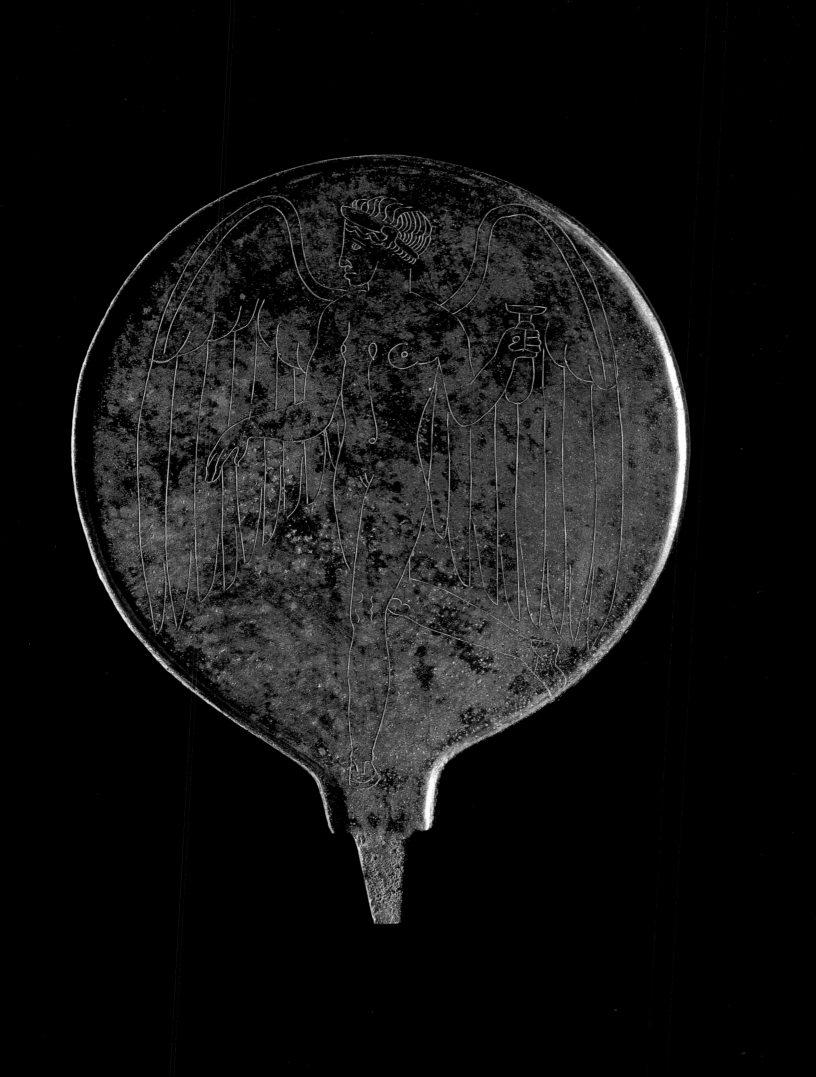

20

Etruscan
ENGRAVED MIRROR, 2nd half 3rd century B.C.
Bronze
Height 15.4 x diameter 11.7 (6⅛ x 4⅝ in.)
Vatican Museums, inv. 12269

The bronze patina is mostly compact brown with sporadic formations of basic copper carbonate, particularly on the reflecting side. The cross section of the disc of this circular mirror is convex. The edge profile is smooth and tilted with a raised rim on the opposite side. On the reflecting side, the edge is circumscribed by a groove and is decorated with a series of engraved notches. The sides of the extension are considerably indented; it is broken off at the joint where the handle, which has not been preserved, was attached. Its provenance is unknown.

A winged female figure is portrayed in the medallion. She moves toward the left and is naked except for headgear, shaped like a Phrygian cap, draping down onto the nape of her neck. Her left arm is bent with her hand hiding behind her back. Her right arm falls slightly toward the front and ends unnaturally in a stylized hand in the form of a flower or bud. It may be possible to recognize the result of the process of stylization in this detail; the lotus flower and the hand that originally held it become joined in graphic fusion. This attribute is expressed correctly in several specimens[1] or is represented in a different way.[2]

The figure portrayed is generally thought to be a *lasa*, although there is some uncertainty and difference of opinion.[3] In the complete iconography (see cat. 19), the subject appears with attributes such as the *alabastron* and the hairpin (*discerniculum*), evoking a woman's world. These were characteristics of the minor deities of the circle of Turan, who was an Etruscan goddess, partially identifiable with Aphrodite.[4]

This specimen is part of a vast series conventionally called the Maestri delle Lase e dei Dioscuri.[5] Some of these works are of much finer quality, whereas others are stereotyped, unoriginal, and second-rate products. This mirror is linked to the latter category.[6]

These works are particularly widespread in northern Etruria, especially in Volterra, in the area around Siena, and in Chiusi and its territory (Populonia, Montefortino). Some are also found in central-southern Etruria: Orvieto, Viterbo, Tarquinia, Norchia, Preneste.[7]
Maurizio Sannibale

1. For example, Heres 1986, no. 38; Cateni 1995, no. 5.
2. Salskov Roberts 1981, no. 12; Von Freytag Gen Löringhoff 1990, no. 10; Szilágyi and Bouzek 1992, no. 2.
3. Rallo 1974, 56–58; R. Lambrechts in LIMC, under entry *lasa*.
4. De Puma 1985, 44–53.
5. Mansuelli 1946–47, 48, 62–65.
6. See, in particular, Höckmann 1987a, no. 3 = Wiman 1990, 166, fig. 12.1: 24; D. Rebuffat-Emmanuel 1988, no. 17. See also Sassatelli 1981a, nos. 11, 31; van der Meer 1983, no. 25; De Puma 1987, no. 2; Lambrechts 1987, no. 17; Heres 1987, no. 3; Liepmann 1988, no. 28; R. D. De Puma, in New York 1991, 282, no. 6.9; Cateni 1995, nos. 12, 17, 22.
7. Mangani 1985, 35–36, group 3.5. For a general background, in addition to the above, see Salskov Roberts 1983; Höckmann 1987b.

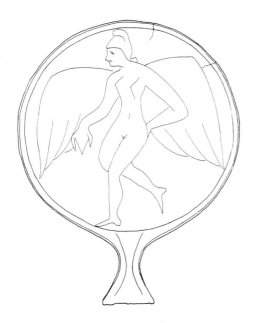

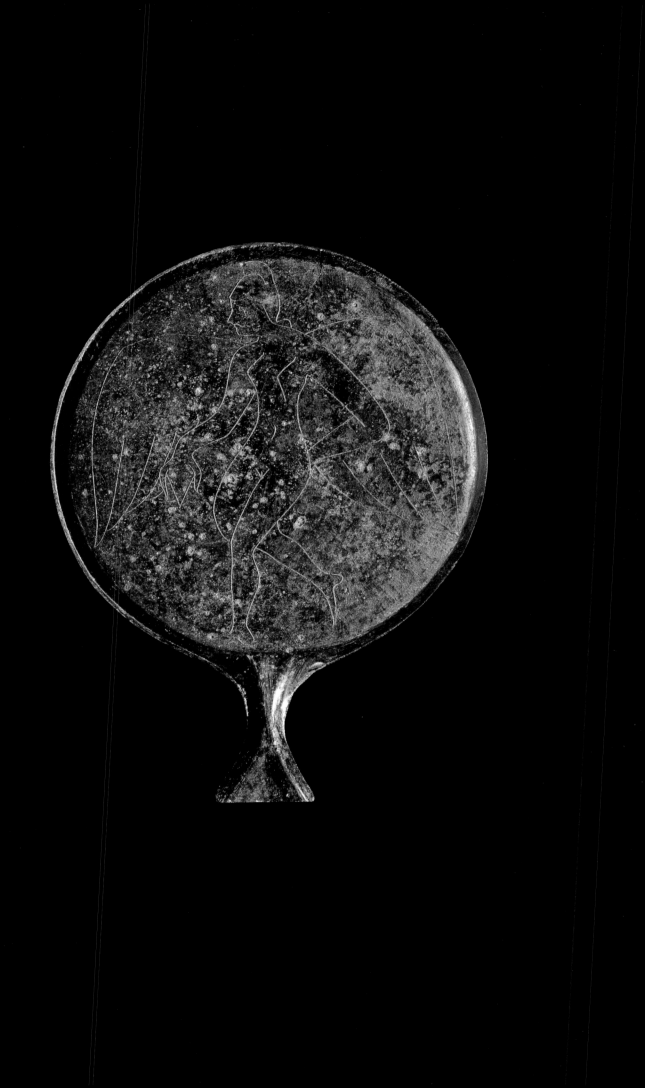

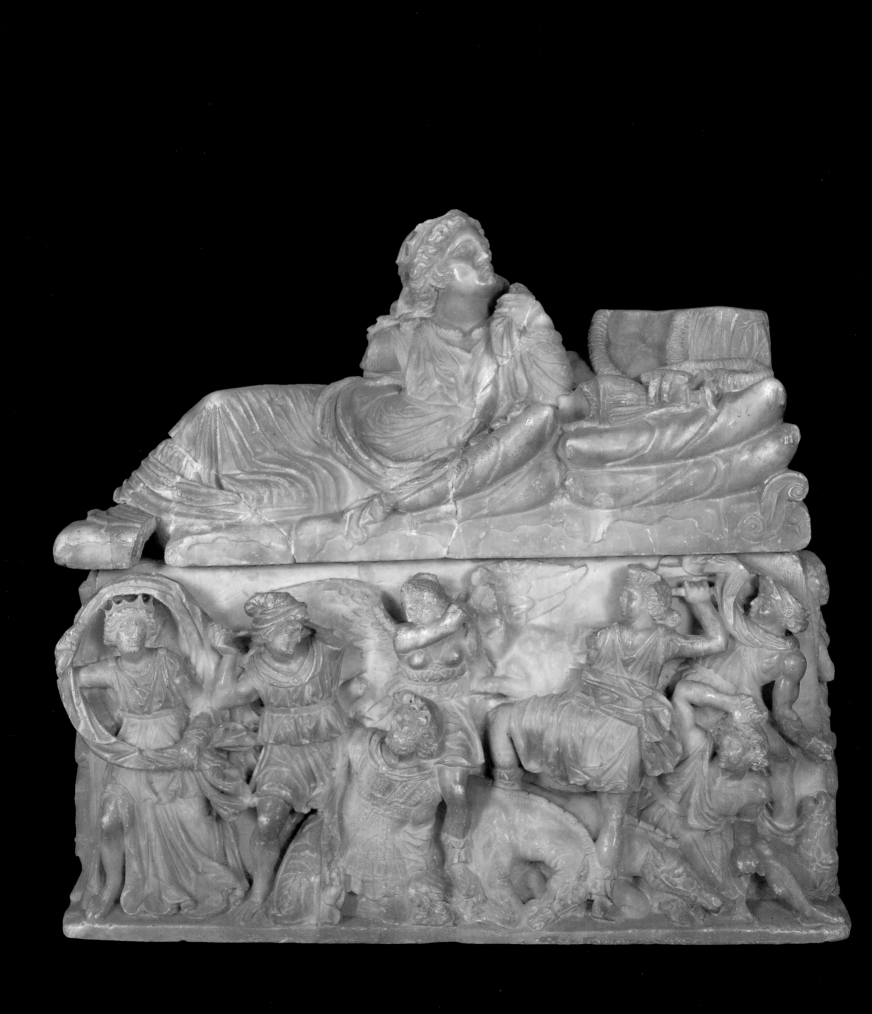

21

Master of Oinomaos (Etruscan)
CINERARY URN, 1st quarter 2nd century B.C.
Alabaster
Urn, 43 x 84.5 x 26.5 cm (17 x 33¼ x 10⅜ in.);
lid, 40.5 x 81 x 28.7 cm (16 x 31 x 2¾ in.)
Vatican Museums, inv. 13887

Exhibitions: Vatican City, Braccio di Carlo
Magno; Budapest, Museo di Belle Arti; Kraków,
Museo Archeologico; New York, Grey Art
Gallery, *Gens Antiquissima Italiae. Antichità
dall'Umbria*, 1989–91.

Literature: Gori 1737, 2:263–64, 3: tab.
CXXXV; Micali 1821, tab. XLIV; Pistolesi
1829–38, 4:111; Gerhard and Platner 1834,
2:155–56, no. 91; Musei Etrusci … Monimenta
(1842), 2: tab. CII, 1; Monumenti del Museo
Etrusco … (1842), 1, tab. XCV, 1; Dennis 1848,
429; Körte 1890, tab. XLII, 4; Nogara 1933, 29;
Toscanelli 1933–34, 2:571, fig. 53; G. Cressedi
in EAA III (1960), see "Enomao," 345, fig. 419;
S. De Marinis in EAA IV (1961), see "Lasa,"
488–89, fig. 573; Dohrn 1961, 1–8, tab. 1:1–3:1;
Helbig 1963, 555–56, no. 740; Bianchi
Bandinelli 1965, 449, tab. 109, 3; Herbig 1965,
tab. 28,2; Banti 1969, tab. 91; Pairault 1972,
169, note 2, tab. 9; Nielsen 1975, 291, n. 2, 295,
298, n. 3; Coarelli 1977, 39, 179, figs. 7–8;
Pairault 1977, 157–59; Pairault 1978, 224;
Pairault 1979, 160, fig. III, 24; Bianchi
Bandinelli 1980, 61, fig. 25; M. J. Strazzulla in
Todi 1982, 184, VI.2.1; A. Maggiani in
Volterra-Chiusi 1985, 36, 43; Nielsen 1988, 72;
F. Buranelli in Vaticano 1988, 66–68, no. 3.3;
F. Buranelli in Budapest-Kraków 1989, 159–60;
Maggiani 1989, 995–1000; Bergamini 1991a,
369–74; Bergamini 1991b, 133–62; Nielsen
1992, 91, 128, no. 26; Pietrangeli 1993, 36–38;
Sannibale 1994, 30–35, no. 2.

The burial urn from the Gregorian Etruscan
Museum was found in 1516 in Todi, not far
from the Basilica of S. Fortunato. It was
transferred to the Palazzo dei Priori in 1645
and subsequently donated to Pope Clement
XIV in 1772, thus entering the Vatican
collection.[1] It is possible that the urn was
taken to the place of its discovery following
other moves during the medieval period.
The conjecture of its having been reused as a
reliquary, which has been suggested, would
explain the worn appearance of all the parts
that project from the surface, typical of objects
displayed before the faithful.[2]

The lid of this cinerary urn is reconstructed
from seven fragments. There is some chipping
and there are some parts missing. The most
notable loss is that in the male figure, lacking
the upper part of the torso and the head and
bearing signs of having been polished in the
post-classical period. A similar intervention
can be noted on the female figure at the point
where the right hand, now missing, would
come to rest on the knee. The surface is worn
along the left hand, the crown, and on the
cushion belonging to the male figure. Behind
the casket itself, a large hole was drilled at
some unspecified time. There are numerous
chips and abrasions, with signs of wear on all
parts that project outward. On the upper part
of the relief, the head and one of the hooves
of the horse next to the female spirit are also
missing. It is likely that the casket as well as the
lid were subject to polishing in the modern era.

The sculpture in the round on the lid
portrays a couple banqueting. The male figure
on the right, partly covered by a cloak that falls
from his left shoulder, is wearing a long wreath
that reaches down to the cushion. With his left
arm, he is leaning on a double cushion with a
tassel, his hand holding a *kantharos* (a ribbed
chalice). His right hand rests on the shoulder
of his companion, who turns to look at her
husband with a twisting movement of the
head. She is wearing a heavily creased tunic,
belted beneath the breast, and a cloak that
covers part of her upper body, shoulders, and
legs. The edge of the cloak, located at the
shoulder, is clutched in her left hand. Her left
elbow rests on a pair of cushions similar to the
others, whereas the right arm, now missing,
would have been extended alongside her body.
Her hairstyle, characterized by ample flowing
locks, is adorned by a crown. Around it there
are four small holes visible, perhaps originally
to secure an ornament in precious metal.
Around her neck she wears a *torques*
(necklace). The lid, which is slightly inclined
in the direction of the feet, realistically
portrays the hem of the cloth and the covers
of the banqueting couch as the latter flow to
the edge of the surface.

The casket is tapered in shape and carved
on three sides. On it, the bas-relief represents
the killing of Enomao at the hands of Pelope.
Enomao, lord of Pisa in the Greek region of
Elide, challenged any pretender to his
daughter's hand to a chariot race from Pisa to
the Isthmus of Corinth. During the race he
would catch up with and kill the pretenders by
running them through with his lance. Only
Pelope succeeded at last in winning, employing
horses given to him by Poseidon. In another
version of the tale, Pelope succeeds in
corrupting Mirtilo, Enomao's charioteer, who
sabotages one of the wheels of his sovereign's
chariot.

Into the heat of the battle, rendered in an
extremely animated composition spread out
over several levels, a winged female demon
intervenes high in the center of the scene.
She is clad in a short tunic and footwear and is
portrayed with her right arm bent in the act
of striking a blow. Beneath her is a bearded
male figure (Enomao) kneeling on the ground,
wearing the *lorica* (cuirass) and chlamys,
raising his arm as if to fend off the blow about
to be inflicted on him by the youth on the left.
The latter (Pelope) wears a short belted tunic,
chlamys, and Phrygian cap. On the left edge is
a female figure in flight (Ippodamia) dressed
in a long belted tunic that leaves her right leg
exposed, with a *torques* at her neck and
wearing a crown. She holds in her hands a
mantle or cloak that billows behind her head
and shoulders in the swirl of activity. To the
right, entangled in the collapse of four horses,
is a group of three figures: a woman wearing a
short belted tunic, mantle, and footwear and
two men dressed in belted tunics and fluttering
chlamys.

On the left side of the casket is a winged
female demon wearing a tunic and footwear.
Her raised left arm supports a billowing
mantle; her right arm, lowered, probably
originally held an overturned torch. On the
right side of the casket is a similar spirit, her
hair drawn back in a bun, moving off to the
left with her hands over her abdomen.

The lid with its representation of a married
couple is typical of a tradition in Etruria going
back to archaic times. In general terms, the
work can be associated with what was produced
in Volterra beginning in the last quarter of the
third century B.C., whereas, from a purely
stylistic point of view, owing chiefly to the tone
of pathos that can be sensed in some of the
faces, it brings to mind exemplars from the
first quarter of the second century B.C.[3]

The casket marks a departure in style,
composition, and iconography from other
reliefs of this sort.[4] The burial urn has been
attributed to the Master of Oinomaos,[5] a
conventional figure associated with the area

22

around Volterra, on the basis of similarities with two burial urns from that area.[6] In the case of the latter two, the compositional plan called for a central axis around which are two tightly knit groups, with intersections on oblique levels. The tone of pathos in the expressions, the greater stress on anatomical detail, and the contortion of the bodies strongly suggest the cultural climate of the first two decades of the second century B.C.[7] On the basis of all these common characteristics, the Master of Oinomaos has been recognized as the initiator of the "baroque style" among Etruscan urn reliefs. Another exponent of this school would be the Master of Myrtolos.[8] But the Master of Oinomaos was almost certainly aware of what was being produced in Chiusi, and he in turn influenced what was going on in Perugia. We can draw this conclusion from a study of urn 1275 in the Berlin Museum, with which it has several points in common.[9]

Maurizio Sannibale

1. Bergamini 1991b.
2. Bergamini 1991a, 370.
3. Sannibale 1994, 33–34.
4. Körte 1890, 109–21, tables V: 1, XLI–XLVIII.
5. Maggiani 1989, 995–1000.
6. See Volterra-Chiusi 1985, 42–43, n. 12; CUE 2, no. 11, n. 233.
7. Dohrn 1961; Coarelli 1977, 39, fig. 7–8; Pairault 1979, 160.
8. Maggiani 1989, 997–98.
9. Körte 1890, 121–22, tab. XLVIII: 16; Sannibale 1994, 34–36, fig. 7:2.

Etruscan
ANTEFIX, c. 2nd century B.C.
Terra-cotta
47.5 x 29.3 cm (18¾ x 11⅛ in.)
Vatican Museums, inv. 14119

Literature: Seroux d'Agincourt 1814, 28, tab. XII:III; Andrén 1940, 510, no. III:4, tab. 159:544.

The provenance of this antefix (upright ornament on a tiled roof) is unknown, though it had been part of the Agincourt Collection. It is made of a very pale brown clay mixture[1] containing particles of silica. The piece is broken at the base of the neck, has gaps at the top of the left wing, and is chipped at the bottom and along the edges of the right wing. It still has a part of the tile and handle attached to the back. A hole has been made on the top of the head. Traces of red background are evident on the head and drapery as well as remains of a layer of preparation for painting color on the rest of the sculpture.

On the front of the antefix, a female figure with outspread wings is represented in relief, holding a kithara in her left hand. She is leaning against a pillar. Drapery hangs down from the pillar, passes behind the nude figure, and wraps around her right thigh and leg. She is shown from the front, standing with her right leg slightly bent in front and her right arm hanging down along her side. Her head is slightly tilted and is framed with long, wavy locks of hair, parted in the middle and crowned with a diadem.

Similar examples of this type of antefix are not known. Two specimens of female winged figures exist from Luni, but they are clothed in drapery. One is intent upon playing a flute with two pipes.[2] The other is leaning against a pillar as in the Vatican antefix.[3] However, the winged female figure, in a standing position and semi-draped, can be found on many of the urns made in Volterra. The strong influence of prototypes from Rhodes can often be recognized on the relief of these urns.[4]

From a strictly iconographic point of view, the figure can be compared with caution to representations of muses found in Etruscan territory. However, they can only be documented by engraved mirrors (see cat. 16) and small votive statues representing a semi-draped seated female figure, intent upon playing a kithara and, above all, without wings.[5]

Maurizio Sannibale

1. Munsell, 10 YR 7/4.
2. Andrén 1940, 294, no. 6, tab. 97:349; Forte 1991, 88, no. 17; Forte 1992, 217, no. 17, type A2.
3. Andrén 1940, 295, no. 7, tab. 97:351; Forte 1991, 90, no. 18; Forte 1992, 218, no. 18, type A3.
4. Sannibale 1994, 48050 and corresponding notes with bibliography.
5. M. Bonamici in LIMC, under entry "Mousa, Mousai (in Etruria)," nos. 3–4.

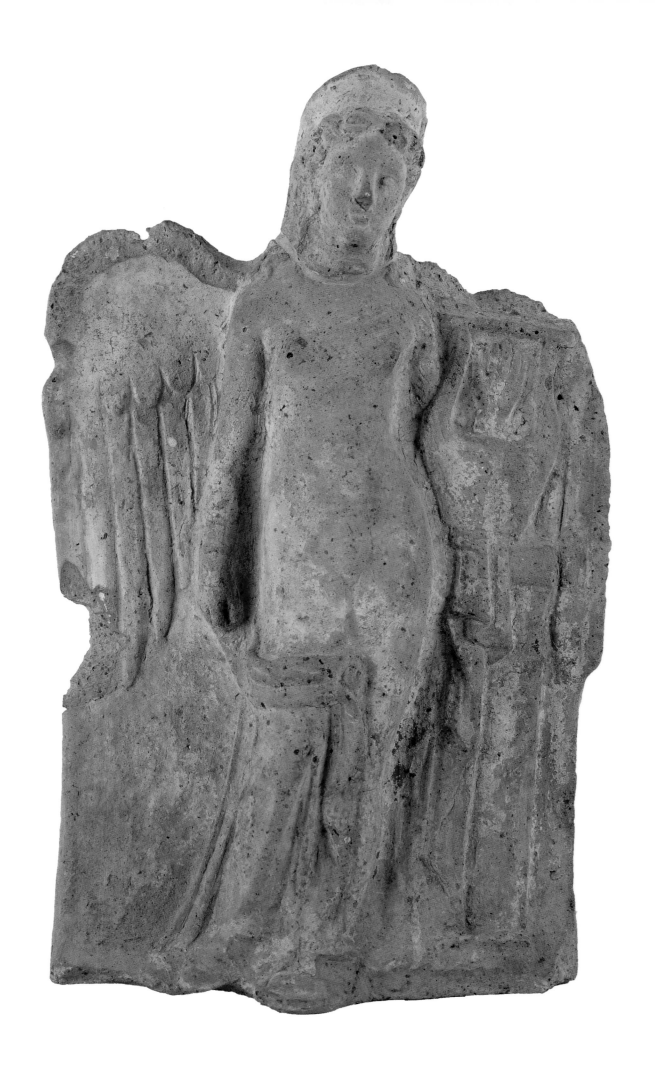

23

Roman
PEDIMENT FROM THE TOMB OF CLAUDIA SEMNE
1st century A.D.
White marble
63 x 102.5 x 20 cm (24¾ x 40⅛ x 7⅞ in.)
Vatican Museums, inv. 10528

Exhibitions: Rome, Palazzo Ruspoli-
Fondazione Memmo, *Via Appia: sulle ruine
della magnificentia antica*, 1997.

Literature: H. Wrede, *Das Mausoleum der
Claudia Semne und die bürgerliche Plastik der
Kaiserzeit*, RM 78, (1971):125–66, 127–28,
no. 3, tab. 77; H. Wrede, *Consecratio in formam
deorum* (Mainz, 1981), 83; Sinn 1991, 41–42,
no. 16, tabs. 43–45; S. B. Matheson, *I Claudia,
Women in Ancient Rome* (exh. cat. New Haven,
1966), 182, 188–89; I. Bignamini, "I marmi
Fagan in Vaticano. La vendita del 1804 e altre
acquisizioni," *Bollettino dei Monumenti Musei
e Gallerie Pontificie* 16 (1996), 363, no. 21;
P. Liverani, *Via Appia: sulle ruine della
magnificentia antica* (exh. cat. Rome, 1997), 43;
I. Bignamini and A. Claridge, *Papers of the
British School in Rome*, in press.

This small pediment was found on the Appian
Way, just outside Rome, during the excavations
carried out by the English painter Robert
Fagan in 1792–93. It was in a tomb that may be
dated A.D. 120–30. The inscriptions found
inside (CIL VI 15593-15594) indicate that the
tomb was built by Marcus Ulpius Crotonensis,
a freedman of Emperor Hadrian, in memory of
his wife, Claudia Semne.

In the center of the small pediment is the
bust representing a portrait of the deceased;
other portraits of her that were a part of the
same tomb are also preserved. The deceased
woman has an elaborate hairstyle typical of
the beginning of the Hadrian age. She is
portrayed wearing the garment of Venus, the
goddess of beauty and love. This is evident
from the specific iconographical detail of her
robe falling off her shoulder and from the
presence of two cupids, one on each side. From
the inscription on the sepulcher, we know that
the husband ordered that his deceased wife be
depicted not only as Venus, but also as the
divine personifications of Spes (Hope) and
Fortune. This represents a private deification, a
widespread phenomenon in the funeral sector
of this period. In this manner, the wife's
qualities of beauty, grace, chastity, and
faithfulness, so often cited in Roman funeral
inscriptions, are depicted plastically by
identifying her with Venus. In the same way,
the other identifications were to indicate that
even though his wife was dead, she continued
to embody the hope of her husband, who was
still alive, and to guarantee him prosperity and
good luck.
Paolo Liverani

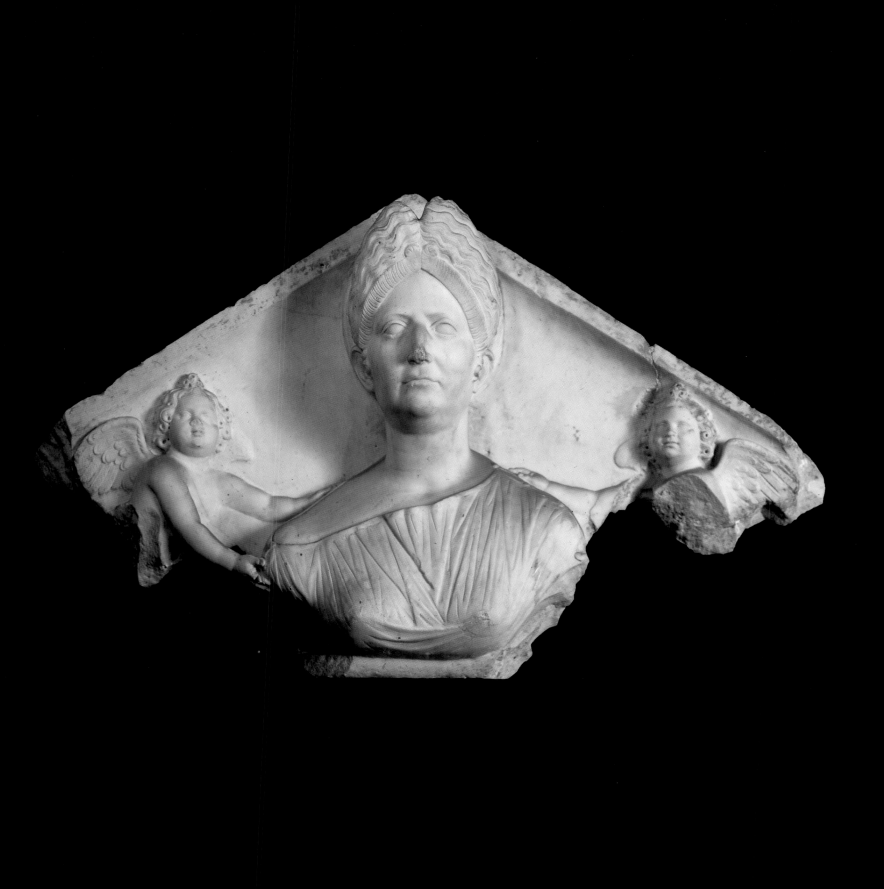

24

Roman
CREMATORY URN OF TITUS FLAVIUS CLODIANUS
WITH WINGED VICTORIES, A.D.150–60
White marble, lightly gray-veined
Urn, height 39.5 x diameter 40.8 cm (15½ x
16⅛ in.); lid, 12.2 x 40.9 cm (4¾ x 16⅛ in.)
Vatican Museums, inv. 5366

Literature: L.Paschetto, *Ostia Colonia Romana.
Storia e Monumenti* (Rome, 1912), 529, n. 291;
F. Sinn, *Stadtromische Marmorurnen* (Mainz,
1987), 243, n. 626, pl. 91d; Sinn 1991, 100–01,
n. 82, pls. 205, 209–10.

This burial urn now in the Gregorian Profane Museum was found in a tomb near S. Ercolano, not far from Ostia, during the excavations carried out by Cartoni in 1824. The small marble container held the burnt remains of Titus Flavius Clodianus, who, as is known from the dedication of a son of almost identical name, was a member of the *haruspices* (diviners of the entrails of sacrificial animals). Indeed, he was *Magistro Primario de LX*, no less than president of the privileged Order of Sixty.

The surface of the cylindrical urn is largely taken up with *S*-shaped decorative motifs. On the front are two winged victories who, precisely mirroring one another's position, bear the frame containing the inscription. The goddesses are wearing the long Roman *peplum*, belted at the waist, flowing down and clinging to the thighs in broad pleats. Their hairstyle is a reprise of what was in vogue under the Antonine emperors (A.D. 138–92), the so-called *Melonenfrisur* (melon-shaped coiffure), which called for numerous parallel partings running from the forehead to the nape, with the hair gathered into a chignon.

Under the framed inscription and between the feet of the winged goddesses, there is a wreath encircled by two large fluttering *teniae* (ribbons). The urn's cone-shaped lid is topped with a handle and decorated with a series of tapering leaves that are alternately smooth or with a central midrib.

The iconography of the piece is common enough in the funerary sphere and no doubt refers to the actual procession that accompanied a deceased person of a certain station to his tomb. Close relatives and family members would hold aloft images, decorated with wreaths and garlands, of the deceased. Inscribed on placards would be his *cursus honorum* (personal data as well as the sequence of positions he occupied).

In like manner, the winged victories would conduct the deceased into the hereafter, bearing the inscription with his name and principal office (*Magister Primarius Haruspicum*), thus guaranteeing him his identity for all time. The winged victory, as is the case for many other divinities and winged personifications, often discharged the role of mediator between the here and the hereafter. Thus ordained, she may be seen in moments of triumph crowning the winners, occasionally appearing in the guise of a charioteer.[1]
Giandomenico Spinola

1. See T. Holscher, *Victoria Romana* (Mainz, 1967), 68–97, pls. 6–10.

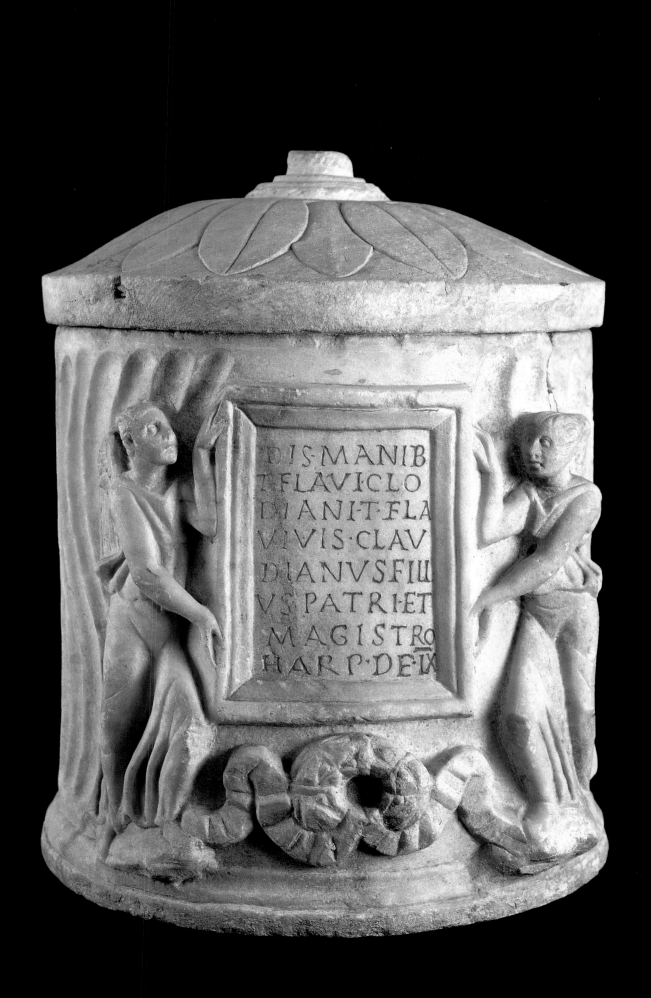

DIS·MANIB
T·FLAVI·CLO
DIANI·T·FLA
VIVS·CLAV
DIANVS·FILI
VS·PATRI·ET
MAGISTRO
HARP·DE·IX

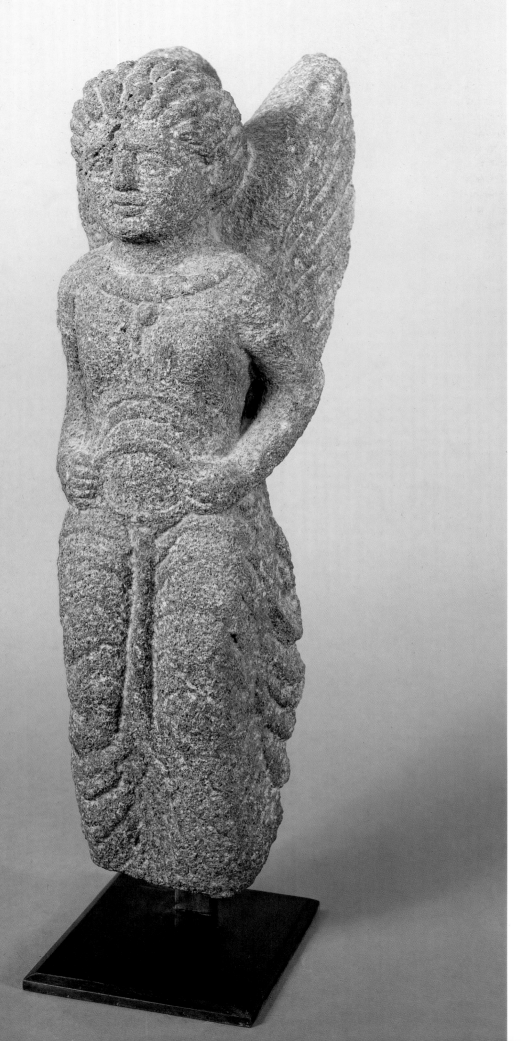

25

Roman
STATUE OF A NIKE HOLDING A WREATH
1st half 4th century A.D.(?)
Basalt
57.5 x 18 x 27 cm (22⅝ x 7⅛ x 10⅝ in.)
Vatican Museums, inv. 53374

This statue comes from the region of Hauran in southern Syria and arrived at the Vatican in 1993, a gift to the Holy Father from Nabih Berry, the president of Lebanon's National Assembly.

The winged female figure is dressed in a close-fitting tunic that covers most of her body, flowing slightly when it reaches the legs. Broad pleats or folds cover the belly and thighs with evident ribbing in the vicinity of the latter. Halfway down the arms are two raised, circular sectors that would suggest armlets or bangles, or perhaps the cuff on the sleeve. What is certainly depicted is an ornament, more precisely a necklace with a decorative central element slightly above the chest. The goddess' legs are slightly flexed, echoing the position of the arms, which are also folded somewhat in the act of holding a small wreath against the belly. The wings, in which there is a clear distinction between feathers and secondary quills, are folded back and held in an upward position. The roundish face is characterized by a certain fixity of expression determined by the large eyes (the corners of which are turned downward), the full but tightly-closed mouth, and the broad and rather flat nose. All the facial features have been rendered summarily and with a certain stiffness. The back of the statue is only partially carved, not finished, with a long, deep cavity between the wings. The drapery tends to vanish gradually into the stone.

If the style is marked by an evident stylization and stereometry common to many late Roman and Byzantine-influenced artistic expressions, the hairstyle (with marked ribbing, recalling the so-called *Nestfrisur*) brings us back to the Severian period (A.D. 193–211) or at least to a successive revival of the same. These apparently contradictory traits actually can be found together in several portraits dating from the time of Constantine or shortly after.[1] Consequently, it is precisely to that period that one may assign this work.

In the donation schedule compiled by Michel Karawani, the winged figure is considered an angel and is dated between A.D. 300–50. In effect, Hauran is a region that was Christianized in the very earliest period; moreover the motif of a hand-held wreath at the level of the waist or breast is not unknown in early Christian art. It can be noted, for example, in the attitude of the apostles on a sarcophagus, containing also a Resurrection scene, kept at the Vatican in the Pio Christian Museum (fig. 1).[2] A curious contemporary variation on the theme is constituted by the sheep in a flock of the faithful who carry the wreath in their mouths.[3]

In any case, the allegorical implication is the same: victory over death, with the promise of a life in the hereafter. However, in the present sculpture one should bear in mind a series of elements, above all the hairstyle and the ornaments, that would tend to secularize the female winged figure. Beyond that, it would be well to remember the long and felicitous tradition of depicting the victory-nike personage in the region of Hauran ("Auranidite" in the Old World), especially in the funerary sphere.[4] If the style assumed and the material employed compare favorably with other works from this same region such as the bust of Nike in the Suweida Museum,[5] one can conclude that the present work too was inspired by well-known, if much earlier, models provided by classical Greek art. These usually depicted the winged goddess not only in flight, but also exposed to a rising current of air owing to her downward movement (compare with the Nike of Paionios, that of Samothrace, and others).

Much of this is visible in the present work. The wings are folded back behind the shoulders. The drapery is seen clinging to the chest, hips, and thighs; and yet, as one may deduce from what remains of the back, it is left to flutter in the area of the legs. The basaltic region of Hauran has always produced a particular form of popular art, at once harking back to remote classical art while also permeated by a wide range of oriental influences such as Palmyrian art. And it is precisely in the latter art where there are points of convergence with the Nike of Hauran.

An example is to be found in a ceiling with recessed panels in the temple of Baal: there, a winged spirit is seen to have the same wide-pleated drapery covering the thighs.[6] In another example, that of a funerary relief, a woman boasts the same coiffure, a reprise of a style in fashion in the Severian period, and a similar necklace with *bulla*.[7] Stylistic affinities may also be noted in several sculptures of Dura Europos, such as the personage with a lamb and garland (or crown?) between the hands.[8] The "Byzantine" tendency toward abstraction, fixity of expression, and general solemnity will become more marked, so that it will be possible to note stylistic similarities between the present winged figure and, for example (toward the middle of the sixth century), the female personages who people the mosaic in the Hall of Hippolyte at Madaba.[9]

It would seem more apt, then, to identify this piece as a Nike-Victory. Moreover, the transformation of the classic nike figure into the angel of Christendom is something that can already be traced to a period slightly successive to ours. It is initially hinted at during the reign of Theodesius (A.D. 379–95) with a nike supporting the Cross, then in the case of the nike-angel on the sarcophagus of Sarigüzel (now housed in Istanbul's Archeological Museum) as well as in the figures visible on the door of S. Ambrogio in Milan. The tendency comes full circle with the mintage carried out under Justinus I (A.D. 518–27).

That this nike-victory statuette almost certainly has a funerary significance is supported by the wreath between the hands, surely a reference (as so often the case in mortuary settings) to victory over death. The winged goddess is decorated and coiffed in the manner of a elegant Syrian woman, probably during the age of Constantine. The clinging folds in front (looser in the back) suggest that the work had a possible function as a figure for a pedestal or some other decorative architectural detail, perhaps on a tomb. This figure, an expression of popular art but no less trenchant or eloquent for that, conveys a certain elegance combined with a relative attention to detail even if expressed in the rough porosity of Syrian basalt.

Giandomenico Spinola

1. See A. Carignani, *Bollettino di Archeologia* 5–6 (1990):189–91, figs. 36–38.
2. See Deichmann 1967, nos. 59 and 208, pl. 19.
3. Pio Christian Museum, inv. 31557; Deichmann 1967, n. 138, pl. 32.
4. E. Will, "La Syrie Romaine entre l'Occident Gréco-Romain et l'Orient Parthe," in *Actes du VIIIe Congrès International d'Archéologie Classique* (Paris, 1965), 515; J.-M. Denteer, *Hauran I. Recherches Archéologiques sur la Syrie du Sud a l'époque Hellénistique et Romaine* (Paris, 1985), 341–42.
5. Denteer 1985, 341.
6. K. Tanabe, ed., *Sculptures of Palmyra* (Tokyo, 1986), 16.
7. M. A. R. Colledge, *The Art of Palmyra* (London, 1976), 144, fig. 93.
8. S. B. Downey, *The Stone and Plaster Sculpture. The Excavations at Dura-Europos* (Los Angeles, 1977), 95, n. 82, table XXII, 82.
9. M. Piccirillo, *Madaba. Le Chiese e i Mosaici* (Turin, 1990), 50–66.

Fig. 1. *Sarcophagus.* Vatican Museums, inv. 31529

26

Roman
FRAGMENT OF A PILASTER WITH CUPIDS
HARVESTING GRAPES
1st half 3rd century A.D.
Brown-veined white marble
54.5 x 38 x 5 cm (21½ x 15 x 2 in.)
Vatican Museums, inv. 10431

Literature: Benndorf and Schöne 1867, 57,
n. 84; F. Longobardo, "Su un Rilievo con Eroti
Vendemmianti nel Museo Gregoriano
Profano," in *Bolletino dei Monumenti, Musei e
Gallerie Pontificie* 16 (1996):113–25.

Fig. 1. *Sarcophagus.* Vatican Museums,
inv. 31554

This bas-relief shows two cupids harvesting grapes. The one on the left, turned partially and completely nude, reaches for the grapes with both hands. The one on the right, facing us and dressed only in the Roman chlamys, has just plucked a bunch of plump grapes and is about to deposit them in the basket perched on his left shoulder. Flowing hair, gathered in a knot above the foreheads, serves to frame countenances at once absorbed and dreamy. Only in the treatment of the faces themselves does the sculpted surface attain a certain softness; both the bodies and the vegetal elements surrounding them seem the product of vigorous stone carving. For all that, the slender bodies convey a sense of sinuous grace owing to the marked shift of weight onto the load-bearing leg and the consequent relaxation of the other. Beneath the vines and between the legs of the cupid on the left, a snake can be seen eating some of the grapes that have fallen during the harvest. Farther down are a series of oblique fluting and ribbing strokes; above the scene, vines intertwine and almost form a knot in the area between the heads of the two figures.

The surface of the relief is slightly convex, and the subordinate cross hatching points to the intention of the artist to cover the walling of a pilaster with vine-like and spiral decorations and with strips, such as this one, that actually depict stories. Such a technique is similar to that of the *columnae coclidae*,[1] wherein whole historical episodes are related in stone. The ornamental composition of vine shoots and branches along the upper margin of the piece, almost in the shape of a bow, points to the possibility that this strip decorated the upper part of a pilaster, just beneath the capital.

Stylistically, the work could be placed in the first half of the third century and might well be the product of a Greek-Oriental workshop. For that matter, the very same fine-grained marble of which it was made (*marmor phrygium,* so-called "Pavonazzetto") is quarried at Dokimion in Asia Minor. A rather similar piece of facing, housed in Rome's Museo dei Conservatori and originally found with its matching capitals in the area of Porta Maggiore in Rome, has been linked to the decoration of the so-called "Temple of Minerva Medica." Since that construction dates from about A.D. 300, it has been assumed that all the marble facings were reemployed from an earlier construction.[2]

The harvesting cupids will live on in early Christian art as can be seen, for example, in a splendid sarcophagus from the second half of the fourth century at the Vatican in the Pio Christian Museum (fig. 1).[3] There, the cupids are associated with the Good Shepherd and otherwise intent in rustic occupation. The Dionysian theme, implied in this particular facing, will be picked up again (if modified) in the Christian repertory, and the transformation of grapes into wine, by then a clear allusion to the afterlife, will assume a connotation exquisitely paradisiacal.
Giandomenico Spinola

1. Longobardo 1996.
2. See M. Cima, *Restauri nei Musei Capitolini* (Venice, 1995), 53–69; Longobardo 1996.
3. Deichmann 1967, 26–27, n. 29, pl. 10.

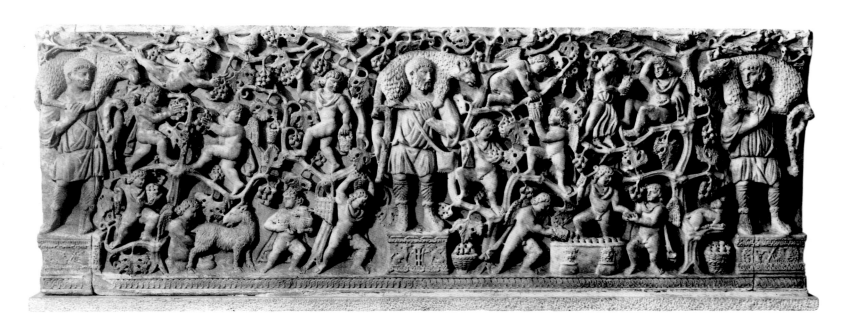

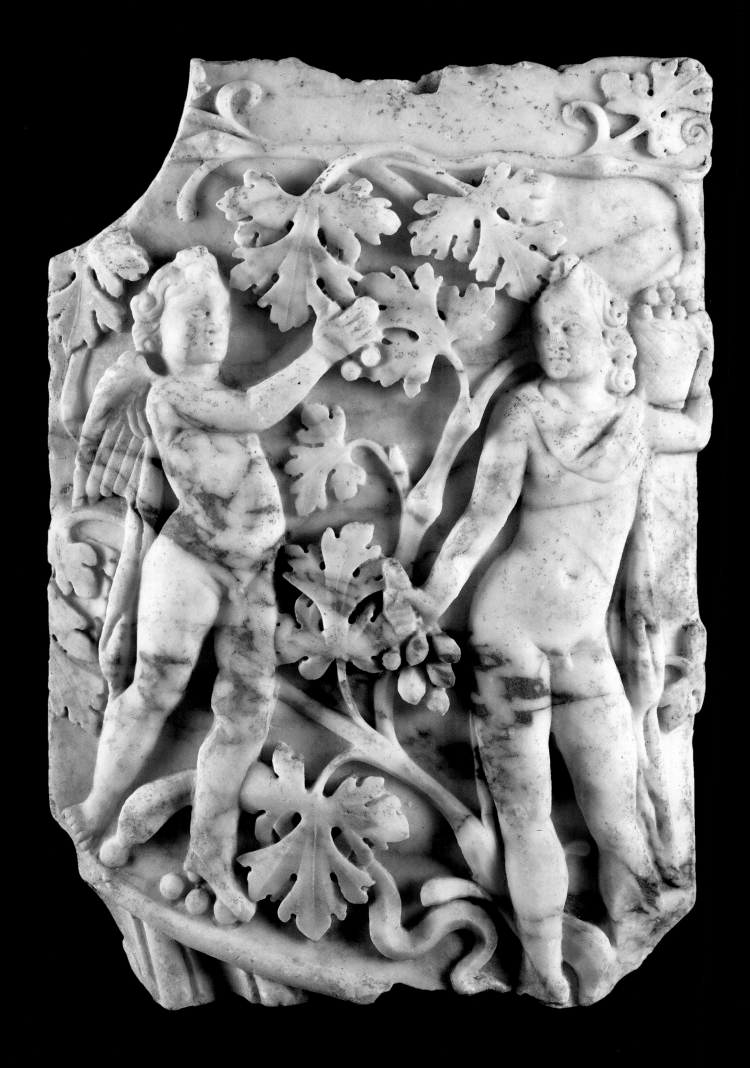

27

Roman
FRAGMENT OF A SARCOPHAGUS LID WITH CUPIDS
SEATED IN A BOAT, A.D. 260–80
White marble
32.7 x 58 x 3.2 cm (12⅞ x 22⅞ x 1¼ in.)
Vatican Museums, inv. 10393

Literature: Benndorf and Schöne 1867, 329, n. 465.

The fragment in question, now in the Gregorian Profane Museum, was part of the curved section of the lid of a sarcophagus. On the right margin of the bas-relief is a lighthouse carved in small size so as to appear distant. It is composed of a tall base, four levels with windows, and a huge flame at its summit. The rest of the visual field is occupied by two winged cupids in a small vessel. At the center of the boat is a mast with its sails folded down. The prow, where one cupid has been rowing, is headed toward the lighthouse, whereas the stern, with the other cupid managing the rudder, faces open sea. From this, one may deduce that the boat is entering the harbor. The distance already covered is indicated with a gesture of the hand of the cupid in the prow; his companion is turned in that direction as if to verify the fact. Such "maritime scenes" are often composed of more elaborate portrayals with numerous boats and cupids engaged in various aspects of fishing.

The style is hasty, the surface relief not particularly pronounced. Facial features and details of hair styling are rendered with rapid and deep incisions of the sculptor's drill. For all that, the scene is clear enough and well expressed, conveying the usual marine tasks with acumen and a genuine spirit of observation. These traits of style and iconography permit one to date the piece between the years 260 and 280 A.D.

Undoubtedly, the implied allegory was completed in the successive scene, unfortunately missing, but one may intuit the journey as being symbolic of life itself. It is no coincidence that, in that same period (A.D. 258) and in a Christian context, the then-bishop of Carthage (and later saint) Cyprian likened the death of a believer to "sailing home."[1] He called it "a journey back home and a safe docking in Paradise." The lighthouse illuminates the awaited berth; the waves are no longer agitated; the sails, no more exposed to the battering winds of the open sea, have been furled. Just a few more pulls on the oars, a serene glance backward toward the distance covered, and the journey is done.

The childish version of such a voyage, with little winged cupids and the fact that such importance is given to the arrival in port, all point to the death of a child, something indeed which might have happened after a brief "navigation."

Giandomenico Spinola

1. *De Mortalitate*, 26.

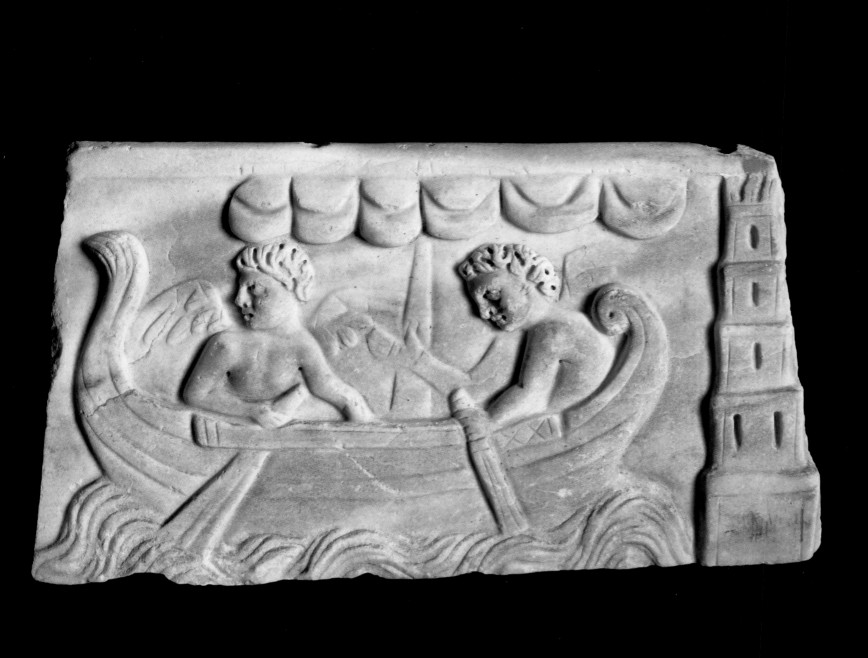

28

Roman

FRAGMENT OF A SARCOPHAGUS WITH CUPIDS AS
MUSICIANS, A.D. 270–80
White marble
36 x 54 x 5.5 cm (14⅛ x 21¼ x 2⅛ in.)
Vatican Museums, inv. 1759

Literature: W. Amelung, *Die Sculpturen des
Vaticanischen Museums,* vol. 1 (Berlin,
1903):603, n. 446, pl. 62; *Bildkatalog der
Skulpturen des Vatikanischen Museums,*vol. 1,
Museo Chiaramonti, 3 (Berlin-New York,
1995):87, figs. 899, 446.

This relief fragment in fine-grained white
marble is either the left part of the front of a
sarcophagus or else part of a slab used to close
an urn niche. The relief was acquired in 1803
by Ferdinando Lisandroni and Antonio D'Este.
Beneath a molding embellished by an Ionic
kyma (a common motif calling for the
alternation of lancets and ovoli) is the visual
field, of which all that remain are two cupids
playing musical instruments and a third one,
possibly wingless but with rustic attributes.
On the right margin of the fragment is the
edge, though no more, of a fourth cupid's wing.
Moving back onto the surface, a cupid is intent
on playing a lyre. The instrument is composed
of an antelope's horn with a horizontal clamp
to which the strings are affixed. The latter are
made to resonate by using the plectrum,
formed of a thin plate of bone or else tortoise
shell, which the cupid can be seen moving with
his right hand. Next to him is a cupid playing a
tybicen (a sort of flute), which he holds in his
hands. Concluding the scene is one more cupid,
posed frontally and at ease, holding in one
hand the *pedum* (shepherd's crook) and in the
other the skin of an animal. All of the cupids
are dressed merely with the chlamys, a long
cloak secured at the neck and left to trail
behind the shoulders. Below, between the feet
of the flautist, is a mask of Pan, whereas next
to the last cupid on the left there is a panther
with his head inclined upward.

The relief is rather flat, and the corporeal
mass of the cupids is neither particularly
distinct nor enriched by anatomical details.
Nevertheless, the bodies move within their
space with ease and a certain grace, suggesting
the repetition of an iconographic model
already well known and applied without
uncertainty. The holes that characterize the
corners of the mouths, the tear ducts in the
eyes, and the drill work visible in the hair
combine to animate the relief, offering
welcome if summarily executed effects of
contrast. The style that emerges is in keeping
with the production of workshops active in
the decade around A.D. 270–80.

The theme is certainly that of a Dionysian
thiasos, the festive procession in honor of the
Greco-Oriental god of wine and inebriation.
The cupid/musicians, in fact, are straight out
of a familiar bucolic context: the mask at the
feet of the flautist, with its horn, whiskers, and
animal features, is a theatrical invocation of
the god Pan; the wingless cupid, with *pedum*
and skin of a wild animal, perhaps a goat, has
the attributes of the sylvan deities; the little
panther looking up to the latter personage is a
clear reference to Dionysus, so often associated
with the feline.

Clearly, such allusions to rustic deities
spring from the desire to create a mirthful
childlike vision that is yet a summoning of
the Dionysian world. Upon the latter's
transformation of grapes into wine is based
the whole allegory of the human cycle,
man's passage from the earthly realm to the
hereafter. The motif of cupid as musician
will be absorbed in successive iconographic
repertories, eventually transforming itself
(for example) into the angelic musicians of
Melozzo da Forlì (frescoes originally painted
in the apse of the Roman church of the SS.
Apostoli and now in the Vatican's Picture
Gallery). But that must be considered an
iconographic "loan," inasmuch as the allegory
by then had been profoundly transformed.
Giandomenico Spinola

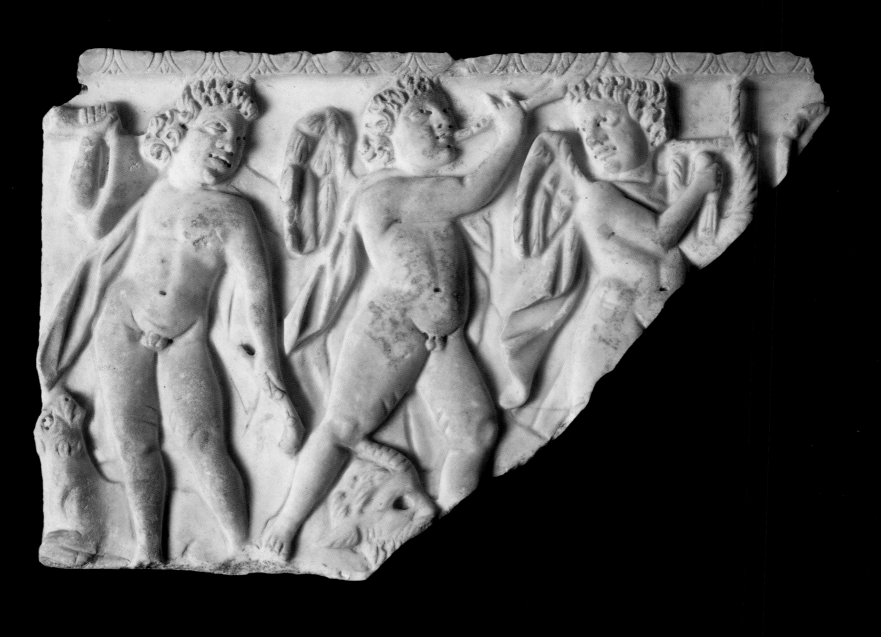

29

Roman
FRAGMENT OF A SARCOPHAGUS LID WITH CUPIDS
ABOARD CHARIOTS, A.D. 270–80
White marble
29.5 x 75 x 7 cm (11⅝ x 29½ x 2¾ in.)
Vatican Museums, inv. 4946

Literature: K. Schauenburg, *Die Antiken Sarkophagreliefs*, vol. 2, *Die Stadtromischen Eroten-Sarkophage*, 3, *Zirkusrennen und Verwandte Darstellungen* (Berlin, 1995): 28 and 95–96, n. 143, pl. 51,2.

The scene, as visualized through the eyes of a child, offers a playful version of a chariot race at the circus. On the left is a two-wheeled coach being drawn by two small horses. A cupid, leaning forward over the railing, urges them on with a whip. Following closely is a second chariot, this one pulled by two panthers. The driver/cupid, this one more concentrated than the first, has just cracked his whip, and with his other (left) hand grips the reins. Below, there are two other small cupids, evidently fallen from their vehicles and even now being trampled. At the left margin of the fragment one can just make out the molding that probably framed the funerary inscription.

The soft treatment of the surface contrasts with the extensive use of hand drills in rendering hair, manes, and fur. The eyes, too, are deep-set, with profound holes for the tear ducts and pupils, both of which are conspicuous immediately below the eyelids. This is an apt technique for imparting a dreamy, abstract look to the cupids and to the animals as well. Stylistically, the work recalls craftsmanship current in the period immediately following the time of Emperor Gallienus (d. A.D. 268).

The scene, as dramatic as it was frequent at the circus, is here reworked in a comic key. In fact, the charioteers are chubby and smiling winged cupids; the animals, even though depicted in the heat of the race with convincing dynamism, are as unreal as they are out of proportion. The horses are too small and the panthers wholly out of place in such a sporting context, though they would do well in any depiction of the Dionysian festivals. The competition thus becomes an ironic, even bitter allegory when applied to what is almost certainly the sarcophagus of a small boy. On the one hand, the scene recalls the overriding, almost obsessive passion of adult Romans for the circus races; on the other, the young cupids who are trampled call to mind the painful premature deaths that do occur in life's headlong course.
Giandomenico Spinola

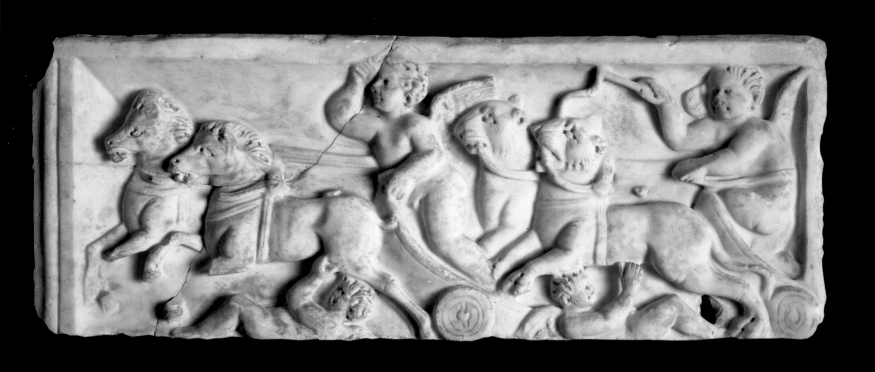

30

Roman
SARCOPHAGUS OF A YOUNG GIRL WITH CUPIDS AND
SPIRITS OF THE SEASONS, A.D. 270–80
White marble
Coffin, 42 x 147.5 x 48 cm (16½ x 58 x
18⅞ in.); lid, 10 x 148.5 x 45 cm (4 x 58½ x
17⅞ in.)
Vatican Museums, inv. 31406

Conservation courtesy of Kathleen Waters in
memory of Irving Waters

Literature: Marucchi 1910, 10–11, pl. 4,4;
G. M. A. Hanfmann, *The Season Sarcophagus
in Dumbarton Oaks* 2, *Dumbarton Oaks Studies*
2 (1951): n. 532; P. Kranz, *Die Antiken
Sarkophagreliefs* 5, no. 4, *Jahreszeiten-
Sarkophage* (Berlin, 1984):57 and 210, n. 93,
pl. 48,5.

This sarcophagus was found in the Pretestato catacombs along the Appian Way and brought to the Lateran Christian Museum in 1931. At the center of the coffin, on a small molded base, is the bust of the deceased, though its features cannot be said to be well defined. Often the physiognomy of such busts was barely sketched out, so that at the moment of sale the real features of the person for whom it was destined could be added. Not infrequently, given the often unforeseeable and tragic nature of such events, there wasn't time to carry out this last phase of sculpting. On each side of the bust is a cupid holding with one hand the *parapetasma* (curtain), which serves as a backdrop for the bust, and with the other the *pedum* (typical shepherd's crook).

The ends of the sarcophagus are occupied by four winged spirits representing the seasons. The first on the left holds in both hands a wild hare, while a dog attempts to snatch it away. The second holds a basket of apples and a branch; the third holds another basket with a sickle; the fourth, surrounded by two small trees, firmly clutches a goat that he is trying to keep out of reach of another dog. Respectively, they represent winter, spring, summer, and autumn. All of the small winged figures are wearing short tunics and cloaks, but whereas the two cupids have full and flowing hair, the spirits of the seasons have shorter hair worn closer to the scalp.

On the sides of the sarcophagus are two pairs of griffins seated next to a brazier in the shape of an amphora. On the back, two cupids are crudely sketched out, holding a *clipeo* (round shield) within which a bust of the deceased appears on a small base. The work was not completed, probably owing to a still-visible crack brought about by the chiseling itself. Instead, the sculptor proceeded to the opposite side, where he slightly modified the iconography. The lid of the sarcophagus realistically reproduces a tiled roof ending with palm leaves as decorative elements, beneath which there is a long vegetal frieze.

The sarcophagus has been restored at various points as testified by the iron braces, and there are modern additions as well. The most visible among these is to be seen on the left side of the front, involving two of the seasonal spirits and the dog below. Everything was executed rather hastily, in spite of which the bas-relief is rich in numerous details and accurate observations. The nude parts offer no anatomical distinctions, but the drapery is well defined and always coherent with the various movements made by the figures. Moreover, the positions of the heads and the happy attitudes evident on the faces are quite varied, even if limited to the essential features. All of these characteristics permit one to assign the sarcophagus to the period bridging the "classicism" of Emperor Gallienus (253–68) and the years of the Tetrarchy (284–305).

Its theme allegorically associates the change of seasons with the various phases of man's life. Life is seen as a natural cycle, and nothing present in these scenes implies the tragedy of death. This is in keeping with the usual canons of pagan art in that period, though the concept can be present in early Christian art as well. It is, indeed, one of those "neutral" themes, which, while clearly traceable to the iconography of the pagan world, was not offensive to the new Christian religion either. It could be easily absorbed, along with analogous "paradisiacal" themes, as an allusion to a blissful life after death and consequently may be considered "crypto-Christian" in spirit.
Giandomenico Spinola

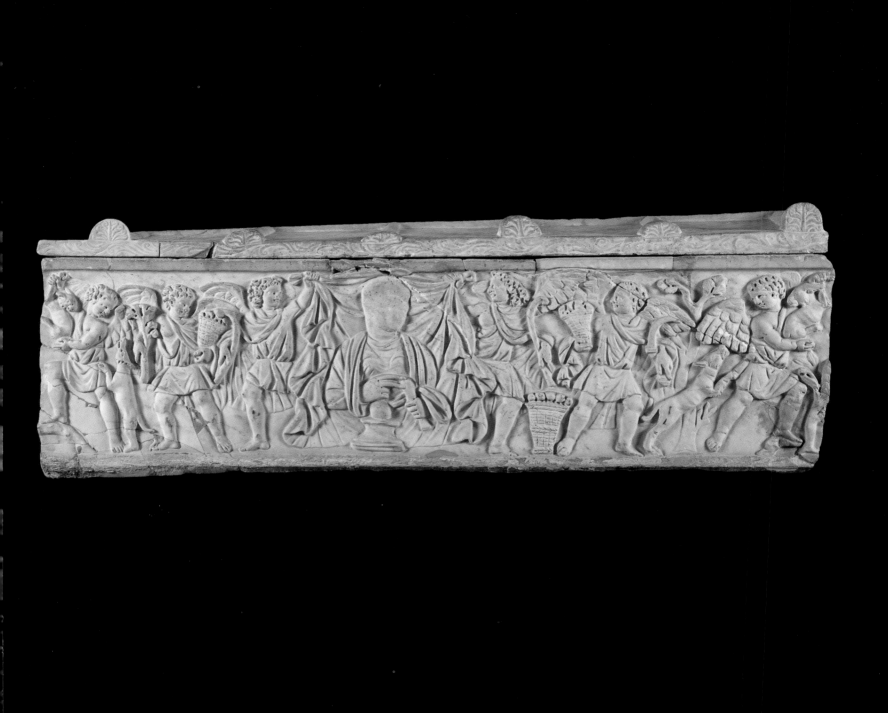

31

Roman
GIRL'S SARCOPHAGUS WITH CUPIDS BEARING THE
BUST OF THE DECEASED, A.D. 220–30
White marble
34 x 126 x 34 cm (13⅜ x 49⅝ x 13⅜ in.)
Vatican Museums, inv. 10397

Literature: Benndorf and Schöne 1867,
279–80, n. 406; Marucchi 1922, 69, n. 687.

Fig. 1. *The Embrace between Eros and Psyche,*
Constantinian era. Vatican Museums, inv. 31408

Citing scholarly mentions already made by
Benndorf and Schöne, Prof. Marucchi states,
"this sarcophagus was employed for a Christian
burial in the Basilica of S. Stefano on the Via
Latina." This basilica is located at the third
milestone along the Via Latina and was
excavated by Fortunati in 1859, presumably the
same year in which the present sarcophagus
was discovered.

At the corners of the coffin are two groups
depicting the kiss between Eros and Psyche.
These in turn frame the central motif of two
winged cupids bearing aloft a laurel wreath
within which can be seen the bust of the
deceased girl. The sides of the sarcophagus are
decorated with two winged griffins, whereas
the back was merely sketched out. A small part
of the front as well as the back corner on the
left have been restored. The girl's face was left
unfinished, having waited in vain for the
personalized features to be added when the
sarcophagus was finally put into use. It is just
possible to make out the hairstyle, which
suggests something similar to that of the so-
called *Nestfrisur*, in vogue in the Severian age
(193–211). Both Eros and the two cupids in
flight have their hair divided in rich and
flowing locks gathered with bows above the
forehead. All of the figures in this composition
are treated with muted delicacy; the faces and
the little bodies are plump, stressing the
childlike tone of the themes being treated.

Stylistic touches place the date of this
sarcophagus at about the third decade of the
third century. The stated themes leave little
room for a possible Christian interpretation.
In fact, the Basilica of Santo Stefano was built
by a certain Demetria or Demetriade between
A.D. 460 and 461, fully two and a half centuries
after the fabrication of the sarcophagus.
While the kiss between Eros and Psyche has
occasionally been present in early Christian art
(an example is the large sarcophagus from the
period of Constantine to be found in the Pio
Christian Museum [fig. 1],[1] wherein the hard-
won love between the two young divinities
is contrasted with the afflictions of the
human soul prior to its ultimate reward), the
absorption of pagan myths into the Christian
realm is something generally dateable only to
a subsequent period, certainly no sooner than
the second half of the third century. Similarly
vague is the motif of the two cupids bearing
the wreath with the bust of the deceased.
Here it constitutes one of the innumerable
variations on the more common theme of a
winged victory, armed with its rounded *scudo*
(shield), conferring heroism to the personage
while exalting victory over death. Thus one
cannot claim any Christianization of pagan
themes here, nor even include this among
the so-called "neutral" sarcophagi.

Any relationship between this object and
a Christian burial place must be considered
extremely doubtful. The only conjecture
possible is that the sarcophagus was used again
subsequently or else that it originally pertained
to a pagan burial ground in the period of
Septimus Severus (A.D. 193–211) that was later
"absorbed" into the Christian burial site.
Giandomenico Spinola

1. Deichmann 1967, 71–72, n. 86, pl. 25.

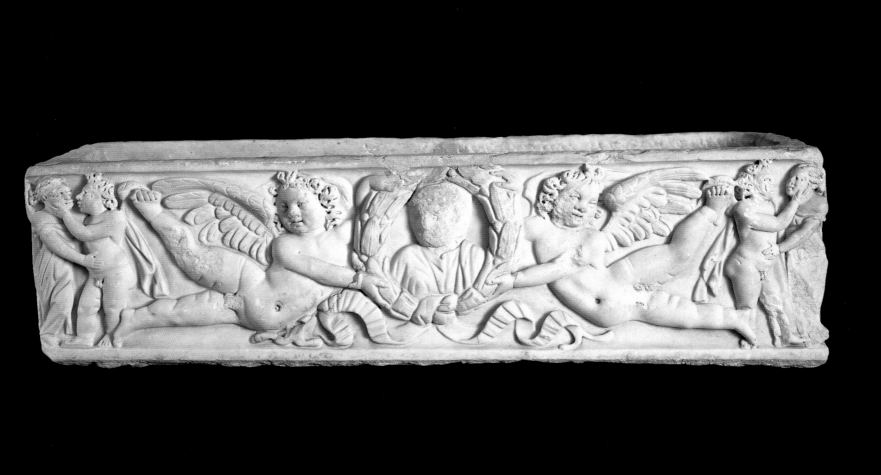

32

Roman
SARCOPHAGUS LID WITH IDENTITY PLAQUE AND
EPIPHANY SCENE, A.D. 370–400
White marble
27.8 x 198 x 7 cm (11 x 70 x 2¾ in.)
Vatican Museums, inv. 31463

Conservation courtesy of James, Angie,
Thomas, Siobhan, and James III McNamara

Literature: Marucchi 1910, 16, pl. 19, 3;
G. Bovini, *I Sarcofagi Paleocristiani* (Vatican
City, 1949), 211 and 327, n. 146; Deichmann
1967, 895–96, n. 147, pl. 33.

At the center of the front of this sarcophagus lid is a plaque intended to accommodate the name of the deceased. His identity might once have been painted there, rather than carved; in any case, it has long since disappeared. A pair of winged cupids, wearing only cloaks, hold the plaque in place. To the left, two winged victories, clothed in the long Roman *peplum*, support the *parapetasma* (curtain) that serves as a backdrop for the draped bust of the deceased. The latter boasts an elaborate hair style fashionable from the time of Constantine, with two large plaits encircling the head from the forehead to the nape. In his hands he holds a *volumen* (scroll), which underscores his high cultural position. On the other side of the lid is an Epiphany scene, with the three Wise Men offering gifts to the Christ child. Baby Jesus is held by the enthroned Madonna. The first of the Wise Men is pointing to the Eastern Star, carved immediately above the forehead of the Madonna.

At the ends of the sarcophagus are two decorative masks, with wide-open mouths and hollowed eyes. Masks in this context allude to life as a theatrical experience, be it comic or tragic. Such an allegory, taken from the repertory of pagan iconography, in this case serves to contrast man's vain and fleeting earthly existence with the much more important hereafter, a notion that came with Christianity and is implied in the Epiphany.

It is noteworthy that there is no distinction in role or identity among the cupids and the winged victories. All are treated as neutral winged spirits who habitually appear in the funerary iconography then current. Their roles could be exchanged without modifying in any way the meaning of the scene. Such personifications had less and less allegorical value as they increasingly served decorative intentions.

Giandomenico Spinola

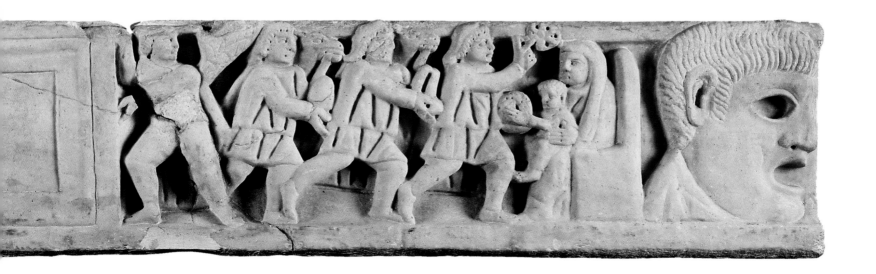

Detail of cat. 42 (actual size)

144

ANGELS
IN THE LIFE OF
CHRIST

33

Domenico Bigordi, called Il Ghirlandaio
(Florence, 1449–94) and Workshop
THE NATIVITY, c. 1492
Tempera on wood
45 x 42 cm (17¾ x 16½ in.)
Vatican Museums, inv. 40344

Inscriptions: GLORIA.IN EXCELSIS.DEO
(in Roman capitals, on the musical scroll
supported by the group of angels above);
VENIENT GENTES/ADORARE
DOMINUM (in Roman capitals, to the right
and left of the head of the Virgin); EGO SUM
LUX MUNDI (in Roman capitals, above the
Infant Jesus).

Restorations: 1930, 1975.

Provenance: Pisa (?); 1867, Vatican Library,
Christian Museum, Cupboard X, no. 2 (Barbier
de Montault 1867, 153); Vatican Library,
Christian Museum, Showcase 0, XVI, no. 120
(D'Achiardi 1929, 9); in the Vatican Picture
Gallery since 1909.

Exhibition: Florence, Palazzo Strozzi, *Maestri e
Botteghe a Firenze alla fine del Quattrocento*
[Milan], 1992–93.

Literature: Crowe and Cavalcaselle 1864–66,
2:496; Barbier de Montault 1867, 153;
F. M. Perkins, "Note su alcune quadri del
Museo Cristiano del Vaticano," in *Rassegna
d'Arte* 6 (1906):122; D'Achiardi 1929, 9;
Berenson 1932, 322; E. Fahy, *Some Followers of
Domenico Ghirlandaio*, Ph.D. Diss., Harvard
University, 1968 (New York-London, 1976),
217; L. Venturini, in M. Gregori, A. Paolucci,
and C. Acidini Luchinat, eds., *Maestri e
Botteghe. Pittura a Firenze alla fine del
Quattrocento* (exh. cat. Milan, 1992), 195,
cat. 7.5.

Fig. 1. Bastiano Mainardi, *The Resurrection of
Christ.* Statens Museum for Kunst, Copenhagen,
inv. 3638

This painting depicts the Nativity according
to the archaizing schemes of late-quattrocento
Florentine art. Immediately arresting for the
conventionality of their pose and the three-
dimensional substance of their volume, the
figures of Joseph and Mary stand out sharply
from the flat gold ground against which
they are placed. The ground is devoid of
perspective, but enlivened by the punching
of the halos and the luminous aureoles
irradiated by the figural groups. Joseph,
overcome by fatigue, is represented sleeping,
his head supported on his hand, according to a
widespread iconographic convention, with the
symbols of the pilgrimage to Bethlehem
placed beside him. Mary, kneeling in adoration
of her son, is distinguished by a heightened
descriptive charm, emphasized by the youthful
appearance of her figure, the sumptuousness of
her dress, and the elegant, fan-shaped arrange-
ment of the lower folds of her mantle. The
child, placed on the ground between them, is
holding his hands to his mouth and sucking his
fingers in a gesture of infantile charm. From
his figure seems to emanate the inscription *Ego
sum lux mundi* (I am the light of the world).
It is complemented by the other inscription,
Venient Gentes Adorare Dominum (The peoples
shall come to worship the Lord), which can be
read behind the Virgin and which underlines
the simplified, didactic character of the image
and its devotional value.[1]

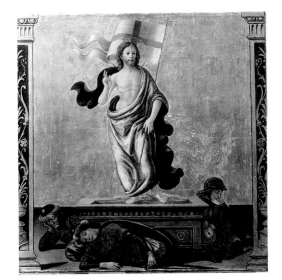

The drastic compositional simplification
of the painting and the reinstatement of the
gold ground are indicative of a conservative
tendency in Florentine religious painting of
this period. Barely touched by the innovative
aspects of Renaissance culture, this archaizing
trend had remained latent throughout the
century in the workshop production of
paintings with a purely devotional character.[2]
In the opening of the last decade of the
fifteenth century, the fervor of Savonarola's
preaching contributed to its reinforcement
and favored the emergence of a severely
penitential climate, averse to the innovative
aspects of perspective representation and
intent on establishing a relationship with
traditional forms of popular piety.[3]

The present painting seems therefore to
have been conceived in the climate of the neo-
Gothic reaction recently elucidated by the
studies of Cecilia Filippini,[4] a reaction that is
at the basis of such diverse works as Filippino
Lippi's *Crucifixion with the Madonna, Saint
Francis, and Angels* (1496, formerly Kaiser
Friedrich Museum, Berlin)[5] and Botticelli's
Mystic Nativity (1501, National Gallery,
London).[6] The iconography of the Vatican
Nativity is, at least in one respect, directly
comparable with this latter: namely, the
group of angels bearing the musical scroll
with the words "Glory to God in the highest"
(Luke 2:14), similar to the motif Botticelli
incorporated into the London painting some
years later.

The *Nativity* in the Vatican was
unanimously attributed to Bastiano Mainardi
from the time of Cavalcaselle (1864) to that of
Fahy in his monograph (1976) with the single
exception of Perkins (1906), who assigned it to
an unspecified follower of Ghirlandaio. It is a
companion, as several scholars have pointed
out, to the *Resurrection* in the Statens Museum
for Kunst in Copenhagen (fig. 1), purchased
on the Danish art market in 1923 and first
attributed to Mainardi by Berenson (1932).
The complementarity of the two little panels
is demonstrated by their identical dimensions,
the similar inscriptions on the gold ground,
and the similar fictive pilasters with
classicizing scrollwork decoration by which

34

the scenes are delimited to either side. The inscription "Insigne Campo Santo di Pisa" on the back of the work in Copenhagen suggests a possible Pisan origin of the two panels. This is indirectly confirmed by the presence of identical marks of provenance on the back of many panels belonging to the collection of "primitives" in the Vatican Picture Gallery.[7]

In wondering whether the pair might originally have formed part of a larger series comprising various episodes of the Life of Christ, L. Venturini proposes their hypothetical dating to the early 1490s, in the period when the contacts of Ghirlandaio's workshop with Pisa were at their closest; at the same time, she advances "a cautious reference to Domenico Ghirlandaio himself."[8]
Guido Cornini

1. The representation closely follows the narrative of the Nativity according to the vision of Saint Bridget of Sweden. See Réau 1955–59, 2 (1957):219, 224–27.
2. On the simultaneous presence of conflicting tendencies in the artistic culture of fifteenth-century Florence, see F. Zeri, "Rinascimento e Pseudo-Rinascimento," in *Storia dell'Arte italiana* 5 (Turin, 1983):545–72. A brief summation of the question can be found in A. M. Bernacchioni, "Le forme della tradizione: pittori fra continuità e innovazioni," in Milan 1992, 171–80.
3. See G. Weise, *Il rinnovamento dell'arte religiosa nella Rinascita* (Florence, 1969); D. Weinstein, *Savonarola and Florence: Prophecy and Patriotism in the Renaissance* (Princeton, N.J.), 1970.
4. C. Filippini, "Il recupero del fondo d'oro e altre tendenze arcaizzanti", in Milan 1992, 181–90.
5. Vasari-Milanesi 1878–85, 3: 464–65; A. Chastel, *Art et Humanisme à Florence au temps de Laurent Le Magnifique* (Paris, 1959), 398. See also L. Berti and U. Baldini, *Filippino Lippi* (Florence, 1991), 218.
6. M. Davies in National Gallery 1961, 106; R. Lightbown, *Sandro Botticelli* (London, 1978), 1:134–38, 2:99–101, cat. B90, and Literature.
7. See, for example, Volbach in Pinacoteca Vaticana 1987, 24, cat. 23 (additional plate I, fig. 37), and 60, cat. 78 (additional plate II, fig. 135). No such mark of provenance is to be found on the back of the Vatican *Nativity*.
8. L. Venturini in Milan 1992, 195, cat. 7.5.

Bartolo di Fredi (Siena, c. 1330–1410) and Workshop
NATIVITY AND ADORATION OF THE SHEPHERDS
c. 1383
Tempera and gold on wood
49.7 x 34.8 cm (19⅜ x 13¾ in.)
Vatican Museums, inv. 40268

Conservation courtesy of Mrs. Dillon-Smyth Crocker in honor of her children

This panel depicts the Nativity and the Adoration of the Shepherds as well as an occasion that took place before these events, when an angel announced the divine birth to the shepherds. Only Luke (2:7–18) among the canonical Gospels tells the story of how the Virgin Mary, having arrived in Bethlehem with Joseph for the census, could not find lodging at the inn and thus gave birth to the Christ child in a stable, where she lay him in a manger. It also tells how Christ was displayed to mankind for the first time, how the angel announced the divine birth to shepherds, and how he was joined by "a multitude of the heavenly host praising God and saying ' … to God in the highest, and on earth peace, good will toward men.'" Thus, the shepherds traveled to Bethlehem to honor the holy infant lying in a manger.

This painting correctly repeats the usual iconography. The Virgin Mary and Saint Joseph are in a cave with the swaddled infant lying in a manger. Behind the Madonna are an ox and an ass, and the shepherds kneel in the front. On the right side, on a much smaller scale, is the angel's annunciation to the shepherds. One shepherd covers his face with one hand, thus showing his surprise and fear, whereas the other hand is holding a bagpipe, an obvious reference to pagan bucolic scenes. The angel bringing the news is holding an olive branch, the symbol of peace and celebration. In the upper portion of the painting, angels have emerged halfway out of a cloud and form a semicircle; they are in the act of singing.

As a sign of devotion, the Virgin Mary is represented in a larger scale than the other figures; above the infant are a dove and a star, which serve to illuminate him almost as if they formed the symbolical representation of the Trinity.

The presence of the ox and the ass, which heated the stable with their breath, is written in the apocryphal Gospel of Pseudo Matthew (14), which makes reference to Isaiah's prophecy (1:3).

The small panel, which bears a wax seal on the back with initials "D. L.," was a part of a triptych devoted to the life of the Virgin. The commission was granted to Bartolo di Fredi by the Company of Saint Peter on May 9, 1383, for the chapel of the Annunciation in the church of S. Francesco in Montalcino. The triptych has since been broken up, and parts of it can be seen in various museums. The original placement of the panel in the polyptych, the photographic assemblage of the latter, and where the other elements are currently conserved, as well as information about the artist and the problem of the date, can be found elsewhere in this volume (cat. 59), in which the *Annunciation to Joachim*, from the same triptych, is analyzed.

From a compositional and stylistic viewpoint, the Vatican's *Nativity and Adoration of the Shepherds* brings to mind the central panel of Bartolo di Fredi's triptych portraying the same subject, which is kept in the church of Torrita di Siena.
Adele Breda

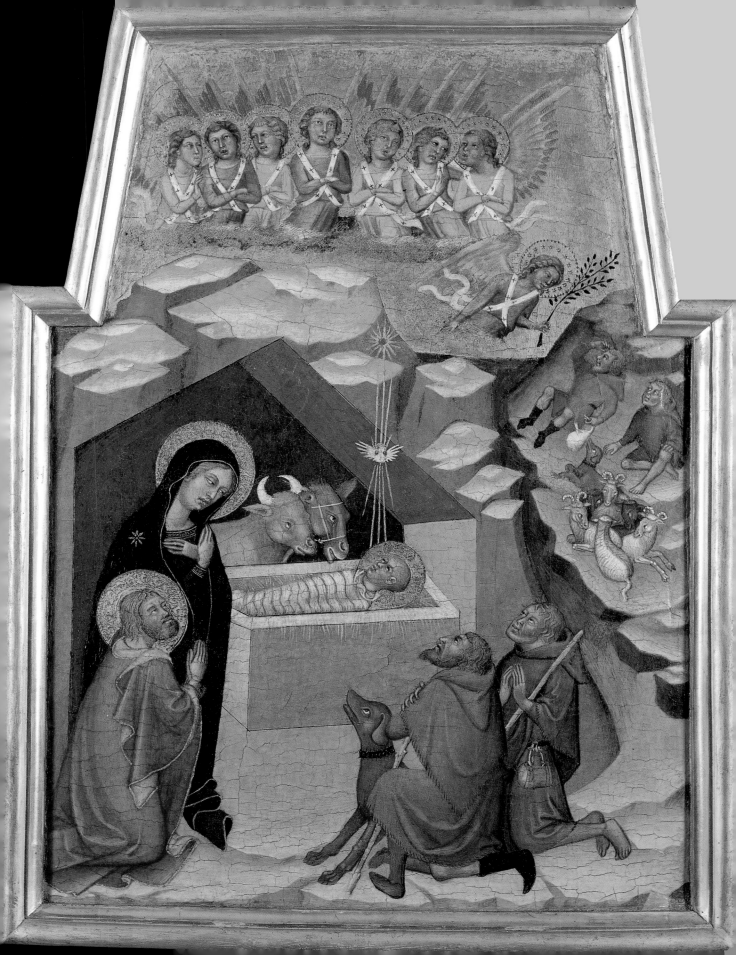

35

Attributed to Francescuccio Ghissi (Fabriano, documented 1359–95)
THE DECEASED CHRIST AND THE ADORATION OF THE INFANT JESUS, after 1373
Tempera and gold on wood
39.3 x 28.5 cm (15½ x 11¼ in.)
Vatican Museums, inv. 40244

Conservation courtesy of Kathleen Waters in memory of Virginia Bennett Rubin

Literature: Rossi in Pinacoteca Vaticana 1994, 60–62, no. 15; *Enciclopedia Cattolica* under the entry "Bridget of Sweden"; *Rosa Rorans Bonitatem* (exh. cat. Vatican City, 1991); Réau 1957, 218–19.

The Incarnation of Christ and his death, important moments of his life, are depicted in this panel, which is divided into two sectors, one above the other.

The deceased Christ is portrayed in half length with his arms crossed on his chest. His head is tilted to one side and his eyes are closed, with a cross on his halo and the stigmata clearly visible on his hands and ribs. It strays from the traditional iconography of the *Vir Dolorum* only in the shape of the sarcophagus, similar to a shrine, from which he is rising. Two angels at his sides are richly embellished with diadems and halos on their heads and with capes and wings. They also have their arms crossed like Christ, a gesture that expresses resignation for the unavoidable divine sacrifice.

In the lower sector, the infant Jesus is lying on the ground, barely covered by a transparent cloth; his small body emits strong rays of light. Two angels kneel behind him with their hands clasped together. They wear diadems and have halos above their heads. The Madonna, with her arms crossed on her chest, and Saint Joseph, with his hands clasped together in adoration, are kneeling before the child.

This Adoration of the Infant Jesus is influenced, with some variations, by Saint Bridget of Sweden's vision of the Nativity. In the year 1372 she completed a journey to the Holy Land. In her *Revelations* (VII: ch. 21), the saint tells how, having arrived in Bethlehem, the Virgin Mary granted her the vision of the moment at which she gave birth to Jesus. The Madonna was kneeling and absorbed in prayer when the child was born, surrounded by a blinding light.[1]

Saint Bridget, the founder of the Order of Saint Salvator, had other visions also, including one of the Passion of Christ. Her symbol was a heart crowned by five flames representing the five wounds of Christ. Her spirituality was similar to that of the Franciscans; in fact, she was a tertiary of that order. A further confirmation of the Franciscan sphere to which this painting belongs is evident in the artist's decision to lay the newly born child on the bare earth, an expression of the extreme poverty intended by the son of God in manifesting himself to humanity. The theme of poverty, characteristic of the Franciscan spirituality, which is also symbolically represented in the "Matrimonio mistico di S. Francesco con la Povertà" (The Mystic Marriage of Saint Francis with Lady Poverty), is indicative of the need to detach oneself from all forms of wealth in order to return to the purest values of Christianity. Thus, this painting may have been influenced by the Franciscans: the angels are worshipping Christ in the tabernacle, as the immolated Host on the altar, a sacrifice made possible by the divine Incarnation, which has effected our Redemption. The link between birth and death takes us back to the vision of God-Christ as the alpha and the omega, the beginning and the end.

The iconographical and stylistic motifs permit one to connect this panel with the Fabrianese cult. The attribution to Francescuccio Ghissi, a collaborator of Allegretto Nuzi (Fabriano, 1315–73), proposed by some scholars, is very likely. In any case, the author of this panel was extremely close to them. Ghissi was influenced by Nuzi, but his works, with respect to the latter, are much more rigid and characteristically archaic, leading one to think of a more provincial and intensely devotional expression.

It is not acceptable to date the work in the vicinity of 1360 as is generally proposed, because Saint Bridget had the vision of the Nativity during her journey in the Holy Land in 1372 and returned to Rome in 1373. It would be logical to date the execution of this panel in those years or shortly thereafter.
Adele Breda

1. The new version of the Nativity was received favorably in Italy and the rest of Europe by the end of the fourteenth century, substituting the traditional one in which the Virgin Mary is lying down. With the Council of Trent in 1564, it was adopted as a model. See cat. 64 in this volume.

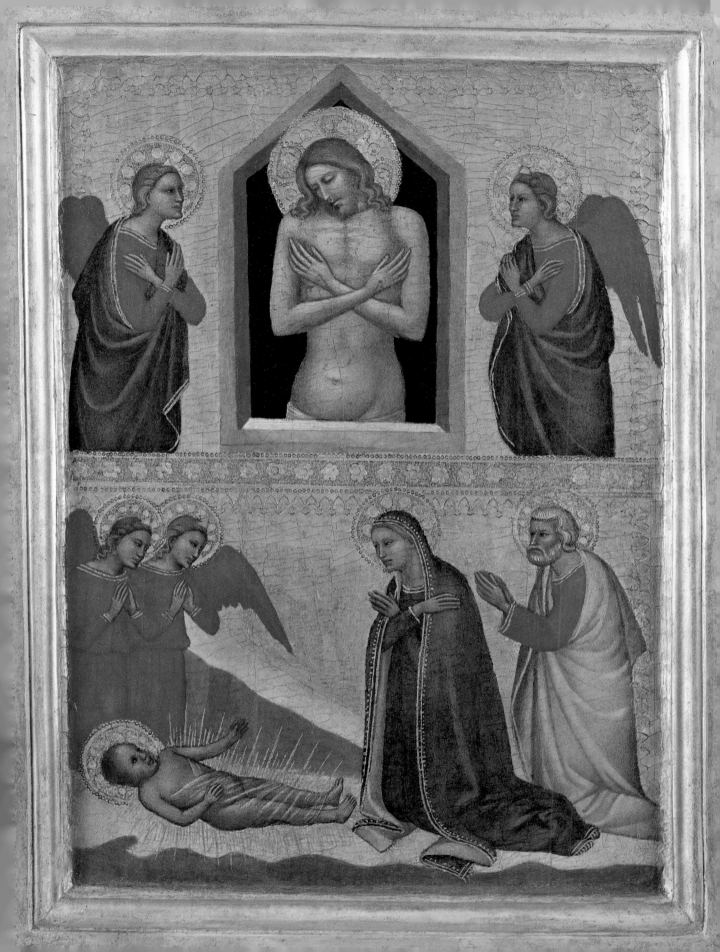

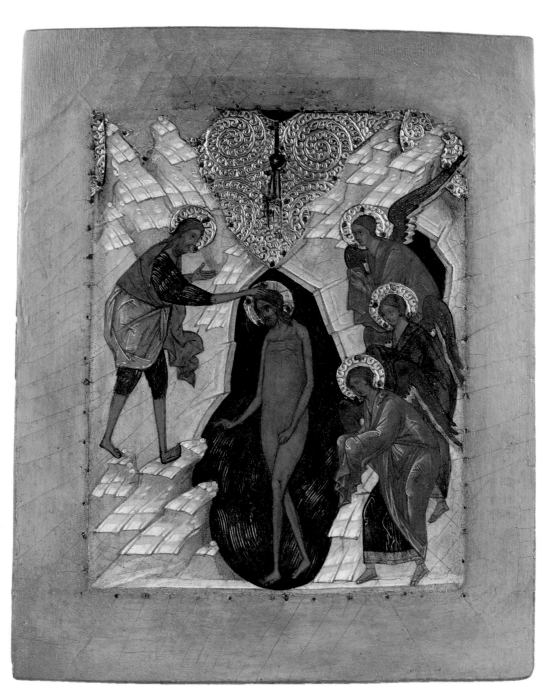

36

Russian, Novgorod School
THE BAPTISM OF CHRIST, early 16th century
Tempera on canvas and wood
25.3 x 19.5 cm (10 x 7¾ in.)
Vatican Museums, inv. 40049

Conservation courtesy of John J. Brogan

Provenance: Vatican Apostolic Library

Literature: Barbier de Montault 1867, 141, no. 13; Muñoz 1928, 15, no. 64, pl. XXXI, 2; Vatican 1934, 16, no. 49; Felicetti-Libenfels 1972, 63, fig. 96; Vatican 1993, 77, no. 4b; Bianco Fiorin 1995, 68, no. 81, fig. 118.

In the historical context of the great feast days of the Byzantine liturgical year, the Baptism of Jesus in the waters of the Jordan at the hands of John the Baptist is the representation par excellence of the divine manifestation of Christ, commemorated by the Church on January 6 under the name of Theophany. The Byzantine hymnal proclaims: "At the time of your baptism in the Jordan, Lord, the adoration due to the Trinity was manifested: for the voice of the Father makes you a witness by giving you the name of well-beloved Son, and the Spirit, in the form of a dove, confirmed the indisputable truth of this word. Christ God who appeared and who illuminated the world, glory be to you!"[1] At the center of the icon, the dark, oval-shaped expanse of the waters of the Jordan serves as a background to the figure of the Messiah, forming, as it were, a dark cavity, a "liquid sepulcher" in which Christ is totally immersed. It is a prophetic image of his future burial: his descent into the depths of the waters, domain of the forces of evil, prefigures his emersion from the baptismal waters and his final victory over the forces of evil by his own Resurrection. So Christ blesses the waters, hitherto a bearer of death, by changing them into "a spring of water welling up to eternal life" (John 4:14). This is the first manifestation of Jesus as the incarnate Word, the inaugural vision of the mystery of the Trinity, of the three persons in their unanimous witness: "As soon as Jesus was baptized he came up from

the water, and suddenly the heavens opened, and he saw the Spirit of God descending like a dove and coming down on him" (Matthew 3:16). In the triple ray of the divine light, visual equivalent of the voice of the Father, appears the dove of the Spirit, which moves from the Father toward the Son.

The arid mountains with their curiously paneled rocks serve as a background to this scene of great intensity, which recurs, in a very different context, in another remarkable panel in the Vatican collections attributed to a "Veneto-Byzantine" atelier of the fourteenth century, and also illustrating the Baptism of Christ (fig. 1). In the present icon, Jesus, entirely nude, is shown being baptized in the midst of the greenish waves of the Jordan, in which fish are swimming. His body and head are turned in three-quarters profile toward John the Baptist, who bows as a sign of respect, standing in profile on the left bank of the river. John is dressed in a dark green undergarment and an ocher brown *himation* (mantle). On the other side of the Jordan, on these same desert-like and chalky mountains, three angels are standing. Arranged vertically, one above the other, they also bow down before the Lord; their outstretched hands are concealed by the sleeves of their mantles as a mark of reverence and veneration, conforming to an oriental usage adopted by the etiquette of the imperial court and by the liturgy of Byzantium. Their vestments, complementary in color and light and luminous in tone, contrast happily with

the pastel shades of the landscape: "It was an astonishing thing to see the creator of the heaven and the earth, naked in the waters of the river and receiving baptism like a slave from the hand of a slave, for our salvation: the choirs of Angels were transported by fear and joy...."[2]

The Vatican icon has already been cited as an excellent example of this particularly suggestive iconographic theme, and rightly compared with another icon in the famous Korin Collection, assigned to the late fifteenth century[3]; it too is a work of the Novgorod school (fig. 2). A further comparison may be made with one of the recently published double-faced "tablets" from the Cathedral of Saint Sophia in Novgorod (fig. 3), dated to the sixteenth century.[4]

The orange ocher pigment of the ground and frame was originally intended to be covered by an ornamental sheathing in sheet metal, leaving the image itself free. This surface ornament, the so-called *oklad*, consisting of small silver plates with spiral decoration, which also covered the haloes, has only been preserved in part. Traces of a cursive inscription in Old Church Slavonic can still be seen on the upper edge of the icon, presumably indicating its title, namely the *Theophany of the Lord*; it was intended to be faithfully reproduced on the contemporary metal cover, it itself substituting the customary gold ground. *Michel Berger*

1. *Troparion* of the feast of the Theophany. On the iconography of the Theophany or Baptism of Christ, mainly in Russia, see Ouspensky and Lossky 1982, 164–67.
2. *Idiomelia* of the Nones of the Vigil of Theophany.
3. Felicetti-Libenfels 1972, 63, fig. 96; V.I. Antonova, *Drevnerusskoe Iskusstvo v Sobranij Pavla Korina* (Moscow, 1966), 34–35, no. 8, fig. 23.
4. V. N. Lazarev, *Pages from the History of Novgorodian Painting. The Double-faced Tablets from the St. Sophia Cathedral in Novgorod*, Russian/English bilingual edition (Moscow, 1977), pl. VIII.

Fig. 1. Veneto-Byzantine School, *Baptism of Christ*, 14th century. Vatican Museums

Fig. 2. Novgorod School, *Baptism of Christ*, late 15th century. Korin Collection, State Tretyakov Gallery, Moscow

Fig. 3. Novgorod School, *Baptism of Christ*, 16th century. Cathedral of Saint Sophia, Novgorod

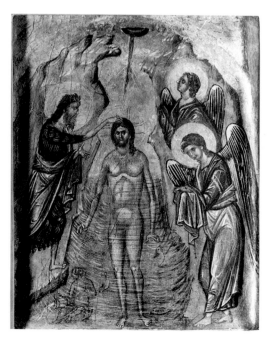

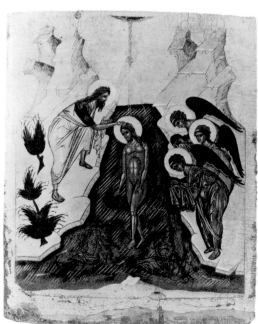

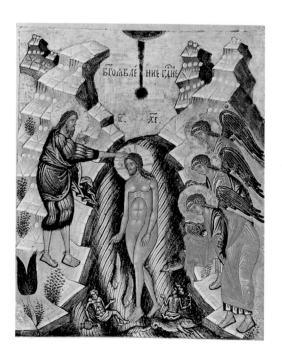

37

Sebastiano Conca (Gaeta, 1680–1764)
CHRIST IN THE GARDEN OF GETHSEMANE, 1746
Oil on canvas
63.5 x 47 cm (25 x 18¼ in.)
Vatican Museums, inv. 40779

Conservation courtesy of Miss Helen Nielsen

Literature: M. A. De Angelis, "Pinacoteca Vaticana: nuove attribuzioni," in *Monumenti Musei e Gallerie Pontificie. Bollettino* 6 (1986):203–09.

This painting is pendant to the *Deposition from the Cross* (fig. 1), with which it entered the Vatican Picture Gallery in December 1913 in a group of paintings given to Pope Pius X (1903–14) by the Sacred Congregation for the Propagation of the Faith. The two paintings are to be found in two manuscript inventories preserved in the Historical Archive of the Vatican Museums ("Carte Pietrangeli, Pinacoteca"), the first, drawn up by Msgr. della Volpe in 1908, referring to the Ferrieri Collection when it was in the Palazzo Mignanelli, and the second, made in 1912 by Pietro Costa, the Regent of the Floreria Apostolica, when the collection of paintings was given to Pius X. In both inventories they bear the numbers 61 and 59 and are attributed to Corrado Giaquinto.

Christ in the Garden of Gethsemane is inscribed below at the right: "Eq. Seb. Conca / fec. Rom. 1746." During the recent restoration, the signature, previously overpainted, was made completely legible.

The exhibited painting and its pendant are of excellent quality, and their style and the manner in which they were painted indicate that they were produced for private devotion, something that was very fashionable in the eighteenth century. The palette is composed of soft tones of brown and green, soberly blending with pink and white. In addition, the two paintings are imbued with that taste for formal elegance in the sacred, which in Conca's case is not just routine empty worldliness but rather the expression of an educated devotion filtered by his exceptional expressive talent. In that same year, 1746, Sebastiano Conca also signed the beautiful oval of the *Madonna and Child and the Infant Saint John the Baptist* in Spoleto's Communal Gallery, the mellow and filtered style of which can be seen to the full in the two Vatican canvases. This is the expression of his mature pictorial mannerism, still bound to classicism but also animated by an almost rococo technique.

The Gethsemane scene is rendered with mournful sweetness, somewhat theatrical in the ample gestures of the protagonists, Jesus and the angels, endorsing the formal taste for the lyricism so favored by eighteenth-century society.

Maria Antonietta De Angelis

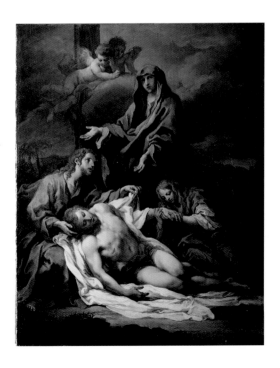

Fig. 1. Sebastiano Conca, *Deposition from the Cross*, oil on canvas. Vatican Museums, inv. 40774

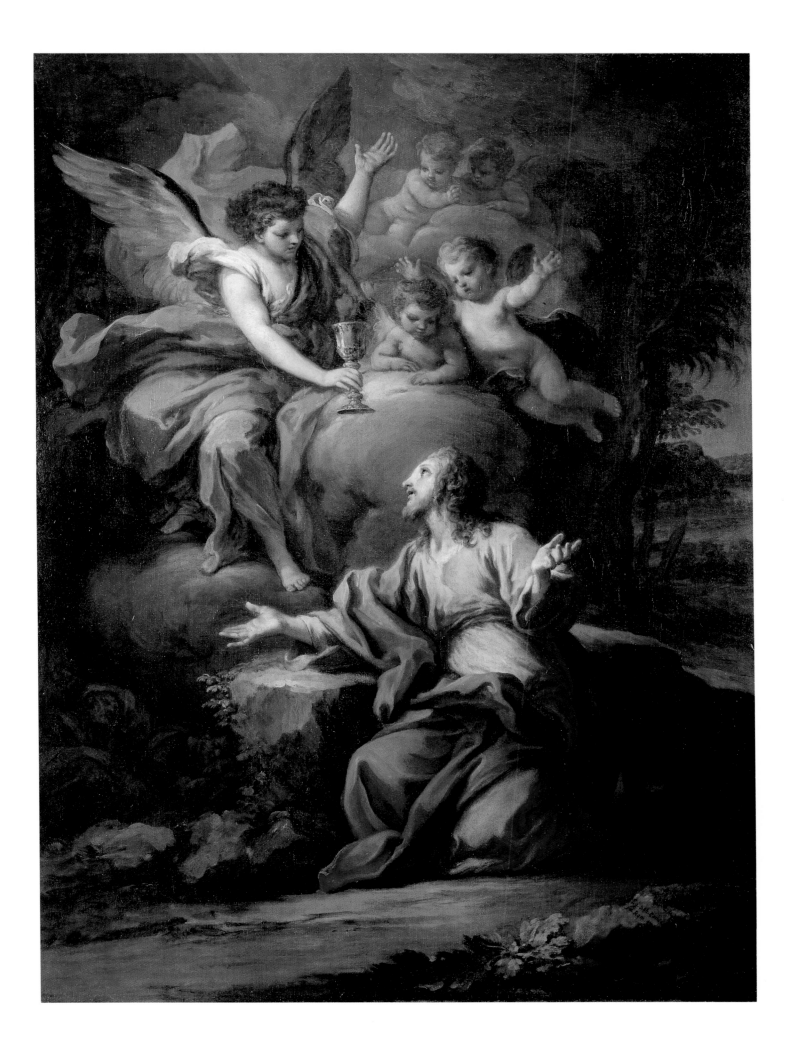

38

Italian
RELIQUARY OF THE MANDYLION OF EDESSA
17th century
Silver, partly gilded, and wood
60 x 48 cm (22⅝ x 19 in.)
Pontifical Sacristy

Conservation courtesy of James, Angie, Thomas, Siobhan, and James III McNamara

Exhibitions: Denver, Colorado, Colorado History Museum, *Vatican Treasures: 2,000 Years of Art and Culture in the Vatican and Italy*, 1993; Mexico City 1993.

The elaborate baroque decoration of this reliquary frames a far more ancient image of Christ painted on cloth. Two sinuous angels stand on either side of the image, holding a crown that rests on Christ's head and is encrusted with pearls and precious stones. The crown is surmounted by a cross with a half-kneeling angel on each side, and the angels' arms are lifted, gracefully pointing toward the cross.

A double inscription along the base reads: "Sor Dionora Clarutia—f.f. anno MDCXXIII." This is a reference to the fact that the reliquary containing the image was made in 1623 for Sister Dionora Chiarucci, a member of the Order of Poor Clares, who took care of the icon when it was in S. Silvestro in Capite in Rome.

The portrait is commonly thought to be the miraculous Mandylion of Edessa, while the symbolism used on the reliquary refers to Christ's Passion. The angels flanking the image symbolize Christ's majesty, even though his expression in the portrait is one of suffering. The pearls used in the decoration are significant because they symbolize the mystery of Christ's Incarnation.
Luciano Orsini

The Mandylion of Edessa is the oldest known image of Christ and is now kept along with other relics in the Galleriola del Romanelli, a small room next to the Redemptor Mater Chapel in the Vatican Apostolic Palace. It is first documented in the year 593, but stylistically the painting resembles Syrian art of the third century. It was painted in tempera on a pre-shaped linen cloth and subsequently glued onto a small wooden panel measuring 40 x 29 cm (15¾ x 11⅜ in.). The image is framed by a sheet of silver that follows the contours of the image.

According to legend, this picture was not painted by a human hand, but was miraculously imprinted on the cloth. The portrait, accompanied by a letter, was sent to King Abgar I, who was extremely ill. The king took one look at it and was cured instantaneously.

The painting remained at Edessa until the year 944, when Emperor Constantine VII had it moved to Constantinople, where it may have been inserted into a triptych about the story of King Abgar. The side panels of this triptych are now preserved at the Monastery of Saint Catherine on Mount Sinai. The Mandylion was kept in the chapel of Constantinople's imperial palace and was thought to safeguard the empire from harm. After Constantinople was conquered by the Venetians in 1204, the relic was carried away to the western world, and from 1587 it remained in S. Silvestro in Capite in Rome until Pope Pius IX (1846–78) decided to have it moved to the Vatican in 1870.

The Mandylion was greatly missed in Constantinople, a token of how deeply it was venerated. In 1384, Emperor John V actually authenticated a copy of the icon, declaring that it was the original Mandylion, and then gave it to the city of Genoa, where it is still preserved in the church of S. Bartolomeo degli Armeni.

In 1996, the relic was thoroughly examined by Vatican conservators, whose tests showed that the wood of the panel (cypress) and the materials used for the image are not inconsistent with Middle-Eastern workmanship, even though they cannot be linked to a specific provenance. However, none of this clashes with the tradition that the Mandylion comes from Edessa.

The tests also provided new information. Christ's image as it appears today was not mounted in the sixth century but at some later date. Thermographic photographs and X rays also showed *pentimenti* on the nose, mouth, and the right eye of the portrait, a strong argument that the Vatican Mandylion is original and not a copy (*pentimenti*, when the artist has second thoughts about his work, are normally found only in originals). The layer of paint is very thin and could easily be damaged. The state of preservation of the painting, however, turned out to be good, showing that in the course of the centuries it has been handled carefully and treated with respect.
Arnold Nesselrath

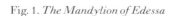

Fig. 1. *The Mandylion of Edessa*

39

Georges Rouault (Paris, 1871–1958)
MISERERE, 1939
Tempera on paper
64 x 50 cm (25¼ x 19¾ in.)
Vatican Museums, inv. 23667

Provenance: Alex Maguy, Galerie de l'Elysée, no. 1183; donated to the Vatican Museums by Piero Campilli.

Exhibitions: Helsinki 1982, cat. 35; Seoul 1984, cat. 51, colorplate.

Literature: Ferrazza and Pignatti in Vatican City 1974, cat. 164, b/w photo; G. Fallani, V. Mariani, and G. Mascherpa in Milan 1974, 103, colorplate no. 50; M. Ferrazza and P. Pignatti, "La Collezione d'Arte Moderna," in *Il Vaticano e Roma Cristiana* (Vatican City: Libreria Editrice Vaticana, 1975), 298–305, colorplate on 300.

The work exhibited here, which is signed by the artist at the lower right, is the painted version of the first of fifty-eight etchings comprising the series engraved by Rouault in the years of the First World War under the title *Guerre et Miserere* (1914–18). Resumed in the following decade, the series was published with the simplified title *Miserere* in 1948 after complicated litigation with the heirs of Ambroise Vollard, Rouault's art dealer and publisher.

"Miserere mei Deus," in the Latin version of the Bible, is the first verse of Psalm 51, the canticle of David invoking the Lord's mercy. Because of its profound religious sense, it has become the classic psalm of repentance and is used in the Catholic liturgy during Holy Week. In funeral ceremonies it is followed by another chant, this time one of hope, addressed to the angels who take the deceased in hand and lead him to the heavenly Jerusalem.

The particularly expressive, tense, and harsh manner of Rouault's usual style of painting here seems to be attenuated. The dark, very dense colors, to which his palette is usually limited, are brighter. The composition is clearer. Set in an architectonic frame, the comforting angel (in the upper part) extends his protective veil over the sorrowful and resigned figure of Christ below.
Mario Ferrazza

Workshop of Gian Lorenzo Bernini
THREE STATUES OF ANGELS WITH INSTRUMENTS OF THE PASSION, 17th century
Wood, partly gilded
c. 56 cm (22 in.)
Pontifical Sacristy

Conservation of *Angel with Column* courtesy of Joseph J. Bianco
in memory of Marie and Salvatore Bianco;
of *Angel with Sudarium* courtesy of John H. Surovek in honor of Janice E. Caiazzo;
of *Angel with Ladder* courtesy of Mr. and Mrs. Leo A. Vecellio, Jr.

Exhibition: Angel with Sudarium, Japan, Sogo-Dentsu,
The Vatican Exhibition, 1987.

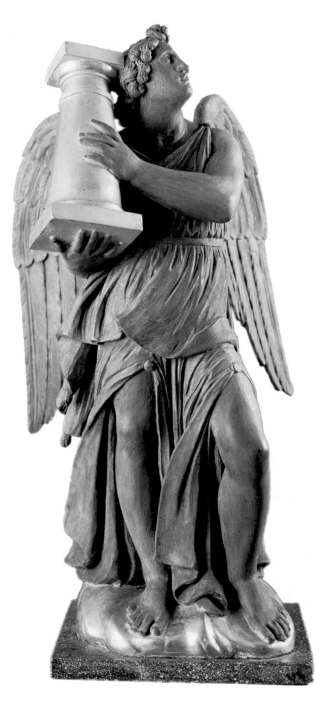
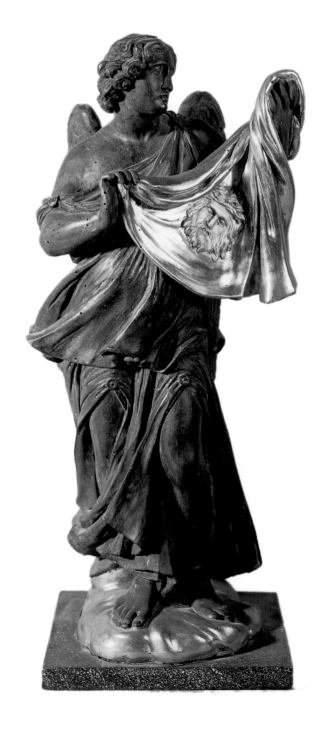

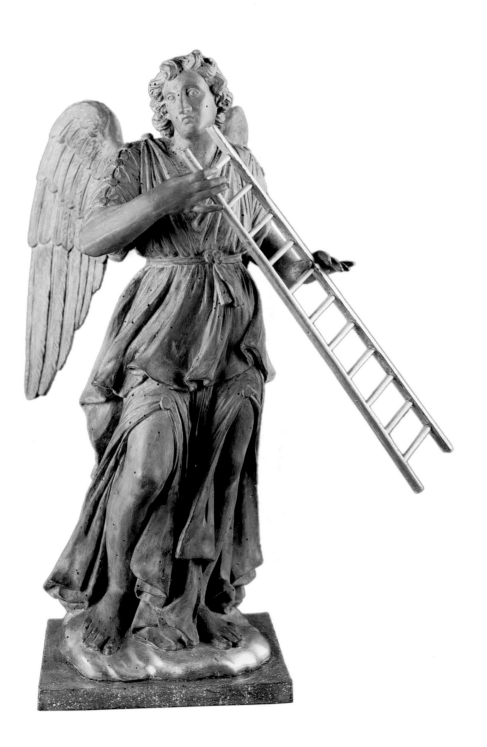

These small statues are generally attributed to Gian Lorenzo Bernini's workshop, though not to the master's hand. Oral tradition holds that they were made as *bozzetti* (preliminary sketches) for the marble angels on Ponte S. Angelo and presented to Pope Clement X (1670–75) so that Bernini could obtain approval for the definitive sculptures. This hypothesis is at least partially confirmed by the fact that the marble angels, which are still on the parapet of the bridge, strongly resemble these wooden statuettes of winged angels holding the symbols of Christ's Passion.

The figures are characterized by the typical sculptural technique of the baroque period and are close to Bernini's own sculptural models. The movement of the drapery and the position of the wings particularly suggest Bernini's capacity for giving life to his works.

The wood was painted to resemble bronze and touched up with gold, which, after conservation by the Vatican Museums in the 1980s, is still visible. These small statues once decorated the inside of the Apostolic Palace's Secret Chapel and were moved many times according to each pope's devotions or the functional criteria of each Master of Ceremonies.

The symbols of Christ's Passion held by the three angels (the column of flagellation, sudarium, and ladder) suggest spiritual participation in the suffering of Christ.
Luciano Orsini

41

Andrea Bonaiuto, called Andrea da Firenze
(Florence, active 1343–77)
CRUCIFIXION WITH MARY, SAINT JOHN THE
EVANGELIST, AND A DOMINICAN FRIAR, c. 1370–77
Tempera on wood
32.5 x 22.2 cm (12¾ x 8¾ in.)
Vatican Museums, inv. 40118

Conservation courtesy of Kathleen Waters in
memory of Anthony Rubin

Literature: Volbach in Pinacoteca Vaticana
1987, 24; O. Sirén, "Alcune note aggiuntive a
quadri primitivi nella Galleria Vaticana," in
L'Arte 24 (1921):98; Van Marle 1924, 3:441;
D'Achiardi 1929, 7; Offner 1947, III/6, 171;
Boskovits 1975, 279.

In the center of the small panel, Christ hangs
on the cross, which is marked "I.N.R.I." His
head hangs onto his right shoulder and shows
the marks from the crown of thorns, with
blood oozing from his wounds.

Mary stands to the left of the cross, her
hands joined in a mournful gesture, gazing
at her son. The figure of Saint John the
Evangelist at the right is depicted in a slightly
more active posture of mourning than the
motionless Virgin. He has his hands joined in
front of his chest, and his look toward Christ
expresses sorrow and disbelief. A Dominican
friar kneels at the foot of the cross, embracing
it, while his lips appear to be kissing the feet of
Christ.

Two angels are at either side of the cross;
they also mourn. The left angel has covered his
face with part of his garment, and the right
angel is supporting his head with his hand.
Two different stages of bereavement seem to
be depicted in these angels. While the left
figure is shown in the act of immediate and
active grief, the right one seems pensive,
contemplating his sorrow and, since he looks
directly at the viewer, he appears to invite the
viewer to do the same. Angels that are able to
express emotions first appear in works by
Giotto. Their depiction soon became very
popular in trecento painting (fig. 1).

The panel is attributed to Andrea di
Bonaiuto. The figure of Christ on the cross
is very similar to that in the fresco of the
Crucifixion in the Spanish Chapel in S. Maria
Novella in Florence, dated 1366–68 and also
executed by Andrea di Bonaiuto.
Johannes Röll

Fig. 1. Taddeo Gaddi, *Crucifixion* (detail).
Church of the Ognissanti, Florence

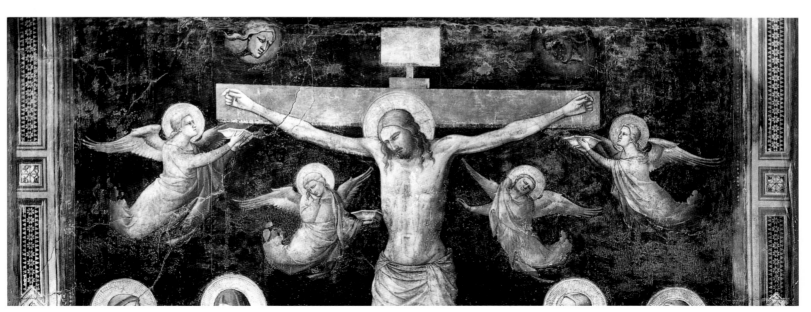

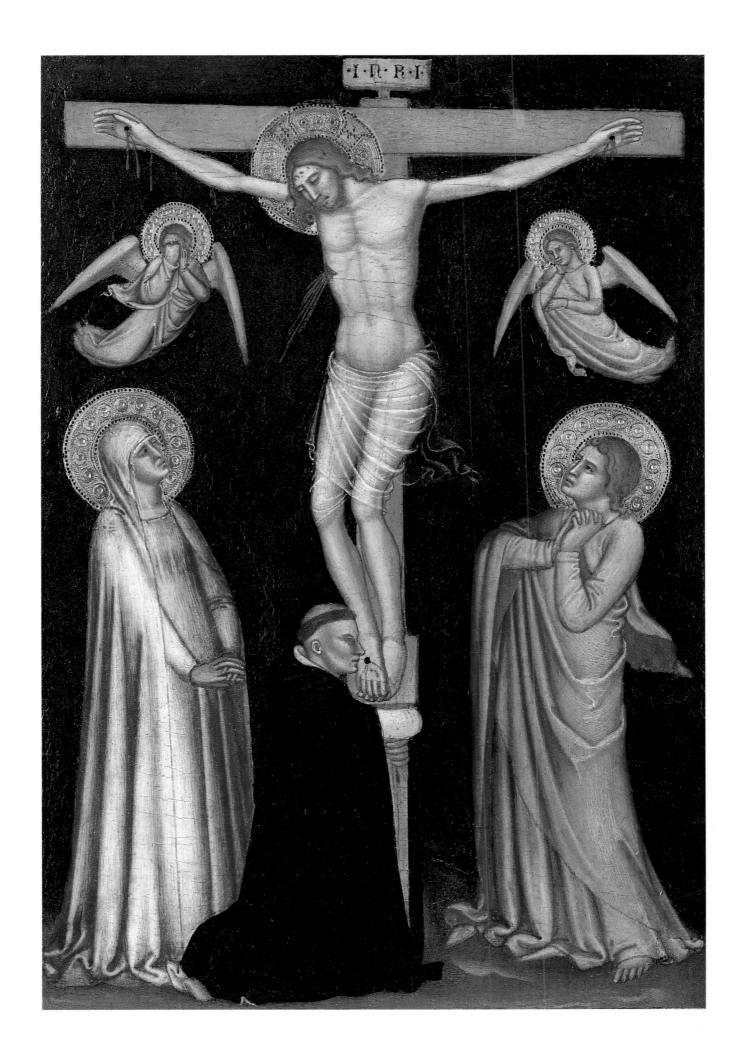

School of Rimini
CRUCIFIXION WITH SAINTS PETER AND PAUL AND
NOLI ME TANGERE, mid 14th century
Tempera and gold on wood
56.1 x 37.7 cm (22⅛ x 14¾ in.)
Vatican Museums, inv. 40181

Conservation courtesy of John H. Surovek

Literature: Rossi in Pinacoteca Vaticana 1994,
122–24, no. 36, fig. 98; R. van Marle, "La scuola
di Pietro Cavallini a Rimini," in *Bolletino
d'Arte* (1921/22):256, n. 1; M. Salmi, "La
scuola di Rimini, II," in *Rivista del R. Istituto di
Archeologia e storia dell'Arte* 4 (1932/33):187,
198; C. Brandi, *Mostra della Pittura Riminese
del Trecento* (Rimini, 1935), 16; Offner 1947,
168; M. Boskovits and E. Schleier, *Gemälde-
galerie in Berlin. Frühe italienische Malerei*
(Berlin, 1988), 132.

The panel is divided horizontally in two parts.
On the top is the Crucifixion with Saint Peter
and Saint Paul, and on the bottom are scenes
of the Three Holy Women at the Sepulcher
and *Noli me tangere*.

The crucifix is in the center of the upper
part. The dead body of Christ is surrounded
by saints and angels. Mary Magdalene kneels
on the left in front of the cross, embracing it
and kissing the feet of Christ. On the right
stands John the Evangelist, his hands joined in
mournful prayer and his gaze lowered to Mary
Magdalene. Behind her a couple of holy
women support Mary, the mother of Jesus, who
swoons unconscious in their arms. Farther
away on the left stands the figure of the apostle
Paul, holding the sword and a closed book.
Peter stands in a symmetrical position on the
other side, with the key and an open book in
his hands. Although their proportions and
places on the same ground seem to indicate
that the two apostles belong to the central
scene, they are actually separated from it by
the internal architecture: Paul is positioned
below a rather archaic roof structure supported
by corbels, while Peter stands before and below
a much more elaborate construction, which
combines elements of ecclesiastical and civic
buildings and is probably meant to be an
allusion to St. Peter's and the Vatican palaces.

The lower part of the panel shows two
closely related scenes. From the left, three
women approach the empty tomb in the center.
They hold vessels, presumably containing
ointments. The woman on the far left has
raised her right hand in a gesture of greeting.
They move toward the angel who is seated on

the lid of the open tomb. This angel, while
looking at the three women, points with his
right hand to the scene on the other side.
There Mary Magdalene can be seen kneeling
before Christ, whose gesture signals her not to
approach more closely and not to touch him
(*Noli me tangere*).

The combination of these scenes is not
uncommon in Italy in the fourteenth century.[1]
Some elements, such as the apparition of
three, and not of one or two, women or the
appearance of only one angel on the tomb
instead of two (John 20:12), were only
established in the trecento. The inclusion of
Peter and Paul, who are not separated by any
kind of frame from the central narrative
representation, is, however, unusual in their
close proximity to this scene. Their iconic
appearance contrasts with the emotional scene
of the crucifixion in the center.

Two types of angels are depicted in this
panel. The angels around the cross are
reminiscent of figures of angels created first by
Giotto, such as the angels in the fresco of the
Lamentation over the Dead Christ in the
Scrovegni Chapel, Padua (fig. 1), or in the
Stefaneschi Altarpiece at the Vatican. These
angels are able to express emotions, in this case
grief. Their inner emotions are expressed by
sad and sorrowful features, accompanied by
traditional gestures of mourning such as
spreading their arms out wide and wringing
their hands.

The angel sitting on the tomb is different in
appearance and size and is more distinguished
than the angels around the Crucifixion. He has
an active and important role in the scene,
linking the two parts together. He is therefore
depicted not light and ephemeral as the
mourning angels at the top; and, in contrast to
them, he has legs.

The origin of this panel is unknown. It
could have been an altarpiece for an altar
dedicated to Saint Mary Magdalene, who holds
a prominent position in both parts of the panel.
The painting is attributed to the school of
Rimini, mainly because it can be compared to
a polyptych in the Museo Civico in Rimini.[2]
Its quality has been described as "inferior,"[3]
but its obvious archaic style has recently been
called "conceptual rather than formal,"[4] and
the reason for this is that it might originate
from a provincial area.
Johannes Röll

1. See Medea 1940, 10, 36.
2. See Brandi 1935, 16.
3. Van Marle 1924, 298.
4. Rossi 1994, 124.

Fig. 1. Giotto, *Lamentation over the Dead Christ*
(detail), after 1305, fresco. Scrovegni Chapel, Padua

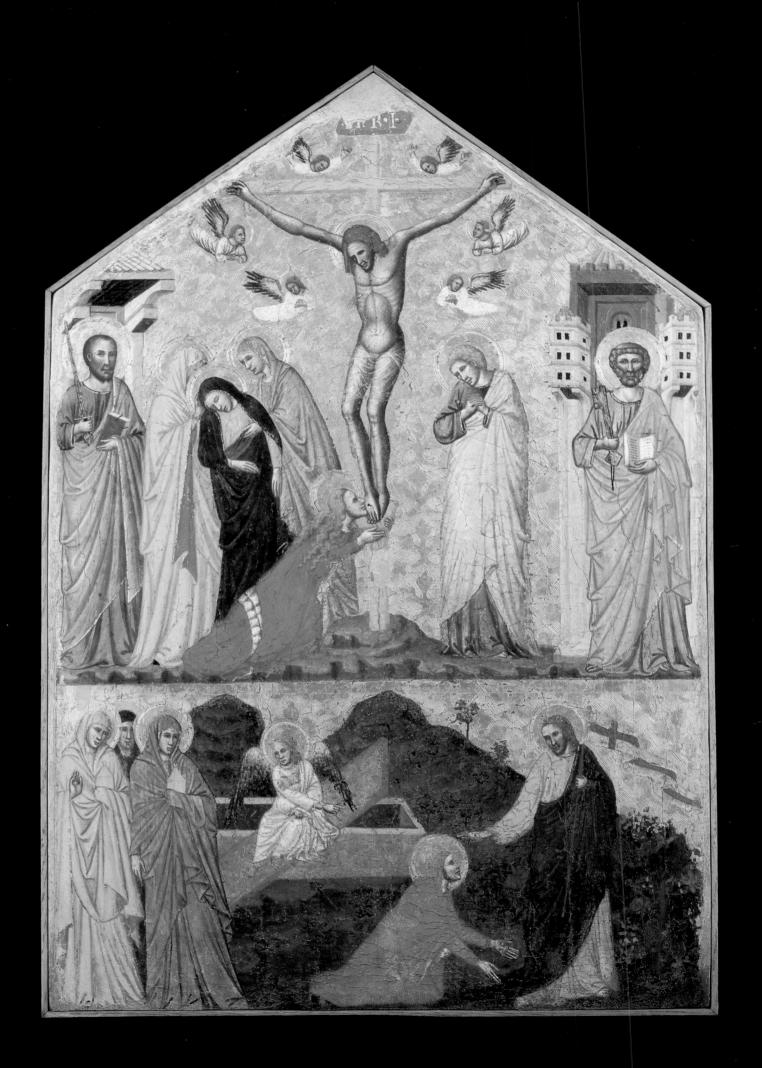

43

Giovanni Francesco Barbieri, called Guercino
(Cento, 1591–Bologna, 1666)
THE PENITENT MAGDALEN, 1622
Oil on canvas
222 x 200 cm (88 x 70 in.)
Vatican Museums, inv. 40391

Exhibitions: New York 1982; Ottawa 1986;
Tokyo, 1989; Bologna, Museo Civico
Archeologico, *Giovanni Francesco Barbieri.*
Il Guercino 1591–1666, 1991.

Literature: F. Titi, *Descrizione delle pitture,*
sculture e architetture esposte al pubblico in
Roma (1675; Rome, 1763), 348–49; G. Passeri,
Vite de' Pittori, scultori, e architetti, che hanno
lavorato in Roma, e che sono morti dal 1641 al
1673 (Rome, 1772), 378; G. and A. D'Este,
Elenco degli oggetti esistenti nel Museo Vaticano
(Rome, 1821), 38; A. Porcella in Vatican 1933,
196; N. Barbanti Grimaldi, *Il Guercino*
(Bologna, 1968), 92; D. Mahon, *Il Guercino,*
catalogo critico dei dipinti (exh. cat. Bologna,
1968), 111–12; F. Mancinelli in New York
1982, 164, no. 87; L. Salerno, *I dipinti del*
Guercino (Rome, 1988), 171, no. 88; D. Mahon,
Giovanni Francesco Barbieri. Il Guercino
1591–1666 (exh. cat. Bologna, 1991), 156, no.
54; A. M. De Strobel and M. Serlupi Crescenzi,
"Il Seicento," in Pinacoteca Vaticana 1992, 323.

When Alessandro Ludovisi, formerly the
cardinal archbishop of Bologna, became Pope
Gregory XV (1621–23), artists who had worked
for his family in his native city were called to
Rome, among them Domenichino, Guido
Reni, Albani, and Guercino, the latter
responding to the pope's invitation in 1621.

Guercino's presence in the Eternal City,
although brief in time since he had already
returned to Cento by 1623, deeply affected
local culture, dominated and divided as it was
in those days by the endless conflict between
classicism and realism.

In his short but fruitful sojourn, he
accomplished major works. These included
the innovative *Aurora* of the Casino Ludovisi,
painted some years after the similar painting
by Reni, and the colossal altarpiece *Saint*
Petronilla Buried and Resurrected in Heaven
(Capitoline Museums, Rome), commissioned
by the pope for an altar in the Basilica of
St. Peter's. Both masterpieces made a great
impression on contemporary artists and had a
decisive influence on the great masters of the
artistic renewal in the seventeenth century.

The Penitent Magdalen was painted for
the church of S. Maria Maddalena delle
Convertite in Rome's Via del Corso. The
church was damaged by fire in January 1617
and rebuilt during the pontificate of Paul V
(1605–21) under the patronage of Cardinal
Pietro Aldobrandini (who may have also
commissioned the painting), with a campaign
of works of art that culminated with the
placing of the exhibited painting over the high
altar in 1622. The year is confirmed by the
same date, which appears on the engraving
taken from the painting by Giovanni Battista
Pasqualini, the engraver and painter from the
region of Emilia. The painting is mentioned
by Passeri[1] and in guidebooks up to the end
of the eighteenth century. In 1798, during the
Napoleonic era, the church was suppressed
and the altarpiece transferred to the papal
residence in the Quirinal Palace and from
there was sent to the picture gallery of Pope
Pius VII in 1817.

Its location in the center of the city made
the painting very accessible and much admired
by numerous artists, clearly influencing Pier
Francesco Mola and inspiring a drawing by
Van Dyck.

The artist depicted the meeting between
Mary Magdalene and the angels in front of
Christ's empty sepulcher as narrated in the
Gospel of John (20:11–13). Guercino's
particular interpretation, aimed at underlining
the high moral meaning of the theme, was not
lost on Passeri who described the work "dipinse
S. Maria Maddalena pentita delle sue vanità,
e de' suoi errori genuflessa in un duro terreno
piangente le sue colpe, e due Angioli assistono
alla sua penitenza, col presentarle davanti agli
occhi quei chiodi, co' quali fu conficcato nella
Croce il nostro Redentore, e per indicarle la
vera speranza, che dee avere della propria
salute, uno di loro le addita il Cielo, e la
conforta in quell' asprezza di tante orridezze
per fare acquisto di una eterna felicità. A dire il
vero quel quadro è impareggiabile, e non riesce
discaro nel costume, e nelle sembianze, come
alcune altre opere uscite dal suo pennello"
(he painted Saint Mary Magdalen repentant of
all her vanities and errors, kneeling on stony
ground and weeping over her sins, with two
angels present at her repentance showing her
the nails with which Christ Our Savior was
fixed to the Cross. And to give her true hope
regarding her salvation, one [angel] points to
Heaven comforting her in that gloomy place in
order that she might find eternal happiness.
In all truth, that painting is incomparable, and
not displeasing in its costume and likenesses as
are some others painted by the same brush).[2]

The characterization as incomparable is in
keeping with the general feeling of admiration
that the painting aroused. Compared with the
artist's youthful works, it manifests an
approach to the classical ideal prevailing at
that time. The greater solidity of the figures
and the static composition, which, only a little
earlier, had been so fluid and "eccentric" give
the critic Mahon the impression that "the
togetherness of the group is in a certain sense
closer to that of a bas-relief placed in front of
a background, rather than that of figures
fused into it."[3] The painting is striking for its
classical, almost statuesque figures, its dense
tonal values, and the clever chiaroscuro play
of the splendid landscape and sky.
Maria Serlupi Crescenzi

1. Passeri 1772, 378.
2. Passeri 1772, 378.
3. Mahon 1991, 156.

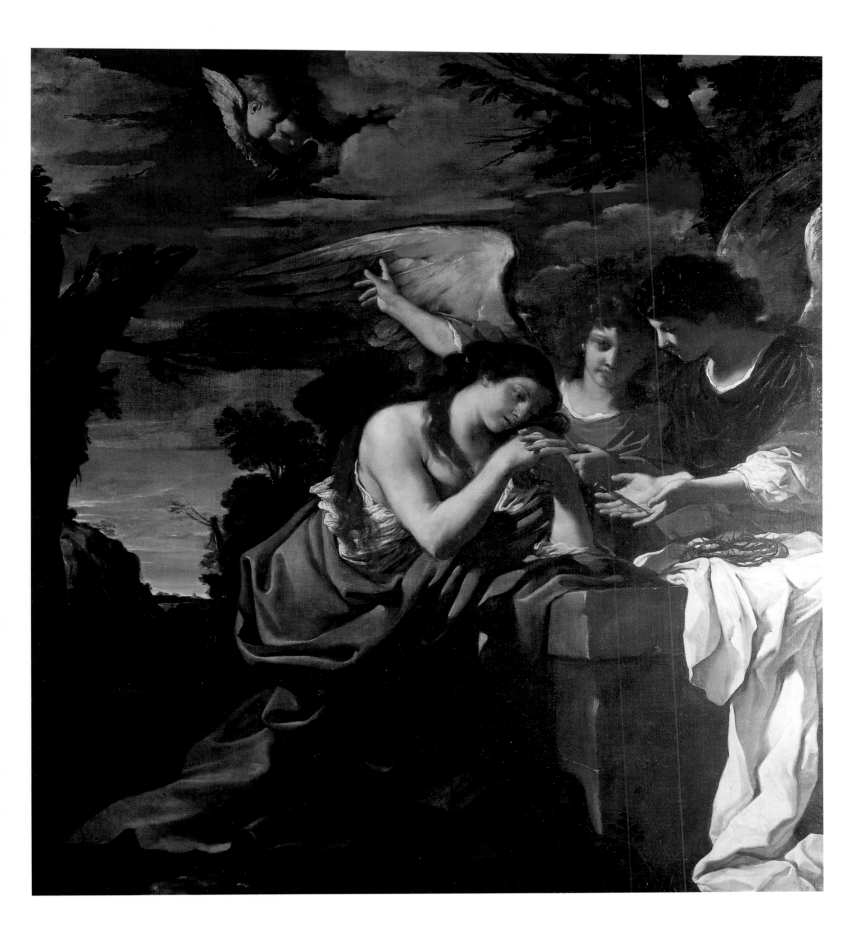

44

Slavic School, Probably Bulgarian
THE RESURRECTION OF CHRIST
4th quarter 17th century
Tempera on linen and wood with gold leaf
24 x 18.2 cm (9½ x 7¼ in.)
Vatican Museums, inv. 40052

Conservation courtesy of John J. Brogan

Provenance: Vatican Library.

Literature: Barbier de Montault 1867, 138, no. 9; Muñoz 1928, 14, no. 56, pl. XXVII, 5; Vatican 1934, 16, no. 52; A. Lipinsky, "Scene della Passione di Cristo in icone bizantine della nuova Pinacoteca Vaticana," in *L'Illustrazione Vaticana* no. 7 (Vatican City, 1933), 244–51; Vatican 1993, 77, no. 3g; Bianco Fiorin 1995, 55, no. 68, fig. 99.

Fig. 1. Creto-Venetian, *The Descent into Hell.* Vatican Museums

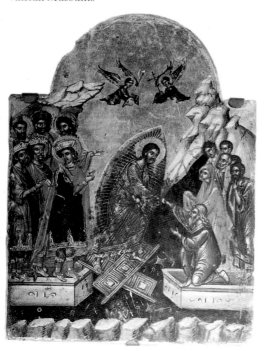

The Gospel narratives, in truth, are silent about the exact moment of the Resurrection of Jesus or the manner in which it took place. In contrast to the art of the Christian West, which almost exclusively shows Jesus himself rising bodily from the tomb, the eastern iconography is in general more respectful of the mystery of the event: it observes the New Testament silence on the Resurrection. To the early Christian representation of the spice-bearing women, or *Myrophores*, who ran to the tomb on Easter morning and received from the angel the announcement that Christ had risen, the Byzantine East would soon add a theological interpretation of the *Anastasis*. This took the form of representing the Resurrection as the *Descent into Hell*, the event in the course of which the Lord, breaking down the gates of Hades, is brought into the presence of and rescues from death the shades of Adam and Eve, the first parents of humanity as a whole. This symbolic image of the Resurrection is based on the account in the apocryphal Gospel of Nicodemus.[1]

The present icon represents, at the center, Christ in glory, resplendent in a burst of golden light. He is placed within an azure mandorla, graduated in tone and hatched with golden rays. Treading upon the gates of hell, which have been thrown off their hinges and flung to the ground, Christ is flanked by two groups of personages: they are the Just of the Old Covenant, prominent among whom are the figures of King David (with the crown), Moses, and Saint John the Baptist. In the persons of Adam and Eve, rising from their tombs in the form of sarcophagi, the whole of humanity is here being won and redeemed. The descent of Jesus into hell is the mysterious event which, according to the apocryphal tradition, took place on Good Friday when, following his death on the cross and before the Resurrection proper, Christ descended to the depths of the underworld, the abode of the dead, and so achieved the last step in his abasement (*kenosis*) by placing himself at the very heart of the fallen creation. Just this mystery is sung by the Byzantine liturgy of Good Friday: "When you abased yourself to the point of death, you, the immortal life, paralyzed death by the radiance of your divinity; when you resurrected the dead from the depths of hell, all the powers of the heavens exclaimed: O Christ, you who gave life, you our God, glory be to you!"[2]

Thus, the Byzantine Easter hymnody proclaims, "the angelic people were struck by admiration in seeing you, as you sojourned among the dead, destroy, O Savior, the power of death, resurrect Adam with you and bestow freedom on all who were in Hell."[3] The Resurrection of Christ is "sung by the Angels

in heaven"; and in the present icon two of them, with wings outspread, flutter in the sky above Jesus, presenting with veneration the instruments of the Passion—the cross, the lance, and the sponge—which had permitted so glorious a victory over the powers of darkness, according to an iconography that spread especially in post-Byzantine painting. In the earliest Byzantine representations, Christ himself grasps in his hand the cross, the instrument of his triumph and of salvation.

The central idea of this image, whose iconography can be traced back to the high middle ages, consists, in short, in the representation of the Savior's triumph over death and over the evil forces of Satan, as celebrated in the Easter *troparion* of the Byzantine liturgy: "Christ is risen from the dead, *by his death he has vanquished death*, and to those who were in their tombs he has given life."

The palette with its radiant joyful colors, the somewhat coarse and popular style, the particular, and typically Byzantine, calligraphy of the Slavonic inscription въскр(есе́)нїе х(рн)с(то́)во, signifying the Resurrection of Christ, the homogeneous frame bordered by a broad and brilliant vermilion band, and lastly the thickness of the wood of the icon, laterally striped with black diagonals against the white of the section, are all characteristics that may relate the icon to those of the school of Veliko Tarnova of the late seventeenth century.[4]

Another feature worth noting is the traditional expression in Greek ὁ ὤν in the cruciform nimbus of Jesus (*He who is*); the term is attributed to iconographic representations of the Three Divine Persons, especially in post-Byzantine art.

It is interesting to compare this icon with the manner, more supple and nuanced, of the Creto-Venetian polyptych or triptych, now dismantled, of the *Descent into Hell* (fig. 1), also in the Vatican Picture Gallery.[5]
Michel Berger

1. On the Byzantine iconography of the Resurrection, see Ouspensky and Lossky 1982, 185–92; R. Lange, *Die Auferstehung*, Iconographia Ecclesiae Orientalis (Recklinghausen, 1966); H.-J. Schulz, "Die Höllenfahrt als 'Anastasis.' Eigenart und dogmen—geschichtliche Voraussetzungen byzantinischer Osterfrömmigkeit," *Zeitschrift für Katholische Theologie* 81 (1959):1–66.
2. *Automelia* 2nd tone, office of Matins of Holy Saturday.
3. *Evloghitaria* of the Resurrection, office of Matins of Holy Saturday.
4. On the painted icons of the school of Veliko Tarnova, see K. Pascaleva, *Les Icônes bulgares IXe-XIXe siècles* (Sofia, 1988), 36–53.
5. Bianco Fiorin 1995, 22, fig. 21.

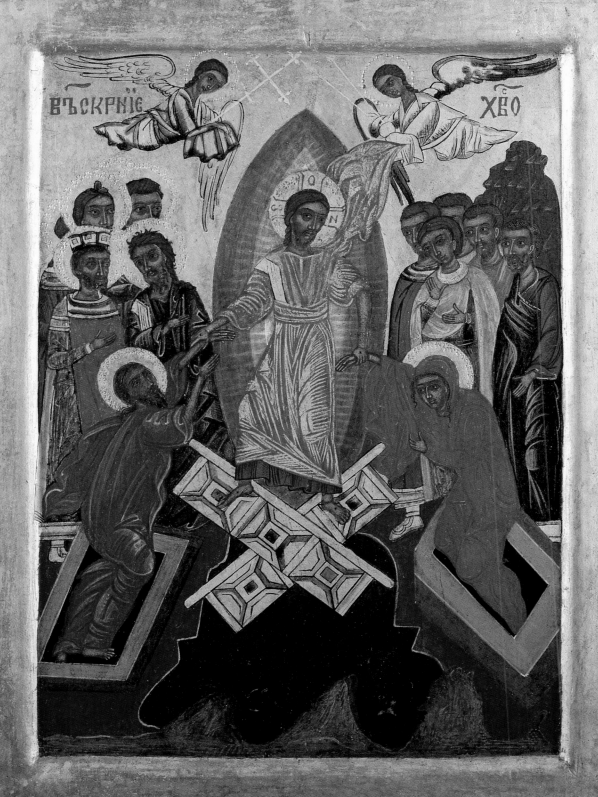

45

Domenico Cresti, known as Il Passignano
(Passignano, 1559–Florence,1638)
THE RESURRECTION, 1st quarter 17th century
Oil on canvas
112 cm x 70 cm (44 ⅛ x 27⅝ in.)
Vatican Museums, inv. 42417

Conservation courtesy of Mr. and Mrs. Robert
A. Day and Family, Mr. and Mrs. T. J. Day, and
The Willametta K. Day Foundation

Literature: Pietrangeli 1982, 143–200,
especially 168, 192, fig. 17.

It is possible to partially reconstruct the history of this small but interesting painting. Writing in ink on the back of the canvas refers to its placement in the latter half of the seventeenth century in the Chapel of Saint Ignatius at the initiative of Father Lorenzo Ricci.[1] The Florentine Ricci (1703–75) was the last general of the Jesuits (1758–73) prior to the suppression of the order. The Chapel of Saint Ignatius, rebuilt around the year 1700, was located in the area known as La Storta, 12 km (7½ mi.) outside Rome on the Via Cassia. There Ignatius of Loyola had a vision in November 1537 while en route to Rome to found his order.[2] The definition "first category no. 19" most likely refers to an inventory by the Jesuits in which the painting was judged to be of considerable value. Requisitioned at the time of the suppression of the Company of Jesus, the picture, together with some floral paintings by Daniel Seghers, was subsequently inserted into the Picture Gallery of Pius VI in the Vatican. There it appeared in a simple gilt frame in an inventory of 1800.[3] For much of this century it was kept in the Floreria Apostolica before being placed in deposit at the Vatican Museums in 1979.

Domenico Cresti (Il Passignano), to whom the picture was rightly attributed from the time it was the property of the Jesuit order, is an artist of Florentine background who expressed himself according to the values promoted by the Counter-Reformation. This picture, probably born out of devotional motives, is a worthy example. Stylistically it resembles the mature works of Passignano, who lived for years in Florence and was a part of the last generation of artists in the school of Giorgio Vasari and the Zuccari brothers, respectively heads of the most important pictorial workshops of the mid sixteenth century. Passignano traveled often to Rome and worked for several popes, from Gregory XIII to Sixtus V and Clement VIII. Eventually he, together with Santi di Tito, became the ideological point of reference in the assignment of all large pictorial commissions of a religious nature. He was actively at work in St. Peter's Basilica under Urban VIII in the second decade of the seventeenth century. At the same time he made frequent return trips to Florence and in fact died there in 1638.[4]

This *Resurrection* conforms to the pictorial requirements of the Counter-Reformation, which encouraged paintings designed to explain theology according to the dictates of Church teachings. Typical, for example, was the use of "captions" drawn from passages in the Bible. In fact, there are two quotes here: from Psalms 15:11[5] and from the first letter of Paul to the Corinthians 15:54.[6] Both refer to Christ's resurrection, to victory over death, and to the glory of eternal life. Passignano created two distinct zones in his canvas: below, there is the darkness of the sepulcher, with the guards asleep next to a nearly spent fire; above, a radiant and triumphant Christ encircled by angels. This is unusual iconography considering the rigid counterposition of light and darkness. The emphasis here is on the dichotomy between life and death, in which the figure of the resurrected Christ is the theological and existential synthesis. The lavish presence of adoring angels, which makes clear the victory over death, is forcibly underlined by the passage from Paul, "absorpta est mors in victoria" (death is swallowed up in victory), whereas the quote from the Psalm makes clear for the believer his destiny in Christ.

The frank mood of glory that characterizes this Resurrection, amplified by the adoring angels and the text from the Psalms, strongly suggests a passage in the writings of the Jesuit cardinal Saint Robert Bellarmine. In 1611, commenting on the same biblical text, Bellarmine called it the ideal expression of Christ's heritage to man. Not only is there the rising up from the dead, conveyed through the splendid metaphor of the Redemption, but also the glory of immortality. The vision of Christ Triumphant comprises the beatitude that overflows into the glory of the body, when at last we will see God face to face.[7] These considerations lead one to suppose that the painting was conceived within the sphere of Jesuit culture in the early years of the seventeenth century.
Maria Antonietta De Angelis

1. On the back of the painting: "Prima classe n. 19. Opera di Dom. o Passigniani dato alle Cape di S. Igni dal M Ro P N Lorenzo Ricci" (First category, n. 19. Painting by Domenico Passigniani given to the Chapel of St. Ignatius by our Very Reverend Father Lorenzo Ricci).
2. E. Levy in Vatican City 1990, 222, no. 140.
3. Pietrangeli 1982, 168, 192.
4. S. Prosperi Valenti Rodino's entry in the *Dizionario Biografico degli Italiani* 30 (Rome, 1984), 741–48.
5. On the front, below: "NOTAS. MIHI. FECISTI. VIAS. VITAE./ ADIMPLEBIS. ME. LAETITIA. CUM. VVLTV. TUO" (Ps. 15:11).
6. On the front, center: "ABSORPTA EST MORS IN VICTORIA" (1 Corinth. 15:54).
7. R. Bellarmino, *Explanatio in Psalmos* (Rome, 1931), 57–58.

ABSORPTA EST MORS IN VICTORIA

NOTAS · MIHI · FECISTI · VIAS · VITÆ
ADIMPLEBIS ME · LÆTITIA · CVM VVLTV TVO

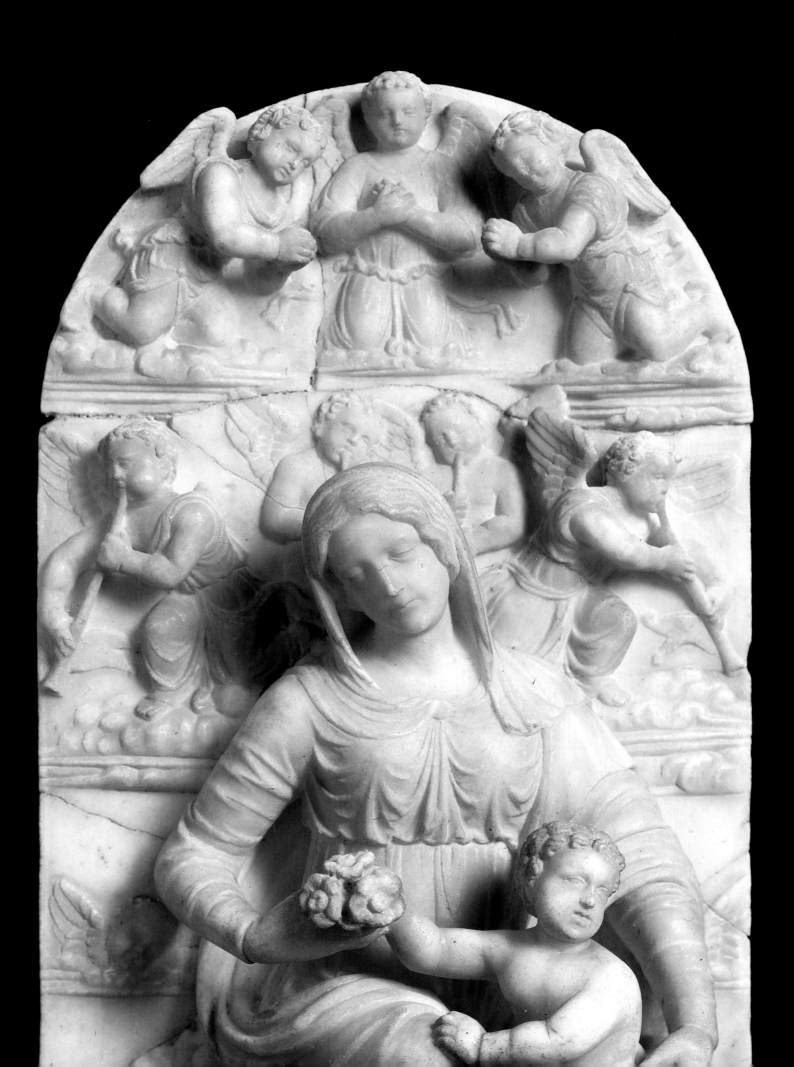

ANGELS IN THE LIFE OF THE VIRGIN

Detail of cat. 54 (actual size)

46

Virginio Ciminaghi (Milan, 1911–)
THE ANNUNCIATION, 1967
Bronze
94 x 162 x 46 cm (37 x 63¾ x 18⅛ in.)
Vatican Museums, inv. 23116

Provenance: Gift of the Faraggiana family.

Literature: Ferrazza and Pignatti in Vatican City 1974, cat. 357, b/w photo; Fallani, Mariani, and Mascherpa in Milan 1974, 90, pl. 35 b/w.

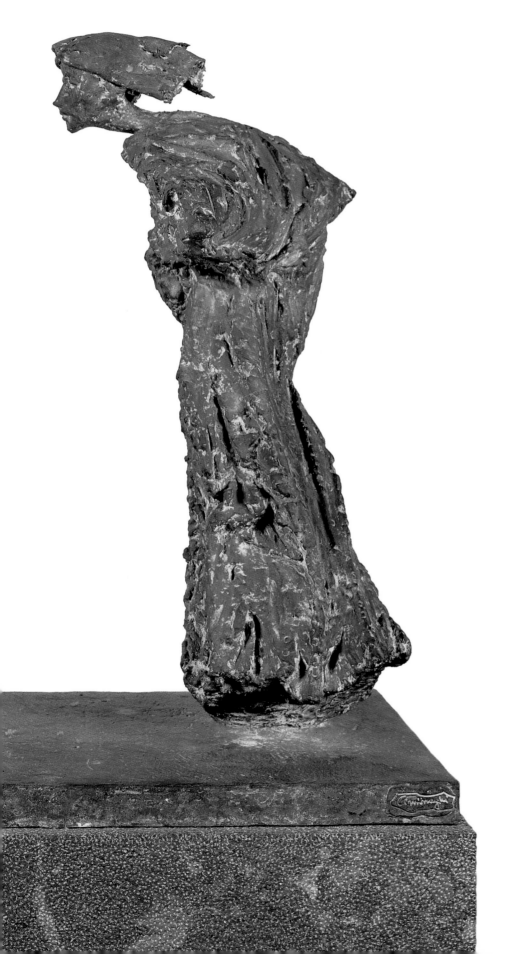

Of all the angels that appear in the Old and New Testaments, the archangel Gabriel, the angel of the Annunciation, is the one who has most inspired artists and stimulated popular piety. The sentimental effusion that surrounds the theme of the angel's annunciation to Mary, with its implicit mystery of the Incarnation of God, is in part due to the pen of the evangelist Luke, a fine and delicate narrator such as to merit the praise of Dante in his *De Monarchia*.[1]

The sentimental emphasis also prevails in this sculpture, which is stamped with Ciminaghi's signature on the base. Eschewing the hieratic impersonality of sacred compositions, the artist favored instead a psychological characterization that emphasizes the more affectionately human aspects of the scene: the intimacy of the encounter, the respectful greeting of the angel, the tender-hearted modesty of the Virgin. The figures, reminiscent in modeling of the Art Nouveau style, suggest a movement in a dance that seems to envelop them in an ascending spiral.

The whole composition displays an elegant and lively mastery of rhythm and form and also reveals what variety of feelings may be inspired by a subtle poetic vein.
Mario Ferrazza

1. 1:16.

175

47

Federico Fiori, called Barocci (Urbino, 1528/35–1612)

THE ANNUNCIATION, 1582–84
Oil on canvas
248 x 170 cm (99 x 68 in.)
Vatican Museums, inv. 40376

Conservation courtesy of the Florida chapter of the Patrons of the Arts in the Vatican Museums

Literature: Bellori 1931, 181–82; E. Calzini, "Federico Barocci e il suo mecenate," in *Rassegna Bibliografica dell'Arte Italiana* 15 (1913):54–64, nos. 5–8; G. Gronau, *Documenti artistici urbinati* (Florence, 1936); H. Olsen, *Federico Barocci* (Copenhagen, 1962), 177–79; E. Pillsbury and L. S. Richards, *The Graphic art of Federico Barocci* (Cleveland, 1978), 105, no. 75; A. Emiliani, *Mostra di Federico Barocci* (exh. cat. Bologna, 1975), nos. 150–51; A. Emiliani, *Federico Barocci*, vol. 1 (Bologna, 1985):198–207; F. Grimaldi and K. Sordi, *Pittori a Loreto, Committenze tra '500 e '600. Documenti* (Ancona, 1988), 70.

Fig. 1. Federico Fiori, called Barocci, *The Annunciation*, drawing. Uffizi, Florence, inv. 11479, F v.

Fig. 2. Federico Fiori, called Barocci, *The Annunciation*, etching. Pinacoteca Nazionale, Gabinetto Disegni e Stampe, Bologna, Fondo Corsini 76165

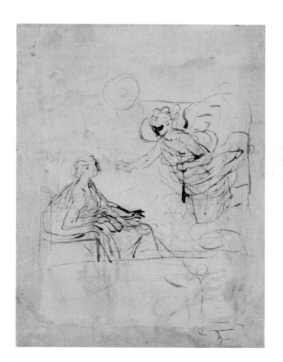

Barocci painted *The Annunciation* for the chapel of his patron, Francesco Maria II della Rovere, duke of Urbino, in the Basilica of Loreto between the years 1582 and 1584. This date is based on two bills and a receipt for "the Loreto picture" recorded in the duke's expenditure ledger, preserved in the Florentine State Archive.[1]

On October 7, 1583, Barocci sent a letter to Giovanni Tommasi di Montebello in which he mentioned the problem of light in the chapel, pointing out that if this were to be improved, "non potrà se non giovare, et far buono effetto, se bene in quanto alla tavola dal' altare, il lume non è al suo luogo, circa puoi di fare l' invetriata dipinta, puoi che S.A. vuol il parer mio, non voglio mancare dirlo liberamente, quale è che in muodo alcuno mi piace, et è cosa oscura et fa anco cativissimo effetto che percotendo il sole in quelli cori del invetriata gli reporta nelle figure, et fa cattivo effetto…" (it can only benefit and look well, even if regarding the altarpiece, the lamp is not in its place, then regarding the making of the stained glass, if Your Grace wants my opinion, I wish to give it freely and say that I don't like it at all, since it darkens and looks ugly with the sun striking on those segments of the stained glass and reflecting back on the figures to give a bad effect…).[2] The next day, October 8, 1583, Duke Francesco Maria wrote to Simone Fortuna in Florence mentioning the Loreto painting, which was still being worked on.[3]

In 1797 the altarpiece was seized by French troops and transferred to Paris, where it remained until 1815. Since it was returned in 1820, it has been exhibited in the Vatican Picture Gallery. Probably because of damage caused on its journey to Paris, the panel was first placed on a cloth base, but since this proved too light in weight, it became necessary to transfer it onto a stronger canvas.[4]

Many copies of the painting are known to exist, the most renowned being the one mentioned by Bellori[5] and Baldinucci,[6] payments for which have been identified as recorded by the duke himself in his *Note di spesa* (expenses).[7] In 1593 the copy was sent to Spain and placed in the vicar's chapter house in the Escorial Palace where it was seen by Conca and others, only to disappear during the Napoleonic wars.

The inventory made on the death of the artist mentions the presence in his workroom of another altarpiece, with proportions similar to the *Annunciation*, roughly sketched in and with the figures dressed differently. The dimensions of this sketch coincide with those of the Vatican painting and would seem to demonstrate the re-utilization of the same preparatory drawing for different works, either by Barocci himself or entrusted to his workshop.

The great number of drawings preserved for the most part in the Uffizi and the Kupferstichkabinett in Berlin testify to the complex origin of the work and the extreme care that this artist from Urbino habitually dedicated to his preliminary phase. After a first sketch that resembles the *Annunciation* fresco in the Casina of Pope Pius IV (1559–65) in the Vatican, painted several years earlier (fig. 1), the other sheets show the new composition that so attracted Ludovico Carracci and inspired his *Annunciation* of 1585 (Pinacoteca Nazionale, Bologna).

The divine event is depicted in terms of simple yet extraordinary humanity as perceived by Bellori in his description.[8] The kneeling Virgin poses with her left hand touching the book on the table "and opens her right hand in humble wonder," the angel has a lily in one hand "e distendendo placidamente verso di lei la destra, annuntia riverente il divino mistero. Espose il Barocci le dolci arie bellissime della Vergine, e dell' Angelo: quella in faccia, questi in profilo; l' una spira tutta modestia, e humiltà verginale, gli occhi inclinati, e raccolti semplicemente i capelli sopra la fronte; senza che le accresce decoro il manto di color celeste, spargendosi dal braccio sù l' inginocchiatore a terra. Ma l' Angelo nel suo bel profilo hà del celeste, sciogliendo sù la fronte, e sù'l collo i crini d' oro, e non solo ne' dintorni, e nella formatione sua si dimostra agile, e lieve, ma il colore stesso palesa la spirituale natura, temperato soavissimamente nella sopraveste gialla, e nella tonaca di un rosso cangiante, con l' ali cerulee, quasi iride celeste" (and calmly holding out his right hand

toward her, reverently announces the divine mystery. Barocci portrays the sweetly gentle looks of the Virgin and the angel: she facing us, he in profile. She is all modesty and virginal humility, eyes cast down and with hair drawn back from her brow, her pale blue mantle hanging from her arms to fall on the footstool adding nothing excessive to her decorum. But the handsome profile of the angel has a celestial aura, his golden locks spill over his forehead and neck, and he appears agile and light; and the color itself subtly reveals his spiritual nature, in his yellow gown and reddish robe, with irridescent sky-blue wings). Behind the figures, an open window reveals that view of the Urbino landscape dominated by the ducal palace that Barocci included in many other of his paintings, from the *Crucifixion* (Galleria Nazionale delle Marche, Urbino, and the cathedral, Genoa), to the splendid *Crucifix* (Museo del Prado, Madrid) and *Christ Appearing to Mary Magdalene* (Uffizi, Florence). Finally, the cat in the foreground, a real-life detail, is a further confirmation of the intention to present the supernatural event in a simple everyday context, making it seem even more real and therefore more effective in performing that didactic-religious function promoted by the Counter-Reformation.

The painting enjoyed a great success, and the "Duca per la gran sodisfattione ... rimunerò liberalissimamente l'arte ingegnosa" (Duke as a result of his great satisfaction ... liberally remunerated this brilliant artistic achievement.)[9] But the painting became even more widely known by his engraving dated sometime between 1584 and 1588 (when Philippe Thomassin also made an engraving of the *Annunciation*) in response to a suggestion from the duke (fig. 2). The engraving, signed "Federicus Barocius Urb./ Inventor excudit," is an authentic masterpiece with its innovative engraving techniques, thanks to which Barocci succeeded admirably in rendering even in black and white the iridescent effects for which the original painting was renowned.
Maria Serlupi Crescenzi

1. Cl.III, F. a XXIII, cc. 691, 696, 698.
2. Grimaldi and Sordi 1988, LXVII, p. 70.
3. Gronau 1936, 154.
4. *Rendiconti della Pontificia Accademia Romana di Archeologia* 13 (1925):943 ff.
5. Bellori 1672, 193.
6. Baldinucci 1702, 338.
7. Calzini 1913, 57.
8. Bellori 1672, 181–82.
9. Bellori 1672, 182.

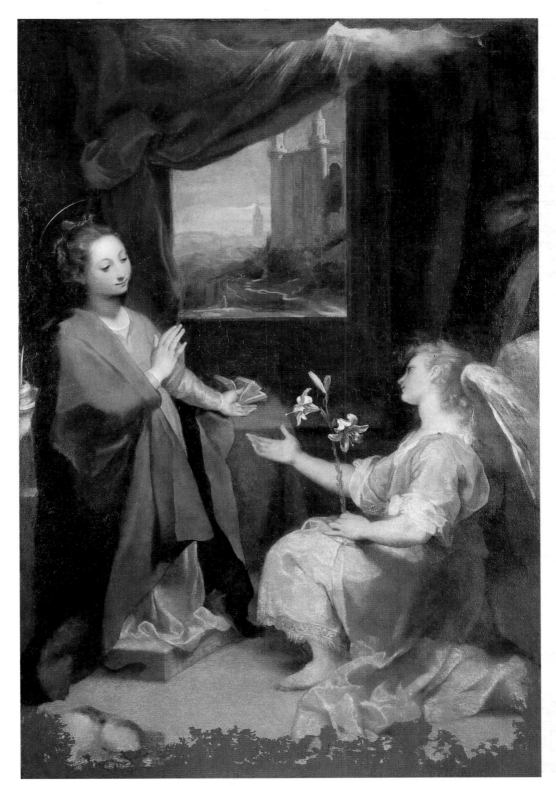

48

Flemish Manufactory, Brussels
THE HOLY FAMILY, 1490–1505
Wool, silk, and silver
125 x 135 cm (49 x 53 in.)
Vatican Museums, inv. 43832

Exhibition: Vatican City 1984–85.

Literature: G.Viatte, *Le XVIe Siècle Européen:
Tapisseries* (exh. cat. Paris, 1965), 33;
G. Souchal, *Chef-d'oeuvre de la tapisserie du
XIV au XVI siècle* (exh. cat. Paris, 1973), 191;
S. Schneebalg-Perelman, "Un nouveau regard
sur les origines et le développement de la
tapisserie bruxelloise," in *Tapisserie
bruxelloise de la pré-Renaissance* (exh. cat.
Brussels, 1976), 183–84; G. F. Wingfield Digby,
*Victoria and Albert Museum: The Tapestry
Collection, Medieval and Renaissance* (London,
1980), 40; C. Adelson, "Sacra Famiglia," in
Milan 1984, 254–56, no. 94.

A blessing (*benedicente*) angel with wings
unfurled and the Holy Family stand out
against the rich, brocaded draperies in the
sumptuous background of this tapestry. A
dossal can be seen at the back, and numerous
bystanders observe the scene from behind two
columned parapets flanking the sides of the
tapestry.

The Virgin Mary is seated on the ground,
following the iconographic tradition of the
Madonna of Humility. The holy child is in her
lap, holding a rattle in his right hand and
extending his left hand toward a piece of fruit
offered to him by Saint Joseph, which might be
an apple (the fruit of salvation), although a
previous restoration has made it impossible to
identify the fruit with any accuracy. Joseph is
represented in the usual fifteenth-century
Flemish fashion, with a pilgrim's staff, a
padded hat, and wooden clogs. The scene is
framed on the sides by two Gothic columns,
which are encrusted with precious stones and
pearls and decorated with a cornflower motif,
while the outer border has a simple but
exquisite motif of entwining red roses.

The tapestry may have been conceived as an
altarpiece for a small chapel and, though its
provenance is unknown, it has probably been in
the papal collection since before the middle of
the sixteenth century. An inventory of the
Floreria Apostolica, dated 1544, describes a
"pannetto fine d'oro et seta, con la imagine
della Madonna col Figliuolo in grembo, et altre
figure, et freggio à mazzi di rose, lungo circa
una canna et è nella Cappella della Camera
Apostolica" (fine cloth of gold and silk, which
has an image of the Madonna with her son in
her lap, and other figures, and a border with
bunches of roses, about one *canna* long, and it
is in the Chapel of the Camera Apostolica).[1]
Many of the details of the description are
found in this tapestry, and since the piece
recurs in all of the successive inventories, it
seems reasonable to suppose that the
description refers always to the same tapestry.

Stylistically speaking, the *Holy Family*
belongs to a group of devotional tapestries
woven in Brussels between 1490 and 1505.

These tapestries share iconographic details,
borrowing their models from contemporary or
slightly earlier paintings. Two known tapestries
resemble this one: a *Holy Family* in the City
Art Museum of Saint Louis (Missouri) and
an *Offering of Fruit to Jesus* in the Musée
Historique des Tissus in Lyons. Their
composition is similar, with a few variations,
but they are twice as large. Instead of the
blessing angel, three angels are grouped
together in a choir; the features and attitudes
of some of the bystanders are different, while
a broader landscape encompasses the scene,
suggesting that they might have been woven
at a slightly later date.

There are also similarities between some of
the figures, the style of the hats, and the
brocade drapery in this tapestry and a *King's
Justice* shown at the Marczel de Nemes auction
in 1928[2] and more particularly with the so-
called "Mazarin" *Triumph of Christ* in the
National Gallery of Art in Washington, D.C.
In fact, the type of figures and the execution of
the two columns in the *Triumph* so closely
resemble the Vatican's *Holy Family* that their
cartoons may well have been drawn by the
same artist and the tapestries woven in the
same shop. Other likenesses can be found
between the face of the Madonna—a long,
broad oval with lowered eyes and a thin,
curving mouth—and a small tapestry
representing the *Adoration of the Child* in
Milan's Archiepiscopal Palace. The outer
border of interwoven rose branches resembles
that of an *Adoration of the Child* in the Victoria
and Albert Museum in London.

The tapestry is an extraordinarily fine
creation, because of the quantity of threads
used in the warp (90–111 threads/ dm)
and the lavish use of silver over the entire
surface, particularly along the border, which
is completely covered with it, and on the
exceptionally rich brocade drapery.
Anna Maria De Strobel

1. State Archives of Rome, Camerale I, 1557.
2. Amsterdam, no. 69.

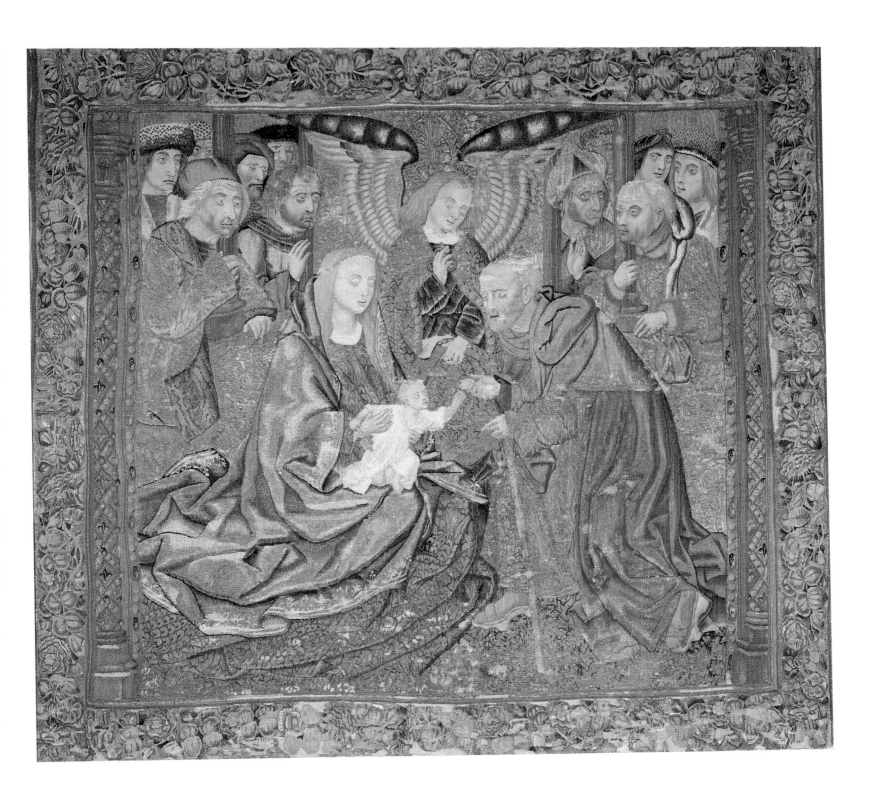

49

Francesco Mancini (S. Angelo in Vado, 1679–Rome, 1758)
THE REST DURING THE FLIGHT INTO EGYPT
Oil on canvas
136 x 100 cm (53½ x 39⅜ in.)
Vatican Museums, inv. 40398

Exhibitions: Tokyo 1989.

Literature: N. Ridarelli, "Un pittore del Settecento: Francesco Mancini," in *Rassegna Marchigiana* 2 (1923–24):322–28; H. Voss, *Die Malerei des Barock in Rom* (Berlin, 1924), 612; Vatican 1933, 203; M. Levi D'Ancona, *The Garden of the Renaissance, Botanical Symbolism in Italian Painting* (Florence, 1977), 365–66; G. Sestieri, "Profilo di Francesco Mancini," in *Storia dell'Arte* 29 (1977), 73; Pietrangeli 1982, 143–46; G. Cornini and M. Serlupi Crescenzi, "Il Settecento," in Pinacoteca Vaticana 1992, 395.

In 1772, during the pontificate of Clement XIV (1769–74), three of Mancini's paintings were bought for 500 *scudi*: *The Rest During the Flight into Egypt* and two others of profane subjects, *Love Conquering Nature (The Struggle between Love and Pan)* and *Chastity Conquering Profane Love (The Virtue of Modesty Flogging a Cupid)*. The first two are in the Vatican Picture Gallery and the third remains in the Quirinal Palace.[1]

Held in the past to have been a work of Carlo Maratta, *The Rest During the Flight into Egypt* was correctly attributed in the guide to the Vatican Picture Gallery of 1933 to Francesco Mancini, an artist born in the Marches but trained in Emilia.[2]

From a very early age, Mancini attended the school in Bologna run by Carlo Cignani, who educated him in a classical mold. In 1714 he was summoned to work in Ravenna (in the library known as the Biblioteca di Classe), later in 1719 to the cathedral of Foligno, and in 1725 he moved to Rome. On his arrival in the papal city he was elected a member of the Academy of Saint Luke and executed several works including the *Miracle of Saint Peter and Saint John* in the Quirinal Palace and *The Healing of Tabitha*, commissioned for St. Peter's Basilica by Pope Benedict XIII (1724–30). Knowledge of Mancini's profane works is rather more limited, and the best of these is the cycle of frescoes with the *Stories of Psyche* in the coffeehouse of the Palazzo Colonna (1735–40). The frescoes of the dome of the Chiesa Nuova dei Filippini in Perugia (1730), those of Our Lady of Mercy in Macerata (1736), and many other paintings bear evidence of his extensive activity in many churches in cities then belonging to the Papal States (Perugia, Città di Castello, Fano, Forlì, Rimini).

Mancini holds a remarkable position in the circle of artists working in the Papal States during the first half of the eighteenth century.

He studied the great models of Emilian seventeenth-century painting but went back still further, fascinated by Correggio's mannerism. During the period he spent in Rome he was influenced by the works of Gaulli and Pietro da Cortona, to whom *The Struggle Between Love and Pan* had been attributed until Sestieri rightly reattributed it to Mancini himself.[3] The various experiences the artist absorbed resulted in painting that was far from academic, characterized rather by a compositional ease and agility of execution that create a vital synthesis of baroque and rococo motifs, enriched by recollections of the sixteenth century.

In *The Rest During the Flight into Egypt*, the figures of the Virgin and child are harmoniously composed, the former holding a small bowl in her hand (inspired by Correggio's *Madonna della Scodella*) with the child Jesus on her lap, turning toward Saint Joseph, who offers him some strawberries, the symbol of his human incarnation.[4] Behind the holy family are the figures of three angels, two of whom make music (one is playing a flute, the other is singing) while the third holds a garland of flowers above the Virgin's head. In the background appears an obelisk and some classical buildings that evoke a Roman landscape.

In the Vatican picture, the refined sensitivity of the artist is confirmed by the fineness of the painting: the Correggesque grace of the attitudes, the atmosphere of intimate familiarity, the softness of the modeling achieved with fluid brushwork that makes masterly use of shading, and a range of bright colors penetrated with light.
Maria Serlupi Crescenzi

1. Pietrangeli 1982, 146.
2. Vatican 1933, 203.
3. Sestieri 1977, 74.
4. See Levi D'Ancona 1977, 365–66.

50

Tommaso di Cristofano Fini, called Masolino da Panicale (Panicale in Valdarno, 1383–c. 1440)
THE BURIAL OF THE VIRGIN, c. 1428–31
Tempera on wood
19.7 x 48.4 cm (7¾ x 19⅛ in.)
Vatican Museums, inv. 40245

Restorations: 1970, 1982.

Provenance: 1428–31, high altar of the Basilica of Santa Maria Maggiore in Rome(?); 1568, Chapel of Saint John the Baptist in the Basilica of Santa Maria Maggiore in Rome (Vasari-Milanesi 1878–84, 2:293–94); 1867, Vatican Library, Christian Museum, Cupboard XI, no. 4 (Barbier de Montault 1867, 156); Vatican Library, Christian Museum, Showcase P, V, no. 125 (D'Achiardi 1929, 8); in the Vatican Picture Gallery since 1929.

Exhibitions: New York 1982; Milan, Palazzo Reale, *Arte in Lombardia fra Gotico e Rinascimento,* 1988; Tokyo 1989.

Literature: Vasari-Milanesi 1878–84, 2 (1878):293–94; Barbier de Montault 1867, 156; A. Schmarsow, *Masaccio-Studien* (Kassel, 1989), 3:74–78; Sirén 1906, 332; A. Schmarsow, "Frammenti di una predella di Masaccio nel Museo Cristiano Vaticano," *L'Arte* 10 (1907):216–17; D'Achiardi 1929, 8; R. Longhi, "Fatti di Masolino e di Masaccio," *La critica d'Arte* 5 (1940):145–90; J. Pope-Hennessy, "A Predella Panel by Masolino," *Burlington Magazine* 82 (1943):30–31; M. Salmi, *Masaccio* (Milan, 1948), 222; K. Clark, "An Early Quattrocento Triptych from Santa Maria Maggiore, Rome," *Burlington Magazine* 93 (1951):339–47; M. Meiss, "London's New Masaccio," *Art News* 51 (1952):23–24; M. Salmi, "Gli scomparti della pala di Santa Maria Maggiore acquistati dalla National Gallery," *Commentari* 3 (1952):14–21; U. Procacci, "Sulla cronologia delle opere di Masaccio e di Masolino tra il 1425 e il 1428," *Rivista d'Arte* 28 (1953):3–55; M. Davies in National Gallery 1961, 352–61; M. Meiss, "The Altered Program of the Santa Maria Maggiore Altarpiece," *Festschrift für L.H. Heidenreich* (Munich, 1964), 169–90; L. Berti, *L'opera completa di Masaccio* (Milan, 1969), 100–101, cat. 25; A. Braham, "The Emperor Sigismund and the Santa Maria Maggiore Altarpiece," *Burlington Magazine* 122 (1980):106–12; F. Mancinelli in New York 1982, 142–43, cat. 73; Joannides, IV, 1985, 1–5; M. Boskovits, "Il percorso di Masolino: precisazioni sulla cronologia e sul catalogo," *Arte Cristiana* 75 (1987):47–66; F. Mancinelli, "La Basilica nel Quattrocento," *Santa Maria Maggiore* (Florence, 1987), 191–96; C. B. Strehlke and M. Tucker, "The S. Maria Maggiore Altarpiece: New Observations," *Arte Cristiana* 75 (1987):105–24; C. B. Strehlke in Milan 1988, 303, cat. 54, 204–07, cat. 54 bis.

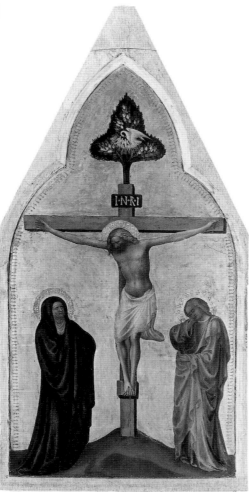

Fig. 1. Masolino da Panicale, *The Crucifixion*, tempera on wood. Vatican Museums, inv. 40260

This small predella panel represents the Burial of the Virgin, or more properly the Transitus Mariae, a subject rather seldom depicted in western art. Not mentioned in the canonical Gospels, it is treated at some length in apocryphal sources.[1] The representation of the episode combines iconographic elements proper to the Burial (such as the sarcophagus in which Mary's body is being placed), with others borrowed from the Dormition of the Virgin (such as the presence of the twelve apostles and of Christ himself, who accepts the soul of his mother, symbolized by the newborn child in swaddling clothes in his arms). The angels, customarily active protagonists in the episode, are here divided into two pairs, respectively placed at either side of the scene; each is limited to supporting a candlestick.

It has been proposed that both the present panel and a companion panel, the *Crucifixion*, it too preserved in the Vatican Picture Gallery, form part of a dismembered polyptych, its panels now divided between museums in Naples, London, Philadelphia, and Rome. The altarpiece in question was commissioned by Pope Martin V Colonna (1417–31) for the Roman basilica of Santa Maria Maggiore and is usually ascribed to Masolino with the collaboration of Masaccio (Tommaso di Giovanni, San Giovanni Valdarno, 1401–Rome, 1428).[2]

The main fragments of the Santa Maria Maggiore altarpiece (as it has come to be called) have survived in pairs, registered in the inventories of the Farnese family in Rome in 1653 and later in 1697. Since it has been ascertained that each of the surviving panels was obtained by sawing the same piece of wood in half (separating the front and the back of the panels), it seems beyond question that the triptych was originally painted on both sides.[3]

The *Crucifixion* (fig. 1) and the *Burial of the Virgin* share the same provenance: they come from the collection of Italian "primitives" formed by Gabriele Laureani (d. 1849) in the Vatican Library and transferred to the Vatican Picture Gallery in 1909.[4] The earlier provenance of the two panels is unknown (on the back of the panels there are no Farnese seals, whereas such seals are present on other panels of the polyptych). But observations made in the course of recent restorations (1970, 1982) confirm that the panels substantially retain their original measurements.[5] According to Kenneth Clark's attempted reconstruction, the centerpiece consisted of the scene of *Pope Liberius, in the Presence of the Patrician Johannes, Tracing the Plan of the Basilica in the Snow* (National Museum of Capodimonte, Naples). This was flanked to the left by the panels with *Saint Jerome and John the Baptist* (National Gallery,

183

London) and to the right by *The Evangelist and Saint Martin* (John G. Johnson Collection, Philadelphia Museum of Art, fig. 2). On the back of the polyptych, the central compartment with the *Assumption of Mary* (also in Naples) was accompanied to the left by *Saints Peter and Paul* and to the right by *A Pope Saint (Liberius?) and Matthew* (respectively in Philadelphia and London, fig. 3).[6] Of the hypothetical gable elements of the polyptych, it seems that only the *Crucifixion* in the Vatican Picture Gallery survives, while a small *Betrothal of the Virgin*, formerly in the Artand de Montor collection but now lost, was published by Pope-Hennessy as a possible pendant of the Vatican *Burial* and associated with the predella of the Santa Maria Maggiore altarpiece.[7]

The problem of the chronology of the altarpiece is closely bound up with that of Masaccio's participation in its execution; scholars are virtually unanimous in limiting his contribution to the *Saints Jerome and John the Baptist* in London. Among the various hypotheses proposed, stylistic reasons exclude too extreme datings and suggest that the work should be assigned to the period between 1428, the firm date both of the journey of Masolino and Masaccio to Rome and of the latter's death, and 1431, the year of the death of Martin V.

The triptych is mentioned for the first time in the second edition (1568) of the *Vite* (Lives of the Artists) of Giorgio Vasari, who affirms it was placed "in a little chapel close to the sacristy,"[8] identified by Procacci as the chapel of Saint John the Baptist, one of the four owned by the Colonna family in Santa Maria Maggiore.[9] There are, in fact, repeated references to their heraldic devices in the altarpiece. This has prompted the supposition that it was commissioned by the powerful Roman family and more probably by the Colonna pope Martin V himself, portrayed, according to Vasari, "di naturale" (from life) in the guise of Pope Liberius and presumably also in that of the papal saint[10] and of Martin of Tours.[11] However, the double-face arrangement of the panels of the polyptych would seem to preclude that its original destination was the small chapel of Saint John the Baptist: only by being placed at the center of the sanctuary could it have been properly visible from both sides. It is therefore presumable that the triptych was expressedly executed for the basilica's high altar, and that the commission was given through the intermediary of Rinaldo Brancacci, cardinal protector of the church (d. June 5, 1447), in circumstances similar to those that had attended the commissioning from Giotto of Cardinal Stefaneschi's polyptych for the high altar of St. Peter's a hundred years previously.[12]

It should also be pointed out that a possible portrait of Emperor Sigismund II, a supporter of the pope ever since his election at the Council of Constance and represented, according to Vasari, "next to him" in the polyptych, has been identified by A. Braham as the bearded man, the fourth from the right in the scene of the foundation of the basilica; according to Braham, the putative *Saint John the Evangelist*, devoid of any specific iconographic features, might even represent a further portrait of the emperor in the guise of his eponymous saint.[13] If the conjecture is correct, the polyptych would be an exceptional testimonial both of cultural and of politico-religious history. On the one hand, the prestige of the commission and the implicit analogy with Giotto would explain the involvement of Masolino and Masaccio, the greatest exponents of the new figurative art of the time; on the other, the carefully devised iconographic program would express in Marian terms a subtle allegory of the end of the schism and the pope's determination to restore the papacy to Rome.

Guido Cornini

1. The legendary narrative of the death of Mary began to proliferate from the fourth century on, giving rise to a number of apocryphal accounts in Greek, Latin, Coptic, Arabic, Armenian, Syriac, and Slavonic. Now considered archetypal texts of this literature are the Greek *Dormition of the Holy Mother of God*, traditionally ascribed to Saint John the Evangelist but probably penned in the sixth century, and the Latin *Transit of the Blessed Virgin Mary*, attributed to Joseph of Arimathea but undoubtedly later in date than the aforementioned *Dormition*. In both accounts is a narration of the circumstances surrounding the dormition (or falling asleep) of the Virgin and her miraculous Assumption from her tomb, widely portrayed by medieval artists both in the East and the West (see *I vangeli apocrifi*, ed. M. Craversi [Turin, 1969], 447–48).

2. For a résumé of the complex attributional problems surrounding the polyptych, see Mancinelli 1987, 191–96.

3. Davies in National Gallery 1961, 356; but on the reconstruction of the altarpiece and the attribution of the individual compartments see the reservations of Longhi 1940, 145–90, Salmi 1948, 222, and Joannides 1985, 1–5.

4. See Pietrangeli 1985, 154 and n. 27, and C. Pietrangeli, "Introduction," Pinacoteca Vaticana 1992, 22.

5. Mancinelli 1982, 142.

6. See Clark 1951, 339–47.

7. Pope-Hennessy 1943, 30–31. According to Longhi 1940, it is presumable that the *Crucifixion* forms the gable of the central compartment in front—where, above the main episode, Christ appears with Mary within a mandorla—and that the scene of the *Assumption* on the rear of the triptych was surmounted by a lost Coronation of the Virgin; following the iconographic practice of the period, the lateral gables in front would have been occupied, on the one side, by the Angel of the Annunciation and, on the other, by the Virgin Annunciate (both lost with their corresponding rear elements), while the episodes depicted in the predella, deliberately Marian in program, would have comprised in front a Nativity and a Betrothal of the Virgin (perhaps the one formerly in the De Montor collection) and on the back, in a central position, the Vatican *Burial of the Virgin* presented here.

8. Vasari 1878–85, (1878):293–94.

9. Procacci 1953, 3–55.

10. Davies 1961, 352–61.

11. Salmi 1952, 14–21.

12. Boskovits 1987, 205.

13. Braham 1980, 106–12.

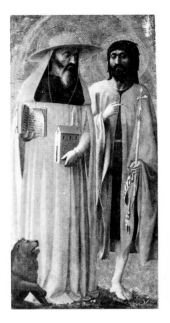
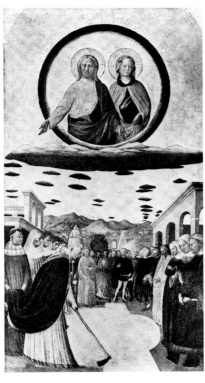
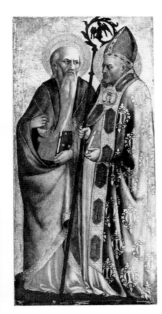

Fig. 2. Reconstruction of the front of the Santa Maria Maggiore Altarpiece according to Sir Kenneth Clark. Left, Masaccio and Masolino da Panicale, *Saints Jerome and John the Baptist*, National Gallery, London; center, Masolino da Panicale, *Pope Liberius, in the Presence of the Patrician Johannes, Tracing the Plan of the Basilica in the Snow*, Museo e Gallerie Nazionale di Capodimonte, Naples; right, Masolino da Panicale, *The Evangelist and Saint Martin*, John G. Johnson Collection, Philadelphia Museum of Art.

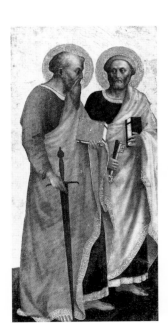
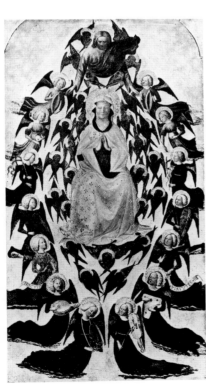
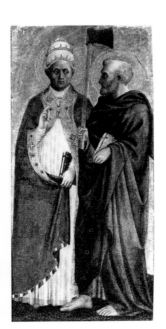

Fig. 3. Reconstruction of the back of the Santa Maria Maggiore altarpiece according to Sir Kenneth Clark. Masolino da Panicale, left, *Saints Peter and Paul*, John G. Johnson Collection, Philadelphia Museum of Art; center, *The Assumption of Mary*, Museo e Gallerie Nazionale di Capodimonte, Naples; right, *A Pope Saint (Liberius?) and Matthew*, National Gallery, London.

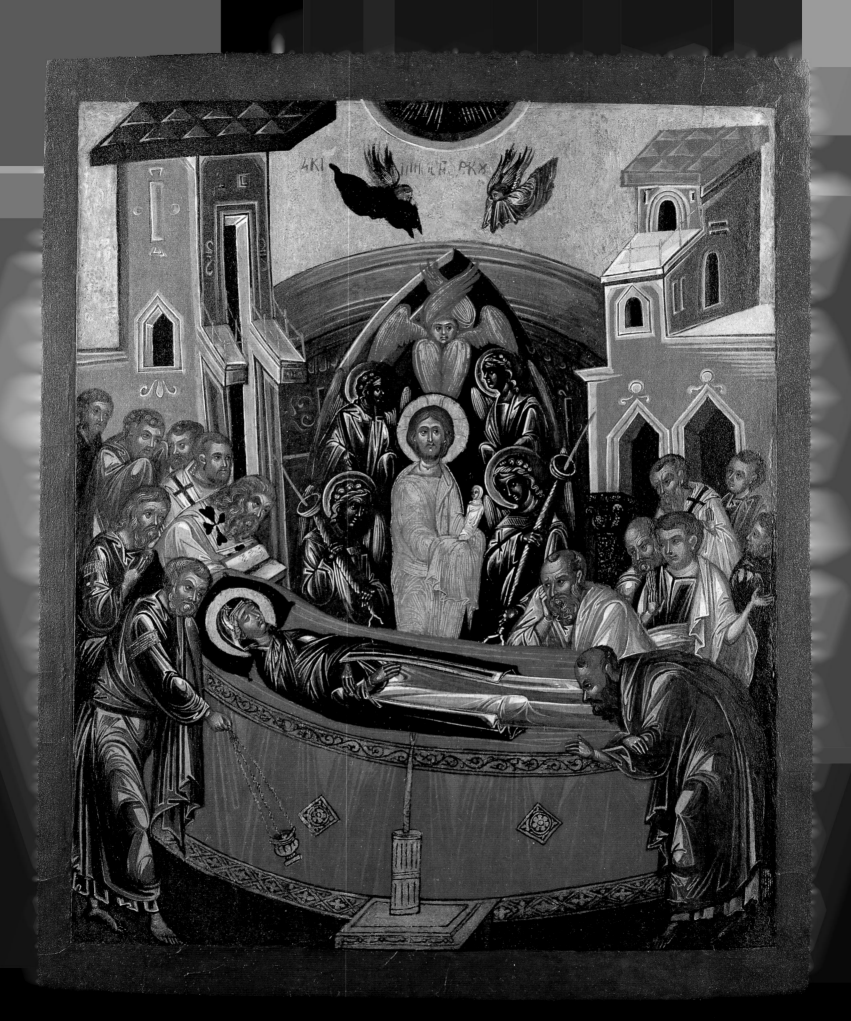

51

Cretan School
THE DORMITION OF THE MOTHER OF GOD
Late 16th century
Tempera on wood with gold leaf
36.6 x 29.4 cm (14 ⅜ x 11 ⅜ in.)
Vatican Museums, inv. 40072

Conservation courtesy of Dr. David, Leann,
Hunter, and Taylor Benvenuti

Provenance: Vatican Library.

Exhibition: Grottaferrata, Italy, Abbey of
Grottaferrata, 1905.

Literature: Barbier de Montault 1867, 8;
A. Muñoz, *L'Art Byzantine à l'exposition de
Grottaferrata* (Rome, 1906), 45, fig. 23; Muñoz
1928, 9, no. 7, pl. IV, 2; Vatican 1933, 18, no. 72;
S. Bettini, *La pittura di icone cretese-veneziana
e i madonneri* (Padua, 1933), 58, n. 2; Vatican
1993, 80, 8 d; Bianco Fiorin 1995, 22, no. 14,
fig. 23; E. Yon and Ph. Sers, *Le Sante Icone*
(Florence, 1994), 242, n. 121.

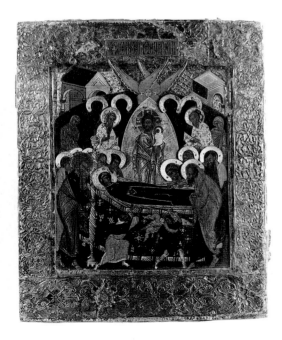

According to the apocryphal tradition in the
East, Mary remained in Jerusalem until
roughly the year 43 A.D. and then withdrew to
Ephesus in the company of the Apostle John,
in order to escape the persecution of Herod
Agrippa, before finally returning to the Holy
City where she was to end her days. It was this
late tradition of the death of the Virgin,
deriving in the main from the apocryphal
account of the Dormition of the Blessed
Mother of God attributed to the evangelist
Saint John himself, to which were added the
subsequent commentaries and reflections of
the Fathers of the Church, in particular John
Damascene, that was to inspire both the liturgy
and the iconographic canon of the feast of the
Dormition, celebrated by the Church on
August 15. This was the feast that concluded
the *Dodecaorton* (cycle of the twelve principal
feast days) of the Byzantine ecclesiastical year.

The iconographic scheme of the Dormition
was formed in Byzantium in the course of the
ninth and tenth centuries. The present icon
shows Christ in glory, escorted by candle-
bearing angels, within a mandorla surmounted
by a seraph with flaming wings. Bearing in his
arms the soul of his mother in the form of a
newborn infant in swaddling clothes, Christ
prepares to take her with him into the glory of
heaven. Around the recumbent Virgin on her
deathbed below are gathered the apostles,
among whom can be recognized Peter, Paul,
and Andrew to the viewer's left, Paul and John
the Evangelist to the right, as well as the
three hierarchs Hierotheus, Dionysius the
Areopagite, and James, the "Brother of God,"
arranged in rows. Two small angels fly
down from above and join in the general
lamentation; their faces, bathed in tears, are
buried in their hands, covered in turn by their
himations (mantles) as a mark of veneration.

Fig. 1. Russian School, *Dormition of the Mother
of God*, 16th century, tempera on wood.
Vatican Museums

This glorification of Mary by her son,
descending from heaven to receive the soul of
his mother, is sometimes accompanied by the
vision of her triumphant Assumption into
Heaven in the midst of the angelic choirs.
Re-created in her integrity thanks to the gift
of the Spirit, Mary the Mother of God is the
perfect realization of a totally regenerated
humanity, the archetypal figure of the Church,
which, in Mary, lives and actualizes her destiny
of salvation already here on earth.[1]

Despite its relative sobriety, the present icon
is not devoid of dramatic vivacity, expressed by
the faces of the personages who participate in
the event and by the dynamic space created by
the architecture of the buildings with their
inverse perspective. The colors are well-
balanced in distribution: the predominant
chromatic value is the dark olive green of the
sun, of the *maphorion* (veil) of the Virgin, and
of the chitons of most of the apostles, as well as
of the mandorla of Christ, with the luminous
heightening in white of the angels portrayed
in monochrome. This is counterbalanced by
the brilliant red and gold deathbed of the
Virgin and by the red or crimson mantles of
the hierarchs or some of the apostles. The
luminous figure of Christ, heightened with
gold, stands out sharply from the surrounding
surface, which is on the whole darker in tone,
complementing in some sense the richness of
the trappings of the catafalque, below which a
lighted torch shines forth. This latter detail,
as well as the golden censer in the hand of
Saint Peter and the pontifical vestments of
the bishop saints, accentuate the essentially
liturgical character of the obsequies.

The Byzantine liturgy of the feast of the
Dormition is above all a hymn to the glory of
the Mother of God and of her Assumption into
Heaven, where she is received by the rejoicing
of all the hierarchies of angels: "The Powers,
the Thrones, the Principalities, the Dominions,
the Virtues and the Cherubim with the
fearsome Seraphim glorify your dormition."[2]

A useful comparison may be drawn between
this icon and a Russian one of the same subject,
presumably dating to the sixteenth century
(fig. 1) and also preserved in the Vatican
Picture Gallery. Painted in the classic

Novgorod style, it adds the detail of the attempted profanation of the mortal remains of Mary by the Jewish priest Athonios, whose hands were severed by the sword of an angel and who, after being miraculously healed, immediately converted.[3]

Below the segment of blue sky and against the gold ground can still be read the original title of the icon, traced in Greek letters, cinnabarred in color: Ἡ κίμησις τῆς θ(εοτό)κου, meaning "the Dormition of the Mother of God." The reddish ocher border of the panel was added during a later repainting.

The icon may, with good reason, be attributed to the Cretan school of the late sixteenth century and considered a somewhat provincial and slightly archaizing version of far more refined and figurally more complex models such as the two icons in the collection of the Hellenic Institute in Venice, clearly earlier in date.[4]

The reverse of the panel is decorated with a cross accompanied by the instruments of the Passion and the traditional Greek monograms IC XC NIKA with foliage ornamentation.[5]
Michel Berger

1. On the Cretan icons of the Dormition of Mary, see in particular Chadzidakis 1962, 33–36, nos. 15 and 16.
2. From the *Stichira* of the Byzantine hymnal, sung during the preliminary *Lucernarium* rite of the Great Vespers.
3. On this Russian icon in the Vatican collections, see Felicetti-Libenfels 1972, 151, fig. 317; Bianco Fiorin 1995, 68, no. 82, fig. 120. On the episode of the Jewish priest Athonios, included in most icons of the Dormition, see Ouspensky and Lossky 1982, 214.
4. Chadzidakis 1962, 33–36, nos. 15 and 16; Bandera Viani 1988, 63–64, nos. 89 and 90; N. Chadzidakis 1993, 70–72, nos. 14 and 14a, with the more recent bibliography.
5. Bianco Fiorin 1995, fig. 22.

Silvestro dei Gherarducci (Florence, 1339–99)
THE ASSUMPTION OF THE VIRGIN, c. 1365
Tempera on wood
41.3 x 26.5 cm (16¼ x 10½ in.)
Vatican Museums, inv. 40116

Conservation courtesy of Eric F. Green and Jock Truman

Literature: Volbach in Pinacoteca Vaticana 1987, 23–24; Sirén 1906, 323; Van Marle 1924, 441; D'Achiardi 1929, 15; M. Levi d'Ancona, "Don Silvestro dei Gherarducci e il Maestro dei Canzoni," in *Rivista d'Arte* 32 (1957):4–37; Berenson 1963, 106; Offner 1947, 33; Boskovits 1975, 425.

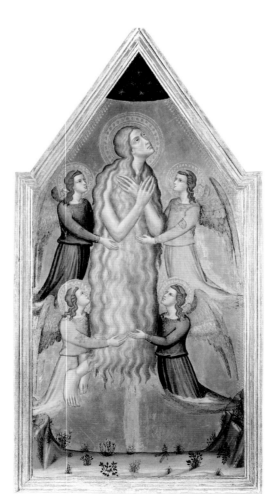

The Madonna, dressed all in white, is sitting on a throne within a mandorla that is supported by six angels, three at each side, as it is being carried up to heaven.

The angels are depicted in the typical mid fourteenth-century style: small and ephemeral creatures with slim bodies covered by long dresses and, apparently, no legs. Their fine and youthful features are surrounded by halos; their expressions show a participating presence that expects no response. Although angels of this type take part in pictorial scenes, they are seldom described in the Bible and the Apocrypha as being there. Their presence is, accordingly, a passive one, even when they engage in such physical activities as supporting the mandorla, in holding the instruments of the Passion, or in mourning the body of Christ.

The small panel shows similarities with works from the circle of Andrea Orcagna, especially Iacopo di Cione and Giovanni del Biondo. The painting had been ascribed to Agnolo Gaddi and to Iacopo del Cione. The attribution to Silvestro dei Gherarducci, proposed by M. Levi d'Ancona,[1] is now generally accepted.[2] A comparison with the *Assumption of Saint Mary Magdalene* by Silvestro dei Gherarducci (fig. 1) confirms this attribution.
Johannes Röll

1. Levi d'Ancona 1957, 3.
2. Volbach 1987, 23–24.

Fig. 1. Silvestro dei Gherarducci, *The Assumption of Saint Mary Magdalene*, tempera on wood. National Gallery of Ireland, Dublin

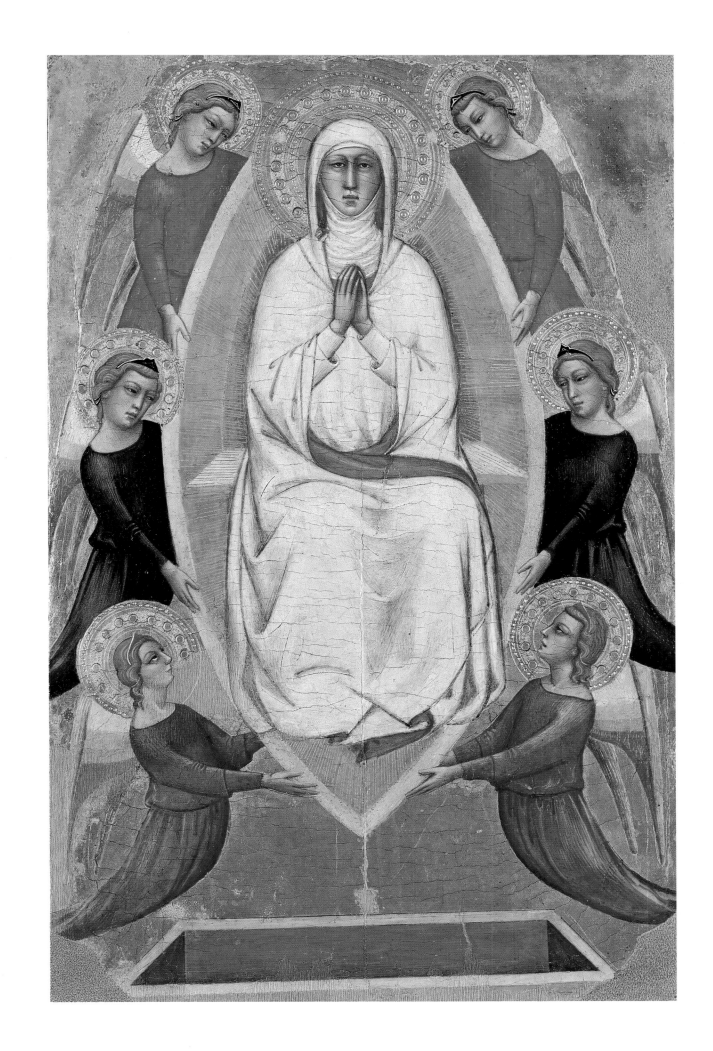

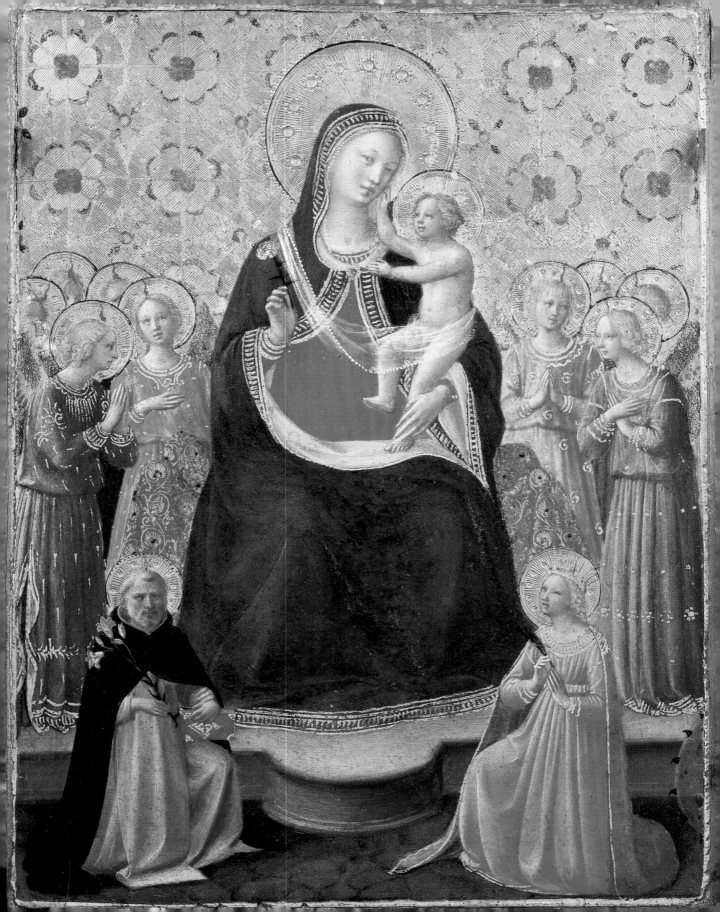

53

Guido di Pietro, called Fra Angelico
(Vicchio di Mugello, c. 1395–Rome, 1455)
MADONNA AND CHILD WITH SAINTS DOMINIC AND
CATHERINE OF ALEXANDRIA, c. 1435
Tempera with gilding on wood
24.4 x 18.7 cm (9⅝ x 7⅜ in.)
Vatican Museums, inv. 40253

Restored: 1948.

Provenance: Early 19th cent., Bisenzio
Collection, Rome; mid 19th cent., Lord Dudley
collection, Blessington, England; exchanged
in 1872 for Murillo's *The Prodigal Son*, given
to Pius IX by Queen Isabella II of Spain in
1856; in the Vatican Picture Gallery since
1877.

Exhibitions: Brussels, Musée Royal des Beaux-
arts, *La Madone dans l'Art*, 1953; Vatican City,
Palazzo Apostolico Vaticano, *Exhibition of the
works of Fra Angelico*, 1955; Rome, Palazzo
Venezia, *Imago Mariae. Art Treasures of
Christianity*, 1988; Paris, 1990.

Literature: Vasari-Milanesi 1906, 2:512;
Cavalcaselle-Crowe 1897, 2; I. M. Strunk,
Fra Angelico aus dem Dominikanerorden
(M. Gladbach, 1927), 78; Pope-Hennessy 1952,
204; Baldini in Vatican City 1955, 11, cat. 5;
Collobi-Ragghianti 1955, 39; Salmi 1958,
10–99; Orlandi 1964, 25; Baldini 1970, 95,
no. 43; J. Pope-Hennessy, *Fra Angelico*, 2nd ed.
(Ithaca, 1974), 233; Pietrangeli 1985, 178;
Angelelli 1988, 107–08, cat. 57; U. Baldini,
Beato Angelico (Florence, 1986), 118;
Mancinelli 1990, 126–28, cat. 47.

This painting shows the Virgin in glory
between two groups of praying angels. She is
worshipped by Saint Dominic and Saint
Catherine of Alexandria, who appear on a
smaller scale at the sides of the throne. The
former, wearing the Dominican habit, holds a
lily in one hand, and in the other the book of
the *Constitutions of the Order of Preachers*
(Dominicans); the latter, recognizable by her
attribute, the wheel, holds the martyr's palm
between her hands. The holy child, standing
on his mother's lap, strokes her cheek with his
right hand while she holds him close, and in
her free hand she holds a white rose, the divine
symbol of knowledge.[1] Both the child's gesture
and the presence of the flower refer to imagery
known in Tuscany from the end of the
thirteenth century onward,[2] but even if the
type of pose and the feelings expressed still
reflect old-fashioned Byzantine models,[3] the
admission of the saints into the space occupied
by the deity anticipates the ideological
framework of Renaissance *sacre conversazioni*,
a form with which Fra Angelico repeatedly
experimented toward the end of the 1430s.[4]
On the other hand, a further link with
tradition is reflected by the angel figures
dressed in supremely elegant robes and yet
playing the role of mere onlookers.

Nothing is known of the early provenance
of this unusual small panel, which is today one
of the most popular works in the Vatican
Picture Gallery. The first certain knowledge
goes back half-way through the nineteenth

century, when the painting, which came from
the Bisanzio Collection in Rome, went to form
part of Lord Dudley's collection in England.
It was later exchanged for a canvas by Murillo,
The Prodigal Son, which had been given to
Pius IX by Queen Isabella of Spain (1856),
with which the collector intended to complete
the series in his possession.[5] In the Vatican
Picture Gallery since 1877, the panel was
considered by Cavalcaselle to be the missing
element of a series of four reliquaries
commissioned from Fra Angelico by the
Dominican Giovanni Masi (who died in 1434)
for S. Maria Novella and are now in the
Museum of S. Marco in Florence (fig. 1).[6]
The identification of the missing piece in a
small panel in the museum in Boston rendered
the above theory untenable, leaving the
Vatican panel again open to investigation and
conjecture. Strunk, in particular, suggested the
identification of this painting in the "Nostra
Donna piccola, bellissima" that Vasari
described in Florence, as the property of
"Don Vincenzo Borghini, at the Spedale
degl'Innocenti."[7] This hypothesis remains
attractive even today, the most convincing one
notwithstanding the lack of documentary
evidence.[8] Of a different opinion is Pope-
Hennessy, who, on the basis of a comparison
with the Bosco ai Frati altarpiece, removes the
panel altogether from the oeuvre of Fra
Angelico, assigning it instead to an assistant of
the master who was active around the middle
of the century, hypothetically identified as

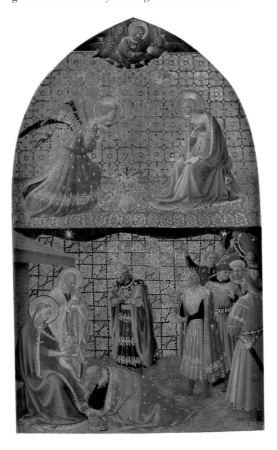

Fig. 1. Fra Angelico, *The Annunciation* and
Adoration of the Kings, panel from a reliquary
casket. Museo di S. Marco, Florence

54

Zanobi Strozzi.[9] Baldini takes a different position to that of the English historian and lays stress on the quality of the panel, which he judges "of great delicacy, both in design and in the use of colour, in no way inferior in draughtsmanship and feeling to some of the best and most securely attributed works" of the Dominican painter.[10]

The extremely high quality of the painting, executed with the tip of the brush on a background of gilded lozenge shapes decorated with a floral design, suggests direct knowledge on the part of the painter of the forms and techniques of miniatures, another feature that suggests the probable author of the painting to be Fra Angelico. Its small size and the richness of the palette indicate, on the other hand, that the panel was intended for private use, thus giving weight to Strunk's suggestion and making "a period close to the year 1435" an entirely plausible dating for the image.[11]

Guido Cornini

1. The iconography refers to the Eulogy of Knowledge contained in the *Siracide*: "I was as exalted as the rose-garden of Jericho … and my flowers produced fruits of glory and richness" (XXIV, 14, 17). The indication of Mary as *Sedes Sapientiae* occurs frequently in the litanies dedicated to her.
2. See Angelelli 1988, 107–08, cat. 57.
3. The type of child shown in the small panel, classified by Sanberg-Vavala as "playful," may be placed in an intermediate position between that of the *Hodegetria* (in which the blessed child is seated on the lap of his mother, who points to him with her right hand) and that of the *Eleousa* (where the Christ child places his cheek close to that of the Virgin). F. E. Sanberg-Vavala, *L'iconografia della Madonna col Bambino* (Siena, 1934), 65.
4. For example in the Annalena altarpiece (1437–40) and that of S. Marco (1438–40), both of which are in the Museum of S. Marco in Florence (see Baldini 1970, 100–101, cat. 59, 101–02, cat. 60). Concerning the birth of the genre, see R. Goggen, "Nostra Conversatio in Caelis est: Observations on the Sacra Conversazione in the Trecento," in *Art Bulletin* 61 (1979):198–222.
5. Pietrangeli 1985, 178.
6. Cavalcaselle-Crowe 1897, 2.
7. Vasari-Milanesi 1906, 2:512.
8. Strunk 1927, 78.
9. Pope-Hennessy 1952, 204, 233.
10. Baldini 1955, 11, cat. 5; Baldini in Milan 1970, 95, no. 43.
11. Angelelli 1988, 107–08, cat. 57.

Workshop or Circle of Agostino Busti, called Bambaia (Busto Arsizio, c. 1483–Milan, 1548)
MADONNA AND CHILD WITH ANGELS
Marble
36.5 x 18.8 x 8 cm (14 ⅜ x 7⅛ x 3⅛ in.)
Vatican Museums, inv. 44089

Conservation courtesy of John J. Brogan

Exhibition: Seville, Spain, Exposizione Universale Siviglia, *Arte e Cultura intorno al 1492*, 1992.

Literature: G. Agosti, *Bambaia e il classicismo lombardo* (Turin, 1990), 193, n. 49; J. Sureda i Pons in *Arte e Cultura intorno al 1492* (exh. cat. Exposizione Universale Siviglia, 1992), 338, cat. 275.

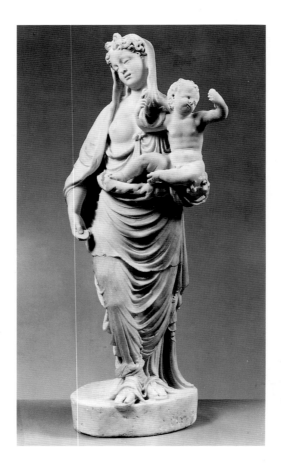

The small marble relief of the Madonna and child has recently been attributed as a work deriving from the circle of the Lombard sculptor Agostino Busti, called Bambaia.[1] Bambaia was possibly trained in the workshop of Benedetto Briosco and was primarily active in Milan. His main work is the monument to the French soldier of fortune Gaston de Foix, originally intended for the church of S. Marta, Milan, but left unfinished in 1522. Bambaia preferred small-scale works in which he was able to combine his subtle technique with the demands of a largely humanist clientele.

The seated figure of the Madonna is wearing a long dress and sandals *all'antica*. Her soft calm features and her hairstyle also betray the use of classical sources. The small nude boy is standing in front of his mother. She holds a bunch of flowers in her right hand, with which she tries to attract the boy's

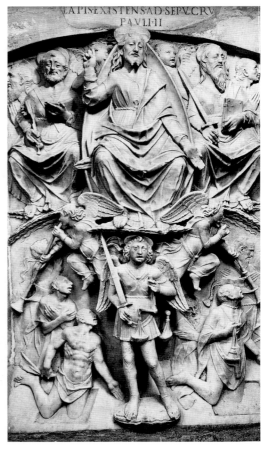

attention. However, the lively child, although touching the flowers with his right hand, has turned his head away. With a tender gesture suggesting motherly protection, the Madonna draws the boy into the center. The classical tendency toward a calm and centralized representation is, however, interrupted by the lively movements of mother and child, creating an artistic tension.

Angels play and pray behind the Madonna. Four angels blow vivaciously into their trumpets, their distended cheeks and outspread wings displaying the energy involved. Above them, on a higher level, are three angels kneeling on small clouds, their hands joined in joyous veneration.

The relief is divided into the more stylistically advanced group of the Madonna and child and the old-fashioned groups of angels arranged in two tiers. The classicizing style of the former belongs certainly to the first half of the sixteenth century, and it is not unlikely that it was executed by the Lombard sculptor Agostino Busti (Bambaia) or a sculptor close to his style, perhaps Marco Sanmicheli. Comparable to Bambaia's oeuvre are the proportions of the figures, the classical features of hair, face, and dress, and the delicate arrangement of the drapery (fig. 1). The angels, however, were surely executed by another artist, probably belonging to his workshop. Their design is similar to examples of the quattrocento, such as the angels in Mino da Fiesole's *Last Judgment* for the *Monument of Pope Paul II* (fig. 2). Their disproportional arms and stereotyped figures are certainly not by the same hand as the elegant group of mother and child.

Johannes Röll

1. Agosti 1990.

Fig. 1. Agostino Busti, called Bambaia, *Charity*. Victoria and Albert Museum, London, inv. 7100–186D

Fig. 2. Mino da Fiesole, *Last Judgment* from the *Monument of Pope Paul II*. St. Peter's Basilica. Vatican

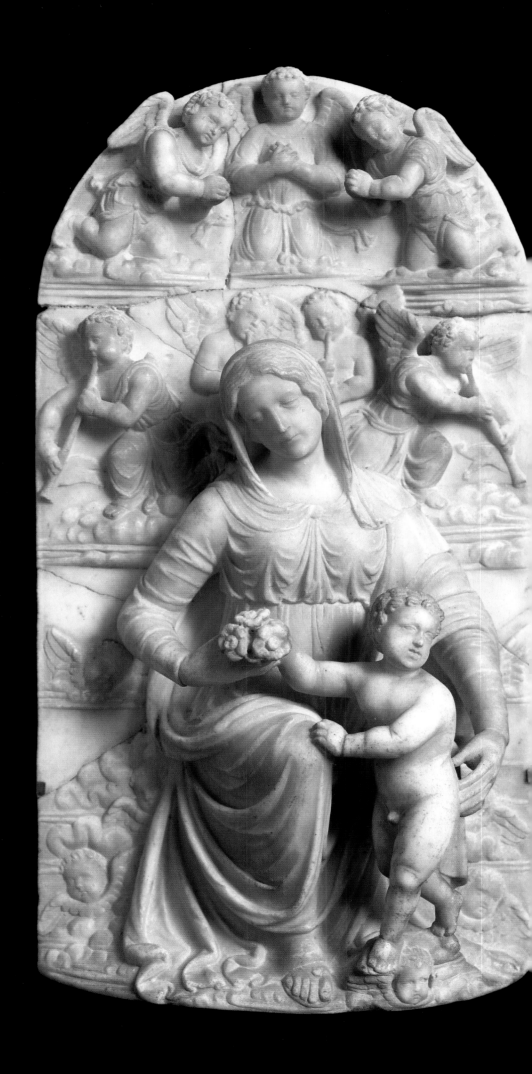

55

Bernardino di Mariotto dello Stagno (Perugia, c. 1478–1566)

MADONNA AND CHILD BETWEEN SAINTS SEVERINO AND DOMINIC, "MADONNA DELLE ROSE," 1512
Tempera on canvas, transferred from wood
50 x 33.5 cm (19⅝ x 13⅛ in.)
Vatican Museums, inv. 40328

Conservation courtesy of Kathleen Waters in memory of Katherine Bennett

Literature: R. Panciaroni, *Una preziosa tavola di Bernardino di Mariotto a Sanseverino Marche* (Sanseverino, 1981); R. Panciaroni, *Un dipinto sanseverinate in America* (Sanseverino, 1984), 24–26, figs. 4–5, n. 47, 49, 51; F. Gualdi in *Dizionario Biografico degli Italiani*, 9:205–07.

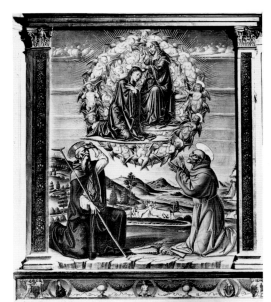

The small painting once belonged to the church of S. Domenico in Sanseverino. It was originally a wooden panel, with this scene exhibited on one side and a depiction of the Resurrection, with Christ surrounded by angels, on the other and the open tomb underneath (now in Museo della Ca'd'Oro, Venice). The panel was sold in 1838 to Vito Enei and later in 1840 to the Cavaliere d'Este, who had the wooden panel separated in two parts. The painting of the Madonna appears in the inventory of 1880 of the Apostolic Library compiled by Carlo Descemet (who also refers to it as "Madonna delle rose"); since 1909 it has belonged to the Vatican Picture Gallery.

Bernardino di Mariotto dello Stagno worked in both Umbria and the Marches. He was trained in Perugia in the workshop of Ludovico d'Agnolo Mattioli. From 1502 he is documented in Sanseverino, where he took over the workshop of Lorenzo d'Alessandro di Sanseverino. He stayed in Sanseverino until 1521 and then moved to Perugia, where he set up a workshop with Marino d'Antonio Samminuzi. During his stay in Sanseverino he traveled extensively through Umbria and the Marches, developing his style within the artistic boundaries and possibilities of the two regions. His paintings show particularly elements of the work of Carlo Crivelli (c. 1430/35–1500), whose panels Bernardino must have studied closely.

The small painting of the Madonna with Saint Severino and Saint Dominic also shows similarities with Crivelli's style, combined with the calm setting of an Umbrian altarpiece (see fig. 1). In the exhibited painting, the patron saint of the town of Sanseverino is kneeling on the left, dressed in his episcopal clothing. Saint Dominic, to whom the church is dedicated, kneels on the right, dressed in the habit of his order. The saints are depicted not only in the act of venerating the Madonna and the child, but they also take an active part in supporting with their hands a rose-decorated plate on which the Madonna is seated.

Fig. 1. Niccolò Alunno, *Coronation of the Virgin.* S. Niccolò, Foligno

Four angels hold a baldachin above the head of the Madonna. The execution of the perspective relationship between these angels and the Madonna is not quite clear, thus underlining the dominant and central position of the Virgin. The tall angels are dressed in elaborate clothes and are shown in various poses, similar to contemporary examples by Pietro Perugino, Luca Signorelli, or Filippino Lippi.
Johannes Röll

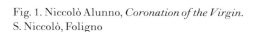

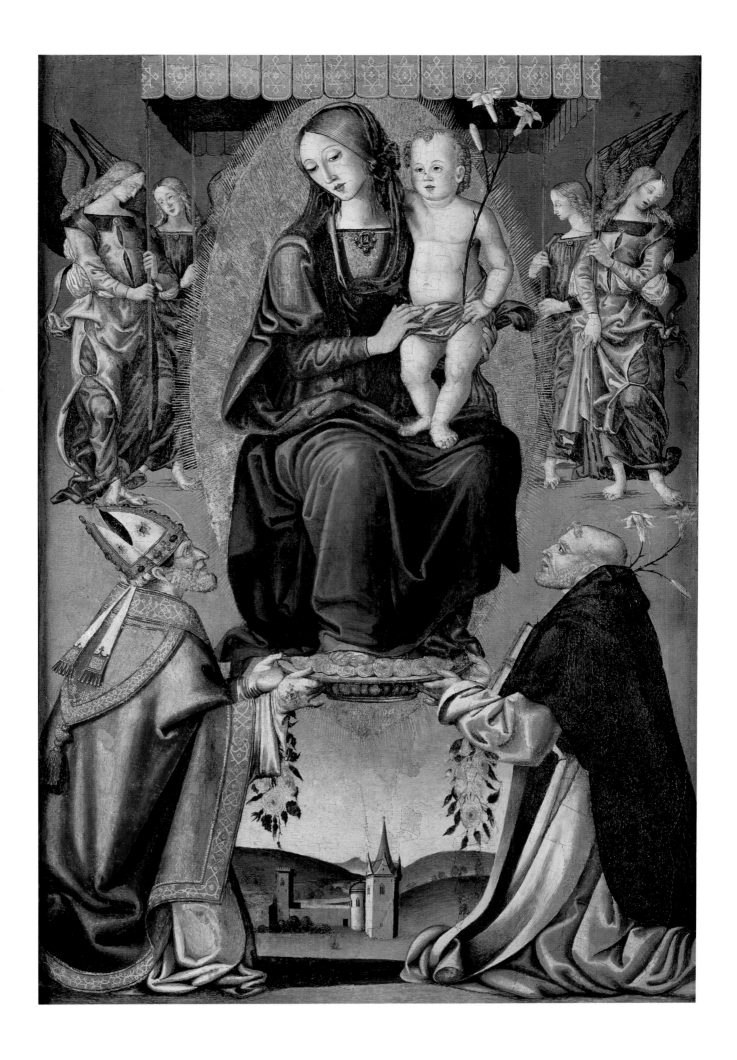

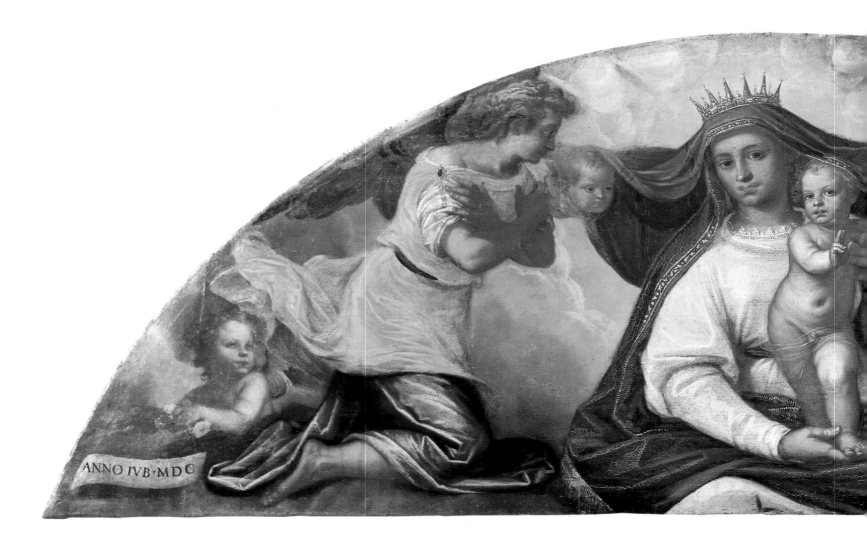

ANNO IVB·MDC

56

Claudio Ridolfi (Verona, 1570–Corinaldo, 1644)
MADONNA CROWNED, WITH THE CHRIST CHILD
AND ANGELS, 1600
Oil on canvas
91 x 270 cm (35⅞ x 106½ in.)
Vatican Museums, inv. 44944

Conservation courtesy of Helen Duston in
memory of Leonard Duston

Exhibitions: Corinaldo in Ancona 1994.

Literature: L.Carloni in *Claudio Ridolfi, Un
Pittore Veneto nelle Marche del '600* (exh. cat.
Ancona, 1994), 50–51.

Fig. 1. Paolo Veronese, *Madonna in Glory* (detail).
Church of S. Sebastiano, Venice

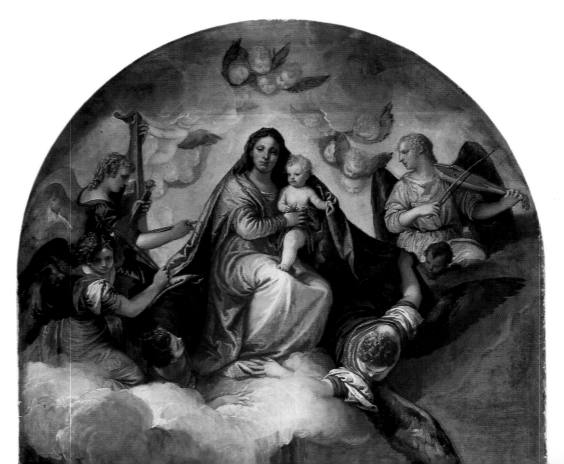

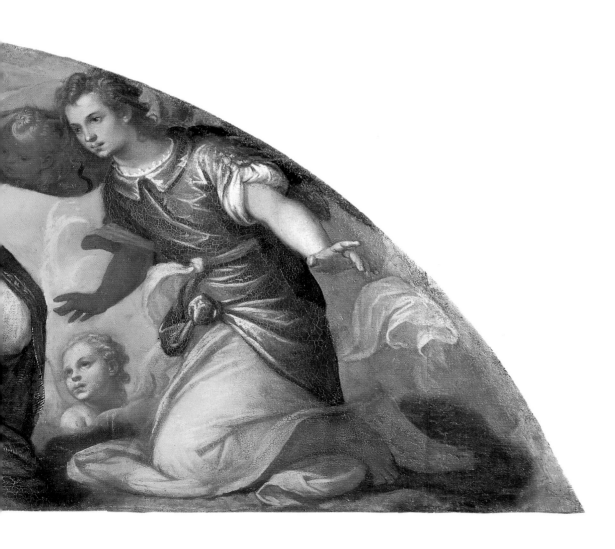

This painting was originally situated above the portal of the church of S. Onofrio in Rome. Together with its adjoining convent, this church was the mother house of the Girolamini Fathers of the Blessed Gambacorta of Pisa. Memoirs and documents pertaining to the writings of the great epic poet Torquato Tasso (1544–95), who lived his last years within its walls, are still housed inside the church.

In fact, S. Onofrio and its adjoining cloister are replete with works by seventeenth–century artists, among them Domenichino (1581–1641). The lunette in question, which was already attributed to Claudio Ridolfi by Mancini in his *Viaggio per Roma* of 1623–24 (an attribution long and inexplicably ignored by other critics), was either a commission or a votive offering on the occasion of the Jubilee of 1600, as inscribed on the painting itself (ANNO IUB.MDC). Since no known trip to Rome was undertaken by the painter, the reason for its execution is uncertain.

Though born and educated in Verona, Ridolfi was active in the Marches in the first years of the seventeenth century. A large number of his works are still to be found there, almost all of them religious in subject and devotional in tone. His narrative style is at once simple and sober, quite in keeping with the spirit of the Counter-Reformation and the tastes that guided commissions and acquisitions at the time.

In this lunette, Ridolfi was undoubtedly following a great model provided by his maestro and mentor Paolo Veronese (1528–88), whose altarpiece for the church of S. Sebastiano in Venice features the same "novelty" of the Madonna and Christ child enveloped in a regal cloak (fig. 1). This particular iconography, not frequent but certainly present in various works by Veronese, seems to hark back to the image of the Mater Misericordiae. In that particular tradition, the Virgin protects her son by taking him beneath her cloak.[1] The Madonna crowned and surrounded by angels is a frequent theme in late medieval and Renaissance painting, frequently inspired by Iacopo da Varazze's compilation of the lives of the saints, *Legenda Aurea* (Golden Legend), which also related incidents about the Madonna after her death and assumption into heaven.

Maria Antonietta De Angelis

1. Réau 1955–59, 2 (1957):113.

57

Francesco Salviati (Florence, 1510–Rome, 1563)

THE CORONATION OF THE VIRGIN WITH ANGELS
c. 1550
Oil on canvas
176.5 x 139.5 cm (62½ x 54⅜ in.)
Vatican Museums, inv. 44942

Exhibition: Canberra, Australia, Australian Gallery, *Rubens and the Italian Renaissance*, 1992.

Literature: Vasari-Milanesi 1878–85, 7 (1881):32; L. Mortari, *Francesco Salviati* (Rome, 1992), cat. 28; M. Hirst in Canberra 1992, cat. 10.

The painting, which has been part of the Vatican collections since 1991, came from the Roman church of S. Lorenzo in Damaso. It was discovered by Michael Hirst in the sacristy of this church and published as a work by Francesco Salviati.[1]

Giorgio Vasari, who had a high regard for Salviati, refers in his *Vite* to a painting by him in S. Lorenzo: "In una capella di San Lorenzo in Damaso fece due Angeli in fresco, che tengono un panno; d'uno de'quali n'è il disegno nel nostro Libro" (In a chapel in San Lorenzo in Damaso he carried out in fresco two angels who hold a drapery; the drawing of one of them is in my *Libro* [Vasari's collection of drawings]). The drawing owned by Vasari is untraced. Although Vasari mentions a fresco and not a painting on canvas, and even though his information about the subject matter is rather vague, there are good reasons to attribute this painting to Francesco Salviati on stylistic grounds, thus corroborating Vasari's information.

An early Roman guidebook by Camillo Fanucci[2] may also refer to this painting. In his description of the chapel of the confraternity of the Immaculate Conception, Fanucci mentions a confraternity standard depicting an image of the Madonna that was painted in the fashion of the venerated image of the *Most Merciful Virgin Mary*, a late medieval icon still in situ. An eighteenth-century source, however,[3] mentions "nella Cappella del Santissimo Sacramento vi sono molti Angeli dipinti da Francesco Salviati" (in the chapel of the Blessed Sacrament there are many angels painted by Francesco Salviati). The two sources are not necessarily contradictory. The old inscription on the back of the painting ("Ven. Archiconfraternità della Santissima Concezione in S. Lorenzo in Damaso") indicates that the *Madonna with Angels* belonged to the confraternity.

The Madonna is shown as a half-length figure rising above the clouds. Her gaze goes to the viewer, and her right hand is stretched out in a gesture of blessing. She is surrounded by nine angels. Two small nude and winged putti fly cautiously to the left and right of her head, delicately balancing a jewel-studded crown above her. Five small heads of cherubim, each with two wings, decorate the band of clouds at the bottom of the painting.

Salviati's main artistic achievement, also admired by Vasari, is the two angels standing to the left and right of the Madonna. They are shown in the act of opening the drapery of a small baldachin, under which the Madonna appears. They open the heavy drapery by stretching its panels apart and away from the center; at the same time they bend inward to look in pious veneration at the Virgin. The invention of these figures certainly derives from the Michelangelesque concept of the *figura serpentinata*. In this case the artistic billowing movement of the angels serves also to emphasize the central position of the Madonna by creating an angelic frame around her. Salviati used a similar pose for the fresco of his figure of the apostle Bartholomew, executed in 1550 (fig. 1). Mortari (1992) dates the painting of the Madonna to not later than 1550, and it is likely that it belongs to the same years as the fresco, although Hirst proposed a later date of c. 1560–63.[4]

Johannes Röll

1. Hirst in Canberra 1992.
2. Camillo Fanucci, *Trattato di tutte l'opere pie dell'alma città di Roma* (Rome, 1601).
3. Pancirolo's *Roma Sacra e Moderna* (1727).
4. Mortari 1992; Hirst in Canberra 1992.

Fig. 1. Francesco Salviati, *Saint Bartholomew*, 1550. Oratorio dell'Arciconfraternità della Misericordia, S. Giovanni Decollato, Rome

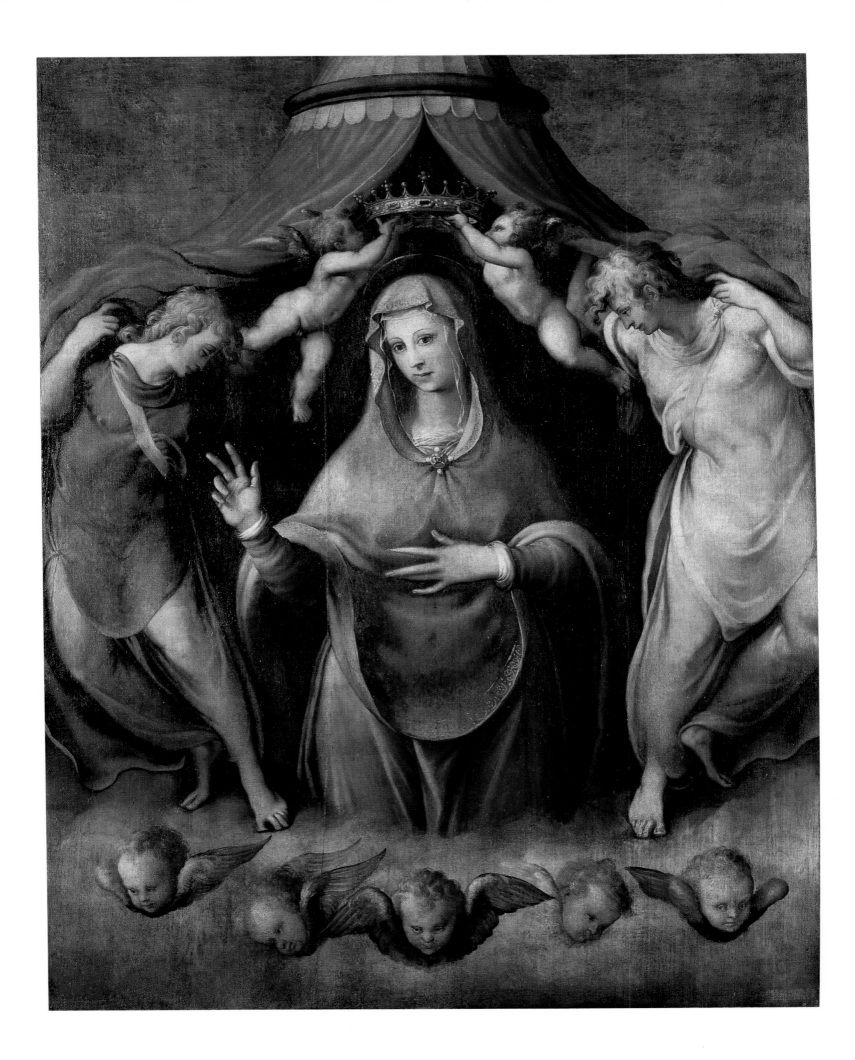

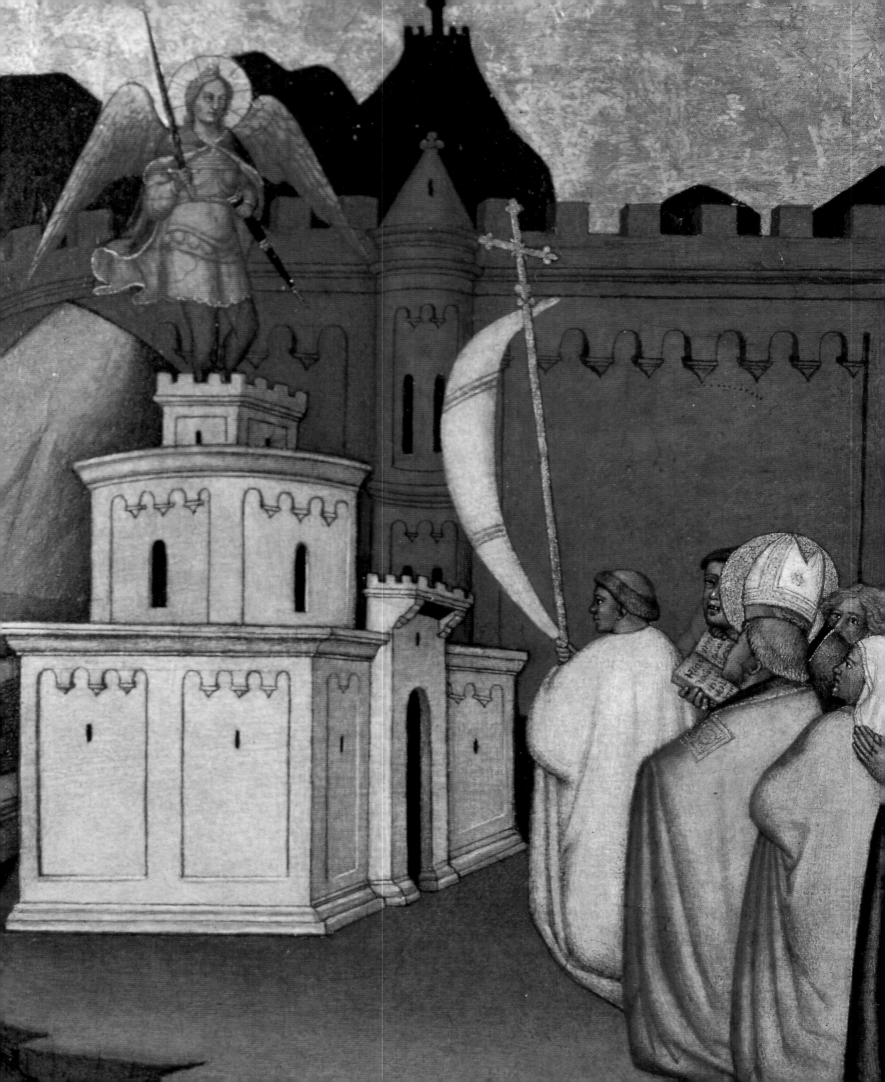

ANGELS IN THE LIFE OF THE COMMUNITY: SAINTS

58

Guido Reni (Bologna, 1575–1642)
SAINT MATTHEW AND THE ANGEL, 1635–40
Oil on canvas
85 x 68 cm (33½ x 27 in.)
Vatican Museums, inv. 40395

Exhibitions: Tokyo 1989; Paris 1990; Mexico
City 1993.

Literature: C. C. Malvasia, *Felsina Pittrice*
(Bologna, 1678), 35, 64; C. Gnudi and
G. C. Cavalli, *Guido Reni* (Florence, 1955), no.
104; E. Baccheschi, *L'opera completa di Guido
Reni* (Milan, 1971), no. 179a; D. S. Pepper,
*Guido Reni. A Complete Catalogue of His
Works* (New York, 1984), 241; F. Mancinelli
in Paris 1990, 148; A. M. De Strobel and
M. Serlupi Crescenzi in Pinacoteca Vaticana
1992, 323.

Guido Reni repeated the theme of the apostles
and evangelists several times. Malvasia
mentions having seen four evangelists painted
for Giovanni Jacobs, a Flemish jeweler and
merchant who was a friend of Guido Reni's,
and also describes "un apostolo di tre quarti
intento a scrivere sotto dettatura di un angelo"
(three-quarters view of an apostle writing as
an angel dictates),[1] referring to the portrait
study of Saint Matthew in the well-known
series in the Barberini collection at Monte di
Pietà. But the series identified as original was
part of the collection belonging to the duke of
Beaufort at Badminton (England), sold in a
Sotheby's auction in July 1967 and bought by
the Bob Jones University in Greenville, South
Carolina, where it still is today.

There are in existence two copies of the
evangelist series in Rome and Naples. The
first one, minus *Saint Mark*, was donated to
an unidentified church and is now in the
private collection belonging to Senator Bosco.
According to Baccheschi, the *Saint Mark* was
painted mostly by Francesco Gessi, a Bolognese
painter close to Reni, with only some parts of
the figure of Saint Mark actually added by
Reni himself.[2]

The Neapolitan series is included in the
collection of Pio Monte della Misercordia
and might possibly be identified with that
mentioned in the eighteenth century as part
of the collection of Prince della Rocca
Filomarino.[3] The latter, which presents the
greatest affinities with that now in Greenville,
has been attributed to Sementi who, together
with Gessi, accompanied Reni to Naples in
1622.

The *Saint Matthew* belonging to the Vatican
Picture Gallery and displayed here is very
similar in typology to those of the previously
mentioned series. It could be part of yet
another lost series or perhaps be the apostle
noticed by Malvasia in the Barberini collection;
no document supports this theory, however,
since no painting of this type is listed in the
family's inventories of the seventeenth century,
and unfortunately no documentation is known
prior to this. In 1924, the picture was acquired
by the Vatican Picture Gallery as part of the
donation from the Castellano collection and
registered as a work by Reni. This attribution,
uncontested at the time, has been queried by
Pepper who, in his monograph of 1984,
describes it as a copy. This view is not accepted
by Mancinelli, who considered the high
quality, rendered especially evident as a result
of a restoration carried out in 1988, of this
Vatican-owned painting. There is also
controversy regarding its date: between 1635
and 1640 according to Baccheschi, while both
Pepper and Mancinelli place it in the same
years as the Greenville series (1621–22), just
before Reni's journey to Naples.
Maria Serlupi Crescenzi

1. Malvasia 1678, 35, 64.
2. Baccheschi 1971, nos. 179/1, 191/1.
3. De Dominicis, *Vite dei pittori ... napoletani* (Naples,
1742–43) and N. Cochin, *Voyage d'Italie* (Paris, 1769),
1:188.

59

Bartolo di Fredi (Siena, c. 1330–1410) and
Workshop
THE ANNUNCIATION TO JOACHIM
Tempera and gold on wood
24.4 x 36.5 cm (9⅝ x 14⅜ in.)
Vatican Museums, inv. 40153

This small panel portrays Saint Joachim in a mountainous setting. The angel Gabriel has come to bring him the news that his wife, Saint Anne, will bear a child. On the right side there are two shepherds near their flock, one of whom holds a bagpipe.

The story of Joachim and Anne, the Virgin Mary's parents, is not told in the canonical Gospel, but is found in the Apocrypha, in the Protogospel of James, in the Gospel of Pseudo Matthew, and in the Gospel of the Nativity of the Virgin Mary. Iacopo da Varazze in *Legenda Aurea* and Vincent de Beauvais in *Speculum Historiae* attached importance to these non-canonical gospels once more, and they became very widespread during the thirteenth century.

The legend tells how Joachim was driven away from the Temple and his offering was refused because he was without descendants. The absence of children was considered to be a sign of a divine curse. Joachim was greatly distressed at being so offended and he took refuge among his shepherds. Left alone, Anne invoked a divine blessing, requesting that she be able to generate a child even though she was an old woman. The angel Gabriel visited both husband and wife, bringing the news that Mary, destined to become the mother of God, was soon to be born. The elderly couple joyously met near the Golden Gate in Jerusalem, and Mary was born from their kiss. During the middle ages, this legend served to explain the Immaculate Conception of Mary.

This small panel was one of a triptych from the life of the Virgin. It was a commission granted to Bartolo di Fredi by the Company of Saint Peter on May 9, 1383, for the Chapel of the Annunciation in the Church of S. Francesco in Montalcino, where the artist had already painted other works.

The polyptych is currently divided between various museums. The photographic assemblage proposed by Freuler and Artini[1] can give an idea of just how grandiose and elaborate the entire work was (fig. 1). On the lower border of the central panel with the *Coronation of the Virgin* (currently in the Museo Civico di Montalcino), there is the inscription: BARTOLUS MAGISTRI FREDI DE SENIS ME PINXIT A.D. 1388. Above it was the cuspidate panel with the *Assumption of Mary in Heaven*, now found in the Pinacoteca Nazionale in Siena. In the four lateral panels, also in Siena, are, on the right side, *The Virgin Mary's Farewell to Her Parents before Her Wedding*[2] and, above it, *The Virgin Mary's Funeral*; on the left side, *The Virgin Mary's Wedding* and *The Farewell to the Apostles*. Laterally, in the upper section, on the left is *The Nativity and the Adoration of the Shepherds* (cat. 34) and, on the right, *The Adoration of the Wise Men* (National Trust of

Polesden Lacey). Above the two panels are two pinnacles with the *Angel Annunciate* and the *Virgin of the Annunciation* (Los Angeles County Museum of Art). The predella included the *Deposition of Christ*, presently in Siena, in the center, and another four sections with the stories of Joachim and Anne: *Saint Joachim Driven from the Temple* (now in Siena); the present panel; *Saint Anne Giving Birth to Mary* (in Siena); and the *Presentation of the Virgin Mary at the Temple* (Panstwowe Zbiory Sztuki na Wawelu, Kracòw). On the sides of the predella are two panels with Saint Anthony Abbot and Saint Paul the Hermit, both in Montalcino; above them there were two corner pillars, each with ten saints, currently divided between Siena and Montalcino.[3]

The polyptych required five years to be completed (1383–88) and, considering that in those years Bartolo di Fredi actively participated in Siena's political life, his workshop, or in particular his son, Andrea di Bartolo, had a major role in executing the work.

There is documentation of Bartolo di Fredi's work in Siena in 1353, where he collaborated with Andrea Vanni. From 1372 to 1401 he held many political offices. His workshop was very active and, after the plague of 1348, it assumed a major role, executing many works in Siena and its environs. His style, influenced by the models of Lorenzetti and Simone Martini, appears to be distinguished by the flexibility of his lines and the way he put unusual colors together as well as by formal simplification and intentional archaism. He collaborated at length with his son, Andrea di Bartolo, who started out by following his father's style faithfully; however, Andrea progressively made the use of Gothic characteristics more conspicuous in his later works.

Adele Breda

1. The polyptych was studied thoroughly by G. Freuler and L. Artini in "Bartolo di Fredis Altar fur S. Francesco in Montalcino," *Pantheon Jahrgang* 43 (1985):21–39. Freuler published the document commissioning the work that is preserved at the Archivio di Stato in Siena (note 5), and he proposed the photographic assemblage of the triptych, reproduced here. See this study also for its bibliography.
2. This has been incorrectly considered to be the *Return of Mary to Her Parent's House after the Presentation at the Temple*. However, it is easy to demonstrate that it refers to another episode, because the Virgin, who appears as a child in the *Presentation at the Temple*, is an adult here, as well as being dressed in the same manner as in the Wedding.
3. For the list of saints, see Freuler 1985, 24, and the *Enciclopedia dell'Arte Medievale* (Treccani, 1991), under the entry "Bartolo di Fredi," 124.

Fig. 1. Reconstruction proposed by G. Freuler and L. Artini of Bartolo di Fredi and workshop, *The Life of the Virgin Mary*

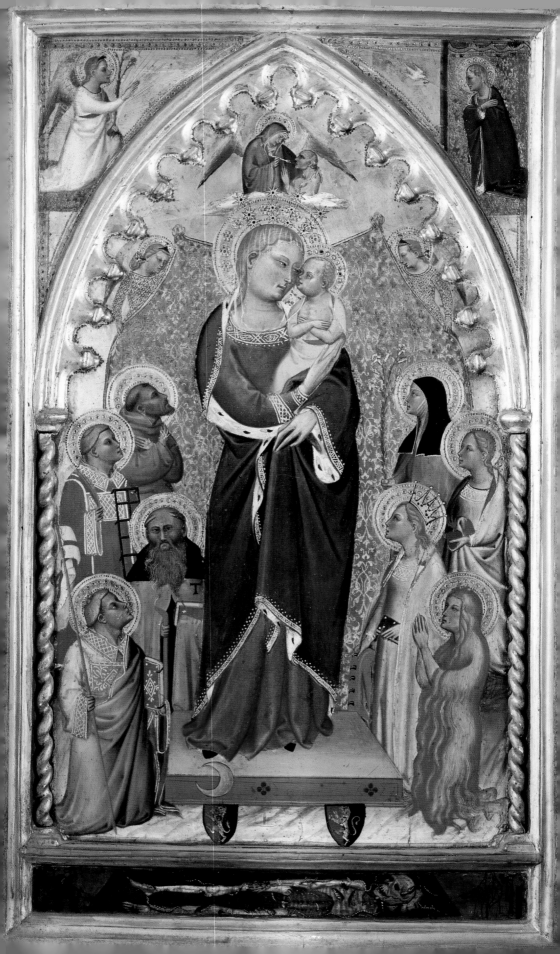

60

Giovanni del Biondo (Florence, active 1356–98)
THE VIRGIN OF THE APOCALYPSE WITH SAINTS AND ANGELS, c. 1391
Tempera and gold on wood in original frame, partly restored
75.4 x 43.4 cm (29¾ x 17 in.)
Vatican Museums, inv. 40014

Provenance: Formerly in the Collection of Seroux D'Agincourt, then in the Vatican Library.

Literature: Seroux d'Agincourt, *Storia dell'arte dimostrata coi monumenti della sua decadenza nel IV secolo fino al suo risorgimento nel XVI, di G. B. L. G. Seroux d'Agincourt*, translated and illustrated by Stefano Ticozzi (Prato, 1826–29), 4:375–76, and 6:372 and 373; Réau 1955–59; Levi d'Ancona 1957, 26; W. F. Volbach in Pinacoteca Vaticana 1987, 17; E. Guldan, *Eva und Maria* (Graz-Cologne, 1966), 105ff; *Enciclopedia dell'Arte Medievale*, ed. Treccani (1991), under "Giovanni del Biondo"; "Francesco d'Assisi"; "Francescanesimo."

This publication offers the occasion to suggest a new interpretation of the rather obscure subject of this painting.

In the upper corners of the panel is the mystery of Christ's Incarnation, with the archangel holding a lily in his left hand and saluting the Virgin with his right hand. The Holy Spirit flies toward Mary, who is kneeling and wears a red gown covered by a blue mantle. Her arms are crossed over her breast, symbolizing acceptance of her destiny.

In the central image of the panel, the Virgin is represented as a queen standing on a raised platform. She is wearing clothes of the same color as the Virgin of the Annunciation above her, but her mantle is lined with ermine; she holds Jesus affectionately close to her. Jesus is also covered by a mantle and crosses his arms over his chest, mirroring the image of the Virgin Mary above him. The statuesque pose and the linked glances of mother and child resemble Gothic sculptures of the late thirteenth century. A crown with twelve stars rests on the Virgin's head, and under her right foot is a crescent moon.

These details were inspired by John's vision in the Book of Revelation (12:1): "a woman clothed with the sun, and the moon under her feet, and upon her head a crown of twelve stars." In the revelation, the woman, after giving birth to her son, was saved from being devoured by the dragon when eagles' wings lifted her out of danger. In medieval tradition, this woman represented both the Virgin Mary and the Church, and references to this woman also can be found in images of the Assumption of Mary into Heaven after her death and of the Immaculate Conception. The subject of the Immaculate Conception of Mary, who was born without original sin, was a favorite of the Franciscan Order.

Above the Virgin, a winged cloaked figure with a halo has an arm around the shoulders of a man who is praying, dressed in penitential robes. The winged figure's right hand holds a rod tipped with burning coal to the penitent's lips to purify him (fig. 1). Scholars have interpreted the scene as a seraph purifying Isaiah's lips (Isaiah 6:6–7). However, traditional iconography at the time of this

panel, or previous to it, usually shows Isaiah with a halo, a beard, and long hair, dressed in a tunic and cloak, while seraphs had six wings. The cloaked figure, dressed like the Virgin Mary but with eagles' wings, may instead be interpreted as the woman of the Book of Revelation who has been given the wings of the eagles who saved her. This would represent both the Virgin and the Church in the act of purifying the soul of a dead man so that he can rise again from sin and death.[1] The purificatory gesture brings to mind both Isaiah and a psalm that was sung during funerals, the *Miserere* (Ps. 50:17): "O Lord, open thou my lips; and my mouth shew forth thy praise."[2] The dead man appears at the bottom of the panel (fig. 2); his skeleton is laid out in a grave, and worms, mice, and cockroaches are devouring him. The two figures kneeling on either side of him are probably a later addition to the scene; one is an old man who points toward the skeleton and has a tree and a monk's cell behind him, and the other is a young man who looks on in horror and is accompanied by a dog. These figures suggest a link with the medieval legend about the Encounter of the Three Living Men with Three Dead Men.[3]

Behind the Virgin Mary with the holy child in her arms are two sumptuously dressed angels with diadems in their hair. The angels hold up a purple drapery embroidered in gold, a sign of their homage to Christ's divine majesty.

On either side of the Virgin are four male and four female saints. On her right are Francis of Assisi, who wears a habit and has radiating stigmata on his hands; Lawrence, with a palm frond and the grill he was martyred on;

Anthony Abbot, carrying the book and pilgrim's staff, and with the *tau*[4] on his cloak; and finally Stephen, who is kneeling, carrying the crusaders' banner and the book. He has stones on the crown of his head, a symbol of his martyrdom.

On the Virgin's left are the female saints: Clare of Assisi with the lily; one with a burning heart in her hand, whom some scholars formerly identified as Ursula or Catherine of Siena, but who actually must be Bridget of Sweden. Next to her is Catherine of Alexandria, with the crown and the wheel, followed by Mary Magdalene, who is covered in her long blond hair and kneeling in a penitential pose.

Underneath the raised platform on which the Madonna stands are two bipartite shields in black and red, and on each one is a silver-white lion rampant.

Several elements clearly show that this panel was made for someone connected with the Franciscan order. These are, for example, the presence of Saint Francis and Saint Clare in the painting and the theme of the Virgin Mary and the Church's victory over sin and death, which leads to the soul's salvation. Saint Bridget of Sweden is also closely linked to the order and with the underlying theme of this painting. She belonged to the Third Order of the Franciscans and founded the Order of the Holy Savior, lived in Rome between 1349 and the year of her death in 1373, and was canonized in 1391. She is easily recognizable here because she holds her emblem of a heart surmounted by five tongues of flame, which symbolize Christ's wounds. The underlying theme of the painting, which centers around giving up worldly goods in favor of a life

inspired by high moral values, is consistent with the virtues of Saint Bridget and with the other saints surrounding the Virgin Mary.

The panel was very probably commissioned for the funerary chapel of a member of the Third Order of the Franciscans, whose family coat of arms is visible on the shields. The painting is attributed to Giovanni del Biondo, who according to documented sources was active in Florence from 1356 until his death in 1398; quite a lot of his work survives. During his lifetime, Giovanni was at first closely linked with the painters Orcagna and Nardo di Cione, but in time grew increasingly independent. He also worked with the younger Jacopo di Cione during the last decade of the fourteenth century. His paintings are notable for the increasing fluidity of the figures and for the characterization of the faces. The males particularly are rendered in a highly advanced form of portraiture for the fourteenth century; the small male figure representing the soul of the dead man in this panel almost looks like a portrait.

The date proposed for this painting is after 1391, the year of Saint Bridget's canonization, since here she wears a halo.
Adele Breda

1. Some medieval manuscripts show the *Ecclesia* (Church), in the form of the Woman of the Apocalypse, saving from the devil the soul of a baptized man. See, for example, the copy of Saint Augustine's *De Civitate Dei* in the Bodleian Library in Oxford (Misc. 469), dated 1130–40.

2. I would like to thank Msgr. Giuseppe Conte for suggesting that the panel could have been made for a funerary chapel, for referring me to this psalm, and also for the competence and kindness with which he dealt with my questions.

3. This eastern legend became popular in the western world because some preachers, particularly Franciscans and Dominicans, used it to impress upon their followers that death awaits everyone, even people caught up in a joyful and happy existence. The original legend, where three young hunters suddenly come across their own corpses laid out in graves, was embellished by the figure of an anchorite, Macario, who chastises the pleasure-loving young men, pointing out what their destiny will be.

4. The Greek letter *tau*, one of Saint Anthony Abbot's attributes, is a symbol of the spiritual life.

Fig. 1. Detail showing the purification of the soul of the deceased, from the pinnacle of cat. 60 (actual size)

Fig. 2. Detail showing the skeleton in his grave, from the predella of cat. 60 (actual size)

61

School of Emmanuel Tzanès
SAINT ALYPIOS, late 17th or early 18th century
Tempera and gold leaf on wood
43 x 32 cm (17 x 12⅝ in.)
Vatican Museums, inv. 40093

Conservation courtesy of John J. Brogan

Provenance: Vatican Library.

Literature: Muñoz 1995, 17, no. 85, pl. XLIII, 2;
Vatican 1934, 21, no. 93; Bianco Fiorin 1995,
33, no. 32, fig. 52.

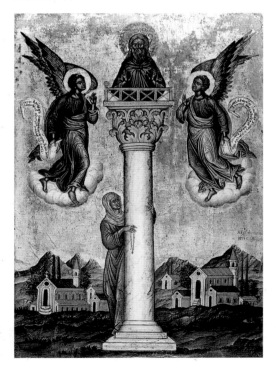

Fig. 1. Emmanuel Tzanès, *Saint Alypios on His
Column.* © Musée d'Art et d'Histoire, Geneva,
inv. 1984-84

The iconography of the panel conforms entirely to the tradition according to which Saint Alypios, who was born in the sixth century and died in 640, withdrew to the top of the column of an ancient pagan building and founded two monasteries at its foot, one for men and the other for women, which he continued to direct from the top of his column. The *stylite* saint is here represented as a bust, the palms of his hands exposed in the gesture of the orant, at the top of the column where he spent fifty-three years of his life. He appears behind a balustrade, placed on top of a Corinthian capital with acanthus leaf decoration of the same gray color. The saint is dressed in a brown monastic habit. His face is austere, his beard venerable, and his hair long, according to the oriental monastic usage. He is flanked by two angels, their feet resting on clouds. They hold scrolls in their hands and regard the saint with admiration. "Exposed to the regard of men like the lamp on its lamp-stand, the saint shone forth by his virtues" (Mt. 5:14–16), reports the *synaxarion*,[1] which adds that "he offered himself like the apostles as a show to the world, to men and to angels, for love of Christ" (1 Cor. 4:9). Embracing the shaft of the column, a woman, with the *chomvoschinion* (monastic rosary) in her hand, represents the saint's mother who, "overcoming the weakness of her nature and her maternal affection, had followed and assisted her son in the accomplishment of his exploits" and who came to join the female community he had founded, "though without immediately assuming the habit, in spite of the wish of her son."[2] In fact, the woman represented in the icon is not dressed as a nun.

Two churches, placed on either side of the column and flanked by typically Venetian bell towers, represent the two monasteries, the one for men, the other for women, founded by Alypios at the foot of his column. "It is an admirable spectacle to hear seven times each day the choir of the virgins and that of the monks burst out in singing the praises of God, and to see the saint standing between the two, terrestrial angel and celestial man, uniting his voice with them and raising his hands toward the God in Three Persons, as he intercedes for the salvation of the world."[3] The scrolls in the hands of the angels contain respectively extracts in Greek from the *Orthros* (office of Matins) of the feast of the Saint Alypios (26 November): Ἄλλον ὡς Σαμουὴλ σε Θεὸς ἡγίασε μητρικῆς ἐκ κοιλίας, Ἀλύπιε μακάριε, καὶ βλέπων τὰ ἔμπροσθεν ὡς προφήτην ἔνθεον ἀπειργάσατο ἀξιάγαστε (Like a new Samuel God has consecrated you ever since you were conceived in the womb of your mother, O blessed Alypios); and

Ἀλυπίου τὸν βίον τὸν ἔνθεον καὶ ἰσάγγελον δεῦτε θαυμάσατε ἱερεῖς, βασιλεῖς καὶ μονάζοντες (Come, priests, kings, and monks, pay homage to the life of Alypios, inspired by God and rendered akin to that of the angels).

The comparatively little-known icon in the Vatican is very close in style to the manner of painting of the Greek priest and icon painter Emmanuel Tzanès (1610–90) at the church of San Giorgio dei Greci in Venice. Tzanès is known to have painted this same subject many times.[4]

The present icon does not seem to achieve the qualitative level of Tzanès's usual style and might be the work of one or his pupils or imitators of the late seventeenth or early eighteenth century. This is especially suggested by a comparison with other autograph works of this master, of which many examples survive.[5] Nonetheless, it does closely resemble the icon of the same subject, signed and dated by Emmanuel Tzanès himself, and now in the Musée d'art et d'Histoire in Geneva (fig. 1).[6] A double inscription, in Greek and in Latin Ὀ ἅγ(ιος) Ἀλύπιος / S(AN)C(TU)S ALIPIOS (sic) (Saint Alypios), traced in red in the upper part of the panel, testifies to the particular context in which many icons of the so-called Cretan-Venetian school were painted. The edges of the panel still bear the mark of the metal frame that must originally have adorned the icon, as was normally the case in this period.
Michel Berger

1. The *synaxarion* is a hagiography read as a lesson in public worship in the Orthodox Church. For the *synaxarion* of Saint Alypios, see *Le Synaxaire, Vie des Saints de l'Eglise Orthodox* (Adaptation par Macaire, moine de Simonos Pétra), vol. 1, September-October-November (Thessalonica, 1987):594–97.
2. Synaxaire 1987, 1:594–97.
3. Synaxaire 1987, 1:594–97.
4. On the life and career of Emmanuel Tzanès, see, among others, A. Embiricos, *L'Ecole Crétoise, Dernière phase de peinture byzantine* (Paris, 1967), 197–212, and the "Nota biografica sui pittori" in Bianco Fiorin 1995, 103–04.
5. For the icons of Saint Alypios expressly signed by or attributed to Emmanuel Tzanès, see, in particular, M. Chadzidakis 1962, 131–32, no. 109 (84), and Bandera Viani 1988, 52, no. 72; M. Bianco Fiorin, *Pittura su tavola dalle Collezioni dei Civici Musei di Storia ad Arte di Trieste* (Milan, 1975), no. 19; Lazovic and Frigeriou-Zeniou 1985, no. 13. See also an icon of Saint Alypios attributed to Constantin Contarinis of Corfu, dating to the early eighteenth century, in *Les icones dans les Collections suisses* (Geneva: Musée Rath, 1968), no. 52, fig. 52.
6. Lazovic and Frigeriou-Zeniou 1985, fig. 13.

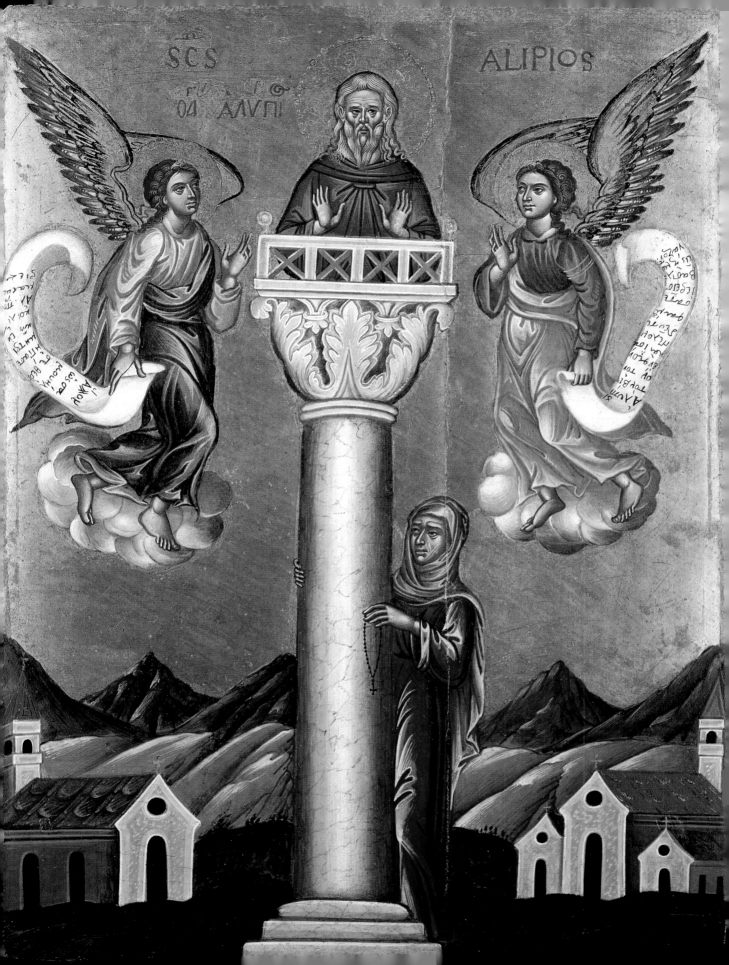

62

Paolo Caliari, called Veronese (Verona, 1528–1588)
THE VISION OF SAINT HELENA, c. 1580
Oil on canvas
166 x 134 cm (65⅜ x 52¾ in.)
Vatican Museums, inv. 40352

Exhibitions: New York 1982; Washington, D.C., National Gallery of Art, *The Art of Paolo Veronese 1528–1588*, 1988; Paris 1990.

Literature: G. and A. D'Este, *Elenco degli oggetti esistenti nel Museo Vaticano* (Rome, 1821), 37–38; G. Fiocco, *Paolo Veronese* (Bologna, 1928), 86, 193; C. Gould, *The Sixteenth-Century Venetian School. National Gallery Catalogues* (London, 1959), 147–48; E. Francia, *Tesori della Pinacoteca Vaticana* (Milan, 1968), 112, 119, no. 193; T. Pignatti, *Veronese* (Venice, 1976), 150, no. 256; F. Mancinelli in New York 1982, 157, no. 81; A. M. De Strobel and F. Mancinelli, "Il Cinquecento," in Pinacoteca Vaticana 1992, 282.

This painting was purchased by Benedict XIV (1740–58) with the Pio di Savoia collection to be shown in the Campidoglio, and in 1820, under Pius VII (1800–23), it was displayed in the renovated Vatican Picture Gallery, where it still hangs.

The subject of the painting is the well-known story of the vision, or more correctly the dream, which, according to legend, brought Saint Helena, the mother of Emperor Constantine, to discover the True Cross in Jerusalem. The cross, which appears before her supported by a winged putto presenting his back to the audience, could be said to be the materialization of her dream. Saint Helena is seated in an attitude of repose, her head resting on her left hand, and her eyes closed. She wears a sumptuous gown, in sixteenth-century style, partly covered by a cloak fastened with a precious clasp. A jeweled crown secures the veil covering her head.

The *Saint Helena* in the National Gallery in London is another version by Veronese of the same subject, and there may have been others, now lost.

Gould,[1] who pointed out how different the iconography used by Veronese was to that commonly adopted in the Veneto, where Saint Helena was usually shown standing beneath the cross, found, however, a prototype for

Veronese in an engraving by a follower of Marcantonio Raimondi. This depicts the vision of a saint (Agnes?) and is a copy of a drawing in the Uffizi attributed to Raphael.[2] The London painting can be dated at around 1570, while the Vatican version, differentiated from the former by the attribute of the cross, which in the previous version was carried in flight by two putti, is variously dated between 1575[3] and about 1580.[4] The Vatican painting is an excellent example of Veronese's mature style. The vitality and decorative genius of the artist, which had brought him such extraordinary success in the region of Venice during the second half of the sixteenth century, is here somewhat muted in a more placid type of composition and a more controlled use of color. The monumental style of the painting does not prevent Veronese from taking delight in certain decorative elements, most particularly in the precious draperies and in the rich costume worn by Saint Helena.
Maria Serlupi Crescenzi

1. Gould 1959, 147–48.
2. K. Oberhuber, *Raphael's Zeichnungen* 9 (Berlin, 1972):95–96, no. 409.
3. Fiocco 1928, 193.
4. R. Marini, *L'Opera Completa del Veronese* (Milan, 1968), 112, 119, no.193.

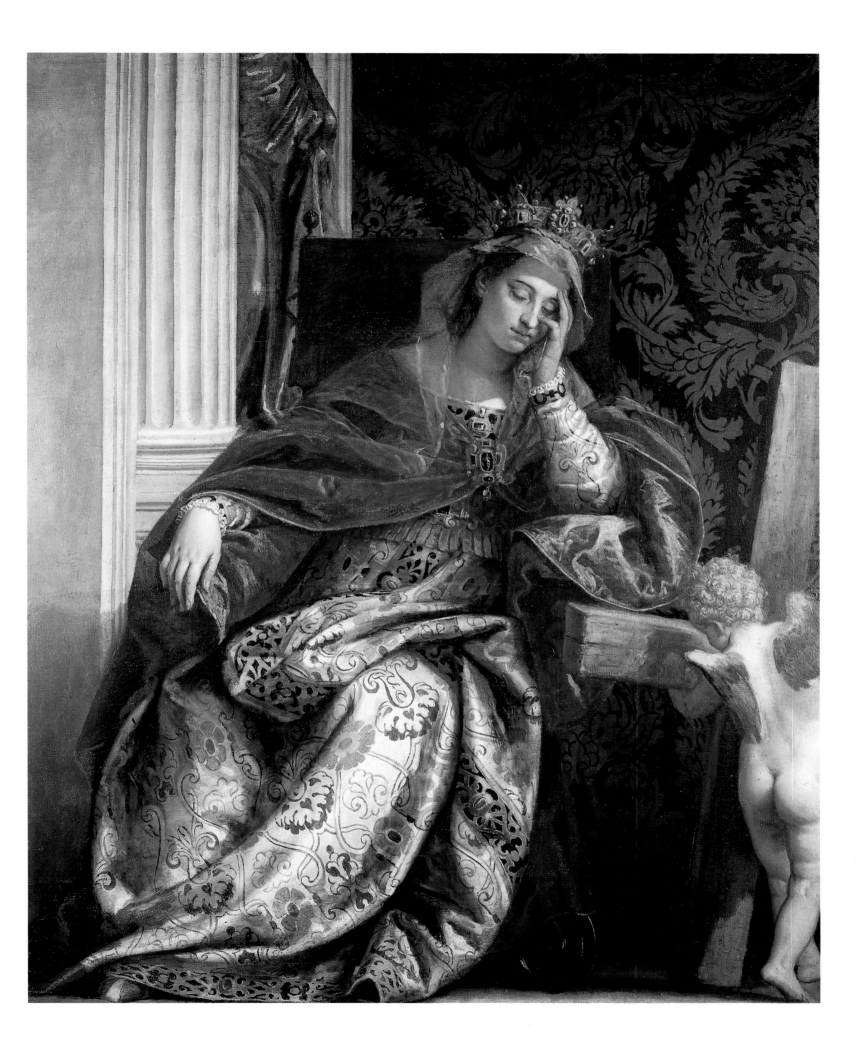

63

School of Bernardo di Betto, called
Pinturicchio (Perugia, 1454–Siena, 1513)
THE MYSTICAL MARRIAGE OF SAINT CATHERINE
Tempera on wood
45 x 34 cm (17¾ x 13⅜ in.)
Vatican Museums, inv. 40314

Conservation courtesy of the Patrons of the
Arts in the Vatican Museums of the South

Restored: 1968.

Provenance: Vatican Apostolic Library,
Christian Museum, Arm. XIII, n. 2, 1867;
Vatican Apostolic Library, Christian Museum,
Case S, XIII, n. 166; in the Vatican Picture
Gallery since 1909.

Exhibitions: The painting is being exhibited
for the first time.

Literature: Barbier de Montault 1867, 159;
Crowe and Cavalcaselle 1869–76, 5 (1873):311;
D'Achiardi 1929, 22–23 and tab. CXIV;
Berenson 1932, 460; Berenson 1936, 395.

The Madonna is seated, her figure slightly
foreshortened, between two winged cherubs'
heads. One of her arms supports the holy child,
and the other arm is around Saint Catherine's
waist, drawing her close in a gesture of
affectionate intimacy. The saint, dressed in a
black, flowered gown and with a jeweled crown
on her head, holds her left hand to her breast as
a sign of devotion and extends her right hand
to the child, who is slipping the wedding ring
on her finger. The jewels and the hemlines are
painted with care, and so are the engraved
haloes, which radiate bands of light against
the gold background.

The subject is taken from the legend of
Saint Catherine of Alexandria, which
first appeared in the tenth century in the
Menologium of Basilius and was subsequently
popularized as a kind of fable in Iacopo da
Varazze's *Legenda Aurea.*[1] According to
tradition, the learned Catherine was well
versed in logic and philosophy. She supposedly
was converted to Catholicism by a hermit who
showed her a picture of the infant Jesus in his
mother's arms, telling her that this was the
only bridegroom worthy of her noble lineage,
her beauty, and her wisdom. The tale of her
conversion eventually gave rise to the legend of
the Mystical Marriage, which, according to
Réau, is not included in the original version of
the *Legenda Aurea* but appears for the first
time in the English translation of the text
produced by F. Jean de Bungay in 1438.[2]

This *Mystical Marriage* originally belonged
to the collection of fourteenth- and fifteenth-
century paintings in the Vatican Library's
Christian Museum in the early nineteenth
century and later became part of the Picture
Gallery of Pope Pius IX (1846–78). It was first
mentioned in print by Barbier de Montault in
1867.[3] In their *Storia della pittura italiana,*[4]
Crowe and Cavalcaselle attribute the painting
to "Pinturicchio's manner," and D'Achiardi's
catalogue picks up the attribution in 1929.[5]
Although Berenson included it among
Pinturicchio's own works,[6] the painting is
now considered an exquisite product of the
master's school, the work of a hand similar to
Pinturicchio's but with a harder and less
fluidly creative line. The painting's small

dimensions and its ornamental decorativeness
suggest that it might have been commissioned
for a private collection. This hypothesis is
indirectly confirmed by the half-length figures
and the subtle characterizations. Devotion to
Saint Catherine was widespread from the
middle of the fourteenth century to around
the end of the sixteenth, and it should be noted
that she was not only the patron saint of virgins
and of the dying, but also of judges of the
Rota tribunal and of all clerics who studied
philosophy and theology. During the first half
of the fifteenth century, Saint Catherine was
also the patroness of some powerful guilds,
including potters, weavers, and barbers.
Guido Cornini

1. Varazze 1995, 963–71.
2. Réau 1955–69, 3 (1958): 262–63, 268–69.
3. Barbier de Montault 1867, 159. On the Christian
Museum and the formation of the Vatican Picture
Gallery, see C. Pietrangeli, *I Musei Vaticani. Cinque
secoli di storia* (Rome, 1985), 154 and nn. 27, 196.
4. Crowe and Cavalcaselle 1873, 5:311.
5. D'Achiardi 1929, 22–23 and tab. CXIV.
6. Berenson 1932, 460; Berenson 1936, 395.

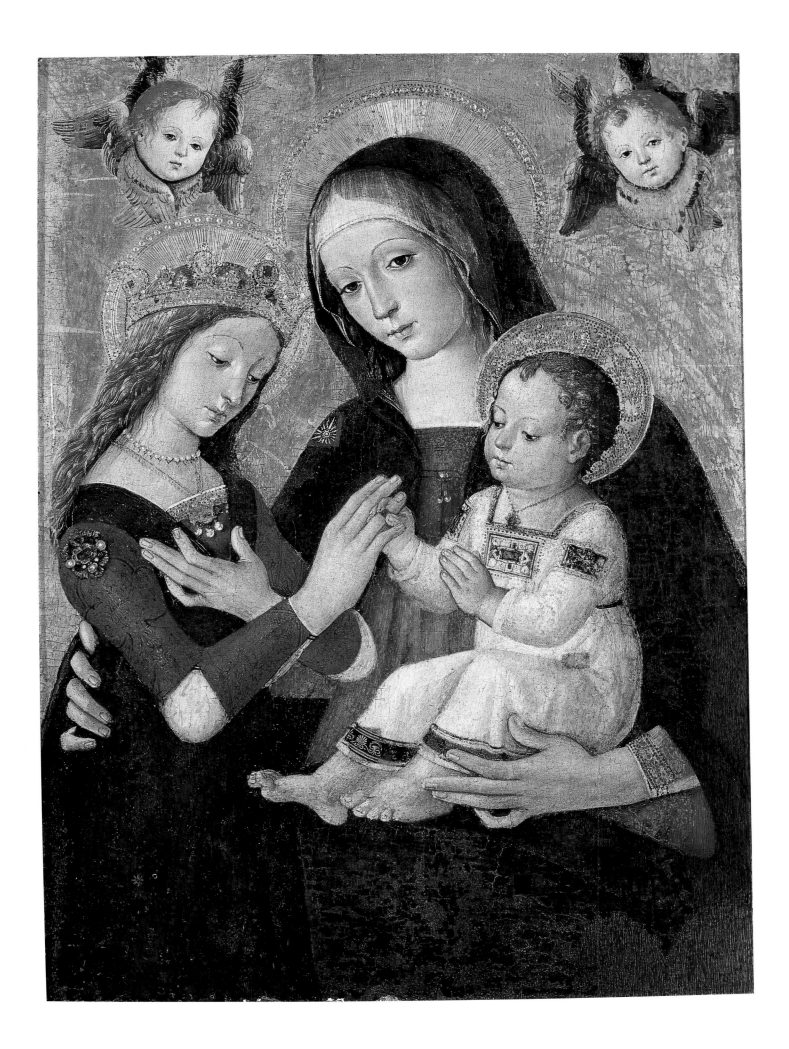

64

Niccolò di Tommaso (fl. c. 1350–80)
SAINT BRIDGET AND THE VISION OF THE NATIVITY
After 1372
Tempera on wood
43.5 x 53.8 cm (17⅛ x 21¼ in.)
Vatican Museums, inv. 40137

Conservation courtesy of Eric F. Green and
Jock Truman

Exhibitions: Rome, Palazzo Braschi, *Svezia-Roma*, 1980; Vatican City, Biblioteca Apostolica Vaticana, *Rosa Rorans Bonitatem*, 1991.

Literature: [P. D'Achiardi], *Guida della Pinacoteca Vaticana* (Rome, 1913), 77; R. Offner, *Studies in Florentine Painting* (New York, 1927), 114 ff.; D'Achiardi 1929, 15; B. Biagetti, "Il Natale del Redentore in alcuni piccoli dipinti della Pinacoteca Vaticana," *L'Illustrazione Vaticana* 1 (1930):41; A. Porcella in Vatican 1933, 38; R. Offner, "A Ray of Light on Giovanni del Biondo and Niccolò di Tommaso," *Mitteilungen des Kunsthistorischen Instituts in Florenz* 7 (1953–56):192; Berenson 1963, 162; *Bibliotheca Sanctorum*, edited by the Istituto Giovanni XXIII of the Pontificia Universita Lateranense, Rome s.d. (1961–70), 3:530 (Celletti); A. Butkovich, *Iconography. St. Bridget of Sweden* (Rosan, 1969), 55; Boskovits 1975, 203; R. Fremantle, *Florentine Gothic Painters from Giotto to Masaccio* (London, 1975); Volbach in Pinacoteca Vaticana 1987, 25–26; F. Mancinelli in Pinacoteca Vaticana 1992, 126, 134.

This small panel was moved from the Sacred Museum of the Vatican Apostolic Library into the Picture Gallery in 1908.

The painting is mentioned in the early guide books[1] as a work by Sano di Pietro. Offner cast doubt on this attribution[2] and judged the painting to be the work of Niccolò di Tommaso. This artist's name appears nowhere in the documentary evidence available, but he was probably born in Florence during the first half of the fourteenth century, and some idea of his artistic personality can be gleaned from a handful of paintings made between 1350 and 1380.

The validity of Offner's theory, which has been unanimously accepted by subsequent critics, is demonstrated by the close stylistic links with other works by the artist, such as the *S. Antonio* triptych of 1371 (Museum of S. Martino, Naples), *SS. Giovanni e Paolo* (Horne Collection, Florence), and the *Nativity* (Johnson Collection, Philadelphia Museum of Art). Offner also suggested a possible connection between this panel and two others in the Vatican Picture Gallery, *SS. Giuliano e Lucia* (inv. 40212) and *SS. Antonio Abate e Giovanni Battista* (inv. 40219), with which the panel would have formed a triptych,[3] convincing Berenson[4] but not Volbach,[5] who made clear, above all, the dissimilarity in size of the works.

The panel provides one of the earliest representations of the Nativity according to the vision that appeared to Saint Bridget in Bethlehem during her pilgrimage to the Holy Land in 1372. On that occasion, the Virgin, keeping the promise made to Saint Bridget many years earlier in Rome, revealed that her divine son was born to her while she was on her knees, without help and without suffering. The Vatican painting, almost contemporary with the miraculous vision, probably describes it with extreme accuracy as to detail, thus making the panel something of a historical document. The writings of Saint Bridget had a notable influence on the iconography of the Nativity from the fourteenth century onward, a subject for which artists had fixed the various compositional elements according to the vision described in the book of Revelations. Besides

the version by Niccolò di Tommaso, a similar painting by a contemporary artist of the Pisan school, the *Visione di Brigida* (Museo Nazionale di S. Matteo, Pisa), comes to mind, as well as numerous representations in popular art, both in paintings and in tapestry, particularly in Sweden.

Saint Bridget of Sweden was a figure of considerable stature, not only moral but also political, heavily involved in the historical events of Europe, then in turbulence owing to the Hundred Years' War and the exile of the papacy in Avignon. She devoted herself with great energy to carrying out her chosen mission: establishing peace between the French and English sovereigns and returning the Papal Curia to Rome, the ideal seat of the Vicar of Christ.

The composition contains all of the traditional elements of the Nativity. Inside the cave can be seen the Virgin and Saint Joseph, identified by the *tituli* of their halos: AVE MARIA GRACIA PLENA DOMIN ... and SANCTO IOSEPUS SPONSUS VIRGINIS. Between them is the child, inside a mandorla, lying naked on the straw. Behind the Madonna, who is kneeling in a prayerful attitude, are her cloak and her shoes, and beside her are the clothes she had prepared for the coming child. From her lips issue the words AD ME VE(RT)ERIS DOMINUS MEUS; DEUS MEUS.... Outside the cave appears Saint Bridget, wearing her nun's habit, kneeling with a rosary in her hands, and with a pilgrim's staff nearby, the latter being a reference to her own pilgrimage. In the background on the right, one of the angels gives the good news to the shepherds. Finally, on high, in the midst of a starry sky and surrounded by cherubim and seraphim singing praises and playing musical instruments, can be seen God the Father in glory, pronouncing the words HIC EST FILIUS MEUS.
Maria Serlupi Crescenzi

1. D'Achiardi 1913, 77; D'Achiardi 1929, 15.
2. Offner 1927, 114 ff.
3. Offner 1956, 192.
4. Berenson 1963, 162.
5. Volbach in Pinacoteca Vaticana 1987, 26.

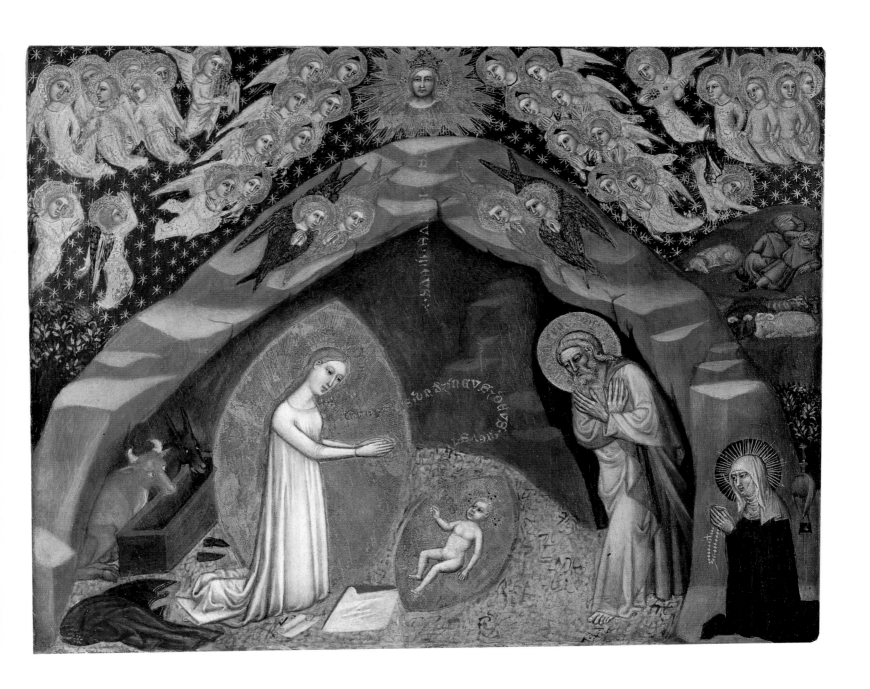

65

Bartolomé Esteban Murillo (Seville, 1618–82)
THE MARTYRDOM OF SAINT PETER OF ARBUÈS
1668–70
Oil on canvas
132.5 x 102 cm (52 x 40 in.)
Vatican Museums, inv. 40746

Literature: P. Lafond, *Murillo* (Paris, 1923);
J. Guerrero Lovillo, "Murillo y Assereto,"
AEArte 23 (1950):133–44; J. A. Gaya Nuño,
"Murillo," *Encyclopedia Universale dell'Arte* 9
(1963):736–38; R. Perez Delgado, *Murillo*
(Madrid, 1972); J. A. Gaya Nuño, *L'Opera
completa di Bartolomé Esteban Murillo* (Milan,
1978), no. 164.

This painting was sent from Spain to the
Vatican Picture Gallery in October 1876 as
a gift to Pope Pius IX (1846–78) from the
Spanish king Alfonso XII. It represents a
variation of the painting that was originally
located in Seville's Inquisition Palace
and purchased for the Hermitage in 1831.
The date of both canvases is generally placed
at 1668–70.

The subject is one of the rare episodes of
violence attempted by the Spanish painter, in
which two hired assassins, daggers in hand,
lunge to attack the kneeling Saint Peter of
Arbuès. Simultaneously, an angel appears to
him, bearing a palm branch, the traditional
symbol of martyrdom.

The saint, born into an aristocratic family
in Spain in 1440, was a teacher of theology.
An austere, pious man, he was known for the
great zeal with which he defended religious
orthodoxy. When Torquemada divided Spain in
several administrative regions, Peter of Arbuès
was named King Ferdinand's representative in
Aragon. Some of the local people, who had not
liked the harsh inflexibility of his government,
plotted against him. In the night of September
15, 1485, while on his knees chanting Matins,
Peter was attacked and killed by a conspirator.
He was beatified in the seventeenth century
and canonized by Pius IX in 1867.

Bartolomé Esteban Murillo painted several
altarpieces and canvases devoted to biblical
stories or episodes taken from the lives of
saints, creating images of refined beauty that
reflected genuine devoutness while sometimes
displaying mannered conventionality. These
works were undertaken almost exclusively for
churches and convents in Seville, the town in
which he spent almost his entire career and in
which he founded an academy of fine arts
(Academia de Dibujo) in 1660. He was not only
the academy's first headmaster together with
Francisco de Herrera, but also its most staunch
and active supporter, so much that it ceased to
function at his death.

His striking success is indicated in the
canvases located in the small cloister of the
Franciscans in Seville, which earned him
immediate notoriety in the fervid atmosphere
of Spanish painting of those times. This first
effort marked the beginning of his uncontested
fame among his contemporaries, a renown
that persisted through the 1700s and 1800s.
His immense success is based on a prolific
production not limited to religious themes, for
which he was celebrated as the "painter of the
Immaculate Conception," but included also
portraits depicting great introspective detail
and scenes of incomparable freshness and
vivacity so advanced in their approach as to
anticipate the pictorial style of the eighteenth
century.
Maria Serlupi Crescenzi

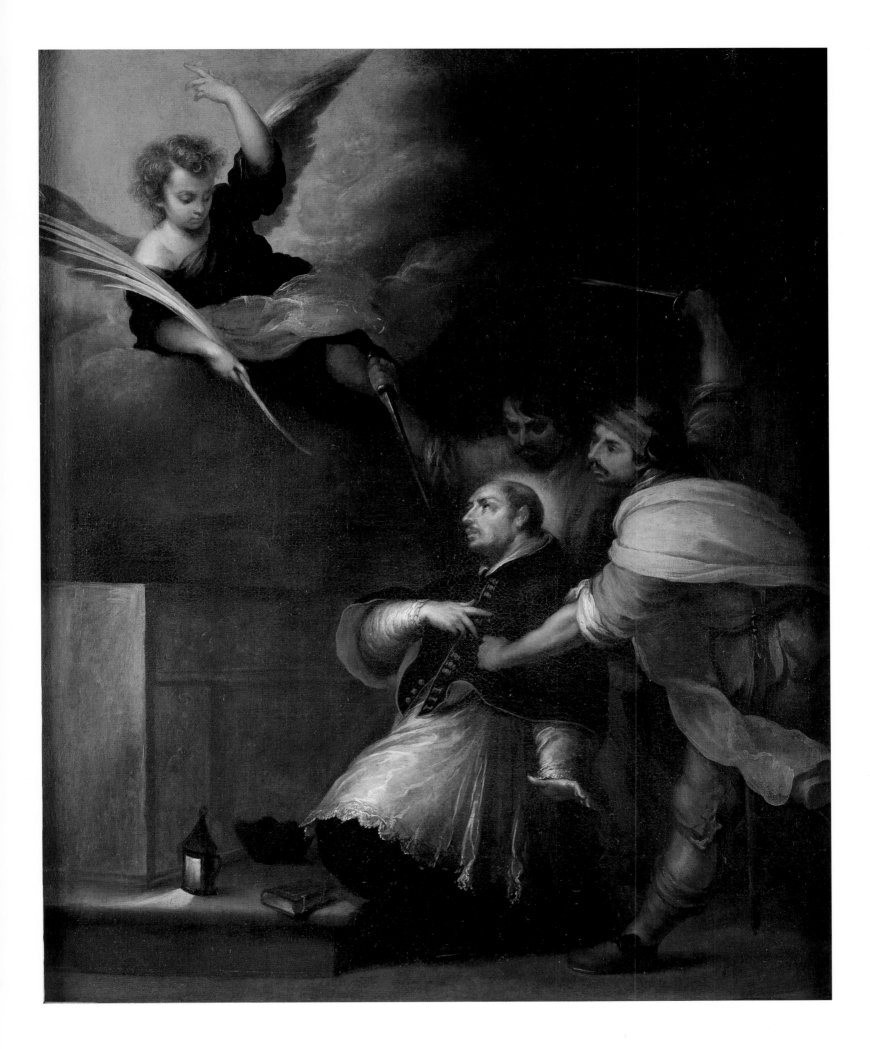

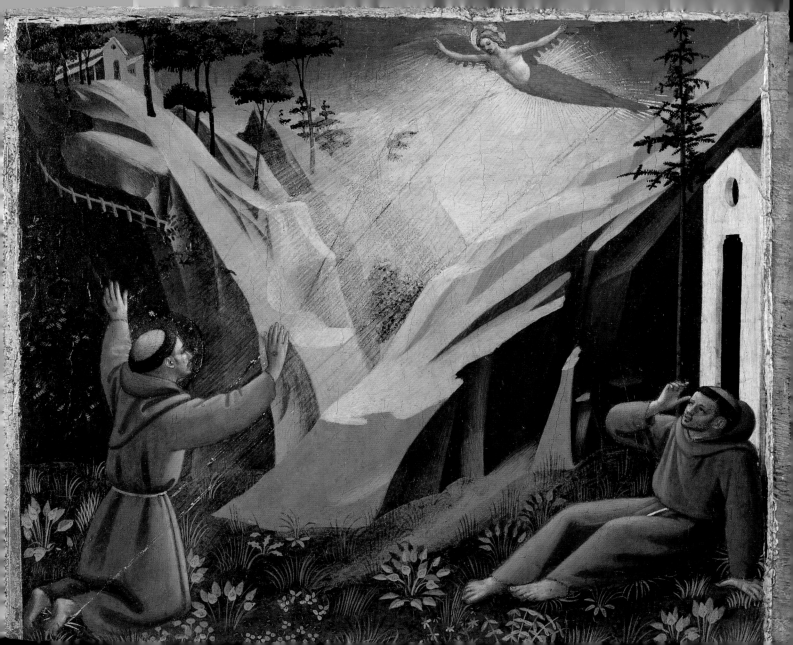

66

Guido di Pietro, called Fra Angelico (Vicchio di Mugello, c. 1395–Rome, 1455)
SAINT FRANCIS RECEIVING THE STIGMATA, c. 1440
Tempera on wood
27.5 x 33 cm (11⅞ x 13 in.)
Vatican Museums, inv. 40258

Conservation courtesy of John H. Surovek in honor of his son, Cory Surovek

Restoration: 1955.

Provenance: 1867, Vatican Apostolic Library, Christian Museum, Cupboard XV, no. 6 (Barbier de Montault 1867, 164); Vatican Apostolic Library, Christian Museum, Showcase Q,V, no. 179 (D'Achiardi 1929, 9); in Pinacoteca Vaticana since 1909.

Exhibition: Vatican City, Palazzo Apostolico Vaticano, *Mostra delle opere di Fra Angelico*, 1955.

Literature: Barbier de Montault 1867, 164; B. Berenson, *Florentine Painters of the Renaissance* (New York-London, 1896; 3rd ed., 1909), 102; F. Schottmüller, *Fra Angelico*, 2nd ed. (Berlin-Leipzig, 1924), 265; D'Achiardi 1929, 9; L. Collobi-Ragghianti, "Zanobi Strozzi pittore," in *Critica d'Arte* 8 (1950):454, 9 (1950):17, and (1950):467; Pope-Hennessy 1952, 15, 178; Collobi-Ragghianti 1955; D. Redig de Campos, in *Mostra delle opere di Fra Angelico* (exh. cat. Florence-Rome, 1955), 61, cat. 36; Salmi 1958, 10–99; Parronchi 1961, 31–37; Baldini 1970, 103, cat. 64.

This painting shows Saint Francis receiving the stigmata, as recounted by Tommaso da Celano, by Saint Bonaventura, and, at a later date, by Iacopo da Varazze in his *Legenda Aurea*.[1]

In a landscape composed of sharp-edged rocks evoking the rough countryside surrounding the hermitage at Verna, Saint Francis kneels in ecstasy before Christ in the form of an angel. From the wounds of Christ on this cross spring rays that imprint the stigmata on Francis' hands, his feet, and his side. On the right, Brother Leone, seated with his shoulders against the chapel walls, is awakened by the blinding light of the apparition. The form of the crucifix follows closely Saint Bonaventura's description of the divine manifestation: a being "with six wings like a Seraph, with his feet held close together and his arms extended, hanging on a cross. Two of his wings were raised above his head, two spread out in flight, while the last two covered his whole body." The receiving of the stigmata is one of the essential events that form a parallel between the figure of Saint Francis and that of Christ and, although clearly modeled on Isaiah's vision of the six-winged fiery angel (Isaiah 5:6), remains one of the most widespread features of the saint's iconography.

The origins of this small panel from the Vatican Apostolic Library are unknown. During the last century, it was judged to be a late-fifteenth-century work by an unknown hand.[2] D'Achiardi (1929), following Sirén (1907), attributed the painting to the school of Fra Angelico,[3] while Berenson,[4] on the grounds of stylistic judgment, claimed the work for the master himself, linking to it the panels with the *Stories of Saint Francis* at present divided between the museums of Berlin and Altenburg (figs. 1–3).[5] The question was taken up again by Schottmüller (1924), who suggested that the series may have formed the predella of the Bosco ai Frati altarpiece,[6] a suggestion accepted in general by subsequent critics with the exception of Collobi-Ragghianti, who considered the stories to be part of a lost polyptych of which the *Madonna* of Pontassieve would have formed the central

Fig. 1. Fra Angelico,
The Meeting of Saint Francis and Saint Dominic.
Gemäldegalerie, Staatliche Museen, Berlin

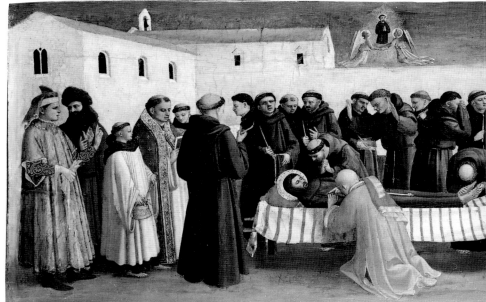

Fig. 2. Fra Angelico,
The Funeral of Saint Francis.
Gemäldegalerie, Staatliche Museen, Berlin

portion.[7] Salmi refused to consider a link with
the Bosco ai Frati altarpiece and thought that
the panel, along with the three from Berlin
and that of Altenburg, could be connected with
the predella of the group, mentioned in
sources, that was originally in the church of
S. Francesco outside Porta S. Miniato (now
known as S. Salvatore al Monte),[8] which he
identified as being the *Annunciation* by
Domenico di Michelino, now in London.[9]
Noteworthy among recent attributions is that
of Parronchi, who recognized in the Franciscan
paintings the predella of the so-called
Annalena altarpiece, which he considered to be
the original of the Bosco ai Frati painting:
although there is no documentary proof of the
scholar's theory, it does at least have the merit
of being able to suggest a rational positioning
for the various compartments of the predella.[10]
Guido Cornini

222

Fig. 3. Fra Angelico,
The Apparition of Saint Francis at the Chapter of Arles.
Gemäldegalerie, Staatliche Museen, Berlin

1. Tommaso da Celano, *Vita prima* (c. 1230), *Vita secunda* (c. 1245); Saint Bonaventura, *Vita* (1263). For the description of the incident that forms part of the *Legenda Aurea*, see Varazze 1995, 821.
2. Barbier De Montault 1867, 164.
3. D'Achiardi 1929, 9 and pl. XLVII.
4. Berenson 1909, 202.
5. Baldini 1970, 103, cats. 63, 65, 66, 67. Specifically relating to the three panels in Berlin at the Gemäldegalerie, Staatliche Museen, Preussischer Kulturbesitz, *Katalog der ausgestellten Gemälde des 13.–18. Jahrhunderts* (Berlin-Dahlem, 1975), 27–28, cats. 61, 61A, 62.
6. Schottmüller 1924, 265. This relates to the altarpiece that came from the Franciscan convent of S. Bonaventura at Bosco ai Frati at Mugello, in the environs of Cafaggiolo, which is today in the Museum of San Marco in Florence (in the main panel: *Madonna and Child between Two Angels and Six Saints*; in the predella: *Christ in Pietà with Six Saints*). For dating and critical fortunes of the group see Baldini 1970, 113–14, cat. 115.
7. Collobi-Ragghianti 1950, 467; Collobi-Ragghianti 1955, 39. This concerns the triptych originally in the parish church at Pontassieve, of which the central panel, the *Madonna and Child*, is now in the Uffizi (Baldini 1970, 96, cat. 44).
8. G. Vasari, *Le Vite de piu eccellenti architetti, pittori, et scultori italiani* (1550; ed. L. Bellosi and A. Rossi, 1986), 347 and no. 12.
9. Salmi 1958, 10–99. Concerning the attribution to Domenico di Michelino, see Collobi-Ragghianti's reservations (1950), 467.
10. A. Parronchi, "Due pale dell'Angelo per due conventi," *Commentari* 12 (1961):31–37. According to this historian, the order of the sections should be as follows: *The Meeting of Saint Francis and Saint Dominic* (Staatliche Museen, Berlin), *Saint Francis before the Sultan* (Lindenau Museum, Altenburg), *The Funeral of Saint Francis* (Staatliche Museen, Berlin), *The Apparition of Saint Francis at the Chapter of Arles* (Staatliche Museen, Berlin), and *Saint Francis Receiving the Stigmata* (Vatican Picture Gallery). For the Annalena altarpiece, see Baldini 1970, 100, cat. 59.

67

Giovanni Battista Gaulli, called Baciccia
(Genoa, 1639–Rome, 1709)
THE VISION OF SAINT FRANCIS XAVIER, c. 1675
Oil on canvas
64.5 x 46 cm (25⅜ x 18¼ in.)
Vatican Museums, inv. 41489

Exhibitions: Vatican City 1990; Manila, The
Philippines, Metropolitan Museum, *2,000 Years
of Vatican Treasures … And They Will Come
from Afar,* 1993–94.

Literature: Enggass 1964, 25–26; E. Levy, in
Vatican City 1990, 197, n. 124.

Fig. 1. Giovanni Battista Gaulli, *The Vision of Saint
Francis Xavier,* c. 1675, oil on canvas. S. Andrea al
Quirinale, Rome

Lying outstretched on a palliasse in the right
foreground, Saint Francis Xavier is depicted
as clasping a crucifix to his breast and
surmounted by angels and cherubim who,
among the clouds, are assisting at his lonely
agony.

Saint Francis Xavier, a Spaniard, stands out
as a person of great stature in the history of the
Church. Known as the "apostle of the Indies
and Japan," he was the founder of the missions
of the Society of Jesus (recognized by Pope
Paul III in 1539) in the Far East, opening up
new paths to evangelization and serving as a
model to revive a modern missionary spirit in
Europe. Having set up the society's province of
India and founded the Church in Japan, he also
wanted to win over China to Christianity.
However, he was prevented from reaching his
goal when, stricken by sickness, he died on the
island of Sanchan in 1552, attended by only
one Chinese Christian. His body, which was
found uncorrupted by decay after some
months, was brought to Goa, southern India,
where it rests today in the church of the Jesuit
fathers, the Bom Jesus.

During his lifetime, Francis Xavier was
glorified by legends based on his exceptional
fame as a worker of wonders, a reputation that
was spread and amplified by popular tradition.
In 1622 he was canonized with the founder of
the Society of Jesus, Saint Ignatius of Loyola,
at a solemn ceremony celebrated by Gregory
XV (1621–23), the first to be held in St. Peter's
Basilica after it had been completely rebuilt.

Witness to Saint Francis Xavier's great
fame is borne out by the many paintings that
depict him, in accordance with the canons of
the Counter-Reformation, in an ecstatic
attitude with his eyes raised to the heavens,
such as in the large painting in the Vatican
Picture Gallery attributed to Van Dyck and his
workshop (inv. 40775), or at exemplary
moments in his life.

The Jesuits' program for celebration
dictated the iconographical choice of paintings
and sculptures, produced by the greatest artists
of the period. In the churches of the Gesù,
S. Ignazio, and S. Andrea al Quirinale, altars
were erected in honor of the patron saints of
the society.

This small painting is the sketch for the
altarpiece by Giovanni Battista Gaulli, known
as Baciccia, for the chapel dedicated to Saint
Francis Xavier in the church of S. Andrea al
Quirinale, erected for the novitiate of the
Society of Jesus (fig. 1).

The Genoese artist Baciccia moved to
Rome when he was young and spent the rest of
his life there. In a short time he established
himself as one of the favorite painters of both
the lay and the ecclesiastical aristocracy besides
becoming an influential member of the

Academy of Saint Luke. A determining factor
in Baciccia's life was his acquaintance with
Gian Lorenzo Bernini, the great baroque
sculptor. The latter was a friend of Father
Giovan Paolo Oliva, prepositor general of the
Jesuits from 1664 to 1681, to whom he had
transmitted his conception of art as an
instrument of persuasion. Though Bernini
himself was not directly involved in the
decoration of the mother church of the order,
the Gesù, Baciccia and the sculptor Antonio
Raggi, both members of Bernini's circle of
artist friends, were chosen to embellish it.
Between 1672 and 1683, Gaulli frescoed the
circular vault of the apse, the apse itself, and
the *Exaltation of the Name of Jesus* on the vault
of the grandiose central nave, an undertaking
in which he succeeded in realizing one of the
most perfect expressions of the spirit of Roman
baroque triumphalism.

Baciccia was chosen also to execute the
decoration of the four side chapels of S. Andrea
al Quirinale, which took until the beginning of
the eighteenth century to complete because of
a series of financial problems, even though in
1672 Prince Pamphilj had promised to set aside
20,000 *scudi* for the project's completion. The
execution of the two lateral canvases, *Saint
Francis Xavier Preaching to the Indians* and
The Baptism of an Oriental Queen, is usually
ascribed to a date toward the end of Gaulli's
life.

The exhibited sketch, of about 1675, was
made a year before the altarpiece was set in
place in July 1676. The theme of the death of
Saint Francis Xavier, which was realized for
the first time as an altarpiece at S. Andrea al
Quirinale, was shortly afterward taken up by
Maratta for the altar dedicated to the saint in
the church of the Gesù.

In the sketch there are additions to the
borders (about 4 cm [1⅝ in.] above and on the
sides, and about 1 cm [⅜ in.] on the lower part)
that are not included in the altarpiece. The
sketch was done in a hurried manner. The
figures are outlined simply, without definition
in their details, with rapid brushstrokes of soft
colors. It is very close to the final composition,
characterized by dynamic gestures and vibrant
coloring, and shows some slight variations in
the position of the saint and of the angels.
Maria Serlupi Crescenzi

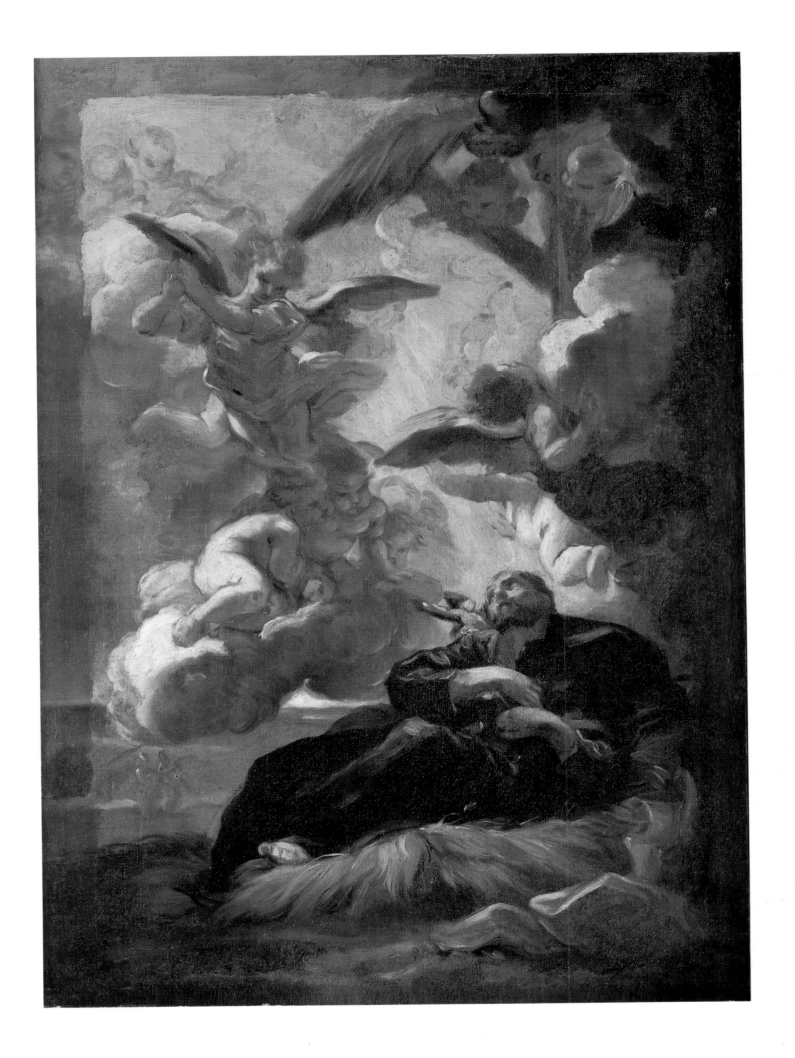

68

Goa (India)
RELIQUARY OF SAINT FRANCIS XAVIER
20th century
Silver-plated metal with silver, precious stones,
and glass
35 x 31 x 19 cm (13¾ x 12⅛ x 7½ in.)
Pontifical Sacristy

Conservation courtesy of John Edward Toole

Exhibitions: New Orleans, La., New Orleans
Pavilion World Expo, *Treasures of the Vatican,*
1984; Brisbane, Australia, Pavilion of the Holy
See Expo 88, *2,000 Years of Vatican Treasures,*
1994.

This reliquary contains several fragments of
the bones of Saint Francis Xavier, a Jesuit
missionary in India and the patron saint of
missionaries. The reliquary is shaped like a
small rectangular tomb, with an architectural
structure resting on four feet. The decoration
is similar on all sides.

The base is divided into two columned tiers,
the lower section supporting an upper loggia.
Along the front, this lower part has seven
sections, each with an octagonal medallion
inside it with episodes from Christ's life or the
life of Saint Francis Xavier. The medallions
stand out against a background of filigree work
decorated with precious gems, and the molding
between the upper and lower sections of the
reliquary is also decorated with precious stones.
Eight delicate, fluted columns rise out of this
molding, each with its own Doric capital.
The columns divide the surface into seven
rectangular areas, and each has a rectangular
medallion in the middle, resting on a
background of filigree and precious stones.

Above the columns is a gem-studded
cornice crowned by little statues of angels.
Their wings are unfurled and their right arms
raised. Between the angels are decorative
motifs shaped like covered jars and decorated
with precious stones.

A small, pyramid-shaped dome rises in the
space behind the angels, topped by another
rectangular cupola flanked by delicate
columns. Both structures are in exquisite
filigree work and again encrusted with gems.
The reliquary is crowned by an oval ornament
bearing an inscription with the saint's
monogram and decorated with a jeweled
pendent on either side and a gem-studded
Latin cross on top.

The shrine containing the relics is in the
lower section, hidden behind a door concealed
by the decoration.

Reliquaries are liturgical instruments used
to preserve fragments of the bodies of saints,
and they are always made out of precious
materials, such as silver, gold, and gemstones.
When the relic is an important part of the
saint's body, such as an arm or a head, and
linked with special forms of devotion, the
reliquary usually imitates the shape of the
relic. Since the relic it contains is less
important, the exhibited reliquary does not
imitate its shape, but is instead in the form of
a small temple and decorated with elements
recalling the saint's life. The angels symbolize
Francis Xavier's role as defender of virtue and
patron of missionaries throughout the world.
In fact, the angels' arms are raised as a sign of
Christ's light spreading to the four corners of
the earth.

The colors of the precious stones scattered
over the entire reliquary represent Christian
values and the capacity to speak directly to the
heart.
Luciano Orsini

EX OSSIBUS S. FRANCISCI XAVERII

69

Angelo Scarabello (Este, Padua, 1711–95)
RELIQUARY OF SAINT GREGORY BARBARIGO, 1762
Gilded bronze and silver
68 cm (26¾ in.)
Basilica of Saint John Lateran, Rome

Conservation courtesy of Mr. and Mrs. James
B. Rettig

Exhibitions: Rome 1975; Paris 1990.

Literature: M. Andaloro in Rome 1975, 79,
no. 168; Lateran Guidebook 1986, 16–17;
O. Naude in Paris 1990, 144, no. 073.

According to an inscription on the base,[1] this reliquary was a gift to Pius VII in 1800, the year of his elevation to the pontificate. The conclave that elected him was held in Venice because of revolutionary upheavals then taking place in the Roman Republic. The reliquary has been attributed to the Venetian silversmith Angelo Scarabelli by Z. Giunta di Roccagiovine,[2] who identified the hallmark. The other inscription, to be found on the front part of the base (fig. 1), incorrect in its date and for which I have hazarded a correction, states that the relic contained within is the liver of the Bishop (later Saint) Gregorio Giovanni Barbarigo of Padua, who died June 18, 1697.[3]

On July 15, 1724, Benedict XIII authorized the cult of Gregory, and he was later beatified in 1761 by Clement XIII and canonized on May 26, 1960, by Pope John XXIII. According to its date (1762), the reliquary was made the year following the beatification, a designation that fits reliably with what is known of Scarabelli's activity as a silversmith.

As an object, the work in question may be considered a monstrance-reliquary in that the glass shrine at the center allows for the relic to be viewed by the faithful. This exemplar is particularly rich in decorative details, both on its base and above the glass partition, where a small angel holds a crosier and a miter, symbols of the ecclesiastical authority of Gregorio Barbarigo.

Two other angels, cast in silver, hold the relic aloft in the manner of elegant caryatids, a standard touch in baroque art. Their lithe and delicate figures contrast with the heavier shapes of the base and the glass case, creating a feeling of precarious equilibrium that is particularly visible from the sides.
Maria Antonietta De Angelis

1. Inscribed behind, on the upper part of the base: "PIO VII. CAPIT. PATAV. MDCCC"; on the lower part of the base: "14" (perhaps an inventory number).
2. Andaloro in Rome 1975, 79.
3. Inscribed in front, on the lower part of the base: "JECUR GREG. BARB. EP.CIƆCLXII" (=1162. Corrected with "CC" in an effort to form the date in Roman numerals: 1762). See I. Daniele, *Bibliotheca Sanctorum* (Rome, 1966), 7:coll. 387–403.

Fig. 1. Detail, cat. 69, front of base

Master of the Life of the Baptist, Giovanni Baronzio? (Rimini, 1st half 14th century)
YOUNG SAINT JOHN THE BAPTIST AND AN ANGEL
c. 1340
Tempera and oil on wood
47.8 x 40.5 cm (18⅞ x 16 in.)
Vatican Museums, inv. 40185

Conservation courtesy of Percy P. Steinhart III

Literature: F. Zuliani, *Tommaso da Modena* (exh. cat. Treviso, 1979), 105; K. Christiansen, "Fourteenth-Century Italian Altarpieces," in *The Metropolitan Museum of Art Bulletin* 40, no. 1 (1982):42–45; D. Benati, "La Pittura del Trecento in Emilia Romagna," in *La pittura in Italia. Il Duecento e il Trecento*, ed. E. Castelnuovo (Milan, 1986), 1:208; M. Boskovits, *Frühe Italienische Malerei, Katalog der Gemäldegalerie* (Berlin, 1987), 15; J. Pope-Hennessy, *Italian Paintings in the Robert Lehman Collection* (New York, 1987), 86; M. Boskovits, "Per la storia della pittura tra la Romagna e le Marche ai primi del '300," *Arte Cristiana* 81, nos. 755, 756 (1993):95–114, 163–82; F. Rossi in Pinacoteca Vaticana 1994, 3:113–18; *Il Trecento riminese. Maestri e botteghe tra Romagna e Marche*, ed. D. Benati (exh. cat. Milan, 1995), 264–69, nn. 50–52.

This painting was part of a large altarpiece that was dismembered and dispersed at an unspecified date. At the center was a *Madonna with Child* (now at the National Gallery of Art, Washington) flanked by scenes from the life of Saint John the Baptist. Other than the central panel and the exhibited one, the scenes were *The Announcement to Zachary* (formerly Street Collection, Bath), *The Birth of John the Baptist* and *The Baptism of Christ* (National Gallery of Art, Washington), *Saint John Questioned by the Pharisees* (Kress Collection, Seattle Museum of

Art), *Saint John in Prison* (formerly Street Collection, London), *The Beheading of John the Baptist* (Metropolitan Museum of Art, New York, Robert Lehman Collection), and *Saint John in Limbo* (formerly Loeser Collection, Florence).

A convincing hypothetical reconstruction of the altarpiece was attempted by K. Christiansen in 1982. He surmised that the scenes from the life of the Baptist were arranged on two tiers, four in each part, at the sides of the central *Madonna with Child*. What link the various fragments of this altarpiece are not only the identical decorative elements of the borders, but also the similar expressions on the faces of the angels and the personages in the narratives in the various panels (fig. 1).[1]

The Vatican panel represents the encounter between the Baptist and the angel Uriel on the Mount of Penitence in Jordan (suggested by the gushing water on the right) and his immediate early vocation at the age of seven. This episode is of eastern origin, derived by Byzantine writers who retold episodes from the Proto-gospel of Saint James. It is quite rare to see it treated in western art. Probably the painter was inspired by a contemporary text by the Dominican friar Domenico Cavalca, *Volgarizzamento delle Vite dei SS. Padri* (Vernacular Lives of the Holy Fathers), written in Italian between 1320 and 1342.

On the left, Saint John as a child is accompanied by an angel. The latter is pointing to the succeeding episode, pictured on a higher plane, in which the saint is seen praying on a mountain. Critics have offered two readings of this scene. Whereas Aronberg Lavin interprets the angel's gesture as an invitation to John to isolate himself from the world in prayer and meditation, Francesco Rossi maintains that the picture illustrates "the miraculous discovery of the camel's skin" that was to become in fact the Baptist's garment. He quotes Cavalca who wrote, "God

had him dressed by the angels when his clothes were in tatters."[2] For Rossi, "there were two angels in the picture, one accompanying the Baptist and the other giving him his new garment."[3] According to both authors, the right side of the painting was mutilated, with the consequent disappearance of either the figure of an angel or the hand of God. Such a conjecture would appear to be supported by the fact that the right side lacks the frame with its alternating lozenges and spheres that characterize the other three panels.

The dual attribution of the Vatican panel and its companion pieces to either Giovanni Baronzio or to the anonymous Master of the Life of the Baptist remains a lively topic among present-day critics. Boskovits, supported by Benati, is of the opinion that works earlier attributed to such fictional personalities as the Master of the Adoration of Parry,[4] the Pseudo Baronzio, or the Master of the Life of the Baptist in fact correspond to various phases in the real Baronzio's artistic activity. The pictures assigned to the first anonymous master would be among the earliest, executed during the 1320s, at which time Baronzio was still firmly tied to the Giotto tradition. A second phase, more elegant and precious, could be imagined in the works long attributed to the second anonymous artist, whereas those traditionally assigned to the Master of the Life of the Baptist could be perceived as part of a third, mature phase in which Baronzio achieved greater narrative powers. This theory is challenged by Francesco Rossi, who cites Zuliani in observing in the works of the so-called Master of the Life of the Baptist a series of nuances that suggest Romagna rather than Rimini as their origin and inspiration. This would tend to link the anonymous master with a different personality rather than merely to a different phase in Baronzio's artistic career. Rossi's speculation is backed by the presence of a seal on one of the compartments, *The Beheading of John the Baptist*, bearing the family crest of the Counts Agnelli Malerbi di Lugo. This would almost certainly mean that the altarpiece originally came not from Rimini but from this important center in the Romagna hinterland.

Anna Maria De Strobel

1. K. Christiansen, *Metropolitan Museum of Art Bulletin* 40, no. 1 (1982).
2. Cavalca, p. 305.
3. Rossi 1994, 114.
4. From the Gambier-Parry Collection of Gloucester, acquired by the Courtauld Institute in 1966.

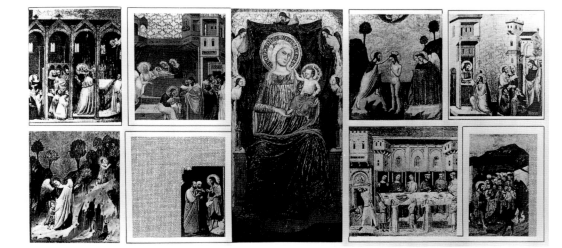

Fig. 1. Reconstruction by K. Christiansen of the altarpiece dedicated to the Virgin and Child with scenes from the Life of Saint John the Baptist.

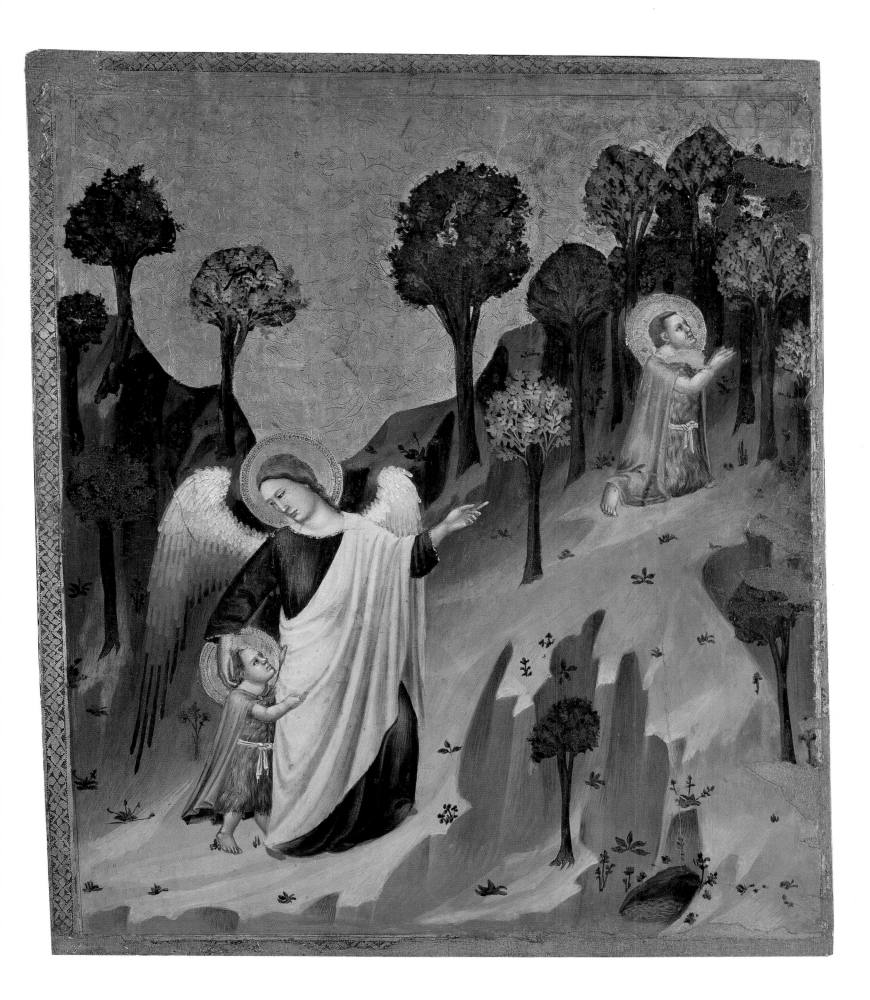

71

Agnolo Gaddi (?) (active 1369–96)
THE APPARITION OF SAINT MICHAEL TO SAINT
GREGORY, c. 1390
Tempera on wood
34.8 x 52.5 cm (13½ x 20⅝ in.)
Vatican Museums, inv. 40528

Conservation courtesy of Maria E. Bernett
in honor of her daughter Darya

Literature: Sirén 1906, 331; D'Achiardi 1929,
15; H. D. Gronau, "A Dispersed Florentine
Altarpiece and its Possible Origin," *Proporzioni* 3 (1950):41–47; G. Kaftal, *Iconography of
the Saints in Tuscan Painting* (Florence, 1952),
461; Boskovits 1975, 303; B. Cole, *Agnolo Gaddi*
(New York, 1977), 76; Volbach in Pinacoteca
Vaticana 1987, 39–40, no. 47.

The *Legenda Aurea* (Golden Legend), a
compilation of the lives of saints written by
Iacopo da Varazze presumably between 1263
and 1273, reports, on the life of Pope Saint
Gregory the Great, a scene depicted on this
panel: "The plague was still ravaging Rome,
and Gregory ordered the procession to
continue to make the circuit of the city, the
marchers chanting the litanies.... We are also
told that the angels were heard ... singing
'Regina coeli laetare, alleluia, quia quem
meruisti potare, alleluia, resurrexit sicut dixit,
alleluja' [Queen of Heaven rejoice, alleluia, for
He whom you were worthy to bear, alleluia,
has risen as He said, alleluia], to which
Gregory promptly added: 'Ora pro nobis, Deum
rogamus, alleluia' [pray to God for us]. Then
the pope saw an angel of the Lord standing
atop the castle of Crescentius, wiping a bloody
sword and sheathing it. Gregory understood
this as an end to the plague, as, indeed, it was.
Thereafter the castle was called the Castle of
the Holy Angel."

Saint Gregory had initiated a procession
through Rome at the time the plague was
ravaging the city. As the procession passes
Hadrian's tomb, an angel appears on its
summit sheathing his sword. The procession,
with Saint Gregory in it, has come to a halt
and is depicted in the act of kneeling and
praying. Some members of the small group,
consisting of clergymen and male and female
citizens, look up at the angel's appearance in
astonishment and almost disbelief, while
others, notably the monk next to Gregory who
is partly covered by the saint's halo, seem to
comment on the miracle and its meaning.

The scene is recognizably Rome. The
facade of the basilica on the right might be
old St. Peter's, with four steps leading up to the
entrance and the tower on its south, which is
represented here as a one-story building. The
river in the left foreground is the Tiber, and
beyond the (Aurelian) walls are the castellated
Roman hills. Hadrian's tomb, smaller in
proportion than the Vatican buildings, is
opposite the basilica.

The archangel is dressed in light armor.
His spread wings and billowing cloak, together
with the act of holding a sword and sheath,

suggest movement and action, contrasting with the calm group of the faithful in prayer with Saint Gregory. Although the angel is not directly fighting evil, his gesture demonstrates that it has been overcome, and one is reminded of the iconographical image of Saint Michael battling against Lucifer and the monsters of hell. The plague is therefore seen as an evil deriving from hell, which only God's help and the angel's execution can bring to an end.

Hadrian's mausoleum was, according to the *Legenda Aurea*, called the Castel Sant'Angelo from that day forward. The legend itself was given its manifestation by a series of representations of the archangel on top of the building (fig. 1). Raffaelo da Montelupo's angel is the first known example, which is preserved and exhibited in the Castel Sant'Angelo. It was replaced in 1753 by a bronze statue by Pietro van Verschaffelt.

The scene is also represented in the marble tabernacle in S. Gregorio Magno in Rome, dated 1469 and probably executed by Andrea Bregno and his workshop. In it the faithful approach Castel Sant'Angelo from both sides, with Saint Gregory kneeling on the left. The angel is more active in this representation, with his right arm raised brandishing his sword (fig. 2).

Pope Gregory, although distinguished from his fellow worshippers by his halo, book, and tiara, is not singled out within the group, his face not being visible. Although this conception would probably have pleased the pope's legendary modesty, it rather points to the fact that the reason for the panel's commission was not veneration of Saint Gregory, but rather the archangel Michael. H. D. Gronau's[1] attempt to reconstruct a triptych was therefore centered around Agnolo Gaddi's *Madonna and Child Enthroned with Angels and Saints*. However, Gronau was, in his attempt, unaware of the laterals of this panel; the polyptych is now joined again under the name of its previous owner as the *Contini Bonacossi Polyptych* (Uffizi Gallery, Florence, temporarily displayed in the Palazzina della Meridiana di Palazzo Pitti).[2]

Two other panels, each with two scenes, must also have belonged to the same unknown altarpiece to Saint Michael. These scenes depict the archangel coming to the assistance of a pregnant woman who had gone on a pilgrimage to the angel's sanctuary on the Normandy coast (Mont-Saint-Michel), the legend of the origin of Monte Gargano (Monte S. Angelo) in Apulia, the archangel and his legion fighting Lucifer, and an unidentified scene (Yale University Art Gallery, New Haven, figs. 3 and 4). Their attribution to Agnolo Gaddi is uncertain.[3]

Johannes Röll

1. Gronau 1950, 41–47.
2. B. Cole, *Agnolo Gaddi* (New York, 1977), 76. I am grateful to Mina Koochekzadeh for pointing out this reference to me.
3. Cole 1977, 76, declares them as "not by Gaddi nor … by anyone from his close circle."

Fig. 1. N. Beautrizet, *Castel Sant'Angelo and Bridge, Rome*, engraving. Gabinetto delle Stampe, Rome

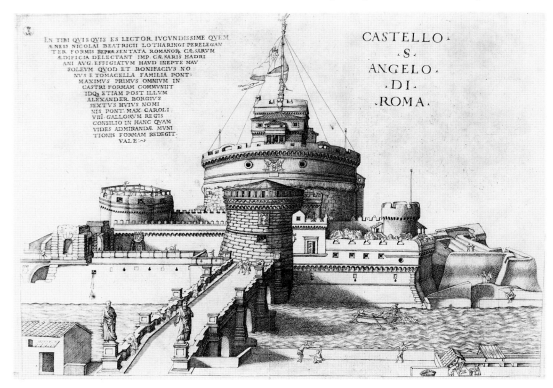

ASTERII · ROMANVS · ABBAS · FIERI·

Fig. 2. Andrea Bregno and Workshop, *The Apparition of Saint Michael to Saint Gregory*, 1469, marble tabernacle. S. Gregorio Magno, Rome

Fig. 3. Agnolo Gaddi or Workshop, *Scenes from the Legend of the Archangel Michael*. Yale University Art Gallery, Bequest of Maitland F. Griggs B.A., 1896

Fig. 4. Agnolo Gaddi or Workshop, *A Legendary Subject and Saint Michael Fighting the Dragon*. Yale University Art Gallery, James Jackson Jarves Collection

72

Anonymous Italian (Bologna, Rome?), early
17th century
SAINT LUIGI (ALOYSIUS) GONZAGA, ACCOMPANIED
BY HIS GUARDIAN ANGEL, OFFERS HIS HEART TO
JESUS AND MARY, c. 1605
Oil on canvas
230 x 169 cm (90½ x 66½ in.)
Vatican Museums, inv. 42214

Literature: Virgilio Cepari, *Vita del Beato Luigi
Gonzaga della Compagnia di Gesù* (Rome,
1606); C. Sommervogel, *Bibliothèque de la
Campagnie de Jésus,* t. 3 (Brussels, Paris,
1882):1575f, for the different editions of Luigi
de Gonzaga, *Meditazione intorno a'SS. Angeli,
tanto in generale quanto in particolare, e
principalmente custodi degli uomini* (Latin title:
*Meditatio de sancti angeli atque de iis imprimis
qui hominum custodie praesunt*), the first
known printed edition of which appeared in
Padua in 1740; *Bibliotheca Sanctorum,* vol. 8
(Rome, 1967):348–57.

Aloysius (Luigi) Gonzaga was born on
March 9, 1568, in Castiglione delle Stiviere
(Lombardy). From 1581 to 1583 he was at the
court of Philip II in Spain where he acted as
page to the heir apparent, Don Diego. In 1583
he decided to enter the Compagnia di Gesù, the
Society of Jesus (Jesuits), starting his novitiate
in Rome on November 25, 1585. He made his
religious vows also in Rome on November 20,
1587, and soon after received minor orders. In
1591 an epidemic swept Rome. The fathers of
the Society of Jesus erected a new hospital,
in which the general himself, with other
assistants, among them Aloysius, cared for
the sick. Several helpers fell sick and died,
including Aloysius who was infected on
March 3, 1591. After seven days of extreme
fever, Aloysius received the sacraments of
Viaticum and Extreme Unction and then
made a brief recovery. However, the fever had
weakened him excessively and he died, at the
age of twenty-three, a little after midnight
on June 21, the Octave of Corpus Christi that
same year, as he had foretold earlier. He was
beatified by Pope Paul V in 1605 and canonized
by Benedict XIII in 1726.

Saint Aloysius Gonzaga kneels at the right
of the exhibited picture, wearing the dress of a
courtier, with the sword on his left side and the
feathered hat placed in front of him. With his
left hand he offers his heart to the young Jesus
who stands in front of him, wearing a rich
damask robe and giving him in return a cross
and lilies. Jesus is accompanied by his mother,
who stands behind him and leans over him in
a protective and tender gesture. The group is
surrounded by adolescent angels wearing long,
exquisite dresses. The gentle action of the
mother is reflected by the tender gesture of the
angel behind the saint, who presents him to
Jesus. This angel, who is dressed in a much
more elaborate garment than the other angels,
is more than likely meant to represent the
guardian angel for whom Saint Aloysius is said
to have had a special devotion as well as for

angels in general. One of his meditations is
accordingly about the subject of "Piissima e
dottissima Meditazione intorno a'SS. Angeli,
tanto in generale quanto in particolare, e
principalmente custodi degli uomini" (Most
holy and most learned Meditation about the
Holy Angels, in general and in particular,
and above all about the guardian angels).
The saint's special patroness from his infant
years was the Virgin, and thus the painting's
representation of the guardian angel and the
Virgin Mary in prominent positions and
symmetrical correspondence might well be
an illustration of Aloysius' devotion. Sitting in
the clouds above the scene is God the Father,
surrounded by angels and cherubim.

The facial type of Saint Aloysius is closely
comparable to a painting of the saint by
El Greco and also a portrait by an anonymous
artist in the Kunsthistorisches Museum in
Vienna. The features of the very young man
have still preserved some of their childish
expressions. The short dark hair and the large,
dark, and serious eyes characterize the ascetic
saint.

The building in the background has not
been identified. Its circular shape, its thick
and castle-like walls, and its isolated position
suggest, however, that it is meant to be the
Castel Sant'Angelo. A comparison with a
contemporary illustration shows the
correspondence of a number of elements, but
the painting's impression of the castle is a
less realistic and almost romantic one (fig. 1).
The identification of this building as the Castel
Sant'Angelo is supported by the fact that one of
the subjects of this painting is the presentation
of the angels. Moreover, the building helps to
identify the particular scene, the beginning of
the saint's novitiate, which took place in Rome.
Third, the building refers also to the death of
Saint Aloysius: just as the plague swept over
Rome in 1591, taking the young man's life, it
also swept over Rome in the time of Pope Saint
Gregory and came to an end only after the
pope saw an angel sheathing his sword on top
of the Castel Sant'Angelo (see cat. 71).

The origin of the painting is unknown.
Its size suggests that it was an altarpiece,
possibly painted on the occasion of Aloysius
Gonzaga's beatification in the year 1605. The
artist is unknown, but stylistic comparisons
infer that the painting derives from the
schools of Bologna or Rome.
Johannes Röll

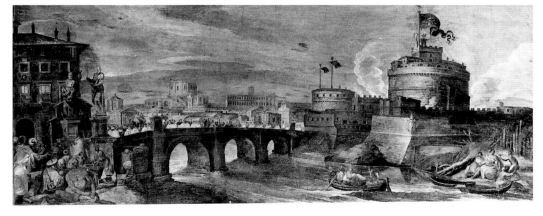

Fig. 1. P. Bril and A. Tempesta, *St. Gregory of
Nazianz.* Vatican Museums

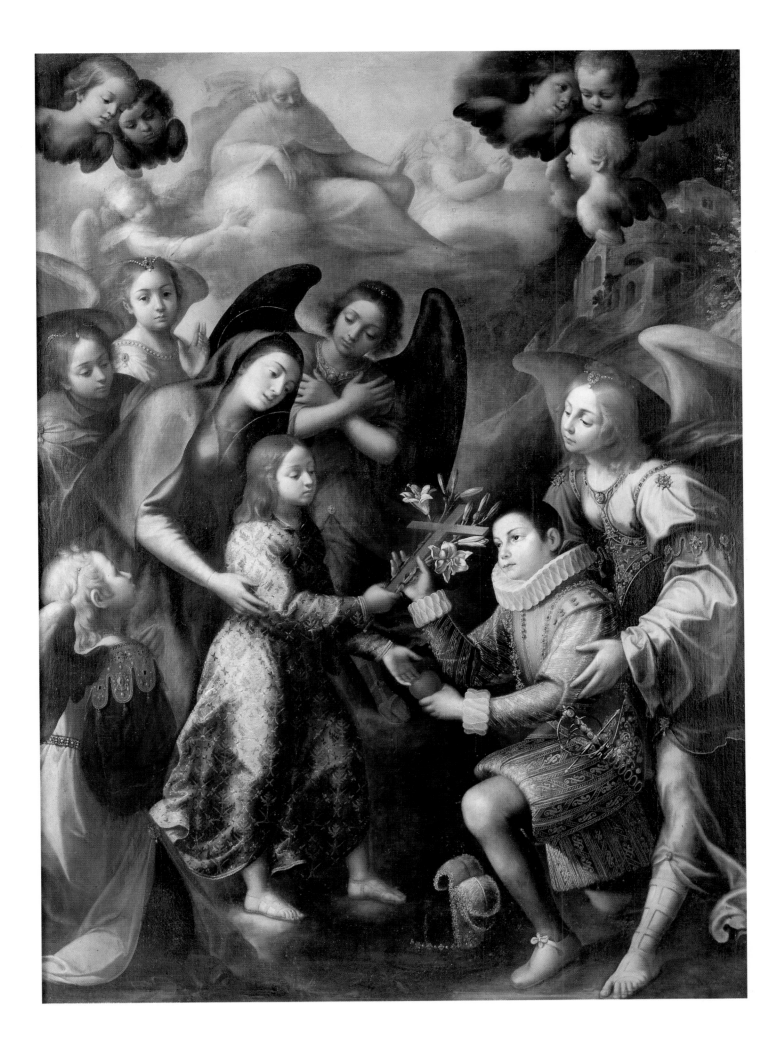

ANGELS IN THE LIFE OF THE COMMUNITY: GUARDIANS AND CONSOLERS

Detail of cat. 75

73

Raffaello Sanzio, called Raphael
(Urbino, 1483–Rome, 1520)
YOUTH FROM THE EXPULSION OF HELIODORUS
c. 1512
Fresco fragment, "strappo" of brush sketch
59 x 82.5 cm (23¼ x 32½ in.)
Vatican Museums, inv. 2329

Exhibitions: Rome 1984, no. 71; Rome, Villa
Médicis, *Raphaël-Autour des Dessins du
Louvre,* 1992, p. 170; Tokyo, The National
Museum of Western Art, *High Renaissance
in the Vatican,* 1993, no. 80.

Literature: F. Mancinelli in Rome 1984,
194–95; D. Cordellier and B. Py, *Raffaello e i
Suoi* (Rome, 1992), 169–70.

When Heliodorus tried, on the orders of King
Seleucus, to unlawfully confiscate the temple
treasure in Jerusalem, God sent an armed rider
accompanied by two youths to prevent the
robbery and punish the desecration. The three
wingless figures, even if a literal translation of
the biblical text, are an indicative example of
the popularity of the representation of angels
without wings during the Renaissance in
Rome.

The scene, recounted in the Old Testament
in the Second Book of Maccabees (3:15), was
depicted by Raphael in the large fresco on the
east wall of the *Stanza di Eliodoro* in the
Vatican Palace (fig. 1). The program of the
room was intended to illustrate the policy of
Pope Julius II (1503–13) to expel the French
usurpers from the Italian peninsula and restore
the supremacy of the Papal State.[1] Seen in this
light, the *Expulsion of Heliodorus from the
Temple* represents the pope's God-given claim
to temporal power.[2] This explains why the
ruling Pope Julius II in his *sedia gestatoria,*
portrayed on the left edge of the painting,
should be iconographically integrated into
the Old Testament episode.

It is presumable that the room in which
this fresco is painted served as an audience
chamber of the pope's private apartment.
The present name of the room stems from the
name of this fresco. Raphael began the fresco
decoration in 1511 and completed it in 1514.
According to Vasari's biography of the painter
in his *Lives of the Artists,* the *Expulsion* was the
second fresco painted by Raphael in this room.[3]

The fragment displayed here is a so-called
strappo, the detached pigment layer of the
underlying brush sketch, which was discovered
below the fresco during the restoration in
1960–63. At that time it had proved necessary
to remove the plaster of paris with which
the loosened brush sketch had been fixed,
presumably by Carlo Maratta, during his
restoration in 1702. At the time of the most
recent restoration, the underlying brush sketch
was removed from the wall and the fresco
fragment reinserted. This is in fact the only
preparatory brush sketch of this kind by
Raphael known to exist; they are otherwise
covered by the frescoes painted over them. For
the head of this youth, the cartoon is preserved
in the Louvre in Paris (inv. no. 3853), so that in
this case a quite unique "stratigraphy of
execution"—the consecutive stages in which
Raphael realized his original design on the
wall—is preserved.
Arnold Nesselrath

1. A. Nesselrath, "La Stanza d'Eliodoro," in *Raffaello
nell'appartamento di Giulio II e Leone X* (Milan, 1993).
2. J. Shearman, "The Expulsion of Heliodorus," in
Raffaello a Roma—Il convegno del 1983 (Rome, 1986),
75–87.
3. Vasari-Milanesi 1906, 4:345.

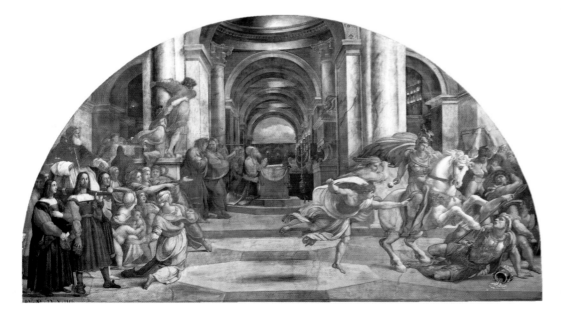

Fig. 1. Raphael, *The Expulsion of Heliodorus
from the Temple,* 1511-14, fresco.
Stanza di Eliodoro, Vatican

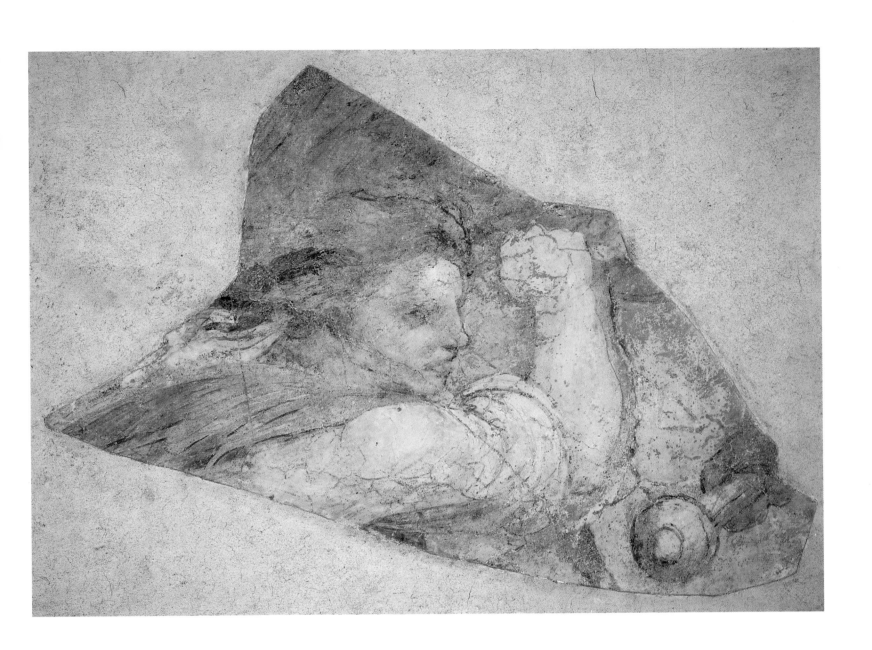

74

Attributed to Giacinto Brandi (Poli, Rome 1621–Rome, 1691)
CHRIST IN THE GARDEN OF GETHSEMANE
mid 17th century
Oil on canvas
99 x 73 cm (39 x 28¾ in.)
Vatican Museums, inv. 40837

Conservation courtesy of Lucia Nielsen Musso

Exhibition: Rome 1996 (National Museum of Castel Sant'Angelo).

Previously assigned to the eighteenth-century Neapolitan school in the old inventories of the Vatican Picture Gallery, this painting is now thought to be a Roman work of a century earlier, with a tentative attribution to Giacinto Brandi. Though direct comparisons with thematically similar paintings by this Roman artist are lacking (partly because there is no detailed monograph of his works), *Christ in the Garden* offers marked affinities with Brandi's artistic sensibilities. In his output of easel paintings, Brandi favored atmospheres that could be called tenebrous and at the same time rich with intense color, particularly reds and blues, that he applied in broad, vibrant strokes.

Today he is considered a minor painter, but in his time Brandi was regarded as a master, certainly on the level of such artists as Pier Francesco Mola, Ciro Ferri, and Carlo Maratta. In 1650 he emerged as the direct heir of Giovanni Lanfranco, with whom he had studied. Brandi gained a reputation as an artist who was able to bring together the classicist style with baroque figurative inventions and above all the light of Caravaggio, something he was aware of through the paintings of Mattia Preti. In fact, Brandi's style is marked by the potent effect of colors amid shadows, color that in some cases was all too strong. Typical examples of his sacred compositions, emerging as it were from amid dense baroque clouds, are *The Assumption of Saint John the Evangelist* (presented in Rome at the Finarte auction of November 12, 1986) and *Saint Mary of Egypt* (Laschena Collection, Rome).[1]

A direct comparison may be made between the face of the angels in the Vatican painting and the head of his *S. Giovannino* (signed, formerly in London's Heim Gallery),[2] in which the same childish visage, with strong features and intense expression, is present.

The Vatican canvas is characterized by an atmosphere of great intimacy. The pyramidal grouping of Christ comforted by two angels emerges as it were from a dense bank of clouds, which appear indeed to be invading the scene from the left. This type of dynamism coming out of the background is a typical baroque expression. It can be seen in the work of such painters as Baciccia or Giandomenico Cerrini whenever they wish to express the intensity of the divine presence. The close relationship between the angels and clouds comes out of an iconographic tradition traceable to a passage in Pseudo-Dionysius' *De Coelesti Hierarchia*,[3] in which the impalpable essence of angels is explained as something "transparent as clouds." This definition was employed by Saint Thomas Aquinas, who defines angels in their visible form as being condensed air in the shape of clouds.[4]
Maria Antonietta De Angelis

1. Both paintings are reproduced in Sestieri 1994, vol. 2, figs. 158, 159. In the first volume (34–37) are biographical notes on the artist and a partial listing of his works.
2. A reproduction can be found in Sestieri 1994, fig. 160.
3. The Celestial Hierarchy XV, 6.
4. Bussagli 1991, 97.

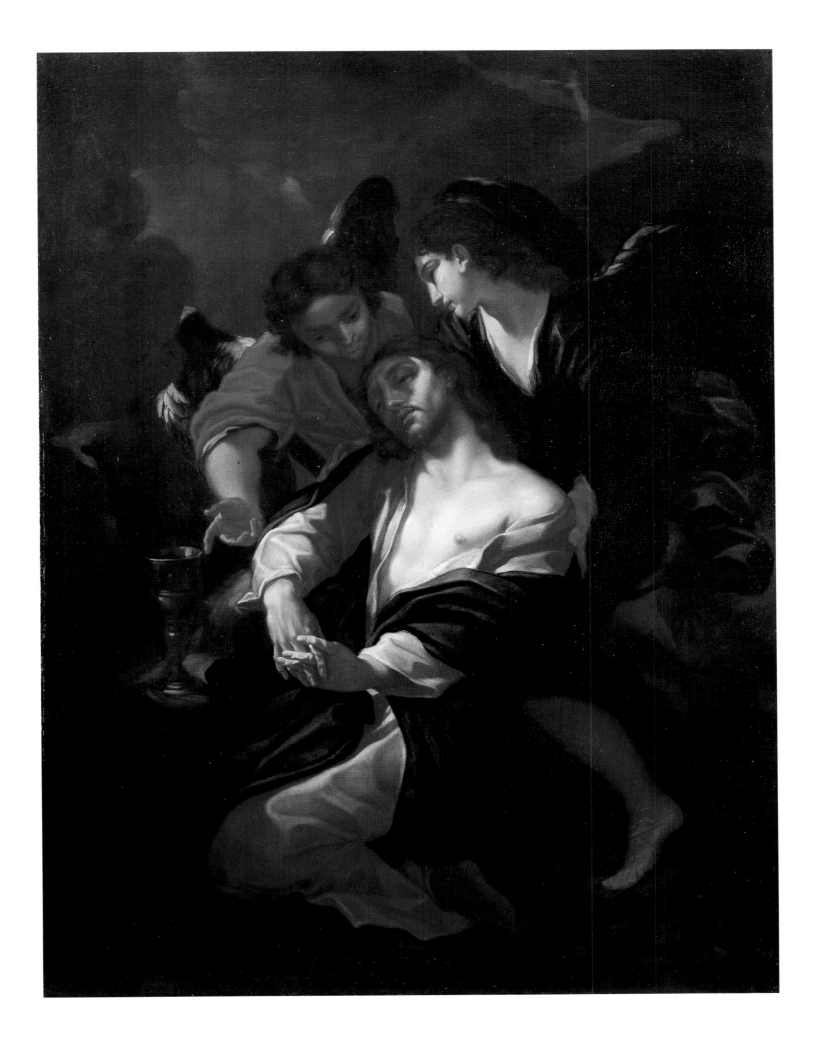

75

Felice Casorati (Novara, 1887–Turin, 1963)
ANGEL IN THE NIGHT, c. 1961
Tempera on linen-backed paper
75 x 67 cm (29½ x 26⅜ in.)
Vatican Museums, inv. 24019

Provenance: 1976, Archivio Felice Casorati
(*The Angel*), no. 471, authenticated by
G. Bertasso; Sotheby-Park Bernet, New York
(*The Sleeper*); Gift of Carlo Pessina.

Exhibitions: Vatican City, Charlemagne Wing
(Bernini colonnade), *San Paolo nell'Arte
Contemporanea* (not included in the
catalogue), 1977; Vatican City, Charlemagne
Wing (Bernini colonnade), *Profezia di Bellezza
—Arte Sacra tra Memoria e Progetto*, 1996.

Literature: G. Bertolino and F. Poli, *Francesco
Casorati, Catalogo Generale. I Depinti
1904–1963* (Turin: U. Allemandi Editore, 1995),
no. 1273, b/w photo; Vatican City 1996,
cat. 118, colorplate.

The angel is here represented in the most
intimate and familiar aspect of the Christian
tradition, the invisible guardian to whom we
have been entrusted by divine providence
(*Pietate superna*). This tradition harks back to
and is complemented by the more ancient
Hebrew tradition according to which there is
no creature here on earth that does not have its
protector in heaven.

This aspect of the domestic angel, quietly
watching over us, contrasts with that of the
more decorative and exuberant protagonist of
baroque culture. It approximates most closely
the common image of the archangel Raphael,
the traveling companion of Tobias, the healer,
the exorcist invoked in the prayer recited and
sung by monks at the end of the day; in short,
the angel most closely associated with events
here on earth.

The sleeping figure and the angel, recurrent
themes of Casorati's maturity, embody the
painter's ideal message: that of the purifying
dream entrusted to the tender and reassuring
gesture of the protecting angel.

The composition is imbued with a
suspended atmosphere. This is rendered with
transparent colors, preponderantly green
and azure in tone, and accentuated by the
perspective of the geometrically patterned
fields receding to the horizon in the distance.
Mario Ferrazza

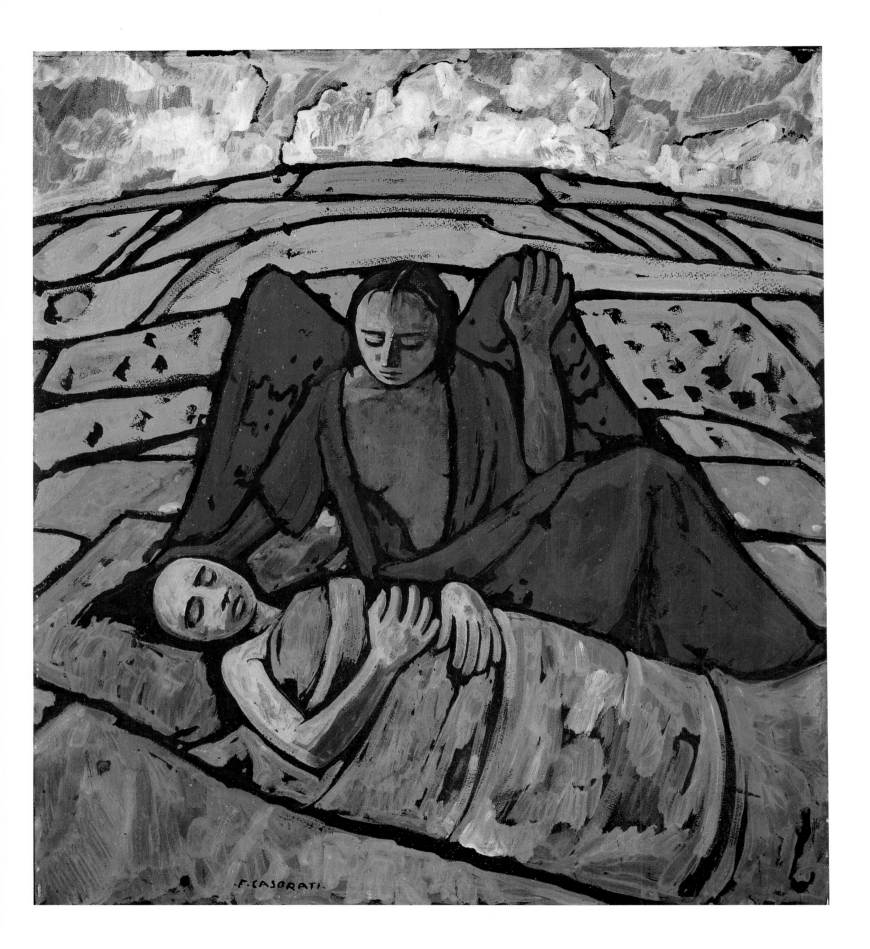

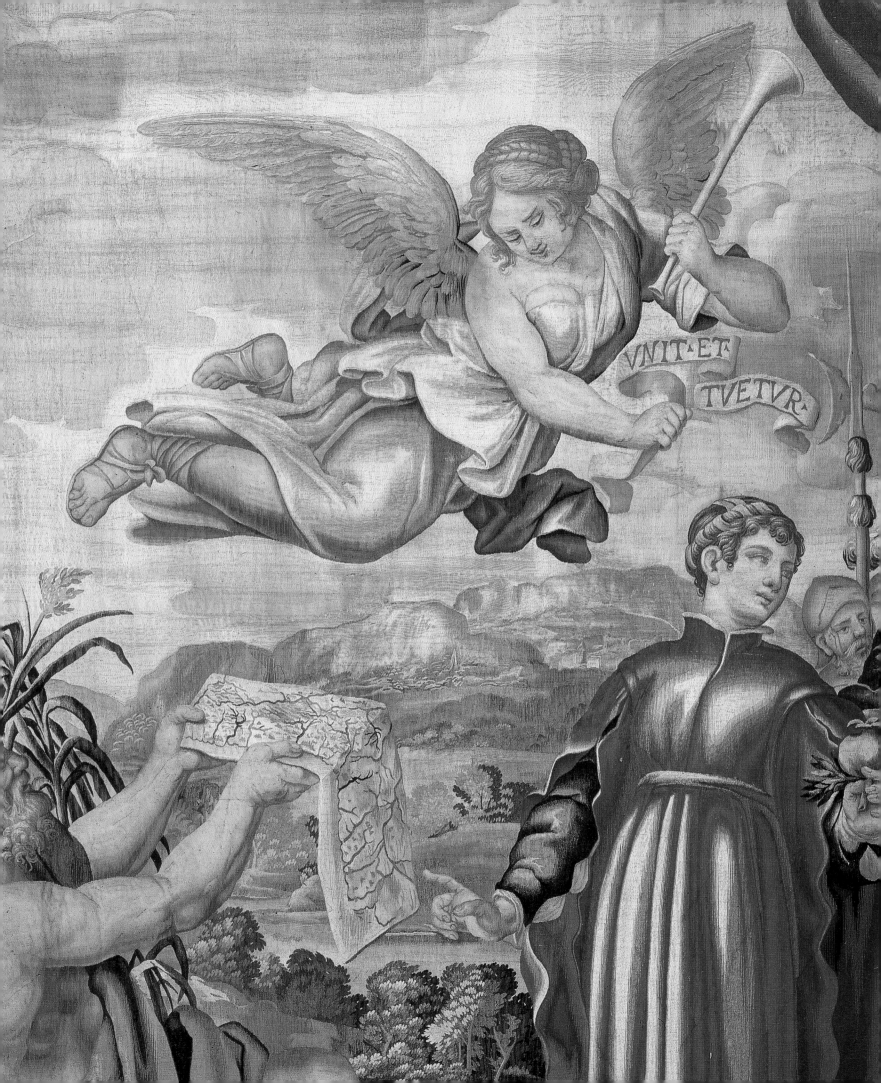

ANGELS
IN THE LIFE OF
THE COMMUNITY:
MESSENGERS

Detail of cat. 76

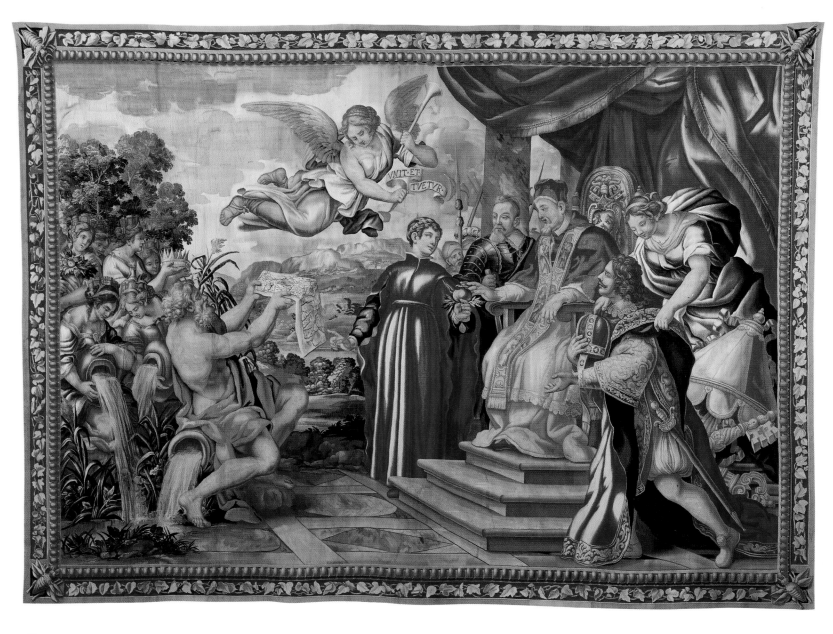

76

Barberini Manufactory (Rome, c. 1627–80)
THE UNION OF THE DUCHY OF URBINO WITH THE
CHURCH, 1669–70
Wool and silk
400 x 530 cm (157 x 208 in.)
Vatican Museums, inv. 43922

Literature: G. Townsend, "Four Panels of
Roman Baroque Tapestry," *Bulletin of the
Museum of Fine Arts, Boston* 55–299
(1957):11–15; U. Barberini, "Gli arazzi e i
cartoni della serie 'Vita di Urbano VIII' della
arazzeria Barberini," *Bollettino d'Arte*
(1968):92–100; A. Cavallo, *Tapestries of Europe
and Colonial Peru in the Museum of Fine Arts,
Boston* (Boston, 1968), nos. 44–47;

A. M. De Strobel, "Le arazzerie romane dal
XVII al XIX secolo," in *Quaderni di Storia
dell'Arte,* ed. Istituto Nazionale di Studi
Romani 22 (1989), 9–50; P. F. Bertrand, "Un
grand décor tissé à Rome au XVII siècle: la vie
du Pape Urbain VIII," *Mélanges de l'école
française de Rome. Italie et Méditerranée* 106,
no. 2 (1994):639–82.

The idea of setting up a workshop in Rome for the production of tapestries must have occurred to Cardinal Francesco Barberini during his mission to Paris in 1625, when he received, as a gift from King Louis XIII, seven tapestries in the series *The Life of Constantine*, which were based on cartoons by Rubens. Production in the works at Rome actually began in 1627 under the direction of the Flemish artist Jacob van den Vliete, a name italianized as Giacomo della Riviera. The task of executing the designs and painting the cartoons was originally assigned to Pietro da Cortona and later to his pupils, among them Francesco Romanelli, Ciro Ferri, Lazzaro Baldi, Antonio Gherardi, Giacinto Camassei, and Pietro Lucatelli.

The tapestries were primarily intended for the Barberini family, which included the then-reigning Pope Urban VIII, the uncle of Cardinal Francesco. Among the most beautiful series to be made was the *Castelli* (the first to be woven), the continuation of the *Life of Constantine*, another series entitled *Putti at Play*, and finally the *Life of Urban VIII*, to which *The Union of the Duchy of Urbino with the Church* belongs.

The last series is composed of ten tapestries with borders, all illustrating important episodes in the pope's life. It was commissioned by Cardinal Francesco Barberini as an act of homage and gratitude to his uncle, who died in 1644. Work was carried out between 1663 and 1679 under the direction of Maria della Riviera.

The intention of glorifying the life and works of this illustrious pontiff must have already been in his nephew's mind as early as 1643–44. At that time, the cardinal's secretary Francesco Ubaldini, who had already begun writing a life of the Barberini pope, laid out a plan for a pictorial decoration in six scenes destined to adorn the walls of the main salon of Palazzo Barberini alle Quattro Fontane. This project was never realized because of the death of Urban VIII and the exile of Francesco Barberini in France. However, four projected episodes of the original plan—*Election to the Pontificate*, the *Union of the Duchy of Urbino with the Church*, *Urban VIII Saves Rome From Famine and Plague*, and *The Pope Makes Peace in the Ecclesiastical State*—were actually chosen as subjects to be inserted among the central scenes twenty years later.

The connecting link among all the scenes is the divine intervention in the pope's election and his providential deeds, with the evident intent of glorifying the pontificate of Urban VIII. The first three tapestries in the series illustrate the ecclesiastical career of Maffeo Barberini, starting with his education and leading to his nomination as cardinal. The successive three tapestries stress his spiritual authority, starting with his election to the papacy on August 6, 1623. The last four treat Urban's efforts to consolidate the temporal powers of the Church. The first among these is an allegorical version of the Union of the Duchy of Urbino with the Church, an event that took place in 1631 when Duke Francesco Maria II della Rovere died without heirs.

The pontiff is pictured seated on the throne with his nephew Taddeo, prefect of Rome, together with the personification of the Church on his left, while on his right appear his brother Carlo and the Countess Matilde di Canossa. The latter personage is offered as an inspiring example in history of fidelity to the Church. She was, in fact, an ally of Pope Gregory VII during the struggle over investiture. Matilde then donated her territorial holdings to the Holy See. This became the cause, following her death in 1115, of a bitter and protracted dispute between the emperor, who claimed her land as a feudal right, and the papacy.

With her left hand, Matilde proffers to Urban VIII a pomegranate, symbol of her generous gift to the Church, while with her right she points to the map of the Duchy of Urbino. The map is presented by the personification of the Metauro River, behind whom are represented female figures symbolizing the towns and rivers of the duchy. Above, an angel holds aloft a trumpet and an ornamental scroll with the motto of the countess, UNIT ET TUETUR, by way of glorification. Indeed, Urban VIII valued Matilde's memory so highly that he dedicated a sonnet to her in his youth, later honoring her by transferring her earthly remains from the monastery of San Benedetto Po to the new funerary monument in St. Peter's itself, by Bernini and his pupils.

The tapestry was surmounted by an upper border (fig. 1), separately woven, bearing a Latin inscription celebrating not only the principal episode, but also a secondary one represented in a lower frieze (now in the German Embassy to the Holy See). The latter depicts the visit made to the Papal States by the queen of Hungary, Maria Anna of Austria, in 1631.

Each of the central scenes of the Vatican tapestries were flanked by two separately woven borders. Although some of these borders are lost, their content is known through archive documents.

The tapestry entitled *The Union of the Duchy of Urbino with the Church* probably was displayed with the lateral borders depicting medallions on one side with the facade of the church of Saint Bibiana (this border is now in the Museum of Fine Arts, Boston) and on the other with the Lateran Baptistery. Such scenes were taken from medallions coined during Urban VIII's pontificate and allude to architectural projects carried out during his reign.

As a project, this series was decidedly a collective effort. The initial design was largely by Ciro Ferri and perhaps Pietro da Cortona, whereas the cartoons were the work of Pietro Lucatelli, Lazzaro Baldi, Antonio Gherardi, Giacinto Camassei, Fabio Cristofani, Urbano Romanelli, Giuseppe Passeri, Pietro Spagna, and Giuseppi Belloni. Belloni was probably the author of the cartoon for the *Union of the Duchy of Urbino with the Church*, which was woven between 1669 and 1670.

The ten central scenes of the Urban VIII series were acquired by the Vatican at three separate times: seven in 1937, given by the Barberini princes; two in 1947, purchased on the antiquarian market; and one in 1966 following an agreement between the Vatican and the Belgian government. The cartoons, on the other hand, are part of the collection of the National Gallery of Ancient Art (Palazzo Barberini, Rome).

Anna Maria De Strobel

Fig. 1. Cat. 76, upper border

77

Workshop of Annibale Carracci
(Domenichino?)
TRANSLATION OF THE HOLY HOUSE
Early 17th century
Oil on canvas
250 x 150 cm (98½ x 59 in.)
Church of S. Onofrio, Madruzzo Chapel, Rome

Exhibition: Loreto, Italy, Palazzo Apostolico
della Santa Casa, *L'iconografia della Vergine di
Loreto nell'arte,* 1995.

Literature: Historic Archive of the Holy House,
Protectors' Letters, 1, c. 211; F. Grimaldi and
K. Sordi, *Pittori a Loreto. Committenze tra
'500 e '600* (Ancona, 1988), 23 and 25;
L. Spezzaferro, "La Cappella Madruzzo in
S. Onofrio al Gianicolo," *I Madruzzo e
l'Europa 1359–1658. I principi vescovi di Trento
tra papato impero* (Milan, 1993), 695–703;
F. Grimaldi in Loreto 1995, 138.

Cardinal Ludovico Madruzzo from Trento
had dedicated a chapel to Our Lady of Loreto
for his family in the church of S. Onofrio al
Gianicolo, of which he was the titular cardinal
from February 9, 1569, until his death in 1600.
However, documents concerning the chapel
date only from 1601, and they are by no means
complete regarding the different stages of its
layout and decoration.

The remarkable spread of the cult of Our
Lady of Loreto in the period after the Council
of Trent led many prelates, confraternities,
nobles, or cities to wish to have their own
chapels in the Sanctuary of the Holy House in
Loreto and to sponsor their decoration. These
included the cardinal of Trento who, however,
was only partially able to realize his wish.
Of the works sponsored by Madruzzo in the
Holy House, none remain there, as they
have been lost during the various restorations
and adaptations to which the sanctuary was
subjected. Only a vague documentary trace
now exists, a short note dating back to the years
1620–22 that limits itself to mentioning the
munificence of the cardinal of Trento in
paying for the decoration of the chapel of
the Immaculate Conception (the one now
corresponding to the Chapel of the Crucifix,

to the right of that of the Blessed Sacrament),
without giving further details. The cardinal
must certainly have gone to Loreto in 1591, for
on May 20 of that year he sent a letter to the
governor of the Holy House asking to be
received.[1] In the end, Ludovico Madruzzo
dedicated his chapel of Our Lady of Loreto in
his own church of S. Onofrio, just as others did
who were not able to have their own chapels in
Loreto itself.

The altarpiece of the Madruzzo chapel in
S. Onofrio depicts the Translation of the Holy
House, which, according to the miraculous
narrative, reached present-day Loreto from
Nazareth on the night of December 9–10,
1294, after a period of three years during
which it was twice moved by the angels.
This place, chosen by the Virgin as the final
destination for the translation of her house,
immediately became the object of particular
devotion. Many pilgrims flocked there
attracted by the cult, not only of the house,
but also of the Blessed Virgin herself, a scene
that has been reproduced through the centuries
in countless paintings and wood carvings.
The prototype of this image may be considered
the one believed to have been painted by
Saint Luke and kept in the holy house as
recounted by Pietro di Giorgio Tolomei, known
as Teramano, who in the fifteenth century
codified traditional Loretan iconography.
The archetype represents the Blessed Virgin
in majesty, holding the child Jesus in her arms
beneath a *baldacchino* (light architectural
structure with a portico), flanked by two or
more angels who embrace the columns as if
to support or suspend it.

Between the fifteenth and sixteenth
centuries, this type of iconography was
replaced by another, with the Virgin and child
set in glory above the house, borne in flight by
angels. Besides being an explicit transcription
of the miraculous event, word of which from
the second half of the fifteenth century was
being spread by printed accounts, this model
responded fully to the dictates of the Council
of Trent regarding the primary role of the
Blessed Virgin. Further it allowed the static
type of *sacra conversazione* to be abandoned,
one which by then had been superseded by

the evolution of the dynamism of sixteenth-
century painting.

The S. Onofrio altarpiece follows this
model. The Blessed Virgin is seated on the roof
of the holy house, which is borne in flight by
three angels; she is crowned by two other
angels. The child Jesus, who sits on her knee,
pours water to give relief to the damned, who
can be seen below in the flames of purgatory.
Our Lady of Loreto assumes the fundamental
role of mediatrix, which the Council of
Trent wished to restore to Mary. In this case,
regarding the souls in purgatory, as in the
refugium peccatorum (a motif found here for
the first time, but which was later to become
widespread throughout the Marches) and
in other cases as the protectress of the sick,
of sailors, of whole towns, Mary is invoked
to bring an end to pestilence and other
extraordinary events.

Seventeenth-century sources in general
attribute the altarpiece in S. Onofrio to
Annibale Carracci, with the exception of
Giulio Mancini, who maintained that it was
designed by Annibale Carracci and "guided"
by Domenichino. The study carried out by
Luigi Spezzaferro after the recent restoration
brought to light that at least two hands
executed the painting: "The one who painted
the group of the Virgin and Child who uses
color in a soft and mellow manner, and the
other who did the angels, who appear more
solid and precisely drawn as well as recalling
Raphaelesque types."[2] It seems possible to
agree with Mancini, who concluded that
Annibale must have conceived the general
layout of the altarpiece and then left it to his
assistants, Domenichino in the first place,
while reserving for himself the right to
intervene on the composition's focal point,
the figures of the Virgin and child.
Maria Serlupi Crescenzi

1. "Con dimostrazione di riverenza e d'affezione che
convengono a un principe e prelato di questa sorte."
(with a demonstration of affection befitting a prince
and prelate of this degree). Grimaldi 1995, 138.
2. Spezzaferro 1993, 701.

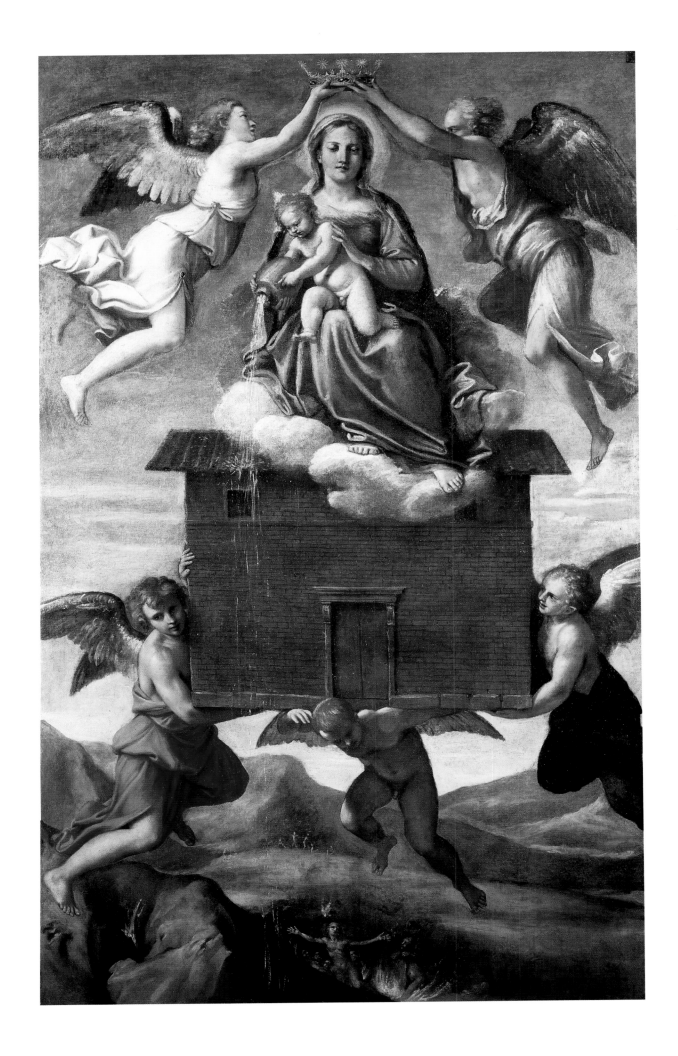

78

Attributed to the Workshop of the Carracci
(Bologna, 1582–c. 1619)
AN ANGEL FREES THE SOULS OF PURGATORY
THROUGH THE INTERCESSION OF THE VIRGIN MARY
AND THE SAINTS, c. 1610
Oil on canvas
44 x 31 cm (17⅜ x 12¼ in.)
Vatican Museums, inv. 42523

Conservation courtesy of Dr. and Mrs. Joseph
V. Braddock

Provenance: Formerly in the Floreria
Apostolica Vaticana.

Literature: Bibliotheca Sanctorum, for the saints
under the entries of their respective names;
Enciclopedia Cattolica under the entries
"Purgatorio," "Ignazio di Loyola,"
"Compagnia di Gesù"; Réau 1955–59 (1957),
under "La Vierge Tutelaire," 110–11, and
"Le Jugement Dernier," 752–53, and vol. 1,
chapter 3; *La Scuola dei Carracci. I Seguaci di
Annibale e Agostino* (Modena, 1995).

This painting is mentioned for the first time
in the *Inventario,* edited by the Floreria
Apostolica Vaticana in 1922 in Castel Gandolfo,
the pope's summer residence.

The painting's small size belies its
monumentality, which suggests that it may
be a sketch for an altarpiece. Its composition
is arranged according to a traditional,
hierarchical subdivision. In the upper half,
the Madonna and child, reminiscent of the
typology of the Virgin of Loreto, are seated on
the clouds surrounded by angels and saints who
intercede on behalf of the souls in purgatory.
In the lower half, an angel descends in order to
save a suffering soul while he points to the
heavenly court that has sent him. Below,
among the flames, are the souls in purgatory
who plead with mournful gestures and
expressions. Above the saints and surrounding
the Virgin Mary's halo are depicted numerous
small angels with the particular typology of
winged heads. This kind of iconography,
formerly used during the Renaissance, was
extremely widespread during the baroque
period.

The Marian cult connected with the
Virgin's intercession for souls in purgatory
became particularly widespread between
about 1550 and 1650. Altars and churches
were dedicated to the Madonna, called Our
Lady of Grace, Our Lady of Suffrage, or Our
Lady Patroness or Mediatrix, because it was
recognized that she played an effective role
as intercessor.

The patron saints of Bologna are portrayed
on the Madonna's right side: with a halberd
and wearing a corselet is Saint Proclus,[1] a
Roman soldier martyred in the city, most likely
under Diocletian; next to him is the other
protector of Bologna, Saint Petronius, bishop of
the city in the fifth century, with the episcopal
insignia (pastoral staff, miter, and cope) and
the book; and finally, Saint Anthony of Padua,
wearing the Franciscan habit, with the book
and the stem of lilies. On her left side are Saint
Francis of Assisi with a habit and stigmata;
Saint Dominic, wearing the Dominican habit;
and Saint Ignatius Loyola, wearing the Jesuit
cassock. Both of the latter have stems of lilies.

In this painting, Ignatius, founder of the
Jesuits, appears in glory and together with the
other saints. His beatification took place under
Paul V in 1609, and he was canonized under
Gregory XV in 1622. By 1540, Paul III had
already approved the foundation of the new
order, which spread quickly throughout
Europe. The Jesuits had devoted themselves to
renewing morals and returning to the purer
values of the Gospel. They soon became an
important instrument used by the pope to
oppose the theories of the Lutherans and the
Calvinists, who refused to recognize the
Church's role as intermediary and proposed a
universal ministry.

The Catholic school of thought reached an
unequivocal formulation of the doctrine of
purgatory based on indications found in the
holy scriptures, such as suffrages, purification,
and atonement (II Maccabees 12:43–46;
Matthew 5:25–26 and 12:31–32). This was
brought about through the use of prayers, good
works, and eucharistic sacrifice in favor of the
faithful who had died.

The founder of the Protestant Reformation,
Martin Luther (1483–1546), believed only in
salvation and damnation, denied the existence
of purgatory, and harshly attacked the sale of
indulgences. Catholic theologians reacted to
his theories with treatises and condemnations.
In 1563, the Council of Trent issued the well-
known *Decretum de Purgatorio,* in which
Catholic doctrine is formulated in clear and
simple terms, and fundamental disciplinary
measures against heresy are promulgated.

This painting represents an iconographical
declaration of the Catholic creed as established
by the Counter-Reformation: the Virgin
Mary, the angels, and the saints, denied by
the Protestants, are intermediaries for the
salvation of mankind. Heaven and hell are
not the only alternatives; there is also the
transitory passage of purgatory.

The visit of angels, messengers of God and
the Virgin Mary, gives special relief to the souls
of purgatory (*solatium purgatorii*). According
to Saint Bernardino of Siena and other mystics,

the guardian angel cannot abandon the one
he is protecting in time of trial. The angel
situated in the lower part of the painting does
not judge the souls, as does the archangel
Michael (who is often depicted with the scales
of justice in the Last Judgment). Instead he
leads the one he protects to salvation, like the
archangel Raphael, the Guardian Angels'
model.

As is made clear by the presence of Saints
Proclus and Petronius, the painting is
connected to the area of Bologna. Its pictorial
representation and structural form make the
work attributable to the workshop of the
Carracci. The presence of Saint Ignatius' halo,
a sign that his beatification had already taken
place, suggests a date of around 1610.

In Bologna, a city politically linked to the
papal court as well as a university town,
Ludovico Carracci (1559–1619) and his
cousins, Agostino (1557–1602) and Annibale
(1560–1609), proposed a new painting style: a
return to a realistic approach and renewed
attention to the great masters of the sixteenth
century, in contrast to the prevailing style of
late mannerism. In 1582 they founded the
Accademia dei Desiderosi, later called
Accademia degli Incamminati, with the
intention of returning to a naturalistic
representation of life conforming to the
guidelines of the Council of Trent, which were
expressed in Bologna by Cardinal Gabriele
Paleotti.[2] The Carraccis worked together until
1594–95 when Annibale and Agostino moved
to Rome; Ludovico remained and continued
running the workshop and the Accademia,
which had a large following of students and
was frequented by scholars and scientists.
Adele Breda

1. In Bologna, the cult of the following saints was
widespread: Peter, Ambrose (until 1378), Dominic,
Francis, Petronius, and Proclus. The cult of Saint
Proclus was spread by the Benedictine monks (who
preserved his bones) in opposition to the diffusion of
the cult of Petronius. In 1251, Proclus was included as
a patron saint of the city. Often the two saints appear
together in Bologna's paintings.
2. In 1582, the Bolognese cardinal, Gabriele Paleotti,
wrote the *Dialogo intorno alle immagini sacre e profane*
(Dialogue dealing with holy and profane images).
Conforming to the new post-council guidelines, in this
work he renounced the arcane exaggerations of
mannerism, wanting holy images to have a simplified,
explanatory clarity and the intent to improve morals.

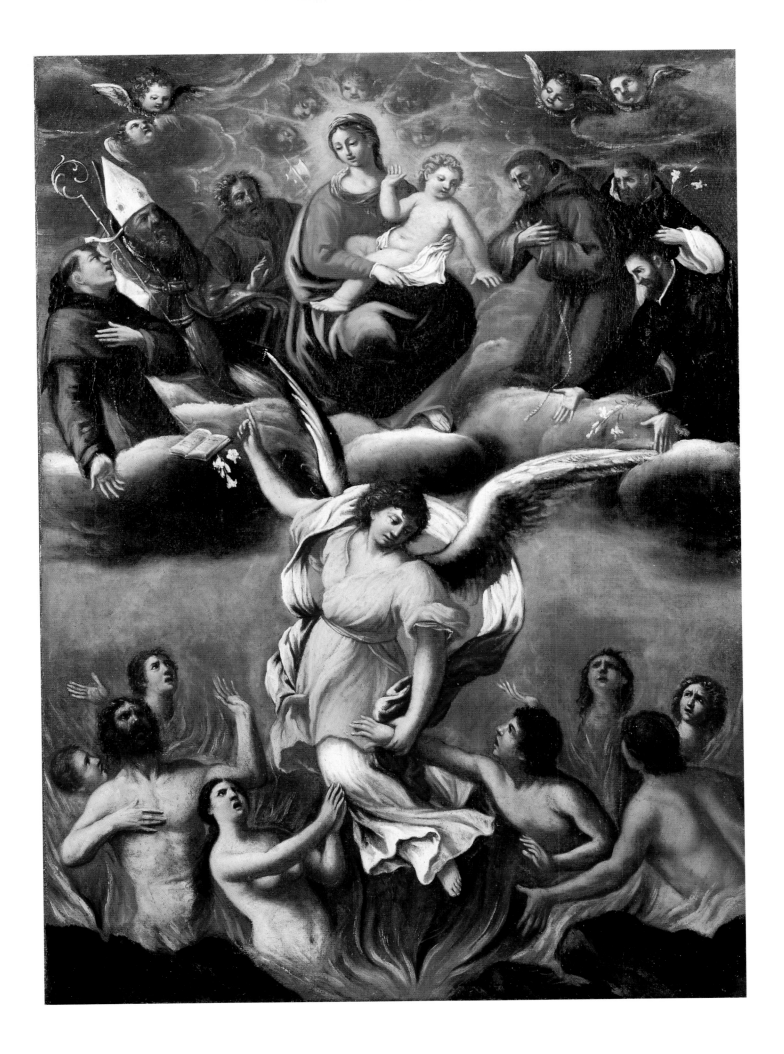

79

Paula Modersohn-Becker (Dresden, 1876–
Worpswede, 1907)
THE ANNUNCIATION, c. 1905
Oil on paper
48 x 48 cm (18⅞ x 18⅞ in.)
Vatican Museums, inv. 23376

Provenance: Gift of an anonymous donor.

Literature: M. Ferrazza and P. Pignatti in
Vatican City 1974, cat. 430, b/w photo;
G. Fallani, V. Mariani, and G. Mascherpa in
Milan 1974, 118, colorplate no. 63.

The sacred scriptures of the people of Israel
and of the Christian Church, essential sources
for helping to understand the complex nature
and action of angels, agree that angels come
from heaven and, though acting like human
beings and speaking and moving like them,
are the visible personification of the divine
message that announces salvation and
pronounces judgment.

In this *Annunciation*, based on traditional
iconography, the artist captures the
significance of the theophany. She expresses
the emotion and wonder of the event by
accentuating the dissolving features of the
protagonists and breaking up the homogeneity
of the dark zones by sudden eruptions of
luminous colors.

Her conviction of the priority of personal
emotion over naturalistic vision lay at the basis
of the original style developed by Modersohn-
Becker. It firmly places her among the
precursors of expressionism.

She had spent her formative years in the
artistic colony of Worpswede, a northern
German village near Bremen. Founded and
animated by the painter F. Mackensen in the
last years of the nineteenth century, this group
of landscape painters cultivated a lyrical
naturalism in part inspired by the poetry of
Rainer Maria Rilke. But only after a stay in
Paris in the early years of the century did
Modersohn-Becker overcome the essential
immobilism bred of this experience. There
she studied primitive art, absorbing its extreme
condensation of form and finding visual
confirmation in it of her own expressive
aspirations.

Modersohn-Becker's painting was
authenticated on the rear of the sheet by the
painter Otto Modersohn in 1920. It is signed
"P. M. B." at the lower left.
Mario Ferrazza

80

Salvador Dalí (Figueras, 1904-89)
ANGELIC LANDSCAPE, 1977
Oil on canvas
76 x 101 cm (30 x 39¾ in.)
Vatican Museums, inv. 23719

Provenance: Gift of His Majesty Juan Carlos, king of Spain.

Exhibitions: Vatican City, Charlemagne Wing (Bernini colonnade), *Acquisizioni della Collezione Vaticana di Arte Religiosa Moderna*, 1980; Helsinki 1982; Tokyo and other cities, *The Message for the Godless Age*, 1987.

Literature: Vatican City 1988, cat. 19, b/w plate; Helsinki 1982, cat. 15, b/w plate; Tokyo 1987, cat. 99, colorplate.

The elements of surrealism and classicism, fundamental components of Dalí's art, are fused together and coexist in a rarified atmosphere, half dream and half hallucination.

In the present painting, the soft monstrous object laid on a slab of stone in the foreground, the direct translation into visual terms of anxieties, nightmares, and memories, contrasts with the dance of the angels. So light as to transcend the earth's gravitational pull, they are a lyrical expression of Dalí's world of dream and fantasy.

It is only from the end of the 1940s that the presence of little angel figures may be noted in the artist's works. In an autobiographical account, he confessed that the religious question was then being posed in his life and "the questions and doubts about pre-mystic inspiration found its most glorious conclusion in the manifesto of 1951."[1] Dalí's angels do not form part of any of the celestial hierarchies. But they are undoubtedly a comforting image of the powers of the spirit and represent its fixed symbol amid the various forms suggested by the artist's volatile genius.
Mario Ferrazza

1. S. Dalí, *I, Salvador Dalí*, (Rome: Del Turco edition, 1954), 4.

ANGELS AND THE LITURGY

81

MONSTRANCE WITH GRAIN, 1750
Silver, partly gilded, and glass
c. 108 cm (42½ in.)
Pontifical Sacristy

Conservation courtesy of
Mr. and Mrs. James B. Rettig

This large monstrance is of the disk-shaped type with two panes of glass over the central compartment, inside which is the lunette for holding the consecrated Host. The style of the work is clearly eighteenth-century baroque, as can be seen from the modeling of the feet and the stem halfway down the monstrance.

The base rests on four feet supporting a section shaped somewhat like a truncated pyramid. Medallions decorate the sides of the pyramid, finishing off the design of four concave specular surfaces, which are embossed and chased. The frontal medallion has an elaborately framed relief of the Virgin with the holy child in her arms. Each corner of the pyramid ends in a volute, and on top of the volutes are the four evangelists, sculpted in the round and carrying their individual symbols. Two cherubs decorate the section between the pyramid below and the stem above, one playfully holding a large cross, and the other seated in an interlocutory pose. These figures are also sculpted in the round.

The stem has the typical shape of a reversed pyramid, with the lower part truncated and decorated in sections with garland motifs, while at the top two small winged angels' heads can be seen on either side of the node. Above the wings around the two angels' heads rises another much smaller reversed pyramid, open at the top, with sheaves of wheat springing from it. The aureole of the monstrance rests on top of the bundle of wheat.

Rays encircle the container for the Host, in the middle of the aureole, surrounded by a graceful flight of six angels holding the symbols of the Passion. Starting from the right and from the bottom upward, the angels hold, respectively: the crown of thorns, the pincers, the hammer, the sponge, the spear, the chalice, the pitcher of water, the ladder, and the nails. Some vine leaves mingle with the sheaves of wheat below the monstrance, symbolizing the Blood of Christ.

The earliest monstrances date from the Gothic period and used all the symbolism connected with the body of Christ. The shape of these sacred vessels used to preserve the Eucharist began to change after the Feast of

Corpus Christi was established in 1264. Three centuries later, when public worship of the consecrated Host became popular in the feast of the Forty Hours Devotion, the Host had to be fully visible, and so a circular display case was created within the monstrance, protected by panes of glass or crystal.

According to various papal prescriptions, the container of the Host, known as the "gloria," must be surrounded by rays of light. It may also be decorated with angels, either full-length figures or simply heads with wings, and the angels may surround the gloria or hold up the entire aureole. Even the lunette into which the Host is inserted for presentation can be shaped like an angel's head.

Monstrances are still used for blessings with the Eucharist, during the Forty Hours Devotion, and for Corpus Christi processions and the Benediction of the Blessed Sacrament.

During a recent cleaning of this monstrance, an engraved inscription came to light, with a date: A. 1790 £5000/ IN DEI HONOREM/ R.C.L. R.I./ D.R.L. ET N.B.
Luciano Orsini

The monstrance bears hallmarks including a territorial mark and an 800-parts-fine guarantee called a turret mark, punched by the marker of the Genoa Guild of Goldsmiths and Silversmiths. Three figures under the mark ("750") indicate the year of manufacture, 1750.[1] The piece also bears the cross of S. Maurizio and S. Lazzaro surmounted by a crown within a circle. This hallmark, for 800-parts-fine large artifacts, was punched by the assayer of the surveyors of the Kingdom of Sardinia from 1826 to 1861 and of the surveyors of the Kingdom of Italy from 1862 to 1873.[2] The third mark, a dolphin curled within a circle, was the territorial mark used by the assayer of the Genoa Surveyors from 1824 to 1873.[3] The first mark indicates the year of manufacture, and the other two, added later, were for export purposes.
Maria Antonietta De Angelis

1. U. Donati, *I marchi dell'argenteria italiana* (Novara, 1993), n. 434.
2. Donati 1993, n. 661.
3. Donati 1993, n. 347.

82

Italian (Rome)
DEVOTIONAL BASE FOR A MONSTRANCE
1st half 18th century
Wood, gilded bronze, and silver
74 x 75 x 53 cm (29⅛ x 29½ x 20⅞ in.)
Basilica of Santa Maria Maggiore, Rome

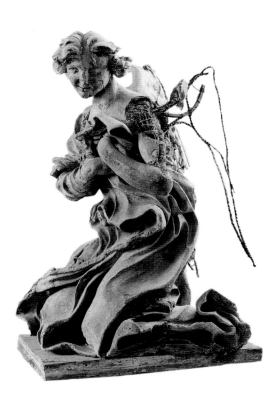

Fig. 1. Gian Lorenzo Bernini and Giovanni Rinaldi, *Model for an Angel in the Chapel of the Blessed Sacrament, St. Peter's.* Vatican Museums

Undoubtedly inspired by the baroque model of the Ark of the Covenant, this example of liturgical furnishing could likewise be referred to as an "ark" because of its large size. Its function was to serve as the base for a large monstrance, the vessel containing the consecrated host, which could thus be displayed for the veneration of the faithful, even during a procession.[1]

The beauty of this large religious piece results from an inspired pairing of gold and silver as well as from a lavish mingling of decorative techniques. The parts in relief comprise leaf-shaped frames, silver swirls, and holy scenes and are themselves framed within smooth gold frames. The principal scene depicts a Last Supper, whereas a Pietà can be found on the side opposite. These two episodes in turn are surrounded by four smaller reliefs in which angels reveal the symbols of the Passion and the Eucharist. These two symbols reappear in the reliefs located on the sides of the ark.

Heads of cherubim, carved in full relief, decorate the devotional base. Since the cherubim are an order of angels in the celestial hierarchy known to be particularly close to God's throne, they are evidently proposed here as being suitable to watch over the Ark.[2]

Two large angels in gilded bronze with heads of silver are kneeling on the surface of the ark. Between them, at eye level, the monstrance is to be placed. Beyond offering a visual interpretation of Saint Thomas Aquinas' celebrated hymn "Panis Angelicus," their adoring presence harks back to the archetypal ark that contained the manna, for Christians a clear foreshadowing of the Eucharist.

The devotional base is in elaborate baroque style, along the lines of seventeenth-century works by Gian Lorenzo Bernini. Typical of this style are the general inventiveness and, in particular, the representation of the angels. Indeed, a very similar design for the support of a monstrance or ciborium (the latter for holding eucharistic bread)[3] has already been attributed to Bernini or his workshop and dated at about 1665.

A direct comparison may be made between the kneeling angels and the models of those made for the chapel of the Blessed Sacrament in St. Peter's. Nowadays one of the models is housed in the Fabbrica di San Pietro and the other in the Vatican Museums. They faithfully reflect the same attitude, the same shape and style of clothing, and the same arrangement of drapery. The models for the chapel have been attributed to Bernini and to his assistant Giovanni Rinaldi and dated 1673 (fig. 1).[4] They also appear in prints such as one by Francesco Aquila that shows the whole altar.[5] A certain affectation, verging on the rococo, would suggest assigning the ark and the kneeling angels to the first half on the eighteenth century, whereas the wooden base with its handles would appear to be a nineteenth-century addition.
Maria Antonietta De Angelis

1. B. Montevecchi and S. Vasco Rocca, *Suppellettile Ecclesiastica* 1 (Florence, 1987), 120 and 404.
2. Réau 1955–59 (1956), 2,1:40.
3. Housed in the Vatican Apostolic Library and reproduced in Vatican City 1981, fig. 269.
4. Vatican City 1981, 15–54.
5. Vatican City 1981, 154.

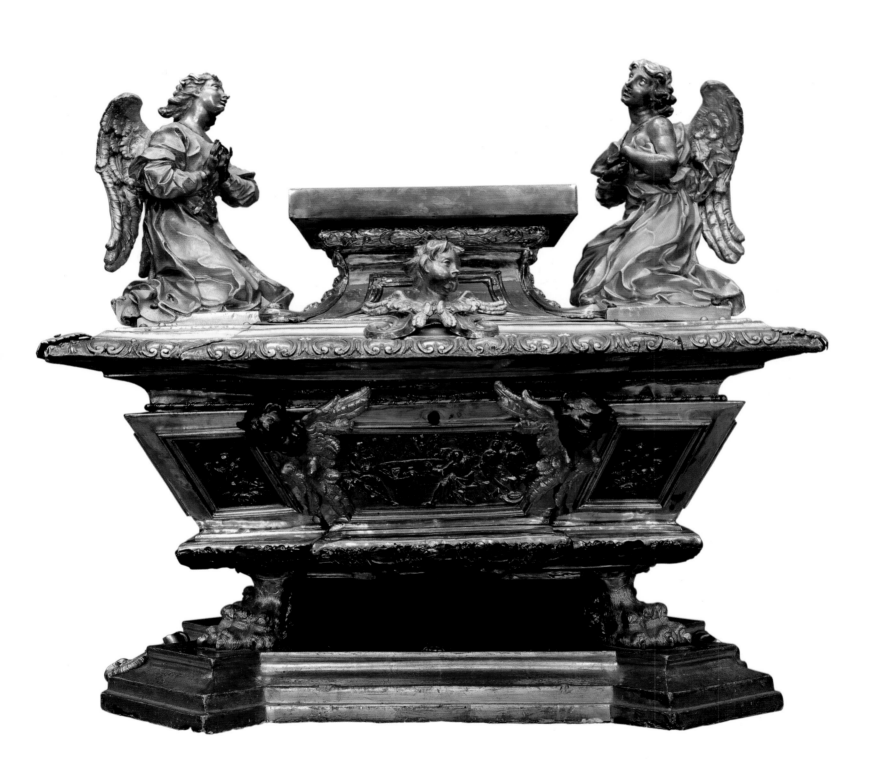

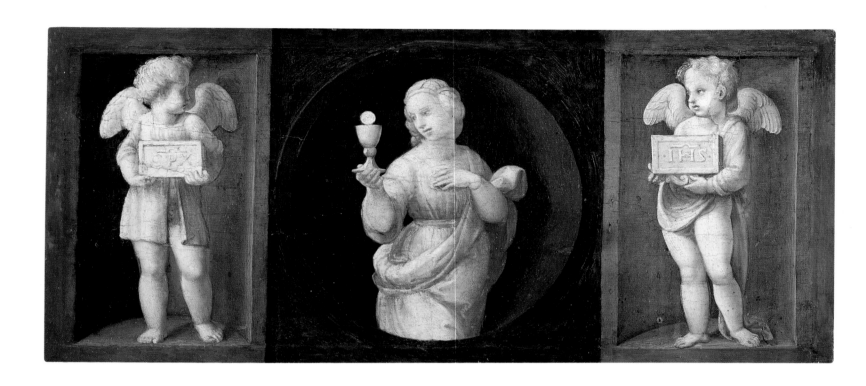

83

Raffaello Sanzio, called Raphael (Urbino, 1483-Rome, 1520)
FAITH, 1507
Tempera on wood
18 x 44 cm (7⅛ x 17⅜ in.)
Vatican Museums, inv. 40332

Exhibitions: New York 1982; Vatican City, Braccio di Carlo Magno, *Raffaello in Vaticano,* 1984.

Literature: G. and A. D'Este, *Elenco degli Oggetti Esistenti nel Museo Vaticano* (Rome, 1821), 45; E. Wind, "Charity," in *Journal of the Warburg and Courtauld Institutes* 1 (1937–38):329 ff.; C. L. Ragghianti, *La Deposizione di Raffaello* (Milan, 1947); L. Dussler, *Raphael* (London-New York, 1966), 23–25; P. De Vecchi, *Raffaello. La Pittura* (Florence, 1981), 244; F. Mancinelli, in *The Vatican Collections. The Papacy and Art* (exh. cat. New York, 1982, 154, n. 79A; S. Ferino Pagden, in *Raffaello in Vaticano* (exh. cat. Milan, 1984), 25–26, n. 5; A. M. De Strobel and F. Mancinelli, "Il Cinquecento," in Pinacoteca Vaticana 1992, 265.

Three sections showing the Theological Virtues combine to form the predella of an altarpiece that Atalanta Baglioni commissioned from Raphael, possibly toward the middle of the year 1506, for the family chapel in the church of S. Francesco al Prato in Perugia. The noblewoman intended the work to commemorate her son, Grifonetto, who had been assassinated in July 1500 during the struggles between rival branches of her family to establish control over Perugia. In keeping with tradition, Atalanta intended that her own suffering should be mirrored in that of the Virgin, while in the young bearer on the viewer's right can be seen a resemblance to Grifonetto (another interpretation suggests a close similarity with Grifonetto's features in those of the dead Christ).

The altarpiece was originally composed of a large central panel, signed and dated RAPHAEL URBINAS M.D.VII (Raphael of Urbino 1507), showing the *Deposition of Christ*

(Borghese Gallery, Rome, fig. 1), a pinnacle with *God the Father, Blessing between Angels* (National Gallery of Umbria, Perugia), and the Vatican predella.

Raphael is generally recognized as the sole author of the altarpiece with the exception of the pinnacle, which is usually excluded from the full catalogue of his work and is considered to be by the hand of one of his pupils (possibly Domenico Alfani), painted, however, according to the master's own design.

The altarpiece remained in place until 1608, when the *Deposition* was taken secretly to Rome by order of Pope Paul V (1605–21), who gave the painting to his nephew, Cardinal Scipione Borghese, to add to his collection. In response to the indignant protests both of the Perugians and of Braccio Baglioni, a descendant of Raphael's original patron, the pope replied with a brief in which the painting was described as "a private matter," and the cardinal merely sent a copy by Lanfranco to Perugia (now lost) and another by the Cavaliere d'Arpino (National Gallery of Umbria, Perugia).

The main panel was transferred to Paris by Camillo Borghese, husband of Paolina Bonaparte, in 1809; the predella, which along with the pinnacle and frame had remained in San Francesco al Prato, had been taken to Paris in 1797 by French troops. In 1816, the central panel was returned to the Borghese Gallery, and the predella was returned to Pius VII (1800–23), thus enriching the important nucleus of works by Raphael in the renovated Vatican Picture Gallery.

The iconography of the predella is most unusual, since this space is normally reserved for episodes from Christ's Passion or from the life of the Virgin, related in some way to the subject of the central panel, or for images of the saints to whom the church was dedicated. Ferino Pagden[1] suggests that a number of extant drawings showing scenes from the Passion or events following the death of Christ, similar in style to that of the Borghese Gallery *Deposition*, could be considered to form part of the original project for the predella, which was subsequently modified. Similarly, many preparatory drawings for the central panel still survive, showing clearly the difficulties involved in its creation and how the subject evolved from that of a Lamentation over the Dead Christ to the more animated final version. The allegorical figures of the predella are painted in monochrome ivory, which contrasts with the dull green background. Here, in the horizontally planned sequence, the Virtues are shown as three-quarter length figures within circular frames, flanked on either side by putti holding their relevant attributes.

Charity (fig. 2), which dominates the predella from its central position, is the most complex of the three predella figures. The tondo with the personification of the virtue has clearly been influenced by Michelangelo's *Pitti Madonna*; on one side a putto holds a flaming torch on its shoulders, while on the other a putto tips coins out of a bowl. *Hope* (fig. 3), forming the right-hand section of the predella, has at its center the allegorical figure which,

according to Ripa's *Iconology*, was to become canonic by the end of the century. On either side are putti in confident attitudes. *Faith*, traditionally identified by the chalice and host, is flanked by two small angels holding plaques with the Greek inscriptions "CPX" and "IHS," alluding to the presence of Christ in the Eucharist. Ferino,[2] besides noting the close relationship between these putti and the two at the feet of the *Madonna del Baldacchino* (Palatine Gallery, Florence), published an unknown drawing from the Fogg Art Museum. This drawing is attributable to an artist from Raphael's closest circle of followers in which the putti are not nude, as in the Florentine altarpiece, but clothed in a manner that links them closely with the putti flanking *Faith* in the predella of the Baglioni altarpiece.
Maria Serlupi Crescenzi

1. Ferino Pagden in Milan 1984, 25.
2. Ferino Pagden in Milan 1984, 26.

Fig. 1. Raphael, *Deposition of Christ*, 1507, tempera on wood. Galleria Borghese, Rome

Fig. 2. Raphael, *Charity*, 1507, tempera on wood. Vatican Museums

Fig. 3. Raphael, *Hope*, 1507, tempera on wood. Vatican Museums

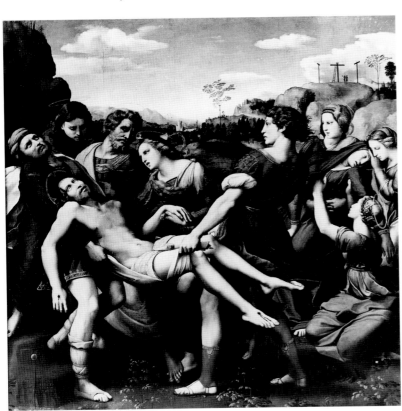

84

POLIDORI CHALICE, baroque era
Gilded silver and metal
31 cm (12¼ in.)
Pontifical Sacristy

This chalice, formerly the property of Cardinal Polidori, is charmingly worked in gold-plated silver using a mixed technique of embossing, chiseling, and casting. The base is variegated in form, with a polished border and typically baroque decoration finished with extreme care. Three graceful winged cherubim sit on the base, sculpted in the round and holding the symbols of Christ's Passion. Between the cherubs are three medallions, each containing a relief with a symbol of Christianity.

Above this is the stem of the chalice, which is elongated and made up of three figures representing the virtues of Faith, Hope, and Charity. Faith, which in this case also represents Religion, is a veiled woman holding a chalice in one hand and a cross in the other. Hope is a similar female figure who leans on the anchor of Salvation, while Charity is a woman with a child in her arms.

Above the three figures, a shiny, smooth ring supports the cup. The lower part of the cup itself is embellished with exquisitely chiseled and decidedly baroque decoration, with volutes and winged cherubs' heads. It contrasts with the smooth surface of the cup, which is conical in shape, rounded at the base, and slightly flared at the lip. All of the gilding on the cup is original.

The chalice is unquestionably the first and most important instrument of the Christian liturgy. It is the only sacramental vessel that Christ himself used during the Last Supper, and later it became part of the sacrament of the Eucharist. Its name comes from the Greek word *calus*, which means cup. In Latin, *calix* means drinking cup, which could be of any shape but invariably was a stemmed, footed cup with a handle on either side. The apostles and their immediate successors for several centuries used common drinking cups made of glass, pottery, ivory, metal, and even wood for their chalices. In the old liturgy, only bishops could bless chalices, whereas now priests may perform this ceremony. The chalice symbolizes the Church, which collects the precious blood of its founder to distribute as nourishment for the souls of believers.

Luciano Orsini

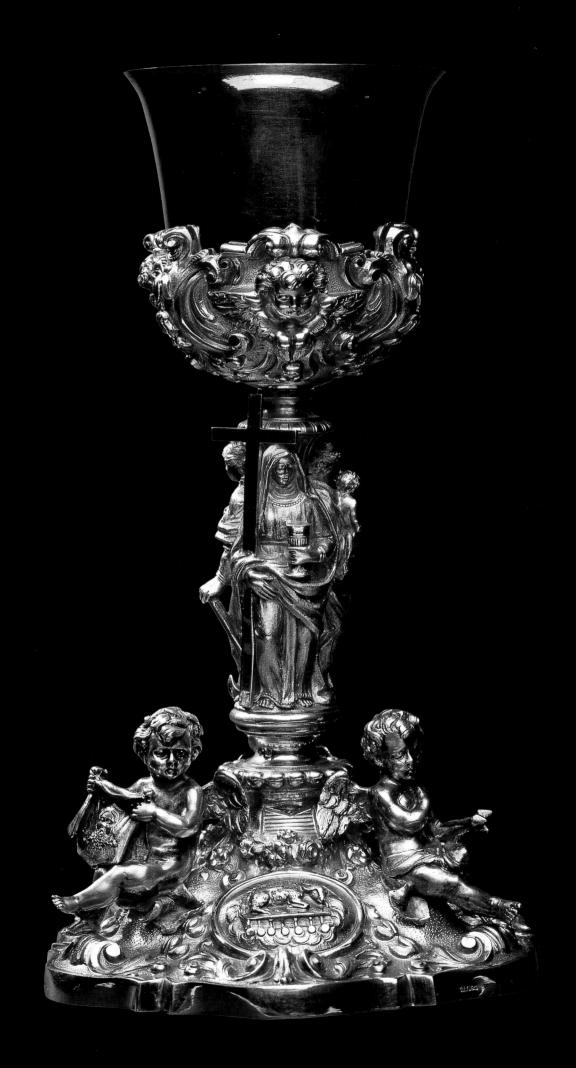

85

Workshop of Vincenzo Coaci (active Rome, 1782–94)
CHALICE, c. 1795
Gilded silver
30.5 cm (12 in.)
Basilica of Santa Maria Maggiore, Rome

Exhibitions: Rome 1975, Paris 1990.

Literature: M. Andaloro in Rome 1975, 90, no. 202; M. A. De Angelis in Paris 1990, 166, no. 092.

Beneath the foot of the chalice there is a large coat of arms of Giovan Francesco Albani, below a cardinal's hat with five orders of tassels and a patriarchal cross (fig. 1). Albani, great-nephew of Clement XI (1700–21), whose name he bore, was created cardinal when he was only twenty-seven years old and was given the titular church of S. Cesareo in 1747 by Benedict XIV (1740–58). Pius VI (1775–99) appointed him archpriest of Santa Maria Maggiore in 1795 to succeed Cardinal Andrea Orsini, who died that same year.[1] Cardinal Albani died in 1803.[2]

Underneath the foot of the chalice is also the double mark of the silversmith Vincenzo Coaci, who was active in Rome between 1782 and 1794, the year of his death. Coaci was born in 1756 in Montalboddo (today's Ostra) in the Marches. He had a workshop in Rome in Via del Governo Vecchio.[3] It seems that these marks were used as a pair by Coaci between 1793 and 1795.[4] Given that Cardinal Albani was appointed archpriest of the basilica only in 1795, one is led to believe that, although the chalice bears Coaci's marks, it was made by another silversmith from his workshop, following the master's design. A replica, also attributed to the workshop,[5] was given to Pius VII (1800–23) in 1801 and is now in the treasury of St. Peter's Basilica. M. Andaloro, who first published this chalice,[6] emphasizes how the style depends on Luigi Valadier, who was Coaci's master.

The round base is decorated with three-dimensional sculptures of small angels supporting bas-reliefs with beaded frames. Depicted on the bas-reliefs are episodes from the Passion (which are somewhat rare for liturgical objects): *Christ before Caiphas*, *Christ before Pilate*, and the *Deposition*. The knot of the stem of the chalice is in the form of a small temple in which is seated the figure of a veiled woman holding a chalice and the Host, the symbolic commixture between Faith and Religion described by Cesare Ripa in his *Iconologia*.[7] The lower part of the bowl of the chalice is decorated with putti who, between vine tendrils, support three medallions with the Pelican, the Phoenix, and the Agnus Dei (Lamb of God), symbols connected with the Eucharistic mystery and the Resurrection.

The function of the angels and the putti in the iconographical context of the chalice seems to respond exclusively to decorative motifs that date back a long time. While the small three-dimensional angels assume the postures of small pieces of sculpture acting as plaque supports, with typically baroque movements, the putti in high relief on the lower part of the bowl of the chalice, in the attitude of dancers, remind one of Renaissance motifs, especially those from Tuscany, almost as if they were pagan ephebes singing hymns of praise to wine and the vine shoots that adorn them.
Maria Antonietta De Angelis

1. See *Chracas*, year 1796, 3, 38.
2. G. Sofri, in *Dizionario Biografico degli Italiani*, vol. 1 (Rome, 1960):604–06.
3. C. G. Bulgari, *Argentieri gemmari e orafi d'Italia, Parte prima, Roma* (Rome, 1958–59), 299.
4. A. Bulgari Calissoni, *Maestri argentieri gemmari e orafi di Roma* (Rome, 1987), 148, nos. 384a, 386.
5. L. Ficacci, *Dizionario Biografico degli Italiani*, vol. 26 (Rome, 1982):420.
6. Andaloro in Rome 1975, 90, no. 202.
7. C. Ripa, *Iconologia… ampliata dal Sig. Cav. Goi. Zaratino Castellini* (Venice, 1669), 523.

Fig. 1. Cat. 85, detail, coat of arms of Giovan Francesco Albani

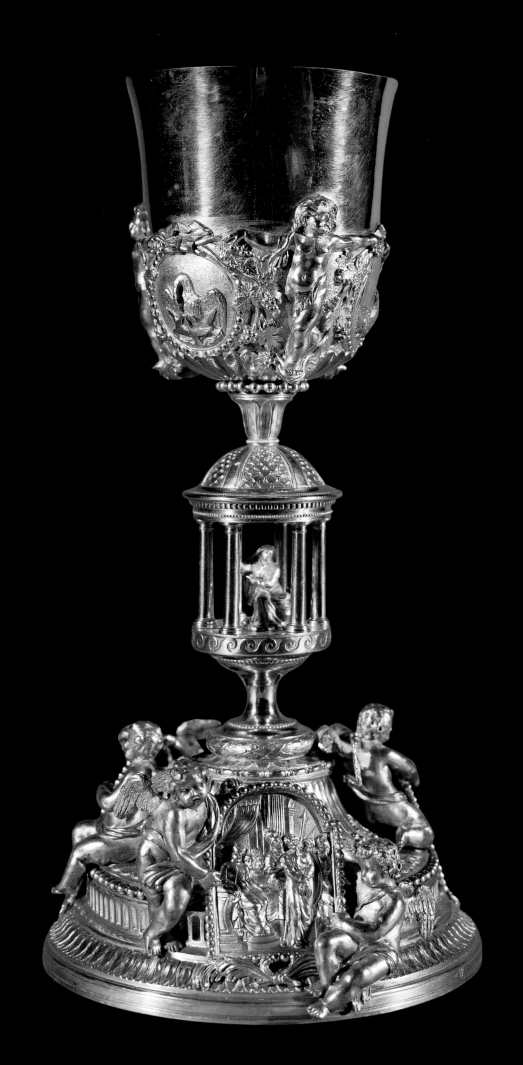

86

PAX, 19th century
Silver, partly gilded, with enamel and gold
16 x 20 cm (6¼ x 8 in.)
Pontifical Sacristy

Conservation courtesy of Nelson Angelo
Monteleone

This instrument for the Rite of Peace rests on a base with a variegated form and raised border, decorated with cast reliefs; the coat of arms of Pope Leo XIII (1878–1903) is in the center. On either side of the coat of arms are leaves that cover most of this area, and on top of the pope's coat of arms are the usual pontifical emblems of the keys and the tiara. Two graceful cherubs, sculpted in the round, rest on the base. They support a small temple decorated with garlands and architectural motifs; two acanthus leaves are on either side of the temple. A medallion showing the resurrected Christ is in the center of this structure, surrounded by incredulous bystanders who move in a space defined by three arches.

Above the medallion is a semicircular area with two pseudo-baroque decorative elements on top of it. On either side are two angels sculpted in the round, who kneel, worshiping a chalice with a Host on top of it that represents the sacrament of the Eucharist.

The instrument for the Rite of Peace consists of a metal sheet framed by artistic ornamentation with a handle on the back (fig. 1). It was passed among the faithful during Mass, who kissed it as a sign of mutual solidarity. Today this practice is virtually obsolete, although some non-Latin rites of the Catholic Church do still use it. During papal high masses, the instrument of peace was kissed by the pope first, then by the clergy, and finally was passed to the congregation.

The presence of angels on this instrument generally symbolizes its mystical quality, embodying the passion for God, who descended from heaven to establish real peace in the heart of humankind.
Luciano Orsini

Fig. 1. Cat. 86, back view

87

French
PROCESSIONAL CROSS OF POPE LEO XIII
Late 19th century
Silver, enamel, and precious stones
269 cm (106 in.)
Pontifical Sacristy

Exhibitions: New Orleans, La., New Orleans
Pavilion World Expo, *Treasures of the Vatican*,
1984; Brisbane, Australia, Pavilion of the Holy
See Expo 88, *The Holy See Vatican Collections*,
1988; Manila 1993–94.

This large processional cross is made of gilded silver and decorated with enamel work and precious stones. It was given to Pope Leo XIII (1878–1903) by the diocese of Moulins, France, on the silver jubilee of his ordination. An inscription on the ferrule reads: "S. Sanctissimo Patri Leoni XIII Pontifici Maximo/ Dioecesis Molinensis feliciter/ Occurrente/ Jubilaeo Sacerdotali/ 31 dec. 1887 gest. rever. Obtulit" (To the Most Holy Father Leo XIII Pontifex Maximus, the Diocese of Moulins on the occasion of the jubilee of his ordination, reverently offered on December 31, 1887). The cross bears Pope Leo XIII's coat of arms.

The design is neo-Gothic, a typical example of French workmanship in this period, borrowing heavily from the French medieval style and richly decorated. The three upper arms of the cross are decorated at each end by the winged head of a cherub in relief, with the wings enameled so that the heads stand out clearly.

Christ stands regally in the center of the cross, wearing a crown and elaborate loincloth and looking more like a king than a man in pain. Behind his head is an enameled halo, surrounded by a symmetrical design of multicolored rays. On the back of the cross is the Virgin Mary with arms outstretched.

Below them, sculpted in the round, are two small praying figures that kneel at the foot of the cross, their pose expressing devotion to Christ. They represent Adam and Eve and symbolize humanity's submission to salvation.

The spherical node below them is decorated with the signs of the zodiac and a bas-relief with a procession of saints. Acanthus leaves, a symbol of immortality, mark the point of juncture between the lower part of the cross and the staff, forming the capital of a ribbed column that has a serpent entwining it. The serpent represents evil, and its head faces downward as a sign of defeat and of Christ's supremacy. Vine leaves, symbolizing the blood of Christ, also appear in the elaborate design. The rest of the staff is decorated with ornamental motifs typical both of the period and the area in which the cross was made.

This type of cross is similar to altar crucifixes; in fact, the latter actually developed from processional crosses. The processional version is fixed on a decorated or painted staff instead of resting on a base.

Processional crosses are still used by the clergy, whenever a mobile cross is needed, both inside and outside churches. They are the most important insignia of liturgical processions. During processions in which the pope is involved, the cross precedes him with the crucifix turned toward him rather than the congregation, as is usual under other circumstances. This symbolizes the fact that the pope is the living model of Christ, who suffered for our salvation.
Luciano Orsini

88

CROSIER WITH SAINT MICHAEL, 19th century
Gilded silver, metal, and enamel
168 cm (66⅛ in.)
Pontifical Sacristy

Conservation courtesy of Bill, Lorraine, and
Corinne Dodero in honor of Corinne Leigh
Dodero

This crosier was probably made during the last century, using a Gothic model. The crook consists of a series of volutes that give it the traditional spiral shape, and the last volute carries the decorative element onto the handle of the staff, ending between the opened wings of an angel. The angel is sculpted in the round, with hands joined in prayer, while the outer curve of the spiral is decorated with a series of playful-looking cherubs.

Inside the curve of the crook, Saint Michael can be seen slaying the dragon, probably referring to a special devotion to the archangel by the patron who commissioned the work or the bishop for whom it was made. Another indication of this is the fact that Saint Michael is shown full-face, looking toward the person who carried the staff.

Below the crook is a hexagonal section, carved and sculpted in the round and divided into panels, some of which have coats of arms on them. This section is supported by winged angels' heads. A ribbed staff adds to the distinction of the crosier, and so does the rich enamel work, making it a unique item.

Crosiers symbolize a bishop's judicial and doctrinal power and are usually about 160 cm (63 in.) high. The bottom of the staff is pointed because the "Shepherd of souls (the bishop) has to prod the lazy and defend the weak," according to the *Bishop's Ceremonial*, which also specifies that the crook serves to "gather in the strays." As early as the sixth century, crosiers were a bishop's sign of office, usually made of wood but sometimes of metal and ivory, with a small *T*-shaped crossbar. From the fifteenth century onward, crosiers in the western world always had a spiral or crook at the top. When a bishop is in his own diocese, he carries the staff with the crook pointing outward, symbolizing his care for his flock, whereas in other dioceses the crook must point inward.

The symbolism of this crosier is closely linked to Saint Michael's role as the soul's protector against the temptations of the devil. This is enhanced by the chromatic effect of the enamel work, because the colors express the sensations felt by souls in God's grace.
Luciano Orsini

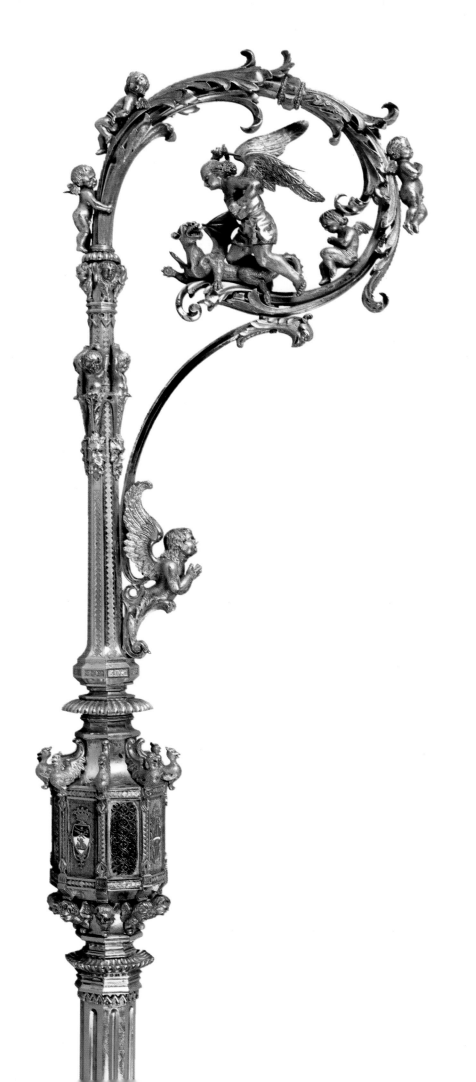

89

JUBILEE CLASP OF POPE PIUS IX, c. 1850–75
Gilded silver, enamel, and precious stones
18 x 12 cm (7 x 4 ¾ in.)
Pontifical Sacristy

Exhibition: The Holy See Vatican Collections,
1988.

This type of clasp, which has a long biblical tradition,[1] was generally used on the cope worn by popes or bishops. In the past, it hooked the cope worn by the pope when he sat on the *sede gestatoria* (papal gestatorial throne).

This clasp belonged to Pius IX (1846–78), to whom it was presented, on the silver jubilee of his consecration as pope, by the Prima Primaria Congregation.[2] It is carved in a special design based around a central image with some asymmetrical decorative elements on the outer border. A blue globe covered with stars is in the center of the clasp, while the upper part is encompassed by God the Father, who looks benevolently toward the globe, and the lower part is supported by a group of three full-length cherubs. On either side, two graceful angels hold scrolls that read: *Sine labe originali* (without Original Sin) and *Non deficiat Fides* (that Faith be not lacking). Decorative half-shell elements form the four corners, with angel heads between them.

Jewels[3] enhance the beauty of the clasp, making it suitably precious for a pope. A delicately engraved wide hook at the back kept the clasp firmly in place (fig. 1).

The liturgical symbolism of the clasp can be understood in terms of its function: it holds in place the papal cope, a symbol of the abundance of God's mercy toward humanity. Thus the clasp represents the "seal" of God's grace on humanity's conversion, and by extension this meaning of conversion can also be applied to the entire cope.

The imagery used on this clasp symbolizes God's closeness to the world at his feet, while the stars suggest an empyrean, limitless universe, or eternity.
Luciano Orsini

1. In the Book of Exodus, Jewish high priests had to wear a square metal "clasp" (actually a kind of pendant) around their necks during the more solemn religious ceremonies and also during some civil ceremonies (Ex. 28:15–28).
2. Previously known as the Congregation of the Annunciation, it became the Prima Primaria Congregation in 1584 by right of a papal bull of Gregory XIII (1572–85). It has been supported by the Jesuits since 1563 and is housed in the Jesuit Collegio Romano in Rome. Its role is to instruct individuals of every extraction to serve the Church, focusing on a special devotion to the Virgin Mary.
3. Originally, the precious stones decorating the clasps used by Jewish high priests for important occasions symbolized the twelve tribes of Israel. The stones were: sardonyx, for the tribe of Reuben; topaz (or yellow quartz) for the tribe of Simon; emeralds for the tribe of Levi; rubies for Jehudah; sapphires for Zebulun; diamonds for Issahar; opals for Dan; agates for Gad; amethysts for Aser; chrysolite for Naftali; onyx for Josef; and jasper for Benjamin. In Catholic tradition, the stones became associated with various saints or with the Virgin Mary.

Fig. 1. Cat. 89, back view

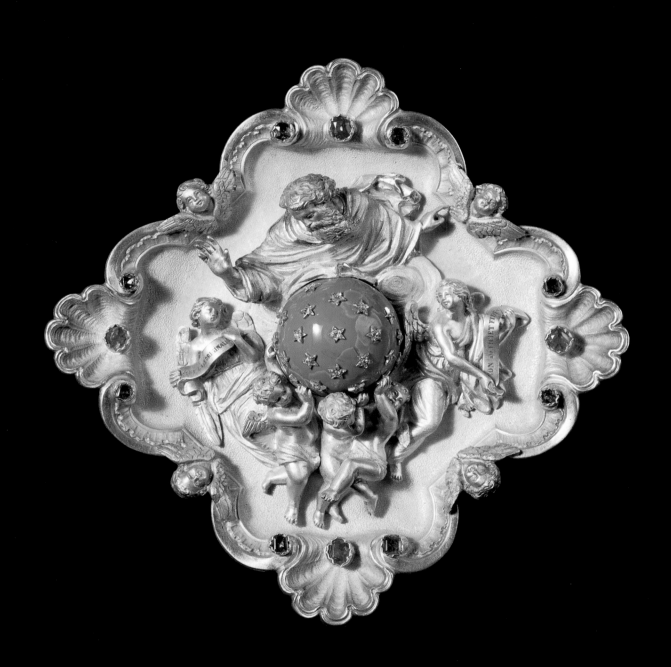

90

Italian (Rome)
PAIR OF CANDELABRA-BEARING ANGELS
Early 19th century
Gilded and painted wood
146 cm (57½ in.) and 144 cm (56¾ in.)
Basilica of Santa Maria Maggiore, Sforza
Chapel, Rome

Conservation courtesy of Florence B. D'Urso
in memory of Rev. Francis J. Perkosky, S.S.

Candelabra-bearing angels are sculptures
of small or medium dimensions that act as
supports for candelabra. They appeared first in
the late middle ages and in the Renaissance,
often as specific decorations for the altar, such
as the famous examples of Niccolò dell'Arca
and of Michelangelo for the *Sarcophagus of
Saint Dominic* in Bologna. Large examples
such as the exhibited works were to be placed
in the area inside the altar rails.[1]

This pair of angels, having to be placed at
the sides of the altar, were designed in their
position and gestures looking at one another as
in a mirror image. The angels are similar, even
if the drapery of their clothing and hair styles
are different in detail. They are standing on
neo-classical plinths decorated with garlands
of leaves and painted false marble. The rather
stylized drapery and the rigid gestures incline
toward a neo-classical style that was already
tending toward pure sculptural forms; thus
dating the sculptures to the first quarter of
the nineteenth century seems the most
appropriate.
Maria Antonietta De Angelis

1. B. Montevecchi and S. Vasco Rocca, *Suppellettile
ecclesiastica* 1 (Florence, 1987):53.

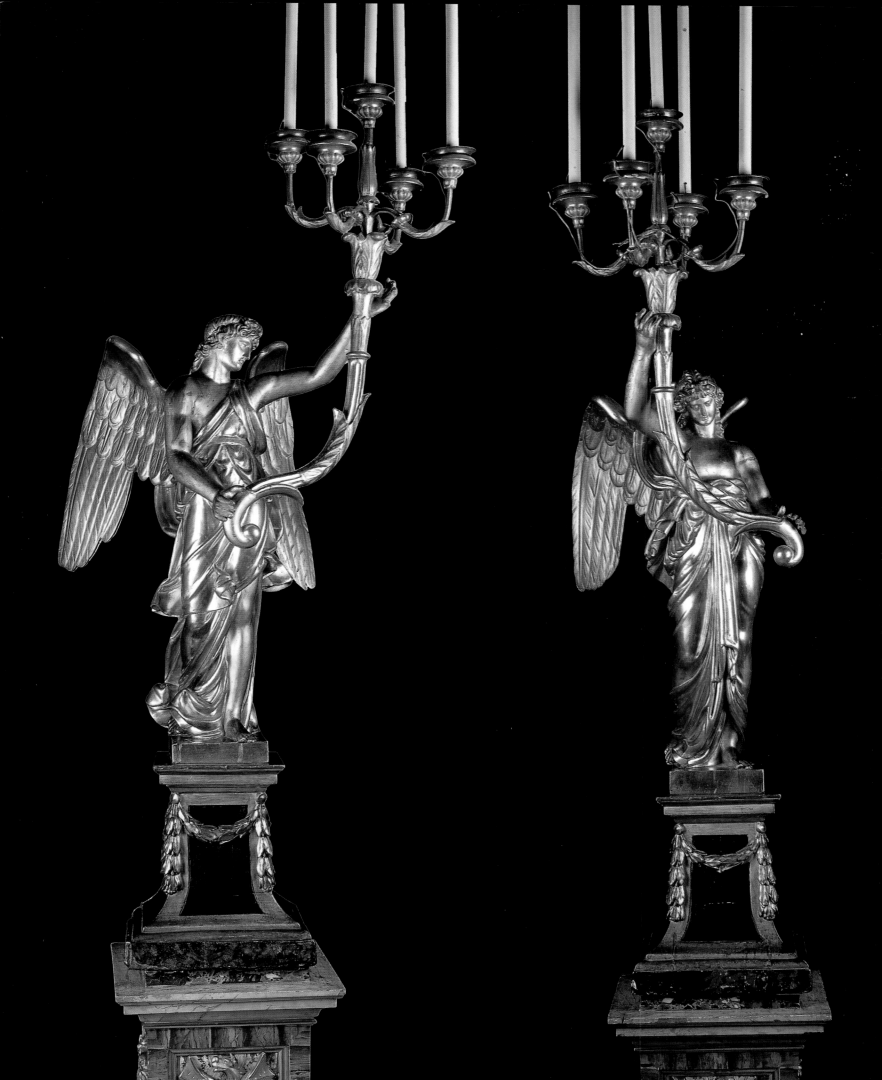

91

Italian
LITURGICAL VESTMENTS, 2nd half 19th century
Silk, gold, silver, cotton, and linen
Chasuble, 112 x 73 cm (44¼ x 28¾ in.)
Stole, 238 x 16 x 7 cm (93¾ x 6⅜ x 2¾ in.)
Maniple, 119 x 17 x 8.5 cm
(46⅞ x 6¾ x 3⅜ in.)
Chalice veil, 58 x 53.5 cm (22⅞ x 21 in.)
Burse, 23 x 24 cm (9 x 9½ in.)
Basilica of Santa Maria Maggiore, Rome

This complete set of vestments for celebrating
the Mass includes a chasuble, stole, maniple,
chalice veil, and burse. The woof is of the *gros*
type, machine-made in silk thread woven to
design. There are gold and silver threads for
highlighting, linings in red cotton sateen, and
a gold-fringed hem. The inner lining of the
burse is white linen. Modern hems are worked
in *broderie anglaise*.

The set represents a complete break with
traditional Italian style, which very rarely
includes images, much less elaborate scenes,
on vestments. The practice of decorating
liturgical furnishings with images, on the
other hand, has been common throughout
central Europe as far back as the Renaissance.

Two episodes from Christ's Passion appear
on the chasuble, which is as crowded with
personages as any theatrical representation.
The *Crucifixion* is on the back and the
Mourning over the Dead Christ is on the front.
Both the stole and the maniple are decorated
with angels, as are the chalice veil and the
burse. Inscriptions in keeping with the
liturgical use of each object can be found
among the angelic choirs. These include the
incipit (opening words) of the *Sanctus* (hymn
of praise) on the stole and maniple and the
Panis Angelorum (bread of angels) on the
chalice veil as if to exalt its function in relation
to the Offertory.

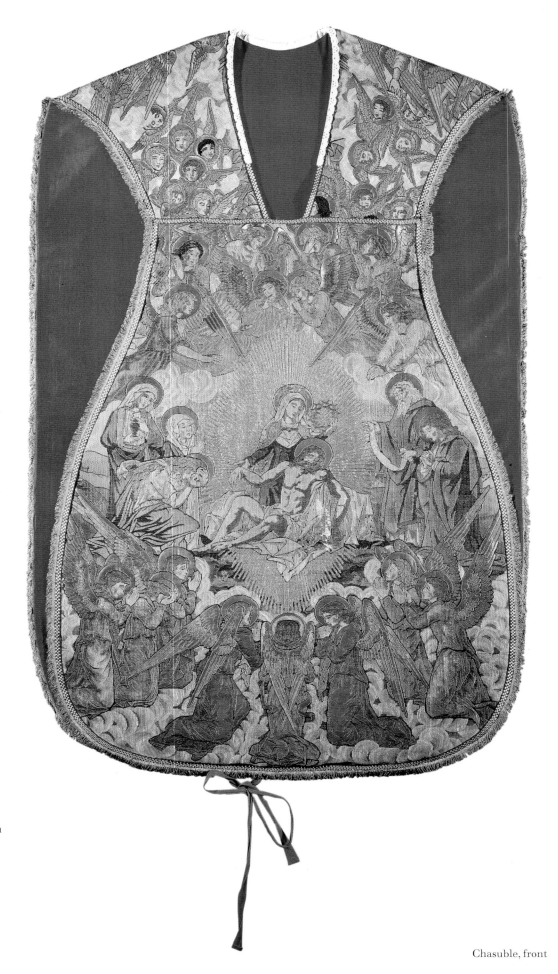

Chasuble, front

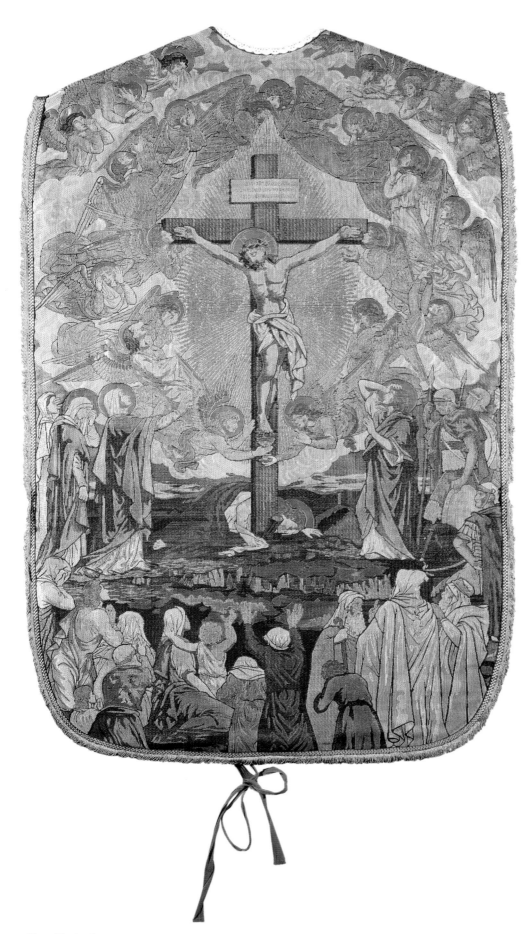

The decorations, on heavy fabrics with silk threading and abundantly highlighted with silver and gold thread, generally reflect the neo-Gothic taste of the late nineteenth century. This style, which grew out of the Nazarene movement of German romantic painters of the first three decades of that century, harked back to medieval or early Renaissance art in Florence. Thus the stylistic spirit can be said to have a twin matrix, Gothic and Renaissance. This can be seen principally in the angels, which are so profusely present throughout these furnishings as to underline, in a decidedly neo-Gothic manner, the laudatory and concerted nature of the liturgical celebration. Both in the case of the full figures and the small heads of the cherubim, angular and rigid lines render even more abstract the highlighting so skillfully executed with gold thread.

A dominant spirit of classicism, on the other hand, imbues the two sacred scenes that appear on the chasuble. This is particularly true of the Crucifixion, the plan of which calls for the figures to be realized in perspective with attention to the disposition of volumes. The coexistence of these seemingly opposed choices would place these liturgical furnishings in an area one might call "eclectic late nineteenth century," which would also explain the utilization of machine-made fabrics.

Maria Antonietta De Angelis

Chasuble, back

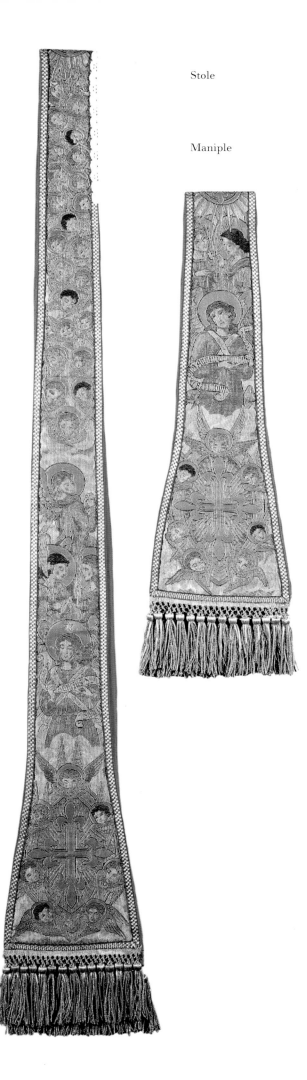

Stole

Maniple

Chalice veil

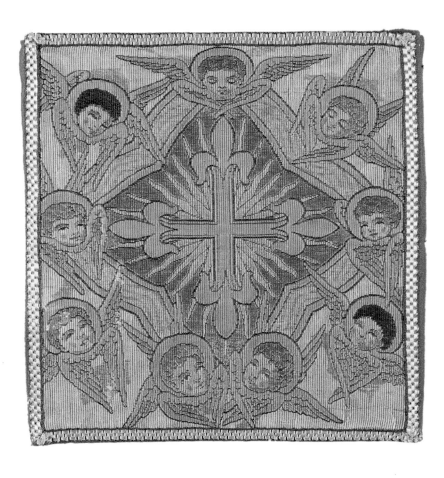

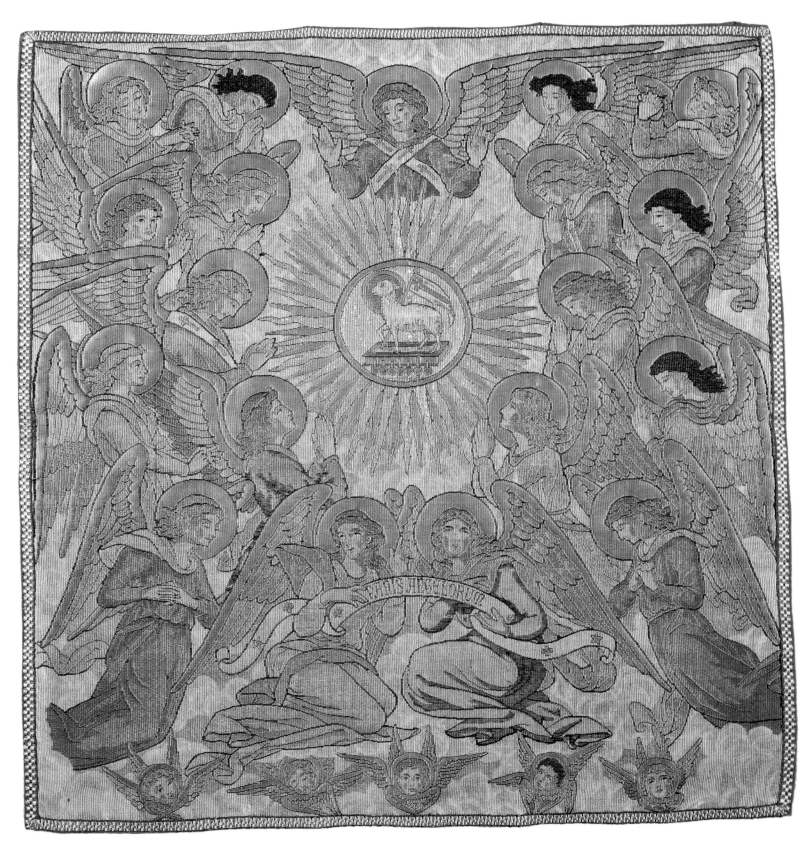

92

Luigi Capponi and Workshop
TWO ANGELS, c. 1500
Marble
115.5 x 42 cm (45½ x 16½ in.), 116 x 42 cm
(45⅝ x 16½ in.)
Vatican Museums, invs. 31320 and 31321

Conservation courtesy of Mr. and Mrs. James
P. Kelly

Literature: The Vatican angels have so far
been unpublished. For Luigi Capponi, see
F. Negri Arnoldi, "Luigi di Pietro Capponi da
Milano," in *Arte Lombarda* 6 (1961):195–201;
G. Casadei, in *Dizionario biografico degli
italiani* 19 (1976):64–65.

These two standing angels came to the
Vatican Museums in 1982 from the small
Roman church of S. Lorenzo in Piscibus (near
S. Spirito in Sassia). Their original location is
unknown, and it is not clear which area they
occupied in S. Lorenzo or whether they might
originally derive from another church.

The two youthful angels stand upright
facing each other. They are symmetrically
conceived, flanking an unknown and possibly
lost central image. They wear long, thin
dresses *all'antica*, which are sleeveless and
girded around the waist. In one hand each
holds a long and elegantly shaped palm leaf,
while the other hands, which are cut off at the
edge of the marble block, probably pointed
toward the central figure or composition.
The angels stand on sketchy clouds, with
small cherubim under their feet.

The figures were probably executed in
the workshop of the sculptor Luigi di Pietro
Capponi da Milano, a sculptor active in
quattrocento Rome with an oeuvre still quite
unclear and undefined. He was born and, more
than likely, trained in Milan (possibly in the
workshop of Giovanni Antonio Amadeo)
and went to Rome in the 1480s. He is first
mentioned there in connection with the
tomb of Francesco Brusati in the church of
S. Clemente in a document of July 8, 1485.
Another document (March 8, 1496) links his
name to the marble altar with the Crucifixion
in the church of S. Maria della Consolazione.
Further documentation is unknown. However,
on the basis of these two works, a substantial
oeuvre has been ascribed to the Lombard
sculptor.

Among the works attributed to Capponi, the
tomb monument to the brothers Antonio and
Michele Bonsi, in the courtyard of the church
of S. Gregorio Magno, holds a prominent place
(fig. 1). The tomb, which follows the antique
concept of the *imago clipeata* by displaying two
busts of the deceased, was executed around
1500 and is among the best examples of this
period. Two standing angels flank a central
relief of the Madonna and Child. These angels
are closely comparable to the two figures
exhibited here. Their garments show the
same billowing folds and a similar light
transparency, and the way their legs are set on
the unstable ground is almost identical. They
are of similar proportions and build, and their
facial features reveal that they may stem from
the same source. The angels of the Bonsi
monument, however, seem to show a more
energetic movement toward the center,
supported by their gestures of veneration and
their outspread wings. The two Vatican angels
are calmer, presenting rather than venerating
the unknown central image. The center was
more than likely not a relief of the Madonna
and Child but rather a depiction of a saint,
as indicated by the palm leaves held by the
angels.

Angels of this type are quite common in
Roman sculpture of the second half of the
fifteenth century (see fig. 2). They flank altars,
tabernacles, portals, and tomb monuments. As
such their execution constitutes an important
element within quattrocento sculpture.
Johannes Röll

Fig. 1. Luigi di Pietro Capponi, *Monument to
Antonio and Michele Bonsi* (detail). Church of
S. Gregorio Magno, Rome

Fig. 2. *Angels from the Tomb of Pope John Paul I.*
St. Peter's Basilica, Vatican. Rome

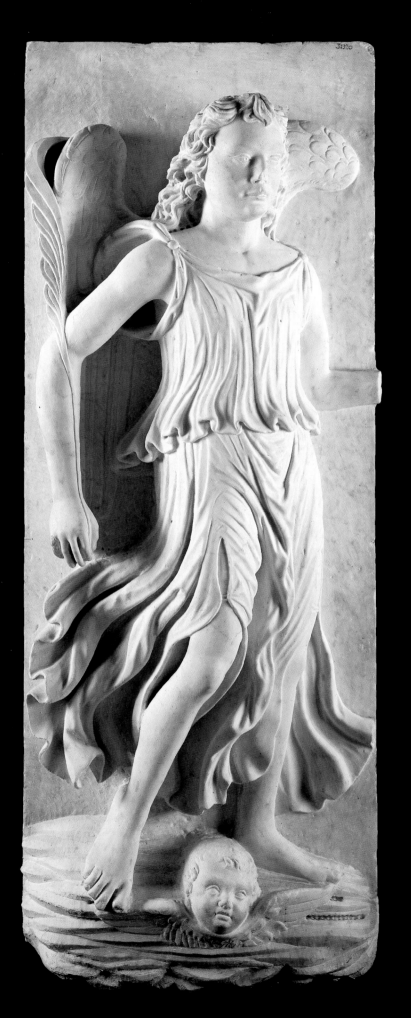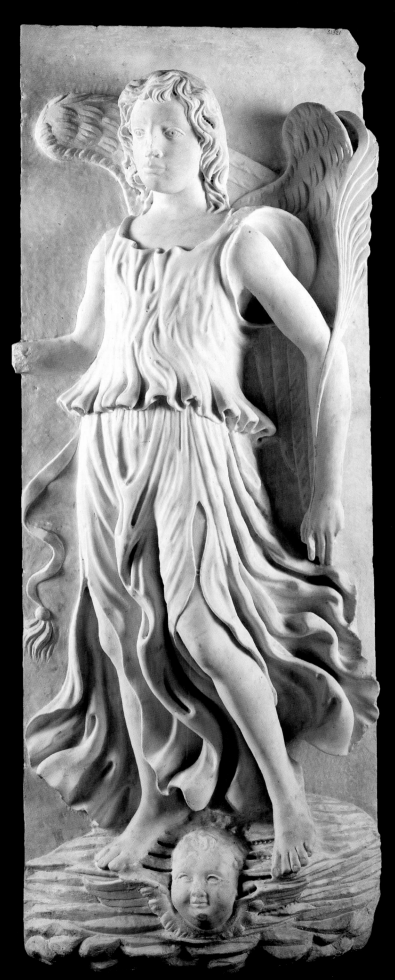

93

Giovanni di Paolo (Siena, 1395/1400–1482)
SAINT MICHAEL THE ARCHANGEL, c. 1440
Tempera and gold on wood
18.5 x 8.2 cm (7¼ x 3¼ in.)
Vatican Museums, inv. 40128

Provenance: Formerly in the Vatican Library.

Literature: Réau 1955–59, vol. 2, 1:39 and ff.;
G.Heinz-Mohr, *Lessico di Iconografia Cristiana*
(Milan, 1982), see "Angeli"; *Enciclopedia
Cattolica*, see "Angeli"; M. Martens, A. Vanrie,
and M. de Waha, *Saint Michel et sa symbolique*
(Brussels, 1979); Volbach in Pinacoteca
Vaticana 1987, 51.

This panel was probably once part of a diptych, now broken up and mounted in frames that are not original. The figure of the archangel stands out against a gold background, wearing armor over a short, skirted garment and a cloak. He has wings and a halo, and his left hand rests on a shield bearing the emblem of a cross, while his right hand holds a spear, piercing the serpent that he tramples underfoot. The image brings to mind Saint Paul's Letter to the Ephesians (6:11–17): "Put God's armour on so as to be able to resist the devil's tactics; . . . rely on God's armour, or you will not be able to put up any resistance when the worst happens, or have enough resources to hold your ground. So stand your ground, with truth buckled round your waist, and integrity for a breastplate, wearing for shoes on your feet the eagerness to spread the gospel of peace and always carrying the shield of faith so that you can use it to put out the burning arrows of the evil one. And then you must accept salvation from God to be your helmet and receive the word of God from the Spirit to use as a sword."

The iconography of the archangel transfixing the serpent comes from the Book of Revelation (12:1–9): Michael fights the dragon to defend the woman and child, who are about to be devoured; the woman symbolizes the Virgin Mary and the Church, threatened by Satan.[1]

For every believer, the archangel thus becomes the embodiment of the victorious warrior, while the fight between Saint Michael and the serpent symbolizes the inner fight waged by each Christian against sin.

Michael has also been identified with the angel who stands by God at the moment of judgment when souls are weighed after death and are either saved or damned. This is why the saint is often associated with the cult of the dead, and cemetery chapels are frequently dedicated to him. This cult, which resembles that of the Egyptian god Anubi and the Greco-

Roman cult of Hermes-Mercury, spread widely in the eastern world during Emperor Constantine's time, and the emperor himself dedicated several churches to Saint Michael. Later the cult spread to Italy, where in the fifth century a sanctuary was dedicated to the saint on Monte Gargano, a mountain in southern Italy that is visited by pilgrims to this day. Another sanctuary, Mont-Saint-Michel, was built in France in the eighth century, and during the ninth century many chapels in Rome and in other cities and towns were dedicated to Michael.

The other half of the diptych, which is also in the Vatican Picture Gallery, shows a Madonna and child, with the latter holding a cartouche with the word EGO written on it (fig. 1). The link between the two subjects lies in Saint Michael's role as defender of the Virgin Mary/Catholic Church against the dragon as described in the Book of Revelation (12). The word *ego* in the cartouche is sometimes completed in other contemporary works of art by the words *sum lux*, a reference to the Gospel of John, where Christ is called "Light" and "Life" (1:4–9).

The diptych has been attributed to Giovanni di Paolo, a painter and illuminator who was active in Siena between 1420 and 1482. Instead of focusing on typical Renaissance issues in painting, his vision of the world has an archaic quality inspired by the painters Pietro and Ambrogio Lorenzetti, while his later works resemble Sassetta's in manner. In this painting, the gold background, attention to detail, and fluidity of line express the artist's deep ties with late Gothic culture, even though the figures have a delicacy of contour and a depth and substance that stylistically belong to the Renaissance.

This diptych, which is dated around 1440 or possibly later, is yet another example of the original, lyrical, and timeless quality of Giovanni di Paolo's work.

Adele Breda

Fig. 1. Giovanni di Paolo, *Madonna and Child,* c. 1440, tempera and gold on wood. Vatican Museums

1. From the Book of Revelation (12:7–9): "When Michael with his angels attacked the dragon.... the great dragon ... was hurled down into the earth, and his angels were hurled down with him."

94

SAINT MICHAEL AND THE DRAGON, 19th century
Gilded metal and silver
33 cm (13 in.)
Pontifical Sacristy

Conservation courtesy of Marilyn and James
M. Augur in honor of Louise G. Augur

This small devotional statue is made of gilded metal, with some parts in silver, and represents (in accordance with Christian hagiography) Saint Michael the Archangel defeating the dragon. The figure rests on an ornamental pedestal, the purpose of which is to increase its height. Saint Michael is sculpted in the round, cast, and then finished with chasing that beautifies the piece and also gives it a realistic quality. The archangel has his right arm lifted, brandishing a sword against the dragon, who is already lying at his feet. His wings are open and some drapery floats from his right side. His head turns proudly downward to observe the dying dragon.

This statuette was used only for devotional purposes and played no role in the liturgy. However, it may well have been part of the altar furnishings of the Pope's Secret Chapel (the chapel of his private apartment) without having a specific function.

The symbolism expresses the archangel's determination to repulse the attacks of the devil by fighting the dragon, who personifies evil.

Luciano Orsini

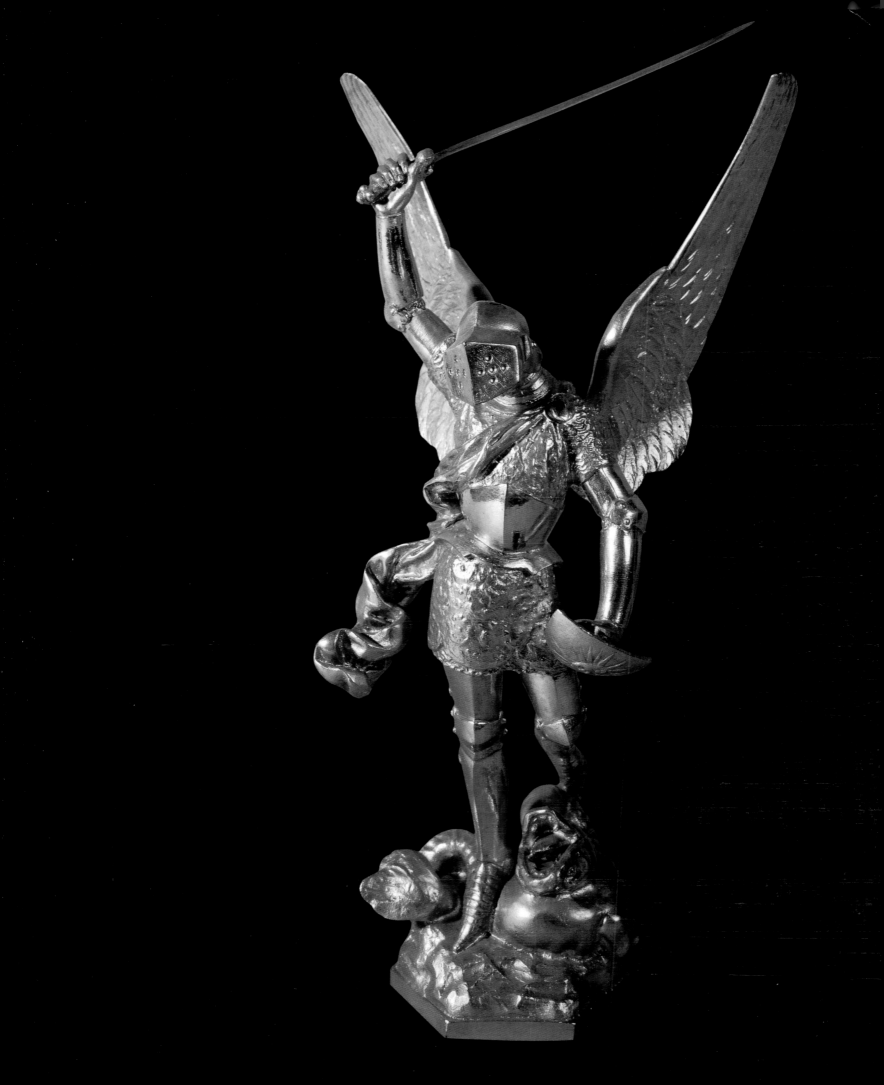

CHRIST THE JUDGE

Detail of cat. 96 (actual size)

95

Russian, Moscow School
SYNAXIS OF ALL SAINTS, early 17th century
Tempera and gold leaf on linen and wood
23.3 x 22 cm (9¼ x 8⅝ in.)
Vatican Museums, inv. 40047

Conservation courtesy of John J. Brogan

Provenance: Vatican Library.

Literature: Barbier de Montault 1867, 120, no. 616; Muñoz 1928, 16, no. 7 and pl. XXXV, 1; Vatican 1993, 77, no. 3g; Bianco Fiorin 1995, 70, no. 86, fig. 126.

Fig. 1. Cretan, *Christ in Glory Surrounded by Angels and Saints*, 17th–18th centuries, tempera on wood. Vatican Museums

The present icon, inspired by representations of the Last Judgment, is in fact an iconographic illustration of the feast of All Saints, which the Byzantine Church celebrates on the first Sunday after Pentecost. This feast had in fact been established in memory of the Resurrection of our Lord and of those of his precursors or followers who had already been crowned in heaven: patriarchs of the Old Testament, prophets, kings, contemporaries of Christ who had joined him and followed his teaching, preachers, hermits, martyrs, hierarchs, priests, devout kings, and defenders of the Church. Moreover, on the second Sunday after Pentecost, the Russian Orthodox Church even adds a feast of All the Saints Who Have Distinguished Themselves in the Land of Russia.

The iconographic scheme translates, into a visual image, the text and the meaning of the liturgical office of the Feast of All Saints. It presents Christ in glory, surrounded by the saints classified by categories so as to display their variety and multitude. It is in some way a telescoped reduction of the fearful event of the Second Coming and of the Last Judgment, but one in which only the elect, those destined for paradise once judgment has been passed, are represented. This particular iconography of Christ in glory surrounded by the saints was already familiar in the Byzantine period, as exemplified by another version also preserved in the Vatican collections, that of the so-called *Dalmatic of Charlemagne*, which is in reality a *saccos* (liturgical vestment of the Byzantine Church), presumably dating to the fourteenth century. But the subject evidently underwent widespread development in the post-Byzantine period when, in most of the paintings representing it, the composition became based on a scheme in the shape of a circle.[1] It was following this traditional scheme of circular type that the iconographic theme became particularly popular in the seventeenth and eighteenth centuries; an example is the central panel of a small Cretan triptych preserved in the Vatican Picture Gallery (fig. 1).[2]

Another scheme of the same iconographic theme, also familiar to us from Cretan painting, is that in which the different groups of personages who participate in the scene are arranged not in a circle, but in parallel horizontal rows. In the upper part, Christ the Judge is represented in glory, surrounded by the Virgin Mary and Saint John the Baptist in *Deisis* (intercession), with the apostles and accompanied by two groups of angels. In the middle of the icon is placed the *Hetimasis* (preparation of the throne of the Second Coming) with Adam and Eve prostrated below it and, further below, the different choirs of the just, their gazes and their hands raised to

the Omnipotent sitting in judgment and, last, at the bottom of the panel, the enclosed garden of paradise with Abraham and the Good Thief placed within.[3]

The present icon displays this horizontal arrangement, with the saints placed in superimposed rows. It was a scheme adopted by Russian painters, from the sixteenth century on, in the representation of the very complex subject of the Hexameron or Days of the Week (*Sed'mitsa*), illustrated by scenes from the New Testament beginning with the first day, which is Sunday, the day of Resurrection, and ending with the seventh day, Saturday (*Subbota*), occupying the center of the whole iconographic composition and forming, in essence, merely a more synthetic version of the preceding Cretan scheme.[4]

Thus the image of Saturday, removed from the context of the entire illustrated week, would give rise to the icon of the Saturday of All Saints (*Subbota Vsjech Svjatych*), familiar from numerous examples dating to the sixteenth and seventeenth centuries in Russia.[5] The icon in the Vatican collection is, at least iconographically if not stylistically, very close to the one in the former George R. Hann Collection,[6] though this is more schematic and devoted exclusively to the celebration of the feast of the Sunday of All Saints (*Ned'elja Vsjech Svjatych*) (fig. 2). In the upper part, the sumptuous, arabesque-patterned throne of the Lord amid the celestial powers is contained within a circular glory, peopled by cherubim and seraphim and supported by the four Living Beings of the Apocalypse. Christ, dressed in a luminous vestment with its rich chrysography (or *assist*), holds a Gospel open at the passage of Saint John (7:24): не на лица судите но судите праведный судъ (Do not keep judging according to appearances; let your judgment be according to what is right).

The *Deisis* is escorted, on both sides, by the choir of the archangels, conspicuous among whom are Michael and Gabriel bearing the monogram of Christ in their hands: І͞С Х͞С.

In the vaulted heaven, with its fleecy clouds, appears the *Hetimasis*, supported by the two "Angels of the Lord": the throne itself is here replaced by an altar supporting the cross and the Gospel, the word for throne (*prestol*) also denoting the altar among the Slavs. Six other angels, crowns in their hands, fly downward toward each of the "abodes" in which the various categories of the just are placed. To the left, one may distinguish the choir (*lik*) of the Ancestors of Christ; that of the Patriarchs of the Old Testament, dressed anachronistically as Patriarchs and Metropolitans of the Russian Church; that of the Prophets, in which one may recognize, in the front row, David, Solomon, and presumably Zechariah; that of the Hierarchs of the Church with Basil the Great, Gregory the Theologian, and John Chrysostom; and that of the monastic saints, including Anthony the Great. Facing them, to the right, are the choir of the kings with Emperor Constantine and Russian princes with their characteristic *shapka* (fur-lined crowns); that of the female monastic saints, with Mary the Egyptian; and, in the front row, the apostles; the martyrs with Saint George and his lance; lastly the choir of the female martyr saints, including Catherine of Alexandria and Saint Julitta with her infant son, Cyr.

This reduced cycle, which consists essentially in the scene of intercession or *Deisis* and in the reward of the just, is, in short, the iconographic scheme preferred by the Russian icon painters to illustrate the theme of the Synaxis of All Saints. In the case of the icon in the Vatican, with its warm complementary colors that enamel the luminous gold ground and its delicate ornamentation characteristic of Muscovite painting in the early seventeenth century according to the manner of the so-called Stroganov school, it is no longer possible to read the original title, which is normally inscribed on the upper part of the frame. This is because the panel was subsequently reduced in size and in thickness, no doubt on the occasion of a previous restoration. The nail holes, which appear at regular intervals along the edges of the paint surface, are all that remain of the metal frame (*Basma*) by which the icon was originally surrounded.

The icon is accompanied by numerous inscriptions in Old Church Slavonic. Apart from the usual Greek monograms І͞С Х͞С (Jesus Christ) surmounting the figure of Christ in glory and placed in the transparent discs or globes held by two of the archangels, on each of the sides of the cross of the *Hetimasis*, the traditional biblical expression ὁ ὤν (The One who is) within the cruciform nimbus of Christ, and the monograms М͞Р Ѳ͞Ү for the Virgin Mary, one can read the abbreviation of the name of John the Baptist in Slavic Іѡа́(ннъ).

The angels supporting the altar of the *Hetimasis* and the others flying down to crown each of the different choirs of the Elect are epigraphically designated as Angels of the Lord, а҃гг(е)ли г(оспо́д)ни, while the choirs (in their accompanying tituli) are respectively identified as: Choir of the Ancestors, лик праѡ(те́)цъ; Choir of the Patriarchs, лик патриа́рхъ; Choir of the Venerable Fathers or monastic saints, лик пр(е)п(о)до́б(ныхъ) ѡ(те́)цъ; Choir of the Hierarchs or Pontiffs, лик с(вѧ)т(и́те)лей; Choir of the Prophets, лик прор(ѡ́)къ; Christ the Kings, лик ц(а́)рей; Choir of the Venerable Women or female monastic saints, лик пр(е)п(о)до́б(ныхъ) же́нъ; Choir of the Apostles, лик апо́(сто)лъ; Choir of the Male Martyrs, лик м(у́)ч(е)н(и)къ; and Choir of the Female Martyrs, лик м(у́)ч(е)н(и)цъ.

Michel Berger

Fig. 2. *Feast of the Sunday of All Saints (Ned'elja Vsjech Svjatych)*. Formerly George R. Hann Collection

1. See, in particular, Millet 1945, 22 ff.; D. Milosevic, *Das Jüngste Gericht* (Iconographia Ecclesiae Orientalis) (Recklinghausen, 1963); E. Haustein-Bartsch, "L'iconografia del Giudizio Universale nella pittura di icone russe e nella tradizione bizantina," in *L'immagine dello Spirito-Icone delle Terre Russe-Collezione Ambroveneto* (exh. cat. Milan, 1996), 41–46.
2. Bianco Fiorin 1995, 24, no. 18, figs. 27 and 29.
3. Th. Chadzidakis, *L'art des icônes en Crète et dans les îles après Byzance* (Europalia Grèce 1982) (Charleroi, 1982), no. 32, fig. 18.
4. See in particular the famous early-sixteenth-century icon attributed to a pupil of Dionisij, and now in the Tretjakov Gallery in Moscow: N. Scheffer, "Days of the Week in Russian Religious Art," in *Gazette des Beaux Arts*, series 6, 28 (1945):326–28, figs. 5a–b, 7; V. I. Antonova, *Gosudarstvenaïa Tretjakovskaïa Gallereïa. Katalog drevnorusskoï živopisi XI–načala XVIII v.v.* (Moscow, 1963), 1:342–44, no. 281; M. V. Alpatov, *Early Russian Icon Painting*, Russian/English bilingual edition, 2nd ed. (Moscow, 1978), 316 and pls. 157–58; V. Lazarev, *L'arte russa delle icone dalle origini all'inizio del XVI secolo* (Milan, 1996), 114, 392, pl. 329.
5. See Antonova 1963, 1:343, 2:117, 292, 339, 341, 352, 366.
6. *The George R. Hann Collection. 1. Icons and Russian Works of Art* (New York: Christie's sale, 1980), pl. 10; V. Teteriatnikov, *Icons and Fakes. Notes on the George R. Hann Collection* (New York, 1980), 1–3.

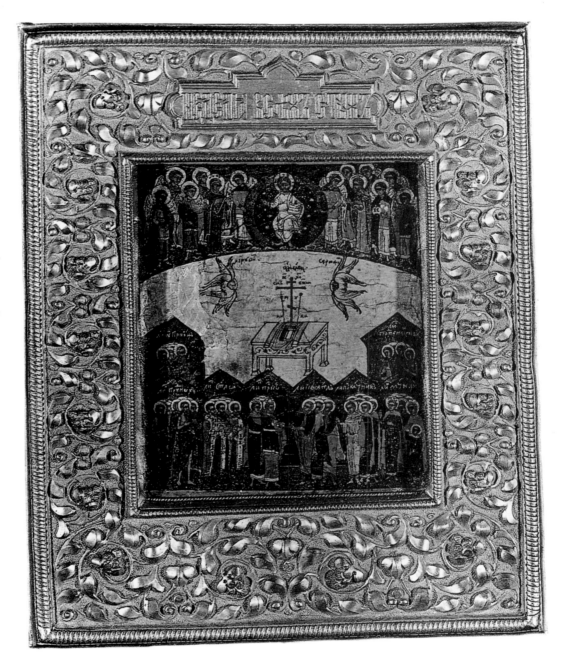

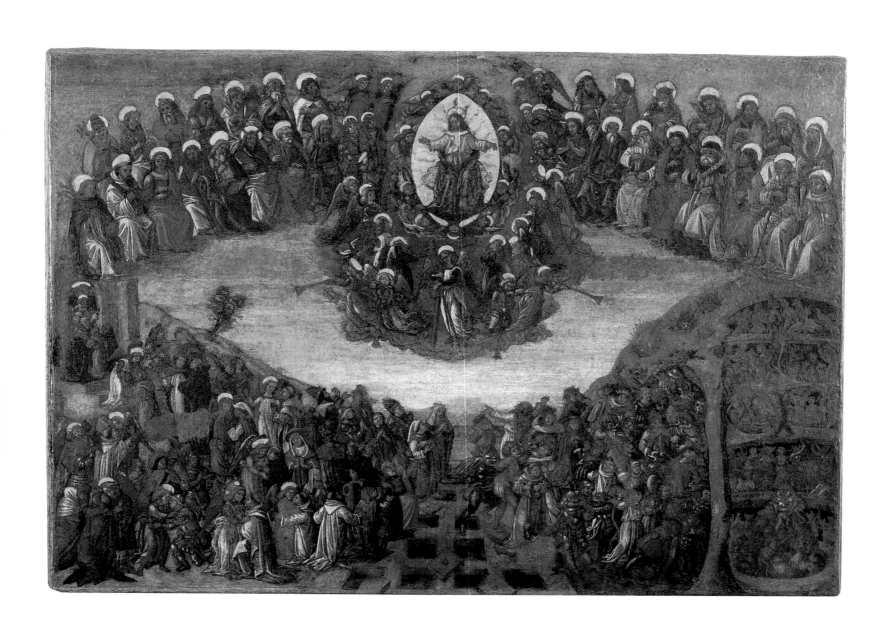

96

Francesco Rosselli (Florence, 1445–before
1513)
THE LAST JUDGMENT, c. 1470–90
Tempera on paper mounted on wood
36 x 51 cm (14 x 20 in.)
Vatican Museums, inv. 40611

Conservation courtesy of Allen Wright
Thrasher in memory of the Thrasher and
Wright families

Inscriptions: LVSSVRIA (Lust), ACCIDIA
(Sloth), IRA (Anger), GOLA (Greed),
AVARITIA (Avarice), INVIDIA (Envy),
SVPERBIA (Pride) below on the right,
beneath each of the seven infernal cavities.

Restorations: 1844, 1996.

Provenance: 1844, Biblioteca Apostolica
Vaticana (restorer C. Ruspi); 1867, Vatican
Apostolic Library, Christian Museum,
Cupboard XV, no. 7 (Barbier de Montault 1867,
164); 1880, Vatican Apostolic Library, Christian
Museum, Showcase Q, VI, no. 180 (Descemet
1880, cc. 231–32); 1954, documented in the
Vatican Picture Gallery.

Exhibitions: This is the first time this work has
been exhibited.

Literature: Descemet 1880, "Rari", cc. 231–32;
Bartsch 1803–21, vol. 13/I, 268, no. B.23;
Ottley 1816, 1:425, 428; Passavant 1860–64,
5:71, no. 72; Barbier de Montault 1867, 164;
D'Achiardi 1929, 28; Thieme-Becker 29
(1935), 37; Hind 1938, 1:139, no. B.III.7,
139–140, no. B.III.8; Pope-Hennessy 1952, 12,
195; Bénézit 1957, 7:361; Baldini 1970, 92, cat.
27; Levenson in National Gallery of Art 1973,
60–63, cat. 12; Baldini 1986, 50, 55, 66; *The
Illustrated Bartsch* 24/2 (1994): 85–86,
cat. .066; 86–88, cat. .067.

There is a curious story behind this panel.
It arrived at the Vatican some time during the
nineteenth century, though the exact date is
not known. It was restored in 1844 by Carlo
Ruspi under commission from Monsignor
Laureani who, at that time, was engaged in
collecting "primitives" throughout Italy for
the Christian Museum of the Vatican Library.[1]
Therefore it can be presumed that the painting
was restored in preparation for exhibition
shortly after its purchase. The receipt for
Ruspi's restoration, traced in the archives of
the Vatican Library, leads one to suppose that
the painting was mistaken for "an antique
panel."[2] When, in 1867, Xavier Barbier de
Montault recorded its presence in Cupboard
XV of the Christian Museum, it bore a curious
attribution to the seventeenth-century Italian
school.[3] Successively transferred to Showcase Q
of the same museum, it was noted by Carlo
Descemet, who left the following hand-written
description: "Nel cielo, Gesù Cristo vestito di
bianco sotto manto azzurro, siede sopra una
nuvola dentro la mandorla dorata e raggiante
fuoco; alla quale fanno corona dieci testine di
angioletti. Gesù stende le braccia aperte. Più
sotto, un angelo stante di faccia, regge gli
istrumenti della passione mentre a destra e a
sinistra quattro angeli librati in aria suonano la
tromba. Sopra quel gruppo, dieci angeli, cinque
di qua e cinque di là, adorano il Salvatore, e più
su ancora trenta santi personaggi, seduti a
doppia fila con maestà, assistono al giudizio.
Dietro al Cristo, molti angeli si schierano
pregando. Sulla terra poi lo spettacolo si divide
in due parti. Nel centro, alcuni sepolcri
spalancati rendono i loro morti alla luce. A
destra, i risorti abbracciati dagli angeli custodi
sono avviati verso una porticella che mette al
Paradiso. A sinistra, i demoni vanno destare ed
afferrare i dannati. All' estrema sinistra sono le
bolge infernali, divise in quattro piani, ed ivi si
vedono i castighi dei sette peccati mortali,
Lussuria, Ira, Superbia, Avarizia, Gola, Invidia,
Accidia. In basso, Satana, seduto di faccia ed
attorniato di demoni, stringe in ciascuna mano
una creatura umana ignuda. Il cielo è turchino
cupo" (In the sky, Jesus Christ, dressed in white
under a blue cape, seated above a cloud inside a
gilded almond shape aglow with fire; forming

a crown around this are the small heads of ten young angels. Jesus holds out his arms. Below, an angel facing us bears the tools of the Passion while to the right and left four flying angels are playing trumpets. Above this group, ten angels, five on either side, are worshipping the Savior and higher still thirty holy persons, majestically seated in a double row, witness the judgment. A group of angels pray behind the figure of Christ. On the ground, the scene is divided into two parts. In the center, open tombs reveal the dead. On the viewer's left the resurrected, embraced by guardian angels, head toward a door leading to Paradise. On the viewer's right, demons are seizing the damned. On the extreme right, the pit of hell is divided into four levels where the punishments for the seven deadly sins are depicted: Lust, Anger, Pride, Avarice, Greed, Envy, Sloth. Below, facing the viewer, Satan, surrounded by demons, grips a naked human being in each hand. The sky is a dark blue color). In the margin, Descemet notes again how "this assembly of the Blessed" was "interesting for its Christian iconography" and worthy "of special examination" for the numerous "curious documents concerning the history of customs" it offered.[4]

In 1938 the panel was still housed in the Christian Museum section of the library, where it was recognized by Arthur M. Hind for what it really was, an engraving made using a burin cutting tool and "colored like a picture" and as such listed in his catalogue on Italian engraving of the Renaissance.[5] Correcting Bartsch's mistaken reference to Nicoletto da Modena,[6] in the second edition of his work Hind was able to identify the artist as Francesco Rosselli,[7] a Florentine engraver close to the school of Botticelli. Hind reconstructed Rosselli's career, attributing to him a second subject of a similar type, the *Preaching of Fra Marco of Monte Santa Maria in Gallo on the Seven Works of Mercy*.[8] The fact that the two engravings had identical measurements confirmed the information contained in Rosselli's own inventory that the two subjects had been engraved on the front and back of the same plate.[9]

Other examples of the engraving are kept in London, Vienna, Basel, Berlin, and Washington (fig. 1). There is little possibility that the coloring of the Vatican version can be considered original, since this type of workmanship, very rarely documented at the end of the fifteenth century, only later began to be more widely used.[10] The restoration carried out for the current exhibition has not even approximately ascertained the age of the pigment.[11] However, the care with which the coloring has been applied, its evenness, and, above all, the decision to allow the light-colored paper base to show through its transparency favor the idea of a very old operation rather than a more recent one.

As far as the original iconographic model is concerned, Passavant[12] had recognized the derivation of the engraving from a famous *Last Judgment* by Fra Angelico, once located in the Florentine church of Santa Maria degli Angeli and today in the Museo di San Marco of the same town (fig. 2). However, against the obvious similarity of composition and the literal repetition of major details, the engraving shows numerous discrepancies that can be only partially explained by the need to compress the uneven outline of the painted original into the rectangular shape of the panel. Given also the particular moment in time in which he was working, it is possible that Rosselli may have intended to update the by-then remote reference to Fra Angelico in the light of a more disquieting mysticism as preached by Savonarola.

Guido Cornini

1. Carlo Ruspi was chief restorer of the paintings in the Vatican Library during the years of Monsignor Gabriele Laureani's regency (see "Nota di molte tavole dipinte antiche appartenenti alla Biblioteca Vaticana ristaurata da Carlo Ruspi per Commissione del Ecc.mo Mons. Laureani primo Custode della suddetta Biblioteca," Arch. Bibl. Vat., fald. 68). Regarding the sphere of activity of Laureani, Chief Custodian from 1838 to 1849, see Pietrangeli 1985, 154 and n. 27.
2. Arch. Bibl. Vat., Fald. 64, c. 33r: "Io sottoscritto o ricevuto da Sua Ecc.za Mons. Laureani Scudi Venti quali sono per aver ristaurato un Giudizio Universale sopra tavola antica, appartenente al Museo della Biblioteca Vaticana, dichiarandomi contento e soddisfatto. Questo Dì 24 maggio 1844, Carlo Ruspi" (I, the undersigned, have received from His Excellency Monsignor Laureani the sum of twenty *scudi* for the restoration of a Last Judgment painted on an antique panel belonging to the Museum of the Vatican Library, declaring myself to be content and satisfied. This day, May 24, 1844, Carlo Ruspi.) This information has been kindly made available to me by Maria Antonietta De Angelis, whom I thank.
3. Barbier de Montault 1867, 164.
4 Descemet 1880, cc. 231–32.
5. Hind 1938, 1:139, no. B.III.7.
6. Bartsch 1803–21, vol. 13/I, 268, no. B.23. Ottley also was interested in the engraving (1816, 1:428), attributing the invention to Botticelli.
7. Regarding Francesco Rosselli, brother of the more famous Cosimo, see Thieme-Becker 29 (1935):37, and Bénézit 7 (1957):361.
8. Hind 1938, 1:139–40, no. B. III.8. Regarding the engraving, see also Ottley 1816, 425.
9. Compare the inventory note written by Rosselli as cited in Hind 1938, 1:307, I,g, item III.40: "1o giudizio d'un foglio reale, e 'l monte di pietà" (a *Last Judgment* in the size of a royal folio, and the *Monte di Pietà*).
10. In this connection, let us consider Stefania Massari's interesting observations on the close link existing between the work of the engraver and the miniaturist. After having recalled Rosselli's role as an engraver, noting the relationship with his activity as a painter, miniaturist, and cartographer, this scholar states: "as in the case of the goldsmith's art, the link between miniature and engraving is extremely close, so much so sometimes as to call for color on the paper. It suffices to cite the oldest example consisting of an anonymous engraving, from a die-plate enriched with color, of *Saint Sebastian* with stories from his life as preserved in Istanbul (S. Massari and F. Negri-Arnoldi, *Storia dell'incisione da Maso Finiguerra a Picasso* [Rome, 1987], 48). Elsewhere Massari considers "plausible" the idea that some of the prints "were glued on boxes or caskets, or anyway used as models for decorating objects in metal, wood or ivory (p. 46).

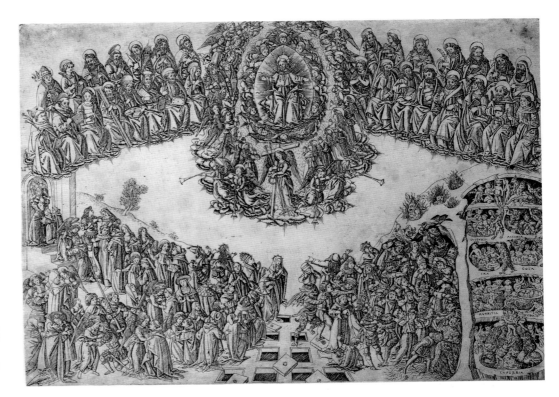

Fig. 1. Francesco Rosselli, *The Last Judgment*, c. 1480–90, engraving. National Gallery of Art, Washington

Fig. 2. Fra Angelico, *The Last Judgment*. Museo di S. Marco, Florence

11. The restoration, carried out by the Laboratorio Restauro Pitture of the Vatican Museums, consisted in the removal of the old paint and glue that were darkening the surface of the painting. Cleaning has revealed the existence of a painted layer of relatively accurate execution superimposed on the engraved image without altering its stylistic data. The presence of a second, more recent overpainting, particularly visible where the color had flaked off, agrees with old photographs that show the work in the depleted condition that preceded the repair operations. (Photographic Archive, Vatican Museums, Neg. XXXIV-19-31). The use of a scanner and an electron microscope have made it possible to verify the presence, below the painted surface, of a paper support relating to the printed image, glued in turn onto a wooden panel. The losses of color, concentrated for the most part in the group of the damned, in hell, and in the area of sky above, have been left exposed, utilizing the color of the paper base, which matches the overall coloring of the picture.

12. Passavant 1860–64, 5:71, no. 72. For the *Giudizio Universale* by Angelico, object of numerous literary studies, see Pope-Hennessy 1952, 12, 195; Baldini 1970, 92, cat. 27; Baldini 1986, 50, 55, 66. For the relationship of Fra Angelico's panel to Rosselli's engraving, consult in particular Levenson in National Gallery of Art 1973, 60–63, cat. 12.

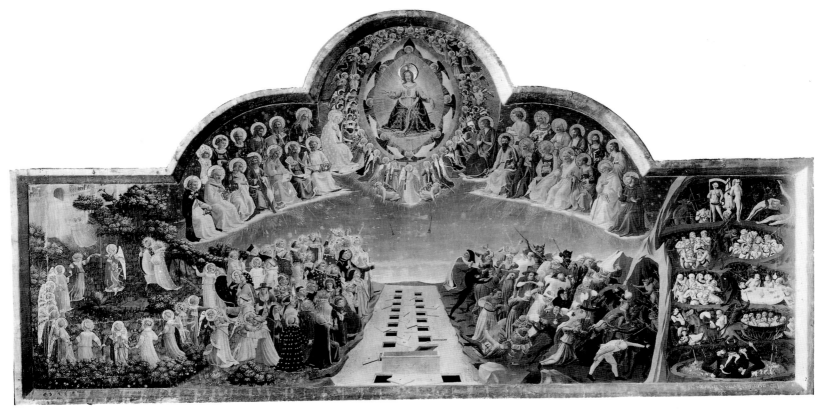

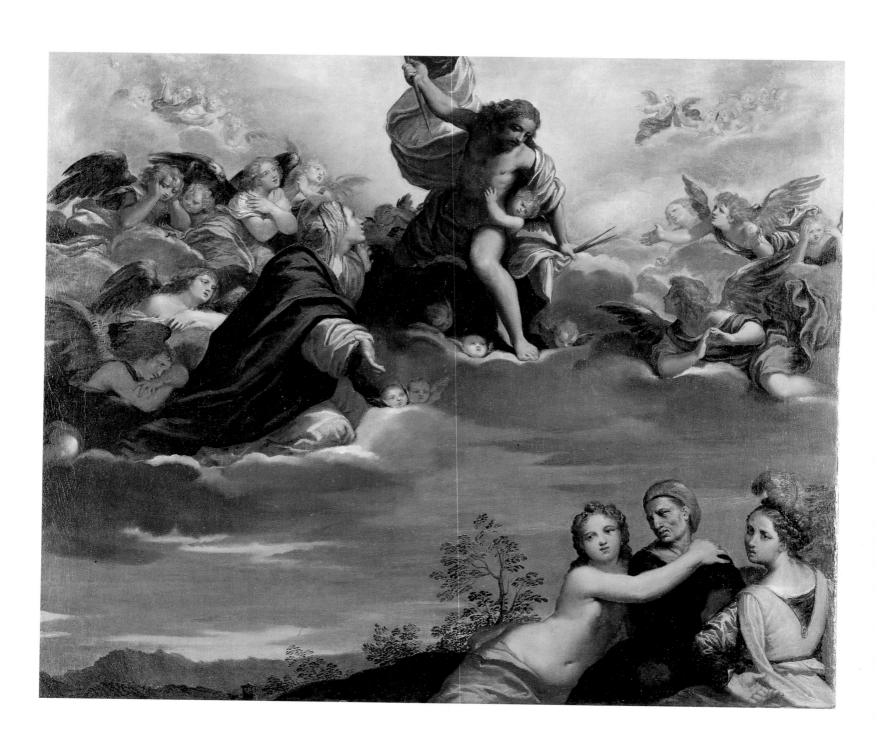

97

Ippolito Scarsella, called Lo Scarsellino
(Ferrara, c. 1550–1620)
THE VIRGIN AND ANGELS IMPLORING CHRIST NOT
TO PUNISH LUST, AVARICE, AND PRIDE
Oil on canvas
87 x 104 cm (34¼ x 41 in.)
Vatican Museums, inv. 44450

Conservation courtesy of Florence B. D'Urso
in honor of her children David, Mark, Donna,
Lisa, and Michelle

Provenance: Sacchetti Collection.

The painting,[1] unpublished, formed part of
the Sacchetti Collection and is listed in its
inventories of 1639,[2] 1726,[3] and 1747.[4] It is
inscribed on the back in italics: "P[rima] classe
n. 2" and (partially legible) "Sacchetti"; on
the stretcher, there are seals of the time of
Clement XIII Rezzonico (1758–69). In the
inventory of 1726 the painting is described as
follows: "Altro [quadro] alto palmi 6 largo
palmi 5 rappresentante Christo, col fulmine in
mano, con la Madonna ed angeli del Dossi,
allievo di Tiziano—[numero] 43 scudi 220"
(Another [painting] 6 *palmi* high and 5 *palmi*
wide representing Christ, with a bolt of
lightning in his hand, with the Madonna and
angels, by Dossi, pupil of Titian—[number]
43 scudi 220). The Sacchetti Collection
was acquired in 1748 by Benedict XIV for
the Capitoline Picture Gallery, on the
Campidoglio. Subsequent to 1818, some of the
paintings in this collection, including the one
exhibited here, were transferred to the Vatican.

The painting has not come down to us in its
original state; its present dimensions do not
coincide with those specified in the inventory
of 1726. On the occasion of the present
exhibition, the painting was restored.[5] The
restoration enabled the marks of the original
stretcher to be identified on three sides,
whereas such a mark is wholly absent on the
lower side, which has suffered the most loss.
It is enough to observe the incomplete wings
and limbs of some of the angels along the
edges and, in the upper zone, the bolt of
lightning in Christ's hand and his truncated
mantle to establish that the painting has been
cropped. But in the lower zone the losses are
even more considerable: here the allegorical
figures are shorn of their lower parts, and the
landscape with a tower construction in the
background seems brusquely interrupted.

In the painting, Christ appears among the
clouds in the act of hurling punitive bolts of
lightning on three figures of women who cling
to each other fearfully below. They represent
allegories of Lust (the young, partially nude
figure to the left), Avarice (the elderly woman
clinging possessively to her bag in the center),
and Pride (the woman clad in showy dress,
jewels, and feathered headdress to the right).

The Virgin, kneeling at Christ's feet, implores pity for the sinners. The surrounding angels echo her plea. This scene seems to be incomplete: is it conceivable that the Virgin would beg her son for mercy for what are considered man's gravest sins? A comparison with a painting later in date than this one, but iconographically similar to it, may suggest a possible intervention on the missing parts in the Vatican canvas. The work in question, a painting by Peter Paul Rubens, is now in the Musée des Beaux Arts in Lyons. It represents *The Virgin and Saints Interceding for the Salvation of the World* and was painted for the church of the Dominicans in Antwerp (now the church of Saint Paul) in the years 1618–20. Among the saints who implore the mercy of Christ in the foreground are Saint Dominic[6] and Saint Francis of Assisi (fig. 1).

Early legends more than once united these two great saints, respectively founders of the Dominican and Franciscan orders: Saint Dominic is said to have dreamed of being together with Saint Francis at the Virgin's feet while she appeased Christ's anger against the vices of Pride, Avarice, and Lust, which he rightly wished to punish, and to which Mary opposed the virtues of Obedience, Poverty, and Chastity exemplified by the two saints for the whole world.[7]

Since the Vatican painting has undergone a significant reduction in its lower part, it is possible that Saints Dominic and Francis were originally painted in the lower left. They too, presumably, would have been represented kneeling and imploring clemency (fig. 2). Given that the painting appears to have been still intact when entered in the Sacchetti inventory of 1747, it may be inferred that it underwent restoration that decidedly altered its character sometime between 1747 and 1769, the *termuinus post quem* indicated by the seals on the stretcher; in the course of these years it was cut and mounted on a new support and stretcher.

The iconography[8] of the Virgin as mediatrix is related to the popular Italian iconographic scheme of the Madonna della Misericordia, in which Mary shields the faithful within her spreading mantle from divine wrath, expressed as arrows, symbol of plague. Thus, in a painting by Luigi Brea for a Dominican convent at Taggia in Liguria (1488), the Virgin holds her mantle protectively around the faithful, defending them from the divine wrath unleashed by the three principal sins of Pride, Avarice, and Lust, which are the cause of the three scourges of Plague, War, and Famine.

Christ the Judge, here represented in the act of hurling lightning bolts, recalls the Christ of the Apocalypse of John, who returns to the clouds at the end of the world to sit in judgment over the living and the dead (Rev. 1:7; 14:14;19:13; see also Isaiah 63:1–6). A significant precedent for the typology of this apocalyptic Christ is the figure of Christ frescoed by Michelangelo in the *Last Judgment* in the Sistine Chapel, finished in 1541 (see Duston essay, fig. 16); the knowledge by the artist of models associated with paganism, such as *Jupiter tonans* and *Apollo sagittarius*, is evident.

The angels form a glory around Christ and the Virgin, and with a variety of expressions chorally repeat the plea for mercy expressed by Mary. Some join their hands in prayer, others cover their faces in despair, one crosses his arms over his breast, another repeats the Virgin's gesture. A putto, emerging from below Christ's mantle, tries to stay his hand. Other putti appear among the clouds in the form of winged heads.

The attribution in the inventory of 1726 to "il Dossi," presumably Dosso Dossi (1474/79–1542), correctly pinpoints the painting's Ferrarese character. Yet, even if its general style is properly judged, the attribution to this specific master is not convincing. It seems more likely that this religious allegory is the work of a later exponent of this school of painting, a master of the second half of the century who faithfully continued the tradition of the Ferrarese style: in short, Ippolito Scarsella, called lo Scarsellino, since he followed in the footsteps of his father Sigismondo Scarsella (1530–1614), also a painter from Ferrara. In the present painting it is precisely the angels that most strongly suggest this attribution.

With the characteristic forms of their hands and wings, these individually modeled, active angels have their parallels in Scarsellino's works: in numerous of his paintings they appear with similar gestural and body language.[9] Also related are his landscapes, largely unpeopled, and the leaves of their trees individually detailed.[10] The influence of Michelangelo on Scarsellino's *all'antica* figures of God the Father or Christ[11] is another common denominator. Moreover, the physiognomic types of the allegorical figures,[12] as of the angels, recur with some regularity in Scarsellino's paintings. Other features of the Vatican panel—the compositional principle of the heaven-and-earth picture (divided into two superimposed zones)[13] and the distinctive *cangianti*—also have their parallels in the works of the Ferrarese master. An attribution to this exponent of the Ferrarese school of painting thus seems entirely tenable.
Adele Breda and Arnold Nesselrath

Fig. 1. Peter Paul Rubens, *The Virgin and Saints Interceding for the Salvation of the World*, oil on canvas. Musée des Beaux Arts, Lyons

Fig. 2. Reconstruction of cat. 97 showing possible composition of missing lower section of painting

1. In the past, the painting was on display in the office of one of the Holy See's departments, from which it was stolen and subsequently recovered in 1995. It is currently in the storerooms of the Vatican Picture Gallery.

2. The painting is described as follows in the Sacchetti Inventory of 1639, published by J. Merz, *Pietro da Cortona* (Tübingen, 1991), 293–95: "Un quadro alto p. 5 inc. con Christo che fulmina, con la cornice dorata" (A painting *circa* 5 *palmi* high with Christ hurling bolts of lightning, with a gilt frame).

3. This painting cannot be identified in the Sacchetti inventory of 1725, published in G. De Marchi, *Mostra di quadri in S. Salvatore in Lauro (1682–1725). Stime di collezione romane, Note e appunti di Giuseppe Ghezzi* (Rome, 1987), 350–57, but is found listed in the Sacchetti inventory of 1726, published in the same volume, 468–86.

4. In the Sacchetti inventory of 1747, published by S. Guarino in *Guercino e le collezioni capitoline* (exh. cat. Rome, 1991), 45–54, it is listed under no. 44; for the bibliography on the history of the Sacchetti Collection, see this publication.

5. The measurements of the painting given in the inventory of 1639 are rather approximate and indicate a height and width of around 5 *palmi*. In the inventory of 1726, the measurements are 6 *palmi* (134 cm) high by 5 *palmi* (111 cm) wide. In the inventory of 1747, these measurements are erroneously reversed (5 *palmi* in height, 6 *palmi* in width), not an infrequent occurrence in the process of compiling long lists when data are transcribed from one inventory to another. The restoration, conducted by Vittoria Cimino in the Vatican Museum's Laboratorio Restauro Pitture, has confirmed that the painting has been cut on all four sides. The former height was 134 cm, the present height 87 cm, a reduction of 47 cm (18½ in.); the former width 111 cm, the present width 104 cm, a reduction of 7 cm (2¾ in.). The signs of the original stretcher, visible 7 cm from the edge on the right side of the canvas, 6 cm from the edge on the left side, 7 cm from the edge on the upper side, but entirely lacking on the lower side, are a further confirmation that the painting has been cut.

6. For information on the saints, see the *Bibliotheca Sanctorum* (Vatican City, 1961–70), under the respective names.

7. The same iconographic motif is found in a painting by Bernardo Strozzi now in the Accademia Ligustica in Genoa. For the legend, see Varazze 1995, c. CXIII, 591–92.

8. For the iconography, see Réau 1955–59, 1:739–52 and 2:2, pp. 116–17.

9. Novelli 1964, figs. 9, 12, 32b.

10. Novelli 1964, fig. 26.

11. Novelli 1955, fig. 44; Bentini 1992, 16.

12. Novelli 1964, fig. 40a; Bentini 1992, 16.

13. Novelli 1964, fig. 32 b.

THE HOLY TRINITY

98

Ludovico Carracci (Bologna, 1555–1619)
THE TRINITY WITH THE DEAD CHRIST, c. 1590
Oil on canvas
172.5 x 126.5 cm (67⅞ x 49¾ in.)
Vatican Museums, inv. 41249

Exhibitions: Bologna, Palazzo
dell'Archiginnasio, *Mostra dei Carracci,* 1956;
Ottawa 1986; Fort Worth, Kimbell Art
Museum, *Ludovico Carracci,* 1994.

Literature: F. Arcangeli in Bologna 1956,
123–24, no. 17; D. Mahon, "Afterthoughts on
the Carracci Exhibition," in *Gazette des Beaux-
Arts* 49 (Apr. 1957):199; C. Pietrangeli, "La
Pinacoteca Vaticana di Pio VI," in *Bollettino
Monumenti Musei e Gallerie Pontificie* 3
(1982):146–60; C. Johnston in Ottawa 1986, 50,
no. 1; G. Feigenbaum in *Ludovico Carracci*
(exh. cat. Bologna, 1993), 73–74, no. 34.

Fig. 1. Ludovico Carracci, *The Martyrdom of Saint
Ursula,* 1592, oil on canvas. Pinacoteca Nazionale,
Bologna

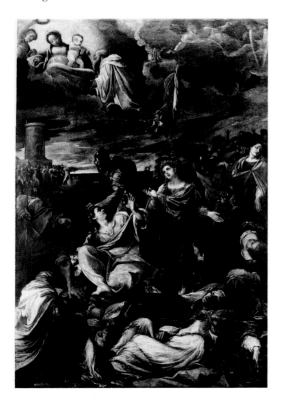

Like many of Ludovico's cabinet paintings of
religious subjects, nothing is known about the
origin of this painting. Malvasia does not
mention it in either his biography of the artist
in *Felsina Pittrice* (1678) or in his guide to
Bolognese pictures (1686). *The Trinity with
the Dead Christ* appeared for the first time in
the *Inventory of the Pictures Existing in the
Palace in the Piazza dei Santi Apostoli in Rome
Belonging to Cardinal Flavio Chigi,* published
between 1666 and 1669. The painting was
added to the papal collections at the end of the
seventeenth century, as on his death (1693) the
cardinal bequeathed it to Pope Innocent XII
(1691–1700).[1] In 1787 it was in the Quirinal
Palace, from 1790 in Pius VI's (1775–99)
Picture Gallery, and later in that of the
Vatican.

The work, summarily described as
"Guercinesque," was rediscovered together
with *The Sacrifice of Isaac* (Vatican Picture
Gallery, inv. 40669) in the storerooms of the
Cancelleria Vaticana by Roberto Longhi,
who attributed it to Annibale Carracci. This
attribution was changed correctly in favor of
Ludovico at the time of the painting's
inclusion in the 1956 Carracci exhibition.[2]

The close stylistic affinities with *The
Martyrdom of Saint Ursula* (fig. 1),which are
particularly evident in comparing the figure of
God the Father with that of Saint Leonard in
the Bolognese altarpiece as well as with the
Cento altarpiece of 1591, make it possible to
date the work to early in the last decade of the
sixteenth century. In this phase, in which there
was a significant change in the painter's artistic
evolution (certainly animated by his contact
with Venetian painting), one recalls the very
similar conception of a space constructed solely
by the intricacy of the figures, at times cut by
the frame, which interact.

In Ludovico's youthful paintings, the
forms are less clearly defined: the outlines,
previously distinct and sharply drawn, temper
off in *The Trinity* in vivid contrasts of light
and shade, with fluid brushstrokes that create a
dense atmosphere, played against the reddish
browns and pinks that evoke the *Madonna
degli Scalzi* (Pinacoteca, Bologna).

"Naturally the work anticipates Guercino;
but it is already, in our opinion, more
profound," wrote Arcangeli in his annotation,[3]
in a certain sense justifying the attribution
of the old inventory and stressing the
extraordinary originality of Ludovico, who
at this moment managed to express the
transcendent in terms of great intimacy and
sincere humanity, qualities that were to be
indispensable in the formation of the young
painter from Cento.

The subject, very unusual at the time of the
Counter-Reformation, goes back to a purely
medieval iconographic idea. Instead of the
traditional, hierarchical representation of the
Trinity with God the Father between the Holy
Spirit and Christ on the Cross, Ludovico
combines this theme with a scene of the Pietà,
in which Christ is received into the Father's
arms rather than those of the Virgin and is
surrounded by angels who bear the symbols of
the Passion.

The composition, which suggests a view
from below, led Johnston to imply,[4] although
this has not been supported by any proof and
there are no signs of any reduction of the
canvas, that the painting may have been the
pinnacle of an altarpiece or was meant to be
placed above the door of a sacristy. Johnston
also suggests that in the figure of God the
Father, robed in a sumptuous cope and
imparting his blessing, one may recognize the
portrait of a pontiff, perhaps the Bolognese
Gregory XIII (1572–85), a contemporary of
the painter: a hypothesis that does not seem
very convincing and that could be clarified by
the discovery of the patron, as yet unknown.
Maria Serlupi Crescenzi

1. Reported by G. Incisa della Rocchetta in Pietrangeli
1982, 146, n. 7.
2. Arcangeli in Bologna 1956, 123.
3. Arcangeli in Bologna 1956, 124.
4. Johnston in Ottawa 1986, 50.

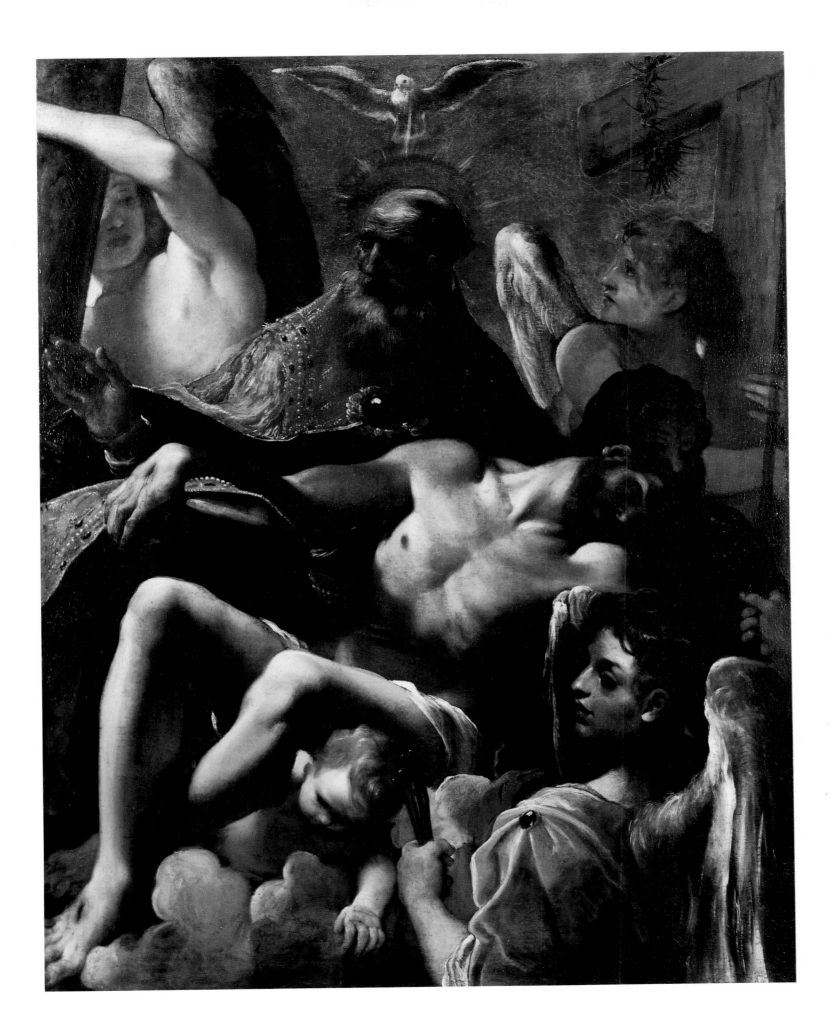

SAINT PETER AND HIS SUCCESSORS

This list of popes and antipopes is derived from one compiled by A. Mercati in 1947 under the auspices of the Vatican; some changes have been made on the basis of recent scholarship, and the list has been brought up to date. The years of each pope's reign follow his name; for popes after the end of the Great Schism (1378-1417), family names are given as well. The names of antipopes are enclosed in brackets, while alternative numberings of papal names appear in parentheses.

Saint Peter (67)
Saint Linus (67-76)
Saint Anacletus (Cletus) (76-88)
Saint Clement I (88-97)
Saint Evaristus (97-105)
Saint Alexander I (105-15)
Saint Sixtus I (115-25)
Saint Telesphorus (125-36)
Saint Hyginus (136-40)
Saint Pius I (140-55)
Saint Anicetus (155-66)
Saint Soter (166-75)
Saint Eleutherius (175-89)
Saint Victor I (189-99)
Saint Zephyrinus (199-217)
Saint Callistus I (217-22)
[Saint Hippolytus (217-35)]
Saint Urban I (222-30)
Saint Pontianus (230-35)
Saint Anterus (235-36)
Saint Fabian (236-50)
Saint Cornelius (251-53)
[Novatian (251)]
Saint Lucius I (253-54)
Saint Stephen I (254-57)
Saint Sixtus II (257-58)
Saint Dionysius (259-68)
Saint Felix I (269-74)
Saint Eutychian (275-83)
Saint Gaius (Caius) (283-96)
Saint Marcellinus (296-304)
Saint Marcellus I (308-9)
Saint Eusebius (309)
Saint Miltiades (311-14)
Saint Silvester I (314-35)
Saint Mark (336)
Saint Julius I (337-52)
Liberius (352-66)
[Felix II (355-65)]
Saint Damasus I (366-84)
[Ursinus (366-67)]
Saint Siricius (384-99)
Saint Anastasius I (399-401)
Saint Innocent I (401-17)
Saint Zosimus (417-18)
Saint Noniface I (418-22)
[Eulalius (418-19)]
Saint Celestine I (422-32)
Saint Sixtus III (432-40)
Saint Leo I (440-61)
Saint Hilary (461-68)

Saint Simplicius (468-83)
Saint Felix III (II) (483-92)
Saint Gelasius I (492-96)
Anastasius II (496-98)
Saint Symmachus (498-514)
[Lawrence (498; 501-5)]
Saint Hormisdas (514-23)
Saint John I (523-26)
Saint Felix IV (III) (526-30)
Boniface II (530-32)
[Dioscorus (530)]
John II (533-35)
Saint Agapitus I (535-36)
Saint Silverius (536-37)
Vigilius (537-55)
Pelagius I (556-61)
John III (561-74)
Benedict I (575-79)
Pelagius II (579-90)
Saint Gregory I (590-640)
Sabinian (604-6)
Boniface III (607)
Saint Boniface IV (608-15)
Saint Deusdedit I (615-18)
Boniface V (619-25)
Honorius I (625-38)
Severinus (640)
John IV (640-42)
Theodore I (642.49)
Saint Martin I (649-55)
Saint Eugene I (654-57)
Saint Vitalian (657-72)
Deusdedit II (672-76)
Donus (676-78)
Saint Agatho (678-81)
Saint Leo II (682-83)
Saint Benedict II (684-85)
John V (685-86)
Conon (686-87)
[Theodore (687)]
[Paschal (687)]
Saint Sergius I (687-701)
John VI (701-5)
John VII (705-7)
Sisinnius (708)
Constantine (708-15)
Saint Gregory II (715-31)
Saint Gregory III (731-41)
Saint Zachary (741-52)
Stephen (752)
Stephen II (III) (752-57)

Saint Paul I (757-67)
[Constantine (767-69)]
[Philip (768)]
Stephen III (IV) (768-72)
Adrian I (772-95)
Saint Leo III (795-816)
Stephen IV (V) (816-17)
Saint Paschal I (817-24)
Eugene II (824-27)
Valentine (827)
Gregory IV (827-44)
[John (844)]
Sergius II (844-47)
Saint Leo IV (847-55)
Benedict III (855-58)
[Anastasius (855)]
Saint Nicholas I (858-67)
Adrian II (867-72)
John VIII (872-82)
Marinus I (882-84)
Saint Adrian III (884-85)
Stephen V (VI) (885-91)
Formosus (891-96)
Boniface VI (896)
Stephen VI (VII) (896-97)
Romanus (897)
Theodore II (897)
John IX (898-900)
Benedict IV (900-903)
Leo V (903)
[Christopher (903-41)]
Sergius III (904-11)
Anastasius III (911-13)
Lando (913-14)
John X (914-28)
Leo VI (928)
Stephen VII (VIII) (928-31)
John XI (931-35)
Leo VII (936-39)
Stephen VIII (IX) (939-42)
Marinus II (942-46)
Agapetus II (946-55)
John XII (955-64)
Leo VIII (963-65)
Benedict V (964-66)
John XIII (965-72)
Benedict VI (973-74)
[Boniface VII (974; 984-85)]
Benedict VII (974-83)
John XIV (983-84)
John XV (985-96)

Gregory V (996-99)
[John XVI (997-98)]
Silverster II (999-1003)
John XVII (1003)
John XVIII (1004-9)
Sergius IV (1009-12)
Benedict VIII (1012-24)
[Gregory (1012)]
John XIX (1024-32)
Benedict IX (1032-44)
Silvester III (1045)
Benedict IX (1045)
Gregory VI (1045-46)
Clement II (1046-47)
Benedict IX (1047-48)
Damasus II (1048)
Saint Leo IX (1049-54)
Victor II (1055-57)
Stephen IX (X) (1057-58)
[Benedict X (1058-59)]
Nicholas II (1059-61)
Alexander II (1061-73)
[Honorius II (1061-72)]
Saint Gregory VII (1073-85)
[Clement III (1080; 1084-1100)]
Blessed Victor III (1086-87)]
Blessed Urban II (1088-99)
Paschal II (1099-1118)
[Theodoric (1100)]
[Albert (1102)]
[Silvester IV (1105-11)]
Gelasius II (1118-19)
[Gregory VIII (1118-21)]
Callistus II (1119-24)
Honorius II (1124-30)
[Celestine II (1124)]
Innocent II (1130-43)
[Anacletus II (1130-38)]
[Victor IV (1138)]
Celestine II (1143-44)
Lucius II (1144-45)
Blessed Eugene III (1145-53)
Anastasius IV (1153-54)
Adrian IV (1154-59)
Alexander III (1159-81)
[Victor IV (1159-64)]
[Paschal III (1164-68)]
[Callistus III (1168-78)]
[Innocent III (1179-80)]
Lucius III (1181-85)
Urban III (1185-87)

Gregory VIII (1187)
Clement III (1187-91)
Celestine III (1191-98)
Innocent III (1198-1216)
Honorius III (1216-27)
Gregory IX (1227-41)
Celestine IV (1241)
Innocent IV (1243-54)
Alexander IV (1254-61)
Urban IV (1261-64)
Clement IV (1265-68)
Blessed Gregory X (1271; 1272-76)
Blessed Innocent V (1276)
Adrian V (1276)
John XXI (1276-77)
Nicholas III (1277-80)
Martin IV (1281-85)
Honorius IV (1285-87)
Nicholas IV (1288-92)
Saint Celestine V (1294)
Boniface VIII (1294;1295-1303)
Blessed Benedict XI (1303-4)
Clement V (1305-14)
John XXII (1316-34)
[Nicholas V (1328-30)]
Benedict XII (1335-42)
Clement VI (1342-52)
Innocent VI (1352-62)
Blessed Urban V (1362-70)
Gregory XI (1370; 1371-78)
Urban VI (1378-89)
Boniface IX (1389-1404)
Innocent VII (1404-06)
Gregory XII (1406-15)
[Clement VII (1378-94)]
[Benedict XIII (1394-1423)]
[Alexander V (1409-10)]
[John XXIII (1410-15)]
Martin V (Colonna, 1417-31)
Eugene IV (Condulmer, 1431-47)
[Felix V (1439; 1440-49)]
Nicholas V (Parentuccelli, 1447-55)
Callistus III (Borgia, 1455-58)
Pius II (Piccolomini, 1458-64)
Paul II (Barbo, 1464-71)
Sixtus IV (Della Rovere, 1471-84)
Innocent VIII (Cibo, 1484-92)
Alexander VI (Borgia, 1492-1503)
Pius III (Todeschini-Piccolomini, 1503)
Julius II (Della Rovere, 1503-13)
Leo X (Medici, 1513-21)

Adrian VI (Florensz, 1522-23)
Clement VII (Medici, 1523-34)
Paul III (Farnese, 1534-49)
Jiulius III (Ciocchi del Monte, 1550-55)
Marcellus II (Cervini, 1555)
Paul IV (Carafa, 1555-59)
Pius IV (Medici, 1559;1560-65)
Saint Pius V (Ghislieri, 1566-72)
Gregory XIII (Boncompagni, 1572-85)
Sixtus V (Peretti, 1585-90)
Urban VII (Castagna, 1590)
Gregory XIV (Sfondrati, 1590-91)
Innocent IX (Facchinetti, 1591)
Clement VIII (Aldobrandini, 1592-1605)
Leo XI (Medici, 1605)
Paul V (Vorghese, 1605-21)
Gregory XV (Ludovisi, 1621-23)
Urban VIII (Barberini, 1623-44)
Innocent X (Pamphili, 1644-55)
Alexander VII (Chigi, 1655-67)
Clement IX (Rospigliosi, 1667-69)·
Clement X (Altieri, 1670-76)
Blessed Innocent XI (Odescalchi, 1676-89)
Alexander VIII (Ottoboni, 1689-91)
Innocent XII (Pignatelli, 1691-1700)
Clement XI (Albani, 1700-1721)
Innocent XIII (Conti, 1721-24)
Benedict XIII (Orsini, 1724-30)
Clement XII (Corsini, 1730, 1740)
Benedict XIV (Lambertini, 1740-58)
Clement XIII (Rezzonico, 1758-69)
Clement XIV (Ganganelli, 1769-74)
Pius VI (Braschi, 1775-99)
Pius VII (Chiaramonti, 1800-1823)
Leo XII (Della Genga, 1823-29)
Pius VIII (Castiglioni, 1829-30)
Gregory XVI (Cappellari, 1831-46)
Pius IX (Mastai-Ferretti, 1846-78)
Leo XIII (Pecci, 1878-1903)
Saint Pius X (Sarto, 1903-14)
Benedict XV (Della Chiesa, 1914-22)
Pius XI (Ratti, 1922-39)
Pius XII (Pacelli, 1939-58)
John XXIII (Roncalli, 1958-63)
Paul VI (Montini, 1963-78)
John Paul I (Luciani, 1978)
John Paul II (Wojtyla, 1978-)

GLOSSARY
Peter Spring

Aegisthus: see Clytemnestra.

akratapeinosis: Greek term for the man of sorrows. The *akratapeinosis* type of the suffering Christ seems to have developed relatively late in Byzantine art: it is found in twelfth-century Byzantine illuminations and thirteenth-century frescoes in Serbia and Macedonia (as at Gradac, predating 1276). In all of these early Eastern examples the figure is confined to the upper torso, and the arms are held straight to the side of the body and cut off just above the elbow. They thus differ from the early Western type of the *vir dolorum* by excluding one of its most characteristic and spiritually enriching elements, the hands with the stigmata crossed over the breast.

alabastron (alabastra): miniature jar, often of alabaster, used for containing unguents and perfumes of the kind described in Mark's Gospel 14:3–4: "a woman came in with an alabaster jar of very costly ointment, pure nard. She broke the jar and poured the ointment on [Christ's] head." The *alabastron* was one of the attributes of the Etruscan winged female spirits known as *lasas* and portrayed, as handmaidens, in scenes of Turan on engraved mirrors.

Alcsentre: Etruscan name for the Greek mythological hero Paris, represented in scenes of Helen and Paris on Etruscan engraved mirrors of the classical period. Where the scenes portrayed on such mirrors represent recognizable Greek myths, the names attached to the figures, in this case *Elina* and *Alcsentre* (Helen and Paris), became a first step toward deciphering the Etruscan language.

all'antica: "in the antique manner." The term is used especially to describe Renaissance or post-Renaissance works of art or motifs that are deliberately derived from, or modeled on, the art of antiquity.

Alpan: minor Etruscan female deity or spirit, part of the so-called Circle of Turan, represented as a winged, seminude female spirit. *Alpan* is one of the handmaidens, or *ornatrices*, who attended to the toilette of *Turan* and help to attire and adorn her, bearing ribbons, *alabastra*, mirrors, perfume dippers, hairpins, and the like. *Alpan* has sometimes been identified as the Etruscan goddess, or personification, of harmony, but the exact significance of her name remains uncertain.

Anastasis: from the Greek term for the Resurrection. It denotes simultaneously Christ's own rising and his raising of the dead. Both senses are merged in Byzantine icons of the Anastasis. In Byzantine iconography, the Resurrection was represented not by Christ's bodily rising out of the tomb (as in the West), but by his visit to the underworld, according to the apocryphal legend of Christ descending to Hades after his death on the Cross and before his Resurrection from his tomb. There he vanquishes Hades' kingdom of the dead and liberates its captives, the dead, starting with the first man, Adam. Byzantine artists chose to depict as the Anastasis the moment when Christ starts pulling Adam from the grave after defeating Hades. The scene is sometimes known as the Harrowing of Hell.

angelology: the study of angels, a doctrine or theory treating of angels.

antefix: an ornament, usually of terra-cotta, affixed to the eaves and cornices of ancient buildings to conceal the ends of the tiles.

Anubis: ancient Egyptian deity, son of Osiris, who condemned the dead to judgment. He is represented with a jackel's head and was identified by the Greeks with Hermes.

archangel: a principal angel, a member of the order ranking immediately above the angels in medieval angelology. Four archangels are known by name from scriptural sources: Gabriel, Michael, Raphael, and Uriel. Archangels, together with principalities and angels, formed the third triad of the nine angelic choirs defined by Pseudo-Dionysius the Areopagite in his *Hierarchia Coelestia* in the fifth century.

armillae: armlets. In the ancient world, armlets for men generally consisted of three or four coils of gold or bronze, worn on the upper arm. In a more general sense, armillae designate any circle of gold or ornamental ring worn by women around the wrist, on the upper arm, or above the ankle.

askos: small pottery vessel, used in ancient Greece for pouring oil into lamps. It is in the form of a low bowl or jug with an overhead arched handle.

aspergillum: instrument, usually perforated, used to sprinkle holy water.

assiste: in Byzantine icon painting, the name of a technique of highlighting using gold lines with the liquid metal, typically on Christ's garments. It was applied after the painting of the icon was finished, unlike other areas of gilding, such as the ground, which were executed before the painting was begun. *Assiste* was a way of investing sacred figures with an aura of divine radiance.

Atunis: Etruscan male deity, the equivalent of Adonis and a popular partner of *Turan* on Etruscan engraved mirrors of the classical period. Numerous mirrors show the lovers locked in an affectionate embrace.

aureole: border of light or radiance enciling the head or body of a sacred figure. The aureole has a classical origin; it is found in Greco-Etruscan art to distinguish a supernatural being.

automelia: in the Byzantine liturgy, a form of short hymn, a *sticheron* or *troparion* having its own melody, but which may subsequently serve to execute other pieces of the same rhythm.

baldacchino: Italian term for baldachin, meaning a structure in the form of a canopy, usually supported on columns, and placed over an altar. The term *baldacchino* is conventionally used to describe Bernini's bronze canopy in Saint Peter's and other similar altar canopies in the basilicas of Rome.

broderie anglaise: openwork embroidery on white cotton or fine linen.

bulino: graving tool, burin, graver.

bulla: in the ancient world, a small rounded metal or leather locket, containing an amulet, worn around the neck. The term later took on Christian signification, denoting a lead seal affixed to a papal document, having a representation of Saints Peter and Paul on one side and the name of the reigning pope on the other (whence the term bull, meaning a papal or episcopal edict or mandate).

burse: flat case used at Mass as a container for the corporal or white linen cloth on which the bread and wine are placed during the Eucharist.

calceus [repandus] (calcei [repandi]): laced half-boots with elongated upturned toes typical of late archaic Etruscan fashion. Worn by both men and women.

cangiante: Italian term from *cangiare*, "to change," meaning a changeable or iridescent color, especially in draperies.

chalice veil: cloth placed over the chalice containing the wine at Mass.

Chalcas: Etruscan equivalent of the famous Greek soothsayer Calchas, who accompanied the Greeks to Troy. Represented on the well-known Etruscan mirror in the Vatican (cat. 24) as a *haruspex* bending forward to examine the liver of a sacrifice, he differs from his Greek counterpart in being winged and thus divine. According to some authorities, *chalcas* is a generic term for seer rather than the name of a specific individual or deity.

chalice: drinking cup used in the celebration of the Eucharist. Ultimately derived from the Greek two-handled drinking bowl, the earliest surviving chalices are of semi-transparent bluish glass. Later, in medieval times, metal, especially copper and silver gilt, was substituted for glass. The originally simple, rounded form of the vessel was elaborated in the Gothic period, when the cup was raised over a pedestal, and in the baroque period, when the whole chalice was richly ornamented and covered with tracery.

Charun: The Etruscan name of this underworld demon is the equivalent of the Greek ferryman of the dead, Charon. But their appearance and attributes are quite different. Etruscan demons of the underworld are generally fearsome. *Charun* is often winged like *Tuchulca*, has grimacing features, a hooked nose, snaky hair, and is generally armed with a hammer.

chasuble: long conically shaped sleeveless vestment, the outermost garment of the priest celebrating Mass.

cherub (cherubs/cherubim): an order of angelic spirits usually ranked after the seraphim and forming one of the nine categories (or "choirs") of angels in the Christian tradition. Cherubs are winged spirits and were apparently represented as such in the carved figures of cherubs placed by Solomon in the Temple of Jerusalem (1 Kings 6:23–29). But since the Old Testament world was deliberately aniconic (see Exodus 20:4), there was no innate Judaic conception of what a cherub might have looked like. So the image of these winged figures was no doubt borrowed from the part man, part-animal mythical creatures of ancient Mesopotamia. In the Old Testament the role of cherubs is essentially one of glorification (as described by Ezekiel 10:1–17). This role is preserved in the Christian tradition. Cherubs can be described as angels who have an intimate knowledge of God and continually praise him. Cherubs are often represented in Christian art as winged children or winged heads of children. Indeed they became, in the Renaissance, virtually indistinguishable from *putti* or, more generally, with an innocent or sweet child.

chiton: Greek linen garment in the form of a tunic, seamed at the side and pinned, buttoned, or stitched at the shoulders or sleeves.

chlamys: rectangular Greek woolen garment worn as a kind of short cloak by horsemen, soldiers, and young men generally.

chomvoschinion: monastic rosary in the Greek Orthodox Church. Unlike the Western rosary with beads, it is made of cloth.

ciborium: tabernacle or freestanding canopy placed over an altar; a vessel containing the consecrated wafers for the Eucharist.

cista: From the Greek *kisté*, Latin *cista*, meaning coffer, chest, basket. In Etruscan culture, a cylindrical bronze container, probably for cosmetics and objects used in the toilette, such as mirrors. Etruscan *cistae* were decorated on the outside with engraved mythological scenes in the form of a frieze.

clipeus: round shield or oval medallion, often used as a medallion within which the bust of the deceased appears on Roman sarcophagi. See *imago clipeata.*

Clytemnestra: wife of Agamemnon, king of Argos. She committed adultery with Aegisthus, to whom Agamemnon had entrusted her care after going off to the Trojan War. Agamemnon discovered her infidelity but, before he could take revenge, was murdered by the two lovers as he stepped out of his bath.

condottiere: commander or soldier in a professional mercenary company in Europe from the thirteenth to the sixteenth century; a familiar figure in Renaissance warfare in Italy.

confessio: shrine raised over the tomb of a martyr or confessor or the crypt or raised presbytery in which the relics are placed. The archetypal *confessio* is the one over the tomb of the First of the Apostles in Saint Peter's; similar shrines, imitative of the mother basilica in Rome, were erected in important churches and cathedrals elsewhere. So sacred is the Confessio in Saint Peter's that, during Bramante's demolition of the Constantinian basilica, Pope Julius II (1503–13) refused to allow the tomb of the apostle to be touched. A temporary structure was built over it to protect it during the demolition and rebuilding.

crozier: pastoral staff of a bishop or an abbot, and as such a symbol of spiritual authority in the Church. The pastoral nature of this authority is explained by the crozier's form, a shepherd's crook. The earliest examples of the form that appear on episcopal and abbatial seals are extremely simple; later, notably in the seventeenth and eighteenth centuries, the crozier, and especially its curved section, became more ornate.

Cupid: Roman god of love, represented as a winged boy with a bow and arrow. His Greek counterpart was Eros. Harvesting cupids, or *eroti*, became popular in Hellenistic art and later took on an allegorical meaning in early Christian art, being associated with the Good Shepherd. See also *putto.*

cursus honorum: in Roman inscriptions, an abbreviated career path itemizing the successive public offices held by the person honored. The order in which these offices could be held, and the period that had to elapse between them, was established by custom and fixed by law. Public service in ancient Rome was rigorously ordered, tiered according to social rank.

cyma: The molding of a cornice, the outline of which consists of a concave and convex line.

dalmatic: ecclesiastical vestment with wide sleeves worn by deacons and bishops in the western Church on certain occasions. Its name derives from the Greek province of Dalmatia, where its woolen prototype originated.

.deisis (or deesis): Greek word meaning "intercession." In the iconographic sense, it refers to the triptych of the Savior, the Virgin Mary, and John the Baptist that forms the central part of the *iconostasis*, or unbroken screen of icons separating the sanctuary from the nave in Orthodox churches. *Deisis* means the standing in prayer before this triptych (composed either of one long wooden panel or of three separate icons), in which Mary is always placed to the right of Christ according to the words of the psalm: "On your right hand stands the queen" (Ps. 45:9).

demon: in the classical world, an attendant or ministering spirit, or *genius.* The Greek word from which the English word is derived meant a divine being normally regarded as good; demons were demigods who acted as guardian spirits or influenced men's character. But later, the Greek word and its Latin derivative *daemonium* were applied preeminently to the forces of evil. They were spirits (the "unclean spirits" of the Gospels) that were hostile to man's spiritual good and that tormented him or caused him harm. This demonology, the doctrine of an infinite number of demons who sowed the whole world with snares, deceits, and errors, was developed in patristic theology. The Etruscan demons of the underworld, Charun and Tuchulca, are, in some sense, a fearsome prefiguration of the demons of the early Christian hell.

devil: supreme spirit of evil and arch-enemy of God. The English word "devil" is derived from the Greek *diabolos*, meaning enemy, accuser, or slanderer. In the New Testament, this Greek word is frequently used. It is one of several synonyms for Satan (others being Beelzebub, Belial, the Evil One, the Adversary, the Enemy). Although strictly speaking there is only one devil, as there is only one Satan, the force of evil he embodies is infinitely multipliable; so in the Gospels the plural devils is often used as a synonym for the evil (or "unclean") spirits by which individuals are possessed, and which Jesus alone had the power to cast out. Jesus foretold that one of his disciples, i.e. Judas Iscariot, was a devil (John 6:70).

diptych: two panels of equal size, usually hinged together so that they can be folded and closed with some form of clasp. The diptych as a work of art seems to have originated in late antiquity as a luxurious form of writing tablet. It was made of ivory. With the rise of the cult of icons, the painted diptych became common in Byzantium from the eleventh century and in the West from the second half of the thirteenth century. Painted diptychs painted by such artists as Simone Martini or Bernardo Daddi achieved the height of their popularity in fourteenth-century Italy. They fulfilled the function of small portable devotional paintings.

discerniculum: long hairpin, an attribute of the Etruscan winged female deities or spirits known as *lasas.*

dormition: literally, "the falling asleep." In the early Christian tradition, the Virgin "fell asleep" and was bodily assumed into heaven. The Dormition of the Virgin was expressed in its canonical form in a body of apocryphal literature called the *Transitus Mariae*, the "passing of Mary." Here Mary's last hours and bodily Assumption are described in great detail. By the end of the fifth century, the Dormition of the Virgin was firmly established in both liturgy and art. It became a favorite theme in Byzantine icons. The feast of the Dormition of Mary on August 15 has continued to be celebrated in the Oriental liturgies to the present day.

endromides: lightweight sandals used for running or hunting.

Eos: Greek goddess of dawn whose Roman equivalent is Aurora. White-winged and wearing a saffron mantle, she is represented either hovering in the sky or riding in her chariot drawn by white horses.

Erinnyes: in Greek mythology, the Furies, the ministers of the vengeance of the gods. They were the (three) daughters of the earth, conceived from the blood of Saturn, who inflicted their vengeance upon earth by wars, pestilence, and dissension. Often represented winged, with serpents writhing around their heads.

Eros: Greek god of love, son of Aphrodite. His Roman equivalent is Cupid. Eros is represented as a winged infant, naked, armed with a bow and quiver full of arrows. His wings allude to his speed and his omnipresence. Like the name itself, Eros assumed generic significance: he was transformed into a plurality of the winged child-gods or *eroti* popular in Hellenistic art. See *putto.*

Eteocles: see Polynices.

evloghitaria: In the Byzantine hymnody, a short poetic hymn or *troparion* accompanying Psalm 118 (119):12: "How blessed are you, Yahweh!" and incorporated in the *othros* or Sunday office of Matins.

exergue: space or compartment on the reverse of a coin, medal, or similar bronze object, above or below the central design, often containing the date, place of minting, or other inscription.

fibula: metal, usually bronze, brooch, a common adornment for holding dress in place in pre-Etruscan and Etruscan society. It underwent successive changes in form in response to changing fashions. The morphology of fibulae is one of the more reliable methods for dating pre-Etruscan or Etruscan grave assemblages in Italy.

flabellum: lady's fan, stiff and with a long handle, the form best adapted to the manner in which it was used in the Greco-Etruscan world, by a handmaid or slave to fan her mistress.

Floreria Apostolica: papal wardrobe, the apartment in which the papal collection of liturgical vestments was housed.

Forty Hours: a devotional practice honoring the forty hours in which Jesus lay dead in his tomb before his Resurrection. It became the practice in medieval northern Italy to depose the consecrated Host in a special altar in the form of a tomb. This form of devotion led in the sixteenth century to the Holy Sacrament being exposed to the adoration of the faithful for forty hours continuously. The Forty Hours as a form of devotion was fostered by Saint Charles Borromeo, by the Capuchins, by Saint Philip Neri (who introduced it into Rome), and by Pope Urban VIII, who in his encyclical *Aeternus rerum Conditor* (1623) ordained that it be celebrated in churches throughout the world.

Gabriel: The archangel sent to explain to Daniel the meaning of his visions (Dn. 8:16; 9:2); who foretells to Zechariah that he is about to have a son, John the Baptist (Luke 1:19); and who announces to Mary the conception and birth of her son (Luke 1:26–38). The bearer of glad tidings, Gabriel is also identified, and sometimes portrayed, as the archangel of the last trump (1 Cor. 15:52–53). He is considered one of the seven angels of the Apocalypse, though not identified as such in the Book of Revelation.

genius (genii): in the ancient world, a *genius* was a good and beneficent spirit, a kind of forerunner of the guardian angel, believed to spring into being with every mortal at birth and to direct his actions and watch over his welfare through life. Not only individual human beings, but also families, societies, cities, peoples, even particular localities (*genius loci*) had their attendant *genii.* Genii also served as personifications of the seasons, holding either animals or fruits alluding to the various times of the year. *Genii* were usually portrayed as beautiful young boys (they are invariably male), entirely naked but for the youthful chlamys flung over the shoulder, and are furnished with a pair of bird's wings. Such winged figures, usually infants, suggesting the eternal repetition of the seasons, were susceptible to a Christian interpretation. See *putto.*

gesso: plaster preparation made from ground gypsum or alabaster mixed with size. Gesso was used in medieval and Renaissance painting either as a preparatory support or for raised ornament. It was applied in several layers. It could also be modeled in relief and impressed to produce punched ornament as part of the decorative gilding that commonly formed the ground in early Renaissance paintings.

glazed terra-cotta: The application of lead-glazed terra-cotta to sculpture was invented, and its technique perfected, by Luca della Robbia (1400–82). Typical of the Florentine quattrocento, the production of glazed terra-cotta was continued by members of Luca's family (his nephew Andrea and Andrea's five sons). It was commonly used for architectural roundels and lunettes and for the wreath-encircled coats of arms exemplified by that of Benedetto Buglioni included in this exhibition (cat. 1). Glazed terra-cotta combines the advantages of durability with polychromy; its glazing does not erode, its colors do not fade.

guardian angel: The concept of the guardian angel, who guards protectively over each one of us, has its ancient equivalent (see *genius*) and, in a Christian context, can be traced back to the Old Testament world (Book of Tobit). Guardian angels are intelligent spiritual creatures divinely deputed to exercise individual care and protection over human beings on this earth and assist them in their attainment of eternal salvation. Their iconography was modeled on that of the archangel Raphael, who leads the one he is protecting to salvation. Commemorated by the liturgy of the Roman Church on October 2, guardian angels are part of the chain of love that links God to his human creation.

haruspex (haruspices): Etruscan priest who practiced divination by examining the entrails of sacrificial animals. Haruspication (foretelling the future by the study of entrails) was a specialized science in the Etruscan and later in the Roman world and had considerable influence on the conduct of public life. The forecasts of the *haruspices* were largely stereotyped predictions of success or warnings of danger in war or politics.

hetimasis: Greek term used to describe a common theme in Byzantine and Russian apocalyptical iconography, the preparation of the throne of the Second Coming.

Hexameron: The Days of the Week (from the Greek word for six): in the Byzantine and later Russian Orthodox liturgy, a sequence of Gospel illustrations, beginning with the first day, which is Sunday, the day of Resurrection.

himation: A voluminous Greek outer garment or mantle, generally of wool. Consisting of an oblong piece of cloth, it was draped over the left shoulder and fastened either over or under the right.

Hippodamia: see Oinomaos.

idiomelia: In the Byzantine hymnody, a *sticheron* or *troparion* sung according to its own melody.

imago clipeata: funerary portrait in pagan Roman art in which one or two portraits of the deceased (members of the same family) are enclosed within a circular medallion or shell. The formula was later adopted in Christian portrait iconography: the series of thirteen *imagines clipeatae* of Christ and his disciples was already established by the fourth century. *Imagines clipeatae* were also used to portray Christian emperors, empresses, and consuls and then extended to bishops and popes.

intonaco: The fine plaster surface on which, while still wet, fresco was painted. *Intonaco* typically consists of a compound of lime, marble dust, and pozzolana.

kantharos: Greek drinking cup with a tall footed stem and two loop-shaped side handles, each extending from the bottom of the bowl to the rim.

kekryphalos: radial hair net.

kelebe: large *krater* of the Corinthian type used for mixing wine and water. It consists of a wide body and mouth, two columnar side handles, and a small circular base.

kithara: ancient instrument of triangular shape with seven to eleven strings, a sort of lyre.

krater: in the Greco-Etruscan world, a large, wide-mouthed vessel, either of bronze or pottery, used for mixing wine and water.

lamassu: Category of Mesopotamian good *genii*, of divine origin, responsible for protecting mankind. They are imagined and portrayed anthropomorphically, but endowed with superhuman attributes such as aquiline wings and, sometimes, with the actual head of an eagle. Their function largely coincides with the angels of the Old Testament. See cherub.

Lasa: Etruscan minor deity, or attendant spirit, represented as a graceful winged woman. The term *lasa* is more likely to be generic than denote a specific deity. *Lasas* (identified by accompanying inscriptions) appear on Etruscan engraved mirrors, forming part of the so-called Circle of Turan, between the mid-fourth and third centuries B.C. They have variable attributes, even in terms of clothing, and may be represented nude, half-clad, or fully clothed. The objects they hold in their hands likewise vary: an *alabastron*, a perfume dipper, a *discerniculum*, a scepter, a scroll, or a ribbon. The lack of a specific iconography suggests that *lasas* are a class of attendant spirit akin to nymphs. Some scholars have interpreted the whole group of Turan's attendants as *lasas*. But their sphere of influence and their function as winged messengers clearly extended beyond the Aphroditic world.

Lucernarium: in the Byzantine hymnody, a preliminary rite of the Great Vespers.

Lucifer, Prince of Darkness: leader of the rebellious angels usually identified with Satan. Ironically his name is derived from the Latin word "lucifer," literally light-bearer. The name is patristic rather than biblical; in scholastic philosophy the idea developed that Satan's name before his fall was Lucifer (see John Milton, *Paradise Lost*, VII.131–4).

mandorla: almond-shaped contour surrounding the body of a person endowed with divine light, usually Christ himself. Perhaps derived from the Roman custom of placing portrait busts within circular medallions or *imagines clipeatae*, the mandorla first appeared in Early Christian art in the fifth century (Santa Maria Maggiore in Rome) and became a common feature of Byzantine icons. The mandorla was particularly associated with scenes of Christ in glory or the Transfiguration.

Mandylion: The oldest known image of Christ, formerly in Edessa (modern Urfa in Syria) and now in the Vatican Apostolic Palace. In the East it is called "the image not made by the hand of man." According to this tradition, Christ himself sent his image to Abgar V Ukhama, prince of Osroene, a small kingdom between the Tigris and the Euphrates rivers. Its capital was Edessa. The Greek word *mandylion* means "handkerchief." *The Mandylion of Edssa* (see cat. 38) was the cloth on which Christ is said to have washed his face and on which his features remained fixed.

maniple: Liturgical vestment in the form of an ornamental band formerly worn over the left arm by the celebrant at the Eucharist.

mapharion: Greek term conventionally used to describe the veil of the Virgin in Byzantine art.

Maris (Maristura): Etruscan male deity whose name in various combinations is found on mirrors of the classical period. The name might suggest an equivalence with Mars, the Roman god of war, but the iconography of Maris does not bear out this correspondence. He is sometimes represented as an unbearded nude youth, sometimes as a bearded nude male, and sometimes as a plurality of child-gods with various added names. The name, like that of *lasa*, may be generic.

Michael: in the Old Testament, Michael the archangel is presented as the angel protector of Israel; in the Book of Revelation, it is Michael and his angels who combat the dragon (Rev. 12:7–9). This role as divine protector, as "chief captain of the host," was preserved in the early Church. In the West, the veneration of Michael as head of the heavenly armies and patron of soldiers was reinforced by his reported apparition during the Gothic invasions of the fifth and sixth centuries. Pope Gregory the Great, while leading a penitential procession to Saint Peter's in 590, is thus said to have looked up at Hadrian's mausoleum (now Castel Sant'Angelo) and seen an angel on top sheathing a bloody sword, surrounded by a choir of angels (see cat. 71). A cult in Michael's honor was instituted: he was the only individual angel with a liturgical observance prior to the ninth century. Michael is invariably represented in art in armor: he is shown holding the scales of justice, or binding Satan with chains, or raising the sword of victory over the dragon, whom he tramples underfoot.

monstrance: receptacle, usually of gold or silver, with a transparent container in which the consecrated Host is exposed for adoration.

Mus: Etruscan female deity of uncertain identification, shown in the mirror from Vulci in the present exhibition (cat. 16) holding a *kithara*.

Myrophores: The spice-bearing women who ran to Christ's tomb on the morning of Easter. Also known as the Three Marys.

Nestfrisur: Elaborate hairstyle popular with aristocratic Roman ladies in the Severan period.

Nike: Winged Greek goddess of victory: see Victoria.

noli me tangere: a work of art depicting Christ appearing to Mary Magdalene after the Resurrection. From the Latin "do not touch me," the words spoken by Christ to the Magdalen in John 20:17.

Oinomaos: Greek mythological figure, king of Pisa, in Elis (Peloponnesus). Warned by an oracle that he would die at the hands of his son-in-law, Oenomaos determined that his daughter Hippodamia would marry only the man who could beat him in a chariot race, an impossible venture, he thought. Many tried and perished in the attempt. But Pelops, having bribed the king's charioteer to equip his master with a defective chariot, won the race, killed the king, and married his daughter.

oklad: silver-sheet decoration placed over painted icons.

Orestes: Greek mythological hero who revenged the death of his father Agamemnon by killing the adulterer Aegisthus and then by stabbing his mother Clytemnestra to death. Tormented by the Erinnyes, Orestes was redeemed and purified by Apollo.

ornatrix (ornatrices): a female slave whose chief function was to attend to the toilette of her mistress, to dress and decorate her person, and to arrange her hair.

ovolo: Convex molding with egg-and-dart decoration.

pallium: Litugical scarf-like vestment worn over the chasuble by the pope, archbishops, and some bishops in the Roman Catholic Church. It is bestowed by the pope on archbishops and bishops having metropolitan jurisdiction as a symbol of their participation in papal authority. The pallium is made of a circular strip of white lamb's wool adorned with black crosses. It is worn over the shoulders; two vertical bands of cloth or wool, extending from the circular strip in the front and back, give the pallium a *Y*-shaped appearance. The pallium probably evolved from the ancient Greek himation, called pallium by the Romans: gradually it became narrower until it resembled a long scarf. The *Y*-shaped pallium probably developed in the seventh century.

parapetasma: curtain serving as a backdrop for a draped bust of the deceased.

patera: shallow bowl, used especially in pouring libations at sacrifices.

pax: from the Latin word for peace, a liturgical object for the celebration of the Rite of Peace in the Roman Church. It usually takes the form of a small metal plate or medallion, often with a representation of the Crucifixion, and was formerly used to convey the kiss of peace from the celebrant at Mass to the faithful, who kissed the plate in turn.

pedum: shepherd's crook, commonly carried by satyrs and by Pan.

pelike: a type of amphora with a pear-shaped body, a wide mouth, and a neck forming a continuous curve with the body. It was used for holding oil or water.

Pelops: Greek mythological hero. Son of Tantalus, king of Phrygia, his kingdom was invaded and he was forced to flee into Greece. Pelops came to Pisa, in Elis, where he became one of the suitors of Hippodamia, daughter of king Oinomaos, and entered the lists against the king, who had promised Hippodamia only to the man who could out-run him in a chariot race. Thirteen suitors had already perished in the attempt. But Pelops corrupted the king's charioteer (who equipped his master with a chariot with a defective axle-tree), won the race, killed Oinomaos, married his daughter, and inherited the kingdom. He gave his name to the peninsula over which he reigned, Peloponnesus.

pentimento: evidence, either visible to the naked eye or detectible on *X* rays, that a painting or drawing was altered, or a figure or detail canceled or added to it, or a composition changed, during the actual process of execution. Such afterthoughts on the part of the artist are generally good evidence that the work of art in question is original and not a copy. If the overpainting has, in the process of time, become semi-transparent, pentimenti may show through the surface of the painting like a ghostly image.

peplos: long woolen outer garment worn by Greek women. It consisted of a simple rectangle of cloth of abundant width, folded about the body and pinned at the shoulders.

phiale: shallow, flat-bottomed drinking bowl without handles and with curving sides and a central boss (*omphalos*) punched up on the inside used especially for drinking or pouring libations to the gods. Of oriental origin, the *phiale* was adopted by the Greeks and then by the Etruscans.

pietà: motif of the dead Christ, supported by the Virgin Mary, exemplified by Michelangelo's marble *Pietà* in Saint Peter's.

plectrum: implement used for plucking a stringed instrument such as a lyre.

Polynices: Greek hero, son of Oedipus, king of Thebes, who contested with his brother Eteocles for the right to ascend the throne of their father. The conflict between them culminated in the single combat in which both brothers were killed.

polyptych: From the Greek *polyptychos*, "of or with many folds," more specifically an altarpiece consisting of more than three leaves, or panels, folded or hinged together. The painted polyptych originated in Tuscany toward the end of the thirteenth century and, especially in Siena, rapidly developed into the multi-story polyptych set in an elaborately carved and gilded architectural frame, with a predella as a base, a typical format of late Gothic and early Renaissance altarpieces in Italy.

predella: a horizontal band, cut from a single plank, placed below the main panels of an altarpiece or polyptych and forming its base. The predella is generally painted with a horizontal alignment of small figures or scenes from the life of a saint that forms an integral part of the iconographic program of the altarpiece as a whole. One of the earliest known predellas is that of the *Stefaneschi Altarpiece* attributed to Giotto, painted for the old Saint Peter's and now in the Vatican Picture Gallery.

primitive: after the mid eighteenth century, the term was used to describe early, gold-ground paintings: Artaud de Montor in 1834 thus described his collection of the works of early Italian painters as "*peintures primitifs*." The term is still used in this sense, but in a descriptive, not an evaluative sense.

Psyche: Greek nymph whom Eros married and conveyed to a place of bliss where he long enjoyed her company. Psyche, whose name means "soul," is generally represented with the wings of a butterfly, to imitate the lightness of the soul. The myth of Eros and Psyche (Love and the Soul) had, by late antiquity, been debased into an erotic love scene. Christianity resurrected its hidden (metaphysical) meaning: the love for the only true God that overpowers the soul. The Christianized motif of Eros and Psyche is found in the catacombs and on sarcophagi.

psychopomp: conductor of souls to the place of the dead.

putto: from Latin *putus* (boy), the winged *putto* is, in origin, a pagan motif. Of Hellenistic origin, the chubby child ousted the adolescent Eros and became a widespread motif in Roman imperial sculpture. *Putti* expressed the bucolic spirit of the four seasons, the joyfulness of the afterlife, and later assumed a Christian, and more specifically Eucharistic, significance: grape-harvesting *putti* appear in the fourth-century mosaics of S. Costanza in Rome and on the porphyry sarcophagus of Constantina, daughter of Constantine, in the Vatican Museums; wheat-harvesting *putti*, on the Christian sarcophagus of Junius Bassus, also in the Vatican. *Putti* of this bucolic type were later revived by such Renaissance artists as Donatello and Luca della Robbia.

Pylades: cousin of Orestes, to whom he was attached by an inviolable friendship and whom he helped to revenge the murder of Agamemnon. Orestes rewarded his fidelity by giving him his sister Electra in marriage.

Raphael: this Archangel is mentioned in only one book of the Bible, the Book of Tobit, where he appears as God's envoy, sent to answer Tobit's and Sarah's separate prayers by healing Tobit's blindness and by providing a husband for Sarah. The cult of Raphael developed rather late in the Church, and images of him before the sixteenth century are rare. Since then, he has been widely depicted as the patron of travelers (reflecting his role in the Book of Tobit).

Rota: The Sacra Rota is the supreme papal tribunal.

sacra conversazione: typical composition of Italian Renaissance painting in which the central group of the Virgin and child, usually enthroned, is flanked on either side by full-length saints, frontally posed in attitudes of silent contemplation. It is thought that the *sacra conversazione* developed from the late-Gothic polyptych, the framing elements being eliminated and the separate panels conflated to produce a unified pictorial space in which the protagonists coexist. This process took place in Florence in the mid-fifteenth century. Domenico Veneziano's *Saint Lucy Altarpiece* (c. 1445–47, Uffizi, Florence) is considered the first true *sacra conversazione*. The form was later developed by Piero della Francesca and perfected by Giovanni Bellini (*Virgin and Child with Saints*, 1505, S. Zaccaria, Venice).

sakkos: Greek head scarf wound around the head by women to confine the hair.

sarcophagus: from the Greek *sarkophagos*, meaning flesh-devouring. Pliny explained the etymology by suggesting that the Anatolian slate sometimes used to line sarcophagi had the property of consuming human corpses. In the classical world, the sarcophagus was a marble (or, in Etruria, terra-cotta) coffin, decorated sometimes with recumbent effigies of the deceased placed on top (as in Etruscan examples) or with a lid with mythological figures (as in the specimens included in the present exhibition) or with a frontal carved with mythological reliefs (as in countless Roman imperial examples). Christian sarcophagi of the third century do not break with this Roman tradition, but introduce Christian or biblical elements into it (such as the Good Shepherd). Sarcophagi, though essentially a pagan element of funerary culture, continued to characterize Christian iconography in Byzantine and later in Renaissance art, in scenes of the Resurrection or of the *vir dolorum*.

Satan: the devil, arch-adversary of God and tempter of mankind, sometimes identified with Lucifer. The name is Hebrew; it is derived from the verb *satan*, meaning to plot against or slanderously accuse. This sense of Satan as the supreme advocate of evil, who tempts or entices man to sin, is preserved in the New Testament. It is by Satan that Jesus is tempted in the wilderness (Matt. 4:10; Mk. 1:12; Luke 4:8) and that Judas is possessed after taking the bread (John 13:27). Satan is the prince of the world whose kingdom is overthrown by the sacrifice of Jesus (John 12:31, 14:30, 16:11) and whose power is destroyed in the celebration of the Eucharist.

seraph (seraphs/seraphim): A member of the highest order of angels in the celestial hierarchy and often depicted as the winged head of a child. The winged nature of seraphs has an Old Testament pedigree; the seraphim are among the fiery winged beings attendant upon Yahweh and devoted to singing his praise, in Isaiah's vision (Is. 6). Isaiah described them as having six pairs of wings: two for covering their face, two for covering their feet, and two for flying. This particular

iconography was adopted in later Christian art, especially in scenes of Saint Francis receiving the stigmata. Seraphs are often depicted as red because their name implies fire: it literally means "the burning ones."

shēdu: Like *lamassu*, a category of Mesopotamian winged *genii*, akin to the angels of the Old Testament.

situla: bucket-shaped container, usually of metal or pottery and often richly decorated. *Situlae* were typical of the north Italian Iron Age and became common equipment in Etruscan orientalizing tombs of the seventh century B.C. Wooden *situlae* with silver open-work overlay are also known from such tombs; the specimen from the Regolini-Galassi Tomb (Cerveteri) in the Gregorian Etruscan Museum in the Vatican is ornamented with friezes of real and fantastic animals.

skyphos: Greek drinking cup, deep and flat-bottomed, with tapering sides. It has two loop handles, usually horizontal, just below the rim.

Sol: Roman god of the sun.

sphendone: headband or scarf worn by women to confine the hair below and at the sides, but usually partly open at the top.

stephane: crescent-shaped metal ornament or diadem worn in the hair over the brow.

sticheron (stichera): category of hymn in the Byzantine rite: a *troparion* intercalated between the verses of two psalms of vespers and matins. The name derives from *stichos* (psalm verse). *Stichera* generally occur in groups. The music book containing these sets of *stichera* was known as the *sticherarion*.

stole: the long narrow scarflike liturgical vestment consisting of a narrow strip of silk or linen, worn over the shoulders and hanging down in front or crossed over the breast. The stole is conferred on deacons at their ordination.

strappo: detached pigment layer of the underlying brush sketch below a fresco. Usually these preparatory sketches remain hidden by the fresco painted on top; the *strappo* of the youth from Raphael's *Expulsion of Heliodorus* included in the present exhibition (cat. 73) is unique.

stylite: ascetic who lived on top of a pillar; from the Greek word for pillar (see cat. 61).

sudarium: cloth for wiping the face, especially that with which Saint Veronica wiped the face of Christ on the way to Calvary and on which his features were impressed. It is one of the symbols of Christ's Passion (see cat. 40).

synaxarion: hagiography, or life of a saint, read as a lesson in public worship in the Orthodox Church; also, a collection of such lives of saints.

synaxis: Orthodox ecclesiastical term meaning a meeting or assembly for worship or prayer, including the celebration of the Eucharist. The term is also used to distinguish special feast days, such as the *synaxis* of the archangel Gabriel celebrated on the day after the Feast of the Annunciation (March 26).

syncretist: someone who, in a period of religious pluralism, as in the later Roman Empire, picked and chose between different faiths, attempting to reconcile or combine different or opposite religious beliefs, both pagan and Christian.

taenia: fillet or bandeau worn around the head for the purpose of keeping the hair in place; also, a fluttering ribbon used for fastening a garland, encircling a wreath, and other similar decorative purposes.

tau: Greek letter *T*, alluding to the *T*-cross often represented on the cloak of Saint Anthony Abbot. Anthony, father of monasticism, is also distinguished, in paintings, by a staff with a *T*-shaped handle.

tempera: colors ground in water and kneaded into a paste with organic gums and glues; more particularly, pigments mixed or "tempered" with egg. The grinding of pigments in egg yolk is described in early Renaissance treatises on painting. Tempera painting appeared in Europe in the twelfth or early thirteenth century, but had long been used in the painting of Byzantine icons.

Tethys: in Greek mythology, the greatest of the sea goddesses. Tethys was the wife of Oceanus and daughter of Uranus and Terra.

Thesan: Etruscan deity, the equivalent of the Greek Eos. She is portrayed on Etruscan mirrors with the distinguishing attribute of a pair of large feathery wings.

thiasos: Greek designation of a society that had selected some god for its patron and held sacrifices, festal processions, and banquets in his honor. The name was especially applied to festivities in honor of Dionysus (Bacchus). In iconographic terms, it refers to the sileni, satyrs, nymphs, and maenads that formed the god's mythical retinue. The Bacchic *thiasos* became popular for sarcophagus frontals in the Severan period.

thymiaterion: incense burner, sometimes placed on a pedestal.

tibia: a varied class of wind instruments common in the ancient world, made of reed, cane, boxwood, horn, metal, and the tibia (shin bone) of some birds or animals. Their common denominator is that they all have holes or stops for the fingers and are sounded by a mouthpiece inserted between the lips. The simplest form of *tibia* is a small pipe, something like a modern recorder. There was also a tranverse type of *tibia*, like a flute, and various forms of twin pipes (or pan pipes).

Tina (Tinia): Etruscan deity, the equivalent of the Greek Zeus. Frequently represented on Etruscan mirrors in scenes of Greek myth such as the Birth of Athens, his iconography is not fixed: he may appear as an enthroned bearded patriarch in canonical Greek mode, or as a youthful unbearded male.

torque[s] (torquis): circular, solid-looking necklace made of twisted strands of metal, usually gold, and worn as a collar.

triptych: altarpiece consisting of a set of three painted panels, usually hinged so that the two wing panels fold over the larger central one to form a tabernacle. With more than three leaves, such an assemblage is called a polyptych.

troparion: in the Greek-Byzantine hymnody, the name *troparion* was given to short prayers written in poetic prose and inserted after each verse of a psalm. Such prayers were simple in structure and rhythmic in cadence, containing the essence of the sacred event or mystery, or life of the saint, being celebrated.

Tuchulca: Etruscan underworld demon, frequently represented on Etruscan sarcophagi, cinerary urns, and wall paintings in tombs. Like *Charun*, he is a fearsome figure. He has ass' ears, a vulture's beak, and snake-infested hair.

Turan: Etruscan goddess, the equivalent of the Greek Aphrodite, the goddess of love. Stories from *Turan's* life and representations of her entourage are frequently found engraved on Etruscan bronze mirrors of the classical period. In such scenes she is usually represented as a fully clothed, elegantly jeweled woman. *Turan's* most frequent companion on mirrors is *Atunis*, the Etruscan equivalent of Adonis; the lovers embrace in the company of other gods or attendant *lasas*. The female attendants surrounding *Turan* in these scenes are commonly referred to as the "Circle of Turan." Their essential role is that of *ornatrices*, whose business it is to attire and adorn the goddess. Some sixteen figures have been assigned to the Circle of Turan; their individual Etruscan names are conferred by their accompanying inscriptions.

tutulus: high cap, made of wool, in the form of a cone.

tybicen: musician who plays the pipes (*tibiae*).

tympanon: hand-held tambourine, formed by a membrane stretched over a frame or resonating cylinder.

Uriel: the name of this archangel (meaning "Light of God") is not recorded in the canonical books of the Bible, though it occurs in the apocryphal 2 Esdras. But in Jewish and cabbalistic tradition Uriel was prominent (together with Michael, Gabriel, and Raphael) as one of the great archangels who rule the four corners of the world.

Usil: Etruscan sun god. On Etruscan mirrors, Usil appears as a beardless youth, seminude, and wearing boots, with an aureole around his head. He carries a bow, the attribute of the Greek sun-god Apollo. His name, in Etruscan, means "sun."

Vanth: Etruscan female spirit whose role was to conduct the dead into the underworld. *Vanth* is a companion and helper of *Charun*. She is generally represented as a fair young woman, usually winged, without the gruesome aspect of other Etruscan demons. *Vanth*, like *lasa*, is perhaps the collective title for a genre of female spirits, generally young, fair, half-clad, wearing high boots, short chitons, and brandishing torches or flourishing snakes in their hands.

Victoria: Victoria, the Roman goddess of victory whose Greek equivalent was Nike. Represented with wings, crowned with laurel, and holding the branch of a palm tree in her hand, victory was one of the abstract cults (including clemency, concord, and peace) introduced into Roman state religion in the late Republic and became inseparable from Roman ruler worship. She was thus shown accompanying the deified Julius Caesar. Winged victories are a common motif in Roman imperial art, typically accompanying the victorious emperor in his chariot or crowning the triumphant emperor. In Christian iconography the winged Victory motif took on an allegorical meaning, the victory over death.

vir dolorum: man of sorrows, an iconographic motif very popular in fourteenth-century Italy. The suffering of Christ as an artistic subject emerged against the background of the rise of Franciscanism and gained added meaning following the harrowing experience of the Black Death (1348). The derivation of the motif is contested. Some scholars posit a Byzantine origin, and others regard it as a typically Florentine genre. Christ may be shown as the man of sorrows alone, with bared torso, drooping head, and the marks of the stigmata on his hands. Or he may be shown standing in his tomb, flanked by the Virgin, Saint John, or other saints.

volumen: roll or scroll of parchment or papyrus, from the Latin word for roll or book.

BIBLIOGRAPHY

Adler 1982
Adler, Mortimer. *The Angels and Us*. New York: Macmillan, 1982.

Albizzati 1920
Albizzati, C. "Saggio di esegesi sperimentale sulle pitture funerarie dei vasi italo-greci." *Dissertazioni Pontificia Accademia Romana di Archeologia* 14, 149–220.

Ancona 1994
Claudio Ridolfi. Un Pittore veneto nelle Marche del '600. Exh. cat. Ancona, 1994.

Andrén 1940
Andrén, A. *Architectural Terracottas from Etrusco-Italic Temples*. Leipzig:Lund, 1940.

Angelelli 1988
Angelelli, A. In *Imago Mariae*. Exh. cat. Rome, 1988.

Aquinas 1981
Aquinas, Thomas. *Summa Theologiae*, 5 vols. Westminster, Md.: Christian Classics, 1981.

Aufnah-Sello 1988
Aufnah-Sello, Gottfried. *Veit Stoss*. Munich: Albert Hirmer, 1988.

Baldini 1970
Baldini, U. *L'opera completa dell'Angelico*. Milan, 1970.

Bandera Viani 1988
Bandera Viani, M.-C. *Venezia, Museo delle Icone Bizantine e post Bizantine e Chiesa di San Giorgio dei Greci*. Bologna, 1988.

Banti 1969
Banti, L. *Il mondo degli Etruschi*. Rome, 1969.

Barbier de Montault 1867
Barbier de Montault, X. *La Bibliothèque Vaticane et ses annexes*. Rome, 1867.

Barlach 1981
Ernst Barlach Werke und Werkentwürfe aus fünf Jahrzehten. Ernst Barlach Katalog I. Plastik 1894–1937. Auswahl und Kommentar Elmer Jansen. Berlin, 1981.

Bartsch 1803–21
Bartsch, A. *Le Peintre-Graveur*. Vienna, 1803–21.

Bellori 1931
Bellori, G. P. *Le vite de' Pittori, Scultori et Architetti moderni*. 1672; Rome, 1931.

Bellosi 1966
Bellosi, L. "I Maestri del Colore." *Gentile da Fabriano*. Milan, 1966.

Bendinelli 1914
Bendinelli, G. "Antichità tudertine nel Museo Nazionale di Villa Giulia." In *Monumenti Antichi dell'Accademia Nazionale dei Lincei*, 23.

Bénézit 1959–62
Bénézit, E. *Dictionnaire critique et documentaire des peintres, sculpteurs, dessinateurs et graveurs*. 8 vols. Paris, 1959–62.

Benndorf and Schöne 1867
Benndorf, O., and R. Schöne. *Die Antiken Bildwerke des Lateranensichen Museums*. Leipzig, 1867.

Bentini 1992
Bentini, Jadranka. *Scarsellino—I misteri del Rosario*. Ferrara, 1992.

Berenson 1932
Berenson, B. *Italian Pictures of the Renaissance*. Oxford, 1932.

Berenson 1936
Berenson, B. *Pitture italiane del Rinascimento*. Milan, 1936.

Berenson 1963
Berenson, B. *Italian Pictures of the Renaissance. The Florentine School*. London, 1963.

Berenson 1968
Berenson, B. *Italian Pictures of the Renaissance. Central Italian and North Italian Schools*. London, 1968.

Bergamini 1991a
Bergamini, M. In New York 1991, 369–74.

Bergamini 1991b
Bergamini, M. "L'urna tudertina del 'Maestro di Enomao,' in quattro manoscritti del XVIII secolo." *Bolletino Monumenti Musei e Gallerie Pontificie* 11:133–62.

Bianchi Bandinelli 1965
Bianchi Bandinelli, R. "Naissance et dissociation de la koiné hellènistico-romaine." In *8éme Congrés International d'Archeologie Classique*. Paris, 1965.

Bianchi Bandinelli 1980
Bianchi Bandinelli, R. *Dall'ellenismo al medioevo*. Rome, 1980.

Bianco Fiorin 1995
Bianco Fiorin, M. *Icone della Pinacoteca Vaticana*. Vatican City, 1995.

Blaxer 1989
Blaxer, Howard A., Sr. *Angels: Their Origin, Nature, Mission and Destiny*. Parchment, 1989.

Bonfante 1977
Bonfante, L. "The Judgment of Paris, the Toilette of Malavisch, and a Mirror in the Indiana University Art Museum." *StEtr* 45 (1977):149–68.

Boros 1976
Boros, Ladislaus. *Angels and Men*. New York: Seabury Press, 1976.

Boskovits 1975
Boskovits, M. *Pittura fiorentina alla vigilia del Rinascimento*. Florence, 1975.

Brignetti and Faggin 1968
Brignetti, Raffaello, and Giorgio T. Faggin. *L'opera completa dei Van Eyck*. Milan, 1968.

Budapest-Kraków 1989
Gens Antiquissima Italiae. Antichità dall'Umbria a Budapest e Cracovia. Exh. cat. Perugia, 1989.

BullInst
Bullettino dell'Istituto di Corrispondenza Archeologica.

Bunson 1995
Bunson, Matthew. *The Angelic Doctor: The Life and World of St. Thomas Aquinas*. Huntington, Ind.: OSV, 1995.

Buranelli 1992
Buranelli, F. *Gli scavi a Vulci della società Vincenzo Campanari-Governo Pontificio (1835–1837)*. Rome, 1992.

Bussagli 1990
Bussagli, Marco. *Storia degli Angeli*. Milano, 1990.

Catechism
Catechism of the Catholic Church. English edition, 1994.

Cateni 1995
Cateni, G. *CSE, Italia 3,I*. Rome, 1995.

Cavalcaselle and Crowe 1897
Cavalcaselle, G. B., and J. A. Crowe. *Storia della Pitture Italiana*. Florence, 1897.

M. Chadzidakis 1962
Chadzidakis, M. *Icônes de Saint-Georges des Grecs et de la Collection de l'Institut Hellénique de Venise*. Venice, 1962.

N. Chadzidakis 1993
Chadzidakis, N. *Da Candia a Venezia, Icone greche in Italia XV–XVI secolo*. Athens, 1993.

CII
Fabretta, A. *Corpus Inscriptionum Italicarum*. Augusta Taurinorum 1867.

CIL
Corpus Inscriptionum Latinarum

Ciste
I,2, Bordenache Battaglia, G., and A. Emiliozzi. *Le ciste prenestine. Corpus*. Città di Castello, 1990.

Coarelli 1977
Coarelli, F. "Arte ellenistica e arte romana: la cultura figurativa in Roma fra II e I secolo a.C." In *Caratteri dell'ellenismo nelle urne etrusche, Atti dell'incontro di studi nell'Università di Siena. Siena, 1976*. Florence, 1977, 35 ss.

Collins 1947
Collins, James D. *The Thomistic Philosophy of the Angels*. Washington, D.C.: Catholic University Press, 1947.

Collobi-Ragghianti 1955
Collobi-Ragghianti, L. "Studi Angelichiani." In *Critica d'Arte* 9 (1955):39.

Colonna 1994
Colonna, G. "A proposito degli dei del fegato di Piacenza." *Studi Etruschi* 59, 123–39.

Colonna 1996
Colonna, G. "Roma arcaica e le vie per i Colli Albani." *Alba Longa. Mito storia archeologia, Atti dell'incontro di studio (Roma-Albano Laziale, 1994)*. Rome, 1996.

Cordellier and Py 1992
Cordellier, Dominique, and Bernardette Py. *Raffaello e i Suoi*. Rome, 1992.

Corti and Faggin 1969
Corti, Maria, and Giorgio T. Faggin. *L'opera completa di Memling*. Milan, 1969.

Crowe and Cavalcaselle 1864–66
Crowe, J. A., and G. B. Cavalcaselle. *A New History of Painting in Italy from the Second to the Sixteenth Century*. London, 1864–66.

Crowe and Cavalcaselle 1869–76
Crowe, J. A., and G. B. Cavalcaselle. *Geschichte der Italienischen Malerei*. Leipzig, 1869–76.

CSE
Corpus Speculorum Etruscorum.

CUE
II,1, *Corpus delle urne etrusche di età ellenistica. Urne volterrane. Il Museo Guarnacci*. Florence, 1977.

D'Achiardi 1929
D'Achiardi, P. *I quadri primitivi della Pinacoteca Vaticana provenienti dalla Biblioteca Vaticana e dal Museo Cristiano*. Rome, 1929.

Danielou 1957
Danielou, Jean. *The Angels and Their Mission*. Westminster, Md.: The Newman Press, 1957.

Davidson 1971
Davidson, Gustav. *A Dictionary of Angels*. New York: Free Press, 1971.

Deichmann 1967
Deichmann, F. W. *Repertorium der Christlich-Antiken Sarkophage. 1. Rom und Ostia*. Wiesbaden, 1967.

De Marchi 1992
De Marchi, Andrea. *Gentile da Fabriano. Un viaggio nella pittura italiana alla fine del gotico.* Milan, 1992.

Dennis 1848
Dennis, G. *The Cities and Cemeteries of Etruria.* London, 1848.

De Puma 1985
De Puma, R. D. "An Etruscan Lasa Mirror." In *Muse* 19:44–55.

De Puma 1987
De Puma, R. D. *CSE, U.S.A. 1.* Ames, 1987.

De Ridder 1913–15
De Rider, A. *Les bronzes antiques du Louvre* I–II. Paris, 1913–15.

Der Parthog 1995
Der Parthog, Gwynneth. *Byzantine and Medieval Cyprus.* New Barnet, 1995.

Descemet 1880
Descemet, C. "Pitture medioevali e cristiane contenute nelle XX vetrine della vaticana. Inventario descrittivo." Ms. Rome, 1880. Archivio Storicl Musei Vaticani, cc. 231–32.

Dimitry of Rostov 1984
Dimitry of Rostov, Saint. *Angels and the Other Heavenly Bodiless Powers.* Eastern Orthodox Press, 1984.

Dohrn 1961
Dohrn, T. "Pergamenisches in Etrurien." In RM 68:1–8.

Dohrn 1963
Dohrn, T. In Helbig 1963.

Drakos 1995
Drakos, Mary. *Angels of God, Our Guardians Dear: Today's Catholics Re-discover Angels.* Ann Arbor, Mich.: Charis Books, 1995.

Dürer 1971
Albrecht Dürer 1471–1971. Exh. cat. Germanisches Nationalmuseum Nürnberg. Munich, 1971.

EAA
Enciclopedia dell'Arte Antica Classica e Orientale. Rome, 1958– .

Enciclopedia Cattolica
Enciclopedia Cattolica. Vatican City, 1948–54.

Enggass 1964
Enggass, R. *The Painting of Baciccio, Giovan Battista Gaulli, 1639–1709.* University Park, Pa., 1964.

Felicetti-Libenfels 1972
Felicetti-Libenfels, W. *Geschichte der Russischen Ikonenmalerei.* Graz, 1972.

Von Freytag Gen Löringhoff 1990
Von Freytag Gen Löringhoff, B. *CSE. Bundesrepublik Deutschland 3.* Munich, 1990.

ES
Gerhard, E. *Etruskische Spiegel* 1–4. Berlin, 1840–67.

ES, V
Klügmann, A., and G. Körte. *Etruskische Spiegel* 5. Berlin, 1884–97.

Fischer Graf 1980
Fischer Graf, U. *Spiegelwekstätten in Vulci.* Berlin, 1980.

Fiumi 1976
Fiumi, E. *Volterra. Il Museo Etrusco e i Monumenti Antichi.* Pisa, 1976.

Forte 1991
Forte, M. *Le terrecotte ornamentali dei templi lunensi.* Florence, 1991.

Forte 1992
Forte, M. "La coroplastica templare etrusca fra il IV e il II secolo a.C." In *Atti del XVI Convegno di Studi Etruschi ed Italici (Orbetello 1988).* Florence, 1992.

Gabelein 1987
Gabelein, A. C. *What the Bible Says about Angels.* Baker, 1967.

Gerhard and Platner 1834
Gerhard, E., and E. Platner. *Beschreibung der Stadt Rom* 2.2. Stuttgart-Tübingen, 1834.

Giglioli 1935
Giglioli, G. Q. *L'arte etrusca.* Milan, 1935.

Godwin 1990
Godwin, Malcolm. *Angels: An Endangered Species.* New York: Simon & Schuster, 1990.

Godwin 1995
Godwin, Malcolm. *Engel-eine bedrohte Art.* Munich, 1995.

Gori 1737
Gori, A. F. *Museum Etruscum exhibens insigna veterum Etruscorum Monumenta aerei tabulis CC nunc primum edita et illustrata.* 1–2. Florence, 1737.

Graham 1986
Graham, Billy. *Angels: God's Secret Angels.* Random House, 1986.

Hamann 1964
Hamann, Richard. *Geschichte der Kunst* 4. Munich and Zurich, 1964.

Hamann-McLean 1976
Hamann-McLean, Richard. *Die Monumentalmalerei in Serbien und Makedonien.* 2. *Grundlegung.* Giessen, 1976.

Haynes 1985
Haynes, S. *Etruscan Bronzes.* London-New York, 1985.

Helbig 1912
Helbig, W., W. Amelung, E. Reisch, and F. Weege. *Führer durch die öffentlichen Sammlungen klassischer Altertümer in Rom* 1. Leipzig, 1912.

Helbig 1963
Helbig, W., and H. Speier. *Führer durch die öffentlichen Sammlungen klassischer Altertümer in Rom.* 1. *Die Päpstlichen Sammlungen im Vatikan und Lateran.* Tübingen, 1963.

Helsinki 1982
Ars Vaticana. Exh. cat. Helsinki: Art Museum of the Ateneum, 1982.

Herbig 1952
Herbig, R. *Die jüngeretruskischen Steinsarkophage.* Berlin, 1952.

Herbig 1965
Herbig, R. *Götter und Dämonen der Etrusker.* Mainz, 1965.

Heres 1986
Heres, G. *CSE, Deutsche Demokratische Republik, 1, Berlin-Staatliche Museen, Antikensammlung.* Berlin, 1986.

Heres 1987
Heres, G. *CSE, Deutsche Demokratische Republik, 2.* Berlin, 1987.

Hind 1938
Hind, A. M. *Early Italian Engraving.* Part I, *Florentine Engravings and Anonymous Prints of Other Schools.* London, 1938.

Höckmann 1987a
Höckmann, U. *CSE, Bundesrepublik Deutschland 1.* Munich, 1987.

Höckmann 1987b
Höckmann, U. "Die Datierung der hellenisch-etruskischen Griffspiegel des 2. Jahrhunderts v. Chr." *Jahrbuch des Deutschen Archäologischen Instituts* 102:247–89.

Joannides 1985
Joannides, P. "A Masolino Partially Reconstructed." *Source Notes in the History of Art* 4 (1985):105.

Körte 1890
Körte, G. *I rilievi delle urne etrusche* 2, 1. Rome-Berlin, 1890.

Ladner 1955
Ladner, Gerhart Burion. *God, Cosmos, and Humankind—The World of Early Christian Symbolism.* Berkeley, Los Angeles, London, 1995.

Lambrechts 1987
Lambrechts, R. *CSE, Belgique 1.* Rome, 1987.

Lateran Guidebook 1986
Buono, R. *Il Museo di San Giovanni in Laterano.* Rome, 1986.

Lazović and Frigeriou-Zeniou 1985
Lazović, M., and S. Frigeriou-Zeniou. *Les icônes du Musée d'art et d'histoire, Genève.* Geneva, 1985.

Liepmann 1988
Liepmann, U. *CSE, Bundesrepublik Deutschland 2.* Munich, 1988.

LIMC
Lexicon Iconographicum Mythologiae Classicae. Zurich-Munich, 1981– .

Long 1970
Long, Valentine. *The Angels in Religion and Art.* Paterson, N. J.: St. Anthony Guild, 1970.

Maggiani 1989
Maggiani, A. "Un Artista itinerante: il maestro di Enomao." *Atti del secondo congresso internazionale etrusco (Firenze 26 Maggio-2 giugno 1985).* Rome, 1989, 995–1000.

Mancinelli 1984
Mancinelli, F. "Raffaello Sanzio (1483–1520): Frammento dell'abbozzo di un angelo della *Cacciata di Eliodoro.*" *Raffaello in Vaticano,* eds. Fabrizio Mancinelli, Anna Maria De Strobel, Giovanni Morello, and Arnold Nesselrath. Rome, 1984, 194–95.

Mancinelli 1990
See Paris 1990.

Mancinelli 1993
Mancinelli, Fabrizio. "Cappella Sistina." In Angelo Tartuferi, ed. *Michelangelo-Pittore, scultore ed architetto.* Bagno a Ripoli, 1993.

Mangani 1985
Mangani, E. "Le fabbriche di specchi nell'Etruria settentrionale." *Bollettino d'Arte* 33–34:21–40.

Mansuelli 1946–47
Mansuelli, G. A. "Gli specchi figurati etruschi." *StEtr* 19:9–137.

Mansuelli 1948–49
Mansuelli, G. A. "Studi sugli specchi etruschi." *StEtr* 20:59–98.

Martelli 1941
Martelli, G. L. *Storia degli specchi etruschi. Sec. IV.* Perugia, 1941.

Marucchi 1910
Marucchi, O. *I Monumenti del Museo Cristiano Pio Lateranense.* Milan, 1910.

MEFRA
Mélanges de l'école française de Rome, Antiquité.

Mexico City 1993
Colegio di San Ildefonso. *Tesoros Artisticos del Vaticano. Arte y Cultura de Dos Milenos.* Exh. cat. Mexico City, 1993.

Micali 1821
Micali, G. *Antichi monumenti per servire all'opera intitolata l'Italia avanti il dominio dei Romani.* Florence, 1821.

Michl 1962
Michl, J. "Engel IV (christlich)." *Reallexikon für Antike und Christentum* 5. Stuttgart, 1962, cc. 109–200.

Milan 1974
Fallani, G., V. Mariani, and G. Mascherpa. *Collezione Vaticana d'Arte Religiosa Moderna.* Ed. M. Ferrazza and P. Pignatti. Exh. cat. Milan: Silvana Editoriale d'Arte, 1974.

Milan 1984
Raffaello in Vaticano. Exh. cat. Milan, 1984.

Milani 1898
Milani, L. A. *Museo Topografico dell'Etruria.* Florence-Rome, 1898.

Millet 1916
Millet, G. *Recherches sur l'iconographie de l'évangile aux XIVe, XVe e XVIe siècles.* Paris, 1916.

Montano 1955
Montano, Edward J. *The Sin of the Angels: Some Aspects of the Teaching of St. Thomas.* Washington, D.C.: Catholic University of America, 1955.

Monumenti del Museo Etrusco …
Monumenti del Museo Etrusco Vaticano acquistati dalla munificenza di Gregorio XVI, Pontefice Massimo e per di lui ordine disegnati e pubblicati. Ed B. Rome, 1842.

Muñoz 1928
Muñoz, A. *I quadri bizantini della Pinacoteca Vaticana.* Rome, 1928.

Musei Etrusci … monimenta
Musei Etrusci quo Gregorius XVI Pon. Max. in aedibus Vaticanis constituit monimenta linearis picturae exemplis expressa et in utilitatem studiosorum antiquitatum et bonarum artium publici iuris facta. Ed A. Rome, 1842.

Nagel 1994
Nagel, Alexander. *Engel der Liebe.* Munich, 1994.

National Gallery 1961
Davies, M. *The Earlier Italian Schools.* National Gallery Catalogues, 2nd edition. London, 1961.

National Gallery of Art 1973
Levenson, J. A., and others. *Early Italian Engravings from the National Gallery of Art.* Washington, 1973.

Nesselrath 1993
Nesselrath, Arnold. "La Stanza d'Eliodoro." *Raffaello nell'appartamento di Giulio II e Leone X.* Milan, 1993, 202–45.

New York 1982
New York, The Metropolitan Museum of Art; The Art Institute of Chicago; The Fine Arts Museums of San Francisco, *Vatican Collections: The Papacy and Art.* Exh. cat. New York, 1982.

New York 1991
Gens Antiquissima Italiae. Antichità dall'Umbria a New York. Exh. cat. Perugia, 1991.

Nielsen 1975
Nielsen, M. "The Lid Sculptures of Volterran Cinerary Urns." *Acta Instituti Romani Finlandiae* 5:265–404.

Nielsen 1988
Nielsen, M. "Women and Family in a Changing Society: A Quantitative Approach to Late Etruscan Burials." *Analecta Romana* 17–18:53–98.

Nielsen 1992
Nielsen, M. "Portrait of a Marriage: The Old Etruscan Couple from Volterra." *Acta Hyperborea* 4:89–141.

Nigg and Gröning 1978
Nigg, Walter, and Karl Gröning. *Bleibt, Ihr Engel, bleibt bei mir.* Berlin, 1978.

Nogara 1933
Nogara, B. *Guide du Musée Etrusco-Grégorien du Vatican.* Vatican City, 1933.

NotSc
Notizie degli Scavi di Antichità.

Novelli 1955
Novelli, Anna Maria. *Lo Scarsellino.* Bologna, 1955.

Novelli 1964
Novelli, Anna Maria. *Lo Scarsellino.* Milan, 1964.

Oberhuber 1983
Oberhuber, Konrad. *Polarität und Synthese in Raphaels "Schule von Athen."* Stuttgart, 1983.

Offner 1947
Offner, R. *A Critical and Historical Corpus of Florentine Painting.* Brattleboro, Vt., 1947.

Ottawa 1986
Ottawa, Canada. *Vatican Splendour: Masterpieces of Baroque Art.* Exh. cat. The National Gallery of Art, 1986.

Ottley 1816
Ottley, W. Y. *An Inquiry into the Origin and Early History of Engraving.* London, 1816.

Ouspensky and Lossky 1982
Ouspensky, L., and V. Lossky. *The Meaning of Icons.* New York, 1982.

Pairault 1972
Pairault, F. H. *Recherches sur quelques series d'urnes de Volterra à représentations mythologiques.* Rome, 1972.

Pairault 1977
Pairault, F. H. "Ateliers d'urnes et histoire de Volterra." *Caratteri dell'ellenismo nelle urne etrusche.* Atti dell'incontro di studi nell'Università di Siena. Siena, 1976. Florence, 1977, 154–67.

Pairault 1978
Pairault, F. H. "Une représentation dionysiaque méconnue. L'urne de Chiusi E39-40 du Musée de Berlin." *MEFRA* 90:197–234.

Pairault 1979
Pairault, F. H. *La maison aux salles souterraines, Fouilles de l'Ecole Français de Rome a Bolsena (Poggio Moscini) V/1.* Rome, 1979.

Pallottino 1930
Pallottino, M. "Uno specchio da Tuscania e la leggenda etrusca di Tarchon." *Rendiconti della R. Accademia Nazionale dei Lincei. Classe di scienze morali, storiche e filogiche* 6,6 (1930):49–87.

Paris 1990
Mancinelli, F. *Trésors du Vatican. La Papauté à Paris.* Exh. cat. Paris, 1990.

Passavant 1860–64
Passavant, J. D. *Peintre-Graveur.* Leipzig, 1860–64.

Passelecq and Poswick 1979
Passelecq, G., and F. Poswick. *Concordanza Pastorale della Bibbia.* Bologna, 1979.

Peterson 1964
Peterson, Erik. *The Angels and the Liturgy.* New York: Herder & Herder, 1964.

Pfiffig 1975
Pfiffig, A. J. *Religio etrusca.* Graz, 1975.

Pfister-Roesgen 1975
Pfister-Roesgen, G. *Die etruskischen Spiegel des 5.Jhs.v.Chr.* Bern-Frankfurt, 1975.

Pietrangeli 1982
Pietrangeli, C. "La Pinacoteca Vaticana di Pio VI." *Monumenti Musei e Gallerie Pontificie. Bollettino* 3 (1982).

Pietrangeli 1983
Pietrangeli, C. *Opere di provenienza tuderte nei Musei Vaticani.* Todi, 1983.

Pietrangeli 1983b
Pietrangeli, C. *Saint Michael and the Angels.* Rockford, Ill.: Tan Books, 1983.

Pietrangeli 1985
Pietrangeli, C. *I Musei Vaticani. Cinque secoli di storia.* Rome, 1985.

Pietrangeli 1993
Pietrangeli, C. *The Vatican Museums.* Translated by Peter Spring. Rome: Edizioni Quasar, 1993.

Pinacoteca Vaticana 1987
Volbach, W. F. *Il Trecento. Firenze e Siena.* Vol. 2 of *Catalogo della Pinacoteca Vaticana.* Vatican City: Monumenti, Musei e Gallerie Pontificie, 1987.

Pinacoteca Vaticana 1992
Pinacoteca Vaticana. Milan, 1992.

Pinacoteca Vaticana 1994
Rossi, F. *Il Trecento. Umbria, Marche, Italia del Nord.* Vol. 3 of *Catalogo della Pinacoteca Vaticana.* Vatican City: Monumenti, Musei e Gallerie Pontificie, 1994.

Pistolesi 1829–38
Pistolesi, E. *Il Vaticano descritto e illustrato.* Rome, 1829–38.

Pope-Hennessy 1952
Pope-Hennessy, J. *Fra Angelico.* London, 1952.

Pope-Hennessy 1971
Pope-Hennessy, J. *Italian Renaissance Sculpture.* London, 1971.

Proietti 1980
Proietti, G., ed. *Il Museo Nazionale Etrusco di Villa Giulia.* Rome, 1980.

Rallo 1974
Rallo, A. *Lasa. Iconografia e esegesi.* Florence, 1974.

RE
Pauli, A., and G. Wissowa. *Realencyclopädie der klassischen Altertumwissenschaft.*

Réau 1955–59
Réau, L. *Iconographie de l'art chrétien.* 6 vols. Paris, 1955–59.

Rebuffat-Emmanuel 1973
Rebuffat-Emmanuel, D. *Le miroir étrusque d'après la collection du Cabinet des Médailles.* Rome, 1973.

Rebuffat-Emmanuel 1988
Rebuffat-Emmanuel, D. *CSE, France 1,I. Paris-Musée du Louvre.* Rome, 1988.

Régamcy 1960
Régamcy, Raymond. *What Is an Angel?* Translated by Dom Mark Pontifex. New York: Hawthorn, 1960.

Richter 1915
Richter, G. M. A. *Greek, Etruscan and Roman Bronzes, Metropolitan Museum of Art.* New York, 1915.

RM
Mitteilungen des Deutschen Archäologischen Instituts. Römische Abteilung.

Rome 1975
Tesori di Arte Sacra di Roma e del Lazio dal Medioevo all'Ottocento. Exh. cat. Rome, 1975.

Rome 1984
Raffaello in Vaticano. Ed. F. Mancinelli, A. M. De Strobel, G. Morello, and A. Nesselrath. Exh. cat. Rome, 1984.

Rome 1996
Tertium ad Millennium. Arte dai luoghi della Fede e della Speranza. Exh. cat. Rome, 1996.

Roscher 1884–1937
Roscher, W. H. *Ausfürliches Lexicon der griechischen und römischen Mythologie* 1–6 (1884–1937).

Salmi 1958
Salmi, M. *Beato Angelico.* Spoleto, 1958.

Salskov Roberts 1981
Salskov Roberts, H. *CSE, Denmark 1.* Odense, 1981.

Salskov Roberts 1983
Salskov Roberts, H. "Later Etruscan Mirrors. Evidence for Dating from Recent Excavations." *Analecta Romana* 12.

Sannibale 1994
Sannibale, M. *Le urne cinerarie di età ellenistica.* Museo Gregoriano Etrusco, Cataloghi, 3. Rome, 1994.

Sassatelli 1981a
Sassatelli, G. *CSE, Italia 1, I.* Rome, 1981.

Sassatelli 1981b
Sassatelli, G. *CSE, Italia 1, II.* Rome, 1981.

Schlégl and Cinotti 1966
Schlégl, István, and Mia Cinotti. *Das Gesamtwerk von Hieronymus Bosch.* Lucerne, Freudenstadt, and Vienna, 1966.

H. and M. Schmidt 1989
Schmidt, Heinrich, and Margarethe Schmidt. *Die vergessene Bildsprache christlicher Kunst.* Munich, 1989.

Sciascia and Mandel 1967
Sciascia, Leonardo, and Gabriele Mandel. *L'opera completa di Antonello da Messina.* Milan, 1967.

Seoul 1994
Images of the Eternal. Exh. cat. Seoul: National Museum of Modern Art, 1994.

Seroux d'Agincourt 1814
Seroux d'Agincourt, J. B. L. G. *Recueil de fragmens de sculpture antique en terre cuite.* Paris, 1814.

Sestieri 1994
Sestieri, G. *Repertorio della pittura romana della fine del seicento e del settecento.* Turin, 1994.

Shearman 1986
Shearman, John. "The Expulsion of Heliodorus." *Raffaello a Roma—Il convegno del 1983.* Rome, 1986, 75–87.

Shearman 1987
Shearman, John. "Raphael's Clouds, and Correggio's." *Studi su Raffaello.* Ed. M. Sambucco Hamoud and M. Letizia Strocchi. Atti del Congresso Internazionale di Studi. Urbino-Firenze, 6–14 aprile 1984. Urbino, 1987, 657–68.

Sinn 1991
Sinn, F. *Vatikanische Museen. Museo Gregoriano Profano ex Lateranense. Katalog der Skulpturen. Die Grabdenkmäler 1. Reliefs Altäre Urnen.* Mainz, 1991.

Sirén 1906
Sirén, O. "Notizie critiche sui quadri sconosciuti nel Museo Cristiano Vaticano." *L'Arte* 9 (1906).

Spinola 1987
Spinola, G. "Vanth, Osservazioni iconografiche." *Rivista di Archeologia* 11:56–67.

Steingräber 1985
Steingräber, S. *Catalogo ragionato della pittura etrusca.* Milan, 1985.

StEtr
Studi Etruschi.

Szilágyi and Bouzek 1992
Szilágyi, J. G., and J. Bouzek. *CSE, Hongrie-Tchécoslovaquie.* Rome, 1992.

Testa 1989
Testa, A. *Candelabri e thymiateria.* Museo Gregoriano Etrusco, Cataloghi, 2. Rome, 1989.

Thieme-Becker 1907–50
Thieme, U., and F. Becker. *Allgemeines Lexikon der Bildenden Kuenstler.* 37 vols. Leipzig, 1907–50.

Thomson de Grummond 1982
Thomson de Grummond, N. *A Guide to Etruscan Mirrors.* Tallahassee: Department of Classics, Florida State University, 1982.

Todi 1982
Verso un museo della città. Exh. cat. Todi, 1982.

Tokyo 1989
Tokyo, The National Museum of Western Art; Fukuoka City Museum; and Kyoto, The National Museum of Modern Art, *Masterpieces from the Vatican.* Exh. cat. 1989.

Tomko 1986
Tomko, Terrie. *The Book of Angels.* St. Paul's, 1986.

Toscanelli 1933–34
Toscanelli, N. *Pisa nell'antichità dalle età preistoriche alla caduta dell'impero romano,* 1–2. Pisa, 1933–34.

Trendall 1953–55
Trendall, A. D. *Vasi antichi dipinti del Vaticano. Vasi italioti ed etruschi a figure rosse,* 1–2. Vatican City, 1953–55.

Trendall 1976
Trendall, A. D. *Vasi antichi dipinti del Vaticano. Vasi italioti ed etruschi a figure rosse di età ellenistica. La Collezione Astarita nel Museo Gregoriano Etrusco.* Vatican City, 1976.

Trendall and Cambitoglou 1978–82
Trendall, A. D., and A. Cambitoglou. *The Red-figured Vases of Apulia* 1–2. Oxford, 1978–82.

Underhill 1994
Underhill, James. *Angels.* Shaftesbury, Dorset: Element, 1994.

Van der Meer 1983
Van der Meer, L. B. *CSE, The Netherlands.* Leiden, 1983.

Van der Meer 1995
Van der Meer, L. B. *Interpretatio Etrusca. Greek Myths on Etruscan Mirrors.* Amsterdam, 1995.

Van Marle 1924
Van Marle, R. *The Development of the Italian Schools of Painting,* vol. 3. The Hague, 1924.

Varazze 1995
Varazze, Iacopo da. *Legenda Aurea.* Ed. A. and L. Vitale Brovarone. Turin: Einaudi, 1995.

Vasari 1906
Vasari, Giorgio. *Le Opere.* Ed. Gaetano Milanesi. Florence, 1906.

Vasari-Milanesi 1878–85
Vasari, G. *Le Vite de' più eccellenti pittori scultori ed architettori.* Florence, 1568; ed. G. Milanesi, Florence, 1878–85.

Vasari-Milanesi 1906
Vasari, G. *Le Vite de' più eccellenti pittori scultori ed architettori.* Florence, 1568; ed. G. Milanesi, 1878–85, repr. 1906.

Vatican 1933
Guida alla Pinacoteca Vaticana. Vatican City, 1933.

Vatican 1934
Guida alla Pinacoteca Vaticana. Vatican City, 1934.

Vatican 1993
La Pinacoteca Vaticana. Catalogo Guida. Vatican City, 1993.

Vatican City 1974
Ferrazza, M., and P. Pignatti. *L'Appartamento Borgia e l'Arte Contemporanea in Vaticano.* Exh. cat. Vatican City: Edizioni Musei e Gallerie Pontificie, 1974.

Vatican City 1981
Bernini in Vaticano. Exh. cat. Vatican City, 1981.

Vatican City 1984–85
Raffaello in Vaticano. Exh. cat. Vatican City, 1984–95.

Vatican City 1990
Saint, Site and Sacred Strategy. Ignatius, Rome and Jesuit Urbanism. Exh. cat. Vatican City, 1990.

Vaticano 1987
Buranelli, F., ed. *La tomba François di Vulci.* Exh. cat. Vatican City, 1987.

Vaticano 1988
Gens Antiquissima Italiae. Antichità dall'Umbria in Vaticano. Exh. cat. Perugia, 1988.

Veit Stoss in Nürnberg. Werke des Meisters und seiner Schule in Nürnberg und Umgebung. Munich, 1983.

Volterra-Chiusi 1985
Artigianato artistico. L'Etruria settentrionale interna in età ellenistica. Exh. cat. Milan, 1985.

Walsh 1984
Walsh, Michael, ed. *Butler's Lives of the Saints.* San Francisco: Harper & Row, 1984.

Walters 1899
Walters, H. B. *Catalogue of the Bronzes: Greek, Roman and Etruscan in the Department of Greek and Roman Antiquities, British Museum.* London, 1899.

Ward 1969
Ward, Theodore. *Men and Angels.* New York: Viking Press, 1969.

Wiman 1990
Wiman, I. M. B. *Malstria-Malena. Metals and Motifs in Etruscan Mirror Craft.* Göteborg, 1990.

Winkler 1936
Winkler, Friedrich. *Die Zeichnungen Albrecht Dürers.* Vol. 1 (1484–1502). Berlin, 1936.

Wirth
Wirth, Karl August. "Engel." *Lexikon der christlichen Ikonographie.* Vol. 19. cc. 627–42.

Zimmer 1995
Zimmer, G. *CSE, Bundesrepublik Deutschland 2, Staatliche Museen zu Berlin. Antikensammlung 2.* Munich, 1995.

Zucker 1994
Zucker, M. J. *The Illustrated Bartsch,* XXIV (Commentary), Part 2, Le Peintre-Graveur 13, Part 1, *Early Italian Masters.* New York, 1994, 85–86, cat. .066; 86–88, cat. .067.

LIST OF EXHIBITED WORKS

Andrea da Firenze (Andrea Bonaiuto), *Crucifixion with Mary, Saint John the Evangelist, and a Dominican Friar*, c. 1370–77, Vatican Museums inv. 40118, cat. 41, p. 162.

Angelico, Fra (Guido di Pietro), *Madonna and Child with Saints Dominic and Catherine of Alexandria*, c. 1435, Vatican Museums inv. 40253, cat. 53, p. 190.

Angelico, Fra (Guido di Pietro), *Saint Francis Receiving the Stigmata*, c. 1440, Vatican Museums inv. 40258, cat. 66, p. 221.

Apulia, Southern Italy, *Askos with a Seated Woman and Eros*, c. 330–310 B.C., Vatican Museums inv. 18109, cat. 15, p. 108.

Apulia, Southern Italy, *Krater with Column-like Handles*, c. 330–320 B.C., Vatican Museums inv. 18079, cat. 14, p. 106.

Apulia, Southern Italy, *Red-figured Pelike*, Vatican Museums inv. 18129, cat. 13, p. 104.

Baciccia (Giovanni Battista Gaulli), *Concert of Angels*, c. 1672, Vatican Museums inv. 40752, cat. 2, p. 81.

Baciccia (Giovanni Battista Gaulli), *The Vision of Saint Francis Xavier*, c. 1675, Vatican Museums inv. 41489, cat. 67, p. 224.

Bambaia (Agostino Busti), workshop or circle of, *Madonna and Child with Angels*, Vatican Museums inv. 44089, cat. 54, p. 192.

Barberini Tapestry Manufactory, *The Union of the Duchy of Urbino with the Church*, 1669–70, Vatican Museums inv. 43922, cat. 76, p. 248.

Barocci (Federico Fiori), *The Annunciation*, 1582–84, Vatican Museums inv. 40376, cat. 47, p. 176.

Bartolo di Fredi and workshop, *The Annunciation to Joachim*, Vatican Museums inv. 40153, cat. 59, p. 204.

Bartolo di Fredi and workshop, *Nativity and Adoration of the Shepherds*, Vatican Museums inv. 40268, cat. 34, p. 148.

Bernardino di Mariotto dello Stagno, *Madonna and Child between Saints Severino and Dominic, "Madonna delle Rose,"* 1512, Vatican Museums inv. 40328, cat. 55, p. 194.

Bernini, Gian Lorenzo, workshop of, *Three Statues of Angels with Instruments of the Passion*, 17th century, Pontifical Sacristy, cat. 40, p. 160.

Brandi, Giacinto, attributed to, *Christ in the Garden of Gethsemane*, mid 17th century, Vatican Museums inv. 40837, cat. 74, p. 242.

Buglioni, Benedetto, *Wreath with the Coat of Arms of Pope Innocent VIII Supported by Two Angels*, c. 1484–87. Vatican Museums inv. 44087, cat. 1, p. 75.

Capponi, Luigi, and workshop, *Two Angels*, c. 1500, Vatican Museums invs. 31320 and 31321, cat. 92, p. 284.

Carracci workshop, attributed to, *An Angel Frees the Souls of Purgatory through the Intercession of the Virgin Mary and the Saints*, c. 1610, Vatican Museums inv. 42523, cat. 78, p. 252.

Carracci, Annibale, workshop of (Domenichino?), *Translation of the Holy House*, early 17th century, Church of S. Onofrio, Madruzzo Chapel, Rome, cat. 77, p. 250.

Carracci, Ludovico, *The Trinity with the Dead Christ*, c. 1590, Vatican Museums inv. 41249, cat. 98, p. 306.

Casorati, Felice, *Angel in the Night*, c. 1961, Vatican Museums inv. 24019, cat. 75, p. 244.

Ciminaghi, Virginio, *The Annunciation*, 1967, Vatican Museums inv. 23116, cat. 46, p. 174.

Coaci, Vincenzo, workshop of, *Chalice*, c. 1795, Basilica of Santa Maria Maggiore, Rome, cat. 85, p. 268.

Conca, Sebastiano, *Christ in the Garden of Gethsemane*, 1746, Vatican Museums inv. 40779, cat. 37, p. 154.

Cretan School, *Angelic Choir of the Nativity*, mid 16th century, Vatican Museums inv. 40031, cat. 3, p. 82.

Cretan School, *The Dormition of the Mother of God*, late 16th century, Vatican Museums inv. 40072, cat. 51, p. 187.

Crosier with Saint Michael, 19th century, Pontifical Sacristy, cat. 88, p. 274.

Dalí, Salvador, *Angelic Landscape*, 1977, Vatican Museums inv. 23719, cat. 80, p. 256.

Etruscan, *Antefix*, 2nd century B.C., Vatican Museums inv. 14119, cat. 22, p. 122.

Etruscan, *Engraved Mirror*, Vatican Museums inv. 12262, cat. 19, p. 116.

Etruscan, *Engraved Mirror*, Vatican Museums inv. 12647, cat. 16, p. 110.

Etruscan, *Engraved Mirror*, early 5th century B.C., Vatican Museums inv. 12250, cat. 11, p. 100.

Etruscan, *Engraved Mirror*, 2nd half 3rd century B.C., Vatican Museums inv. 12269, cat. 20, p. 118.

Etruscan, *Patera with Handle Representing a Female Figure*, 4th century B.C., Vatican Museums inv. 12275, cat. 17, p. 112.

Etruscan, *Type A Candelabrum*, 2nd half 5th–late 4th century B.C., Vatican Museums inv. 12406, cat. 18, p. 114.

Etruscan, Master of Oinomaos, *Cinerary Urn*, 1st quarter 2nd century B.C., Vatican Museums inv. 13887, cat. 21, p. 121.

Flemish Tapestry Manufactory, Brussels, *The Holy Family*, 1490–1505, Vatican Museums inv. 43832, cat. 48, p. 178.

French, *Processional Cross of Pope Leo XIII*, late 19th century, Pontifical Sacristy, cat. 87, p. 272.

Gaddi, Agnolo (?), *The Apparition of Saint Michael to Saint Gregory*, c. 1390, Vatican Museums inv. 40528, cat. 71, p. 233.

Gentile da Fabriano and workshop, *The Annunciation*, c. 1425, Vatican Museums inv. 40601, cat. 9, p. 94.

Il Ghirlandaio (Domenico Bigordi), and workshop, *The Nativity*, c. 1492, Vatican Museums inv. 40344, cat. 33, p. 146.

Ghissi, Francescuccio, attributed to, *The Deceased Christ and the Adoration of the Infant Jesus*, after 1373, Vatican Museums inv. 40244, cat. 35, p. 150.

Giaquinto, Corrado, circle of, *Satan before the Lord*, mid-18th century, Vatican Museums inv. 40800, cat. 5, p. 86.

Giovanni del Biondo, *The Virgin of the Apocalypse with Saints and Angels*, c. 1355–60, Vatican Museums inv. 40014, cat. 60, p. 207.

Giovanni di Paolo, *The Annunciation*, Vatican Museums inv. 40131, cat. 8, p. 92.

Giovanni di Paolo, *Saint Michael the Archangel*, c. 1440, Vatican Museums inv. 40128, cat. 93, p. 286.

Goa (India), *Reliquary of Saint Francis Xavier*, 20th century, Pontifical Sacristy, cat. 68, p. 226.

Guercino (Giovanni Francesco Barbieri), *The Penitent Magdalen*, 1622, Vatican Museums inv. 40391, cat. 43, p. 166.

Italian, *Liturgical Vestments*, 2nd half 19th century, Basilica of Santa Maria Maggiore, Rome, cat. 91, p. 280.

Italian, *Monstrance with Saint Michael*, mid-18th century, Basilica of Saint John Lateran, Rome, cat. 7, p. 90.